Sculpture in the Age of Doubt

Thomas McEvilley

School of
VISUAL ARTS

ALLWORTH PRESS
NEW YORK

04 03 02 01 00 99 5 4 3 2 1

Published by Allworth Press
An imprint of Allworth Communications
10 East 23rd Street, New York NY 10010

Copublished with the School of Visual Arts

Cover and book design by James Victore, Beacon, NY
Page composition by Sharp Des!gns, Lansing, MI

Back cover photo © 1999 Bill Beckley
Author's photo, back flap Maura Sheehan
Cover photo: *Device to Root Out Evil,* 1997. Collection of the Denver Art Museum, Denver, Colo. Gift of Ginny Williams, Denver, Colo. Photo: Edward Smith, Venice, Italy.

ISBN: 1-58115-023-7

Library of Congress Catalog Card Number: 98-74535

AESTHETICS TODAY
Editorial Director: Bill Beckley
Beauty and the Contemporary Sublime by Jeremy Gilbert-Rolfe (November 1999)
The End of the Art World by Robert C. Morgon
Uncontrollable Beauty edited by Bill Beckley with David Shapiro
The Laws of Fésole by John Ruskin
Lectures on Art by John Ruskin
Imaginary Portraits by Walter Pater

Printed in Canada

112999-2196D2

Contents

Part Four: Secular Iconographies

Doubting Thomas

If you are not certain of any fact, you cannot be certain of the meaning of your words either.
—Ludwig Wittgenstein

Late one postmodern evening, I stood at a door in the East Village. I had traveled from the west along a wide expanse of macadam for some time, then briefly north. Undoubtedly they were there, the volcanic forces beneath the pavement. On my left hand, a diversified expanse of city rolled its burden of fat things from skyscraper to hovel, between the Hudson and East rivers. The towers, sparkling jewels glowing red, green, and white, stared blankly down at the Village. I had passed from street to avenue, past bodega and tavern, counting numbers until I came to the innocent door.

A whole generation had been exactly in the position in which I now found myself. An older ideal, moral and religious, certain theories of man and nature, still haunted humanity at the very moment when it was called to enjoy the present with an unrestricted expansion of capacities. Might one enjoy? Might one eat of all the trees?

The door buzzed open. I passed through a long hallway leading to a blank set of stairs, which I climbed to an upper floor.

On the way to my first meeting with Thomas McEvilley, I felt, admittedly, a little like Gaston de Latour, the character in a story by Walter Pater who in his wanderings through another age of uncertainty (the late Renaissance) comes, one day, to meet with the essayist Michel de Montaigne.

I first met McEvilley because of my anthology, *Uncontrollable Beauty*. His essay "Doctor, Lawyer, Indian Chief" was included in the anthology, along with the exchange it sparked with William Rubin and Kirk Varnedoe, curators of the Museum of Modern Art's 1984 exhibition *Primitivism in Twentieth-Century Art*. Already more than twelve years old, the essay, along with the consequent exchange, had become, in retrospect, a seminal discussion of cultural relativity in the arts.

In it, McEvilley argues vehemently against the validity of unchanging standards of quality. So, as an experiment, I had bought a good bottle of wine and rationalized the expense as an investment in wisdom. If McEvilley liked it, maybe I could pin him down to some definition of goodness. Our agreement would constitute a consensus, and a significant one, since no one else was coming to dinner that

night. (Of course, a good bottle of wine only has to be a good bottle of wine for one evening.)

A poet-friend had, evidently, hallucinated meeting McEvilley at some point in the distant past. From his description, I expected someone vast, robust, grandiose. McEvilley's telephone voice, and the heroically reasoned quality of his writing, certainly fit with that description.

Then saith he to Thomas, Reach hither thy finger, and behold my hands; and reach hither thy hand, and thrust it into my side: and be not faithless, but believing. —Saint John

The door opened. Instead of a giant, a wisp of a man, reminiscent of the delicate image burned into the shroud of Turin, greeted me. He wore sandals and an Indian robe and stood surrounded floor-to-ceiling by his books. He welcomed me in and disappeared behind a curtain. After a clatter of pots and pans, he reappeared with bowls of vegetable soup and put on a record.

He was happy to field my questions. In half an hour, I seemed to have known him all my life. But on that particular night Thomas wasn't drinking. It could not be through the bottle of Margeaux (harvested in the early 1960s, incidentally, from regions near Montaigne's estates) that I questioned him on the concept of quality and other postmodern issues, so I asked the determined disbeliever in universals, "What's the difference between believing in universals and believing you are right?" It was damn good soup.

McEvilley responded to my question with a soliloquy on the value of doubt. (He later expanded that soliloquy to a chapter in this book.) Where I had stumbled was in comprehending the difference between uncertainty, mistrust, and doubt. In arguing the positive aspects of doubt in judgment, you could say of McEvilley what Pater says of Montaigne in Gaston de Latour (another good wine): "Did Hamlet learn of him that 'there is nothing either good or bad but thinking makes it so'?"

In *Cosmopolis,* Steven Toulmin compares Montaigne (1533–1592) with René Descartes (1596–1650). Whereas in his time, Montaigne embraced doubt, accepting it as a positive and unavoidable fact of life, Descartes employed doubt to establish his certainty. As Toulmin laments, Descartes won. But only for a while, albeit a long while. As we enter this era of transition, like Gaston de Latour in the unraveling of the Renaissance, we may learn to suspend our belief just as we learn to suspend our disbelief when we go to the movies. I mean, at least Gaston knew what was ending. Who the hell even knows what's coming apart now?

Certainly the schism between "relativists" and "believers" has intensified. The difference of perspectives is the root of the cultural wars today, a conflict between people who are "grammar" oriented, who go by the rule (a handbook or supposed universal), and those who are "text" oriented, who first look at the situation at hand in order to make a decision from it. If you would really like to experience this difference, spend an evening in Düsseldorf where, no matter what (even at

two in the morning with no car in sight), when the sign at an intersection indicates DON'T WALK, people really don't walk. Then go to Naples. Any decision to cross the street is a result of the immediate text of the situation. How many cars? How far away? How fast can I run?

In America, these two dispositions exist side by side and often collide, a continuing collision largely responsible for this age of doubt. It is the root of the conflict between the right to life and the right of choice in the woman's movement, as well as the basis of our moral decisions, particularly in judging presidents. This collision exists in aesthetic discourse as well, most pointedly in the historic debate between McEvilley, Rubin, and Varnedoe. As Wendy Steiner so brilliantly stresses in *The Scandal of Pleasure*, the conflict is in no way resolved, but already it has precipitated vast cultural change. As both Ruskin and Pater understood, this change is synonymous with aesthetic development.

Like the earlier Thomas, who through the sensation of touch aspired to know Christ, our wanting to touch is an essence of sculpture. In experiencing sculpture we are penetrating the space denied us by so many twentieth-century paintings.

It may very well be that McEvilley is the Montaigne of our time. But more importantly, he is the McEvilley of our time, a rigorous philosopher of both contemporary and ancient thought, one of our most influential art critics, a wisp of a man, and a giant.

If a blind man were to ask me "Have you got two hands?" I should not make sure by looking. If I were to have any doubt of it, then I don't know why I should trust my eyes. For why shouldn't I test my eyes by looking to find out whether to see my two hands? What is to be tested by what? (Who decides what stands fast?) —Ludwig Wittgenstein

On a lazy Sunday afternoon, I walked with my little boy up Broadway from Houston Street—past Shakespeare and Company, The Wiz, The Strand Book Store, Grace Church—on my way to a kids' shoe store on Fourteenth Street. I wanted to buy him slippers. We passed the courtyard of the church. Beneath the tall spires jutting to the sky, a young man, twenty years old or so, sat in a shady spot intently drawing the façade of the church, with all the accouterments of an artist from another time. Two metal clasps held his watercolor paper tight to the board.

A massive urn stood in the center of the lawn, fixed at the bottom to a bronze stand weathered green with age. The old black pot had a huge crack in it. As I stepped on the grass to get closer, my shoes left a damp imprint. I weighed the guilt of this small transgression against my desire to touch the green moss that grew at the edge of the fissure (wanting to touch is an effect, not a proof, of sculpture).

Though the little boy bounced a blue ball both noisy and bright, our intrusion did not distract the young man who continued drawing, getting all the spires right. The boy pulled a Megatron, a Cheetor, a Tarantulus, an Optimus Primal, and an egg timer from his knapsack. He plopped them all on the grass, the

timer upright, the plastic beasts arranged in various positions of frozen engagement. Then he folded his arms around his knees and waited till the sand poured down.

We gathered the toys, the ball, the timer, and left. The young man kept drawing, ignoring our coming and going.

We didn't buy slippers. The only slippers in the store had large bobbly white eyes sewn to the end of the toes.

<div align="center">

BILL BECKLEY
New York, January 1, 1999

</div>

Part One

Groundwork

This book is arranged in four parts. The first, consisting of three chapters, is introductory. Chapters 1 and 2 deal with history in a large sense, and with the major intellectual issues surrounding doubt and post-Modernism in intellectual history in general and in the arts in particular. These chapters make a frame through which the rest of the book is seen. Each of the remaining chapters focuses on a single artist—a figure in the frame.

Marcel Duchamp appears in chapter 3 as the first figure to enter the frame. Larger than life, he occupies this space majestically for a while by himself, setting out the artistic directions that will influence the discussion of the remaining twenty-four artists.

Marcel Duchamp's work changed radically in about 1914; the difference between the earlier and the later work is the first demonstration of the difference between "Modernism" and "post-Modernism." The shift seems to have been prompted in part by reading about the ancient Greek skeptic Pyrrhon of Elis, who in the sixteenth century had been a strong inspiration to a now-largely-forgotten group of French skeptics, sometimes called the "neo-Pyrrhonists." Perhaps Duchamp was influenced by this earlier French intellectual movement. In any case, his work amounts to a systematic critique or "deconstruction" of the Kantian, or aesthetic, theory of art. It was post-Modernist in theory, form, and attitude. And though the work arose from a condition of doubt, it must be remembered that doubt has often been found to be a liberating and joyful experience. One sees both that joy and that liberation in Duchamp's work.

Chapter One
The Art of Doubting

The present historical period is one that attempts to present itself as somehow without boundaries and directions, yet nevertheless possessed of a strong character. This is not really unusual; it is characteristic of periods that might be called ages of doubt, including periods embracing a number of great philosophical traditions. Still, to those who became accustomed to the purposive and ideological age that seems to have recently ended—and that is commonly called "Modernism"—the condition of uncertainty feels bizarre.

The Barbarous Noise

Modernism was what might be called an age of certainty, feeling itself to be founded on universal truths and to grasp clearly the direction in which they tended. In contrast, the new age, with its conspicuous lack of universals and directions, strikes many beholders as confusing and undefined; so accustomed are they to boundaries and markers that without such indicators, they feel there is no frame for meaning. For them, the new age dawns with a sense of betrayal. Their attitude is exemplified by Bertrand Russell's remark in *The Will to Doubt* that an outlook which does not recognize the objective existence of an "ideal rationality" is "very dangerous, and in the long run, fatal to civilization." [1]

The most widely used name for this era is "post-Modernism" [2]—an odd name because it does not seem to refer to what the period *is* but to what it comes *after*. Even the experts writing about it are apt to say that they don't know what it means. Surprisingly, it is often the advocates, rather than the critics, of post-Modernism who claim they are helpless to understand it. [3] They must espouse it, then, from a surfeit of the last age—a willingness to accept almost anything in preference to it. This is because the last—the Modernist—age is widely perceived today as having been a raw power trip that proceeded not only by deceiving others but by self-deception. Those who advanced the various Modernist endeavors were really speaking of "contingency while believing themselves to narrate necessity, of particular locality while believing themselves to narrate universality. . . ." [4] Their obsession with universality, certainty, and the absolute thinly disguised a manic desire to control: "The target of certainty and of absolute truth was indistinguishable from the crusading spirit and the project of domination." [5]

On the other side are many who feel that the last age was exactly what they wanted. They oppose post-Modernism at a fever pitch. They are sure that it is not just an unclear term but one that is actually fraudulent; its seeming lack of identity is a confusion deriving from its skepticism, and its skepticism is a covert license to dismantle civilization as heretofore known. For these people it does not hold true that "Postmodern recognition of the final demise of all Authority, of all higher discourse, of all centers, leads to an acceptance of chaos. . . ."[6] For them, rather, the demise of authority leads not to "the postmodern tolerance of uncertainty,"[7] but to insecurity and hopelessness. In their view Modernism is still whole and real and in control; since it is universal, nothing can ever usurp its position of dominance. Still, post-Modernism is seen as launching a strong attack on Modernism. Jurgen Habermas, for example, has argued that post-Modernism is nothing more than an attempt "to disrupt the liberatory project of modernity, launched by the French Revolution and the American Declaration of Independence."[8] When such residual Modernists encounter the post-Modern discourse, they seem to undergo the experience described by John Milton: "When straight a barbarous noise environs me/Of owls and cuckoos, asses, apes, and dogs."[9] The sound of doubting voices is inhuman, a sound of beasts. Worse than nonsense, it is insidious nonsense—aiming at nothing less than the discrediting of faith in Modernism through a gratuitous doubt—the "radical epistemological and ontological doubt," which is "absolutely central" to post-Modernism.[10]

The Great Doubt

In Western cultures since the Greco-Roman era, there has been an unusual stress on the quality of faith because the institutionalized religions have emphasized dogma to the extreme point of burning alive individuals (such as Giordano Bruno) who could not live comfortably with the prevailing belief system. Conversely the quality of doubt has acquired a sinister connotation of something undesirable—something so dangerous that it could result in your being burned alive. In such a situation, it is easy to believe that doubt is a snare of the devil. But it has not always had this negative connotation; on the contrary it has had its advocates.

Even in the Christian West, doubt has been valued by thinkers such as Francis Bacon and John Locke (who called it clearing away the underbrush of superstition on the way toward truth). In the empirical tradition, doubt represents rational criticism—much what Karl Popper meant when he said, "The scientific method means questioning *everything*."[11] But there have been cultural traditions in which the advocacy of doubt went much farther, in which it was seen not merely as a way to clarify one's thought but as a spiritual awakening—an awakening from a world on which a grid of distinctions had been imposed onto a gridless world of openness and freedom of movement. The problem in Europe was that a populace long accustomed to a closely controlled world might feel threatened, rather than liberated, by the dawning of an uncontrolled one.

Several philosophical traditions, from the Greek schools of skepticism to

the Buddhist Madyamika school to Renaissance neo-Pyrrhonism, have instilled in their students a systematic mental practice based on doubt. The Japanese Zen master Hakuin advised the cultivation of what he called the "great doubt." He meant something like Popper's view of science—"questioning *everything*"—but at a more fundamental level. Hakuin's concept of doubt applies not only to empirically testable statements about the sensory world but even to the method of doubt itself. His branch of Buddhism employed *koans*—incomprehensible or paradoxical statements whose contemplation was meant to arouse doubt—and even these hallowed devices were to be treated with doubt. "If you don't doubt the koans," said Fu Kuo, a predecessor of Hakuin, "you suffer a grave disease"[12]—that is, having a mind burdened with unjustifiable assumptions. The belief that one needs any assumptions at all must be eradicated: "When a person faces the great doubt . . . ," says Hakuin, "it is just as though he were standing in complete emptiness. . . . At the bottom of great doubt, lies great awakening. If you doubt fully, you will awaken fully."[13] In this tradition, doubt was not regarded as a depressing or confusing situation, as many in Europe experienced it after the long conditioning of the Christian millennium. On the contrary, as Hakuin described it, to bring before yourself the great doubt is to experience the great death and feel the great joy.[14] The "great death" seems to mean the moment of awakening out of the world's arbitrary grid of order, of being dead to that world, since that world itself no longer exists for you; the "great joy" is the ultimate relief of awakening into the gridless openness of no assumptions.

What Do You Know?

Something similar was taught by the Greek author Sextus Empiricus— known as a Pyrrhonist, after Pyrrhon, the founder of his lineage. "The originating cause of skepticism," Sextus explained, "is the hope of attaining quietude."[15] For this purpose he advises the cultivation of a suspension (*epoche*) of judgment about all matters whatsoever: "This suspension solidifies into an inner balance (*arrepsia*) in which the mind neither affirms nor denies. . . . This balance between affirmation and negation expresses itself in a state of vocal and mental silence (*aphasia*) which ripens finally into freedom from phenomenal influence (*apatheia*) and imperturbability (*ataraxia*). . . ."[16] Sextus was a medical doctor associated with the Methodic School of Alexandria, and evidently purveyed his great doubt or suspension as a cure for mental ills—perhaps like Fu Kuo saying, "If you don't doubt the koans, you suffer a grave disease." Hakuin himself is said to have been ill throughout much of his youth, and when he acquired the great doubt "all my illnesses were healed."[17]

In both the Greek and the Indian philosophical traditions this positive evaluation of doubt as a clarifying and strengthening force goes back to the earliest stages. In Greece it is found as early as Zeno's paradoxes, and in fact even in the poem of Parmenides, which encourages doubt of sensory experience on logical grounds. In India it was found in several early schools, including the Buddhist. Thousands of years before Hakuin, the *Sutta-Nipata*, widely regarded as the earliest

layer of the Buddhist tradition, declares (*Sn.* 802) that the enlightened person is one for whom "there is not the slightest prejudiced view with regard to things seen, heard, or felt . . . who does not dogmatically grasp any views."[18] "The intention of the Buddha," says another ancient text, the *Mahaprajnaparamita Sastra* (63c), "is this: my disciples [should be] free from passion for doctrine, free from attachment to doctrine, free from partisanship. . . . They do not quarrel about the nature of things."[19]

In the mainstream of the Western tradition, where dogmatic religions (especially Christianity and Islam) have dominated for so long, this attitude seemed barely comprehensible. In the various religious conflicts, such as the Thirty Years' War (1618–1648), which have convulsed Europe, the point has been to hold exactly the right opinions; even a slight difference of opinion between, say, a Catholic and a Protestant is enough to bring a sentence of death on the one who is judged to be mistaken and, after death, an eternal sentence to punishment in Hell. In Christian or Islamic wars about dogma, it is true that nothing, literally nothing at all, is more important than the correctness of the opinions one holds—and this even though the opinions in question deal with matters that are obviously unknowable. Granted the intense weight that is placed on opinions, skeptical claims are regarded as foolish or parodic because it is assumed that they are clearly untrue and therefore to hold them could only be a deliberate perversity meant for the sake of being outrageous for the amusement of others. Even in today's supposedly secularized Western society, students receive with derision, as if they were jokes, the three propositions of the skeptical Greek philosopher Gorgias: (1) that nothing exists, (2) that if anything does exist, it can never be known, and (3) that if, perchance, something exists and can be known, it can never be communicated to anyone else. Yet in the Greek tradition and in several other great philosophical traditions, this attitude is no joke, but has serious underlying purposes.

The various traditions mentioned have different arsenals of intellectual equipment for cultivating the great doubt or suspension. The development of such equipment for our own time is what a great deal of important post-Modernist literature has been working on—the development of a means or a practice through which our time might enter into the great doubt (and undergo the great joy). The various post-Modern skeptical arguments—from Derrida's *différance* to Baudrillard's simulacra to Rorty's contingency and irony—all seek to establish such a practice.

Anyone who earnestly pursues a systematic practice of this type soon brings into focus the fact that there is no postulate that seems able to survive such a trial. To members of a society that has emphasized faith—or superstition—as the highest mental goal, the idea that no concept whatever should survive the test of reason seems not only surpassingly strange, but even terrifying. At first it seems grotesquely, even absurdly, impossible that not a single concept should stand up to rational inspection; then almost at once it seems devilish, nihilistic, and destructive; it seems that one could hold such a view only out of perversity.

The feeling that the outright rejection of all views contains some perverse wishful thinking was an essential point of distinction between two ancient groups of

Greek skeptics, the Academics and the Pyrrhonists. The Academics—known primarily through secondary accounts (such as Cicero's *Academica*) of the great teachers Arcesilas (c. 315–241 B.C.) and Carneades (c. 213–129 B.C.)—disproved the assertions of other schools and subsequently declared them false. For this they were known by the Pyrrhonists as negative dogmatists: they were persuaded by their negations and had become dogmatic about them. The Pyrrhonists, in contrast, suspended judgment on all questions, refusing to declare whether something might be true or untrue; they practiced not negative dogmatism but suspension (*epoche*) of judgment, neither affirming nor negating the truth of any proposition. As Metrodorus of Chios expressed the position: "I know nothing, not even whether I know nothing."[20]

Headache

The Pyrrhonist tradition was a long accumulation of arguments running back to the time of Zeno and Parmenides and including input from the Democritean line, the Sophists, the Socratic schools and Cynics, and the Academy.[21] Most of these arguments were systematic or formal turning logical principles against one another through the dichotomy-and-dilemma method: A question is dichotomized into two options, A and not-A; then each option is reduced to absurdity through circularity, infinite regress, or contradiction, leaving no available answer to the question.[22] An example of the reduction by infinite regress would be the application of one of Zeno's paradoxes against the concept of things in series: In order for one entity in a series to remain separate from the entities it is contiguous to on both sides, there must be boundary markers or separators on both sides of it; in order for these separators in turn to remain separate from the entities on both sides, there must be other separators on both sides of the separators; and so on ad infinitum. In order to keep an entity separate from one it is contiguous to, there must be an infinity of separators between them. But since a human life is finite, one would never succeed in traversing the separators and getting to the contiguous position. The argument can be applied to number series or any other series of entities. In the Western tradition since, say, the mid-seventeenth century, given its obsession with affirmative propositions, arguments of this type have been dismissed as sophistries; but the fact is they are formally legitimate arguments and the reason they are dismissed is that no positive logician can handle them: better to pretend they don't exist.

A modern approach to skepticism perhaps more familiar to some readers is found in the logical positivist tradition, for example in A. J. Ayer's book *The Problem of Knowledge*.[23] First, Ayer rejects deductive arguments by criticizing the concept of the universal categorical statement: It is possible, after all, that the next man inspected might turn out to be immortal. He then dismisses inductive arguments on the grounds that, without a complete itemization of a category, nothing definitive can be said about it. At this point, echoing Wittgenstein's famous last sentence of the *Tractatus*, he concludes tentatively, "If our aim is never to succumb to falsehood,

7

it would be prudent for us to abstain from using language altogether."[24] Still, pressing onward, he considers two other classes of statements. First, the purely demonstrative or gesticular statement, such as pointing at something and saying, "This," is held to be beyond logical reduction; it contains no information, however, but is a species of tautology, since pointing at something and saying, "This," in regard to the thing pointed at are semantically the same. In addition Ayer was inclined to allow demonstrative statements that add a little bit of empirical information, as in expressions of elementary awareness going on at the present moment. Thus the only non-tautological statements that could be said to have truth value are of this type: "I feel a headache," or, "This looks to me to be red."[25] If one assumes that the words are spoken in good faith, it would be difficult to deny the veracity of such a statement—with three exceptions. First, Ayer neglects to consider the time lapse between feeling or seeing and speaking about the feeling or sight; "A moment ago I felt a headache" is perhaps better than "I feel a headache." Second, there is the problem of the self; it might be best to eliminate the unargued assertion of selfhood by revising the statement to say, "A moment ago there was a feeling of a headache." And finally, there is the issue of the accuracy of memory; perhaps "It seems that a moment ago there was a feeling of a headache" is as close as one can come to a statement which, granted the sincerity of the speaker, is unimpeachable. But is this form of statement worth anything? The hedging qualification "It seems" reduces the statement to meaning, more or less, "Perhaps a moment ago there was a feeling of a headache"—and since that statement is true at any time anywhere, it is hardly a statement at all. There are, then, literally no statements whatsoever that are invulnerable to a rational doubt.[26]

The Pendulum Swings

In the Western tradition, ages of certainty and ages of doubt have alternated with a slow rhythm. In ancient Greece the classical period (like our Modernism) was an age of certainty; it was based on a belief that universals were being realized in history—that this was, in fact, the work of history, as Hegel would later say of events in Europe. In Kimon's day, or Pericles', history was carried out with a sense of certainty and a spirit of confidence; because of its supposed foundation in universals, there was a brash belief that it simply could not go wrong. The hands-on altering of the form of the state was the essence of it, but in the arts and sciences too, universals seemed to be actively involved, giving cultural pursuits the feeling of transhistorical quests for a certainty that was known to be there and was certain, ultimately, to be achieved. It seemed that the purposes of history (roughly those of the Enlightenment) had stated themselves with remarkable clarity in various arenas of activity and were working themselves out in the confident advances of a society which carried historic import with it—meaning Athens as described by, say, Thucydides.[27]

This age of certainty seems to have been bound up with the emergence of democracy and the various social and cultural forms associated with it that were

revived for modern times in the Enlightenment; it lost much of its momentum—its confidence, its certainty—with the collapse of the Athenian democracy, which had, supposedly, been the principal carrier of the universals. The age of certainty then was followed directly by an age of doubt; though other teachings were current in the Hellenistic or Alexandrian age, skeptical systems for the first time became dominant. It soon came to seem that the situation of the classical age had been misunderstood, its high purposes had been hoaxes, and history had turned out to be no more than a grim disappointment. History—which, fueled by universals, supposedly could not go wrong—had in fact gone wrong. Universals were discredited or pushed into the right wing of culture, the Platonic enclaves where they would still be nested two thousand years later, among the seventeenth-century Cambridge Platonists.

It was during or immediately after the lifetime of Alexander the Great (d. 323 B.C.), after whom the new (Alexandrian) era was named, that a presentation of absolute doubt was made by Pyrrhon of Elis (c. 360–275 B.C.), which was carried on after his death by his student Timon of Phlius (c. 315–225 B.C.). After Athens had become a part of the empire of the Roman Republic in 146 B.C., this tradition, called the Pyrrhonist, was formulated systematically by Aenesidenus (c. 100–40 B.C.); after the collapse of Greek autonomy altogether in the Roman Empire, this tradition found its most thorough spokesperson in Sextus Empiricus, probably in the second or early third century A.D. In the same period the mode of negative dogmatism was developed in the Academic tradition by Arcesilas and Carneades. The skeptical tendency had been present in Greek philosophy since the so-called Eleatic *elenchus*—the trial (of an idea) through critical analysis—of the early fifth century B.C.; it had contributed to the sophistic movement of the fifth century and the Socratic schools of the late fifth and fourth. But the skeptical tendency had never risen to the height of dominance that it gained after the collapse of a period in which metaphysics had asserted itself publicly through a communal dream or ambition that was worked out on a large scale in society, then failed and was abandoned.

Viewing history for a moment as a quick series of large storyboards, one sees this ancient age of doubt in turn repressed and replaced by the Christian age, in which faith in universals again overrode skeptical tendencies. Then, after about seven hundred years, classical Greek modes of rational inquiry and doubt began to return into Europe by way of Islamic carriers; and the balance began to shift again, the resurgent critical trend developing into a full-fledged age of doubt in Renaissance humanism in the sixteenth century, when the works of Sextus were rediscovered, first showing themselves in John Pico della Mirandola's work around 1520. Thus in the Renaissance, as in the transition from the classical age to the Alexandrian, doubt and skepticism gained cultural prominence in the wake of a communal or political folly that had been supported by metaphysics, in this case the medieval Christian dream of establishing the City of God on earth.

Seen broadly, the alternation between faith and reason seems like a pendulum swing in Western cultural history. This does not, however, appear to be a universal trait of history but a local one that arises from the peculiar circumstances of the Western tradition. Specifically, it can be conceived as an alternation between

the Judeo-Christian and the Greco-Roman aspects of our cultural heritage, which are innately inimical, and one of which usually has the upper hand.[28] (It would seem unlikely, for example, that such radical pendulum swings occurred in Neolithic cultures; perhaps the phenomenon was rare in pre-Modern cultures in general.) The dual nature of the Western heritage is like a challenge to effect a synthesis. The Greco-Roman may be regarded as the thesis of a Hegelian syllogism, the Judeo-Christian as the antithesis. Somehow a sublation seems to be called for that would put the whole situation on another plane and create a synthesis that would open the way for movement into a different future. This sublation has not yet been found, though it may be that post-Modernism is searching for it.

Vanity and War

The rediscovery of Pyrrhonist texts in the sixteenth century was initially a part of Renaissance humanism, as in Pico's *Examen vanitatis doctrinae gentium* (*Examination of the Vanity of the Teaching of Nations*, 1520). The revival of Pyrrhonism was a part of the Renaissance revival of paganism in general, but it soon became embroiled in the Christian sectarian disputes that dominated Europe for two centuries after Luther's decamping in 1517. Renaissance humanists might be inclined to use the Pyrrhonist arsenal against Christian dogma in general (subjecting the dogma of the church to the skeptical reductions of Sextus Empiricus was called the *crise pyrrhonienne*, the Pyrrhonian crisis),[29] but once the schism had occurred, Catholics and Protestants used the skeptical reduction against one another, each side using Pyrrhonism as an aid to establishing its own version of the Christian point of view.

The conflict between papists and Protestants elicited two purposes for systematic doubt: cross-purposes that could not have been more ideologically opposed. In the hands of Protestant thinkers the triumph of skepticism was ironically made into an argument for irrational faith. Since reason cannot establish any truth whatever, Luther argued, it is better to abandon reason altogether and rely only on the intuitive dictates of the conscience when it has been stimulated by the reading of Scripture. Meanwhile, in the hands of Catholics, the Sextian arguments were used to support probabilities rather than absolutes. Luther's papist opponent, Erasmus, held that since reason cannot establish any truth whatever, it is best to accept those beliefs that come with their higher probabilities warranted by social evidences such as tradition, consensus, and institutionalization; the fact that the teachings of the Church have been affirmed by councils of sages for a thousand years makes them the more probable candidates. Thus both the Protestant and the Catholic sides in the religious controversies of the sixteenth and seventeenth centuries used the reemerging arguments of the ancient skeptics against the original purposes for which they had been formulated: They used Sextus's arguments to validate one doctrine against another rather than exercising the Pyrrhonist *epoche*, or suspension of belief, universally and neutrally on every matter whatever, as Pyrrhon had advocated. Both Catholics and Protestants declared the doctrines of the Church to be beyond rational demonstration, that is, to be essentially and irredeemably

irrational. It could be said, in fact, that the object of worship, or *numinosum*, which the Christian tradition promulgated was the irrational itself. Thus, as the religious wars heated up—especially the Thirty Years' War—the Pyrrhonist suspension or "great doubt" became increasingly embroiled and lost in disputes over the irrational.

Adrift Amid Poison and Smoke

In Pyrrhonist terms, these Catholics and Protestants, misusing the arsenal of the great doubt to establish mastery in opinions, were poisoning themselves. To the Pyrrhonist all opinions are like smoke in the air: unsubstantial, shifting, and meaningless. To imbibe them, one has to poison oneself. Clearing the mind of false opinions—that is, *all* opinions—was, like purging the body, the way to restore it to health. But to a dogmatist this Pyrrhonist purgation threatened to destroy the soul itself, and with it the chance of paradise in the hereafter. Advocates of both positions developed polemical rhetorics.

The French scholar who first published Sextus's work in Latin, Henri Estienne, presents a version of the Pyrrhonist therapeutic argument. He recounts that he had been very ill in the previous year "and during his illness developed a great distaste for belles-lettres. One day, by chance, he discovered Sextus in a collection of manuscripts in his library. Reading the work made him laugh, and alleviated his illness. . . . He saw how inane all learning was, and this cured his antagonism to scholarly matters by allowing him to take them less seriously."[30]

In addition to the therapeutic model, other metaphors expressed praises for the ideal of the skeptical mind. In 1548, Omer Talon, an advocate of an Academic type of skepticism, argued, as Cicero had before him in his *Academica,* that skeptics are "as much above other philosophers as free men are above slaves, wise men above foolish ones, steadfast minds above opinionated ones."[31] The idea of the mind uncluttered by superstition lay at the root of Bacon's primitive empiricism as well as Locke's assertion of the necessity of clearing away the underbrush that obscures the path to knowledge. In the sixteenth century Sebastian Castellio of Basel wrote, but did not publish, a tract called *De arte dubitandi* (*On the Art of Doubting*); the title is important for showing that doubting seemed to have become aesthetically nuanced, even formalistic, in that time, as in the art and philosophy of the 1970s and '80s. One can see something of this in the work of sixteenth-century artists like Caravaggio, and in the humor and contradiction of the baroque and rococo.

The opposite point of view was taken by the dogmatists, who felt that Pyrrhonism cut them adrift from all moorings and thus threatened all the stabilities of life. A character in *Les Dialogues de Guy de Brues, contre les Nouveaux Académiciens,* 1557, bemoans, "O miserable Pyrrho, who has made all into opinion and indifference!" A seventeenth-century English Catholic philosopher, Thomas White, would refer to "that deadly Pyrrhonic poison," inverting the therapeutic metaphor of skepticism as a purge.[32] Feelings ran so high that the circumstances that framed the death of Giordano Bruno included his favorable discussions of Pyrrhonism in some

of his dialogues. Bruno was burned alive in the public square of Rome in the year 1600 for heresy—he had imbibed the "deadly poison."

The revival of ancient skeptical modes of thought led to a relentless argumentation that let nothing go unquestioned. As Sextus, and Pyrrhon before him, had recommended, nothing was to be taken for granted, no matter how simple or obvious it seemed in terms of ordinary common sense. In response, for example, to the Church's insistence on papal infallibility, the new Protestant doubters asked, "But who can tell who is the Pope? The member of the church has only his fallible lights to judge by. So only the Pope can be sure who is the Pope; the rest of the members have no way of being sure, and hence no way of finding any religious truths."[33] Similarly, in response to the Church's insistence on the absolute truth of the Bible as revelation, the skeptic replied that no one can ever be absolutely sure just exactly which book, out of all the books around, *is* in fact the Bible; one would have "to substitute a doctrine of personal infallibility for the acceptance of Church infallibility."[34]

The currency of revived ancient skeptical thought in the sixteenth and seventeenth centuries goes beyond anything our conventional intellectual histories tell us. In 1596, one Petrus Valentia wrote a history of ancient skepticism in which he referred to Sextus Empiricus's *Outlines of Pyrrhonism* as a work "that almost everyone possesses."[35] One can imagine an author in the United States in our age of doubt—say, in the 1980s—referring to Derrida's *On Grammatology* or Baudrillard's *Precession of Simulacra* in similar terms. In seventeenth-century France, Sextus Empiricus became known as "*le divin Sexte*," from whose "irresistible" arguments no claims of human knowledge whatever could escape.[36] Science did not avoid the universal doubt that the divine Sextus's irresistible arguments instilled; in fact, it was then, as now, a favorite target. As Richard Rorty and others in recent years have taken on the sciences' claims to knowledge, so in the sixteenth century Henry Cornelius Agrippa wrote a book *De incertitude et vanitate scientarum* (*On the Uncertainty and Emptiness of the Sciences*); Gassendi's *Sixth Dissertation in the Form of Paradoxes* . . . begins: "That there is no science. . . ."[37] The seventeenth-century neo-Pyrrhonist Francesco Sanchez's *Quod Nihil Scitur* (*That Nothing Is Known*) aimed especially at the claims of the sciences. Every chapter ended with this little dialogue: "Nescis?" "At ego nescio." "Quid?" which might roughly be translated as: "Are you ignorant?" "Yes, I am ignorant." "Of what?" Sanchez seems to mean that if one does not know whereof one is ignorant, then one doesn't really know that one is ignorant. *That Nothing Is Known* is then a reflexive or Uroboric statement of Metrodorus's type: Nothing is known including whether anything is known.

The Higher Lunacy

The great French neo-Pyrrhonist Michel de Montaigne (1533–1592) referred to the claims of scientists in general as "the comedy of the higher lunacy."[38] Many regard Montaigne as a late figure of the Middle Ages—or of the Renaissance when it is seen as the end of the Middle Ages—rather than as a foundational figure

of Modernism. The latter role has been usurped by Descartes because Descartes dealt with universals, and Modernism was based on universals. Montaigne, a skeptic and relativist who was not concerned with universals, is left as a minor curiosity in between the Aristotelian universalizing trend of the late Middle Ages and the more or less Pythagorean-Platonist universalizing trend of Modernism, which was formed on principles of unified science founded on mathematical certainty. (Montaigne is not even mentioned in W. T. Jones's *History of Western Philosophy*;[39] in Windelband's *A History of Philosophy* he appears only as a name in a list of those whose thought "ran in the ancient track.")[40] In fact, it seems more plausible to regard Montaigne as an early spokesperson of the last great age of doubt before our own, the age which began with Renaissance humanism and culminated in the Enlightenment.

Though the influence of Sextus is first encountered in the writings of Pico in the early sixteenth century, it is not fully present till the works of Montaigne late in that century. Montaigne presented himself as a Christian of the fideist type, who emphasized faith as the only foundation of religious belief on the Sextian ground that no position could be established by reason. Many, however, have felt that his Christianity was not heartfelt so much as an instance of the tokenism that Sextus recommended: On the ground that nothing could be established, the Pyrrhonist was advised to follow with no conviction the customs prevalent in his society, much as he was recommended to acknowledge the situation of heat when he seemed hot or of hunger when he seemed hungry. In culture, as in nature, lacking any certainty about anything except appearances, the Pyrrhonist was to go along with prevailing conditions. "We live," Sextus wrote, "in accordance with the normal rules of life, undogmatically, seeing that we cannot remain wholly inactive" (*Outlines* 1.23).[41] Montaigne's Christianity seems likely to have been of this type.

In regard to the question whether Montaigne represents the end of the Middle Ages or the beginning of Modernism, Popkin refers to Montaigne's *Apology for Raimund Sebond* as "the womb of modern thought."[42] In this view, Modern Western thought grew not from the Aristotelian-based rationalism of Leibniz and Spinoza, nor from the Platonic-based mathematical thought of Descartes and Newton, but from the Pyrrhonist or Sextian skepticism of Montaigne and others such as Pierre Bayle.

Arguing as a man of the world who is concerned more with the solitary unexplained selfhood of contingent details than with alleged explanations of them that operate through invoking universals, Montaigne's "essays" unconcernedly accept the world in the unadorned contingency of its inexplicable selfhood:

> Is it not better [he asks in the *Apology*], to remain in suspense [Sextus's *epoche*] than to entangle yourself in the many errors that the human fancy has produced? Is it not better to suspend your convictions than to get mixed up in all these seditious and quarrelsome divisions? . . . Take the most famous theory, it will never be so sure but that in order to defend it you will have to attack and combat hundreds of contrary theories. Is it not better to keep out of this melee? . . .[43]

It does not matter to Montaigne whether one, or none, of the hundreds of theories should be true, since this would be unascertainable by reason anyway. Montaigne anticipated Foucault in his sense that most arguments are not really about truth but about mastery. Only the Pyrrhonists are exempt from this observation, since they do not care about winning in any conventional sense. Whether their opponents' or their own positions seem vanquished, it is all the same to them. In either case some claim or other has been erased and the field of consciousness has been partly cleared:

> The Pyrrhonians have kept themselves a wonderful advantage in combat, having rid themselves of the need to cover up. It does not matter to them that they are struck, provided they strike; and they do their work with everything. If they win, your proposition is lame; if you win, theirs is. If they lose, they confirm ignorance; if you lose, you confirm it. . . .

The Pyrrhonist, having accomplished the project of clearing the mind of the "errors of human fancy," is left with experience in the raw, to be dealt with by another type of consciousness than that which can only affirm and deny:

> I can see why the Pyrrhonian philosophers cannot express their general conception in any manner of speaking; for they would need a new language. Ours is wholly formed of affirmative propositions, which to them are utterly repugnant. . . .

Without the use of affirmative propositions, there can be no foundations of thought; without foundations, there is no reason to build one structure rather than another. What is left is a shifting foundationless structure, which is held to offer a greater freedom than the bondage to foundations of certainty.

> . . . beginning, middle, and end—is nothing but dreams and smoke. . . . The impression of certainty is a certain token of folly and extreme uncertainty. . . .[44]

What is far too little known in the West about our own intellectual heritage is that this attitude was commonplace in the sixteenth and early seventeenth centuries. The neo-Pyrrhonist Pierre Bayle, for example, wrote, "All is illusory . . . the absolute nature of things is unknown to us . . . nature is an impenetrable abyss. . . ." This was not an eccentric and perverse view adopted to be outrageous and amusing. It was the expression of a prominent professor of philosophy in a book that Voltaire would call "the arsenal of the enlightenment."[45]

Thinking is Happening

Renaissance humanists of the sixteenth century, like Montaigne, living in a period of heightened doubt, experienced the liberation, joy, and quietude of the realization that the huge body of dogma they had been laboring under had been unnecessary all along, and happily laid it down (at least in spirit). But for many who

could not simply lay down a millennium of authoritarian dogmatism, this resolution was too easy. The burgeoning spread of Pyrrhonian openness transpired against a background of darker and more threatening countertendencies.

The brief success of the neo-Pyrrhonists provoked crude and uncomprehending attacks ranging from the Inquisition's condemnation of Bruno to Galland's sixteenth-century work *Contra novum academiam Petri Rami oratio* and Guy de Brues's *Dialogues contre les Nouveaux Académiciens.*[46] Such works, which attempted to reverse the tide of the growing age of doubt, might be compared to works aimed against the skeptical principles of our own time, such as Robert Hughes's *Culture of Complaint,* Dinesh D'Souza's *Illiberal Education,* the ongoing contributions of Hilton Kramer and others to the *New Criterion,* Allan Bloom's *The Closing of the American Mind,* and less crude but still hostile texts from the Marxist point of view, such as Alex Callinicos's *Against Postmodernism* and Christopher Norris's *Uncritical Theory* and *The Truth about Postmodernism.*[47] But at the time, in the immediate aftermath of sixteenth-century neo-Pyrrhonism, the most enduring strategy turned out to be that which fomented René Descartes's *Meditations on First Philosophy.*

A traditional account of European philosophy would begin by noting that Western thought attempted, in the sixteenth and seventeenth centuries, to make a new beginning that would abjure the obvious superstition that had weighed down the rationalist enterprise of the Aristotelian Scholastics. To do so it attempted to ground itself in something that was absolutely sure, however elementary. For Francis Bacon, in his formative work on early empiricism, *Novum Organum* (1620), this foundational grounding was to be sense experience and inductive reasoning based on it.

That was a promising impulse from the English tradition, which has often featured the empirical position.[48] But like the new Pyrrhonism, it was perhaps too easy a way out of a millennium-long ordeal. What was really more in the continental European mold was the continued appeal not to sense but to reason, and on the continent the search was on, about the same time Bacon wrote, for some rational (rather than empirical) principle which would be as simple and unencumbered as the sense impression that one was seeing the color red. In 1641 René Descartes, in his *Meditations on First Philosophy,* made a proposal that was, and still is, widely accepted as filling this need.

As Popkin tells it, Descartes, in the "First Meditation," attempted to give a Pyrrhonist version of things—to pretend, in effect, to be a neo-Pyrrhonist. It may be that his goal, still unspoken at this point, was precisely to refute neo-Pyrrhonism, and that his motive in the "First Meditation" was to establish credentials for this refutation by pretending to be a convinced neo-Pyrrhonist—and then, lo and behold, coming up, in the "Second Meditation," with a solution that even he, supposedly a devout neo-Pyrrhonist, could not deny. This solution was his proposal for a new universal self-evident principle, the so-called cogito: *cogito ergo sum* ("I think, therefore I am"). Like Ayer's skeptic, he has observed himself to be thinking, much as he might observe himself feeling a headache or seeing the color red. From this supposedly rudimentary beginning, the whole construction of later European philosophy (Sanchez's *quid*) was to flow.

So favorably—indeed, relievedly—was this suggestion received by the philosophical readership of Europe (still essentially Christian and glad to contemplate a solution based hiddenly on the idea of the soul) that it has come down through almost four centuries as the ultimate rational-skeptical bottom line of thought. Yet the popularity of its rationalist leaning toward universals cut off from the record the philosophical achievement of the sixteenth century, and what's more, it was deeply flawed in ways that now seem painfully obvious.

To begin with, Descartes (like Ayer's skeptic) errs in switching from the impersonal third person to the first person, which involves the positing of a soul-like being who is somehow behind it all. In other words, the "I" is adventitious; instead of "I think," Descartes might better have written, "Thinking is going on." In addition, the "therefore" is also adventitious; the assumption that inference is valid does not follow from an elementary act of perception. If the "I" and the "therefore" are both deleted, "I think, therefore I am" is reduced simply to "Thinking is happening," or, to be even safer, "Thinking seems to be happening," or "There is an impression that thinking is happening."

Nevertheless, from this first principle—disguised as an inductive observation—a new age of rationalist constructivism grew, based on what Rorty has called "the neurotic cartesian quest for certainty."[49] From the foundation stone of the cogito arose the complex structure of Leibniz's system and the subsequent lineage of continental European rationalism down to and including Husserl and Heidegger. Bacon's rudimentary empiricism was relegated to the British Isles (where it quickly bore fruit, as in Robert Boyle's experimental work in the seventeenth century), and Montaigne's view that it didn't matter which side seemed to win was left to run in the ancient track. A philosophy which had supposedly ended with the apparent demise of the rationalism of the Scholastics was reborn as a new, thinly disguised rationalism.

Here the gauntlet was flung down. Montaigne's neo-Pyrrhonism had seemingly been countered—and repulsed—by a new universal rational principle. To an age which had for so long been Christian—thus based on universal principles—yet which had seen its supposedly universal principles lose the power to convince, the advent of a seemingly new and unassailable principle was experienced with a sigh of relief. Soon other such principles followed and seemed to add to it. Descartes's *Meditations* was published in 1641, but his passion soon swerved to "his attempt at producing an all-embracing system of theoretical physics."[50]

Though he is primarily known today as an epistemologist, Descartes was a mathematician and physicist of great renown in his own time. He is credited with the invention of analytic geometry, the treatment of negative roots in algebra, and the organization of the so-called Cartesian coordinates. His intention was nothing less than the extension of mathematical method to all areas of human knowledge, including philosophy. And "in the early years of the seventeenth century the importance of mathematics for natural science was being more and more generally recognized."[51] This realization consisted of the ancient Pythagorean insight that the world was constructed on mathematical principles. As Galileo put it in *Il Saggiatore* (*The Assayer*):

Philosophy is written in this grand book, the universe, which stands continually open to our gaze. But the book cannot be understood unless one first learns to comprehend the language and read the letters in which it is composed. It is written in the language of mathematics, and its characters are triangles, circles, and other geometric figures, without which it is humanly impossible to understand a single word of it; without these one wanders about in a dark labyrinth.[52]

There are parallels to this statement in Plato's Pythagorean passages, and the fact that it is stated purely in terms of geometry also links it with the Pythagorean-Platonic tradition. That this is the philosophic tradition which, more than any other anywhere, is associated with the postulation of universals is not empty coincidence. The mathematical thought of the seventeenth century was based on universals. Seventeenth-century science had "founded its method by means of the mathematical spirit, with the absolute domination of reason in the study of external nature." Cartesian rationalism, confirmed as it seemed to be by the achievements of Descartes and others in mathematics and physics, spread its influence throughout French culture, including the realms of art and poetry: "In France the scientific spirit in general, and the genius of Descartes in particular, indulged a[n] . . . exacting rationalism, hence the omnipotence of rules [in art] and the poetical art of Boileau." But rationalism was not the end of it; the worship of Reason showed a Platonizing tendency to become idealist or transcendental. Cartesian rationalism became "circumfused with a halo of transcendency . . . Platonic or neo-Platonic." Art was reconceived as a "science . . . of the learned, that consists in the Idea, in reason, in truth. . . ." In Poussin's day, it was believed that "the imitative practice of the painter is valid only if it is controlled by a rational doctrine," and "Only the light of reason can attain" beauty. Cartesian rationalism had given birth to "a transcendent standard of art, called Idea."[53]

Fundamentally, in the sixteenth and seventeenth centuries, every scientist and theoretician of science leaned toward either the Aristotelian or the Platonic approach, that is, the experimental or the mathematical method. While Descartes honored both, his primary goal as a scientist was to treat natural science as mathematics. Every postulate in physics, in his view, should be deducible from a priori axioms, as in Euclidean geometry. As a theoretician of science, Bacon, on the other hand, emphasized the experimental approach. His motto was "Natura non nisi parendo vincitur" ("Nature is only conquered by obeying her"). Descartes spoke quite differently when, in the final chapter of the *Discourse,* he wrote that science will make us "maîtres et possesseurs de la nature" ("masters and proprietors of nature"). It was the renewed invocation of universals, with the feeling that one could contact them and through them control the world, that led to this mood of mastery and proprietorship—and it was mathematics that led one to direct contact with the universals.

In 1687, Newton's *Philosophiae Naturalis Principia Mathematica* (*Mathematical Principles of Natural Science*) followed. Newton seemed to establish universal rational principles for dealing with science that were expressed through mathematics—particularly the Law of Gravitation presented in book 3. The rush of the exact

sciences was under way, and through it the seventeenth century seemed to rediscover universality and thus wipe out the particularity—or anti-universality—of the sixteenth.

The Scientific Irrational

From a certain point of view, then, the revived skepticism of the sixteenth century seems to have taken a wrong step in the seventeenth. Sixteenth-century thought was bound to the contingencies of its momentary situation; seventeenth-century thought, however, had returned to the universalist orientation. In this shift the Pyrrhonist openness was circumscribed by internal limitations—imprinted by Platonic mathematical universals, directed by the universal metanarrative of history, constrained by unbending ethical laws—as the seventeenth century experienced, and in certain circles promoted, the gradual undermining of sixteenth-century skepticism.

Thus it was that a contradiction within the theoretical history of science was revealed. On the one hand, scientific method was based, as Karl Popper said, on the skeptical principle of questioning *everything*; on the other, the reality of science as a status quo was based on universal principles which, by their definition as universal, discouraged questioning. By the time of Newton, Western thought had substituted scientific universals for religious ones, when the point had been (in the minds of sixteenth century humanists anyway) to eliminate universalism from thought altogether. Henceforth, thinkers continued the quest for religious certainties through the search for scientific absolutes. When such seemed to be found, they were greeted reverentially like new religious truths—but even better because they transcended any specific religion (thus transcending the sectarian disputes that sundered Europe as in the Thirty Years' War) and were demonstrated as truly universal by the Pythagorean-Platonic appeal to their ultimate foundation in mathematics. Such truths were not, in other words, truly empirical because they did not ultimately deal with sense data but with those semi-metaphysical entities that Plato had called "the mathematicals."

So at the moment when empiricism and the pragmatic reliance on experience had at last been reformulated after the long night of "the Christian millennium," rationalism once again (as in the Scholastic era) intervened with a devastatingly impressive new apparatus: Instead of the Aristotelian syllogism, it was the Platonic "mathematicals," which traditionally resided at a higher level in the cosmic hierarchy than the syllogism or any other sense-based approach. The science of the mathematicals then rebounded onto philosophy and revised it correspondingly.

In part because of the demonstrations of Newton and others, philosophers became, as Nietzsche put it, unable to free themselves "from the belief that the fundamental concepts and categories of reason belong by nature to the realm of metaphysical certainties. They always believe in reason as a fragment of the metaphysical world itself."[54] Philosophy, following in the unquestionable advance of

science, became "more or less entirely *theory-centered*."[55] With a stunningly ironic reversal, the moment of empirical-pragmatic grounding in experience had in fact led to "the outright expulsion from philosophy of all practical concerns."[56] In a sense such concerns were expelled from science too (relegated down the hierarchy to technology) as purity and the nonsensual exactitude of the "mathematicals" held sway.

In the age that followed, science made great strides while increasingly basing itself on an ultimate appeal to the irrational. It was its emphasis on mathematical abstraction, its insistence on the universal and absolute, its commitment to power, and its worship of hypostatized contradiction (as in the coexistence of relativity and quantum mechanics) that situated it in this way.

So the odd paradox arose that a tradition of thought which featured rationalism came to worship the irrational, which it reconceived as a hyperrational. Such was the collegiality of Romantic feeling and exact science that held sway in the West for about a century and a half. A higher mind than ours, it was presumed, would immediately perceive the perfect rationality of a hypothetical entity such as might underlie, say, both relativity and quantum mechanics, though our own limited and contingent minds would have to take this hyperrationality on faith.

In time this situation would develop into a hothouse for the growth of totalitarian states. Ideologies—which, as Hannah Arendt said, "can explain everything and every occurrence by deducing it from a single premise," and are "so disturbingly useful for totalitarian rule"—are "known for their scientific character."[57] Their desire, for example, to deduce everything from some universal premise, is based precisely on the model of mathematical science as developed by Descartes, Newton, and their successors.

The Sound of the Owl's Wings

The philosophes "wrote the history of the human mind as the history of its rise from myth in classical antiquity, its disastrous decline under Christianity, and its glorious rebirth."[58] The "rebirth" was the Renaissance, and the Enlightenment has been called the "last act of the Renaissance."[59] It was a rebirth, in other words, that took centuries; slowed by the resistance left over from the Christian millennium, this age of doubt took about four hundred years to come and go.

Writing fairly near the end of that period Hume said, "Affairs are now returned nearly to the same situation as before, and Europe is at present a copy at large, of what Greece was formerly a pattern in miniature."[60] This concept of the copy did not apply just to culture as a whole, but to individuals within it. Rousseau characteristically described himself as "ceaselessly occupied with Rome and Athens; living, one might say, with their great men . . . I thought myself a Greek or a Roman."[61] Diderot agreed. "In my early years," he wrote somewhat as a pedigree, "I sucked up the milk of Homer, Vergil, Horace, Terence, Anacreon, Plato and Euripides."[62] Diderot signed himself "Diogenes." Adam Smith was like "a Roman Eclectic in modern dress."[63] As Gibbon trod the Roman forum he mused that the

classicism that joined him with the ancients was, as a modern has put it, "a bridge thrown across the Christian millennium."[64]

Eighteenth-century intellectuals were plugged with uncanny directness into the classical stratum. By mid-century, Europe was about to embark again on the writing of democratic constitutions, as the ancients had. Still, these men spoke not at the beginning but at the end of the four-centuries-long period from the Renaissance to the Enlightenment. They spoke with such optimistic enthusiasm not as the light of reason was being grasped again anew, but at the last moment before it was plunged into the darkness and irrationality of the Romantic era. The owl of Minerva, as Hegel remarked, flies at dusk—meaning that a civilization or era does not fully understand its own meaning until it is approaching its end.

So by the time the eighteenth century had dawned, the Enlightenment was more or less over before it had begun. Though it was supposedly validated by pure science, it was not the belief in Baconian contingency but the belief in Newtonian universals that sustained it. The philosophers, confident in the foundation of their new order in science, did not notice that it was still founded on universals, which usually underpin a form of religion or crypto-religion. Beneath its surface, the revised, pseudo-secularized universalism of the seventeenth century was already tending toward a religious revival. The insights for which the philosophes fought sound revolutionary and new, but in fact they were already old and beginning to lose their grip.

Turned Upside Down and Torn Apart

One sign that Enlightenment ideals were already tiring and losing their grip by the mid-eighteenth century—if not earlier—was the gradual reappearance of the idea of the sublime. This discourse began, for the modern world, when the conservative Irish author Edmund Burke wrote *A Philosophical Inquiry into the Origin of Our Ideas of the Sublime and the Beautiful* (1757).[65] Burke's long essay was loosely based on an ancient work of the Roman imperial period, Pseudo-Longinus's *Peri hypsous* (*On the Sublime*). There "Longinus" had argued that in addition to beautiful (pretty or pleasing) artistic effects there are others, called "sublime," which work by arousing terror in the reader through evoking indifferent out-of-scale entities. In order to approach the discussion of the sublime, Longinus says, we must first "raise our faculties to the proper pitch of grandeur."[66] This, it turns out, is because the sublime is "suggestive of terror" but at the same time its "total effect" results "from dignity and elevation."[67] It is a "noble emotion," which "forces itself to the surface in a gust of frenzy. . . ."[68] It involves "vast, cosmic distances." A sublime picture, for example, might literally show "the whole universe being turned upside down and torn apart."[69]

Longinus's sublime partook of the irrational more than the rational. It retained this aspect in the early eighteenth century, when Longinus's text became prominent again and when one author, in 1719, wrote that the sublime "must be Marvellous and Surprising. It must strike vehemently upon the Mind, and Fill, and

Captivate it irresistibly."[70] It is not of the ordinary, wrote another author about the time of the Battle of Jena (1806), but rather "speaks a language so little cultivated or even rudely known, that none but minds the most highly enlightened can be made fully sensible of its essence."[71] It occurs (wrote James Fenimore Cooper) when the poet "gazes into the illimitable void . . . the expanse of ocean . . . the obscurity of night."[72]

In contrast to the pretty pictures of his own day—such as those, in France, of Boucher and Fragonard—Burke, around the mid-eighteenth-century apogee of the Enlightenment worship of reason, seems to have sensed the return of the irrational sublime as of the repressed. A generation before the French Revolution enshrined the Terror, he discussed the sublime in terms of terror, defining it with an approach that has come to be known as the "terror sublime" or the "terrific" sublime. He characterized the beautiful as human-scale and pleasing, tending to reinforce human ideas about the nature of selfhood, and the sublime as terrifyingly out-of-scale, threatening, tending to crush and rend conventional ideas of selfhood. The sublime was characterized by four examples: mountain peaks, storms at sea, Milton's description of Hell, and infinity. Stated baldly, the beautiful might be equated with the rational, the sublime with the irrational. In terms of the particular dynamics of Western civilization, the rational and beautiful lined up with the Greco-Roman heritage, the irrational and terrifying with the Judeo-Christian. In terms of deities, the sanity and clarity of Zeus or Apollo (as Julian the Apostate put it) were set against the rage and destructiveness of Yahweh. The ingredient of fear in the sublime is "a sub-category, as it were, of the religious awe that is central to the idea."[73] In theological discourse, Rudolf Otto's idea of the holy as the *mysterium tremendum*—the mystery that makes you tremble—is a close corollary.[74]

Burke was writing at the end of the long Renaissance confrontation between humanism and the Inquisition, foreseeing the almost immediate reimmersion in the darkness and terror of the sublime which the Romantic movement would soon enough reinstate as cult. Voltaire's optimistic motto *"Écrasez l'infame"* ("Crush the infamous thing"—meaning the dark attraction of the sublime as enshrined in the Church) was not to be fulfilled. It is true that several centuries of the progressive resurgence of the Greco-Roman way of thinking—especially in the climactic expressions of Voltaire and other philosophes—had rendered Christianity temporarily void or ineffective. But the same darkness of the irrational that lay in the praise of faith—especially in Pascal's equally famous counter-slogan adopted from Tertullian, "Credo quia absurdum" ("I believe because it is absurd")—was looming (or slouching) back in the Romantic worship of nature and the infinite already dominant in Goethe's charter of the Romantic movement, *The Sufferings of Young Werther*, in 1774. What happens to Werther is simple, the fundamental ideal of the Romantic movement and the antithesis of the philosophes' Enlightenment: He fell in love with the sublime (as encountered above all in the poems of "Ossian") and killed himself ecstatically.

Can it be mere coincidence that, just as the Enlightenment was giving way to the Romantic movement, the French Revolution veered from democratic ideas

into the Terror? The passage of *The Declaration of the Rights of Man* in 1789 had by 1793 given way to the Reign of Terror; the beautiful had given way to the sublime. The terror sublime—which was the world turned upside down and torn apart, which was gazing into the illimitable void, which was Milton's description of Hell— reigned darkly supreme where lately the beautiful of the philosophes had seemed about to carry the day.

In Hegel's writings on the French Revolution, he is concerned with terror as the sublime, or, as he puts it, as absolute freedom. In *The Philosophy of History* he equates virtue with terror because virtue is apt to bring tyranny with it: "Reason itself revolted against this terribly consistent Liberty, which in its concentrated intensity exhibited so fanatical a shape."[75] In *The Phenomenology of Spirit*, published half a generation earlier, reason had revolted more ambiguously. "Universal free- dom," which equates roughly with the sublime, "is merely the rage and fury of disappearance and destruction," he wrote. Because absolute freedom "cannot allow itself to be represented, it can achieve no positive result whatever: it can only reveal itself negatively in a general fury of liquidation."[76] This is virtually a description of the sublime. The Terror, as Arendt said, "eliminates individuals for the sake of the species, sacrifices the 'parts' for the sake of the 'whole',"[77] much as Burke had said that the sublime is out of scale with an individual person. "In a perfect totalitarian government," Arendt adds, "all men have become One Man. . . ."[78] It seems that Hegel is trying to take the right side in these passages after a youthful period of enthusiasm for terror as an instrument of history. Still, he leaves it very ambiguous; terror's closest approximations are absolute virtue and absolute freedom. It is the sublime turning Enlightenment ideals into ecstatic suicide.

A Cloud of Darkness

Western Europe in general, inspired by Hegel's apparent espousal of the terror-sublime as an essential force of history, became desensitized to the individual claims of non-Western peoples around the world. Hegel had said that such cultures were "ahistorical" because they lacked the impetus toward "absolute freedom," which was increasingly becoming the driving force of the Western world and its idea of "progress." In Hegel's view of the end of history—the moment when all the world's peoples would dress, speak, and comport themselves like the Prussians of his day— one sees Arendt's prophecy that through the totalitarian domination of the sublime "all men . . . become One Man." The West, as the primary carrier of the sublime, convinced itself it had the responsibility of dragging supposedly ahistorical peoples—those of Africa, Asia, and South America—into History.

Behind the surface events of European history since the Renaissance lurks a subtext of sinister milestones marking the advance of the European sublime around the world: from as early as the first Portuguese slave raid on sub-Saharan Africa in 1442, to 1509, the year in which the first shipload of enslaved Africans docked in the New World, and so on until the culmination in 1884–85, when the western European nations, at the Berlin Conference, redrew the map of Africa as their own domains, unleashing the "scramble for Africa," which culminated the long

colonial-imperial era. Though colonialism had begun in the age of the Renaissance humanists, it began small, and only burgeoned into the nightmare of history it became after Hegel's justifying arguments. It didn't really get going, that is, until the age of the sublime, whose ultimate flowering was in the Romantic era.

Though the alternation between ages of certainty (which foster the sublime) and ages of doubt (which eschew it) seems inherent in the makeup of Western civilization, it seems also to be linked to contact with outside cultures. The age of Classical Greece, when the Athenian state and some others felt that their actions were justified by universal principles, followed the closing off of Greece from the rest of the world after the Persian Wars. The Alexandrian age, when a post-Modern cultural configuration was fully enunciated, was characterized above all by contact with outside cultures; that contact brought in its wake skepticism about one's own inherited idea of universals, and relativism about cultural claims in general. Medieval Europe was hermetically sealed off from all contact with the outside world; then Islamic contact, beginning in the late eleventh century, led to Renaissance humanism and the rebirth of skepticism and relativism. The colonial era that followed involved plenty of contacts with other cultures, but denied them; they were virtually hidden by the cover story of the self-sufficiency of the colonizing culture itself, as in a Jane Austen novel one never hears about what the absent men of the household or community are busily doing on foreign shores to dark-skinned peoples. Oddly, it was in the colonial period that most Westerners were to have the least awareness of foreign cultures and the least contact with them. It was only with post-colonialism, and post-Modernist multiculturalism, that they sprang back into our awareness. At the height of the colonial period itself—the late eighteenth and nineteenth centuries—the incomprehensible vastness of the sublime came in like a protective cloud of darkness to conceal what was really happening.

The Secret of Nothingness

When Burke reenunciated the idea of the sublime in the *Inquiry* of 1757, that darkness-in-which-infinity-lurked was beginning to make itself seen, primarily in landscape painting. This genre was newly emerging, perhaps as a reflex of the increasing liquidity of real estate as private property, which was no longer tied over ages to a specific family but had now begun to change hands freely. As the bourgeoisie, with its desire to own land, grew, landscape painting became partly an advertisement, partly a celebration of such ownership (like the Pompeian frescoes depicting the facades of private houses).

Certain differences between the works of Boucher and Fragonard trace the path of the sublime. In Boucher's rococo pictures like *Diana Resting at Her Bath* (c. 1750) or *Blonde Odalisque, Louise O'Murphy* (1752), the anthropomorphic figure fills most of the frame—in conformity with Burke's statement that the beautiful is human-scaled. Furthermore, the frame tends to be filled with light: There are no secret darknesses in it—in line with Burke's feeling that the beautiful is pleasing to humans in that it confirms the rightness of their sense of selfhood. But in Fragonard's pictures, even festive ones such as *The Fête at St.-Cloud* (1773) and

The Swing (1768–1769), this complacent ideology is ambiguous, at times even reversed. The human figures are greatly reduced in scale and often appear tiny and antlike in the frame. At the same time, most of the frame is filled with nature, which seems to loom, often darkly and threateningly, over the frivolous-seeming human festivities. In one sense, culture remains the beautiful, but it is now offset by the overpowering presence of nature as the sublime; culture is the finite (human-scaled), and nature, as Burke said, the infinite (mountain peaks, storms at sea). When a finite thing enters infinity, it is at once, by definition, annihilated, for in infinity everything is everything; the finite cannot hold its boundaries there. An underlying theme of Fragonard's work of this type is that nature, the infinite and sublime, will ultimately gobble up all the finities and filigrees of culture. The theme of the oceanic rise and fall of civilizations, a post-Modern leitmotif pointing to the relativity of cultures, shows itself here. (The theme of the "pleasure of ruins," as Rose MacAulay put it,[79] had already manifested itself in the remains of Second Campanian style paintings at Pompeii and elsewhere.)

In Caspar David Friedrich's self-conscious ideological glyphs, he places the cross on a mountaintop or a glacier as a sign of eternity triumphant over time, even though the earthly church is portrayed lying in ruins. The cross, in his work, signifies the sublime—"absolute freedom," as Hegel called it—which is unknowable and seemingly inhuman when witnessed from a bound, finite point of view.

In J. M. W. Turner's late paintings, from 1842–1845, the locus of the sublime shifts from landscape to sea—as Burke, almost a century before, had mentioned storms at sea in his classic list of four instances. The ship of state—that is, culture, the beautiful—is portrayed as sinking into the oceanic wholeness of the infinite sublime. In another sense, viewed in terms of the pictorial frame, the diminution of the figures and the increasingly hungry animation of the ground express the fact that, basically, the figure is the beautiful and the ground is the sublime. The figure is human scaled and reassuring in its involvement in humanly understandable motives and interactions; the ground is secret, omnipresent, infinite, lurking everywhere, waiting to pull down the innocence of the figure.

This distinction is prominent in the genre of painted portraiture. David and Ingres maintained a strong and clear outline of the figure—that is, a strong and clear distinction between the figure and the ground, almost as if to protect the figure from the ground. In their portrait-based works, the ground is not articulated or variegated; it is a neutral background that does not exert any force upon the figure but allows it to state itself clearly and untroubledly. A generation later, however, in the portrait-based works of, say, Delacroix (especially his self-portraits), the ground is not neutral and self-effacing but turgid and filled with forces thrusting up as if from another world which underlies the figure and threatens its wholeness and integrity. The figure is the beautiful, the ground the sublime, threatening to devour it.

It was this tendency of the ground to devour the figures (as the infinite devours the finite, as the sea pulls down the ships) that led to abstract painting. As the figures increasingly disappeared, the ground became increasingly abstract—the

ground became in fact the subject matter of the painting; as the ground steadily took over the picture from the figure, the abstract sublime came into being. This staged development was given a primal expression in Kasimir Malevich's essay "Non-objective Art." There Malevich compares the search for non-objectivity (which culminated in the *Black Square* and the White on White series) with the difficult ascent of a mountain; as the seeker goes higher and higher, he writes, the world below, the world of form and cultural distinction, fades from his sight. First the world of farms and cities grows dim and misty. Then it begins to pass from view; finally, it has disappeared and the subject is left alone in "a desert beyond form," which is non-objectivity.[80] The metaphor of the soul's difficult ascent of a mountain at the top of which is the secret of Nothingness is the same metaphor that Saint John of the Cross used for his staged program of spiritual advancement as set forth in detail in the poetic treatise called *The Ascent of Mt. Carmel*, c. 1585.[81] There he presents the cultivation of a sequence of mystical insights through the metaphor of the ascent of a mountain. Among these are precepts that parallel the reductionism so prominent in the tradition of the abstract sublime, with its elimination of the figure, of representation, and of the entire world of the senses. "To come to the knowledge of all," Saint John writes, "desire the knowledge of nothing;" "To arrive at being all, desire to be nothing;" and so on. Referring to the "mortification of the senses," he writes that "the night of the senses resembles early evening, that time of twilight when things begin to fade from sight,"[82] much as Malevich had spoken of the world fading from sight as one ascends the mountain of non-objectivity to the desert beyond form. The *Black Square* meant the fading away of the world as the ground devours the figures, and continues to mean that, in a visual-conceptual tradition that now includes *Black Square*–based works by Jannis Kounellis, Bob Law, Richard Serra, Pat Steir, and others. The abstract sublime, in other words, involves cultic celebration of the disappearance of the figure, the end of the world.

Mondrian also sought to portray not the beautiful but the sublime—not the figure but the ground. He schematized the seemingly invisible articulations which still, as in Plato's *Timaeus*, evince internal metaphysical structure within the supposedly neutral ground. This was indeed the great unspoken theme of late Modernist art: the empty ground, the blank of phenomena, viewed mythically as the end of the world. This was the actual subject matter of art from Malevich to Mondrian to Newman. The art of the abstract sublime—the portrayal of the living force of the ground rather than the figure—was an art of the end of the world. It is no coincidence that it arose at the time of the First World War—nor that Einstein's Special Theory appeared in the same year as the *Black Square*.

Dream or Nightmare

Like a recurring bad dream that is nevertheless somehow thrilling, the abstract sublime faded between the wars, then came back with a vengeance with World War II. One might say that it represents what James Joyce, in *Ulysses*, called the nightmare of history. As Europe lay in suicidal ruins for the second time in this

century (the ecstatic suicide of the Romantic sublime again), it became increasingly difficult to believe any longer that Europe was, as Hegel had said, leading the world to its desirable culmination. Impoverished and crippled, Europe lost its nerve and began to withdraw from its colonies around the world—a process that took roughly from Britain's withdrawal from India in 1947 until Portugal's withdrawal from East Timor in 1976. Modernism had ended; post-Modernism was ambiguously getting under way.

Post-Modernism, understood in these terms, was an attempt by the figures to wrest control of the picture back from the ground, to reassert the human-scaled, the beautiful, the contingent. The terror sublime of Modernism had seemed at first like an adventure dream; then it became a nightmare. Post-Modernists came to view Modernism, with its scientific exactitudes and mathematical universals that faded into devouring sublimes, as an essentially destructive force. Neither political nor scientific nor philosophical absolutes were any longer bearable; they all turned into that absolute freedom which expresses itself only in frenzies of relentless undis-criminating destructiveness. The age of doubt, however dangerously late in reap-pearing, was upon us again.

A "New" Age of Doubt?

If one opens a textbook on post-Modernism, such as Best and Kellner's *Postmodern Theory* (1991),[83] there is a simultaneous feeling of déjà vu and of disjunction. On the one hand it seems like the attitude of Renaissance humanism and the Enlightenment all over again; on the other, it contains no references to this similarity and seems concerned to deny it. Instead one finds repeated somewhat strident assertions that post-Modernism is a new cultural and social formation that needs new cultural and social forms. This insistence seems a continuation of the Modernist idea of progress and innovation; the willful blindness about facts which it involves also seems forbiddingly and sinisterly Modernist.

"Postmodern theorists," according to Best and Kellner, ". . . claim that in the contemporary high tech media society, emergent processors of change and transformation are producing a new postmodern society and its advocates claim that the era of postmodernity constitutes a novel stage of history and novel sociocultural formation which requires new concepts and theories. Theorists of postmodernity (Baudrillard, Lyotard, Harvey, etc.) claim that technologies such as computers and media, new forms of knowledge, and changes in the socioeconomic system are producing a postmodern social formation. . . ."[84] Yet the intellectual makeup of this time seems far from new historically; in fact, it seems a recurring moment, though the reaction against that moment each time the turn toward dogmatism reaffirms itself has had the effect of dimming or blurring memory.

In other words, what we are experiencing as post-Modernism may be nothing new historically, but something that always *seems* new: namely, the end of an age of irrational dogma and communal folly. At the time of Renaissance human-ism and neo-Pyrrhonism, the irrational dogma that was ending was Christianity

and the communal folly was the attempt to set up a theocratic kingdom of God on earth. In the era of the sublime, the irrational dogma was Eurocentrism, and the communal folly was the colonialist attempt to spread European hegemony around the world as a universal or Platonic ideal whose purview was everywhere. Such ages seek to create an impression of their own eternality; since the dogmas they purvey are held to be eternally true, it follows that they must have been around, in some sense, forever. Ages of certainty always exaggerate the duration of their existence through the denial that their own ends are approaching; hence their ends, when finally they come, are experienced as surprising, untoward, and, finally, unacceptable.

It seems clear that Western history has been dominated by oscillations between the beautiful and the sublime. What we are currently experiencing as "post-Modernism" seems to be a cyclic recurrence of this internal contradiction in the Western tradition—not in fact a new social formation requiring new social forms.

For us, Nietzsche, Dewey, Derrida, Foucault, Baudrillard, and Rorty are what Pico, Sanchez, Montaigne, Voltaire, and Hume were to an earlier age. Despite the frequent density of their texts, the various masters of post-Modernist thought can be assigned simplistic—and familiar—locations in the Western discourse without major distortion of their intentions. The way or practice of systematic doubting they instilled was not too distantly based on the ancient one. Derrida, for example, may be construed as having spun a formidable discourse out of an elementary ancient argument that goes back to Zeno of Elea. In one of his paradoxes, Zeno argued that it is impossible to traverse a certain space because one must first traverse half of that space. Having traversed that half, there still remains a smaller half, then a smaller, and so on. Through the infinite divisibility of space, there always remains another half, however tiny. The traveler, being of finite life span, will never reach the other side. The finite is reduced to absurdity by involving it with the infinite, in this case through infinitesimality or infinite divisibility. Arguments of this form remained standard equipment of Greek dialecticians from Zeno to Sextus.

Derrida revives this line of argument in his critique of the relationship between signifier and signified. If one is seeking the meaning of a word and points either to another word or to some other mode of representation, then one has not gone from signifier to signified but merely from one signifier to another—and so on ad infinitum.[85] Through this infinite displacement or slippage of signifiers, the initial problem is reduced to absurdity, as any finite concept is reduced to meaninglessness through being involved with infinity. Derrida's argument against meaning is clearly this type, and he would seem to have picked it up from the ancient Hellenistic-Roman skeptical tradition—but he never mentions that fact. Sixteenth- and seventeenth-century thinkers such as Montaigne or Bayle openly referred to Sextus when basing an argument on his text; Derrida and other so-called post-Modernist skeptics seem concerned with concealing this foundational level of their argumentation—still, perhaps, to promote the Modernist idea of progress.

One could expand such a listing. Foucault's reflections on power and knowledge, for example, do indeed owe a debt to Nietzsche, which he acknowledges, but even deeper is the unacknowledged debt to tendencies in Plato such as

the argument of Thrasymachus at the beginning of *The Republic*. Post-Modern thought in general, and Foucault in particular, have declared that the claim of truth "arises . . . solely in the context of hegemony and proselytism. . . ." Truth "is an aspect of the hegemonic form of domination or of a bid for domination-through-hegemony. Modernism was . . . such a bid. . . . The part of the world that adopted modern civilization . . . was bent on dominating the rest of the world by dissolving its alterity."[86]

Similarly, Baudrillard's precession of simulacra can be seen as a neo-Eleatic spin-off of Plato's Great Chain of Being, rearranging the ideas of original, copy, and infinity into a conundrum that harks back to Zeno. Other such correspondences could be noted.

In fact, the degree to which post-Modern thinking has derived from a revival of ancient skepticism can hardly be exaggerated, yet is not acknowledged by the thinkers themselves, who seem more concerned to maintain the impression of innovation rather than acknowledging their rootedness in tradition. It is the repudiation of the quest for certainty—the central feature of the ancient skepticism—that has led to the charge that this age of doubt is irrational. But in fact it was the insistence on certainty that was irrational, and the emergence of an age of doubt—"new" or not—was a correction of course; irrational only in the sense that it refuses to worship rationality as an hypostatized absolute, this doubt is rational in its acceptance of limits and uncertainty.

The Bottom Line

A half dozen or so approaches are current. There is the account by new communications technologies; the account by the overwhelming realization, in the twentieth century, of the nightmare of history; the account by transnational capitalism ending the age of the nations; the account by the end of colonialism, which led to multiculturalism; the account by the failure of the Enlightenment; the account by science's destruction of micronarratives.

Some of the elements of this shifting set can be seen as working together: The nightmare of history, for example, led to the Western loss of nerve with consequent withdrawal from the colonies; this withdrawal in turn allowed the former colonies, over a period of a generation or so, to shift from Third World sources of raw materials and cheap labor for the West to independent producers and exporters of manufactured goods, thus promoting the rise of multinational capitalism, fomented by the emergence of new world-shrinking communications technologies.

In this synthetic account, the wild card is the sense that the Enlightenment has failed, a Nietzschean attitude prominent in Foucault's earlier work. Best and Kellner summarize it as follows: Even though the Enlightenment, through the production of Modernity, was supposed to alleviate human suffering in general, "yet the construction of Modernity [in fact] produced untold suffering and misery for its victims, ranging from the peasantry, proletariat, and artisans oppressed by capitalist

industrialization to the exclusion of women from the public sphere, to the genocide of imperialist colonization."[87]

In the years since this account was written, more weight has been given to the end of colonization in appraising recent shifts of situation and attitude in the geopolitical arena. The bottom line is that in 1950 there were 50 nations in the United Nations and now there are 180-some. Those 130-some "new" nations had previously all been colonies; subjugated, exploited, treated like beasts of burden, silenced, unheard, unrepresented in the global public sphere, suppressed, repressed, excluded, raped, abandoned, looted, murdered, and so on. The freeing of these 130-some communal voices and systems of representation is the single most massive change in the generational shift from Modernism to post-Modernism. This shift far outweighs, say, the development of new communications devices, though the latter no doubt has eased the conversation in which these formerly silenced peoples now speak to one another and to the rest of the world. This multiplication of communities and discourses is the fundamental fact about post-Modern globalization, pluralism, and relativization. When Deleuze and Guattari write of nomadism, when Homi Bhabha writes of hybridity, when Danto writes of pluralism, and Rorty of relativism, this and this alone is what they all are ultimately referring to in terms of concrete history. The relativity and lack of absoluteness that Montaigne had found through an evaluation of varying knowledge claims was underlined by the multiplication of voices telling the story of the world.

Anyone's Guess

In the colonial period the Modern theory of art was relentlessly Eurocentric. It was rooted, by way of the third earl of Shaftesbury, in the belief system of the somewhat reactionary enclave of early-eighteenth-century thinkers called the Cambridge Platonists, whose thought was still deep in the age of certainty, when the rightness of things was guaranteed by universals. Cambridge Platonism can be viewed as the place where the universals, and with them the idea of soul, resided hidden during the age of doubt, to rise again when summoned forth by the blast on the horn of the sublime.

Thus the universalizing commitment—reinforced by art's historic attachment to religion—stayed with art through the Kantian-Hegelian period and up until the labored and gasping end of Modernism. That is one of the reasons why the age of doubt was slow to dawn in the realm of art: Until the postwar era, people's thoughts and feelings about art were still regarded as sacred, as among the most direct expressions of their souls, as, in the Platonic view, recollections of the prebirth vision of the divine rising into consciousness through the membrane of intuition. (Is this universalizing commitment, this connection to the prebirth vision of the Real, all that Adorno was referring to when he wrote, "Aesthetic questions always boil down to this: is the objective spirit in a specific art work true?")[88]

The first absolutely clear sighting of doubt in art history—the first moment it raised its head as from a trench of World War I—is in the works of Duchamp. In

their small, perverse, and antipretentious way, the Readymades—everyday objects exhibited without significant alteration—functioned as a clarion call to doubt. The Dada group was involved in this call, but finally the aloof individual Duchamp was more instrumental. When his legacy—which had slumbered through the Depression years—came to life in the immediate post–World War II period at Black Mountain College and elsewhere, post-Modernism reached its second stage in art history in the 1950s works of Cage, Rauschenberg, Johns, and others. Further stages took it through the classical age of Conceptual and Performance Art in the 1960s and '70s, but there was a certain misunderstanding still involved. Many of the artists who invented Land Art, Body Art, and so on still thought they were pressing the forward edge of history, not that they were calling a halt to such pressing. That full awareness came only in the 1980s, with the realization of quotational pastiche in its many varieties, then flowed after a while into the next stage, multicultural pastiche with its apparent (though sometimes tricky) abandonment of the Western identity and its purposes. This was tricky because the same apparent abandonment was taking place in the larger world roundabout through transnational capitalism, with a hidden agenda that can now be seen to have been, for the time being anyway, to the West's advantage.

So the new art—some of which will be presented in the anthology part of this volume—was not simply forging ahead on some art-historical jag, but expressing a major shift in our cultural history. To a Modernist, this seemed like the end of art itself. As Adorno wrote, "Whether art will survive . . . is anyone's guess."[89] When doubt came to infiltrate not only the practices but the premises of art, "true" art, "an art which is true to the idea of truth," according to Adorno, "has been forced to 'challenge its own essence' and to revolt against itself. It does this . . . 'by developing the aesthetic concept of anti-art.'"[90] It is time to look more closely at that development.

Chapter Two

Sculpture, Painting, and the Post-Modern Reversal of Values

It made simple sense, in terms of the plain facts of history, that the mid-twentieth century would be referred to as the postwar era. The term seems neutral and chronological, merely descriptive. But that seemingly innocent term vibrates with other resonances that seem to have been lurking in it and that revealed themselves through the appearances of a series of related terms. Steadily the terminology of what some have called "post-cultures" unfolded. Over the course of a generation Western society declared itself to be not only postwar but post-Modern, and also post-industrial, post-historical, post-philosophical, post-Enlightenment, post-critical, post-humanistic—even post-human. Since the mid-1980s, "post-Modern" and "post-colonial" have become the dominant terms, and one can see with increasing clarity that the concepts postwar, post-Modern, and post-colonial are intimately linked characterizations of the period after World War II.[1]

"Post"-cultures

The ideology of Modernism, with its legitimating myth of history as a progressive force under European leadership, was the cover story or justification for European colonialism; reciprocally, the end of colonialism—which occupied the period from 1947 to 1976—coincided with the step-by-step disintegration of the Modernist paradigm.[2] At the same time, both these terms refer implicitly to "postwar," since it was World War II which put an end to the Modernist/colonialist ideology by discrediting European claims to moral leadership in the world. So postwar, post-Modern, and post-colonial refer to the same internal changes going on in the same period. The war was the tolling of the bell that ended Modernism and with it colonialism.

The repeated prefix "post-" underlines a strong sense of disjunction from what had gone before. It refers to the impression that the period in question seems to have been a cognitive turning point of historic dimensions—at least in the Western world—an example of what Gaston Bachelard called a *coupure épistémologique,* or epistemological break.[3] Alongside social and economic changes the period witnessed rearrangements of cultural attitudes and vocabularies. Art history, for example, in the period of decolonization from 1947 to 1976, witnessed more

radical changes in both practice and theory than in any other historically visible period for tens of thousands of years.

Pulling the Rug Out

It was this development that led to a 1982 edition of the *Art Journal,* a publication of the College Art Association of the United States, dedicated to "The Crisis in the Discipline," meaning the discipline of art history. The crisis was that the inherited view of history had worn out; it was no longer clear which things that happened on the stage of history were important, either politically or aesthetically— or if importance were not just a hegemonic or hierarchizing concept anyway. The crisis was much larger than art; it was the end of the age of certainty about history in the large sense, and with it any certainty about small byways such as art history. In 1987, as the crisis deepened, a book appeared with the title *The End of Art History?* In the following year, the College Art Association, already attempting a resuscitation of the corpse, held a session called "The New (?) Art History," and in the same year a book appeared with the title *Rethinking Art History.*[4]

In terms of the theory of art, what had ended—or what needed to be rethought—was the "Kantian tradition" (or the "Kantian-Hegelian tradition"). This theory, which was at the center of artistic Modernism, included Kant's emphasis on form over content; Hegel's interpretation of history as an inevitable advance; the combination of these two ideas by the so-called critical historians Schnaase, Riegl, and Wölfflin; and a stream that flowed out of this lineage to include such non-German thinkers as Roger Fry, Clive Bell, and, finally, Clement Greenberg. For almost two hundred years this tradition had been the theoretical basis of art historiography. The crisis of the discipline was that the Kantian tradition was losing credibility; the skeptical Humean age that Kant had ended by reestablishing the realm of universals was on the rebound. The "end" of the discipline amounted to a claim that the Kantian lineage was now, at last, over. Art, it seemed, had become post-art-historical. It was a specialized instance of the end of the age of certainty in a new age of uncertainty or doubt.

This proclaimed "end" pulled the rug out from under almost the entire Modernist practice of art historiography, including most of what was being done in academic departments in the field. In the universities, the offices of journals, and the studios of artists, things toppled into a kind of free fall. But this floating period was not really random; it was an alter ego or shadow of the past. The "old" art history had operated with a clear set of taboos, and the previously tabooed materials now rose to the surface and stated their claims in the newly cleared field. A "new" art history began to develop, which has no clear central lineage yet, but a loosely related multiplicity of directions, each representing one of the previously forbidden avenues of investigation. Thus art turned round and became exactly the antagonist of what it had been before. To those who still yearned for the old types of art, and the old ways of thinking and feeling about it, this was a nightmare beyond anything they had imagined might happen in the world of connoisseurship.

Reversals

In a classic text of the Kantian-Hegelian lineage, Heinrich Wölfflin, in the nineteenth century, had posited two "roots of style" in an artwork. These are the visual or internal root, which is the link with previous art, and the social or external root, which is the link with the contemporaneous surrounding culture.[5] Formal considerations such as those emphasized by Kant, when they are historicized as in the Hegelian approach, were regarded as rising exclusively from the first root; these were regarded as aesthetically *inside* the artwork. Everything else—such as cognitive decipherment and social relevance—rose from the second root and was essentially outside of the artwork. The visual root was the only proper arena of art history; the materials relegated to root two, though they might be of interest to sociologists or cultural historians, had nothing directly to do with art history.

Now, as the crisis took shape, it appeared that the most fundamental betrayal of the aesthetic aspect of the artwork had occurred: In the overthrow of the Kantian-Hegelian paradigm, the hierarchy of the "roots" has been reversed. Now, though both are regarded as *in* the artwork, root two, which was previously banished, is, for the time being, dominant. The many avenues shunned by Modernist art history as growing from the nonvisual external root are now being explored in art history texts and classrooms. These include the classic social triad (race, class, and gender); political contents encompassing repressed ideological subtexts; difference in general, especially ethnic differences and community identities; the mystery of representation and its secret agendas; and so on. Thus the age of doubt has opened itself precisely to those experiences the previous age of certainty had condemned and avoided.

As the series of reversals multiplies and continues, a new aesthetic is falling into place, called post-Modernist, and featuring criticism, analysis, cognition, social commentary, wit, humor, surprise, and reversal—all aspects of the work that derive from the second root. This new aesthetic directly undermines what was previously regarded as the integrity of art. The once dominant visual track emphasized the wholeness and consistency of both an individual artwork and the oeuvre it belonged to. In order to preserve the integrity of the oeuvre as a whole, if a major shift occurred within it, then either the work before the shift was dismissed as early or the work after it as late. The Museum of Modern Art's retrospective of De Chirico was like that: Though called a retrospective, it showed only work of the first half or so of the artist's career; since the later work differed, and thus introduced disunity into the oeuvre, it was excluded, and the oeuvre, as presented, appeared seamless. The integrity of individual artworks was preserved in similar ways. In museum installations, for example, the Modernist practice was to give each work ample space, so the viewer could feel that he or she was seeing it in its purity, uncontaminated by the influences of adjacent works. Similarly, on art magazine covers or in illustrations in art books, a work would usually be reproduced whole and by itself. Modes of reproduction that dismembered the work or mixed different works were introduced in the post-Modernist mid-eighties.

Gradually the Everyday World . . .

As the Modernist era once fetishized unity or sameness, so the post-Modernist era has come to fetishize multiplicity or difference. Ihab Hassan has described post-Modernism as characterized by "openness, heterodoxy, pluralism, eclecticism, randomness, revolt, deformation . . . ambiguity . . . perversion . . . unmaking, decreation, disintegration, deconstruction, decenterment, displacement, difference, discontinuity, disjunction, disappearance, decomposition, de-definition, demystication, detotalization, delegitimization. . . ."[6]

With such a determined commitment to indeterminacy, the age of doubt, suspicious of the theological sound of an insistence on unity, opted for the principle of pastiche, or mixing elements formerly thought of as inappropriate together.[7] Thus the tradition of the self-sufficiency, unity, and wholeness of the artwork was bound to be violated; placed on a pedestal as it so long had been, it was a sitting duck—it was asking for it. Similarly, media and genres that had once been kept puristically separate were melted into one another (somewhat along the lines of the Menippean satire in literature), a process that has led, after a generation or so, to the ascendancy of installation art.

At the same time, a critical stance toward society and politics replaced the transcendent otherworldliness of the art of the age of certainty. The worship of originality was replaced by the reductivist practice of quotation, or the open incorporation of past artworks, or pieces of them, into present pastiches. Along with innovation, the intimacy of the touch of the artist's hand (like the saint's touch upon a relic) was replaced by the use of things manufactured by nature or culture for other purposes. Gradually the everyday world took over the realm of the artwork. The painting or sculpture stood in the previously sanctified space with a certain irony, but also with a bald-faced, somewhat defiant posture. Finding itself in a hallowed position that it had not sought, post-Modern art is often heavily saturated with ironic doubt, an attitude not much found in Modernist art. In Modernism, one encountered irony primarily in literature. It is hard to see much irony in the abstract sublime. The *Black Square* is not ironic but straight-faced and blunt in its occupation of the sacred space.

Perhaps the most fanatically convinced artistic phase of the age of certainty was its last, Abstract Expressionism. Other artists, from Kupka to Mondrian to Fontana, had thought their work was a conscious reflection of universals. But the Abstract Expressionists seem to have felt this more personally because of their special connection with the idea of American spontaneity that led to Action Painting. Even those who were not Action Painters, like Newman, seem to have felt that their work was especially tuned in to a collective unconscious, that it was as far as one could go in immediate intuition of the sublime; it was an immediate reading of the mind of God, with its unchanging array of eternal ideas on which the universe is formed. That is why Abstract Expressionist paintings, as great as they may have been in their position in history, look embarrassingly earnest today. And that is why their solemnity has been replaced by ironic wit, their ostentatious

certainty by an ostentatious doubt. (Compare the situation in literature; as Gerald Graff writes: "Perceiving that the modernist's seriousness rests on admittedly arbitrary foundations, the postmodern writer treats this seriousness as an object of parody.")[8]

Bailing Out of History

The terminology—Modernism/post-Modernism—suffers from an overemphasis on chronological succession. What we call Modernism and post-Modernism are cultural attitudes that have been present in shifting ratios for millennia in the Western tradition, loosely equatable to attitudes of absolute or relative, universal or particular, faith or reason, certainty or doubt.[9] "Post-modernism," as Hassan saw it, is "the full flowering of what had for a long time been an undercurrent in the history of Western culture."[10]

In terms of twentieth-century art history, the skeptical forces that now are called post-Modern were already present on the scene at the time of the First World War, in the works of the Dadaists and Duchamp and others, but they remained in the background for about two generations. Duchamp's Readymades implicitly rejected the tradition of the sublime, suggesting that the appearances of everyday things constitute reality, not some higher spiritual code supposedly hidden inside them. This shift of emphasis occurred twice in this century: once, during World War I, with Duchamp and Dada; again, immediately after World War II, in a variety of manifestations from Les Nouveaux Reálistes to Black Mountain to neo-Dada to Fluxus. The first time it didn't take. Duchamp had taken the soul out of sculpture with his Readymades, but the move he made on history was made very fast and did not prevail at once.

By the late twenties the Dada impulse had run out. The Great Depression provoked a retreat to safer and more consoling types of art. The soul maintained its ascendancy, either direct and pure, as in abstraction, or in the old figurative way, as in, say, Picasso and Matisse. The second time this shift occurred, immediately after World War II, it seems that it did take—though for how long remains to be seen.

It is hard to ignore the chronological association of these art historical developments with the two world wars. More of the shape of twentieth-century art history derives from the punctuation of the century by those wars than is commonly acknowledged. Both the sublime and the Dadaist approaches to art seem associated with the wars. The abstract sublime first unambiguously appeared during World War I in the work of Malevich; it did not recur again so aggressively until the immediate post–World War II era, in the works of numerous American and European artists. It would seem that the absolute transcendent vision is stimulated by civilization's experiences of pure self-destruction—the terror sublime, as Burke portrayed it, or, as Hegel saw it, the destructive impersonality of absolute freedom.

At the same time, the desire to puncture precisely those metaphysical pretensions associated with the sublime was equally stimulated by the same wars, in the Dada period of World War I and in that second irruption associated with

neo-Dada after World War II. The sublime, as celebration of the end of the world, and the ridiculous, as an attempt to denigrate that celebration with a reverse spin on the magic, both flowered in response to world wars.

The connection of soulism with Modernism is that Modernism attributed a soul not only to individuals but to History as a communal spirit, an Oversoul. The post-Modernist rejection of the tradition of the soul thus involved a rejection of History in the Modernist sense, as a transcendent purpose working its will through immanence in embodied individuals. It is in this sense that Duchamp and the Dadaists were harbingers of post-Modernism; they first signified, by their works, the attempt to bail out of history and jettison the myth of the soul that was associated with it. As Duchamp's Readymades were soulless everyday objects that could not be suspected of harboring transcendent hidden purposes, so post-Modern sculpture has devoted itself for a generation now to the portrayal of soulless objects and figures, as a kind of attempt to clean out the Augean stables of the Platonic tradition.[11] The general attitude of much sculpture of the last generation or so—derived ultimately from the Readymades—is that reality does not involve hypothetical universals supposedly hiding behind appearances. Rather, reality simply *is* the appearances—the appearances equal objecthood—and objecthood equals sculpture.

These developments mandated, for the time being anyway, a diminished arena for painting. As a little-attended part of the massive cultural shift, a historic reversal has occurred in the relationship between the two great branches of Western art, painting and sculpture—a relationship that was formed by powerful philosophical forces in antiquity and did not break for thousands of years.

The Madness of the Poet

In the millennia-long period that may be called "traditional painting and sculpture," the two media were regarded as mutually supporting modes of representation; it seemed as clear to Michelangelo as it had once seemed to Pheidias that painting and sculpture both portrayed insights into the reality of the same world, rather than of different and opposed worlds. Furthermore, the insights seemed sympathetic to one another; the two media were regarded as conveying the same ideological and spiritual values.

The main distinction was a hierarchical one based on the greater materialism of sculpture, which rendered it seemingly more labor-intensive than painting—more proletarian. One could work up a sweat through practicing sculpture, less easily through painting. As Leonardo is reported to have said of Michelangelo that he was just a stonecutter, so ancient Greek aristocrats who patronized the arts in Plato's time looked down on manual labor as an activity proper only to slaves. The painter, after all, was using a material that had no practical function except the creation of illusions, which is the special calling of a ruling class. The painter, it seems, felt like the aristocrat, while the sculptor, with his heavy materials and his toolkit like the ordinary stonecutter's or bronze-worker's, was a proletarian. The Renaissance inherited this attitude.

But despite this hierarchical distinction, there was an ideological symmetry between the two media, a close-knit relationship that seemed to reflect the overall unity of the universe. In terms of one of Plato's theories of art, both the painter's and the sculptor's activity can be categorized as what the *Phaedrus* calls the madness of the poet: Both have had a primal vision of the realm of pure forms and base their works on inspired recollections of it. This aspect of art was bound up with the widespread influence of the Pythagorean-Platonic tradition, according to which a Great Chain of Being runs through the universe, unifying its levels and branches.

What Pheidias Saw

Most of the evidence of both panel painting and wall painting in the Greco-Roman period is gone, but one can see hints of its character in works in more durable media that have survived, such as the Second Campanian–style frescoes in the homes at Pompeii and Herculaneum. Many of these works are dominated by the practice of linear perspective, usually with a frontal position assumed for the viewer so the single vanishing point lies about in the center of the composition. Outdoor scenes, such as the *Odyssey Landscapes,* were also perspectival, positing an observer who by observing participated in the composition. In terms of the cultural mentality of the ancient Greeks, this practice relates to the Pythagorean-Platonic emphasis on geometry as the signpost of the inner unity or integral meaning of everything. The position of the viewer gazing at a perspectival architectural rendering is much like that of a geometer gazing over a construction of Euclidean axioms. In the Greek view, the fact that the same geometric laws apply to everything was taken to show that everything has the same inner cognitive construction; the same mysterious intentions and metaphysical strategies have been enfolded into everything by the Demiurge.

Perspective in a picture lays special stress upon the viewer's collaboration. Not only is geometry present in the heavy emphasis on architectural rendering, but the single vanishing point unifies the lines, planes, and forces of the picture and, even more so, unifies them *with* the subjectivity of the hypothetical perfect observer standing in the certain exact spot which makes sense of the perspectival unity. It is implicit in the artists' procedure that the perfectly placed viewer's subjectivity constitutes the picture by validating its perspectival methods. Platonically, that viewer is performing an analog of a world-constituting act of perception.

In ancient Greek sculpture too, this Platonic spirituality was involved. Cicero, when discussing the transcendental vision behind sculpture, observes that "Pheidias did not contemplate any human model from whom he took a likeness, but rather some extraordinary vision of beauty was present in his mind, and fixing his attention on it and intuiting its nature, he directed his hand and his art toward making a likeness from it" (*Orator* 9).[12] Plotinus (*Enneads* V.8.1) may be thinking of this passage when he says that, in making the likeness of Zeus, Pheidias was gazing not upon a mortal model but upon the Platonic ideal of the deity.[13]

The Platonic view of art was characteristic of the classical era. Subse-

quently, it survived through the less Platonic Alexandrian age in sheltered conservative enclaves such as the Academy itself and various scattered venues such as Plotinus's circle in Rome in the second to third century A.D.—a mode of survival that was echoed by the sheltered enclave of the Cambridge Platonists in the seventeenth century. In this age, the Pythagorean-Platonic measured or mathematical sculpture, incorporating ratios like spells—from the archaic measured head of the Lady of Elche to Polycleitus's *Canon,* the Critias Boy, the Lemnian Athena, and so on—came to be regarded as a relic of a noble antiquity. (The Greeks already thought their own art history had passed its apogee in, roughly, the Periclean age.) It was replaced in the forefront for a while by a realistic sculpture that seemed to deny universals in favor of conditionals (such as the Roman portraits that are based on particular human beings rather than on a universal idea of the human).

Still, when Greek things were revived in the Renaissance, it was believed that something like a mainstream had been comprised by the Platonist agenda of art, and this supposed mainstream was reconstituted by Marsilio Ficino's Platonic Academy in Florence, where the Medici young were schooled and whence Botticelli received conceptual sketches of his works as part of his preparation for them. The Pythagorean-Platonic agenda involved seeking to approach, through representation of the human, an ideal which is mathematical in nature. The measured head incorporated simple ratios of whole numbers, as did the perfect harmonies in music. The ratio between, say, the eyes and the space between the eyes was seen as ideally embodying a Pythagorean principle of the universe—the "plummet-measured face," as Yeats put it, involving "calculations that look but casual flesh."[14]

Partly, the idea was that these particular ratios would contribute to the beauty of the piece, but in addition one has to suspect a certain fetishism. In the much later Neoplatonic tradition, Porphyry taught a type of sculpture where it was believed that the deity represented by the sculpture was actually *in* it. The deity would be ritually invoked into the sculpture in various ways not clearly known. The same type of ritual investiture goes on with Tibetan mandalas—the deity is invoked and installed in the physical matter of the image—and in many other places. It is a part of what our culture long called the primitive aspect of things that the Greeks still participated in.

The ratios installed in the measured heads of late archaic and early classical sculpture may have been regarded to a degree as magical ingredients. They may have been conceived more or less as *living* within the stone or bronze and exerting an effect through the material embodiment. Since these ratios are those to which the human soul is tuned, the work directly or vibrationally addresses the soul, and also it contains a kind of soul, in that it contains the tuning.

The ancient sculptors' desire to create a model of human perfection was related to Plato's idea that for each species there is an absolute model of perfection on which individual embodiments are, however distantly and imperfectly, based. When Pheidias, according to Plotinus, portrayed the figure, he was portraying it as Pure Idea rather than as observed fact. The mathematical ratios involved in the composition of both face and figure were a way of incorporating this inner Idea.

Both the face and the figure embodied, through mathematical ratios, the harmony of the spheres. The individual human being was, in effect, portrayed as a deity.

The Art of the Soul

This was not exactly the art of the figure; its intentions had more to do with portraying the soul. The Pythagorean-Platonic tradition recognized, within the human self, an unchanging metaphysical soul, tuned, like a musical instrument, to certain ratios, which could exist independent of a body and which in fact ideally *should* remain separate from matter. According to Plato's Doctrine of Recollection, the soul was inherently omniscient or godlike, but the upper reaches of its consciousness were superficially obscured by the accumulated traces of embodied experiences. The fundamental truth of the soul's divinity was obscured by its condition of embodiment—or imprisonment, as the Orphics called it. The body was regarded as the tomb or prison of the soul, in which the soul is interred or confined for a period of punishment or purification. It is this soul which a sculptor such as Pheidias was aiming to portray, seeking its original radiance right through the obscuring conditions of its embodiment. So when the sculptor portrayed the figure, or the body, it was only as a dim trace of the sleeping or imprisoned presence of the ideal soul within it. Even sculpture like the *Laocoön,* though it shows the soul suffering, nevertheless shows the soul.

The art of the soul remained prominent in the Western tradition for literally thousands of years. In the Middle Ages and Renaissance the harmony of painting and sculpture around shared ideas of perfection was maintained, though the Christian thematics changed the appearance of the iconography. Painting and sculpture were so much in tandem that there seemed nothing inappropriate when an artist such as Michelangelo practiced both. In either medium the human being was usually represented in such a way as to suggest the soul within the body. Actually, the inner spiritual meaning of the artworks negated the body even while they outwardly seemed to be portraying it. The art of the "figure" really meant the art of the "soul."

The emphasis on the presence of a soul remained a unifying principle of European art from the Renaissance until the Second World War—though there were, again, conspicuous exceptions from, say, Caravaggio to Daumier. Along the way this tendency of art was incorporated into various social and political agendas. Externally, by representing the European as an ideal, it served in the cause of colonialism. Internally, the insistence on the primacy of the soul served the psychological purpose of protecting the figure from the consequences of its own actions. The presence of a soul within the figure was a palliative to the parade of disgraces and atrocities that the historical figure was involved in externally, in the real world. The dream of the soul, posited by the beautiful artwork, suggested that history was still salvageable, still workable, still going somewhere, since the soul was still in there, inside the figure, just waiting for its moment to awaken into perfection and manifest itself in the world. The presence of the soul within the figure represented a

kind of insistence that human perfection would win through. At least as late as Rodin one feels the presence of the soul within the sculptural figure.

The twentieth century saw the material affirmation of the immaterial soul intensified through the turn to abstraction. Abstraction was a radical shift toward pure spirituality: Instead of the inner nature being shown as if glowing through the outer appearance, it was to be shown directly. As in Plotinus's dictum about Pheidias, the artist attempted to portray not the human figure and its passing scene, but the unchanging geometrical or metaphysical realities that underlie and consti-tute both the figure and its scene: Only the unchanging originative forms were to be shown, not the passing phenomena they throw off as excrescences. From neo-Plasticism to Abstract Expressionism, both painting and sculpture attempted to portray the soul, primarily in its Pythagorean geometrical form, directly rather than by implication. This is more or less the situation that obtained around mid-century, that is, in the immediate postwar period.

Coupure

That, of course, is when the *coupure* occurred. Soon, as if they had been quietly waiting, all the "posts" fell into place—post-industrial, post-historical, post-colonial—in the complex rearrangement of geopolitical balances that followed the war. And, as cultural realities fell in line and began to undergo their own rearrange-ment, painting and sculpture, for the first time in their long history, fell out. Disjunctions were suddenly perceived between them that had escaped notice in the millennia in which they had coexisted peacefully before.

The difference that lay at the root of the discord could be summed up in several ways. Sculpture might, for example, be described as more materialistic and painting as more illusionistic. An alternative phrasing might say that sculpture involves an empirical presence and painting an implied or symbolic one. Again, one could say that sculpture occupies the same space that the human body occupies and that social interactions transpire in, whereas painting points to an illusionistic space that might be anywhere or anything, that might indeed be an entirely metaphysical "space," a beyond, or absolute, and so on. The idea that a painting is a kind of window on the wall—a *veduta,* or "view," as Leonbattista Alberti called it in his *De Pictura* of 1435—means that it points directly away from the here-and-now. In fact, a painting, seen as a *veduta,* or window, is a channel specially devised to facilitate avoidance of the here-and-now, a channel that leads only into some place and/or time other than the here and now.

Beginning in the 1960s, with the widespread feeling that Western civilization had gone out of control like a car that was about to crash, the previous evaluations of this situation began to reverse. Whereas the art that evoked the metaphysical beyond had formerly seemed of transcendent value, it now seemed an unreal distraction from the pressing needs of the real world, an almost malicious cover-up for the failure of history. Consequently, painting in the old sense did not survive the *coupure épistémologique* of post-Modernism. The pretentions to other-

worldliness that persisted from Malevich and Mondrian to Pollock and Newman came to be seen as antisocial, even amoral. First Pop Art deconstructed these pretensions through associating painting with the vulgar icons of popular culture, that is, treating it as emphatically of *this* world rather than some hypothetical other one. Then Minimal painting in various forms drew painting closer to sculpture, with an assertion of its objecthood standing in front of any implications of representation or illusion. Those who attended passionately to the arts came to see painting as associated irredeemably with the old art history, the age of certainty, and the invocation of Platonic-Kantian universals.

Sculpture, in turn, became associated with the new art history, the age of doubt, and the contingency of the non-illusionistic object. Painting was a part of the nightmare of history; sculpture was a way out of it. For perhaps the first time in their long association, sculpture, with its location in the midst of the real, gained the ethical upper hand.

With the tide turning its way, sculpture expanded its domain until it threatened to absorb painting into itself. Painting sought a way out of its illusionistic mode, but as soon as it became purely an object, it became a sculpture.[15] The paintings of Robert Ryman, for example, are "paintings" only in terms of their materials; meant to be looked at not as representations of something else but just as the objects that they themselves actually are, these paintings may be seen as crossing the line into sculpture or objecthood—presence rather than representation.[16] The sculptural use of the stretched canvas, painted or not, has been seen in the works of widely dispersed artists: Imants Tillers in Australia, who has exhibited his paintings not as pictures on the wall but as objects stacked on the floor; Luciano Fabro in Italy, who has used paintings, scattered like discarded papers on the floor, as parts of sculptural installations; Marcel Broodthaers, who displayed a stack of stretched painted canvases as a sculpture; and Richard Jackson of California, who has made sculptural-architectural installations using stacks of painted stretched canvases like building materials. Thus, once sculpture had taken the upper hand, painting tried to insinuate itself into sculpture to share its new advantage. But paint itself turned out to be part of the problem.

The Worker

Representational sculpture refers to things and is illusionistic, like painting. Still, its materiality is so foregrounded, in contrast to that of painting, as to somewhat offset and diminish the force of its illusionism; its materials are often more present to the viewer's mind than its symbolic referent. Its representational function is obscured or complicated by the facticity of its presence.

Conversely, painting uses materials—support, pigments, binders—but these are not ordinary materials. Paint really has no function except the creation of illusions; anything reified in its medium is automatically at a remove from everyday reality and involved in a trajectory beyond it. The sculptor may create an illusionistic presence, but with materials—wood, metal, stone—that are not at a remove,

materials you could trip over or use in the making of houses, tools, and other non-illusionistic things. So that what is crafted out of the traditional materials of sculpture has something in common with the everyday, both on a materialist and an industrial basis.

Still, the reversal of the hierarchy encouraged painters to find ways to sculpturize their work. Paint can, with deliberate effort, be held to a critical and materialistic agenda—as in works by Karl Appel, Lucian Freud, Frank Bowling, and others, whose practice has involved the heavy sculpture-like buildup of paint and gel medium on the surface, to emphasize the materiality of paint and convert its presence into something like mini-sculpture. But in traditional Western painting, from Geometric vases to de Kooning canvases, the painted surface has been used primarily as a reference to something outside of and beyond itself and outside of and beyond the ordinary everyday reality that the artist and the viewer both live in. In the distinction between the emphasis on presence and the emphasis on representation, an ethical difference between the two media emerges. Stated starkly: Painting means escapist fantasy; sculpture means direct dealing with the material world.

A social ramification of this reversal involved the ancient aristocratic idea of the sculptor as a proletarian. In Plato's day, the aristocratic illusionism of painting had seemed superior, and that hierarchization had been maintained down until the mid-twentieth century; in the early period of Minimal Sculpture, however, the sculptor claimed the more proletarian role as his own proudly, scorning the aristocratic falsity of the picture plane—wearing the laborer's bib overalls as a badge of honor.

The View from the Window

These differences were not remarked on much until about 1960. What drove awareness of them out into the open was the devastatingly negative new sense of history that emerged from the world wars, the Holocaust, and other definitive twentieth century events—the dawning of the age of doubt. The *coupure* in the long relationship between painting and sculpture is a minor manifestation of the massive break that was indicated by James Joyce when, in *Ulysses,* he wrote that "history is a nightmare from which I am trying to awaken."

History, seen as a Hegelian term, means Modernism; seen from one point of view, it is Modernism that was the nightmare, and post-Modernism that offers the possibility of an awakening from it. For ages the sanctification of the human form as a nearly transparent veil over the spiritual seemed to absolve it from the nightmare of history, to indicate that, like an Orphic practitioner dressed all in white, it was in this world but not of it. But history had perhaps never before seen such disasters as the present century witnessed with horror and endured with sinking heart: "The nightmare of history . . . ," as Graff wrote, "has overtaken modernism itself."[17] After the Second World War and the Holocaust, it did not seem so easy to absolve the figure, to affirm pure spirituality. The Platonic-Plotinian

idea that art expressed transhistorical universals seemed a kind of aristocratic cop-out or, worse, deliberate obfuscation or cover-up. The spiritual idea of art suddenly, and nightmarishly, seemed complicit in the horrors of the Modernist age—through its omnipresent Christian iconography that whispered, God is on our side; through its glorified icons of knights, conquerors, and merchant-colonizers; and through its use, by the critical historians and after, as a miniature demonstration of the Modernist view of history as progress.

After mid-century the myth of progress through Western leadership no longer seemed credible; it seemed like a kind of illusion that had been temporarily drawn across the screen of world consciousness by the European hegemons. And painting, the central and emblematic artistic medium of this myth, seemed polluted by its complicity with the process of illusion. It had been too ready to open the window on the wall to a deluding phantasm. Gazing out the window might distract attention from the drama inside the closed room that the window offered a view out of. It even justified the drama in the room, however dispiriting, by shadowing forth the outlines of a transcendent realm. Western leadership was supposedly leading there, advancing doggedly through the nightmare.

Anti-art

Immediately after the war, the effects of the *coupure* could be seen in such phenomena as the late-forties works of Cage, Cunningham, and Rauschenberg at Black Mountain College in the United States and, in Europe, the works of Yves Klein, Piero Manzoni, and others. There was a general turn toward sculpture, and soon toward so-called living sculpture, later known as performance. To the sadness of many who had been perfectly happy with the Kantian formulations, a critical, deconstructive attitude toward painting took over. These immediate postwar events gained steam steadily and, by the mid-sixties, had progressed through Pop Art, New Realism, Minimal Art, Conceptual Art, Performance Art, and more. Each of these was, at one level, a direct assault on formalist and transcendentalist painting. The hierarchy of painting and sculpture was now, definitively (at least for the time being), reversed. For the first time painting and sculpture seemed inimical to one another; they stood revealed as ideological enemies.

Actually, even as they separated ideologically, painting and sculpture were undergoing similar experiences. In the 1960s and '70s, both media were being reconceived along the lines of Conceptual Art. In the case of painting this began with Pop Art and culminated in the cross-cultural pastiche of quotational painting in the eighties. It was this infusion of conceptualism into previously formalistic art media that constituted the turn to what has sometimes been called "anti-art."

From the point of view of an adherent of the old art history—the art history from the age of certainty—anti-art is simply art that is opposed to the Kantian theory. Clement Greenberg, for example, said that where there is no issue of taste, there is no art—which is to say, outside the Kantian theory, there is no art. From this

point of view, anti-art, or post-Modern art, is not really art but a fake substitute for it that only outright fools will be taken in by. It is all fakery and pretense.

In another sense, anti-art is art that uses traditional media to demolish the theoretical premises on which it had previously been based. Both painting and sculpture incorporate a dose of Conceptual Art and become neo-Conceptual genres (they now breach the Kantian admonition against cognition). Post-Modern neo-Conceptual painting proceeds to destroy Modernist aesthetic painting with its cognitive satire, its parodic pastiche, and its quizzical quotation. In this case anti-art is a spirit of fatal curiosity, causing an art medium to commit suicide out of curiosity to see what might come of it.

Like anti-matter attacking matter, each anti-medium turns against its most integral traits from past millennia. Each becomes what would have been its worst enemy in the age of certainty. Painting emerged from the first stage of the *coupure* as anti-painting, and sculpture as anti-sculpture. Despite the parallel terminology, this revision was not exactly the same in the cases of the two media. Anti-painting was reacting against the exclusiveness of the aesthetic commitment of traditional painting; anti-sculpture was reacting against the representational, that is, illusionistic aspect of traditional sculpture. Traditional sculpture almost always involved some form of representation or reference; anti-sculpture was a parody of the very idea of representation, presenting objects that refused to pretend to be anything but themselves.

Duchamp initiated anti-sculpture in the teens of this century by exhibiting everyday household objects as artworks in gallery and salon contexts. His first Readymade (though not yet so called) was made in 1913 and exhibited, with the designation "Readymade," in 1916. This stunning reversal turned everything inside out in an instant, collapsing the breach between art and life, reducing to absurdity the Platonic/soulist approach, confounding the tradition of the artist's touch, of his originality, his spiritual adventurism, and much more. Above all, what made the Readymades such a nightmare in relation to traditional sculpture is that they were objects that refused to represent anything outside themselves, but insisted on remaining simply and intransigently what they had been to begin with. They did not represent, neither had they been transformed. They denied that the quality of being sculpture resided in the transformation of a material. They denied, as Greenberg noted about "sub-art," that there was any issue of taste involved. It was just an issue of criticism, a parody of the idea of taste. In terms of the whole tradition of art as involving representation, the Readymades were the first embodiments of the age of doubt. They happened at the beginning and in the midst of the First World War and represented a revolt or protest against "the pretentiousness of art in the scheme of exalted values that just happened to be responsible for World War I."[18]

Creation by Designation

A central element of the old art theory was the cult of genius, a thinly disguised latter-day version of the cult of saints in which the artwork touched by the genius's hand became equivalent to the saintly relic. Genius, regarded in the

Romantic era as a rare ability to recollect more directly and easily than most the primal vision of the metaphysical shape of things, was confirmed by the artist's supposed ability to create things which, as in Wordsworth's "Intimations of Immortality," come into this world with the aura of the beyond still clinging freshly around them. These are entities characterized by beauty in the poet Schiller's sense, as "freedom in phenomenal appearance." The definition is deliberately paradoxical since phenomenality is precisely the web of causality, so nothing in it can be free.

But in Schiller's view—characteristic of the Romantic era—the Genius, by repeated contact with such miraculous entities, becomes like them, becomes himself free in phenomenality. He becomes the "*schöne Seele*—the beautiful soul—which does not know . . . internal conflict because its nature is so ennobled that it fulfills the moral law from its own inclination. And just this ennobling is gained by man, only through aesthetic education. . . ." The artist-genius becomes, in other words, something like a demigod in Greek mythology or a saint in Christianity. Merely by practicing his art he becomes a law unto himself; other people cannot judge him, as he, unlike them, is free in phenomenality. "[T]he man of genius," writes Windelband, "free from all external determination by purposes and rules, merely lives out his own important individuality as something valuable in itself,—lives it out in . . . the forms shaped by his ever-plastic imagination."[19] This view of the artist as an idiot savant remained firmly in place until the very end of the Modernist period. It is how Jackson Pollock was understood by those who were fully convinced by his art, and probably how he understood himself. This theological concept of the artist was one of the mainstays of the age of certainty. Universals made that age certain, and the Genius-artist could directly contact the universals and warrant their reality.

This concept of the artist as a kind of demigod or mythological hero was regarded, once the age of doubt had dawned, as dangerous and antisocial. It was one of the main targets of Duchamp's radical doubt ("I don't believe in the creative function of the artist")[20] and of the post-Modernists who followed his signposts a half century later. One of Duchamp's principal tools against this tradition—one of the signatures of anti-art—was to hold the idea of untrammeled artistic creation up to mockery through making art by designation (the practice of designating as art something that had been produced for different reasons altogether, such as the snow shovel he designated as an artwork in 1915). Though Duchamp had previously been a painter, and it was painting that the Readymade replaced in his own life,[21] still his practice suggests that the Readymade was conceived with sculpture in mind in particular. Any object can be designated a sculpture; but designating a preexisting picture as one's painting is more problematic.[22] For these and other reasons, though painting and sculpture underwent parallel transformations into anti-painting and anti-sculpture, it was sculpture that emerged as if newborn, and painting that still seemed saddled with the onus of its past.

As the age of doubt took hold more and more firmly, the terms "painting" and "sculpture" diverged increasingly into separate paths. Even though painting too had undergone the conceptual transformation, it remained circumscribed to two-dimensional pigmented pictures. The term "sculpture," however, underwent a

semantic expansion to include more or less anything in the universe. This was possible because of its objecthood; a picture is always, in some sense, a picture *of* something. But a sculpture is just an object.

The tendency of those who cling to traditional sculptural modes and their metaphysical auras is to reject the Duchampian Readymade as not really sculpture but a kind of prank. Rosalind Krauss, for example, refers to the Readymades as non-sculptures that Duchamp "slipped into the stream of aesthetic discourse," causing, like a prankster, much confusion by so doing. She refers to them as 'sculptures,' the quotation marks suggesting that the claim is charlatanry.[23] The implication is that the lack of the artist's touch, along with the renunciation of imaginative transformation, makes the sculpture of the found object—the sculpture of designation—inauthentic. Yet sculpture for the last generation or two has been dominated by the Readymade more than by all other models or influences put together. Duchamp radically turned around the concept of art in general and sculpture in particular—the use of scare quotes ('sculpture') will not change the fact that the concept *has really* changed. To reject the Readymade as sculpture is to reject most of the sculpture of the last twenty or thirty years—including the work of most of the artists treated in this book.

Since Duchamp, any *thing* can be rendered a sculpture by designating it as such, and in the post-Modern perspective a sculpture is just a "thing"; it doesn't even need material solidity, but can be an immaterial "thing." As Duchamp's influence spread in the 1960s, the use of the word "sculpture" stretched almost to infinity. By 1970 Gilbert and George were calling their performances—or their moods, or their momentary situations—sculptures. Various artists including Linda Montana, James Lee Byars, and Chris Burden designated themselves and their every thought or action for a specified period of time as sculptures. (Duchamp had foreseen this when he said to Pierre Cabanne in 1968 that one could consider one's every breath a work of art.)[24] Because of its occupation of the real space of the body and society, sculpture became a term that could designate anything real. One could regard a painting as a sculpture insofar as it was an object; but you could not regard a sculpture as a painting. The category of sculpture not only had the upper hand ideologically, but also expanded more easily and became bigger—big enough to partly engulf and absorb the category of painting. Lawrence Weiner's words painted on a wall were not called paintings but sculptures—and so on. Sculpture was to become the primary medium of at least the first generation of the age of doubt.

Marcel Duchamp, Fresh Widow, *1920. Collection: The Museum of Modern Art,*
New York. Photo: © 1999 The Museum of Modern Art.

Chapter Three
Duchamp, Pyrrhonism, and the Overthrow of the Kantian Tradition

A recent collection of essays bears the title *Marcel Duchamp, Artist of the Century.* While the title was, clearly, meant to be provocative, it merely states what all art-world afficionados have known for years. Another author calls Duchamp "the most influential artist of the twentieth century."[1] A generation ago almost anyone, if asked who the artist of the century was, would have answered Picasso. The shift from Picasso to Duchamp is a concise and revealing indication of what has happened to our culture since World War II. It signifies not only a change of taste but something more fundamental: a change of theory. If the same underlying theory of art were in place but taste had changed, one's choice might shift from Picasso to someone fairly like him—from Matisse to Schnabel—but never to the polar opposite. Clearly, the culture itself has turned around in some fundamental way. On both sides of the shift tempers are heated, and claims about what the shift means—what Duchamp means—are wildly discordant.

The critical literature exemplifies this discordance, portraying many different Marcel Duchamps: there is Arturo Schwarz's alchemical dabbler, Octavio Paz's tantric initiate, the full-scale occult master described by Jack Burnham, the publicity-seeking self-mythifier of Gianfranco Baruchello, the critical rationalist of the dialogues with Pierre Cabanne, André Breton's "most intelligent man of the twentieth century," the failed artist and tragic neurotic portrayed by Alice Goldfarb Marquis, the "psychotic" and "imposter" filled with "self hatred" described by Donald Kuspit, John Canaday's "most destructive artist in history," and others.[2] Most of these models hinge on interpretations of Duchamp's radical change of his artistic production in about 1913–1914. This two-year period saw a sudden and thoroughgoing change in the form, material, purpose, and style of his work, a change that suggests a major shift in his attitude toward life. And the significance of this change in turn depends on the reconstruction of events between mid-1911 and mid-1913, that is, around Duchamp's twenty-fifth year.

As Paz says, 1912 was the "climactic year of [Duchamp's] most important oil-on-canvas works."[3] This was the year of *The King and Queen Surrounded by Swift Nudes; Nude Descending a Staircase, No. 2; The Passage from the Virgin to the Bride; The Bride;* and other paintings (as well as of the first drawings for *The Bride Stripped Bare by Her Bachelors, Even;* also known as the *Large Glass,* 1915–23). These paint-

ings, though some considered them daringly innovative in their day (especially the *Nude* . . .), were safely within the aestheticizing easel-painting tradition that had held sway in Europe since the Renaissance. They were recognizable stylistic extensions of formal sequences already under way in Cubism, Futurism, Orphism, and elsewhere; their oil-and-canvas substance was the most common and traditional in Western art; and their claim to attention was based on the concepts of aesthetic composition, formal evolution, craft, and subjective inspiration that were fundamental to the Modernist ideology. Through 1912, in other words, one can safely say that Duchamp was a Modernist artist; his achievements and, apparently, his goals would not have been so different from Picasso's.

However, in the next year, 1913, all these Modernist qualities were erased from Duchamp's work, with the stunning suddenness of a conversion. Easel painting stopped; the traditional emphasis on the artist's hand and skill stopped. The Romantic exaltation of the creative act and even the notion of the artist's sensibility as a guiding force were denied. As an alternative to these, Duchamp introduced the chaotic force of chance, first in the *Erratum Musical,* then in the *Three Standard Stoppages,* both 1913. This also was the year of the first Readymade (though not so called until 1915), *Bicycle Wheel.* Painterliness gave way to a style close to mechanical drawing, confrontationally rejecting personal expressiveness, in *Chocolate Grinder, No. 1.* Linguistic elements, including puns, began to supplement optical ones; irony, mockery, and lampoon came to the forefront. These new approaches annihilated from Duchamp's work the inherited codes that his paintings had been pursuing only the year before, and foreshadowed a widespread shift in the art ideology that happened a half century or so later.

In attempting to understand this turn, which was to be so portentous for the art of the rest of the twentieth century, many critics have scrutinized the events of Duchamp's life in 1911–1913 for clues. Burnham, for example, focuses on the two-month trip to Munich in 1912. Little is known of Duchamp's reasons for going there, and Burnham hypothesizes that he was seeking obscure alchemical texts whose perusal effected his change of direction in the following year.[4] Marquis and others argue that the course of Duchamp's life was altered by the Salon des Indépendants' rejection of *Nude Descending a Staircase, No. 2* in the same year—an event that he described frankly as "really a turning point in my life, I can assure you."[5] The shock of this rebuke, Marquis feels, awakened him to the limits of his abilities as a painter (he couldn't draw hands, she says); and, to salvage a career seemingly doomed to be overshadowed by those of his older brothers, Jacques Villon and Raymond Duchamp-Villon, he undertook methods that both demanded less skill and were less susceptible to judgments of quality. In 1954, Jean Reboul mapped out a third approach to the question, beginning the psychoanalytic analysis of Duchamp from his art, which he declared to be the work of a "schizophrenic"—strong language indeed to apply to someone whose life does not seem to have been characterized by psychic breakdowns. In supporting his argument, Reboul cites the works on glass, quoting an authority's opinion that "it is as if there were a pane of glass between them [the schizophrenics] and their fellow-men."[6] (But surely this is a misleadingly simple

inference; wouldn't it follow, for example, that those who paint on opaque canvas or board cannot even see other people?) Duchamp, perhaps thinking of Reboul's article, told Cabanne in 1966, "I've never had . . . melancholy or neurasthenia."[7]

It is rather amazing how persistently the psychoanalytic interpretation of Duchamp as a psychotic has recurred, considering how extraordinarily little basis for it there is. It is as if his corrections of course for the art and culture of the twentieth century were so flabbergastingly odd as not to be conceivable from a sane person. Schwarz is a strange case because, unlike the Modernist detractors, he was sympathetic to Duchamp's work; still, working in the sixties, he fleshed out the psychoanalytic approach intuitively, without, it seems, any particular evidence for his proposals. On the basis of themes in Duchamp's paintings of 1911–1912, he concluded that the artist was incestuously obsessed with his sister Suzanne, and that when she married in 1911 he underwent a trauma that, like an earthquake, rearranged his mind, his work, and his life. It was the need to repress or at least conceal these feelings that prompted him to turn away from his oil paintings toward new media both less personal and more obscure, to abandon an expressive form for a depersonalized art that would sidestep his unhappy subjectivity. Schwarz argues his case well,[8] though the evidence for his theory, which seems to read a lot into Duchamp's rather oblique paintings, is cryptic at best. Still, his psychoanalytic interpretation interacts creatively with his alchemical one, translating Duchamp's supposed unfulfilled desire for Suzanne into the eternal quest for the alchemical union, whose tantalizing postponement is, in that lore, the force that drives the world. The bachelors' eternal inability to attain the realm of the bride in the *Large Glass*, then, has both a personal and a cosmic significance. In the upper panel, the bride, in the bridal chamber, is stripped bare for her mating; below, the bachelors masturbatorily grind their chocolate by themselves, all of them participants in the self-sustaining activity of a world awakened to life by the driving force of unconsummated desire. Similarly, Schwarz argues that *Young Man and Girl in Spring*, the painting from 1911 that was Duchamp's wedding present to his sister, both represents the idyllic childhood relationship of Marcel and Suzanne—and its ideal unattainability in adult life—and echoes alchemical diagrams of the solar and lunar (male and female) forces symmetrically flanking the Hermetic Androgyne in the center. Though Duchamp received such ideas with an amused and tolerant irony, they do to a degree seem true, not necessarily to the events of his life but at least to his general attitude. He said to Cabanne, for example, that it is not consummation that makes life alive, but the wooing, the seeking.

Schwarz's psychoanalytic model is argued more fully, and without the softening influence of his Jungian/alchemical approach, by Marquis, in her openly hostile biography of 1981, *Marcel Duchamp: Eros, c'est la vie*. Marquis documents Duchamp's feeling that his mother was cold and distant, and proposes that he shifted his oedipal desire for her to Suzanne. After the shock he felt at his sister's marriage, the biographer suggests, his life was dominated by a paralyzing repression of his feelings, and this repression, interacting with the Salon's rejection of the *Nude* . . . in 1912, ultimately led to an impotent withdrawal from painting. By

Marquis's scheme, Duchamp disguised that withdrawal, claiming it as a transcendence of art rather than a failure at it. On the basis of interviews, memoirs by those who knew him, and readings of his work, she finds him to have been remote and impersonal, never to have been intimate with women (his first marriage, in 1927, was brief, and may have ended unconsummated, and he did not marry again until he was sixty-seven), and to have made his art into an elaborate defensive wall behind which to hide a torment of unresolved feelings. The gradual deadening of his ability to communicate with others supposedly underlay not only his invention of an alter ego, Rrose Sélavy—his sexual (possibly homosexual) and creative self seeking to break out of the prison of his repression—but also his solipsistic obsession with games, especially with chess, as an alternative to life. And the techniques, ideas, and qualities that came to dominate his art in 1913 and after—chance, the creation of art by mental or linguistic designation of it rather than by the physical making of it, mechanical drawing, the interest in machines and the depiction of human beings as machines, cryptic verbal puzzles, mocking sardonic humor, ironic detachment, emphasis on the absurd and irrational—all these, according to Marquis, were depersonalizing tactics, expressing "the need to overthrow the subjective element," to liberate himself, "in a manner however tortuous and painful, from the emotion-laden ties of family and childhood."[9] Duchamp "muffled his, perhaps unconscious, emotional storm, inside an emotionally neutral, and increasingly icy, anaesthetic statement."[10]

In 1996, Kuspit added his opinion about the psychoanalytic situation, calling Duchamp a "psychotic." According to his account, the trouble surfaced in 1913–1914, when Duchamp produced the first Readymades. Kuspit feels that he did this, somewhat as Marquis had said, because he realized his inadequacy at making real art.[11] "The readymade is not a work of art," Kuspit says, echoing Rosalind Krauss, "but only poses as one." Duchamp was fortunate in his ploy, however, because in time the public took the bait and insisted, wrongly, that the Readymade *was* in fact a real work of art. "We play along with the readymade," Kuspit says, "because we are afraid to admit we are crazy enough to be taken in by an imposter."[12] Duchamp, although knowing at some level that we have been fooled, then played along with us in turn by keeping up the imposture. This falsity arose because he did not have the emotional equipment to be a real artist. Bad mothering in the early years (again an echo of Marquis) had crippled him emotionally. So he played along with the spectators' emotions, "for he desperately needed them to convince himself that it was possible to be an artist without having any emotions of his own, at least openly." What happened with the change in his style was, much as Marquis had thought, "his massive repression, indeed deliberate suppression of emotions." This led to the "perverse 'art' game" he played, "insidiously seducing the spectator only to destroy him." His dependence on the spectators' foolish response was because he was "full of basic self-doubt," and his desire to "destroy" the spectator by taking him in with false art was a result of "his basic self hatred."[13]

Marquis and Kuspit both mistrust Duchamp's 1913–1914 turn away from subjectivity, a movement they seem to see as flatly unhealthy in terms of psychoana-

Marcel Duchamp, Three Standard Stoppages, *1913–14, in their box.
Courtesy of Arturo Schwarz, Milan, Italy.*

lytic values. In a broader cultural context, however, the desire to overthrow the subjective viewpoint appears as a more positive force. It has been a major goal of many important philosophers both ancient and modern, both Eastern and Western, from Plato's emphasis on universals to Edmund Husserl's phenomenological reduction. It is the goal of many religious and meditational practices, from Patanjali's raja yoga to the Greek Orthodox "prayer of the heart." It is also the fundamental purpose of the scientific method. Doubtless there is a correlation between Duchamp's emotional state in 1913 and his subsequent art, and one would like to know more about it. Still, this background information, even if known, would have little significance to the oeuvre's ever-ramifying meanings in twentieth-century culture—or even to the meanings Duchamp intended, as far as those can be divined.

This crucial period of Duchamp's life, 1911–1913, contained other events besides his trip to Munich, his sister's marriage, and his rejection by the Salon. Various influences to which he is known to have been exposed at this time seem to have contributed in specific ways to the reformation of his work: the ambient interest among artists in the Golden Section and ideas about the fourth dimension, Henri Bergson's emphasis on coming to terms with the machine age, Alfred Jarry's absurdism, Francis Picabia's iconoclasm, Guillaume Apollinaire's humor, Stéphane Mallarmé's linguistic ambiguities, Jules Laforgue's provocative titles, the recently published notebooks of Leonardo da Vinci, Raymond Roussel's punning and the machines for making art he described in his novel *Impressions d'Afrique* (a performance version of which Duchamp saw in 1911), and other things. But while these influences can explain details or aspects of Duchamp's post-1912 oeuvre, they cannot explain the apparent revolution in his general attitude. One influence that Duchamp himself openly acknowledged, however, though it has been largely

ignored in the critical literature,[14] can account not only for specific details in his oeuvre but also for the change in his attitude around 1912–1913.

It was in those crucial years that Duchamp worked at the first and almost the last job of his life, in the Bibliothèque Sainte-Geneviève, in Paris.[15] He later told Cabanne that he took the position out of disgust with art and art politics after the Indépendants' refusal to exhibit *Nude Descending a Staircase, No. 2*. "Cubism had lasted two or three years," he noted, "and they already had an absolutely clear, dogmatic line on it. . . . as a reaction against such behavior coming from artists whom I had believed to be free, I got a job."[16] In the library, Duchamp sat at a desk for four hours a day with no duties but occasionally to give advice about where to locate a book. By his own account he read and thought a good deal and withdrew from social contacts, living quite solitarily. And he told Schwarz that during this time he "had had the chance . . . of going through the works of the Greek philosophers once more, and that the one which he appreciated most and found closest to his own interests was Pyrrho."[17] The recollection has been treated as minor, but in fact it was very rare for Duchamp to speak in such terms of anyone.[18] Being French, he may have been pointed toward Pyrrhonism by the tradition of Montaigne and the sixteenth-century phenomenon of neo-Pyrrhonism; Pyrrho's attitude of extreme skepticism had at that time been somewhat naturalized in France and was not such a rare and foreign import as elsewhere. If so, Duchamp, in inaugurating this recent age of doubt—at least in the art discourse—did so through a direct link with the previous age of doubt, using its mainstay, neo-Pyrrhonism, as his instrument. In any case, the evidence suggests that his reading of some account of Pyrrho's life and teaching in the Bibliothèque Sainte-Geneviève exerted a formative influence, confirming his own emerging skepticism.

Pyrrho of Elis (c. 360–275 B.C.) is an important but little-known Western philosopher. Interestingly, in terms of Duchamp's 1913 rejection of easel painting and his putative 1923 retirement from art in general, Pyrrho started out as a painter but abandoned art for philosophy. "He had no positive teaching," says an ancient authority, "but a Pyrrhonist is one who in manner and in life resembles Pyrrho."[19] Two sayings attributed to him have survived. First, "Nothing really exists, but human life is governed by convention." To exist, in the context of Greek thought, means to have an unchanging essence, so that statements about an existing entity are objectively either true or false. Instead, Pyrrho suggests that things indefinite in themselves are made to appear this way or that by human conventions and opinions, which may claim to be based on essential truths, but are not. The second saying reinforces this idea: "Nothing is in itself more this than that." The reality that we seek to delimit through our judgments and opinions, then, actually has no limits. According to Pyrrho's teaching as reported by one of his students, Timon of Philius,[20] things are indistinct from one another, and thus are not to be preferred over one another, but should be regarded with indifference. Without fixed essences, they are nonstable, and hence are nonjudgeable—unable to be contained by concepts. If nothing is true, the Pyrrhonists felt, then nothing is false either, for the false can only be defined by its contradiction of the true. Therefore, Timon con-

cludes, "Neither our perceptions nor our opinions are either true or false." Language, in other words, is simply irrelevant to claims of truth; the delimiting of reality is not its proper function, which lies at the simpler levels of practical locutions such as "Please pass the salt." Accordingly, Timon says, we should remain "without opinions" and "indifferent," beyond the tumult of the fluctuations of yes and no. Thus the Pyrrhonist moves into a posture characterized by "nonspeech" (*aphasia*). This, presumably, is why Pyrrho wrote no treatise on his thinking, but taught by example, demonstrating his ideas in his behavior.

Crucial to the Pyrrhonist position is a notion honored by both logic and metaphysics called the "law of the excluded middle," which holds that any proposition must be either true or false—that there is no middle position between yes and no, this and that, true and untrue, and so on. Pyrrhonism confutes this so-called law, establishing a position that is neither affirmation nor negation but a kind of attention that is neutral and impartial while remaining alert and vivid. Pyrrho's central concept was the "indifference" (*apatheia*) that would lead to "imperturbability" (*ataraxia*). He recommended, for example, an attitude of indifference toward not only philosophical questions but also the entanglements of everyday life, which are based on hidden philosophical presuppositions. It seems that Duchamp had a natural sympathy for this stance, and that Pyrrho articulated it for him, providing it with an intellectual basis.

As early as 1913, immediately after studying Pyrrho, Duchamp spoke of the "beauty of indifference" and, at various times, of the "irony of indifference" and the "liberty of indifference."[21] Pyrrho's recommendation to cultivate a neglect of opinions is reflected frequently in Duchamp's discourse. When asked about his "moral position" at a certain time in the past, for example, he once replied, "I had no position."[22] Similarly, when discussing some critical notes he had written on various artists, he said, "I didn't take sides."[23] To Arturo Schwarz he explained, "You see, I don't want to be pinned down to any position. My position is the lack of a position."[24] "To talk about truth and real, absolute judgment," he also remarked, "I don't believe in it at all."[25] The following dialogue took place with Cabanne:

CABANNE: One has the impression that every time you commit yourself to a position, you attenuate it by irony or sarcasm.
DUCHAMP: I always do. Because I don't believe in positions.
CABANNE: But what do you believe in?
DUCHAMP: Nothing, of course! The word "belief" is another error. It's like the word "judgment." They're both horrible ideas, on which the world is based.
CABANNE: Nevertheless, you believe in yourself?
DUCHAMP: I don't believe in the word "being." The idea of being is a human invention. . . . It's an essential concept which doesn't exist at all in reality.[26]

Duchamp's "irony of indifference" directly relates to Pyrrhonism, as does much else in the exchange. The critique of the concept of being, with its presumption that being involves essence, is central to Pyrrhonism ("Nothing really

exists . . ."). The being/nonbeing pair are alternatives like yes and no, or true and false, and the Pyrrhonist "position" is outside such pairs. It is thus also, as Duchamp saw, outside the concepts of self, which supposedly *is*, and belief, which either affirms or negates. It is an absolute, universal doubt.

This Pyrrhonist antiposition laid the foundation for key areas of Duchamp's work, with which he proposed to articulate this doubt in the realm of art—it led, in other words, to anti-art. When he was asked, for example, what determined his choices of Readymades, he replied, "It's very difficult to choose an object, because, at the end of fifteen days, you begin to like it or to hate it. You have to approach something with an indifference, as if you had no aesthetic emotion. The choice of Readymades is always based on visual indifference and, at the same time, on the total absence of good or bad taste."[27]

Thus, to regard the Readymades as demonstrating that ordinary objects possess the aesthetic qualities usually valued only in art would seem a misunderstanding of Duchamp's intention. "When I discovered Readymades," he wrote in 1962 to Hans Richter, "I thought to discourage aesthetics." But later artists, he continued (referring to the neo-Dadaists), "have taken my Readymades and found aesthetic beauty in them. I threw the bottle-rack and the urinal into their faces as a challenge and now they admire them for their aesthetic beauty."[28] The Readymades carry Pyrrhonist indifference into the realm of art. Similarly, Duchamp explained the famous door in his Paris studio, at 11 rue Larrey, which when it closed one doorway opened another, as "a refutation of the Cartesian proverb: 'A door must be either open or shut'"—that is, as a refutation of the law of the excluded middle.[29] Other works, such as his roulette system that enables the player to break even rather than win or lose, reflect the same attitude. *L'Opposition et les cases conjuguées sont réconciliées* (*Opposition and Sister Squares are Reconciled*), the book on a rarely encountered chess endgame that Duchamp wrote, with Vitaly Halberstadt, in 1932, has been described as follows: "The king 'may act in such a way as to suggest he has completely lost interest in winning the game. Then the other king, if he is a true sovereign, can give the appearance of being even less interested.' Until one of them provokes the other into a blunder, 'the two monarchs can waltz carelessly across the board as though they weren't at all engaged in mortal combat.'"[30] Duchamp himself said that following the system in the book "leads inevitably to drawn games"[31]—that is, to the Pyrrhonist position between yes and no—aesthetically, between beautiful and ugly, morally between good and evil, and so on.

In a letter of 1929, Duchamp wrote, "Anything one does is all right and I refuse to fight for this or that opinion or their contrary. . . . Don't see," he went on, "any pessimism in my decisions—they are only a way toward beatitude."[32] Pyrrho's "imperturbability," a state of perfect equanimity beyond the distinction between yes and no, seems to have been what Duchamp meant by "beatitude." Such a position is not pessimistic, any more than Duchamp's assertion that he believed in nothing is nihilistic. For his statement was a critique not of life, but of the authority that opinions hold over life. Duchamp might say he believed in nothing, but he could also declare, "I'm antinothing. I'm revolting against formulating."[33]

Many have commented on the apparent similarities of attitude between Duchamp and the later Ludwig Wittgenstein, the Wittgenstein of the *Philosophical Investigations*.[34] When Duchamp, late in life, was given a précis of Wittgenstein to read, he commented that he saw the similarity but hadn't known anything of Wittgenstein's work before. This is not so surprising, since what echoes Wittgenstein in Duchamp is equally reminiscent of Pyrrho. Duchamp's Pyrrhonist remark "There is no solution because there is no problem,"[35] for example, finds close parallels in a number of Wittgenstein's statements, such as "The deepest problems are not problems at all."[36] The same applies to the correlations that critics have made between Duchamp and Zen.[37] His denial of language-based constructions of reality, renunciation of opinion, avoidance of affirmation and negation as unreal alternatives, maintenance of a posture of indifference, and focus on the quality of the passing moment have seemed to many to be oriental in flavor; this impression arises from Pyrrhonism's striking similarities with the Zen tradition.[38] Duchamp's statement "Every word I am telling you is stupid and wrong,"[39] could have been uttered by Pyrrho, and also by the Zen master who said, "The moment you open your mouth you are wrong."[40] The commonalities that John Cage and others noticed may be accounted for by Duchamp's solitary reading and reflection on Pyrrho in the Bibliothèque Sainte-Geneviève in his twenty-fifth year.

If a true Pyrrhonist is, as the ancient text says, "one who resembles Pyrrho," Duchamp could well be given that title. The essence of Pyrrho's teaching, in the words of an ancient author, was that "he would maintain the same composure at all times"[41]—something frequently said of Duchamp. Similarly, the report that Pyrrho "would withdraw from the world and live in solitude" recalls Duchamp's often reclusive lifestyle. The Pyrrhonists never presented a positive teaching, save a Zen-like admonition to attend to the quality of every present moment without the distracting overlays of opinions or interpretations; Duchamp never wrote a manifesto or pontificated on what art should be, except by example. He turned from a so-called "retinal" art to an art with a philosophical function immediately after reading that Pyrrho had quit painting for philosophy. And finally, the Pyrrhonist stance outside affirmation and negation, outside speech, recalls what is meant by "the silence of Marcel Duchamp."[42] His was not a literal silence, like that of the ancient philosopher Cratylus (a forerunner of Pyrrho who refused to teach verbally, thinking that to make any statement whatever was to submit to "formulating," but, says Aristotle, would only hold up his finger, pointing to the direct experience of the moment). On the contrary, Duchamp was a man of many words. As far as expressing opinions goes, however, these amounted to a silence, for in his use of language he attempted to avoid assumptions that would limit reality. Casual conversation was acceptable, since it is involved in the pleasure of the moment. Like James Joyce, he enjoyed puns and other multidirectional verbal objects, which go beyond positing or negating, reflecting instead the labyrinthine relationships that seem to converge on any given moment of experience. The notes in *The Green Box* (1934) and elsewhere are cryptic enough that they too avoid direct statement. (If Duchamp was in fact interested in alchemy,

incidentally, that may in part have been because it too posits an ultimate attitude beyond the distinction between yes and no.)

The Pyrrhonism of Duchamp's work from 1913 onward offers a philosophical context in which to view his youthful turning point. Personal factors must, of course, have been involved; the search for an objective, detached stance is at the same time a move away from some subjective situation or other. Still, it is not necessary to believe that whatever emotions Duchamp wanted to outdistance seethed tormentingly inside him for the rest of his life. Perhaps the imperturbability, or "beatitude," of indifference flowed coolly in to calm the troubled surface of his young and adaptable mind.

The psychoanalytic model holds that Duchamp's work after 1912 is itself the proof that his inner problems were not resolved but hidden by his ongoing repression. This seems to be suggested by the paucity of his oeuvre, its mute lack of self-expressiveness, its mocking ironic distance, its unnaturally prolonged enfant-terrible rebelliousness, its hints of repressed sexuality, its subterfuges of critical evaluation, its determined absurdity, its solipsism, and so on. The problem with this approach is that it subjects Duchamp to the very affliction he sought to remedy for art: It removes his work from its context in the world of ideas. Yet when the work is seen within such a context, it acquires a directness and a coherence that are altogether rational.

It has sometimes been objected that there is a contradiction in a philosopher's espousing indifference and then proceeding to argue against the views of other philosophers. But in the Pyrrhonist tradition the undermining of one view is not held to imply the affirmation of the contrary view. (That would represent acceptance of the law of the excluded middle.) The indifferent position, or non-position, does not preclude one from engaging in debate; it only precludes one from maintaining a positive doctrine. One mode of late Pyrrhonist practice was to attempt to turn others toward imperturbability by analyzing their views of reality and revealing the unproven assumptions and inner contradictions hidden within. Some Pyrrhonist authors forged massive collections of negative arguments, intended to annihilate all types of opinion and to leave nothing in their place but the "non-speech" of opinionlessness. ("Is it not better," the neo-Pyrrhonist Montaigne had asked, "to remain in suspense than to entangle yourself in the many errors that the human fancy has produced?"[43]) Similarly, Duchamp's indifference did not keep him from arguing, in the mute acrostics of his work, against what he perceived as prevailing dogmatic rigidities. Such a program, in fact, underlies his oeuvre in general, alongside the other levels of meaning and intention that activate its complex dynamism.

Duchamp once described himself as engaged in "a renunciation of all aesthetics, in the ordinary sense of the word."[44] The qualifying phrase "in the ordinary sense of the word" shows that his attitude was not, as it has often been called, an "aesthetic nihilism."[45] In European art since the eighteenth century, aesthetics "in the ordinary sense of the word" means the aesthetic theory adumbrated by the third earl of Shaftesbury and fully articulated by Kant in his *Critique of Judgment* (1790), along

with various German metaphysical elaborations by Hegel, Schelling, Schopenhauer, and others. Whether Duchamp studied these philosophers along with the Greeks at his desk in the Bibliothèque Sainte-Geneviève is unknown and unimportant; unlike Pyrrhonism, the ideas in question were pervasively in the air, as familiar to any well-read person—and certainly to as cerebral an artist as Duchamp—as his or her address. According to Marquis, the collector and patron Walter Arensberg once "thought he discerned a pattern in Duchamp's work. 'I get an impression,' he wrote, 'when I look at our paintings of yours from the point of view of their chronological sequence, of the successive moves in a game of chess.' Duchamp readily agreed to the analogy."[46] It was specifically the system of Kantian aesthetics, and its hold on Modern art, that Duchamp's work was devised to checkmate.

There were two sets of ideas dominating Kant's theory that Duchamp focused on. First was the trichotomy of faculties embodied in Kant's distinction among *The Critique of Pure Reason, The Critique of Practical Reason,* and *The Critique of Judgment.* The idea behind the distinction is adopted from *The Nicomachean Ethics,* where Aristotle says that the human is made up of three faculties: the cognitive, the ethical (what Kant calls "practical"), and the aesthetic (taste or "judgment"). Though Kant expresses himself with varying degrees of rigor on this point, his basic view seems to be that these three faculties are innately separate and isolated from one another, as each of the senses is isolated from the others. The cognitive faculty cannot be used to confirm or refute a judgment of either of the others, and so on. Each faculty is alone in judging its proper domain. This is the root of formalism in art theory: If *only* the aesthetic faculty can be relevant to judgments of taste, then nothing ethical or cognitive enters in—only the unmediated response to forms and colors. When Duchamp declared (in an interview with James Johnson Sweeney) that he wanted "to put painting once again at the service of the mind," he was directly attacking this doctrine, announcing that he would make art based on the cognitive rather than the aesthetic faculty.[47] This was the foundational principle of what would later be called Conceptual Art.

The second major group of ideas that Duchamp wanted to reduce to inconsequentiality is found in the section of *The Critique of Judgment* called "The Analytic of the Beautiful." There Kant posits what he calls four "moments," each comprising a related group of propositions. According to the first "moment," the pure aesthetic judgment or sense of taste has nothing to do with cognition or concepts. This, as already remarked, was perhaps the central target of Duchamp's revisions—the basis of his desire *not* to be "stupid as a painter." Kant's second moment attributes universality to the aesthetic judgment, which is held to be the same in all people, a *sensus communis*, as Kant put it. Some disagreement may of course arise, but only because of subjective distortions of a faculty everywhere constant in itself. In this view an artwork is objectively good or bad, right or wrong, depending on its conformity to the universal sense of taste. But only the individual whose sense of taste is not distorted can make the unerring judgment. This is the basis of formalism's emphasis on "quality" and its elevation of the critic, such as Clement Greenberg, to an authority without appeal. The third moment argues that

the aesthetic judgment is purposeless or functionless, that it is, in other words, above the tumults and desires of worldliness. This is the basis of formalism's distinction between high and low, or pure and practical, art. It is also related to the idea of art as a higher spiritual realm, above the baser instincts. And the fourth moment, rather like the second, posits the a priori necessity of the aesthetic judgment, which, properly exercised, is held to be necessarily correct, as assumed in the dogmatic authoritarianism displayed by many formalist critics.

The four moments collaborate in defining the foundation of the Kantian doctrine, the notion of a special faculty of taste through which we respond to art. Being like a sense, like seeing or scenting, this quality is noncognitive, non-conceptual; it is innate and identical in everyone; it is a higher faculty, above worldly concerns; it is governed by its own inner necessity. Duchamp's work at once intuitively and systematically illuminates the flaws in this teaching. For example, Kant's theory implies that literature or language cannot be art, since words are conceptual entities; Duchamp's inclusion of linguistic elements in his work—punning titles and inscriptions, sets of notes—forces the dilemma that either these works are not art or art is conceptual as much as sensual. The Readymades take aim at the idea of the universal sense of taste—calling a urinal "art," for example, resulted in a rift of opinion so intense as to throw into question the idea of a *sensus communis*—at the idea of art's noble separateness from the world, and also, of course, at the Romantic myth of Genius which demonstrates itself through innovation. The introduction of chance procedures illustrates a mode of artistic decision-making that takes literally Kant's injunction that aesthetics should lie outside human desires and prejudices, and yet is not even conceivably acceptable in Kantian terms. At the same time, it lampoons the Kantian notion of aesthetic necessity. And so forth.[48]

What is most significant in Kant's aesthetic is the idea that taste is a universal constant, an unchanging faculty—an essence. This is the element of his thinking that most contradicts the Pyrrhonist position, which denies the possibility of essences and abstains from all the judgments of a thing's quality to which they give rise. Duchamp astutely focused his attack on this crucial point. Aesthetics for him had nothing to do with some transcendentally autonomous and self-validating faculty, like a soul. Instead, he proposed a relativistic view of taste as "a habit. The repetition of something already accepted. If you start something over several times, it becomes taste. Good or bad, it's the same thing, it's still taste."[49] Taste, then, is simply the shape of one's limitations, the ingrained habitual system of prejudices that is the stumbling block to a generalized appreciation of life. As Duchamp told Cabanne, "One stores up in oneself such a language of tastes, good or bad, that when one looks at something, if that something isn't an echo of yourself, then you do not even look at it. But I try anyway."[50] His goal, then, was "to reduce my personal taste to zero."[51] If the constrictions of habit, of "taste" and its belief system, could be eliminated, Duchamp felt, life could be a "sort of constant euphoria,"[52] a Pyrrhonist realm of beatific imperturbability and generalized openness.

Many of the qualities that have been regarded as deficiencies in Duchamp's oeuvre are calculated demonstrations of this point of view. The work's visual

unimpressiveness expresses its avoidance of judgment by the conventional criteria of taste. Its appearance of internal inconsistency, and its shift of modes, genres, and materials express his desire not to define or to delimit the space in which art unfolds. The paucity that psychoanalytically inclined critics have taken as evidence of emotional problems in fact suggests Duchamp's refusal to repeat himself, on the ground that repetition would establish his work as merely one style among many, competing with others for authority, like the dogmatic Cubism of the 1912 Salon. To create many works on the same principle is to be dominated by a dead habit. Chance and the Readymade, Duchamp's two great tactics for creating art that neither pleased nor offended his own customs of taste, were his avenues for the discovery of objects that he had not been taught to see by his experience of looking at art. Aware that taste changes from one historical phase to the next, and thus cannot really be either universal or necessary, Duchamp referred to it as "a fleeting infatuation," which momentarily "disappears."[53] "Why," he asked, "must we worship principles which in 50 or 100 years will no longer apply?"[54]

A second major element of "aesthetics in the ordinary sense of the word" was the myth of art's sacredness promulgated by Kant's successors. To Hegel, for example, the successful artwork was an embodiment of the absolute or the infinite; it represented, he wrote, the "spirit of beauty . . . to complete which the history of the world will require its evolution of centuries."[55] According to Hegel's contemporary Schelling, art "opens . . . the holy of holies . . . When a great painting comes into being it is as though the invisible curtain that separates the real from the ideal world is raised."[56] For Schopenhauer, similarly, art was "the copy of the [Platonic] Ideas"—that is, the embodiment of eternal and sacred truths.[57] The Romantic tradition, which includes Modernism, deeply incorporated this idea. For Duchamp, however, art was not a link to the universal and permanent, a channel toward the sublime,[58] but a device with which to break mental and emotional habits, and to discourage the projection of one's self and one's opinions, or the opinions of one's culture, as absolute. It was a vehicle of Pyrrhonist indifference. Where the Romantic artist was supposedly a kind of priest or mystic adventurer, Duchamp, in connection with quitting art, remarked that he was "defrocked."[59] "I'm afraid I'm an agnostic in art," he said. "I just don't believe in it with all the mystical trimmings. As a drug it's probably very useful for a number of people, very sedative, but as religion it's not even as good as God."[60] His works were a systematic undermining of the whole phenomenon of an "aura," which Walter Benjamin was to discuss. Everyday objects have no "aura," nor are they "unique" or "original." Neither are the photographs and mechanical reproductions that frequently appear in Duchamp's work. The use of chance also takes traditional aesthetic decision-making out of art, emphasizing its embeddedness in nature. The technique of mechanical drawing bleaches the emotionality out of images. Even Duchamp's adoption of a female persona, Rrose Sélavy, was a negation of art's essentially male-heroic tradition.

Duchamp's work, clearly, is not merely a survivalist response to "an over-whelming inner conflict"[61] nor the effect of an infantile destructive nihilism. It could only seem so, really, to commentators for whom there is no world outside the

Kantian inheritance. It is, instead, a precise and mature theoretical critique, an overthrow of the Kantian aesthetic along with the demonstration of a Pyrrhonist openness as a space for the art of the future to move in.

And Duchamp did indeed have an enormous effect on that future. Historically, Duchamp and Dada seem to have been summoned into action by disgust at the events that were leading to and then comprising World War I. As Arthur Danto put it, "The ready-made was a kind of thumbed nose at the pretentiousness of art in the scheme of exalted values that just happened to be responsible for World War I."[62] Not long after the First World War, the European art world moved away from Duchamp and Dada and back into the Kantian aesthetic of Picasso and Matisse. World War II, however, brought the urgency back into the air. Art seemed to be having no effect on the self-destructive quality of Modernism—perhaps it was even encouraging it through the promotion of transcendental fantasies or asocial aestheticism. After the war, it was clear that something outside of the "four moments" was needed to redirect art's impact on society. The availability of the Duchampian model became known at just the right moment—first when the Arensberg collection of Duchampiana was opened at the Philadelphia Museum of Art in 1954, second when Robert Lebel's book on Duchamp appeared in 1959, and finally when the Pasadena, California museum retrospective of his work, with an influential catalog, appeared in 1963.

In terms of the post–Abstract Expressionist crisis in American art history, the timing was perfect. Many artists who knew they were turning away from traditional media—but did not know exactly what they were turning toward—found powerful hints in his work, hints that had not yet worked themselves out art historically though they had been there, waiting to be activated, for almost half a century. The great hints were the method of designating a previously non-art object as art, the de-emphasis of "touch" and innovation in the Readymade, the incorporation of chance procedures into art-making (with the values of chaos and surprise), the emphasis on wit (with its natural involvement of language and in general of the project of returning art to "the service of the mind"), the tendency toward the interactive (as in Duchamp's remark that the artwork was completed by the audience), and the willingness to collapse the category of art completely into the category of life (as in Duchamp's remark about every breath as an artwork).

Beginning in the 1960s and continuing into the 1970s, many artists in both Europe and America began to investigate how the incorporation of these principles into their own sensibilities and impulses could provide a map of the unknown terrain of the future. Artists who were coming of age at that time, and looking about restlessly for alternatives to Greenbergian formalism, saw the usefulness of his example at once. After more than forty years of obscurity, Duchamp became, overnight, what Krauss called "the artist of postmodernism." Compare William Camfield: ". . . the burgeoning interest in Duchamp [in the sixties] coincided with exhilarating developments in avant-garde art, virtually all of which exhibited links of some sort to Duchamp." And Jack Burnham: "The Ready-Mades have revealed the consistency of many art works attempted during the 1960s, while chronologi-

Marcel Duchamp, In Advance of the Broken Arm, *1915–1916.*
Courtesy of Arturo Schwarz, Milan, Italy.

cally predating these same works by ten to fifty years." And Timothy Shipe: "Duchamp's emergence as the seminal influence on contemporary art since the 1960s . . ." This is why one author wrote that Duchamp "seems to belong to a younger generation—that of the post-1945 artists of Pop Art, Happenings, Op Art, Minimal Art, Fluxus, Conceptual Art, Postmodernism." The view is widespread and firmly in place. As another critic wrote, "The ghost of Duchamp haunts postmodernism." Yet another critic, Amelia Jones, has recently described Duchamp as the "origin of radical postmodern practices," "authoritative source of postmodern art," "father of postmodernism," "source of American postmodernism," "paterfamil-

ias of postmodernism," "authoritative origin of postmodernism," "originating paternal function for postmodernism," and so on.[63]

The same author argues that "Duchampian postmodernism" is based primarily on the Readymade, not on the rest of Duchamp's oeuvre.[64] This assessment seems accurate. Duchamp himself called the Readymade "perhaps the most important single idea to come out of my work,"[65] and it has in fact turned out that way historically. "The readymades," Jones wrote, "break the Greenbergian 'circle of belief,' substituting for it the (anti-Greenbergian) *post*modern." The Readymade is "paradigmatic of the inherently critical object," and, "The readymade gesture is seen to have precipitated the breakdown of modernism and the instigation of the radical other." In a similar spirit Max Kozloff called the Readymade a "radical metaphysical act," and Greenberg, knowing an enemy when he saw one, referred to readymade art as "sub-art."[66]

It was the utter simplicity of Duchamp's Readymades that managed to confound all four of the Kantian "moments" and emerge as "paradigmatic of his postmodernism."[67] Residually formalist critics go on extolling the *Large Glass* as his greatest work because it is the closest thing to the Kantian aesthetic value system that he has left from his maturity. But as subsequent chapters will illustrate, it was unquestionably the Readymade that has dominated the work of Conceptual Art sculptors from the early sixties until today. (The introduction of chance in the art-making procedure is perhaps second in influence.)

Duchamp actually succeeded, then, in ringing the death knell for formalism, for the belief in art as a spiritual transcendence, and for the Romantic cult of beauty. But of course that cult still has its faithful, and they have rightly perceived him as the enemy. So despite his work's enormous art-historical importance, it is the object of a deep strain of hostility. In his *New York Times* obituary for Duchamp, for example, Alexander Keneas calls his work "vaudeville."[68] Roger Shattuck concurred, calling him "the court jester of twentieth century art." John Canaday, also in the *New York Times,* similarly spoke of the work in terms of "horseplay," "a parasitic appendage, an amusement, a vaudeville performance."[69] Elsewhere, with somewhat more dignity, he refers to Duchamp as "the Leonardo of the Age of Intellectual Despair"[70]—which is to say, of the age of doubt. Thomas Hess, referring to Duchamp's influence on younger artists in the sixties, called him, echoing the ancient charges against Socrates, "a corrupter of youth." Similarly, according to Canaday, Duchamp was, "along with Picasso and Matisse, one of the trio of most powerful influences on 20th century art," yet "unlike his two peers, [he] has exerted an influence primarily destructive."[71] In fact, he was no less than "the most destructive artist in history."[72] This attitude is still dominant in the Marquis biography of 1981, which presents Duchamp as a failed artist and an essentially destructive force—"a powerful figure which knew how to destroy in the most creative ways"[73]— and in Kuspit's 1996 ruminations on Duchamp's imposture and his desire to "destroy" the spectator.

Other types of responses have acted to tame Duchamp's work in less obvious ways. One is the common description of both the artist and his work as

"enigmatic." The headline of the *New York Times* obituary, for example, reads, "Marcel Duchamp Is Dead at 81; Enigmatic Giant of Modern Art." Calvin Tomkins similarly called Duchamp "the most enigmatic presence in contemporary art."[74] This often-applied term neatly slots Duchamp's work away into the category of the mysterious and the vague, of things whose meaning is deliberately obscure enough that we need not trouble ourselves too long to understand it. A related response has been to focus on Duchamp's legendary status. Baruchello, Marquis, and others propose that his primary achievement was his own self-mythification— as if the work had no point in itself but to draw attention to its maker. Duchamp remarked sanely that "the idea of the great star comes directly from a sort of inflation of small anecdotes,"[75] and clearly he himself was the subject of this kind of inflation. His occasional collusion in the process—the deliberately mythmaking photographs he posed for, say—should not obscure the fact that his work had definite purposes, which it went about in a direct and businesslike way.

Yet another strategy to tame the critical thrust of Duchamp's work—and, tacitly, to reestablish the hegemony of Kantian aesthetics—has been articulated by Greenberg, Baruchello, and others. In this reading, Duchamp was one avant-garde tactician among many. His techniques were on the same scale as those of, say, the Fauves, or the Cubists, or, later, the Abstract Expressionists. But the fact is that they were not. Duchamp's avant-gardism overthrew the Kantian foundation on which most of the other varieties were based, from Impressionism to Color Field. It was a *meta*-avant-gardism, which went beyond proposing a new embodiment of the Kantian ideology to overthrowing it altogether. Similarly, Tomkins, as if to compliment Duchamp on his subversiveness (but really making him ordinary), claims that "art has a way of undermining all aesthetic theories."[76] But Duchamp's undermining of theory was not just one among many; he dismantled a theoretical structure that had accommodated most of the avant-gardes that were growing up around him, and that had been solidly in place since the eighteenth century.

Greenberg, finally, makes a curious argument that has not been much discussed: "Duchamp . . . locked advanced-advanced art into what has amounted to hardly more than elaborations, variations on, and recapitulations of his original ideas."[77] Duchamp's legacy and influence, in other words, did not lead anywhere but remained stagnantly in one place. This would seem to reflect Greenberg's evaluation of post-Modernism: that to go from Modernism to post-Modernism is to go nowhere. Since Greenberg wrote this sometime before 1974, it is not easy to see what he meant. The sixties and seventies were full of great artists who took Duchamp's example to heart and followed it into previously unexplored terrain that was richly rewarding, and there are many others active today. Clearly the main thrust of Greenberg's claim would have to be rejected by any supporter of the post-Modern achievements in art and culture. Still, his critique—taking it minimally to mean that Duchamp's "sub-art" can lead to leaden imitations as well as dazzling breakthroughs—cannot be dismissed altogether. There have, after all, been widely divergent outcomes of the impulse that Duchamp pioneered. Greenberg's claim might better be narrowed in compass and applied selectively. One area of art activity

that seems almost to solicit such an application includes certain mid- and late-eighties tendencies such as neo-Geo or Simulationism, which did briefly seem to reduce the Readymade to a style, without much concern to maintain its ideological stance. Much of that work, though it may be attractive, and even intelligent in its focus, cannot be regarded as Duchampian *in spirit*. It may *look* Duchampian, but to concentrate on the look is to miss the point. Duchamp's Readymades functioned as a *rejection* of style; at the height of the eighties art market, the readymade briefly *became* a style—even what could be described as an academic style.[78] Where *Fountain* shocked, as did the snow shovel aimed at indifference, many examples of that generation of readymades were more concerned about placating and pleasing. His works are often involved in language; those sleek marketable versions were mainly mute form. He rejected commodification ("Above all I wanted as much as possible not to make money");[79] those objects affirmed it. What Duchamp saw happen to painters through the repetition that he opposed—"They no longer make pictures; they make checks"[80]—also came true for certain recent readymade artists, who, riding a market crest, relentlessly repeated, writing checks against what had become a habit or taste.

So the Duchampian heritage has become split. On the one hand are many important artists who, guided by his signposts, led the way into momentous and historic new adventures that have contributed to shaping the post-Modern reorientation of the culture as a whole. On the other hand are opportunists who collaborated in the taming and commodification of Duchamp's indifference by what Adorno called the "culture industry." The absorption of the once-critical Readymade into the mainstream market indicates not that Duchamp's theoretical critique has lost validity, but that his formal embodiment of it may be living itself out, as he himself said that an aesthetic criterion dies in fifty or one hundred years. An accurate receiver of the Duchampian message might plausibly choose to stay as far from the look of his work as possible, since the look of his work has now showed a tendency to become part of the rigidity of habit that it was designed to pry loose. The point of Duchamp's violation of the gallery space—the urinal flung in their faces—was not to establish a new *style* of exhibited object, but to suggest that humans can exhibit *anything at all* to one another, with the countless ranges of meaning and types of appreciation that this realization opens up. When Arensberg likened Duchamp's paintings to a chess game, Duchamp responded, "But when will I administer checkmate or will I be mated?" The slavish and academic imitation of the mere *look* of his work constitutes, however unconsciously, the closest approach yet to checkmating Duchamp.

Part Two

Compass Points

So at first, after the frame is erected, Duchamp stands alone in it—larger than life, hailed as the father of American post-Modernism and so on. Then the 1960s generation took up his example, and a few of them were seminal in their turn, finding ways to use his basic discoveries—Readymade, designation, chance—in terms of their individual sensibilities. Perhaps a dozen artists of that generation achieved this stature. Here are four of them, who enter the frame now and rearrange it into a quaternity, like four compass points directing the energy here and there. Although each of them occupies the frame individually during the time the reader devotes to his chapter, still it is to be understood that the single figure of Duchamp has been replaced by a crowd of four who now, in a sense, occupy the frame together.

Marcel Broodthaers deconstructed Modernism into fragments and recombined them into new alphabets as if for a new age. Still, his optimism about finding a new age with suitable substance was restrained by a somewhat self-effacing irony. While doubt is not always dominant in his work, it usually is. His quest was less to find some new age than to imagine in what grotesquely unfamiliar alphabet it might even be spelled.

Dennis Oppenheim began making his work at the moment when the legacy of Duchamp and Dada was about to mature, and had a great deal to do with maturing it. Nevertheless, early in his oeuvre, the Modernist feeling that history was rushing toward some culmination was still in force, and Oppenheim's works joyously raced on in their daring investigations of the new lands liberated by the discovery of a fruitful doubt.

Jannis Kounellis is a post-Modernist for whom Modernism is still an incomplete project. He mourns its passing in much of his work, but fundamentally acknowledges that something new is needed and that it is the artist's duty to work it out. He does not celebrate fragmentation but uses it as an icon of the lost wholeness it implies.

Lucas Samaras is one of those who was in the right spot at the right time when the new age of art began as a part of the new age of doubt. He is at once an avant-gardist and almost an outsider—with his work laboriously crafted for many years in his little kitchen, relentlessly alone like a one-man band. In the danger of his work one sees the dark joy of liberation into the unknown.

Marcel Broodthaers, Une armoire d'oeufs *(1965) and* Un table d'oeufs *(1965) together.*
Courtesy Marian Goodman Gallery, New York.

Chapter Four

Another Alphabet: The Art of Marcel Broodthaers

Faithfully in spite of the winds that blow, I, too, am an apostle of silence. —Marcel Broodthaers

Until his fortieth year, Marcel Broodthaers was a poet with an interest in the visual arts, of which from time to time he wrote criticism. His conversion from poet to artist was marked by a 1964 exhibition in which the fifty remaining copies of his recent book of poems *Pense-Bête* (*Think like an Animal*)[1] were ensconced in a plaster ball and exhibited as sculpture. After twelve years of artistic work, Broodthaers died in 1976. He had contradicted and recontradicted in the most deliberate way many of the public statements he had made about his art in the form of "open letters" and exhibition announcements. Accordingly, at his death, a critical void surrounded the work. No standard discourses about it had yet developed; it lay like an uncolonized territory inviting the planting of flags of possession.

A major traveling retrospective of Broodthaers in 1989 presented his work to the American audience as perplexing or mysterious.[2] Marge Goldwater of the Walker Art Center, Minneapolis, for example, who, along with Michael Compton, organized the exhibition, uses the word "enigmatic" twice in her brief catalog introduction; an advertisement for the Walker catalog says that Broodthaers's "work is ultimately enigmatic and its meaning elusive."[3] Benjamin H. D. Buchloh has similarly referred to "the highly enigmatic and esoteric character of his work."[4] As in Duchamp's case, the appellation "enigmatic" suggests that one might as well not try to figure it out. So the cupboard filled with eggshells still looks mutely at the viewer like a big question mark—as do the human thighbones painted in various colors, the child's stool with the beginning of an alphabet painted on it, the plastic panels with huge commas hanging like clouds in the sky, and more. Even in the post-seventies free-for-all, this oeuvre appears especially "enigmatic." Joycean in its uncompromising challenge to the intellect, it seems either to aspire to a status of evocative meaninglessness, propped up by carefully constructed networks of inner contradictions, or to insist on its openness to a variety of arbitrarily devised accounts, none privileged above the others.

In 1978 the young Belgian critic Marie-Pascale Gildemyn wrote her master's thesis on Broodthaers and followed it with several articles in which, without heavy critical intervention, she worked out a cautious iconographic ap-

proach to the most obvious elements of the oeuvre. A similar approach has been taken in Compton's various writings on Broodthaers, from his own Tate Gallery catalog of 1980 to his much longer essay in the Walker book. These writers conceive Broodthaers's iconography as a personal one based not on the broad image traditions of cultural history but on private intentions. Eggshells and mussel shells, for example, both of them prominent elements of Broodthaers's early plastic vocabulary, are discussed not in relation to the long tradition of fertility and aphrodisiac meanings associated with the objects, but as symbols of a kind of ornery independence of personality. These kinds of shell, in this view, assert the reality of forms of life shaped not by society's molds but by their own. This reading derives in part from Broodthaers's poems, with their Joycean-Duchampian love of puns such as *la moule* (mussel) and *le moule* (mold). Similarly, to both Gildemyn and Compton, the eagle, a prominent icon in Broodthaers's later work, represents simultaneously the idea of the independent, transcendent artist and the power emblems of society—of individual independence on the one hand and, on the other, society's tendency to curb or compromise that independence.

A related yet significantly different approach was begun in 1974, with Michael Oppitz's Marxist-influenced interpretation of Broodthaers.[5] More recently and more extensively, Buchloh, in various writings, has interpreted Broodthaers's objects as encodings of Marxist doctrines or reflections of them. This approach casts the work as dealing with the commodification of art by the mainstream culture industry—the complex of forces generating the public images and discourses that cloud our awareness of social processes. Both the Compton and the Buchloh interpretations situate the work in reflections on society and the individual, but there is also a major difference. Compton seems to feel that Broodthaers's works are riddles to which no pat answers are to be found—"rebuses," as Broodthaers himself called them, but deliberately indecipherable ones. Determined meaninglessness is itself a meaning here, having to do with overturning conventional expectations and questioning the integrity of meanings in general. Buchloh, on the other hand, who refers to Compton's approach as the "conservative" one,[6] seems to find answers more prominent than questions in Broodthaers's art, and these answers tend to be cast in the terms of Marxist thought, especially Walter Benjamin's.[7] The inner contradiction in the work, for Compton an avoidance of taking a position, becomes an embodiment of the Marxist idea of dialectic. Compton's readings about unique individuality become Buchloh's readings about sociological processes. In 1987 Buchloh guest-edited an edition of *October* on Broodthaers, in which many of the essays tend to support a Marxist vision of the art's overall meaning. In the Walker catalog, an essay by Douglas Crimp continues this approach.

Broodthaers was a member of the Belgian Communist Party for a few years in the late 1940s and early '50s, then left it. In 1968 he participated in an artists' sit-in in the Brussels Palais des Beaux-Arts, the museum where he had once conducted docent's tours and where he would later give a major exhibition of his own work; he left, however, before the occupation was over, rendering his response to it ambiguous. Clearly he was touched and inspired by the events of 1968 (as were

Marcel Broodthaers, La Peste, *1973. Courtesy Marian Goodman Gallery, New York.*

numerous Western intellectuals of various political stances). Finally, he took a course in Baudelaire from Lucien Goldmann, a follower of Georg Lukacs, in the winter of 1969–1970. It is questionable whether these connections with Marxism— distinct connections, to varying degrees, but hardly pervading the artist's life— should control interpretation of the oeuvre. Broodthaers did not express himself verbally as a Marxist, at least in his statements as a visual artist. He does not seem to have read Marxist authors widely and, with the exception of Goldmann, professed a lack of interest in them. Buchloh actually acknowledges this silence, saying,

"In Broodthaers's work from the mid-sixties onward rarely, if ever, do we find an explicit reference or claim to the political nature of his artistic endeavour."[8] Nevertheless, Buchloh and others read politics as the endeavor's core. Indeed, Douglas Crimp, in the Walker catalog, seems to believe that his readings according to Benjamin are known to have been those intended by Broodthaers.[9] Of course one can apply a Marxist analysis to anything at all; the question in this case is whether that reading makes or implies undue claims about the artist's intentions.

The photographer Maria Gilissen, Broodthaers's wife from 1961 until his death, does not remember his intentions thus. Buchloh met Broodthaers, she recalls,[10] in 1972, and they got together occasionally thereafter. In 1974, according to Gilissen, Buchloh broached his observations about the relevance of Benjamin to Broodthaers's work, and Broodthaers replied that he was unfamiliar with Benjamin's writings. Later that year Buchloh arrived with two books by Benjamin, which he left with Broodthaers. Sometime later he reappeared, excitedly asking if Broodthaers did not now see that this was what his work was all about, whether he had consciously realized it or not. Broodthaers replied that he had not looked at the books, as they were in German, a language he did not read. Buchloh later returned with a Benjamin book in French, and Broodthaers was seen to leaf idly through it once or twice. This took place in 1974, two years before Broodthaers's death. Most of his work had been done by then, and all of its main themes clearly articulated, apparently without knowledge of the works of Benjamin.[11] Yet Crimp mentions Benjamin thirty-one times in his twenty-two-page catalog essay. So the apostle of silence has been given a voice—and it is not his own.

A counterview would argue that Broodthaers's voice is in fact more complex and subtle than any exclusive ideological tendency would allow. It is a kind of multiple voice, incorporating a network of references, and it is neither as personally nor as art-historically hermetic as the intimidating claims of its mysteriousness would suggest. In fact, it is deeply related to the art of its time. Broodthaers selected certain anchors with which to position his entry into and practice of the visual arts. He chose the two most drifting, shifting moorages possible: "I have just followed," he wrote in 1965, "the footprints left in the artistic sands by René Magritte and Marcel Duchamp."[12] In the catalog for his Dusseldorf exhibition in 1972, Broodthaers reproduced Duchamp's *Fountain* (1917) and Magritte's *La Trahison des images* (*The Treachery of Images*, 1928–1929)—the painting that contains the words "*Ceci n'est pas une pipe.*" In effect, he proposed these as presiding icons over his oeuvre.

The format of Duchamp's *L.H.O.O.Q.* (1919)—altered found photograph with attached verbal element—marks the beginning of Broodthaers's work: In the announcement for his first exhibition, the text explaining his conversion from poet to object maker ("I had the idea of inventing something insincere," he wrote) was printed over magazine photos. Duchamp's use, in the same piece, of a postcard reproduction of a classic European artwork is echoed in Broodthaers's *Musée d'Art Moderne, Département des Aigles, Section XIXème Siecle* (*Museum of Modern Art, Eagle Department, Nineteenth-Century Section*, 1968–1969), in which he displayed postcards of famous French paintings in the living room of his home for a year.

Duchamp's exhibition of empty vests is echoed in Broodthaers's exhibition of empty shirts. Duchamp's *Box in a Valise* (1936–1941) is echoed in Broodthaers's suitcases containing such unexpected art materials as mussel shells, charcoal, and bricks. Broodthaers's exhibition of altered store-bought shovels is more than an allusion to a Duchamp work: It is an actual repetition or recreation of one.

Broodthaers apparently identified also with Duchamp's attitudes toward art and art history. When he says, for example, "I try as much as I can to circumscribe the problem [of the social engagement of art] by proposing little, all of it indifferent,"[13] he seems to be referring to Duchamp's "aesthetics of indifference," in which the idea of indifference takes on positive meanings.[14] In the same passage Broodthaers connects the Duchampian "indifference" with the Duchampian rejection of the profession of aesthetic-object-maker: "At what moment does one start making indifferent art? From the moment that one is less of an artist, when the necessity of making puts down its roots in memory alone."[15] This is deliberate Duchamp-talk. In another echo, Broodthaers wrote, "I don't believe in the unique artist or the unique work of art. I believe in phenomena and in men who put ideas together."[16] Duchamp's refusal of the role of priestly artist, his rejection of the unique masterpiece and his desire to put art back in the service of the mind are in the background of these remarks.[17] Evidently, Broodthaers felt that the only acceptable stance from which to practice art in the mid-sixties was the Duchampian one of indifference, irony, contradiction, and mocking insincerity. He was not alone in feeling this at the time when Duchamp's influence, dormant for two generations, was arising and taking its revenge on the cult of beauty.

Broodthaers's redefinition of himself at midlife also involved the model of his Belgian countryman Magritte. A childlike rendering of a pipe like that in *La Trahison des images* is a fundamental vocabulary element in a number of his works, where it functions as a complex shorthand for a critique of the Kantian separation of (verbal) cognition and (visual) aesthesis (a separation that both Duchamp and Magritte rejected when they incorporated linguistic and conceptual elements into their artworks) as well as for the Magrittean project of turning different modes of representation against one another. "It was with that pipe that I tackled the adventure," Broodthaers wrote.[18] He also borrowed Magritte's formula "This is not a . . ." for another Musée d'Art Moderne installation in 1972. One of his works contains the street name "rue René Magritte"; he photographed Magritte and had photographs of himself taken with Magritte. The influences of Duchamp and Magritte on Broodthaers are explicit, and no one argues about them. His aim was to go beyond these models into even purer realms of unaccountability than they achieved.

In terms of the art history of Broodthaers's own time, the crucial period from 1964 to 1976, there has been a marked neglect of the project of contextualizing the artist's work—a taste for arguing that the oeuvre is unique and uncategorizable. Yet when he declared that he was following in the footsteps of Duchamp and Magritte, Broodthaers continued, "and those new ones of George Segal, Roy Lichtenstein, and Claes Oldenburg." Though not willing to submit himself completely to either American Pop Art or its European relative Nouveau

Réalisme, Broodthaers consciously worked on their themes and images. His art shared with Pop, among other things, the use of advertising imagery and the general revival of Dada ridicule of mainstream culture. It also contains specific references to Pop motifs. In 1963, for example, Jim Dine had exhibited a painting of a bowler hat with a real bowler on a shelf beside it, painted black. The work seems in part an homage to Magritte, and Broodthaers not only reviewed it as a critic[19] but himself made at least two works involving real hats within the following two years, *Chapeau blanc* (*White Hat*, 1965) and *Chapeau buse avec trou* (*Dunce Hat with Hole*, 1965).

Some of the critical and subversive elements of Pop Art—its interest in market forces, its deadpan humor, its quizzical approach to the art object—entered Broodthaers's oeuvre, then.[20] His work also overlaps with classical Conceptual Art (even more, perhaps, than with Pop).[21] Both have strong ties to language and to its encoding in writing; both feature the influence of Duchamp and the introduction of found materials alongside linguistic elements; both critique modes of representation; both cultivate a position between, around, and outside the traditional media of painting and sculpture; both feature the theme of tautology;[22] and, through a variety of tactics, both deconstruct the tradition of easel painting.[23] The idea of the unique art object, for example, was mocked by Broodthaers's previously discussed exhibition of postcards of paintings, and in *Dix-neuf petits tableaux en pile* (*Nineteen Small Paintings in a Pile*, 1973) and *Pyramide de toiles* (*Pyramid of Canvases*, 1973), painted canvases are stacked up to be experienced not as pictures but as sculptural presences or mere mute matter. To focus on unevennesses in the relationship between language and image was a common aim in Conceptual Art and in other art of the 1960s and '70s: Paintings of alphabets, for example, were characteristic at one time or another of Jasper Johns, Robert Rauschenberg, Piero Manzoni, Jannis Kounellis, Arakawa—and Broodthaers. In many Conceptual works the linguistic representation of a painting replaces the painting: In his Mechanism of Meaning series, 1963–1971 and 1978, for example, Arakawa painted a landscape by putting on an otherwise blank canvas the words "sky," "trees," "house," and so on. Broodthaers similarly, in *La Salle blanche* (*The White Room*, 1975), set words like "light," "shadow," "sun," and "clouds" high on a wall, and lower down the names for things found under the sky, such as "water," "coast," "images," "eye," and "museum."

This sort of drifting and shifting of categories appears in nonverbal form in *La Malédiction de Magritte* (*Magritte's Curse*, 1966), where a printed photograph of a blue sky and a painted blue sky, set together on a panel, are fronted by shelves holding four jars of cloudlike cotton wool, two of them painted blue on the inside to match the image behind them. Neither photograph nor painting nor sculpture alone constitutes the work; none appears self-sufficient or stable. (Magritte's curse indeed.) The use of jars containing paint here echoes Duchamp's idea of the paint tube as a readymade,[24] Yves Klein's exhibition of his paint-rollers as sculpture, Arman's accumulations of paint tubes in a picturelike surface, and other works in the Duchampian, Pop, and Conceptualist traditions. Another Broodthaers piece shows two windows marked respectively *toile* (canvas) and *huile* (oil); the traditional sense of the picture as a window is satirized by breaking painting down into its physical

parts and then transposing these material elements into linguistic ones. Elsewhere Broodthaers presents the pictorial surface covered with eggshells or mussel shells, echoing Manzoni's canvases studded with dinner rolls, Lucas Samaras's exhibition of plates with foodlike things on them as picturelike surfaces, Daniel Spoerri's *Tableau Piège,* and so on. In all these strategies the tradition of the transcendent representational capacity of the picture is parodied by a reduction of the painting to mere matter, by a transposition of its values into language, or by a shift of the category "culture" into that of "nature" (as in the egg- and mussel-shell paintings).

Other works by Broodthaers vary and extend the vocabulary of this multibranched critique of painting. *La Peste* (*The Pestilence,* 1974–1975) undermines a specific painterly mode in an exaggeratedly Expressionist canvas with the French word for "pestilence" penciled over it. In other works Broodthaers simply painted his initials on the canvas as a "picture," and in *Il n'y a pas de structures primaires* (*There Are No Primary Structures,* 1968) he painted, in elegant script, the French word "signature." Beside conflating linguistic and pictorial representation, as the artist did in so many works, these pieces put in play the ethical question of the primacy of artist over work, of life over art. The gesture echoes the check Duchamp exhibited for the sake of his signature, Kounellis's paintings of his own initials, and many other works of Conceptual Art. The genre evokes Yves Klein's remark, suggested in countless works of Conceptual and Performance Art, that the artist has only to create one work, his- or herself, constantly.[25] In this respect, Broodthaers's practice of having some auratic photographs of himself made, in an echo of both Duchamp and Klein, was essentially performative.

The positioning of some of Broodthaers's work between Performance and Conceptual Art is demonstrated by his 1971 gesture of selling gold bars at twice market value. The "contract" for these sales was based largely on Klein's 1959 ritual for "relinquishing" what he called "zones of immaterial pictorial sensibility" in exchange for gold. Article seven of Broodthaers's contract states, "The purchaser is free to have his ingot or bar melted, so as to obliterate the mark [of the eagle] or to burn the letter of identification in order to enjoy fully the purity of the substance and the freshness of the original intention." In Klein's piece the purchaser of a void "zone of sensibility" burned his or her receipt, and the artist threw half the gold into the river Seine. Broodthaers's decision to accompany each bar of gold with a "manuscript letter from the curator in order to prevent the production of fakes" also recalls Duchamp's emphasis on the signature and, more distantly, Manzoni's "Certificates of Authenticity," which accredited their signers as works of art. Broodthaers himself possessed one of these certificates.

The practice of writing or otherwise working directly on the walls of the exhibition space—as Broodthaers did in *La Salle blanche,* and as many Conceptual artists have done, including Lawrence Weiner and Daniel Buren—invokes another mainstay of the Conceptual tradition, the emphasis on the primacy of the context over the thing viewed within it, and the consequent redefinition of the gallery space as the material of the work. This goes back to Duchamp's seminal realization that a thing apparently not art can be designated as art by involving it in the art system of

signatures, galleries, and so on. Duchamp also addressed the volume of the gallery as a material in his mile-of-string installation of 1942, as did Klein in *Le Vide*, 1958. In a parallel almost surely unconscious, Samaras reproduced his bedroom in a gallery in 1964, just as *La Salle blanche* is a museum reproduction of one and a half rooms of Broodthaers's home—the rooms in which his fictive museum had been performed. Various differences in sensibility are involved: Broodthaers's work, for one thing, involves a reflection on the museum setting that I would not attribute to Samaras. But the vocabulary, the tactical maneuver being used for whatever purposes, was the same—and it was a vocabulary very much in the air during Broodthaers's twelve-year career.[26] Marge Goldwater says that Broodthaers "merged art with life"[27]—perhaps the most typical preoccupation of Pop, Performance, and indeed the whole Duchampian tradition of the Readymade and the rejection of Kantian aesthetics.

I have tried to show by this web of allusions, parallels, and echoes in Broodthaers's art that it is neither unique nor, really, enigmatic *in the terms of its own time,* but deeply embedded in its time and cognizant of it. The work contains elements of Dada, Surrealism, Pop Art, Conceptual Art, and Performance Art, and is in effect a conflation of them—as is Beuys's work, and Klein's, and Manzoni's, and Kounellis's, and Samaras's. This kind of conflation is a known, characteristic type of seventies art. Due in part to the feeling that Broodthaers's oeuvre is unique, and in part to its premature identification with a limited ideological set, however, it has not been subjected to much rounded analysis.

The artist himself suggested an avenue into the work when he remarked that for him *Le General mort fume un cigar eteint* (*The Dead General Smokes an Extinguished Cigar*, 1968), a found portrait of a Belgian general into whose mouth Broodthaers has stuck a real cigar butt) and two pieces incorporating painted human thighbones were the works that held up best.[28] The altered painting deals with the themes of the found object re-signed and appropriated into another portfolio, denying the primacy of authorship; of the slippage from an illusionistic into a real space; of mockery of the artwork, the cigar butt resembling Duchamp's mustache drawn on the Mona Lisa; and of traditional art versus contemporary art, or versus so-called anti-art. These ideas we have already seen present in the Conceptual and Magrittean/Duchampian elements of Broodthaers's work. But the image of the Belgian officer also introduces the themes of nationality and power, themes equally prominent in the two thighbone works. One of these, a male human femur, is painted black, yellow, and red, the colors of the Belgian flag (*Femur d'homme Belge, Belgian Man's Leg Bone,* 1965); the other, a female human femur, is painted red, white, and blue, the colors of the French flag (*Femur de la femme française, French Woman's Leg Bone,* 1965). Three levels of reality are suggested by these objects. First is the real, biological reality of the bones, which asserts that these two people shared the fundamental identity of humanness, a biological, precultural species-identity. Over this sameness is laid a distinction, partly biological and partly cultural, between male and female; and on top of this is the thoroughly cultural distinction of nationality, designated by the references to the flags of two

Marcel Broodthaers, Pense Bête, *1963. Courtesy Marian Goodman Gallery, New York.*

nations. Humans, the pieces say, are all more or less the same biologically, but as we get involved in culture we spin out superficial distinctions that obscure and divide. This basic liberal humanist thinking (not unlike that underlying Jean Renoir's 1937 film, *La Grande Illusion*) criticizes divisive cultural overlays in favor of an underlying sameness. The work's subject matter seems to be false difference, its political foundations, and its generation from political motives.

A pair of pieces involving maps, from 1968–1973 and 1968, relate to these flag references: In the manufacturer's printed title, *Carte du monde politique,* the word "politique" is crossed out and replaced in one case with the handwritten word "utopique," in the other with the word "poétique." As with the human skeleton in the painted thighbone works, the physical reality of the earth is seen to be the same, whatever differences a label imposes on it. Thus the world of political divisions becomes an arbitrary, artificial overlay on a material reality that lacks it. The world can equally easily be seen as political, utopian, or poetic; and humans can do whatever they want with the world—politicize it, poeticize it, utopianize it. In *Le Problème noir en Belgique* (*The Black Problem in Belgium,* 1963) intact eggs splattered with black paint sit on a newspaper with the headline "Il faut sauver le Congo" ("The Congo must be saved"—at the time, this former Belgian colony had only recently gained its independence). Again there is a suggestion of underlying natural

sameness (both Belgians and Congolese are born from the same eggs) beneath overlays of cultural difference. But here, contrary to Compton, it surely seems appropriate to refer to the general symbology of the egg—to wonder whether the latency or gestation of African culture is suggested, its need to emerge from its shell, to be born into the contemporary world. In these works generally, the eggshell as a symbol of birth is no less prominent than its meanings as vessel of food, as mold, as form from nature. Broodthaers once drew an eggshell inside and around which he wrote and rewrote his initials; the letters are again a cultural label imposed on the egg to create difference, yet they are also suffused through the egg and inextricable from it. This casual-looking drawing suggests the possibility both of being nurtured by culture, of feeding on it, and of being born out of it, of having potentiality. The idea of latency and potential emergence is applied to Broodthaers himself, to the individual in general, and, in *Le Problème noir en Belgique,* to national or racial groups.

The bivalve shell, since antiquity, has been symbolically associated with the vagina: In a fragment of Plautus, for example, when Aphrodite tells her young girl devotees to raise their skirts, she says, "Show me your little shells." The egg, of course, has a related iconographic content. There is no reason to suppose that Broodthaers was unaware of these connotations of the materials of his work. He wrote of eggs and shells as both containers and voids,[29] and I take the void here to mean potentiality, fullness-emptiness—that is, the emptiness that is full of yet-unmanifested life. (This was the meaning the void had for Klein.) Nature (the bone, the earth, the egg, the shell) is viewed in Broodthaers's work as offering this kind of infinite and indefinite potentiality to a humanity whose culture, supposedly its means of expression, paradoxically operates as a rigid, constricting force.

The polarities "container/contained" and "nature/culture" are controlling structural tensions, like architecture's stress-bearing girders, in many of Brood-thaers's works. They are seen, for example, in *Bureau de Moules* (*Sideboard of Mussels,* 1966), the sideboard topped with mussel shells, and in numerous parallel combinations: shells (whether mussel or egg) in a cabinet, in a pan, in a bucket, in a suitcase. Can nature contain culture? Does culture contain nature? The container/contained theme suggests infinite regress: The cabinet (or bucket, or suitcase) contains the shells, but the shells are containers themselves. These works bring up questions of whether art stands apart from or partakes of reality (the question posed by the portrait with the cigar), whether art is natural or cultural (born or made), whether it is compromised in either or both cases, whether it can be removed from one container and put into another, whether humans are nurtured by it, have control over it, and so on.

Many of Broodthaers's works focus a critical eye on the Hegelian distinction between culture and nature. Hegel called culture "Work" because it is under human control, supposedly, and, also supposedly, because it has a purpose. Nature, on the other hand, he called "Madness" because he saw it as heading in no direction, and under no humanly accessible control. Broodthaers suggests that the madness of nature may be saner than the work of culture. (Recall his work *Pense-Bête, Think*

like an Animal.) *Une Pelle* (*A Shovel*, 1965) is a spade, in an obvious reference to Duchamp's snow shovel. Broodthaers's spade, however, unlike the snow shovel and like his egg and mussel pieces, relates to the theme of fertility, for its metal blade is covered in wood-grain paper drawn over with a tree's root system. It looks, in other words, as if it had grown up out of the ground, in a reversal of its actual function of digging down into it. Again the Hegelian nature/culture distinction is reversed: Human work—the human effort to control and manipulate nature—is seen as itself rooted in nature, dependent on it. Culture is proposed as a disguised or unrecognized natural process. The issue is readdressed in a piece from *Un metre pliable* (*A Pliable Meter*, c. 1974), a folding ruler four of whose ten segments have been painted either green, red, or black. In a sense, the calibrated measurement numbers are elements of culture—of the human tendency to measure, categorize, label—and the colored areas represent nature, a visual, nonlinguistic, nonnumerical presence. On the other hand, the measurement may be seen as representing nature, the reality of space, and/or matter's extension in space, and the colored areas may represent art, the cultural aestheticization of reality. The piece recalls Duchamp's *Three Standard Stoppages* (1913–1914), in which the artist made three eccentric rulers by dropping meter-long pieces of string and recording the shapes into which they fell. Duchamp also was dealing with Madness and Work—was attempting to get more nature, in the form of randomness, into culture.

The eagle represents Broodthaers's later work much as the egg- and mussel shells do the early period. In the 1968 *Musée d'Art Moderne, Département des Aigles, Section XIXième Siècle*—the show of postcard reproductions of nineteenth-century French paintings—the appellation "Department of Eagles" was unexplained. In 1972 came the installation *Musée d'Art Moderne Departement des Aigles, Section des Figures, der Adler vom Oligozan bis Heute* (*Museum of Modern Art, Eagle Department, Figures Section [The Eagle from the Oligocene to the Present]*). Here the artist-as-museum-curator gathered over three hundred objects containing images of eagles—some of them artworks, some ancient emblems, some commercial objects, packaging, and so forth. None of these distinctions mattered: Every piece (except for three eagle eggs) involved the image of an eagle, and that category overrode all others. Every piece was attended by a label bearing a number and the statement, in French, German, or English, "This is not a work of art"—a conflation of Duchamp's tactic of designating something as art and of Magritte's "This is not a pipe."

Since antiquity the eagle, mighty among predator birds, has been associated with power. There is also a long connection with art:[30] Supposedly like the poet or artist, the eagle rises above everyday affairs and at the same time looks down upon them with an acute, farseeing eye. The two themes can be reconciled in the idea that if the eagle ascends to realms inaccessible to others, it can also fall with terrifying force upon what it sees. Myths and icons found worldwide describe the human who rides to heaven on an eagle's back, and the eagle fighting a serpent; in both, the eagle represents the ability to transcend worldly reality and also to intervene in it for its betterment.[31] The artist, analogously, can be a force not only of observation but of intervention, that is, of social involvement. (Though the eagle

may also suggest the frightening power of distant—usually more or less invisible—social authority.)[32] Broodthaers wrote in the press release for his exhibition of eagle images that his "fictive museum takes its point of departure from the identity of art and eagle."[33] The related remark that his museum was born in the 1968 occupation of the Palais des Beaux-Arts[34] suggests that the subject of the piece is how to use art for social change. The label "This is not a work of art," then, may be read as an attack on the restriction of art to a special, sheltered niche in society, precluding its social engagement. This restriction is enforced conceptually by the system of Kantian aesthetics and physically by the institution of the museum. Broodthaers's denial of the art status of his eagle icons releases the force of images, the force that Plato feared in his *Republic*, and undoes the ideological subjugation or co-option of art. The label does a real thing, makes a real ontological change. Naming, or labeling, like a magical incantation, can *make* what it asserts, by asserting it.

This recognition was acted out in Broodthaers's switch of his own label, in mid-career, from poet to artist. Much of his subsequent work investigated the relationship between labels and things. *Sculpture* (1974), for example, is a suitcase of bricks with the word "Sculpture" painted on it. The container/contained dichotomy is combined with that of the thing and its label, and of the presence of a thing and its representation. Does the suitcase contain a sculpture or is it a sculpture? Are the bricks inside the suitcase a sculpture, and if so, are they such by virtue of their labeled container—their physical and ideological context? Do they suggest the rubble of the old society or the raw material with which to build the future? They are hidden in the suitcase as art is hidden in museums, but they lie there with the past and the future in them. Again, a milk bottle painted with the word *lait* (*Milk*, 1973), reproduces the common relationship between container and label: The bottle contains what the label denotes. In the coffeepot inscribed *écrit* (*Writing*, 1967), on the other hand, it is the label, not the vessel, that contains the thing named in the label. The label is a thing in its own right. Like a flag, it changes situations, creates divisions, multiplies categories. Broodthaers's negative uses of the label are a counterlabeling, a freeing of labeled things from their assigned categories. His acting-out of the idea of language's control over reality participates in a prominent theme of seventies art.

Before his career change Broodthaers had already dealt with labels in the tours of the Palais des Beaux-Arts that he gave as a docent. (Sometimes he behaved performatively during these tours—wearing a kilt, for example, to discuss Scottish art.) The docent's work—with its didactic pointing and naming, usually on a fairly simple level—surely helped Broodthaers to formulate his ideas about the museum. As a rudimentary educational exercise, it recalls the teaching of the alphabet to a child; this suggests the coherence in Broodthaers's thought between his Musée d'Art Moderne pieces and his extensive use of the alphabet. Generally in his work, the alphabet is understood epistemologically and ethically as a grid with which to control perception and reality toward some unacknowledged end. It is a concept serving impulses of control and repression. Broodthaers undermines it in various ways. *Palette P* (1974) shows letters of the alphabet beside colors on a painter's

palette; the conflation relates to Broodthaers's statement—made of a single work, but it might apply to all his art—"it was an attempt to deny, as far as possible, meaning to the word as well as to the image."[35] An alphabet running around the borders of a square of sand on the floor, with a potted plant at its center, suggests culture's ensnarement of nature in a conceptual grid in *Le Tapis de sable* (*The Carpet of Sand*, 1974). A partial alphabet painted on a child's stool shows the closeness of the first conceptual imprint—that it is absorbed early, through virtually immediate contact in *Tabouret* (*Footstool*, 1968). *Casier avec alphabet* (*Cubbyhole Rack with Alphabet*, 1967–73) is a shelf of cubbyholes, each with a letter of the alphabet painted inside it, suggesting the process of fragmenting reality into separate categories. There is a deliberate avoidance of pattern, order, or predictability in many of these, and in other alphabet works. "I see new horizons approaching me and the hope of another alphabet," Broodthaers wrote in 1974,[36] and he once referred to a group of his alphabet works under the general title "Apprendre à lire" (Learning to Read). Many of his works raise the possibility of alien alphabets that might rearrange meanings and restate the world. But before Broodthaers could discover such alphabets, he had to erase the old one. The theme of the erasure or prohibition of reading, canceling or nullifying the alphabet that created the present mind and the present world, appears in the transitional piece from his work as a writer—the poetry books cast in a matrix of plaster for *Pense Bête*. Embedded in their base, the books are unreadable, but to remove them would destroy their status as sculpture. The visual and the verbal preclude one another, somewhat as in Magritte's riddle of the pipe. The piece denies a fundamental human assumption about reality: that different modes of perception may perceive the same thing and that different modes of representation may represent the same thing.

Similar themes appear in Broodthaers's plastic plaques and artist's books. The plaques are mock paintings made in small multiple editions. Through their material and technology of facture, they reject the belief in the sacred body of the work of art. Sometimes they pose the museum as, in effect, an alphabet, a categorizing system that enforces a view of reality. A plaque reading *Museum: Enfants non admis* (*Museum: No Children Allowed*) suggests the possibility of an underlying innocence of mind prior to the impression of categories upon it, and also proposes the museum as a dangerously corrupting place. Many of the plaques, addressing themselves to this innocent level of mind, resemble pages from children's instructional books. This again recalls Magritte, whose *La Trahison des images* imitates an image in a child's alphabetical almanac and subverts a level of cultural conditioning operant in childhood—that of learning to read and to identify pictures with words. Broodthaers's plaques also simulate devices for a child's learning of the alphabet or, sometimes, of the number series, but systems are always subverted or rendered Other through inner contradictions.

Sometimes a repetition or decontextualization of an element reduces the sequence to absurdity, as when four large different-sized commas (in the colors of the Belgian flag) cluster in the picture space (*Cinéma Modèle*, 1970). Elsewhere, series of letters or numbers are interrupted by omissions, or by analphabetic and

nonnumerical elements. In *Modèle: La Virgule* (*Model: The Comma*, 1969), Magritte's pipe is substituted as an alphabetic element in four successive plaques and in the fifth stands triumphantly alone except for a comma rising from it like a puff of smoke. The pipe represents the Magrittean paradox, the thing that is not itself or the representation that does not represent its object. It is the alphabetic sign of chaos, the indefinite, the signifier with no signified, the unknown quantity, the universal blank, the wild card. The comma rises from the pipe as the vapor of the indefinite; it is the brief silence in which one takes a puff of smoke, and the dissolution of what is solid in smoke's Delphic swirl.

Broodthaers's plaques are a child's instructional devices designed to drive an adult insane—or into Madness, into freedom from Work as enforced mental servitude. Broodthaers the poet became an artist to subvert the alphabet, the material of poetry, by making and remaking it endlessly into randomness. "The alphabet," he wrote, "is a die with 26 faces."[37] As the die is cast, various orders are denied. One plaque shows a row of four commas, below it the numerals 1 to 5, and below that the terms of an art-historical list: David, Courbet, Ingres, Ingres, Wiertz. The duplication of Ingres confutes sequence, and the inclusion of the relatively obscure Belgian artist Antoine-Joseph Wiertz mocks the hierarchical structure of art history. Elsewhere words are arranged spatially, like a picture, as they are in *La Salle blanche,* but they may not connote anything pictorial—"society," for example, or "empty paper"—and may make transitions between usually distinct categories such as culture and nature without visible discontinuity. Broodthaers referred to the plaques as "rebuses," those puzzles made up of a mixture of visual and verbal elements. But these juxtapositions are inwardly self-obscuring; neither word nor picture is absolute, nor do they constructively complement one another. There is something here of the ancient sophistic argument that the senses may report on different unconnected worlds.[38] They leave an indefinite space between them, and in that space, if anywhere, is to be found the real, which then remains undefined— symbolized by the pipe that is not a pipe.

In Broodthaers's book *Un Coup de dés jamais n'abolira le hasard* (*A Throw of the Dice Will Never Abolish Chance,* 1969), the original typesetting of Mallarmé's poem of the same title is reproduced as patterns of solid bars. Mallarmé's poem is well known for its exploration of the spatial arrangement of poetry, for moving poetry into the visual realm. Broodthaers has drained out or covered over the verbal aspect and left only the visual. There is a sense of potentiality here, of the possibility of different alphabets, different ways of reading and of cognition, as in Mallarmé's remark that the perfect poem would be a blank sheet of paper—a void. Broodthaers's prototypical alien alphabet not only might present alternatives to the arbitrary, cultural straitjacket of any moment, but might be the moment's future, its breaking out of the eggshell. By eliminating language he returns a classic Modern text part of the way from culture back to nature—from acculturated human thought to thinking "like an animal," to seeing the page as, say, a dog might.

In exhibiting the *Section des Figures, Der Adler vom Oligozän bis Heute* wing of his modern-art museum, Broodthaers rejected considerations of form, of history,

Marcel Broodthaers, Monument an X, *1967. Courtesy Marian Goodman Gallery, New York.*

and of cultural categories such as art, advertising, functional object, and so on. His category—the eagle—was a simple slice through the reality of life. The reality of the subject matter appeared as directly as in a child's catechistic book—an almanac, an alphabet, or a bestiary.

This latter form—the pictorial and verbal book describing a selection of nonhuman species—Broodthaers had admired in La Fontaine and had worked on himself; his last poetry book invokes it. The bestiary is a map of reality according to a breakdown of species. Its author composes, as it were, an alphabet of species, a

basic reality list. But *Pense-Bête* is an unusual bestiary containing brief descriptions of a cockroach, a boa, a parrot, maggots, a lizard, a mussel, and a jellyfish. It is an alien alphabet that surreptitiously raises the question of what the future holds—of what the human species might *become.*

The bestiary theme reappears in Broodthaers's visual oeuvre in the slides projected for the installation *Un Jardin d'hiver* (*A Winter Garden,* 1974), in a work titled *Les Animaux de la ferme* (*Farm Animals,* 1972), in the bird and shellfish references scattered through his art, and elsewhere. Restating the questioning of the line between nature and culture, it reveals the cultural organizing, categorizing, arranging in sequences, and so on, that are the basis of the museum, and of difference in general. Yet at the same time its subjects are completely real, nonabstract natural beings of obvious existential persuasiveness: "Think like an animal." What is missing from the bestiary's list of species is the human animal, which has both made the bestiary and left itself out of and above it. Again the issue is raised of whether nature contains culture or whether culture captures nature through its categorizations and representations. And this leads back to the question of the cigar in the portrait's mouth—the question of art as a natural, untutored human faculty or as a divisive cultural activity tending, like others, to produce illusory yet powerful feelings of difference.

Broodthaers's book *A Voyage on the North Sea,* 1973, reintroduces the theme of colonialism, which he focused on from time to time. The book presents itself as a tour of two pictures, one a photograph of a modern sailboat at sea, another an old painting showing an eighteenth-century fleet out on one colonialist enterprise or another. The reader is led page by page around these two images, observing cropped and enlarged details of them, as if pointed to different patterns of recurrence by an invisible docent. This pictorial alphabet, perfuming the atmosphere of the book, suggests the colonialist diffusion of European category-systems (alphabets) into cultures that had their own perceptual systems already in place. Alternatively, it implies the innocent mind of the rest of the world before the colonialist reprogramming. Ships hasten on their way to pressure the dark-skinned natives of non-European lands to channel their gold and pearls this way. At the same time, the book's detail shots, with their emphasis on the grain of the canvas and with the quasi–Abstract Expressionist value of their out-of-context perspectives, both invoke and critique the mystique of Expressionist art. Our subjective expression is the Other's objective oppression.

The inner pages of the book are uncut. In a remarkable manipulation of the reader, Broodthaers has us gently separating signatures and peeking into them in case something might be written inside. (As with *Pense-Bête,* to open the pages would be to destroy the art object.) Inside the covers of *A Voyage* one reads, "Before cutting the pages the reader had better beware of the knife he will be wielding for the purpose." Before entering culture (and a book is an embodiment of culture), remember and fear its destructive effects. "Sooner than make such a gesture," the author goes on, "I would prefer him to hold back that weapon, dagger, piece of office equipment which, swift as lightning, might turn into an indefinite sky." The

difference between culture and nature is slimmer than you think. Nature always has the last word (death), but that last word is often spoken through the mouth of culture. Culture—those ships on the sea—is, in effect, a predatory part of nature.

To point out the limitations of categorical systems was part of the critique of representation that was an originating philosophical force in Conceptual Art. Beneath the project lay a tacitly theological, subliminal faith that an unconditioned state of mind was possible; that cultural overlays might be erased from the mature mind so as to restore to us the state of mind of the child who has not yet entered the museum, has not yet been subjected to its conditioning lessons. This assumption was a long-term presence in Modernist art, and Broodthaers seems to have been impressed by it. The paradoxical nineteenth-century belief in innocence achieved through intelligence, as in the poems of Baudelaire, Rimbaud, and Mallarmé, stirred and at some level convinced him: His use of the phrase "*Sauver le Congo,*" for example, echoes Baudelaire's fascination with the African as the primordial innocent, the natural mind uncorrupted by (the Western) cultural imprint. Still, on the whole, Broodthaers seems to have dissolved this idea in a critical perception of colonialism, Europe's cultural relationship to the the world, and the arbitrary mechanisms by which such categorizing notions are imposed.

When Broodthaers talked about his work, it was not in terms of ideological content but, with whatever ironies in place, in terms of beauty. A level of sentiment and nostalgia sweetens the sometimes-bitter draught of the oeuvre. *Langage de fleurs* (*Language of Flowers*, 1965) is a palette with a rose in the center and vowels written here and there about it; flowers speak only in vowels. *Il est défendu*, 1975, a large painting on canvas, declares, in an elegant script, "It is forbidden to enter the garden with flowers in your hand; it is forbidden to enter the garden with flowers."

Dennis Oppenheim, Theme for a Major Hit, *1974. Courtesy of the artist.*

Chapter Five

The Rightness of Wrongness: Modernism and Its Alter Ego in the Work of Dennis Oppenheim

In 1914 Marcel Duchamp initiated the practice of regarding something as art not because it was made with the intention of being art, but because it was later designated or contextualized as art, although it had originally been made for some different purpose. Duchamp would take an everyday object, such as a snow shovel, add a linguistic pun to it, sign it, and exhibit it in an art context. As these works became accepted into art history, they exerted a powerful subversive influence. In time, the prevailing ideas about the nature of the art object and the art-making activity were revolutionized. This did not, however, happen at once. Duchamp's legacy did not bear fruit for about two generations. During that time, the eras of the schools of Paris and New York, the traditional Romantic view of the artwork as an aesthetic object created by an inspired genius, such as Pablo Picasso or Jackson Pollock, was more or less unquestioned. Duchamp's snow shovel lay, as it were, among the forgotten stuff in the attic or basement, waiting to be rediscovered.

The rediscovery happened around 1960. By that time many had come to feel uneasy with the highly aestheticized art of the schools of Paris and New York. The winds of social change were in the air on a global scale with the advent of decolonization and the emergence of the so-called Third World, and the very survival of the earth was seemingly in question in the midst of the Cold War, superpower politics, and endgame weaponry. In this atmosphere, the works of Jackson Pollock, Mark Rothko, and others, while undeniably great in their way, had come to seem disturbingly precious, otherworldly, and removed from the real issues of life. In a world tossed by a tumult of cognitive reevaluations, from the Cultural Revolution in China to the Black Panther movement in Oakland, the bestowing of aesthetic pleasure in and by itself seemed less a contribution to reality than a distraction from it. This feeling gave rise to a succession of "movements"—Pop Art, Minimal Art, Conceptual Art, Earth Art, Body Art, and others—designed to locate the artwork somehow in the reality of life, not merely aesthetic reality, but cognitive and social realities as well. This was the moment when Duchamp's anti-aesthetic gestures became widely known. In 1959 Robert Lebel's book on Duchamp appeared, and in 1963, the Pasadena Art Museum mounted a retrospective of his work with an influential catalog. Duchamp's practice of creation by designation offered itself as a useful instrument for blurring the distinction between art and life. Artists

began devising new methods for designation in addition to Duchamp's methods of signature and context.

In 1960 the French artist Yves Klein began to designate existing objects as his artworks by painting them with his patented pigment, "International Klein Blue." The Italian artist Piero Manzoni designated objects and persons as art by placing them on a sculpture pedestal (the Magic Base) and issuing "Certificates of Authenticity" designating them as his artworks.

In America the practice of designation came to be associated with the ethical imperative of the site. Aesthetic art had separated itself from the life-world inside the sheltered environments of museums and galleries. The site was, on the contrary, a location in the real, outside world. As a real-life object could be designated an artwork, so a real-world place could be designated an art context. For many artists of this generation the idea of the site became a new dogma, a value emerging from a reversed hierarchy. The museum or gallery had once functioned as a sacred or sheltered space, setting the artwork off from the surrounding world; now the fact of a work being embedded in a real-world location was to be of its essence. There were complications, however, in dealing with career necessities such as gallery exhibitions.

In response to this situation, Robert Smithson began, in 1968, a series of works called Nonsites to indicate their somewhat reluctant capitulation to the gallery principle. Smithson brought heaps of rocks into galleries and exhibited them along with photographs of the sites from which they had been taken. The photograph represented the site; the rocks in the gallery were the "nonsite." In this arrangement, the traditional hierarchy of places was reversed. The gallery, which had traditionally been regarded as spiritually and culturally higher than the everyday world, was regarded with a certain contempt for its fakeness—for the absence of real life within it. Conversely, the site in the outside world, which was commemorated in the photograph, had acquired, as the natural location of reality, something of the reverence, the temple-like quality, that the gallery used to have.

Smithson's Nonsites are often treated as the art historical indicators of this reversal of values. But in fact, a series of works by Dennis Oppenheim—Sitemarkers (1967)—had established the same point a year earlier. Oppenheim would choose a site, usually on Long Island in New York, where he was working at the time as a junior high school art teacher. He would photograph the site and document its location, assign it a number, and then manufacture an aluminum stake with a number on it corresponding to the number of the site. The physical artwork consisted of a transparent plastic cylinder containing the photograph and the documentation of the site and a fitted sack containing the stake. The documents and the surveyor's stake connected to the site by its number could stand in for the site in a gallery.

The Sitemarkers effectively clouded the traditional distinctions between the artwork and the utilitarian object, and between the art context and the outside world. The simplicity and directness of such works were matched only by their efficiency at cutting the ground from under the traditional strategies of Modernist

aesthetics. The revolutionary efficacy of the first generation of American Conceptual Art proceeded, in this way, with a cunning that belied its look of innocence.

Reversing

Oppenheim's Sitemarkers were followed by his Viewing Stations (1967). As the Sitemarkers reversed the relationship of art and world (from separation to an ambiguous union), the Viewing Stations reversed the relationship of subject and object, or of viewing and viewed. These artworks are not things to look at but places to look from—small platforms on which a single person could stand to gaze upon the world. From being an aesthetic object to be activated through contemplation out of context of the outside world, the artwork became a device to encourage insight into that world. The Viewing Stations also look like sculpture pedestals—they are not unlike Manzoni's *Magic Base*—and function similarly. Not only do they define the artwork as a means with which to view the real world, they also treat the viewer and his or her act of viewing as the subject matter of the work; the act of beholding is itself what is beheld. It is with these pieces that Oppenheim's work begins to acquire its special emphasis on epistemology, or mental process, which would increasingly characterize it for the next few years.

A third series of works from 1967–1968 that was concerned with redirecting art energy and setting new and broader parameters for the art experience was the Indentations. Oppenheim would find an object that had lain in the dirt in a vacant lot (in New York City, Amsterdam, or Paris) and would remove it, leaving the indentation of its shape in the dirt.[1] The site would be photographed both before and after the removal. The indentation, that is, the absence rather than the presence of an object, was the artwork. In the rejection of Modernist aesthetics, with its obsession with the object, the idea of art as a removal rather than an addition was also being pursued in both Europe and America. Klein had given an exhibition in 1962 that consisted of removing the paintings from a gallery in the Museum of the City of Paris. Other artists, both European and American, were engaged in related gestures. Rather than adding yet another object to the already crowded world, the artist would begin to clear things away, in an analogy to clearing away illusions.

In America this tendency was associated in an ironic way with the fading authority of Clement Greenberg, the most influential of the aesthetic critics, who had advocated reducing the artwork to its absolute essentials. Minimal Art, starting in the early 1960s, had subversively carried Greenberg's reductive program beyond his intention by attempting to eliminate aesthetic elements as well as nonaesthetic ones; Conceptualism eliminated the physical process and even at times the object itself, in what came to be known (in a parody of the idea of Spirit which underlay the Greenbergian imperative) as the "dematerialization of art."

The themes of dematerialization, removal, and the anti-object informed another series of works from 1968 called Decompositions. In these works, Oppenheim heaped the gallery floor with a powdered version of the materials of which its walls were made, such as sawdust or powdered gypsum. Here the artwork is seen

both as a physical demolition of the gallery itself—an attack on its ideology of preciousness and separateness, dissolving its walls to let in the outside world—and as a means of reversing the traditional aesthetic process wherein raw material is made into coherent form. Here art functioned as a way of undoing what had been unnecessarily done, a force that dissolved form back into the shapeless stuff from whence it came.

The Earth

In 1968 Earth Art was born in the works of Oppenheim and a group of other young artists—Michael Heizer, Walter De Maria, Robert Smithson, and others. Most of these artists were recently out of art school and inspired by the sense of multiplying options in the air. Earth Art was a multifaceted strategy to redirect the art energy. On the one hand, it located the artwork in the real world of the landscape—indeed, it often made the landscape the work, but not in the sense of the Romantic reverence for scenery; it could be a scene of urban decay and desolation, or a strip-mined area, that was brought into the expanded realm of art. In this sense, Earth Art, like other tendencies of the time, was about demystifying art by taking it out of its sheltered milieu into the world. On the other hand, for some of its practitioners Earth Art had certain ancient resonances, harking back to the era of megaliths, pyramids, and other monumentally scaled sacred objects sited in the landscape. In this somewhat contrary sense it sought to regain a pre-Modern feeling of the extra-aesthetic sacredness of art through a change of scale and location. Oppenheim's work was more of the first type than the second, but it had a theoretical focus that was different from either: It involved dispassionately working out certain principles that related primarily to a quasi-scientific methodology for art making rather than to aesthetics, ideas of sanctity, or the project of demystification.

Oppenheim's *Landslide* (1968), executed off Exit 52 of the Long Island Expressway, was one of the first earthworks that was actually realized rather than merely contemplated or sketched out; it was used by both *Time* and *Life* magazines in that year to indicate the beginning of the trend. Almost didactic in its dispassionate approach, *Landslide* involved angled boards arranged around a slope. It extended the idea of Minimal Sculpture into nature with suggestions of longitude and latitude lines, while simultaneously evoking the idea of a bleacher or a communal viewing platform. Oppenheim thought of it as "activating" a preexisting area of the world. Insofar as an area of the world would be changed into an art area by this activation, the beginnings of Systems Art, named by Jack Burnham in the 1968 *Artforum* article "Real Systems Art," can be seen. (Systems Art operates by transferring an object or site from one semantic system to another; it, like so much else, derives ultimately from Duchamp, in this case from his example of transferring everyday utilitarian objects into the semantic system of art.)

In the spring of 1968, Oppenheim worked furiously at these theoretical proposals, defining the parameters of the emerging genre of Earth Art as he went along. *Directed Seeding* (1969), was a wheat field harvested along lines pre-set by the

artist in an oversize parody of Action Painting and painterly composition in general. In *Annual Rings,* the pattern of growth rings from a tree trunk was transferred to a huge scale and etched into the snow-covered ice of a waterway occupying the United States–Canada border and crossing a time-zone line. Oppenheim's tactic of reconceiving something by radically altering its scale (usually by enlarging it) was emerging in these pieces, as well as his tendency to emphasize borders—temporal, spatial, behavioral—the breaching of them, the exchange of systems and contexts, and so on.

The rules that emerged for these works involved a found or real world element, such as the map lines, as an ethical surrogate for the site. Oppenheim, like other classical Conceptualists, felt constrained to work by preconceived extra-aesthetic rules that go back in form to Duchamp's quasiscientific instructions for *3 Standard Stoppages* in 1913–1914.[2] Among other things, this served to deny the traditional aesthetic view of art as an absolutely free play of intuitions—a view that seemed somewhat irresponsible in its disregard for external realities. The Romantic-Modernist belief that art was opposed to science was annulled by the introduction of scientific elements into the vocabulary. At the same time art was to be relocated culturally in an area of practical rather than dreamy endeavor. What was emerging as a guiding principle in Oppenheim's work was a requirement that any element be justified by some external or found index. The lines, for example, of *Annual Rings* or *Contour Lines* could not be drawn freehand by the artist out of an expressive impulse; tree rings, map signs, or whatever, they had to have some real world, semantic context from which they were being appropriated into the "creative," or recontextualizing, act.

Sometimes the real-world index appears flexible and somewhat subjective. In *Salt Flat* (1968), Oppenheim spread rock salt over a rectangular area of earth on Sixth Avenue in Manhattan; the size of the area was dictated by the amount of the material he could afford to buy. The arbitrary, real-world index that served as limit for the piece was the money in his pocket. For the most part, however, the method remained linked to a kind of objectivity outside of the artist while carrying forward the issues of the moment, such as the critique of the relation between the gallery and the outside world. In the Gallery Transplants, for example, Oppenheim took the dimensions of a gallery, then marked off a similarly bounded space outdoors. A cognitive reversal is involved; the real-world index ironically was derived from the gallery, and then transposed to the outside world as a rejection of the reality of the gallery. Structurally, Smithson's Nonsites are similar in mediating the ideological opposition between the autonomous artwork isolated in the gallery and the engaged artwork sited in the outside world. The Nonsites are simpler, however, than the Gallery Transplants in that they do not involve the ironic reversal.

Another transplant piece, done for the first Earth Art show, which was organized by Willoughby Sharp for the Cornell University gallery in 1969, further complicated the method. Oppenheim redrew the boundary lines of the gallery in the snow of a bird sanctuary nearby. The gallery space transplanted into nature was then randomly activated by flocks of birds alighting on it in different compositions

that were unaffected by the artist's intentions.[3] The piece involved another important anti-Modernist rule or tendency that was being articulated in the works as they emerged. The Modernist aesthetic view of art promulgated a myth of the complete control exercised by the artist—in whose work, for example, it was supposedly impossible to change anything without losing aesthetic integrity. Duchamp had articulated the counterprinciple, that of allowing chance to decide parts of the work (again in *3 Standard Stoppages*), and that part of his artistic legacy was also bearing fruit now. In Oppenheim's Cornell Gallery Transplant, for example, the intervention of flights of birds was an element outside the artist's control. Increasingly Oppenheim would come to feel that the artist should create the circumstances for an artwork to occur in—or set going the chain of causes which would produce it—but not the work itself, which remains hidden or unknown till it appears out of the manipulated causal web. The concept resembles the Modernist idea of the artwork as something self-created or miraculous, but reverses the power hierarchy. In the Modernist discourse the artwork, though in a sense self-created, still sprang somehow from the artist as medium; in this approach the artwork springs from the world as medium, the artist being more distanced.

Various works of the period investigated siting the art event within the agricultural and climatic time cycles of nature. The Gallery Transplant in the bird sanctuary, for example, was done in the winter and disappeared when the snow melted. It was like a part of nature in other words, and aged with the changing of the seasons. In *One Hour Run* (1968), Oppenheim parodied Action Painting by cutting snowmobile tracks intuitively or expressively in the snow for one hour. Such pieces flaunted both their ephemerality and their conditionality, operating against the Modernist crypto-religious belief in the artwork as eternal and autonomous like a Platonic Idea. The work is subject to the conditions of nature like everything else, in opposition to Modernist work, which was conceived as outside of nature and not susceptible to its rhythms of change and decay.

Oppenheim's work is characterized not only by the kind of clear analytical seeing of theoretical issues that is found, for example, in Smithson's work of the period, too, but also by a tendency to complexify methods of presentation through structural reversals. In *Cancelled Crop* (1969), a crop was harvested in the shape of an ×, and the harvested wheat was kept from processing and never consumed. A cultural sign, the × of cancellation, has been applied to a field of wheat as it might be applied to another sign on a sheet of paper. Culture has co-opted nature. The retention of the wheat from processing and consumption is again symbolically a subversion of aestheticism—a denial that the raw material of life needs reshaping as art and presenting to an audience. So nature re-engulfs culture again, but on culture's terms. There is little hint of the flower-child mood of affirmation of nature as a solution to the problems of culture.

For Oppenheim, the commitment to the earth as a site was part of a more general commitment to the site. Other sited pieces located the artwork in urban rather than rural matrices. In *Sound Enclosed Land Area* (1969), four tape recorders were buried in cages at four points in Paris, delineating a rectangle of five hundred

by eight hundred meters. Each tape loop projected a voice repeating its respective cardinal point: North, South, East, or West. Here the solipsistic emphasis of much early Conceptual Art was stressed. Joseph Kosuth's work showing a chair and a photograph of the chair, or William Anastasi's picture of a wall hung on the same wall, and other works of the era are related. In something of the spirit of Frank Stella's famous remark about Minimal paintings, "What you see is what you get," works like these tend to emphasize the self-identicalness of the real-world elements of the piece, in opposition to the Modernist idea of the alchemical transformation of real-world elements by the art-making process.

Turning Around

Oppenheim's oeuvre as a whole is characterized by a long, slow series of shifts in scale, from huge to tiny and back again. The first of these is the shift from the macrocosmic scale of Earth Art to the microcosmic scale of Body Art. The preparation for this shift can be seen in three final earthworks. In *Reverse Processing* (1970), Oppenheim entered guerilla-like at night into East River barges that carried unrefined cement from a cement factory, and inscribed huge, white cancelling ×s in each barge in refined cement powder. What he had in mind was a comment on the artwork. Symbolically returning the processed stuff to its origin, to its preprocessed and prerefined state, implies stopping the artist's pigment from becoming illusion on a canvas, stopping the sculptor's cement from becoming rigid, cancelling the tendency of a style or line of work to become as enduring as bronze. In a related piece, powdered calcium was returned to the mine whence it had once been removed in unrefined lumps. Carl Andre's gesture of exhibiting unaltered bricks, rather than a structure built of them, is related, as is Duchamp's remark that a painting could be reduced to just a canvas and tubes of paint. Earth Art, the aspect of Oppenheim's work which was now receding, and Body Art, the aspect which was emerging, crossed paths in *Maze* (1970), a work that was sited in the earth but acted out in the body. In a field where cattle browsed, an enlarged version of a rat's laboratory maze was installed in the form of walls made of stacked bales of hay. The cows' food was put at the other side of the maze. The cows were led into the maze. As a piece that intended to concretize cognitive processes or to make sculpture of them, the idea was that the cows would be led through the maze daily and after a few days they would have learned their way through it, like big rats. This rearrangement of the cognitive equipment of other beings was to constitute the artwork; the artwork, in other words, existed in the mind of the cattle, was installed in their consciousness. (But the reality of the body overcame the cognitive aspect. When the cows learned where the food was they just ran right for it, knocking down the hay walls.)

Much of what is called Body Art is really an art of rearranging cognitive patterns, that is, of accessing the cognitive realm through the channel of the body. The epistemological aspect of Oppenheim's work was coming to the foreground in the shift from the earth as site to the body as site. (In this sense, Oppenheim's work

has more in common with Vito Acconci's than with Smithson's, Heizer's, or De Maria's, with their continuing emphases on land masses that suggest pre-Modern ritual zones and states of religious awe.) *Color Application for Chandra* (1971) shows Oppenheim's work developing its coherent theoretical web. To the idea of consciousness as the sculptural material (or really to the idea of cognition, since it is not raw consciousness that has interested Oppenheim, but consciousness as it processes specific materials), Oppenheim conjoined a tendency more or less unique to his oeuvre: to regard his children as composing with him a larger genetic body eligible as a carrier of Body Art. In *Color Application,* Oppenheim taught his two-and-a-half-year-old daughter, Chandra, the names of colors by projecting them and repeating their names; an audio loop of Chandra's voice repeating the color names was played twenty-four hours a day to a parrot until he had learned to say them as well, but without the association with the colors. Here a kind of stripping-away occurs in which the cognitive signs, the words, are passed on, but without comprehension of their signifieds. Culture has translated into nature, but a lot has been lost in the translation. A transgressive tendency in regard to the limits of the self also appears here. As in *Maze,* the artwork takes place within the minds of other beings; the artist intervenes directly in their cognitive processes without their requesting it.

Various other works from the end of 1970 and the beginning of 1971 advanced the transition into Body Art, introducing both the artist's body and the theme of the endangerment of the body as parameters in relation to real sites in the earth. In *Two Jumps for Dead Dog Creek* (1970), the artist jumped across the actual creek twice, storing in his body a memory of the dimensions of the natural site. He then repeated the jump from memory on a sand floor in a gallery, embodying the dimensions of the creek in the footprints in the sand. Here the artist's body became the mediating device that brought outside and inside together. As in Smithson's Nonsites, an element from nature was brought into the gallery, but not in simple physical fact, as Smithson had it, so much as suspended in the material of cognition and carried inside within the artist's body as part, now, of himself.

The scale shift that was involved in the transition from earthwork to bodywork accelerated in *Glassed Hand, Leafed Hand,* and *Rocked Hand,* all 1970. In each of these works Oppenheim's right hand progressively covered his left hand with the indicated natural materials. The process was photodocumented. As in *Reverse Processing,* there is a suggestion that culture should return to nature, not in a sentimental quest for salvation by natural forces, but in a relinquishing of the boundaries of the self. The steadily progressing scale shift went to the limit in *Material Interchange* (1970). In the first stage, the artist's semi-detached fingernail was "installed" in a crack in the floor; in the second, a splinter from the floor was installed in the skin of the artist's finger. The transition from *Cancelled Crop* to *Material Interchange* is a massive, multifaceted shift in focus, like turning the cognitive process inside out, from macrocosm to microcosm, outside to inside, object to subject. First the landscape of the artist's body, then that of the mind, has replaced the earth as the privileged site for art.

The Body

The use of the body as site brings with it implications of sacrificial rites somewhat paralleling the implications of ancient ritual zones in Earth Art. Both genres had relationships with pre-Modern ideas of the body, the earth, and a sacrificial symbiosis between them. *Cancelled Crop,* for example, could be read in terms of the myth-cluster of the Dying Year God in ancient agricultural societies, a type of seasonal ritual intended to offset the harvesting of the crop by offering a variety of stategies ranging from human sacrifice to withholding a portion of the crop from use. Oppenheim has mostly attempted to distance his work from this level of meaning. In contrast, some artists of his generation who were engaged in related work were explicit about its mythic roots or parallels. In the work of the American artist Carolee Schneeman, for example, and of Viennese Actionists such as Hermann Nitsch, these mythic roots were acknowledged. In the sixties, Schneeman revived a Neolithic type of orgiastic rite in the realm of Performance Art; Nitsch performed symbolic human sacrifices in his *Orgy Mystery Theater.* Oppenheim entered this area of ritualistic meaning with a pronounced skepticism. The loss of a fingernail, for example, in *Material Interchange* was an ironic gesture toward self-sacrifice.

This type of understated gesture repeats and entrenches itself in *Reading Position for Second Degree Burn* (1970), in which Oppenheim lay shirtless in the sun for five hours with an open book lying on his chest. Afterward, his chest bore the outline of the book in sunburn marks. There is a humorous interplay between the ideas of leisure and sunbathing on the one hand, and self-endangerment and sacrifice on the other. In addition, the piece carries for Oppenheim, as always, a comment on the artwork and its possible permutations. "The piece has its roots in a notion of color change," he has said. "I allowed myself to be painted, my skin became pigment."[4]

A series of works in which Oppenheim performed minute physical acts in awkward positions in the gallery setting presaged performative modes of narcissistic bodily presence shared by Joseph Beuys, Dan Graham, and others. In *Extended Armor* (1970), for example, Oppenheim lay belly-down on the floor with his face wedged into one end of a structure of three boards with a channel in the middle.[5] From the other end of the channel a video camera recorded his face in close-up. Meanwhile, a tarantula was released in the other end of the wooden channel and moved toward him. He fended off the spider's threat by pulling out strands of his own hair, spinning them into balls, and blowing them down the channel with his breath to interrrupt the spider's advance.[6] Like the spider spinning a web, he used his own bodily threads to survive. There is something shamanistic here as he becomes like the spider, adopting its mode of behavior in order to deal with it, but at the same time there is a rejection of heroic poses or a mock heroism.

The complementary themes of self-endangerment-as-art and of gallery critique mingled in *Protection* (1971). An area of land was marked off and protected from incursion by human bodies as if it were a sacred or hellish place; whether the

space was being protected from the humans or the humans from the space was debatable. Twelve trained German shepherd attack dogs were tethered to stakes around the rectangle of ground near, but outside of, the Museum of Fine Arts in Boston. The dogs, if they were all lunging at the ends of their tethers, could not quite manage to bite a person walking in and out of the protected space with an exact knowledge of the dimensions involved. (During the realized piece, the dogs mostly slept.) The elaborate security system was in place to protect an inner space that held nothing, that had no reason to be protected, in parody of the nearby museum, with its elaborate protection system for artworks. It was a condemnation of the museum as a place dedicated to an incorrect view of art as an eternal commodity to be sheltered from change and incursion.

Danger

The endangerment of the body, which was a central theme of Body Art, occurred as an artistic theme at about the same time in America in the works of Oppenheim, Acconci, and a few others; in Europe in the works of Klein (especially the *Leap into the Void,* which was executed in 1960) and the Viennese Actionists; and in Japan in the works of members of the Gutai Group. The tendency arose from widely felt ideological roots in the anti-Modernist debate, which was a debate of sufficient philosophical consistency that its meanings could be read similarly in unconnected cognitive acts in Europe, America, and Asia. This ideological rift had to do with a contradiction within Modernism, an era approximately contemporaneous with the Romantic period.

In the Kantian-Hegelian Romantic ideology that underlay the theory of art of Greenberg and his disciples, the artist was believed to act out a heroic role as a metaphysical adventurer, going out on the razor's edge of spiritual discovery for the sake of all mankind, whose salvation was conceived as in some way dependent on these gestures, just as once it had depended on the gestures of renunciative monks or self-punishing shamans. Yet, contrariwise, in actual practice the activity of the artist or poet was completely, even absurdly, removed from any danger to the artist's physical self. The Romantic feeling was that the artist and poet exposed their spiritual selves to a greater danger through their incorporation of the horrific vastness of the sublime as described by Edmund Burke. But in actual physical fact, the artist merely daubed colors with a little brush and the poet merely made marks on paper with a pencil.

The absurd discrepancy and separation between the ideas of spiritual and physical risk was one of the secret inner paradoxes of Modernism that the artists of the critical anti-Modernist period set about exposing and critiquing as if it were a kind of fraud. The insistence of Body artists on putting their actual bodies in danger was a kind of tough guy one-upmanship of the formalists. Klein jumped off a high ledge without a cushion. Chris Burden, in 1971, had himself shot in the arm as a performance. Oppenheim's most extreme gesture of this kind was *Rocked Circle—Fear* (1971), in which he stood in a five-foot-diameter circle for half an hour while a

Dennis Oppenheim, Cancelled Crop, *1969. Courtesy of the artist.*

collaborator on the third floor of an adjacent building dropped rocks into the circle. There were no direct hits, but they were close enough to inspire fear; a video camera captured his changing facial expressions under the impact of the surges and ebbs of feeling. What is interesting and characteristic about this work is not the macho display—an element more prominent in the Klein and Burden pieces—but the complexity with which cognitive, performative, representational, and theatrical

elements intersect in what seems superficially to be a primally simple event. In so far as the fear *is* the artwork, Oppenheim has exhibited an intervention in his own mental processes, echoing *Two Jumps for Dead Dog Creek* and other works.

The Spirit

Oppenheim's work up to this point in his life had carried a heavy burden of theory. It was a visual philosophy that embodied with startling clarity certain ideological issues. As it grew, it increasingly incarnated anti-Modernism, drawing it from the depths of inarticulation into a clearly and extensively thought-out instantiation. But Modernism and anti-Modernism could not at once be completely separated in the works of artists who had grown up in a Modernist culture. This highly theoretical period, extending from early Conceptual Art until the Return of Painting in the late 1970s, presented a theoretical inversion of Modernism, an alter ego of Modernism that followed its structures through negation. A genuinely post-Modern art, which would not be obscurely based on the structures of Modernism, would have to await the collapsing of these distinctions.

In Conceptual Art, Earth Art, Body Art, and so on, there was a sense of higher meaning or historic significance that had a hidden basis in the Hegelian idea that history has a driving purpose. This Modernist idea was still deeply pervasive in the equally puritanical anti-Modern phase. At the same time the reaction against Modernism took the opposing direction of a revival of pre-Modern options, as in the complex of ancient ritual associations that both Earth and Body Art displayed. (Pre-Modernism, since it became credible again with the collapse of Modernism, can now be seen as part of the expanded post-Modern array of options.) The critical and parodic aspect of the self-endangering theme of Body Art was post-Modernist; the blood-aware, self-sacrificing aspect of it was an appeal to the pre-Modern. The bottom line was that the Modernist (Hegelian) idea that art history was the trail of universal Spirit's progressive self-realization through human agency still obtained, but Spirit seemed to have veered into new directions, involving both a pre-Modern revival and an attempt to springboard into the future off an inversion of Modernism into anti-Modernism. First Conceptual Art, then Earth Art, and then Body Art felt themselves to be the new arenas to which Spirit had turned to intensify and drive onward its project of self-realization through self-expression.

Genetic Extension

At this time—the early seventies—the idea of the self was in flux in Western thought, undergoing a loosening of boundaries that came to be called the "decentering of the self." This shifting definition of self was one of the preoccupations of Oppenheim's work. In the genetic works, which have already been mentioned, for example, he chose to regard his relationships with his children as extensions of Body Art. In the *Two-Stage Transfer Drawings (Returning to a Past State) Dennis to Erik Oppenheim* and *(Advancing to a Future State) Erik to Dennis*

Oppenheim (1971), Oppenheim drew on his son's back and his son transferred the drawing as tactilely comprehended into a copy on the wall in front of them. They then reversed roles. "I am drawing through him," Oppenheim observed. In the reversed form of the piece Erik was drawing through his father. The genetic unity of their bodies created a larger self that was drawing reciprocally through them both.[7] In *A Feedback Situation* (1971), Oppenheim senior drew on Oppenheim junior's back while Oppenheim junior transplanted the drawing to Oppenheim senior's back. It is a single bi-personal being, like the left and right hemispheres of one brain, reciprocally messaging. In these works, the medium of drawing, the most elementary and traditional of art genres, is radically relocated as a part of the body.

Several related works sprang from Oppenheim's father's death in 1971. In *2000' Shadow Projection* (1972), a highly coherent beam of carbon arc light extended the artist's shadow for two thousand feet while he blew a single foghornlike note on a trumpet. A sense of the surging onwardness of the gene line, conceived as his father's will extending itself through him, was acted out in a mythic *Götterdämmerung* vocabulary. *Polarities* (1972) again embodied the genetic process as art material by way of drawing. Oppenheim obtained two drawings: One was the last graphic record left by his father (an engineer); the other, one of the first drawings made by his daughter, Chandra. The drawings were separately "enlarged and plotted with red magnesium flares" out of doors in a broad field on Long Island at night.[8] They could be viewed as drawings only from an aerial position, suggesting the disembodied afterlife realm as an analogue of the dematerialized zone of merely intended art. The artwork became a pooling place for the genetic stream.

The Surrogate

The genetic and body works, with their subtheme of danger and bodily death, converged with a menacing tone in *Untitled Performance* (1974), at the Clocktower in New York. The work involved the production of a cultural sound and the correlation of this sound with the death and decay of a mammalian body. There was a kind of scenario (though not in the form of a written narrative): An organist dies and falls over the keyboard, producing an odd, cacophonous chord or tone-cluster hanging as an unpreconceived sound-sculpture in the air. Meanwhile, the outside world does not intervene and the event transpires in its natural time. The organist's body decays, fills with gas, empties, and so on, altering the sound sculpture in the transplanted sign system of its death-and-decay. The work was first realized in dummy form with Oppenheim's daughter, Chandra—whose drawing had already communed with death through the genetic superimposition with her grandfather's last mark—standing in as the organist, falling as if dead over the keyboard, and being photographed. When publicly realized at the Clocktower, a substitution took place: The body of a dead German shepherd dog lay over the keys and decomposed musically for a day.

Here the theme of sacrifice was being gradually distanced through a type of ancient ritual substitution. In Euripides' *Iphigenia at Aulis,* for example, Agamem-

non's daughter, Iphigenia, is to be sacrificed on an altar; but at the last moment the body of a deer is substituted for her body as, in this series of pieces, the dog is substituted for Chandra. Many historians of religion believe that the era of human sacrifice led to the era of animal sacrifice through a long period of such ritual substitutions. In Oppenheim's case, the ritual substitution was to lead from the era of Body Art to that of the surrogate.

The theme of the surrogate, seen first in the substitution of the dog for Chandra, was more openly worked out in *Attempt to Raise Hell* (1974), a tableau in which a puppet figure, whose face looks like Oppenheim's but whose body is seated like that of a Buddhist monk in meditation, periodically leans forward, striking its head against the rim of a hanging bell. As in *Untitled Performance,* the piece consists in the production of a sound by a body, but now an inorganic body has been substituted for the canine corpse, which, in turn, was a substitute for a living body. The puppet represented Oppenheim's attempted withdrawal from the use of his own body—individual or genetically extended—as an endangered art material. In *Theme for a Major Hit* (1974), a twenty-four-inch-high puppet was attached to wires that were operated by a machine overhead, causing strange contorted motions to be repeated over and over. The Oppenheim face on the puppet suggests that the artist, despite the Romantic-Modernist myth of his autonomy, is at every moment being manipulated by external forces in ways that do not necessarily make any desirable sense.

Lecture #1 (1976) was also a transition marker. An Oppenheim-faced puppet with lip synch delivered, in Oppenheim's voice, a lecture written by him to an audience of empty chairs, except for one in the back row on which a marionette of a black man was seated, apparently listening. The amusing text announced the lecturing marionette's discovery of a conspiracy to murder all the avant-garde artists of Oppenheim's generation, beginning with the death of Smithson in 1973, which was declared a fake accident. The era of Earth and Body Art, the piece seemed to proclaim, was over. The art of pure theory was at an end, and a counterforce was already threatening to destroy it (New Image and the return of painting).

In keeping with the end of the age of theory, the piece marks a turn toward representation rather than presence. Earlier works involved living cognition as a material of the piece; here the cognitive process was externally represented—carried out as a communication between puppets. The cognitive thrust now occurs between the artist and the viewer rather than between the artist and his material. The piece initiates a major redirection of Oppenheim's oeuvre in external modeling of the cognitive processes that the earlier work had directly involved.

The Machines

Beyond the Tunnel of Hate: A Nightmare in Search of Structure was installed at Kent State University in 1979. A skeet-throwing machine hurled clay discs down a tunnel into the gallery, where they ricocheted off a trough and met elements called "shape collectors" and "template walls" that directed them to one destination or

another. As a site-specific piece, the work incorporated a reference to the shooting of five students at Kent State by the National Guard in 1970. In terms of the anti-Modernist project, the piece engaged the gallery in a violent confrontation, bringing a real-life danger into a usually sheltered area and canceling its privileged status as a zone set off from life and the body. Oppenheim characteristically thought of it as a modeling of mental events—a thought speeding unexpectedly into the mind and ricocheting off other mental constructs. As a mechanical representation of thought processes, *Tunnel* bears a noticeable similarity to Duchamp's *Large Glass* (1915–23). Both represent psychology as machinery and apply fantasy names to mechanical parts; Oppenheim's "template walls," for example, recall Duchamp's "Malic Moulds," and so on. The random element created by the different itineraries that the missile could follow, depending upon the variables of path, ricochet, and receptacle, again recall Duchamp—for example, the toy cannon shots that marked unpredictable spots on the *Glass* (the "Nine Shots"). Duchamp's idea was, in part, to drain the Romantic aura out of the artwork both by leaving elements of its design to chance and by rendering it like a mechanical drawing, eliminating the human face and figure in favor of the machine. Oppenheim's works of the next five years or so— the Factories or machine works and Fireworks—would follow this thread far past the limit at which Duchamp left it.

The Factories are large, intricate, machinelike sculptures using references to the factory production systems of the past as a way of externally modeling cognitive events. Oppenheim remarked that "machines are a rather perfect device to use as a metaphor for thinking. [Through these] industrial and mechanical systems . . . I felt I could objectify the mechanics of thought."[9] Mining ore, for example, suggests coming up with an idea. Diamond cutting suggests the refinement of a thought-object. A launching structure suggests the moment of putting a thought into action. And so on.

The Factories are part of a long tradition of twentieth-century art that sought to avoid the sentimentality of the Romantic idea of the self. They connect, as does much of the art of this age of theory, with the earlier avant-garde age in the years before, during, and after the First World War—the era when Henri Bergson, for example, emphasized the necessity of coming to terms with the machine age and when Filippo Marinetti and the Futurists glorified machines as symbols of liberation. Also in the background lie the machines for making art which Raymond Roussel described in his novel *Impressions d'Afrique* (a theatrical version of which influenced Duchamp in 1911); Duchamp's own *Coffee Grinder, Large Glass,* and other works; various fantasy machines devised by the Surrealists; and, from the post–World War II avant-garde era, Jean Tinguely's works, perhaps especially *Homage to New York* (1960); the Engineering, Art and Technology (EAT) project organized by Billy Kluver in 1968; and the 1969–1971 Art and Technology project organized by the Los Angeles County Museum of Art. The machine theme in Oppenheim's work began in 1973 with *Wishing Well* and gradually intensified until it entered the foreground in 1979.

Something similar was occurring at this time in his friend Acconci's work

also. For both Oppenheim and Acconci the era of directly embodying theory through the use of mental process or consciousness itself as material had passed, and questions concerning the nature of the physical art object and its representational force had reasserted themselves.[10] In American art history in general, something like this was happening. The *kenosis*, or emptying out, of Minimal and Conceptual Art was replaced by a *plerosis*, or filling up, in terms of new projects in a reconceived arena, first of sculpture and, very soon, in the works of other artists, of painting.

Oppenheim's Factories operate on a number of levels of scale. Synaptic and other microprocesses are imaged big and take on a look as of cosmic models, recalling Ezekiel's vision in the Old Testament of fiery wheels turning in the sky, or the descriptions of wheels within wheels in Plato's quasimechanical conceptions of the universe. Meanwhile, at a middle level of scale, in between the cosmic model and the synaptic exchange, these works suggest the factories and factory machinery they are named after. Some suggest industrial architecture, as architecture stands at times—in the pictures of M. C. Escher, say—as mind stuff objectified. The spaces of the mind, once conceived as a temple, are reconceived as a factory in the spirit of the Industrial Revolution. Others refer, either by their look or by their titles, to types of industrial machinery. *Final Stroke, Project for a Glass Factory* (1980), for example, resembles an assembly line or conveyor belt; *The Diamond Cutter's Wedding* (1979) suggests a quarrying operation; *Impulse Reactor, A Device for Detecting, Entering, and Converting Past Lies Traveling Underground and in the Air* (1980) recalls a nuclear reactor; *Launching Structure # 1 (An Armature for Protection),* from the Fireworks series (1981), evokes a missile launcher.

The conflation of industrial and cognitive metaphors in these works is often suggested in their titles. *An Operation for Mining, Elevating, and Converting Underground Memories of a Fifth Season* (1980), for example, substitutes the mental-ist term "Memories" for a materialist term, such as iron ore or coal, putting the piece into the area of subjectivist or idealist allegory. *Accelerator for Evil Thoughts* (1982); the afore-mentioned *A Device for Detecting, Entering, and Converting Past Lies Traveling Underground and in the Air* (1980); and others also participate in this deliberate mixing of mental and material references.

The Machine works do not present an idealized or universal model of cognition so much as a series of distinct personalities with different idiosyncrasies. "An idea, which arises from the depths of the consciousness," as one critic wrote, "is developed, refined, embellished and transported along a tortuous path. It endures trials and difficulties, highs and lows, and encounters numerous mental blocks in the course of the process."[11] The idiosyncratic differences among Oppenheim's Machine works represent the varying neurotic formations of personalities. Each achieves coherence, as another critic put it, "because of the uniformity and consistency of their madness."[12]

Personalities

I will describe the workings of eight of these machines. Though the reader may not be able to picture each clearly, he or she should be able to sense the aura of each emerging into form from verbal description.

Waiting Room for the Midnight Special
(A Thought Collision Factory for Ghost Ships), 1979

Waiting Room for the Midnight Special, the piece that led into the Machine works, is a scale model for a large site-specific piece that was never realized. It has four elements: a tunnel that approaches a circular depot or switching device; a "smoke transmission chamber" at about two o'clock on the circle; templates and molds for "ghost ships" farther around the circle; and a V-shaped vent that exits from the circle and goes to the ocean. As in Duchamp's *Notes in the Green Box,* a collection of documents forming a kind of commentary on the *Large Glass,* each element has a name and a description of its function, however fantastical. The switching device waits for something to enter the tunnel, its tracks meanwhile rotating; depending upon the speed of entry, and the speed with which the switching track turns, something coming down the tunnel could shoot directly across the track and exit at once into the central ghost ship, or it could exit at either the smoke chamber or the vent to the ocean. There is, in other words, only one entry point into the system but there are three possible exits, with an uncertainty as to which will eventuate. There is also uncertainty about what these three outcomes represent—the ghost ship implying a transport to the afterlife, the smoke chamber an incineration, and the vent to the ocean an escape from the system into nature. There is even an uncertainty about what the awaited thing is; Oppenheim thinks of it, along the lines of *Beyond the Tunnel of Hate,* as a thought about to enter the mind. In another sense, the awaited thing is the sculpture that is never seen, which the machine is only an armature to produce. The work is charming in its simplicity and unclutteredness, almost naïve, like a child's model railroad. It is difficult to see in it what one author has referred to in Oppenheim's work as its "auto-revelation of its own premises."[13]

Way Station Launching an Obsolete Power (A Factory in
Pursuit of Journey). (A Clip in a Rifle Weapon), 1979

Way Station Launching an Obsolete Power is a very different presence. It is blunt and clumsy where *Waiting Room* is transparent and balanced. Here there are clear entry and exit points. A cab is being loaded from above with what Oppenheim calls "ghost bullets"—that is the entry. A curved conveyor belt made of metal wheels offers an exit. Around this elementary system a little industrial universe unfolds: There is an air-conditioning intake blowing cold air which turns rotating vents on top of stacks; a rubber conveyor belt exits on the left, moving continually to the window of the exhibition space. The whole massive device is conceived as ready to

Dennis Oppenheim, Diamond Cutter's Wedding, *1979.*
Courtesy of the artist. Photo: S. Licitra, Milano, Italy.

Dennis Oppenheim, Diamond Cutter's Wedding *(pencil sketch), 1979.*
Courtesy of the artist. Photo: Lisa Kahane.

be launched from a ramp. As in most of the Machine works, only some of the parts really move, because Oppenheim tended to follow Duchamp's immobile fantasy machine rather than the suspect trail of kinetic art with its links to the tradition of aesthetic sculpture.

The Diamond Cutter's Wedding, 1979

The Diamond Cutter's Wedding is an early masterpiece of this series, representing a classical stage in it. Coal or some other raw material lies in carts at the left; the carts are slingshot-mounted in huge rubber straps that, if released, would shoot them into the system. These carts are the entry. If shot, or released, they pass their materials through three differently shaped openings in a template wall—triangle, square, and arch; this wall acts as a screen or sieve separating the raw stuff by its differently shaped elements. Meanwhile a pendulum behind the template wall swings ominously back and forth, threatening to affect the movement of the particles that are sifting through. The particles engage the hanging templates on pulleys and are further refined by them, then move onto three " shape-converters" that have adjustable "photographic blinders" on the other side to adjust the aper- tures. Finally the stuff falls onto motorized, rotating sieves of the type that are used to separate stones of different sizes. The series of stages in the process represents

different transformational characteristics that affect whatever goes through the apparatus.

Sculpturally the work exerts a clear and realized presence. Peering into it one seems to see a mind that knows where it is going and calmly processes its thought matter. Finally a diamond is produced by a gentle process of refinement that lacks any look of blockade, detour, or horror. It is a basically happy view of the unconscious as a machine that produces from mind-stuff the gems of culture. Though there are some variables along the way—such as the question of which shaped doorway the matter passes through in the template wall—and some random or uncontrolled interventions—especially by the swinging pendulum behind that wall—still, the process overall is clear and simple, not like a trap or obstacle course. Entry is at one end, exit at the other, and each step along the way represents a progressive refinement with no detours or retrograde movements.

Diamond Cutter shows the Factories series having attained its mature power but not yet approaching the point of exhausting its expressiveness and seeking to rejuvenate itself by incorporating new meanings and materials. Consciousness, or thought material, is portrayed from the stage of being a twinge in a synapse in the brain stem to emerging as a fully articulated cultural object, such as an artwork or a philosophy book. The portrayal of the process, from coal lump to diamond, is clear, abstract, and elegantly serene.

Saturn Up-Draft, 1979

More threatening is *Saturn Up-draft,* which centers around a cage containing a giant juicer or whirling four-bladed cutting device. One entry is via a gasoline-powered sled, which could be mounted by a viewer; above it is a vent to exhaust some gaseous residue of unstated but possibly sinister origin. Another entry is via the raw material sled slingshot-mounted and hovering threateningly in the air. In this piece, the mental process begins to cloud over, becoming dangerous and unpredictable. The two divergent entries confuse the beginning of the process, and the center of the process, the whirling cutting device, suggests a violent reduction of the consciousness-stuff, rather than a gentle refining of it. The purpose of the project is uncertain, though there is an implication that some ethereal byproduct of the material rises through the updraft cone at the end.

Caged Vacuum Projectiles, 1979

In *Caged Vacuum Projectiles,* the bodies of vacuum cleaners lie on the floor outside a cage; the hoses of the vacuum cleaners enter the cage. The vacuum cleaner bodies out on the floor connect with ovenlike "shape transmission chambers," with three primary-shaped entrance holes. (Again, as in *Diamond Cutter's Wedding,* there is a suggestion of a material universe founded on three elements that, like the elements in Plato's *Timaeus,* are represented by primary shapes.) It is unclear exactly

where the entry to the process is, what kind of raw material is involved, and what kind of processing it will undergo. The vacuum cleaners give the apparatus a slightly comical air at the same time that they recall Duchamp's snow shovel.

Crystal Recorder (Stroking the Throat of Tornado Diane).
An Early Warning System, 1980

In *Crystal Recorder*, crystal prisms that look like chandelier elements hang from strings that go to pulleys attached to what look like piano or typewriter keys. In Oppenheim's narrative for the piece, a writer is typing; meanwhile the vibration of the keys loosens the chandelier above his head, and eventually the chandelier falls on him; the prisms pierce his head and release the content of what he was writing, which has to do with crystals. So what is happening inside and outside are the same; the macrocosm surrounding the microcosm of consciousness has the same crystalline structure; an elegant solipsistic cosmos is suggested, like jeweled boxes within jeweled boxes. The most romantic of the Factories, *Crystal Recorder* is a lyrical piece, in stark contrast to the mute, brute presence of *Way Station Launching an Obsolete Power.*

The Assembly Line (with By-products from a Mechanical Trance), 1980

The Assembly Line begins to extend the cognitive modeling into altered states and psychedelic frontiers. There is a metronome at the center of the work (which can't be seen in photographs). An assembly line begins on tables that are suspended from spidery-looking steel structures. The machine is hypnotized and produces a visual correlate of the hypnotized state in the air sacks that float overhead like dirigibles or balloons. These, the hallucinatory by-products of the machine's trance float above it like dreams over a dreamer's head. The big bowl that catches the air sack is a kind of cauldron. On the ceiling a revolving wheel-like armature holds the air sacks, potentially placing first one, then another, into the cauldron. The hypothetical product of the transformation of the hallucinated air sack in the cauldron is the artwork itself, which is never seen and is not directly under the control of the dreaming, hypnotized, or hysterical artist.

Occasion for Expansion—A Combat of Structural Projections, 1981

In *Occasion for Expansion*, this psychedelic tendency runs amuck. Two performers, a man and a woman, lie on hammocks that attach to a huge bellows. Over them hang tanks of exotic gases. These are certain medical gases which put you to sleep and produce dreams of different types—trylene, for example, which is used as an anesthetic in abortions and is said to give vivid technological dreams. The performers first breathe the exotic gases, then engage in sexual intercourse, activating the bellows through their undulations. Pressure from the bellows goes through

many channels and ends by pumping up the stacks of an expanding industrial city on the left, which represents the hallucination experienced by the lovers; this city expanded by their act of love *is* their chemically induced dream or shared hallucination. The dream city rises from clusters of tubes like a big bagpipe or pipe organ. Hovering in the air over the pipes are suspended discs that could be lowered onto the tops of the stacks, thus shutting them off. The discs are attached, through a system of ropes and pulleys, to rings that control the shape of a giant balloon-airship, giving it the appearance of an atomic explosion when inflated by the ignition of the butane gas tank beneath it. The whole apparatus is controlled by the sex-activated bellows.

This piece, with its organic connection of sex and catastrophe, relationship and disaster, explores terrain far from the simple cognitive transaction of *Waiting Room* or the refined clarity of intuition in *Diamond Cutter's Wedding*. Here, the idea from which the series ostensibly began has gone out of control. It represents a state when the Factory works become increasingly linked to invisible purposes and indefinable processes, with unknown materials undergoing transformations of place and quality whose effect cannot be predicted or described.

Occasion for Expansion is the closest of the Factories to the complex sex-based machine-cluster system portrayed in the fantastic plan in Duchamp's *Large Glass*. The bellows, for example, recalls Duchamp's bellowslike portrayal of the bride (both in the painting by that title of 1912 and in the *Large Glass*), and the bride's exhalation in the *Glass* of a cloud of sexual feeling. It is also, after two years in which Oppenheim conceived and produced one of these massive works every month or so, about to explode from conceptual overload. Cluttered, unstable, unserene, and unsimple, it is a masterpiece of the series, but a terminal masterpiece, in which the idea behind the series has intensified itself to the point of spilling over into hysteria. The causal sequence from dream gas to sex act to dream city to mushroom cloud is conceptually unclear though provocative and imbued with a vaguely poetic sense of unspecified yet ominous meaning.

Over a period of about three years the Factory works emerged, found their identity, and wandered from it. Losing sight of the original motive of modeling cognitive processes as machine-like, they began to take odd, unpredictable turns that have a variety of relationships to human life. Some recall mystical allegories like the fantastical devices of alchemists, but leave the transcendentalist implications unfulfilled; others may be compared to Beuys's systems of batteries and filtration devices, but without their implications of holistic therapies. In terms of history, they suggest both machines of bygone days and an inscrutable technology from another species or another world, machines that don't work in our world or for us, but which seem to suggest another humanity or another reality for which they did once work—and might again someday.

The Fire

The hysterical overload that characterized *Occasion for Expansion* took over the subsequent development of the series, becoming the basic force of the final mind-machines called Fireworks. The Fireworks consummate what the Factories implied. If the late Factories show the mind getting ready to shoot off its contents, the Fireworks pieces show it doing so. The Factories, to put it differently, "enact the goings-on inside the mental plumbing of creation as a mystery play,"[14] while the Fireworks focus on the climactic moment of the mystery—the Transfiguration, so to speak—and enact it over and over. The Factories represent displays of thought processes that have cooled down and solidified enough to be looked at. The Fireworks show them heating up out of control again. (The artist's earlier works with flares and skywriting lie in their background.) Again I will describe only a sampling (two) of these large and complex works.

Formula Compound. A Combustion Chamber.
Exorcism, from the Fireworks series, 1982

Formula Compound. A Combustion Chamber. Exorcism was erected on the beach. Looking like an amusement park in miniature, it featured rockets, fountains, and flares mounted on an armature of ladders, suspended bridges, and transparent spinning cylinders. Around it on the sand stood a number of human-sized shields with little windows, mounted on upright frames, behind which spectators could stand and observe in safety. Ignited at night in the midst of nature (as Oppenheim had earlier sited large flare works outdoors on Long Island), the work was an explosion that did not invite cool and analytic thought from the spectators (as the sparks rained down around them) so much as a nervous combination of silence and laughter.

Launching Structure #2 (An Armature for Projection),
from the Fireworks series, 1981–1982

Launching Structure #2 (An Armature for Projection) had shields with windows mounted on four-wheel bases that one could steer here and there to get different views of the action. Even so, when the ignition came—this time indoors, in a gallery in New York's Soho district, on an evening when only critics had been invited to preview it—the huge complex structure laced everywhere with fireworks created havoc and cleared the gallery. Mobile towers with tanks of butane gas were used to ignite the different areas; wheels turned, chain reactions occurred, fires swept down swooping ramps as from the sky, and the piece exploded like a house of cards. Some critics hit the floor, others headed for the door. The fire department came and broke the windows to clear the smoke. Everyone's clothing had burn marks from flying sparks. The sparking synapses of hysterical mental processes had

become a model for a universe out of control and exploding in a kind of terminal orgasm, both big bang and black hole at once.

Pause

There followed a period of latency, quiescence, and reconsideration. After five years, roughly 1979–1984, of intense and constant production, Oppenheim devoted a period to reading, thinking, tending to his physical health, and refeeling his place in the world and that of his art. When he dove energetically into a new line of work, significant changes had occurred. His work had, of course, always involved periodic changes of direction. This change, however, which began to reveal itself in a new series in 1987, was somewhat different in scale. It involved a meta-change in the sense of history—which is to say, of purpose—that supported the motivation of the oeuvre. This change reflected events in the surrounding cultural mood.

Arthur Danto observed in his 1984 essay "The End of Art" that, according to his understanding of the Hegelian (which is to say Modernist) view of history, art had reached its culmination in the Conceptual period. Danto was referring to early conceptual pieces that involved working with pure cognition ("Spirit") as much as possible. Having become pure Spirit, in this view, art had worked out its historical imperative and had no further place to go. But for the practitioners themselves, the sense of historical imperative did not seem to pass away with their early work. The Earth Art and Body Art movements were still Modernist in the sense that the artists involved felt they were carrying on, stage by stage, a certain evolutionary unfolding of awareness. For Oppenheim, this feeling extended to the period of machine works, which still seemed to be somehow intuiting avenues of civilization yet to come—or, at least, gesturing hypothetically toward them. It is true that Oppenheim and some of his peers had rejected painting, but they had not rejected the whole Modernist myth of historical advance with it. On the contrary, their rejection of painting was for the sake of going beyond it, stretching the envelope of art history into new regions, climbing yet higher on the Modernist hierarchy of linear ascendance. Indeed, though the sense of historical inevitability that had characterized high Modernist art began to deteriorate with Pop Art in about 1962, it was not until about 1983 or 1984 that post-Modernism, or post-History, became a pervasive and mainstream attitude in the visual arts. This altered shape of things came through to Oppenheim at that time, in part through his reading of Jean Baudrillard and other post-Structuralist authors, with their intensified focus on the incoherences and discontinuities of things. The post-Structuralist sense of the disintegration of the Modernist paradigm of reality was a difficult confrontation for Oppenheim and others of his generation who had felt that they were helping to push history over the top by freeing art from archaic aesthetics and rendering it cognitively self-aware.

Coming out of his period of reorientation, Oppenheim found that the motivation of history was no longer as available as it once had been. There was no

longer an overriding sense that an evolutionary force inherent in the work was propelling it onward through the envelope of history. Not only did the nature of his work change with this realization, but his discourse about it developed an exacerbated sense both of humor and of darkness, in place of the pseudo-scientific distance of his earlier utterances. Of course, there had been dangerous and ominous elements in his work from the beginning, but they had been contextualized within the sense of an onrushing history. The black humor already present, for example, in the text of *Lecture #1* (1971), with its conspiracy of assassinations, was about history, its inner purposes, and the obstacles to them. But now, beginning in about 1987, Oppenheim spoke as if this basic matrix were gone. He referred to a disarray in the world around him, described images as having "jitters," and spoke of his work as "objects in their terminal condition," expressions of "the disease of the real," "symptoms of overload," and so on.[15] The "image jitters" that Oppenheim spoke of in connection with his work of the late 1980s came in part from the sense of no longer being securely embraced by a surrounding matrix of history that assured meaning. It was the jitters of waking up alone in the meaningless landscape of post-Modern or post-Historical culture, where the motive for making art could no longer rise from a meta-narrative.

Jitters

At this time Oppenheim began to make smaller works that can be seen as parts broken off from hypothetical larger works and invested with a hyperintensity of individual focus. Cut loose from a sense of history (which is to say, meaning), they stand alone in the surpassingly weird lunarscape that their own strangeness implies. Though it would be an exaggeration to describe Oppenheim at this time as a committed post-Modernist, his works of the late eighties embody the post-Modernist deconstructive force of disintegrationist critical thought more acutely than perhaps any other sculptures of their day. They are beyond the late-Pop pseudo-kitsch of Jeff Koons in their oddness and, occasionally, their analytic contemplation of bad taste. Their humanistic size represents a rejection of Modernist monumental synthesis. They are disconnected fragments of narratives that either have fallen apart or were never really held together except by the projected emotions of wishful thinking. They aver both the reduced ambitions and the permission, or relaxation, of the post-Historical situation.

A unifying theme that occurs in many of these pieces, offsetting the euphoric Modernist sense of immortality underlying the bodyworks and geneticworks, is an exacerbated awareness of mortality. The theme is expressed sometimes through motifs of animal energy, heat, and breath, at other times through motifs of threat, tremor, and amputation. *Steam Forest with Phantom Limbs* and *Stove for High Temperature Expression,* both 1988, involve heating coils, as from a stove, installed at the tops of fiberglass tree trunks. On the heating coils stand glass bowls of water, which the heating apparatus will turn to steam. The bowls have faces and serve as replacement heads for the decapitated stumps. The decapitated being represented by

the tree trunk is thus offered the opportunity of reappearing in other forms, transferred from solid to liquid to vapor. A primitive idea of spirit as an energy that leaves an overheated body informs both these works and a number of others. In *Hot Voices* (1989), three-foot-wide masks with flames coming out of their mouths repeat the primitive theme of spirit as breath, as speech, and as a fiery exhalation of an excited—or dying—organism.

The heating coils and tree trunks of those works inject the theme of heat-spirit into the domestic and common stuff of everyday life. (Perhaps in this there is a memory trace of Duchamp's use of domestic implements such as a snow shovel and a bottle rack in his Readymades). The same theme informs the Appliance Spirit series, 1988, consisting of cookstoves whose heating coils extend upward into spring-like beings, one human and one quadruped, which rise as spirit-forms or attenuated bodies from their emanation of heat. In *Digestion: Gypsum Gypsies* (1989), the relationship between animal body and heat is reversed; the heat arises as a sign of health and vitality from the bodies of forest animals. Five deer are disposed around a space (one halfway through a wall) with butane flames shooting from their antlers. The piece has a presence of both surprise and recognition, and a quasi-surreal sense of the rightness of wrongness.

The fiery apparition of the deer conveys a hint of an idyllic power in nature that one can also sense, understatedly, in some of the earthworks, but that is just as clearly controverted in other works where nature is presented as a kind of dysfunction. In *Above the Wall of Electrocution* (1989), animal masks are attached to inflatable fabric bodies that have been turned inside out, pulled out through the masks, and hung from a rack overhead with devices to inflate and deflate them periodically. One of Oppenheim's most discomfiting pieces, *Above the Wall*, suggests a slaughterhouse or a selfhood gone berserk and imploded.

Other works express not just the primitive cult of animal energy, but an anxiety about losing it in a tremor, misfire, or implosion. These works often convey an intense bodily uneasiness that is presented with a Beckett-like matter-of-factness or coolness. In *Thought Bones from between the Fingers of Fear* (1988), fiberglass casts of human thighbones with blades inserted into their ends are driven into the gallery wall or into a timber on the floor. In *Tremor* (1988), human teeth chatter under a hot light on top of a pole. *Virus* (1988) and *Bad Cells Are Comin'* (1989) radiate a fear of cellular disorder that, in reference to art, is conflated with the spread of kitsch. In *Virus*, a latticelike armature is punctuated with Mickey Mouse effigies. *Bad Cells Are Comin'* is a ring of drum-set cymbals with saclike laboratory bottles of black ink attached, a butane torch rotating in the center heating all the bottles, and no one present. While the grotesque and the tragic mingle in these works, there is also a wry dose of gallows humor in them.

Black Pool (1990) involves a pool table covered with black felt, with stacks of bowling balls for legs, and above it a kind of genetic model made of black pool balls. In Oppenheim's mind it expresses "genetics gone amuck."[16] Allegorically, a gene, like a pool ball, misses its destination and ricochets around the available arena; the pattern of its misplaced movement is three-dimensionalized in the lattice

structure above the table. The title, *Black Pool,* punning on pool table, refers to a gene pool as a game, and suggests the operations of nature are most perfectly realized in errors and random developments that rewrite the rules. "There's something natural about how things fall apart," Oppenheim remarks.[17] (Recall Duchamp's idea that chance, which is in a sense error, reveals a purer or more universal purpose than design.)

In 1989 the Power Tool series began, works that include tools that made them as parts of the piece's "auto-revelation of its own premises." In *Four Spinning Dancers* (1989), for example, the dancers' bodies, made of accumulations of different-sized buffing disks, are mounted on the upright shafts of electrical drills that would ordinarily hold those disks singly and that now hold a whole construction of them and spin them around. As they spin, they appear to have skirts flying in the air. Similarly in *Vibrating Dolls* (1989), a group of electric saws shakes the dolls up and down in a motion referring to sexual intercourse. Oppenheim's use of dolls harks back to his use of marionettes a decade earlier.

A new turn toward homage and art-historical reference occurs in *Kissing Racks* (1990), which incorporates enlarged replicas of Duchamp's *Bottle Rack.* This rare "quotational" moment in Oppenheim's art is especially significant. It represents not only his acknowledgment of a sense of artistic rootedness in the opening up of options that Duchamp is perceived as historically initiating, but also his acceptance of the post-Modern moment as one condition of his present work.

Development

Like Klein, Duchamp, and a handful of others in the experimental anti-Modernist mode, Oppenheim has tossed off works on which another artist might have constructed a whole career. The diversity and changeableness of his oeuvre have seemed to some to indicate an instability of purpose or lack of overall coherence. One critic questioned, for example, whether his oeuvre showed "development." "There is change in his career," he noted, "but not 'development.'"[18] The question is not simple. To begin with, there are exceptionally clear and strong developmental sequences within large areas of the work. The Land Art period, the Body Art period, the marionette works, and the Factories and the Fireworks—each of these sequences separately exhibits a strong and clear internal development. It might be asked, then, whether there is a sense of development that bridges the gaps and encompasses all these phases. Various opinions could be offered on that point, but a more relevant question may be whether, or how, it matters.

The idea that one developmental sequence has to be traceable through an entire oeuvre may be an outdated Modernist anxiety, deriving as it does from the sub-Hegelian teaching of Karl Schnaase in 1831, from an age obsessed with the idea that History is the temporal embodiment of Reason. This was the tradition behind Greenberg's approach, in its preoccupation with formal development. Oppenheim's work, with its emphasis on discontinuities and ruptures, implies a different, more dialectical, relationship to the sense of evolution. In fact, a kind of

Aufhebung, or overleaping of the self through incorporation of its other, underlies a lot of the shifts in Oppenheim's sequences. In this, the work seems to offer an analogue to the art history of a changing and volatile era—an era when the Hegelian idea of Spirit as the moving force of art became mobile, the Spirit moving restlessly from one lode to another for its fuel. It is arguable that Oppenheim's shifts have not been strictly in response to this generalized shifting of the Spirit of things, but that, in part, they have been a guiding force of the series of shifts.

America experienced late Modernism in a peculiarly puritanical way that involved a series of discrete "isms," each of which was emphatic in its insistence on purity. The European case was different. While America was bridging the gap between Modernism and post-Modernism with a series of post-Greenbergian puristic encampments on history—Color Field painting, Minimal Sculpture, Primary Shapes, Conceptual Art, Earth Art, Body Art, Site-Specificity, Pop Art, Camp, New Image Painting, Bad Painting, Pluralism, neo-Expressionism, Quotationalism, Simulationism, neo-Conceptualism—Europe was in a more amorphously shifting age of synthesis. The postwar period in Europe can be characterized through reference to a type of Leonardian multimedia career exemplified by a few iconic figures: for example, Klein, who practiced painting, sculpture, Performance, Conceptual Art, Minimal Art, and, in an odd sense not previously discussed, Simulationism. The outlines of Klein's career are similar in their catholicity to the record of Beuys's oeuvre as well as that of Jannis Kounellis and other artists. I don't mean to invite specific comparisons between the works of these European figures and Oppenheim's, or attempts to elucidate one by appeals to the discourses about the other. I just mean to point at a species of artistic career since the Second World War that has felt free to enter any area, engage any genre or material, and continually rearticulate itself in escalating but always rigorous intellectual terms. Oppenheim's oeuvre, while going with the appropriate shame and guilt through the puritanical stages of the American sequence, has at the same time demonstrated the European, all-engulfing, post-Hegelian, omnivorous promiscuity of a History that includes many histories.

The oeuvre as a whole (and it is not complete) has both an air of deathly awareness and an insouciant joyousness of action. I will conclude my discussion by comparing Oppenheim's oeuvre to two of its constituent works that might be used as emblems of it.

Object with a Memory (1983) was a large, houselike construction that was conceived as a camera or cameralike reality-processing device. As it takes a picture, it contorts, and an image comes out of it into physical reality. Each picture the construction takes becomes a part of it, as memory but also physically. In fact, part of its structure is the tools with which it was made—from the pencils with which it was initially sketched out to the saws with which its wooden parts were cut. It is constituted, in other words, by its memory of its own making and its own earlier stages. At the present stage of its development, it has taken pictures of a house and a boat and these have coagulated into parts of the mechanism. The film rolls onto the floor as more pictures are taken.

Whirlpool—Eye of the Storm (1973) seems to allude to an obscure strain of spirituality within the work. A skywriting plane drew a tight spiral that was intended to extend from sky to earth as a connecting channel, but which was truncated when the pilot got dizzy. It hovers elusively over genres. Incorporating the festivity of the air show or carnival, it also bespeaks the solemnity of an apparition. As painting it is ephemeral, dispersing like mist. As sculpture it is immaterial and out of reach, yet visible. As sign it is merely indefinite. As icon it resonates with the Transfiguration, the channel between above and below, the Shekinah, and the descent of Zeus upon Danaë in a cloud.

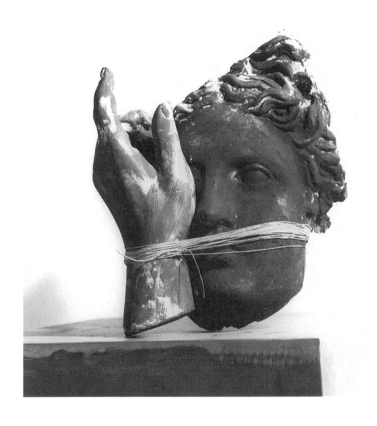

Jannis Kounellis, Untitled, *1978. Collection of Professor Jung,*
Aachen, West Germany.

Chapter Six

The Art of Jannis Kounellis

Section One: Mute Prophecies (1986)

Piraeus is a primal port town. Departure smells from its waterside cafes and crowded
streets where boys hustle passengers to the boats. It tends to smell of coffee as well as
diesel fuel and gasoline exhaust. It is a beautiful city in its way and nearly as ancient as
Athens, though it receives—and deserves—none of the cultural credit Athens gets. In
terms of Athens, it is a somewhat deprived neighborhood to grow up in. In terms of the
world, it is a mighty port from which one can get almost anywhere in the Mediterranean
any day, and many places more distant. But Piraeus does not feel itself a tributary of
Athens or a gateway to the world. It is simply itself, the primal port city, redolent of
coffee, bags of lemons from the islands, and gasoline. It was here that Jannis Kounellis
was born in 1936 in the shadow of approaching war.

War was a major element in Kounellis's early life. When the Second World
War ended, he was ten, but in Greece warlike activity did not really end. The world
war gave way immediately to the civil war, which lasted for another four years, then
dragged on without total resolution for six more, until Kounellis was twenty. In the
midst of a civilization that seemed to be breaking apart, he lived a life whose
personal aspects—childhood violin lessons, early artistic aspirations, marriage at age
seventeen—were somewhat overshadowed by the workings of large, seemingly
impersonal, forces. The fact that his life from age three to age twenty was lived in a
country at war on its own soil left a fundamental imprint on Kounellis's person, his
view of life, and his art. In order to understand this, one must take into account
certain broad facts of Greek history and its relation to the history of the rest of the
world.

In the Greek classical age—the age of Aeschylus and Sophocles, Plato and
Aristotle—the broad outlines of Western civilization were laid down, including
democracy, historical consciousness, and artistic individuality. Toward the time of
Christ, Greece became a part of the Roman Empire. Toward the end of the Roman
Empire, it was torn away from the very history of which it was the source: The
emperor Constantine, in dividing the massive empire into two administrative
sections, east and west, established the center of the eastern segment in Greece.

From that moment until this, Greece has been artificially isolated from Europe and thrust, by way of its view across the Aegean, into Asia. Even today the fact that Greece's national enemy is Turkey relegates it to Asian, not European, politics. Yet Greece—the cradle of Western civilization—is, obviously, not plainly and simply Asian. Ambiguously placed between Europe and Asia, its politics and culture neither one nor the other, it has fallen into a kind of blank space where it is in a sense outside of history.

In the Middle Ages, the Greek language and culture were isolated in the tiny Byzantine Empire—caught between the Scylla and Charybdis of European and Middle Eastern barbarisms. In 1453, after a thousand years of isolated and timeless Byzantinism, Greece was conquered by the Turks. Greek scholars fled west to the cities of northern Italy, where their arrival was the crowning element of the Renaissance, or recovery of Greek culture. The Renaissance got Europe moving again, propelling it into the eighteenth-century Enlightenment, the historical conception of things, and Modernism. Meanwhile, as Europe was propelled up out of the comparative slumber and darkness of Latin Christendom and into the great adventure of history and historical consciousness, Greece remained for four hundred years under Turkish rule, slumbering in a provincial corner of an Asian despotism, where Enlightenment, Modernism, and history could have little meaning.

After almost four centuries of Turkish rule, the Greek revolution restored a democratic government, a cultural form that had not existed there for over two thousand years. But the democracy had survived less than four years when a German royal dynasty was imposed on Greece, reducing the cradle of Western civilization to colonial status. A Danish continuation of this dynasty was still in power when the Second World War began. At the end of the global war, the Greek Civil War commenced; the official dates of that war are 1946–1949, but there were factional elements of it that continued for six more years or so. The monarchy survived until 1967, when the Greek military ("the Colonels") threw out the monarchs in a coup d'état commemorated in the movie Z. In 1974 the government of the Colonels fell and democracy was restored.

Kounellis left Greece in 1956, the year the last ragged remnants of the civil war ended in the renewed imperium of the German colonialist rulers. Young and hungry to be a part of history, he left his homeland behind, in its slumbering mythical status outside of the concept of history formulated by European thinkers such as Hegel. Caught in a pocket between Europe and Asia, and between the past and the present, he followed in the footsteps of many Greek intellectuals and artists who have left their homeland.

The act was not casual; the trip was not a vacation. For over twenty years Kounellis did not set foot in Greece. By the end of 1985, he had returned only four times, and usually for only a day or two on business. Arriving in Rome, he swore never to speak the Greek language again, and did not until, returning reluctantly to Greece, he found it a foreign language.

In Greece, Kounellis had known that modern art existed but had never seen any, though he sensed it strongly as his destiny. What he found by going to

Italy was history, purpose, a path for effort. His subsequent immersion in Italian art and in the political feeling of the Mediterranean as seen from Italy has been more or less complete. In his work the autobiographical Greek element peers like a repressed level of content from beneath the sense of embeddedness in Italian tradition. He has remarked, "I am a Greek person but an Italian artist." To this day he resists interpretations of his work that involve Greek parallels and sources. Often such interpretations are plainly true at some level, but that is not the level that matters to him—in fact, it is precisely the level he seeks to escape. "I want to leave Greece behind me," he said still in 1985, and to a remarkable extent he has. Of course, Kounellis brought a level of Greek conditioning and attitude with him to Italy. Still, the more conscious level of his work is erected on this Greek substrate like a Renaissance structure of reason and self-awareness on the hidden, rocky soil marked with goat paths. What this conscious level says is that the personal element must subserve the imperatives of history in order to belong to it.

When Kounellis and his wife, Efi, arrived in Rome, they both enrolled in the Academia di Belle Arti on Via di Ripetta, near the Piazza del Popolo, the square where the small Roman contemporary art scene was centered. History hangs heavy over the Piazza del Popolo. It has an obelisk brought over in Augustan times, and a pair of identical basilicas side by side from the seventeenth century. The French Academy is nearby, and the Roman art world felt deeply in its shadow. *L'informel*, the dominant painterly style of the day, associated most popularly with Jackson Pollock in America and Georges Mathieu in France, lacked Italian roots and was perceived as a kind of colonizing force to be resisted.

That moment of Italian cultural history is the moment from which Kounellis was born into a new historical identity. In the fine arts this was the moment of Lucio Fontana and Alberto Burri, each of whom represented an Italian Modernist force not co-opted into the Franco-American establishment of *l'informel*. While still a student, Kounellis felt himself drawn into the broad stream of the European avant-garde that is rooted in Russian Constructivism, especially in the work of Kasimir Malevich. The next few years were intensely stimulating. This was a moment of rebirth for the radical Constructivist avant-garde all over Europe. Depoliticized art was seen in part as responsible for the war, as an abdication of the duty of art to belong to history and reflect concern for its eventualities. Art associated with history and revolution was seen as a curative influence and model.

Two strains of Modernism flowed together at this time and mingled their currents. There was a transcendentalist Modernism represented by Malevich and others whose concern was to approach the Sublime and the Absolute through art, and a critical Modernism represented by Marcel Duchamp and others whose goal was to demystify the art activity and return its form to the plane of earthly existence. Both influenced Italian art in the late 1950s, but the transcendentalist Modernism of Malevich was somewhat dominant. Of his painting *Black Square* (1915), which has appeared and reappeared as a quoted element in Kounellis's work, Malevich wrote: "This was no empty square I had exhibited, but rather the feeling of non-objectivity."[1] By "non-objectivity" he meant an absolute reality beyond form—a

transcendentalist notion with little meaning in a materialist or critical or political sense. Despite his placement at the apparent forefront of the history of his day, Malevich's attitude toward history was ambivalent. On the one hand it postulated a conscious effort in the service of a concept of progress, but on the other hand, it saw progress leading away from the world of sociopolitical realities: "The ascent to the heights of non-objective art is arduous and painful. . . . The contours of the objective world fade more and more and so it goes, step by step, until finally the world becomes lost to sight."[2] Malevich assumed the myth that Western art history, having mastered nature through representation, was next, through non-objectivity, to master the Sublime and the Absolute. This was conceived as a type of historical progress, a fulfilling of the Hegelian idea of the destiny of Western civilization; but at the same time, it was antihistorical because it led away from the world of form, where alone history can take place. This contradiction informs much of the European Constructivist avant-garde. It was basic to the ambience within which Kounellis's work developed, and has to a degree remained a part of his work to this day.

Lucio Fontana (1899–1968) was the most electrifying living example for young Italian artists in the late 1950s. He embodied this contradiction between historical involvement and transcendental intention in a crystalline way, presenting the idea of progress toward the Sublime in technological, hence concretely historical, terms. The major Italian representative of the international Malevichian avant-garde that dominated European art of the late 1950s and the 1960s, he was part of the attempt to escape from the Expressionism of *l'informel.* One outcome of this attempt was that painting would give way for a time to sculpture. Fontana was among the first to sculpturize his paintings, in the works called *buchi,* or perforations, begun in 1949. These were white monochrome canvases perforated with holes, sometimes at random, sometimes in cosmic symbols like the vortex. In 1957 these perforations began to give way to the more famous slashes, first slashed papers, then, after 1959, slashed canvases. In the same period, Fontana added objects to the canvas: pebbles, bits of glass, fragments of canvas, and ceramic shards. His attention was turning from the surface to space and to real objects in space. Malevich had written in 1917: "The artist (the painter) is no longer bound to the canvas (the picture plane) and can transfer his compositions from canvas to space."[3] In 1965, echoing Malevich, Fontana wrote: "I do not want to make a painting: I want to open up space. . . . What must I do to go beyond?" he inquired, meaning beyond painting as much as beyond the world of form."I make a hole in the canvas and the infinite comes through. . . ."[4] The painting, in other words, was to be transformed into sculpture, but not into a traditional sculpture understood as an object in space. Sculpture was to be as much about space as about the object. The object was to be conceived not so much as contained or enclosed by or in space but as an instrument to open space up, to point to space itself. This became a basic project for Italian artists of Kounellis's generation, and for Kounellis himself.

In the middle to late 1950s, Kounellis's student years in Rome, Alberto

Burri (b. 1915) was the other great influence, the other artist who, to a younger generation sick of the Paris School and *l'informel*, represented a set of new—and Italian—options for the future. As different as he and Fontana were, there yet were congruences. Burri's use of industrial materials such as burlap related to Fontana's belief that art and science should join forces and was a significant predecessor of Arte Povera's emphasis on non-art materials. Burri's use of burlap, for example, is echoed repeatedly in Kounellis's work, partly as an homage. Burri's use of collage, in turn, related to Fontana's impulse to convert painting into sculpture and may also be seen as a predecessor of Arte Povera's preference for the installation form, in which materials are selected and combined within a space.

American influences at the time seemed less maleficent than the French, not only because they were more distant but because they also arose from a raw and colonized society. Jackson Pollock (1912–1956) was especially influential. Artists of Kounellis's generation felt that he also, like Fontana and Burri, had pointed the way "beyond"—beyond the limitations of the tradition of painting. The great pointer that Pollock gave was his infinite expansion of space, the "epicness," as Kounellis calls it, of his space. Franz Kline (1910–1962) had a powerful impact for a similar sense of epicness in his treatment of space. Pollock and Kline of course represented *l'informel,* but they also represented the downfall of the School of Paris, and it was the School of Paris's *l'informel* that was perceived by young Italian artists as the enemy. Around the Piazza del Popolo, where artists gathered (and have done so for a century), the School of Paris was seen as something of an oppressor. In the shadow of the French Academy, something Italian was sought, and also something that was international without being specifically French or, later, specifically American. The search was to lead by fine stages from painting to sculpture to the installation.

In the 1950s, painting was at its height as an ethical statement. The idea proposed by formalist theorists such as Clive Bell—that art was necessarily ethically good—seemed to apply to painting most of all. In the existentialist milieu the painter standing before the canvas seemed to be trying to wrench some self-definition, some definition of humanity, from the void of nonmeaning. But toward the end of the 1950s, this feeling began to change. Painting began to acquire negative ethical associations on the ground that it was divorced from—perhaps even opposed to—real life; its flatness held it to the wall and out of the flow of things. Insofar as it was representational (and even abstract painting was representational, though in a diagrammatic rather than an illusionistic way), it was viewed with the opprobrium with which Plato had viewed it—as an imitation of the real rather than the real itself. The ethical edge began to turn toward sculpture and related new forms. Sculpture, unlike painting, did not posit an illusion of another space but occupied the real space of the beholder; it was a real object in space, not a mere surface for the representation of objects. It forced a kind of participation by the viewer even if that went no further than walking around it. Out of the shift toward sculpture grew Happenings, Performance Art (sometimes initially called living sculpture), and installation work. Two European artists who faced this problem

while Kounellis was in art school—and who are useful as markers to place Kounellis—are Yves Klein and Piero Manzoni.

Klein (1928–1962), a transcendentalist Constructivist of eternalizing and mystical tendency, presented Modernism draped in the ritual clothing of the past. His reduction of painting to monochromes, as well as his use of fire, gold, raw pigment, found objects, and his own body—and his mixing of the genres of painting, sculpture, installation, and performance—had a pronounced effect on European art in general. Still, Italian artists shied away somewhat from his metaphysical view of history and his antique ritualism, which seemed to bespeak concern for another world rather than an involvement in this one.

Manzoni (1933–1963) was electrified by Klein's example while at the same time, it seems, repelled by it. Having seen Klein's exhibition of identical blue monochrome paintings in 1957, he responded in an act of conceptual one-upmanship with his achromes. When Klein championed the infinity of color, Manzoni made infinite lines. His career became a strange parody or inversion of Klein's, correcting Klein's transcendentalist Modernism into a critical and materialist intentionality. When Klein exhibited the gold of the other world, Manzoni, calling him back to real history, exhibited the shit of this one. The relationship between the works of these two artists is one of the originary situations from which Arte Povera arose. Kounellis's work especially seems to stand squarely in between that of Klein and Manzoni. No transcendentalist, he yet uses gold and fire, as Klein did, and participates in an extreme poetic evocativeness that suggests a kind of transcendentalist *symbolisme*. No materialist, he yet is rooted in history and real politics, as Manzoni was. Like Klein, Kounellis believes in tradition but, unlike Klein, he believes in a tradition of human, not supernatural, events. Kounellis admires Klein's incorporation of archaic cultural elements, such as the blue of medieval French heraldry, into his Modernism, much as he admires James Joyce's incorporation of *The Odyssey* into a Modernist oeuvre. Like theirs, Kounellis's work involves a contrast of the fragmentation of the present with an apparent wholeness suggested by incorporated materials from the past. Still, like Manzoni, Kounellis has remained more concerned with the present as the present, that is, with politics and a quest for a future.

In the late 1950s both Klein and Manzoni felt keenly the ethical shift away from painting. Klein hung his paintings a few inches in front of the wall like sculptures and, like Fontana, incorporated real objects into them—sponges, pebbles, flowers—mediating between painting and sculpture. His use of his own body as an art object, in what would now be called Performance Art, was his final solution. Manzoni incorporated real-world signs—such as stenciled letters, a map of Ireland, or a calendar—into his paintings. His achromes—unpainted canvases with various things from wool to dinner rolls affixed to them—were rejections of representation in favor of real objecthood. Klein died in 1962 and Manzoni in 1963. The years of their brief careers were Kounellis's formative years as an artist. He, too, felt this ethical shift, which governs the early development of his work.

Kounellis's early work, while he was still a student at the Academia, was

painting, but painting that contained already, instinctually, a number of strategies to move it ultimately into the third dimension and real space. In 1960, when Kounellis was still a student in Rome, he had his first show at Galleria La Tartaruga—the first gallery of contemporary art in Rome, located in the Piazza del Popolo. Other shows followed, and the works were soon widely known in Italy. Kounellis, it seems, was immediately assured of a certain kind of success as an artist if he wanted it. Yet in 1965 he radically rethought his relationship to painting.

Kounellis's period of exhibiting only paintings extended from 1960 to 1966—the crucial years in which the shift in question was taking place. His paintings of those years show several strategies for breaking out of a hermetic chamber of pure form and establishing contact with the real-world roundabout. The exclusion of images of natural forms in favor of letters, numbers, and signs—such as arrows or arithmetical symbols—brought the work partly out of the range of the image, whether abstract or surrealistic, and into an interface between plastic form and conceptual discourse. The letter and number paintings of Jasper Johns (b. 1930) in the same years were related, but their emphasis on the working of the surface related more to the painterly tradition of Abstract Expressionism; Johns's letters and numbers seem meant to be viewed as graphic, not semantic, elements. Manzoni also used stenciled letters, along with other elements, in the painting *Chissa* (*Who Knows*, 1956). Kounellis's work began from this position and developed in a series of steps that left sculpture finally as its dominant element.

From the beginning Kounellis called most of his works *Untitled*. This designation might seem to associate him with formalism and the formalist view that only the optical surface of the work is needed to get the point—indeed, that this alone *is* the point. But in fact it has more to do with the content of the works, indicating that they deal with the same themes over and over, or that taken together they form a continuum. To give them different titles would be misleading. True to Kounellis's professed materialism, it is usually the list of materials after each title that differentiates one from another.

In his first exhibited works, Kounellis used letters and numbers that were stenciled, de-emphasizing painterly touch and taste. In some of these, whole words appeared, usually words found on signs in the street, such as "tabac" (tobacco) and, ironically, "olio" (oil)—elements that brought the street and realm of everyday transactions into the paintings. In 1960 he incorporated an actual street sign—a found sculptural element—into a painting. In the same year he donned one of his letter-paintings as a garment (based on Hugo Ball's famous costume from the Cabaret Voltaire in 1916) and performed an action in his studio as, in effect, a part of one of his own paintings. Painting, sculpture, and performance were mingling to show a way out of the traditional aesthetic vocabulary. In 1961, Kounellis painted on newspaper, embedding his aesthetic markings in the world of politics and society. By 1963, found elements of various kinds dominated the paintings. One painting lists the names of the days of the week. Another contains three bars of music from a song by Sydney Bechet, *La Petite Fleur*, and the word "petite." In general, a trajectory away from painting was inherent in the development of the paintings themselves.

By 1965, Kounellis had come to feel that an art based primarily on painting could not be maintained with integrity at that moment of history. For two years he made no art, but thought things out. An ideology developed in him—the son, as he once put it, of "a family of leftists"—that provided the deep structure of meaning in his later work. In order to understand that later work, one must understand this ideology, which can be approached through one of the materials it led Kounellis to use—gold. Both Klein and Kounellis used gold, a heavily ideological substance, as an art material. In the general iconography of modern art, this material is usually associated with a myth of a golden age, or with some parallel sense of longing for the return or reconstitution of a past period that is conceived as perfect in comparison with a flawed present. Klein, for example, held the Rosicrucian belief in a golden age which had been lost in the past but would be restored in the future; his use of gold is often a reference to this belief. Kounellis's use of gold is related in meaning but within a historical rather than a mythical framework.

Kounellis speaks of times in the human past when "synthesis," or totality, was in effect. Such times are marked by a healthy and primary societal structure. The defining trait of such a culture is that the various functions of society are integrated into a synthesis that contains, equalizes, and relates them all, without significant inner contradictions in the system. The element that is necessary to such a synthesis is a "measure" (*una misura*)—that is, a unit that applies across the sociocultural board. A measure is not a particular cultural element, not a certain kind of constitution or religion or unified educational tradition (though it may involve the last). It is an indefinable inner commensurability that prevails among all elements and aspects of a system. In a riven society—such as Europe after the world wars—incommensurability reigns among the various aspects of the system; there is no single measure that will unify them, tune them, as it were, to the same scale. In such a society, totality is lost and fragmentation is the dominant principle.

"Man," as the Greek philosopher Protagoras said, "is the measure." The "measure," in other words, is always a measure of humanity, a conception or understanding of what it means to be human. Thus in a society where fragmentation reigns, human selfhood is necessarily fragmented by internal incommensurabilities or contradictions. Then society must go through the difficult and painful task of finding, or creating, a new measure—that is, a new humanity—in which synthesis will be restored and the principle of totality will replace the principle of fragmentation. The measure varies with each age and is not determined in a simplistic sociocultural way. It is not, for example, class-bound. The measure of an age can arise from any class. The Renaissance was a society of totality or synthesis in which the measure arose from the aristocracy. At certain moments in the twentieth century, a measure has seemed to arise from the bourgeoisie, at others, from the proletariat, or from an idea of the proletariat; neither proved to be lasting moments.

Europe after the Second World War was a seriously fragmented society. In such a case premature fantasies of wholeness are apt to arise as attempts to escape the truth of fragmentation. For Kounellis this is the case with the artists who, in the last ten years or so, have again thrust painting into the forefront of art practice,

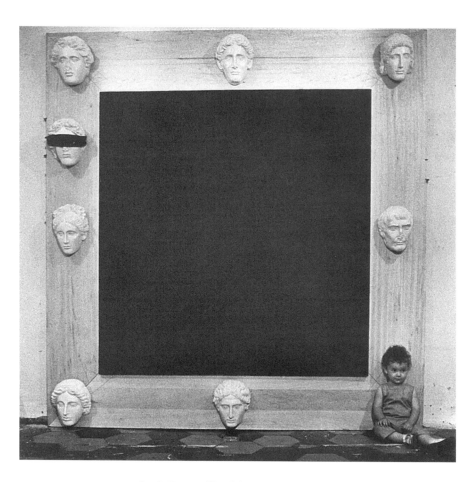

Jannis Kounellis, Untitled, *1973. Collection of the
Museum Boymans–van Beuningen, Rotterdam.*

despite the fact that the social synthesis in which the domination of painting made
sense has long been broken. In this view the full-scale, unrestrained return to
painting may seem premature at best, at worst a fake claim that synthesis still
survives or has already been regained. Such premature claims are dangerous since
they may prevent more serious attempts by seeming to close the issue. The artist,
Kounellis reflected during his two years of withdrawal from art, if he or she accepts
the responsibility of the Modernist project, must above all realize that he or she
belongs to history. This is a kind of sacred duty to the artist—though its sacredness
is comprised of its secular and historical value. The artist must seek the new
measure in his or her work without hollowly faking it or over-optimistically think-
ing that personal enthusiasms might comprise it. The measure is a more difficult

and more communal thing than that. It must arise from the strivings of a genera-
tion, or of several or many generations. It is not the result of the individualistic
genius of a single individual. For the measure is not simply a personal act of self-
expression; it is the basis on which society will cohere and from which a new
synthesis will grow. Thus a part of the artist's responsibility is to hold off impulses
toward premature graspings at synthesis. He or she must patiently accept fragmen-
tation, deal with it as material, and let the working of it gradually reveal the measure
of the future, which lies lost or hidden, yet potential, within the jumbled fragments
of the past.

 This ideology seemed to Kounellis to necessitate an art that would, at least
for a time, base itself primarily on practices other than painting. Once a new
synthesis has been created, it may be possible to return wholeheartedly to paint-
ing—assuming a painting practice redefined within a new totality. But painting, the
chief artistic tool of the old synthesis, cannot, in Kounellis's view, be used as the
primary means to find the new; it is too encumbered with the past at a time when
we have been forcibly severed from the past by global wars and the real, not mythi-
cal, prospect of the end. Since 1965, Kounellis has continued, sporadically, to
produce paintings, sometimes as parts of performance-installations, sometimes as
independent commodities, but not as the mainstream and center of his work, which
has had to find other means.

 In 1965, Kounellis felt that his number and letter paintings had become a
settled style for him, and a settled style suggests that one knows where one is within
a totality—a suggestion inherently false in a society that lies in warring fragments.
At that time in cultural history, style represented ossification around a design
concept which would in time lose whatever content it might once have possessed
and become empty decoration or signature without meaning. In 1957 many Euro-
pean artists—including Klein and Manzoni—signed a *Manifesto Against Style*. At
the time "style" meant primarily *l'informel*. To Kounellis, *l'informel* was a kind of
deception, an illusion of unity: It created emblems of totality that falsely gave the
impression that totality was generally in effect; it presented a purely stylistic unity
that masked the fact that social unity was gone. Hence the rupture with style was
the first important step toward the regaining of totality. The rupture with the false
unity of *l'informel* inaugurated a period of open contradictions, which finally might
lead to a different measure—regained from the fragments produced by iconoclasm
and the rupture with style—and a new totality. The centrality of *l'informel*—its
appearance of being central—is to Kounellis a sign that its claim is false. Centrality
is too directly affirmative. Kounellis avoids it in his work. In a fragmented world
there are no centers, only peripheries.

 During two years of thinking about the problem of making art in a
fragmented world, Kounellis determined that henceforth the nature of his work
would change as soon as it attained a recognizable and predictable style. His work
since then has tended to run in periods of about three years, in each of which a
certain type of work—the living beings, the music, the fires, the traces of smoke, the
stoned-up entranceways, the fragments of antiquity—would be investigated and

developed in a series of related works. Later these various series interpenetrated in complex syntheses in which various past elements are recombined or inserted into new works.

Kounellis's first work after the two years of silence and thought—like most of his works it is called *Untitled*—pointed in two directions. On a stretched canvas three cut-out canvas fragments resembling roses are glued. This part of the work resembles both Manzoni's achromes and Fontana's use of canvas fragments. But at each side of the canvas, Kounellis affixed a second element that neither Fontana nor Manzoni would have foreseen: twelve small bird cages each holding a live bird. Kounellis's youthful habit of regarding painting as the central art mode was not yet fully transcended, but his use of living creatures as materials pointed far beyond it into zones of art virtually unknown at that time.

The transition from an art centered around painting to an art centered around sculpture and performance was further explored in other works of 1967–1968. In some, Kounellis adapted Burri's careful, painterly use of burlap into found sculpture; rather than working bits of burlap into elegant, aesthetic compositions, he exhibited burlap sacks whole, hanging them on the wall, tying them to a metal bed frame, or piling them on a small wheeled platform on the floor to suggest their use in the transport of goods. In other works of the same year, clumps of raw wool, a material that Manzoni had affixed to blank canvases, were bound to wooden poles, which were either tied into a framework like a picture frame or leaned against the wall. These works were a literalistic attempt to convert painting, or a single specific painting, into a sculptural principle. The central inspiration behind the wool-tufted poles were the almost upright lines that gave the title to Pollock's painting *Blue Poles*, in which Kounellis saw in a two-dimensional situation the sense of epic space that he sought in three dimensions in his own work. Pollock's painted poles, which seemed to lean in flat, allover space, were converted to sculpture and leaned against the wall of a real room. As the poles' position in the room was altered, they established the space as allover. Going well beyond Manzoni's use of wool, Kounellis's homage to Pollock converted the allover space of painting into an allover space for sculpture.

Other works of this period involved a dialectical interplay between two aspects that Kounellis refers to as "structure" and "sensibility." In them an element of inorganic form, which Kounellis calls structure, is combined with an element of organic presence, which he calls sensibility. Often a living or once-living substance is found upon or within a metal ground or frame. The situation is an allegory for human presence within an unforgiving causal structure. In an installation of 1967, three examples of structure and sensibility pairs were conjoined. A living parrot (sensibility) was seen on a perch fixed to a rectangular sheet of steel (structure). Nearby a bale of soft cotton (sensibility) was compressed between four steel plates (structure). In front of them was an installation of cacti (sensibility) growing through holes in the tops of steel boxes (structure). Another 1967 work (which, like Oppenheim's Sitemarkers, preceded Robert Smithson's exhibitions of bins of rocks

as "nonsites" by one year) referred to familiarly as *Carboniera* (*Coal Bin*) featured lumps of raw coal contained in an open-topped steel box on the floor. The structure-and-sensibility works were translations of painting—the frame (structure) containing the image (sensibility)—into something else that was no longer painting; they were a stepping stone by which Kounellis's work entered the fullness of space. The structure-and-sensibility pattern still underlies later works such as the one of 1970 involving a human body on a metal base and the work of 1969 in which a hen's egg was displayed on a steel shelf.

In the late 1960s, the world was involved in a radicalizing political turn: in China the Cultural Revolution; in America the antiwar movement, the black liberation movement, the feminist movement; in Europe the events of May 1968 and the turmoil preceding and following them. Kounellis's work reflects his feelings of involvement in these attempts to find a way to a new "measure" for society. In 1969 he expressed support for the forces of social and political change in a work that incorporated in chalk the names of Marat and Robespierre and the words "Liberto o Morte" (Liberty or Death). Throughout this period his use of live birds and animals stressed the need for art to be involved with real life. The live birds of 1967 led to the installation of live horses in a gallery in Rome in 1969. (This work was "reconstructed" for the Venice Biennale in 1976.) In the same year Kounellis released live birds to fly in the Kunsthalle in Dusseldorf. These works relate to others in the air in the same period—such as La Monte Young's release of a butterfly in a concert hall in 1960—but represent less the flower-child approach characteristic of America at the time than a postwar European sense of the delicacy of life and the forces that threaten it. In 1971 at Galleria L'Attico, Rome, and again in the following year at Sonnabend in New York, the artist appeared mounted on a horse and holding a plaster cast of a face of Apollo in front of his face. Works of this kind dissolved any residuum of painting and entered a new exploratory zone of performance and living sculpture. In the following year Kounellis photographed his two-year-old son, Damianos, as part of a work which, like many of his post-1965 paintings, involved quotation of Malevich's *Black Square.* In these works, living beings appear in a static, containing framework that suggests a measuring device.

Another element that appeared at the politically tumultuous end of the 1960s was the use of fire as a material. Fire always means transformation. Kounellis refers to it as signifying "punishment" in the medieval worldview—a "punishment" that is precisely the requirement of being transformed for the sake of the totality, as the part is melted into the whole. Kounellis's feeling for fire is practically pre-Socratic. His idea of justice is like that of the Greek philosopher Anaximander, who said that each thing yields justice to the totality by being transformed back into the whole. Transformation into what one is not balances the one-sidedness of what one was and constitutes justice or necessity. The principle of fire as it is used in Kounellis's work recalls the philosopher Heraclitus's dictum "All things are exchanged for fire and fire for all things." This is the "punishment" or justice that fire brings. In 1967 the untitled work referred to as the *Margerita* (Daisy) initiated the fire pieces. A metal, flowerlike shape about a meter in diameter emitted a jet of

hissing gas flame from its center. This piece was transitional, involving the structure-and-sensibility relationship but going beyond it. More than a sensibility, fire is like a metaphysical principle in its connection with destruction, process, and change. It embodies directly the process of social and cultural change through which civilizations rise and fall as one measure or unity is burned away and from the mouth of the flower another hisses out.

Over the next few years, Kounellis made fire a material particularly his own. Though it had been used by Klein, and though a few other artists have worked with it since, Kounellis is preeminently the artist of fire, which he usually presents without aestheticizing it or concealing its apparatus. In a typical installation, the tank of gas sits on the floor, with a hose about six feet long reaching up from it to hang on a hook on the wall, the nozzle at its end emitting a hissing flame at the viewer's eye level. This is then repeated down the length of the room or, in some cases, around the entire room. The fires at eye level bring the principle of inevitable and merciless transformation into scale with the measure of humanity. Their unremitting, hissing heat is a hard-edged reminder of the need to transform humankind and society into a new synthesis based on a new measure. In another installation the hoses lie on the floor, all tending in one direction away from the tanks, with the fires hissing at their ends. Unconsciously echoing Heraclitus, Kounellis says of this work that the flowing fires are "like a river."

In 1969, the Fire works entered a strange and profound union with works using metal bed frames as materials. A single-bed frame, as much as a coffin, is a measure of the human, made to the size and proportion of the human body: Metaphorically it is a measure of a human life, as the place where a person is begotten, born, begets, and dies. In Kounellis's work, bed frames refer to the project of creating (begetting) a new form, that is, a new formal sensibility, a new measure from which the art of the future may emerge into a harmonious synthesis. The metal frame with the absent but implied human figure is a development of the structure-and-sensibility pattern. The structure is there but the sensibility, the living being, is awaited. In one work of 1969, a bed frame had a gas torch attached to it, shooting flame. The bed was the measure of the human, but it was subjected to the fire of change. It is the measure itself that is being burnt into change, forced by fire into transformation. In another work of the same year, two bed frames stood side by side; on one were piles of raw cotton, on the other were forty small fires, made with fire-starting pellets, each lasting about one minute. The two beds balance birth (the cotton bed with its soft invitingness) and death (the fire bed like a torture rack) as two measures of a human, or as pointing to the remaking of the measure, which must be burned up and born again. A bed work dating from 1971 involves a bed frame with many small fires on it beside another bed frame, on top of which is a cage (made to simulate mattress springs) containing white rats. A related work of 1969 shows a woman lying on a bedlike iron base; she is wrapped in a blanket except for one foot that protrudes, and to this foot is attached a torch with a hissing gas flame. The wrapped woman suggests the hiddenness or unknownness of the new

measure of humanity—a new measure of which she is the faceless or unknown mother. In another work of the same year, a metal double-bed frame leans against a wall; from a transverse bar attached to the center of the bed frame hang five measuring pans like those used to weigh commodities in commercial scales. On each balance pan a little fire burns. The balance pans are perhaps the most direct of Kounellis's references to the idea of the measure. The fires burn the measure within the bed where an absent couple will procreate the future.

Kounellis's responsiveness to political conditions can be seen in his progressions. The Fire works of the late 1960s reflected the optimistic belief of that period in transformations about to arise from human effort and suffering. In the following years, when the revolutionary feeling of the 1960s seemed to have been betrayed or quenched, the Fire works gave way to smoke works. In 1976 Kounellis installed a furnace with a chimney in a gallery; above the cold chimney was a smudge of greasy smoke on the ceiling, a melancholy trace of a fire that had gone out. In other works, smudges of smoke—made by burning rags that have been soaked in dirty automobile engine oil—hung above small shelves on the wall like memory traces of lost opportunities, moments of potential change that combusted and are gone. "Smoke creates ghosts," says Kounellis, "and the chimney looks like a castle." The castlelike appearance suggests the totality of medieval culture, but the fireplace is cold and the life has vanished from it; the ghosts of the lost primary culture have dried like grease marks on the wall. The smoke marks are traces of something that cannot come back into being, and of potential things that lack the historical situation which might bring them into being. The smoke is a metaphor for time and history and for the mystery of the new conditions that will make possible a new configuration.

The fundamental image of containment made its appearance in 1969, a year in which Kounellis's artistic vision came of age almost explosively, creating a series of major icons which he would follow up and develop for a decade. Alongside the Fire works, the bed works, and the live animal works, the most important of the creations of this year was the door blocked with stones in a peasant style of masonry. This image has recurred in various works from 1969 onward. The walled-up doors and windows are usually interpreted as involving the theme of blockage, as clearly, at a literal level, they do. Some critics have called them a protest against the gallery, against the separation of art from life: The blocked doors close off the gallery and prevent it from getting sustenance. But this common Anglo-American avant-garde theme is not acknowledged by Kounellis, who denies that the interpretation is meaningful to him. A Greek critic was impressed by the fact that the style of masonry Kounellis uses in these works is characteristic of the Greek countryside and village cultures.[5] Not only are retaining walls for terraced hillsides built in this mode, but one sees from time to time in the Greek countryside abandoned buildings whose windows have been blocked by stones to protect the interior from the weather. From a modern Greek point of view, these works express a feeling of closure and isolation, almost of ostracism. Kounellis rejects this interpretation also,

as he usually rejects interpretations of his work that depend on Greek parallels and meanings.

In Kounellis's iconography, these works relate to his characteristic theme of history and measure. The measure, as stated earlier, is always the measure of a person; it is an object or framework made to human dimensions and proportions. Like the bed, the doorway is such a measure, as is the window. The building stone is also a kind of measure. It is like a head from a broken classical statue fallen to the ground; it is part of a wall that men build to their own measure; and it is sized for the grasp of the human hand which, like the head, is (and has been since Egyptian Old Kingdom canons of proportion) a human measure. Modern windows and doorways are measures from one age, and the ancient stones placed one on top of the other to make a wall are measures from another, more ancient one. Compressed together they constitute yet another image of a complex of interrelated ideas—including the changing of the measure with the flow of history, the measure appropriate to each age, the loss of the measure, and the need to regain, or rather reshape, a new one. Like so much of Kounellis's work, they embody the passage of human history, of the changing of the human self and of its products.

These works must be seen somewhat complexly. While the artist's intentions cannot be regarded as circumscribing the meaningfulness of a work and cannot be allowed to effect a closure on the interpretation of it, they must nevertheless, unless faked, be given a certain power and priority in our minds. Kounellis's personal view of these works is subtle and powerful and rings true. Nevertheless, the Greek interpretation peeps through the more polished and theoretical European model like repressed material through a persona. One cannot ignore the relationship these walls have to the Greek countryside and its antiquity, but this is not a question of influence. Kounellis has seen very little of the Greek countryside, and he does not remember seeing the blocked windows, though he acknowledges he may have.

The claustrophobic tension of the blocked windows and doors, the sense of being implacably locked into one's box of historical circumstance, relates in feeling to the works involving references to the Latin Christian cross. The cross in Kounellis's work signifies an attitude toward history. Though he is not a Christian believer, the cross is a part of his cultural history and appears in his work as an inherited element that must be accepted by one who realizes that he belongs to history. This view seems to contradict Kounellis's own desire to leave Greece behind him, and confirms one's suspicion that elements of his Greek cultural heritage peek through the work from its background or even, as in the case of the blocked doors and windows, shine out from its foreground. In a work of 1972, Kounellis placed cast gold replicas of his baby son's shoes on the foot-support of the truncated vertical member of a large wooden cross. The work is a kind of testament, as if the father were leaving history to his son, or a kind of allegory of the onrushing, riverine process by which each generation leaves to the next its crucifixion upon a certain intersection of time and space. The shoes on the cross suggest crucifixion upon history; the gold of the shoes indicates the sacredness of accepting that condition as one's definition and responsibility.

The scene at Golgotha brought to mind by the cross is strangely like Kounellis's *Tragedie Civile* (*Civil Tragedy*—one of Kounellis's few works that have titles). The gold-leafed wall, in front of which stands a bentwood hatrack with a hat and coat hanging from it, is one of Kounellis's most evocative and poetic installations, which he made three times between 1973 and 1985. The golden wall is a reference to the golden ground in Byzantine art, and in a deep sense the piece refers to the figure/ground relationship. Of course, the dark hatrack with dark hat and coat hanging on it functions as a figure on the gold ground, but this is more than a formal situation. The figure/ground relationship is a matter of content too; it speaks about selfhood, about the relation between whole and part, about the integrity of separate objects or selves against the absorbing and featureless quality of the universal ground. In Byzantine art, there are human figures on the gold ground— figures either royal or divine that are eternalized by the gold; the relationship of figure to ground in that case asserted the eternality of the human soul or, put slightly differently, of a certain measure, the measure of a culture that saw itself as founded on eternal verities and thus more or less unchanging. But the figure has fled from Kounellis's piece, leaving an empty hat and coat as lonely traces of its vanished presence, and pointing to the theme of the loss of the measure and the fragmentation of the self in a society where synthesis has been lost. Kounellis associates the hatrack with hat and coat on it with Middle European café scenes, especially those of Vienna. For him the hatrack in between the viewer and the golden wall signifies the culture of Vienna which, he says, is a bridge to Byzantium. (Is it the ancient separation between the eastern and western Roman Empires that prepared the way for *Civil Tragedy*?) By the culture of Vienna, he means the work of Gustav Mahler, Franz Kafka, and other authors whose theme was the lack of wholeness in modern selfhood, after the First World War.

By the mid-1970s, Kounellis's work had developed not only a new art vocabulary but also an inner coherence among the elements of the vocabulary that allowed a poetic evocativeness of epic scale to emerge in his installations. Among his elements, there is a shifting network of quasi-narrative connections. Central statements of the work bring with them peripheral statements that deepen their expressiveness. The syntactical relationship that appeared among the elements confirmed the accuracy of the intuition that selected them in the first place. The sense of containment and isolation, for example, of being locked out of history, trapped in the false eternity of a golden wall, as it increasingly blossomed in Kounellis's oeuvre, brought with it as corollary a series of images of blocked vision. These images were not the central intention but offshoots or resonances of it. The blocked windows or doors inevitably suggest, as their negative implication, the blind viewpoint of one trapped inside the blocked-up room. As parts of other works, Kounellis remade a set of doors in lead and replaced glass windows with steel. Once he blindfolded a head from a classical statue (a work reminiscent of de Chirico's *Portrait of Apollinaire*, which shows a classical marble head wearing dark glasses). Several times he has incorporated into complex installations the Malevich-derived

black square, which in the place of a picture, represents the dark. These pieces are multilayered metaphors for a dark seeing, or a blockage of sight. In a work of 1973, a framed, stretched canvas containing a black square is surrounded by classical heads, one blindfolded. Another work of the same year is a framed stretched canvas with a curtain rod in front of it and a curtain drawn three-quarters of the way across; outside the frame a few feet away on the wall, an oil lamp burns. In other works he has wrapped things—a human female, broken pieces of statuary, stones— in scraps of blanket so they cannot be seen. For Kounellis this aspect of the work is a dialectical retort to the superficial seeing embodied in an easy-to-like pictorial art; it signifies a deep and definitive seeing beyond that of the illusionistic picture surface, a seeing that is currently blocked or inaccessible in a world of superficial and fragmented vision. Whole seeing would be a seeing of totality, possible only in a society where synthesis prevails.

Another characteristic of the oeuvre as a whole is its dialectical balancing. The sense of claustrophobic trappedness or containment, for example, is dialecti- cally balanced by a motif of travel that seems to a degree clearly autobiographical. The works embodying this theme bring with them memories of the long history of the Greek diaspora, Kounellis's own childhood in the port of Piraeus, and his escape from the historical cul-de-sac of modern Greece. His work from 1967 on is full of images of travel. The burlap sacks and the coffee measures, for example, signify both commerce and travel. At the very beginning of his repositioning as an artist in 1967, Kounellis mounted whole burlap sacks on the wall; later, as parts of the complex installations, he stacked them on the floor, sometimes making walls of them. A work of 1967–1968, in which three burlap sacks lie loosely folded on a little car or dolly, also evokes the connection of burlap or of sacking with transportation. It is in burlap sacks that materials are transported from one culture to another. They are a common measure that unites various cultures along the diffusion trail of transporta- tion. In a piece of 1969, various kinds of grains and beans were exhibited in burlap sacks, embodying the theme of the diffusion of civilization, as the goods and measures of various cultures are exchanged. The coffee works also involve the theme of travel. Kounellis notes that ports—and especially perhaps Piraeus—smell like coffee. "Coffee for me," he says, "is something that is linked to harbors." Coffee signifies the process of import and export, coming and going, influence and diffu- sion. Like boats and sacks, it marks the path of civilization.

Kounellis's work contains an implied picture of the whole process of travel and trade. The sacks in which goods are carried and the goods that are carried in them are complemented by images of vehicles and parts of them. In 1979 a ship's mast and sails from an archaic time were exhibited leaning against a smoke-stained wall. In 1978 a model boat was exhibited on top of a pile of burlap sacks, before a yellow canvas. This last-mentioned work (and several others of the late 1970s that introduced references to easel painting) had an additional semantic level involving prophecies of the imminent return of easel painting to the forefront of the art world.

In some works the theme of travel becomes allegorical. In 1977 Kounellis twice showed model electric trains. In one case, the train was in a fixed position on an upwardly spiraling track surrounding an architectural column; in the other the train moved continuously on a circular track around a column. While these works relate to the theme of travel, they also present allegorically two views of human activity: one of effort moving upward toward a culmination (Modernism, Italy), the other of motion in a circle getting nowhere (pre-Modernism, Greece).

As Kounellis's vocabulary developed syntactical depth and scope, the power of the syntax rebounded into the vocabulary, layering and deepening the meanings of individual elements. The horses, for example, have meanings of various kinds at once. To begin with, they, like the fires, are living elements within the rigid space of the gallery, and this situation involves a remnant of the structure-and-sensibility theme from which the works began. Horses also strongly suggest the peasant society and, as revealed in the piece where the artist sits astride a horse holding an Apollo mask to his face, they involve a human measure insofar as, from a human point of view, the horse implies a rider. Finally, they are images of travel and of changes in civilization through commerce, migration, and conquest.

The theme of travel operates, as do all of Kounellis's themes, on two levels. On the one hand the works are references to or memories of Piraeus where the artist grew up amid the rush of ships, the combustion of gasoline, the smell of coffee, the loading and unloading of sacks, the air shot with fragments of music. On this level they signify his own departure from Piraeus and from Greece, his journey from nonhistory into history. Enlarging the focus slightly, they signify the transport of the Renaissance from Byzantium to Italy. Still more broadly seen, these images refer to the whole diffusion process by which civilizations and cultures—which are constituted essentially of different measures or commensurabilities—are carried from place to place and redefined.

Perhaps the ultimate image in Kounellis's work, the ultimate theme, the one that unites all that we have seen so far, is the theme of the fragment. Though all his work is involved with history and hence with the political sense, it is here that the politics of his work is centered. In embodying his feeling of the fragmentation of European life and culture since the world wars, Kounellis has made the fragment quintessentially his own material and theme. Most famous, of course, is his use of fragments of classical sculpture which, alongside the blocked windows and doors and the fire pieces, have become something like his signature.

Other Arte Povera artists have used fragments of classical sculpture. The practice, in Italy, derives from the work of Giorgio de Chirico (1888–1978), who influenced deeply the artists of Kounellis's generation. De Chirico's particular Surrealist look has to an extent penetrated all their work, as much as has Fontana's dynamic sense of empty space. The fragment motif, of course, is not meaningful in itself, but in how it is used. Ezra Pound, for example, influenced by the beautiful evocativeness of the fragments of the poetry of Sappho, made the fragment into an aesthetic totality. This romanticizing of the fragment suggests that a fragmented

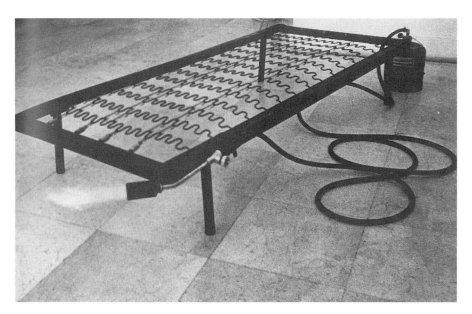

Jannis Kounellis, Untitled, *1969. Collection of Friedrich Erwin Rentschler, Laupheim, West Germany.*

culture is sufficient or even desirable; by making the fragment seem a whole, it attempts to hide the fragmented state of things behind demonstrations of aesthetic totality, that is, of style. Kounellis focuses the fragment differently, and does not lose sight of the fact that it is a fragment. He has called his work "the iconography of iconoclasm." It is the iconography of the broken image, of the lost totality, the lost vision, the dark—but also of the new vision being born in the dark space, where it is even now being put together from fires and fragments. In his work the fragment is not meaningful in itself—only a totality could be. It is meaningful only as a mute reminder of the lost totality and as a blindfolded pointing toward the totality to come. As was implicit in the *Manifesto Against Style* signed by many European artists when Kounellis was in art school, artists were to realize that art alone cannot restore totality; when it tries to, it is forced to produce a style that gives a false, that is, a purely stylistic, appearance of totality. Still, social organization and politics reflect underlying assumptions about what it means to be human, and in this area art, like philosophy, can contribute in a practical way to the process, by suggesting new parameters of the meaning of humanness.

The politics of Kounellis's work lies in its emphasis on materials and its constant pointing to the loss of social totality and the need to regain it within history—the themes wrapped in a tight seed in his use of fragments. In the middle to late 1970s, he used fragments of classical sculpture as parts of sculptural complexes, usually combining them with one or more other characteristic motifs, in works that retain a classical feeling of simplicity. In 1975, a part of a classical head,

lying as if asleep on a steel sculpture pedestal, is pierced through the ear by a propane flame. In a work of 1978, a partial cast of the head of the Belvedere Apollo is tied with household twine to an upward-pointing hand from another Greco-Roman sculpture, joining the two human measures, head and hand, as if in an attempt to tie them back into working order together. In another piece from 1978, a head of Athena stands on a sculpture pedestal, blindfolded and smoke-stained. The characteristic iconographic motifs here can be added cumulatively—for example, the theme of the classical fragment plus the theme of the blocked vision plus the theme of the trace of smoke—in an oeuvre that has by this time developed inner iconographic coherence without becoming entrapped in a single style. These fragment-sculptures are often used in combination with other elements, either in complex installations or in installation performances.

The motif of the fragment is complemented by the motif of the shelf, which Kounellis first used in 1969. Around 1979, as his works grew more complex and synthetic and grouped more objects together, he began presenting sculptural fragments and various other motifs on steel shelves. The shelves became part of his iconography, representing accumulation, the past, the ruins of the past, the attempt to collect and put back together the fragments of history, and so on. They are like an archeologist's storage area where lie the fragments that one must study in search of a way toward a new measure. On the shelves various accumulations of stones, sculptural fragments, wrapped sculptural fragments, and found pieces of wood are made briefly iconic. As accumulations became a basic principle for a while, sculptural fragments were stacked like stones in doorways; stacks of wood closed off windows or archways as they were integrated into the architectural environment.

It is perhaps in the performance-installations that the poignancy of the fragment comes through most clearly. These works are complex syntheses of motifs, usually combining sculptural and musical—that is, spatial and temporal—fragments. In a work of 1970, a pianist in formal attire seated at a grand piano facing into the corner played over and over again two phrases from Verdi's *Nabucco*—from a song of rebelling Jews, rather like "The Marseillaise"—for two to three hours. The piece was repeated with variations in 1977 in Naples, where the windows of the room were covered with tar paper, combining the themes of blocked vision, the enclosure, and the fragment. In a work of 1971, Kounellis, returning briefly to his days as a painter of musical notes, painted a fragment from Igor Stravinsky's *Tarantella* on a large pink canvas. Next to it a violinist stood against the wall and played the same fragment repetitively, with breaks in between the repetitions. A ballerina in classical costume repeated a pattern of dance steps in front of the canvas each time the music was repeated.

Also in 1971, a large green painting presented a passage of Bach in musical notation while a cellist seated in front of the painting played the same passage over and over. In another work of the same year, four musicians playing the same fragment of music by Mozart were disposed around a building in different rooms and on different floors. From any position one heard the musicians at different ghostly

distances. Here the temporal fragmentation of the music was complemented by the fragmentation of three-dimensional space effected through the separation of the players and their comparative isolation from one another. In a work of 1972, two steel boxes with one side open, rather like photographic booths, were installed in the Sonnabend Gallery in New York. In one booth, Kounellis stood holding before his face the Apollo mask; behind him two mirrors reinforced the question of identity. In the other booth a flautist half-sitting on a stool played a fragment of Mozart over and over. The overwhelming sense of cultural wholeness that Mozart's music brings with it was used as a found material, broken apart into fragments, and strewn around.

Apollo (1973) was the culmination and the end of the period of using musical fragments as found materials. The piece took place for two to three hours a day every day for two weeks. Kounellis sat behind a table on which lay fragments of classical sculpture, but not ones that could comprise among them a whole figure. He held the Apollo mask before his face. A stuffed blackbird perched on a marble torso. A flautist repeated a fragment of Mozart about thirty seconds long, with pauses of two minutes or so in between repetitions. The blackbird is Edgar Allan Poe's raven, croaking "nevermore" from atop a bust of Athena, and more generally, in European mythology, a bird representing tragedy, a bird that does not merely prophesy doom but also symptomatizes it.

Apollo is, in the artist's words, a "request for identity," an attempt to "regain the holy, the sacred, in a secular historical sense." It is about the role of the artist, for this regaining of the sacred without sentimentality is, in Kounellis's view, "one of the powers of the artist"—indeed the central and most awesome one. The same subject matter is represented by the ordinary real-world hat with the gold laurel wreath of the poet around its brim, and by the gold lips which the artist silently wore in a piece of 1972. Both these works are about the role of the artist as an instrument of mystery and prophecy, in this case a silent prophecy of a totality that cannot yet be articulated.

Apollo is the aftermath of war: God looks with a cold Apollonian gaze on human disasters. The most beautiful products of our civilization lie broken, as Apollo—an archetypal collectivity—contemplates the remains. The piece is prophetic of doom as well as amid it, contemplating it. Still, it has the future in it as a question or a potentiality. The accumulation of sculptural fragments always suggests the possibility of putting them back together again, and the artist sits there ready to do it, or try it, under the guidance of Apollo. It is significant that this piece in a sense brought Kounellis back to Greece for the first time since his departure in 1956. In 1977, at the invitation of the Jean Bernier Gallery in Athens, Kounellis returned to Greece for a single day and in the evening performed *Apollo* again—not in a gallery setting but in an old taverna that was open to the public as usual.

As these works grew more complex—and after about 1975 Kounellis's pieces were often recombinations of earlier separate pieces into tableaulike installations—the principle that the artist calls "interruption" came increasingly into play. A series of similar objects is interrupted by some symbol of human expressiveness. In a

piece of 1977 in Lucerne, a series of fires at eye level was interrupted twice, once by a painting by Chaim Soutine, again by a man in an Apollo mask that had been made yellow with powdered pigment and glue. This piece, like others mentioned above, has as part of its meaning a forecast of the return of painting. In a work of 1979, a piano interrupts a series of fires, and in a work of 1980, the interrupting element is a cello. These works still echo the early period of structure-and-sensibility combinations. The fire, an abstract force of creation and destruction, is like the given condition of things, the frame in which sensibility finds itself. The interrupting elements are always symbols of human expressiveness, or sensibility. They are like moments when the cosmic and abstract force of the fire concretizes itself into a limited and recognizable expression. The painting by Soutine, like the references to James Ensor and Edvard Munch in paintings by Kounellis, has an innately tragic or sorrowful mood, which offers a suitable tonality for a world of fragmentation.

In the mid-1980s Kounellis's work entered a phase of still more complex and synthetic installations. A work of 1984 in Naples, for example, involved a wall covered with large steel sheets hung above floor level as paintings are hung. On this steel backing, or structure, various elements from Kounellis's earlier work were affixed: a bed frame with a fire attached to it, the tank of gas standing openly on the floor; a black square; shelves with wrapped stones on them; a shelf with pieces of found wood; and so on. A show in Rome of the same year included an installation with a bed frame and a hen's egg on a steel panel affixed to a steel sheet on the wall. In Munich in 1985, the steel backing on one wall held the partial wooden crucifix, the black square, and pieces of burnt wood on shelves, while on another wall the bed frame formed part of an accumulation dominated by pieces of found wood. In this period, wood became a prominent material in Kounellis's work, always wood found near the exhibition site, usually from torn-down or decaying buildings. It represents again the theme of fragmentation, both formally in the Cubist sense and metaphorically as the fragmentation of a civilization torn down or in ruins. It speaks of the need to build anew. In Milan in the same year, three walls were covered by the long steel backing-sheets with fires and the partial crucifix attached to the steel. In Bordeaux in 1985, the steel sheets were combined with fires and burlap sacks. Shelves with smoke smudges above them stood beside an archway partly walled up with a pile of burlap sacks; nearby, another archway was partially walled in with a pile of stones in burlap sacks, one stone to a sack. Other archways in the same large architectural space were filled with vertical and diagonal accumulations of found wood. The fires on the steel sheets sounded loudly all around; through a doorway, the *Margerita* hissed its snaky message of death and rebirth, of losing one skin (or measure) and growing another.

These works sum up Kounellis's iconography while remaining to a degree site-specific. In them a rebuilding program, or synthesizing, seems to begin, yet the elements are modest, fragmentary, almost anti-aesthetic. Clustering around the periphery of the large space, they leave the center open as a questioning, a space for the future, which cannot yet be defined, though its periphery is defined by the fragments of the past.

An overall contradiction can be stated for Arte Povera as a whole: that in general the artists of Arte Povera have regarded themselves as political artists—yet their work seems the dreamiest stuff compared to the works of overtly political artists such as Hans Haacke and Victor Burgin, and saturated with apparent transcendentalist overtones, as in Kounellis's motif of the prophecy uttered by mute golden lips. This art called "povera" looks oddly sumptuous and elegant for the name. Of course the materials of Arte Povera are often "political" and in this, Arte Povera equates loosely with Minimalism in American art history, a movement with which Arte Povera had a certain interplay, though neither group was actually formative on the other and they have their differences. The Poverists tend to feel, for example, that the Minimalists were too formalist, too polished and hard-edged, too concerned with purity of form, too ahistorical. The Minimalists might feel, on the other hand, that the Poverists were excessively poetic or literary, and that they obscured by their romanticism the industrial implications of some of their materials.

Perhaps in the long run, a more accurate analogy might be made between Arte Povera and post-Minimalism. Minimalism arose in America and Arte Povera in Europe as ways beyond the situation of formalist art which, with its depoliticized posture, tacitly supported the social status quo. In America artists stripped away decorative elements and focused attention as much on material as on form. Conceptual Art went even further, stripping away the last remnants of formalist aesthetics. The European solution was different. While industrial materials were used, they were not the central issue. At the center of Arte Povera is a poetic iconography that makes its statements without either the idealism of formalist art or the reductionism of Minimalism. Anglo-American Conceptual Art was shaped to a considerable extent by its reaction against formalism; Arte Povera may be construed as a more positive gesture, less shaped by negation.

Kounellis's work embodies the basic contradictions of Arte Povera. On the one hand it shines with a kind of poetic evocation that seems to claim timeless or archetypal status in the tradition going back to de Chirico, Surrealism, Symbolisme, and, ultimately, Romanticism. Gold and fire, for example, are elemental entities to a degree ahistorical in their cultural implications: They traditionally represent the value that transcends historical vicissitude and is not shaped or destroyed by it. Yet history is the central theme of the work, and its content orientation is revealed by the fact that it invites literary and allegorical interpretations somewhat more openly than the types of purely visual analysis associated with formalism. It is true that it is present as an image—but always a somewhat literary image, like the images of Surrealism. Kounellis's work expresses less a visual aesthetic than a visual poetic. A similar contradiction in the work centers on its suggestions of alchemical intention. The alchemical approach to art is essentially transcendentalist: It involves a wished-for escape from the mortal condition, a fantasied wholeness. Kounellis's use of gold, lead, and fire clearly implies an alchemical reading, but the artist rejects such a reading; insofar as it is present, it must be understood, paradoxically, as a secular, humanistic alchemy that does not mean to escape history but to celebrate it. These contradictions arise from a simultaneous acceptance of tradition (history) as the

given and a rejection of it as broken and no longer valid. "Since the war," Kounellis says, "our culture has operated through contradictions; we have only contradictions."

In traditional cultures art offered visual and other types of definitions or embodiments of the prevailing cultural and philosophical measure. In times when the measure is broken into contradictory fragments, the role of the artist, in Kounellis's view, is also shaped by contradiction. The artist must be at the same time social and political on the one hand, individually creative and self-expressive on the other. When the measure is changing, art can function either adversarily to destroy lingering credulity about the past measure or positively to fashion or define a new one. This is the great power of art and the great and serious role of the artist. The artist performs an interruption in the stream of measure, or of false measure as in our time; this interruption is the creative/destructive act through which the lingering appeal of the old measure may be destroyed and a new measure found. In Kounellis's view, an artist who attempts something else in his or her work does not understand the solemnity of truly belonging to history. His or her art does no real work. It enters the world of the market or of entertainment or of the mass media but it does no real work with the roots of culture and the problem of human nature.

The politics of the art world in general are divided between those whose work is informed by historical and social consciousness and those whose work often very deliberately avoids such involvement. At this moment in history (and in its subsections such as art history), there is a deep rift, an actual confrontation between a historically based consciousness (Modernism) and an antihistorically based consciousness (post-post-Modernism). This rift is being felt throughout the cultural world. In Italy it has led to a confrontation between two generations of artists. The artists of Arte Povera intended to express political contents involving being in history and belonging to it. In 1980 their position was threatened and shaken by the appearance of the so-called Italian Transavant-garde, a group of younger artists who have been presented to the world as a self-consciously post-Modern event, whereas Arte Povera had been self-consciously Modernist. The concept of the Transavant-garde is based on the belief that history is over and ideology is dead. These young artists, untouched by world war and thus perhaps innocent of the need for rebuilding, overleap history to evoke primordial or archetypal levels of feelings that are often regarded as ahistorical. This movement is sometimes seen by the Arte Povera artists as a betrayal of the seriousness of the artist's role and of the whole project of history and Modernism to which they dedicated themselves. The Transavant-gardists, on the other hand, reject the Poverists' attempt to co-opt them into the values of an earlier generation. They are mostly of a generation that did not experience the war, and instead were formed by 1970s pluralism. The two things are connected. One who experienced the war may be wary of pluralism, on the grounds that, in a really pluralist society, dissent may become impossible, just another cultural form. Under the cloak of pluralism, Kounellis feels, the Transavant-garde has made a faked return to totality—faked, because it ignores history and by doing so has endangered the dissenting function of art and the serious social role of the artist. From this point of view, the current enthusiasm for their work—which

centers in America, a country where the war was not directly experienced—represents an escapist desire to shrug off the responsibility of history. It seems to reject the future by returning to the past.

For Kounellis history is an overpowering fact. There was the period before the global wars and the period after them—a sociological difference so great as to be almost mythic or metaphysical. His concern with the future and with its changing prospects from one political moment to the next is present in his work even in its most poetic moments. As the fires of the late 1960s gave way to the smoke smudges of the late 1970s, so the live birds of the late 1960s gave way to the stuffed bird of *Apollo* in 1973, and, finally, to the arrow-shot birds of an installation of 1979. Arte Povera in general and Kounellis's work in particular arose not only during the political upheavals of the 1960s but as manifestations of them. In a sense, its moment has passed. Yet its investigations have not lost their validity. Kounellis's work conjoins poetic and political feeling in art objects that are almost like a visually embodied philosophy. In his oeuvre personal creativity does not conflict, as traditionally it so often has, with collective concerns. Kounellis has somewhat reconciled the contradictions between transcendentalist Modernism and critical Modernism. By avoiding settled style he, along with other artists of his generation, has demonstrated the artist's ability to create a new vocabulary that is more than mere provocation or challenge to the old.

Section Two: Winnowing Fan on His Shoulder? Kounellis's *Voyage* (1995)

In 1995 Jannis Kounellis gave a unique exhibition inside the cargo hold of an old freighter ship, the *Ionion*, moored at a dock in Piraeus harbor. The oil slicks on the water lapped at its rusted hull as the gulls wheeled by overhead. From outside, it looked like any beat-up old ship that had pulled its thousands of miles through seas rough and calm, and now looked forward to an old age of rust and rest. But hidden in its belly, in the cargo hold where the valuables are couched in the dark before loosing their radiance upon the world, secrets lay.

Descending in semidarkness, one could walk about. In a sense it was as a ship should be: everywhere signs of commerce, transportation, and industrial materials in shipment punctuated the dim uterine space. Sheets of steel were stacked in bins and shelves. Burlap sacks lay heaped upon wheeled dollies, ready to go into action at dockside. But as one gazed, these things began to relate in unusual, nonpragmatic ways. Steel bars strapped bunches of burlap sacks to walls. Coffee-measuring scales hung in an empty space in the center, as if tiny retail quantities were to be measured from the sacks right here. Sheets of pierced and lacerated lead hung overhead. Large stones dangled on metal rods from the ceiling. Heavy sheets of metal swung back and forth with the rocking of the boat. Six large rusted iron sheets mounted on one wall held gridlike rows of chunks of coal strapped tormentedly onto them, each piece of coal individually fixed with wire. Across the cargo bay, scrap

wood was stacked, its rugged and ragged surfaces lying in wait for some new construction project. It was like a lifetime's accumulation of stuff by some mad miser.

Everywhere were implications of cargo and shipment, trade and movement, and the crossing of boundaries under the auspices of the industrial revolution and its aftermath. But the vision was skewed into an archetypal focus: At the same time it referred to flux and change, and also to eternity. At the very end of the cargo bay, like a portent hovering over it all, hung the bottom half of a crucifix. It signified, among other things, the measure of a human being; the outline of a figure only half there implicitly invited proposals as to the unseen half. Its location in the cargo bed of a freighter ship suggested that a new or revised humanity was to be found through travel, commerce, and the sublation of capitalism into higher cultural realms through trade and the intrusions across boundaries that it entails.

In the Aegean heat the atmosphere in the hold became oppressive: the darkness, the heavy metal, the scrap, the hieratic solemnity of the things mounted high on the walls, the lack of almost anything standing in the center of the space except for a four-wheeled cart piled with folded burlap sacks; over all rolled a drumbeat of the implacable advance of industrialization and its imminent obsolescence as these huge sheets of corten rust and the sacks rot—and it just goes on and on, like the timeless rocking of the boat.

The exhibition was a distillation of several major themes that have informed Kounellis's oeuvre for decades. He often has recombined earlier works into new arrays which are themselves new works, refocusing the iconographic thrust of one element off another at a new angle. His shows have often been mini-retrospectives in which the rearrangement of elements is itself the central opus. That trait has never been more obvious than on the *Ionion*. The ship itself, rocking gently at dockside in the harbor of Piraeus where Kounellis spent his childhood and youth, its belly full of hidden wealth and portent from its far-flung travels, was a compact megasculpture that summed up more than an exhibition in a museum or gallery could. The site-specificity was double in intensity: the ship itself and the harbor around it.

Themes of travel, commerce, and industry have occupied Kounellis since the beginning of his oeuvre—and his travels. The wheeled dolly with stacks of folded burlap sacks, for example, first appeared as *Untitled* in 1967–1968. Another work (*Untitled*, 1968) was a wheeled dolly, as for loading or unloading a cargo vessel, piled with lumps of raw coal, signifying not only commerce but the spread of industrialization as the basic fuel of nineteenth-century industry sailed outward around the world. In a work of 1969, seven burlap sacks filled with red beans, white beans, coffee, corn, lentils, green peas, and rice stood mutely against a wall, awaiting their commercial dissemination over the earth like seeds. The catalog of such works could go on. The materials, forms, and references constitute an encyclopedic encapsulation of our socioeconomic world; the industrial revolution and its aftermath; coal, steel, stone, hanging bells summoning unseen workers to their toil as if announcing a sacrament.

Kounellis's oeuvre is layered like an archeological trench showing different strata of history and the different attitudes he holds toward them. On top is the contemporary world, which for Kounellis is a huge question mark, an entanglement not yet disentangled—the missing half of the cross on which the tragedy of industrial humanity is displayed. Beneath the contemporary is the world of the Renaissance, which figures as a kind of ideal of certainty, self-confidence in human nature, and sane goal orientation, which has been lost through the subsequent disasters of history, leaving the void of the contemporary question mark in its place. And on the bottom, always hidden yet always lurking there, unacknowledged yet taken for granted, is the ancient stratum of classical Greece of which the Renaissance was the partial rebirth. In general, Kounellis has de-emphasized this last, in a sense fundamental, stratum. As a contemporary artist, his sensibility is primarily with the contemporary. And behind the contemporary, as a ground of order from which the contemporary has strayed, but which is still available as a guiding memory, lies the Renaissance. In the stratigraphy, Greece lies almost hidden, as a repressed level of memory. There are also personal reasons for this, which are another prominent part of the *Ionion* show and as such are practically unique; Kounellis rarely has referred to the personal in his work, which has been, for reasons of social ethics, more communally oriented.

Kounellis grew up in a Greece that was still haunted by the residual aura of the Ottoman Empire and had not yet fully entered the modern world; a Greece which in a troubling way was caught between humanism and progress on the one hand, despotism and the past on the other. At age eighteen, seeking Modernity and the air that it offered to breathe, he went to Italy, the cradle of the Renaissance, and for some twenty years did not speak Greek or return to Greece. With his exhibition aboard the cargo ship *Ionion* he reclaimed—or admitted or acknowledged—the ancient stratum of these three layers, the original home of the Enlightenment, and at the same time acknowledged that Greece, no longer residually Ottoman, has emerged into the contemporary world. In terms of his personal Odyssey, he retraced his steps to Piraeus like Odysseus returning years later to Ithaka.

Art relates to ideas of time in different ways, sometimes gesturing toward an eternal beyond, sometimes toward an eternal present, sometimes pointing toward process and change under the direction of archetypes, sometimes with no direction but materialistic interplay or randomness. It's safe to say that Kounellis's work is rarely, if ever, merely random; also safe to say it does not gesture toward an eternal beyond. Kounellis's work at times induces a sense of timeless confrontation with a present moment which in itself is ordinary but which seems to have a certain sheen of higher meaning cast around it by the intense contemplation the artist has stimulated from the viewer. In the cargo hold of the *Ionion* there were many moments like this. The belly of the old ship itself, abstracted from the literalness of its function, seems to hark back over ages in which ships appeared in harbors, having sailed from unknown places. The cargo on Kounellis's ship, what he brought home from his years of wandering, was strange and new, other, unknown. It rode

the waves, quietly waiting like a monstrance at dockside, a question mark above the gentle lapping of the Aegean on the rusted hull. The coming of the Bronze Age, at the end of the Neolithic, to an Aegean island city such as Kea, must have consisted precisely of the arrival of one ship—with new, unknown goods—which, moored in the harbor, mutely invited onward toward unforeseeable events.

Standing in the heat and dimness of the hold, facing the sculptures of unworked, massive, rusting steel, one seemed again to confront a quiet provocation, a question mark: Into what shape, finally, will these unworked blank sheets be wrought? There is an emphasis on potentiality in them, as when Lao Tzu, in the *Tao Te Ching*, says: "They want sculpture? Give them the uncarved block!" These abstract building blocks of civilization, rusted and used, having come through ages of toil and endurance and still here, face us as if awaiting our desire, however wrong and perverse: What do you want us to do now, their presence implicitly asks?

But perhaps the most apt category is that of process taking place under distant archetypal sponsorship. The idea of art as voyage suggests that it is always beginning, never ending. As the Zen master Dogen said, "There is one word wise men never use: Complete." A ship as it goes from port to port, shedding here, accumulating there, carries objects with cultural as well as material meanings from their home matrices into strange settings where they are intrusive without yet showing the hidden intention behind their intrusion.

On a spiritual or personal level the idea of art as voyage suggests a path orientation; it implies that art will get you somewhere on its voyage without known destination, that it will accomplish something through carrying goods without known use or meaning. This is a voyage of transport for which a merely mercantile explanation would be strangely inadequate, a cover-up of some purpose more cloaked—more potential. There is, in Kounellis's Piraeus show, an echo of T. S. Eliot's remark that at the end of all our wandering we find ourselves back where we began, and understand the place for the first time.

The first thirty years of Kounellis's work were Modernist in their belief that history is a linear process going forward. But return—the archetype Return—is less linear than cyclical. It is a phase of the adventure of the hero addressed in myth for ages, whose ultimate archetype in Western cultural history remains the return of Odysseus.

That hero, having descended to the Underworld, inquired of the prophet Tiresias what would be the end of his roamings, what would be his death. He was told that, upon his return to Ithaka, he should walk inland with an oar on his shoulder until he was so far from the sea that the people knew it not at all. One day a stranger, seeing the oar he carried, would say, "Is that a winnowing fan on your shoulder, stranger?" There, at last, he should bury the oar and cease his wanderings. The function of the oar—to push life always onward restlessly—was no longer for him. He would be an ordinary man again.

But it has long been thought that this simple resolution of Odysseus's wanderings is not enough. Dante shows us, in the *Inferno*, an Odysseus who, tired of the quiet sedentary life, took up his wanderings again, ending in an underworld

different from the one he had visited to speak to Tiresias. Most prominently, Alfred Tennyson's Ulysses, in the great poem of that title from the poet's old age, acted out the Dantean resolution without the threat of Hell. After reentering, for a while, the life-role of an ordinary man, Ulysses grows restless and takes to the sea again for no reason except the voyage itself. "How dull it is," he says, "to pause, to make an end, to rust unburnished, not to shine in use!" He accepts, as in Kounellis's work, the idea of process never completed yet still given unchanging inner meaning by archetypes brooding over it. "I cannot rest from travel," he declares. "I am become a name, for always roaming with a hungry heart."

Lucas Samaras, Room #1 *(detail of installation at Green Gallery, New York), 1964.*
Courtesy of Pace Wildenstein. Photo by Wes Russell.

Chapter Seven

Intimate but Lethal Things: The Art of Lucas Samaras

Lucas Samaras, much like Kounellis, spent his childhood in his native Greece, during World War II and the Greek civil war that followed it. Samaras's father worked in the United States, creating an American connection that would come to dominate his life as Kounellis's move to Italy would dominate his. During the war, Samaras's family home in Macedonia was damaged by artillery fire, which killed his grandmother and injured his aunt. His childhood was spent amid wreckage and in deprivation; such toys as he had he made from empty food boxes or anything else at hand. In 1948, at age eleven, he moved to the United States with his mother to rejoin his father, in a new family home, an apartment in West New York, New Jersey, where his sister was born in 1951. After high school, Samaras went to Rutgers University, where he majored in art, coming into contact there with Allan Kaprow, George Segal, Robert Whitman, and other artists, and became a practicing artist while still living in his family home.

When Samaras graduated from Rutgers, contemporary art was in transition, as traditional forms began to yield to new media, and Action Painting led to Happenings. Samaras was fortunately positioned for this moment, both in terms of his acquaintances from Rutgers, some of whom moved immediately into the forefront of the new era, and in terms of proximity to New York. What the Piazza del Popolo had been for Kounellis, the exhibition spaces of New York would be for Samaras.

His work found an audience early. In 1959, at age twenty-four, he exhibited paintings and pastels at the Reuben Gallery in New York, the gallery where the early Happenings were germinating. Then, like many members of his generation, he turned to media that often incorporated found materials—exhibiting, in New York, an early box work at the Martha Jackson Gallery in 1960, a work of wood and feathers in *The Art of the Assemblage* at the Museum of Modern Art in 1961, pin-covered books and boxes at the Green Gallery in 1963. In addition, he was drawn to the Happening and to avant-garde film, and he acted in both media several times between 1959 and 1963.

Superficially, Samaras's development in these early years seems characteristic of artists of his generation. His transition from exhibiting paintings to exhibiting new media and participating in Happenings is typical of the widespread turn away

from formalist idealism toward art forms that related more directly to life. But despite certain obvious similarities, Samaras was different; like an archetype—or an outsider artist—he has remained peculiarly and unavoidably himself. His themes and preoccupations were to lead into investigations of the elusive facts of selfhood rather than of social relevance and connection. In fact, it was the most difficult facts of selfhood he compulsively addressed.

In 1964, Samaras's parents and sister moved to Greece. He was left strangely alone in New Jersey. There was no mistaking the moment: It was time for him to move out of the family home to an apartment of his own in Manhattan. The move involved laying a claim to a kind of citizenship that was more than national; it required leaving behind the family identity and initiating himself into a reality longed for but only vaguely known, until he should become, as Samaras has re-marked, "a member of the club of all the artists who have lived and died." This rite of passage was undertaken in an installation called *Room #1*, in the legendary precinct of the Green Gallery, under the direction of founder Richard Bellamy.

Samaras persuaded Bellamy to construct in the Green Gallery a room about the size of the artist's bedroom in the family home in West New York. Into this space, rather than into his new apartment, Samaras moved the furnishings and accumulations that had filled his room through his teenage years, his college years at Rutgers, and his early explorations of art. For over a decade the little room had been his private space in a double sense—both his bedroom and his studio. In it were partly finished artworks and piles of small objects he had collected from the world at large for use as art materials—as once he had collected cast-off things to make toys in wartime Greece. Loosely placed and stacked around the little space were tangles of colored yarn, bags of beads, aluminum foil sculptures, rectangles covered with pins and mounted on the wall, partly finished boxes, little sculptures of plaster-soaked cloth, paintings, pastels, a handful of books—and, at the center of it all, a monumental icon of selfhood and isolation, a metal-frame single bed with a blanket stretched starkly on a sheetless mattress, the string from the central ceiling light dangling downward to be in reach of someone lying on the bed who longed to go into darkness. In the dark this nameless self would lie among the childish things he made, as if embraced by a familial love, while wandering away, on paths they have suggested, into dreams that lead always back to himself.

In the context of its times, the installation is related to various works—from Robert Rauschenberg's *Bed* (1955) to Chris Burden's *Bed Piece* (1972)—that aimed, at least in part, to heal the breach between art and life that the era of the formalist sublime had promoted. The Rauschenberg and Burden works especially, by bringing elements of the bedroom into the gallery, suggest that art is not a thing that transcends life but a part of the life process, so much of which—birth, sex, sleep, dreams, illness, death—takes place in bed. Yet Samaras's work, although it was part of the momentous transformative project of healing the breach, of reintegrating art and life, inherited by his generation, was more complex. It involved counter-indications, negative electrical surges which would annihilate the self and its world in the very act of seeking them. Perhaps because of his early wartime experiences,

Samaras knew that before one can integrate art and life one must first locate the self in which they can coexist, and it is the elusiveness, the shatteredness, of this self—hence implicitly the futility of the project—on which his bedroom installation focused.

For Samaras the piece connects even more closely with van Gogh's painting of his bedroom at Arles than with contemporary strategies for conflating art and life. What both works ask is this: Here is the artist's room; where is the artist? In van Gogh's case the portrayal of the artist by his absence seems to presage his imminent death. We see the nest after the artist has flown from it. Something similar but less final occurs in Samaras's *Room #1*.

The emptiness of Samaras's bedroom installation pointed, on one level, to the plain fact of his move out of his family home and into another of his own; it signified a kind of death, an end to one identity and the beginning of another. But, seen without its immediate biographical context, the piece is generally about the absence from view of any identity at all. An intimate history was laid bare in the objects of someone's growing years, but over it hung an absence that asked who, in fact, it might be, this self that accumulates objects, creates history, leaves traces.

More even than the place of birth and death, the bedroom is the arena where the self defines itself in the midst of life through intimate activity. *Room #1*, with its presentation of the bedroom as a cosmos, expressed Samaras's desire to eroticize the world of his art. Samaras would later refer to his artworks as "intimate but quite lethal things." Here is the font of the intimate-and-lethal, its throne and its playing field—the place of solitude, of solipsism, of autoeroticism, also the place of being at home, of belonging, of being not only a citizen but, even, a master of one's own domain. And, finally, here was the place of sleep and dream, the place of nocturnal transformation that has remained at the heart of Samaras's work.

The absent human figure, when suggested by its traces, is a haunting kind of presence. The prototype of such presences is the ancient broken statue, an image basic to the Romantic sensibility. Viewed art historically, in terms of the millennial dominance of the art of the figure, Samaras's work is a reversal. Without becoming architecture, it shows not the figure but the places it has emptied by departure or no-show. Without becoming furniture, it lingers over the seats it has lately arisen from to walk away. Finally the figure shows itself only in ghostly photographs, flexing its devilish muscles at the edge of the frame. Most manmade artifacts contain hints of the figure, and Samaras has incorporated such absent but implied presences into his work everywhere, demonstrations of a selfhood not itself to be seen—eyeglasses shaped to the human head, knives shaped to the hand, above all, chairs with their arms, back, and (as we call them) feet.

In early Buddhism, an empty chair was a symbol of the Buddha, who had realized the unreality of the self and hence was presented as an absence, as one who is no longer there. There is something similar in Shinto ritual, where an empty chair indicates the presence of a ghost, as it does in the banquet scene of Shakespeare's *Macbeth*. The chair, in effect, provides a trace or the mold of a human figure to look at when for one reason or another it is no longer possible to look directly and

unashamedly at the human figure itself. As with an empty suit, even when the figure is gone, it is seen, invoked, invited. Like the ruined ancient sculpture pedestal, the empty chair presents itself on the one hand as a sculpture, on the other as a sculpture base from which the real sculpture, the human figure, has escaped.

A year after the bedroom exhibition, in 1965, Samaras began making "chair transformations." He continued to make them until 1970, then took them up again in 1985 and 1986. Sometimes these works are altered chairs; sometimes they are chair-shaped, coat-hanger armatures to which various transforming elements have been attached—pins, razor blades, knives, artificial flowers, wool yarn, mirrors.

Samaras's chairs are a kind of art of the figure for a time when the human figure lacks credibility. They are like a perfume hanging in the air, wafting the scent of a person not seen. Flowery or spiky, embracing or threatening, they mean humanness in all its difficult selfhood. They are made to our shape, to our definition and our measure; a visitor from outer space could know us from our chairs. They are negative pictures of ourselves, traces of our handiwork and the desires it springs from, remnants of our dreams of comfort in the body, monuments of our triumphant passivity in just sitting there as ourselves.

There is a stage-set or stage-prop quality to many of these pieces, a quality that restates the theatrical self-presentation and self-withdrawal that is a unifying theme of Samaras's oeuvre, from his early appearances in Happenings to the teasing self-portrait drawings of 1986. *Room #1,* especially, is like a concentrated stage set for the drama of the self, which dominates by its absence. The art materials stored in bags and buckets and piled into mounds, the wool and fabric and other things out of which future works would be woven and stitched and otherwise composed, are a promise of Samaras's artistic future. The open door shows him walking away from the past. (Does he walk serenely or flee in a desperate panic? Whatever. The door hangs open behind him.)

For Samaras's generation the project of bringing art back into life involved the task of exploring the transition from two to three dimensions—from painting to sculpture, and then from sculpture to performance and installation. Between the late fifties and the mid-seventies, the relationship between the two- and the three-dimensional realms was analyzed by a variety of mappings (ethical, formal, and so on) of the terrain between them. This process was under way equally in Europe and the United States. One major transitional device was the monochrome painting. In the fifties, in the work of Yves Klein, Ad Reinhardt, and others, this genre functioned as a diagram of the sublime or absolute, a visual analogue of the metaphysical idea of oneness, emptiness, or the void. About 1960, before the origin of Pop Art and in a sense presaging it (along with other things), the monochrome painting ceased functioning as a flat symbol of the absolute and became instead a quasi-sculptural object; denuded of all representation except its selfhood, it became the predecessor of Minimalist sculpture as much as of Minimalist painting. Klein, in 1957, moved his blue monochromes away from the wall to become sculptural objects to be viewed in the fullness of space. Piero Manzoni, in the early sixties, took the map a step further, treating floating blank objects as sculpture-bases rather

than as sculptures, affixing to them such three-dimensional objects as balls of unspun wool and dinner rolls. From having a representational function, the surface of the painting had come by a series of steps to have a presentational function. Not only was it present, rather than represented, by virtue of the objects adhered to it, it also functioned as a blank space—an arena, a stage—on which presented objects, like actors and props in a theater, might strut their stuff.

Rauschenberg's change of mood in interpreting his white paintings of 1951 encapsulates this turning point: He spoke of them first as "one white as one god," later (in 1968) as "open compositions . . . responding to the activity within their reach."[1] The idea of theological presence had evaporated into the social. The white painting was now to be understood not as an icon of the absolute but as a surface onto which the spectator's shadow was to be thrown, involving on the once-illusionistic picture plane the real events in the three-dimensional space surrounding it. Rauschenberg's combines, along with certain works of Jim Dine, Claes Oldenburg, Jasper Johns, and others, made the transition from painting to sculpture in the United States, as, in the work of Segal, Whitman, and others, the transition from sculpture to performance and installation occurred.

Samaras's work is less easy to place, less conformable to a designation by school or movement or program. This quality of not exactly belonging in the mapped cultural universe is an aspect of its outsider identity. In a vocabulary at once more personal and more ambiguous than art-historical groupings allow, he made his peculiar mapping of the ground precise and clear. His paintings of the late fifties cross the threshold into sculpture and installation in various ways. A special icon of this moment in art history, like Manzoni's achrome with dinner rolls or Rauschenberg's monochrome for spectators' shadows, is Samaras's monochrome surface of 1960, onto which sixteen double-edged razor blades have been affixed at right angles. A related work of the same year shows a monochrome surface from which the pointed ends of nails face the viewer. There is an outsider honesty about human feeling in this work, a recognition of the emotional significance of moving from illusion to presence, from representation to presentation, that goes beyond the achromes of Manzoni, the combines of Rauschenberg, the sponge-and-gravel paintings of Klein, and other works of the time that move out from the wall and incorporate objects into them. Whereas those other works stride confidently into real space with a certain bravado, as if there were nothing to fear there, Samaras's works, relentlessly outside, creep from the wall into the viewer's space armed for defense; they keep the spectator away instead of inviting him to reach and touch. They suggest a human consciousness of the fact that, when moving out of the hiding place of illusionistic flatness into the open, where real people stand, one needs defensive armor, like the razor blades—or perhaps invisibility, as in *Room #1*.

The next stage in this development is represented by the pin-covered books and boxes that Samaras exhibited in a group show at the Green Gallery in 1963. Books and, especially, boxes are media that Samaras has worked with for over thirty years. What they share is not only a general shape and size but, above all, their function as containers. The photographs of *Room #1* reveal a fascination with

containments; there are paper bags filled with various kinds of stuff, an overflowing bucket, a vitrine-like cabinet, a shelflike box decorated with windings of wool on the inside walls. *Room #1* is itself a large box-work, with its lid partly open and its mysterious presence/absence inside. It would not be unreasonable to regard Samaras's boxes as his most characteristic medium, though there could be other candidates. The boxes go a step beyond the monochrome painting with added objects in the transition from the two- to the three-dimensional. They incorporate both painting, in their decorated flat rectangular surfaces, and sculpture, in their three-dimensional presence in general but especially in the secret and dark volume of their interiority.

The aesthetics of the box has been a major but largely unacknowledged element in the twentieth-century exploration of forms between painting and sculpture or including both. Marcel Duchamp's *The Green Box* (1934), containing texts on paper, is a conception of the box—as was the case with Samaras at first—as a kind of book, a repository of information. *The Box in a Valise* (1941) opened the book, moving it toward sculpture, but still contained, like a book, reproductions of things, instead of things themselves. Joseph Cornell rendered the box into a truly sculptural rather than symbolic form, placing real found objects, rather than representations of them, inside. Many of the works of the Fluxus artists were boxes (Flux-Boxes) that in general belonged to the emerging tradition of Conceptual Art, in contrast to the sensual object-art of Cornell.

To Fluxus artists the box was important as a break with aesthetic tradition—because of its portability, which denies that art is a thing that happens only in special venues such as museums and galleries; its invitation to the found, as opposed to the crafted, object; and the ease with which it bypasses pictorial treatment. George Brecht, for example, exhibited at the Reuben Gallery in 1959 a piece called *Koan* that consisted of three boxes. In the first a child's alphabet blocks were exhibited nonsensically, simultaneously displaying and denying their function of creating verbal meanings; in the second the blocks were painted one color, denying alphabetic difference and obscuring their constructive function; the third box was empty. The piece was a conceptual critique of the process of representation, both visual and verbal.

Samaras's boxes have much more in common with those of Cornell than with the conceptual works of Fluxus artists. They are not statements against easel painting or representation or the museum. They are covered inside and out with sensuous decoration and often present the box as a series of interconnected picture planes. Yet they contain a message, a thematics, that goes beyond Cornell and beyond decoration and beyond the picture plane to constitute an authentic philosophical insight that is characteristic of Samaras's work. Often his boxes are less about what is put inside them than about the facts of boxness itself, the facts of containment. They emphasize not only the fact that the box unites qualities of sculpture with qualities of painting, but also that it marks the boundary between an inside and an outside and as such involves suggestions of privacy and secrecy. Samaras focuses on the relation between the inside and outside of the box, its totally

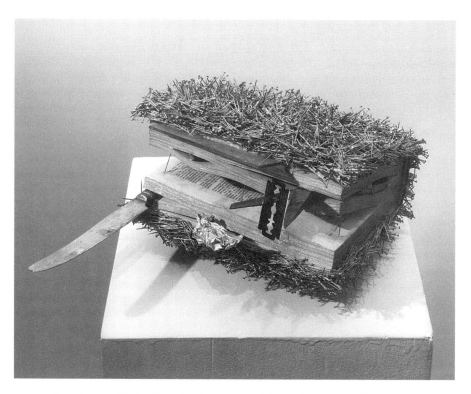

Lucas Samaras, Book 4 (Dante's Inferno), *1962. Collection: The Museum of Modern Art.*
Photo: © 1998 The Museum of Modern Art, New York.

visible and accessible exteriority and its dark interior hiddenness, its inner night, its absence, its soul.

Most of Samaras's boxes are about the size of a human head. At least one of them contains a picture of a human brain. They are often only slightly open, offering a difficult glimpse of their contents. The outside, which stands naked to the world, is apt to be protectively or seductively built up in various ways. Often, in the early boxes, such as those exhibited in the Green Gallery in 1963, the exterior is threatening or thorny, covered with pins or razor blades. The box, unlike the painted surface on a wall, involves an invitation to the hand to reach, grasp, and open it—an invitation that the threatening exterior cancels at the same time it is offered. These works, then, incorporate the human paradox more fully than the related wall-hung surfaces did. They express the difference between the taboo area inside a human being—both the inside of the body and the inside of the personality, the thoughts, feelings, intentions, and ambitions that no one outside ever fully and surely knows of—and the outside, that aspect that faces the world, that is there to keep away the world from that hidden interior, to protect its secret life. They tease by their slight openness while repelling by their forbidding surfaces. They seem to ask, "Is there

really anything inside? Reach if you dare." They are about the boundaries that make one a certain person and everyone else certain other people; they are dangerously concerned with crossing those boundaries, with the fear that those boundaries will be crossed, with the longing to cross them in others—and to have them crossed in oneself. They are about the possibility and the impossibility of relationship. They are not so different in this from the act of inviting the world into one's bedroom, then not being there oneself.

The vital and private quality of these works echoes associations from Samaras's childhood. In the Greek churches near his home were reliquary boxes containing human remains—skulls and bones and dust—that children would look at to scare themselves. At the same time the box, in the form of the Red Cross package or a mailed gift from Samaras's father, was associated with delight, surprise, and nourishment. The contradictory character of these associations is echoed in the simultaneously seductive and threatening nature of Samaras's boxes, their extremely exacerbated sensitivity to the boundary between inside and outside. This boundary is presented from many angles, through an iconographic vocabulary in which elements recur in varying recombinations. A box covered with pins, with a photograph of Samaras's face on the outside and a tangle of soft many-colored yarn visible within, suggests a personality that is soft inside and needs a lot of defensive equipment on the outside—a common pattern throughout Samaras's work, where inviting and repelling elements frequently combine and balance one another. *Box #102*, covered outside with pins and filled inside with pencils, suggests a personality ready to express itself endlessly, screeding on and on, while repelling or distancing the listener to compensate for the very force of the urge to communicate. *Box #105*, with twisted forks protruding from it, suggests a similar nexus of soft and hard, nourishment conflated with threat, the fork as an instrument for feeding oneself or for attacking another.

Some of the works expand this emotional ambivalence into a cosmographic statement. *Box #32* (1965), for example, is covered with black hair and has two frontal protuberances that suggest eyes at one moment, when the box is seen as a head, and breasts at the next, when the box presents itself as a torso. On the figure's left breast is a vegetable, and from the right breast a skeletal white ivory foot protrudes. The piece is like a double-goddess icon from the Neolithic Age, expressing both the anabolic and the catabolic, both the nourishing and the devouring aspects of the life force. Some icons of this type—from Catal Huyuk, c. 6000 B.C. in Asia Minor—have the jaws and beaks of predatory beasts and birds concealed inside molded clay breasts. In later Bronze and Iron Age versions of such icons, one breast gives life and the other death. This is a motif psychologically associated with the mother (the "good breast" and the "bad breast"), and the infant's desire both to recombine with the mother's body and to differentiate itself from it. The "potential space" concept of D. W. Winnicott, that misty space of infancy where one is neither identical with nor separate from one's mother's body, is a plausible arena in which to conceptualize the birth of much of Samaras's art—and a plausible correlate of that central icon of it, *Room #1*.

Many of Samaras's boxes after 1967 show a different posture of self-presentation. Rather than standing alone, they incorporate large ornamental supports that represent less the body on which the head rests than extended ego-exteriors or personae. The public equipment of the boxed personality extends and ramifies itself in surrounding auras of seductive form. Though their exteriors are often more inviting than those of the earlier, unsupported boxes, this apparent ease of approach is negated in various ways—sometimes by their being tightly closed (as in *Box #74* and *Box #76*, both 1968), sometimes (as in *Box #72*, 1968, and *Stiff Box #12*, 1971) by the distancing and protective surround of the lightninglike and dragonlike support, sometimes by a delicate balancing that would be unbalanced by removing anything from or adding anything to the box itself. Like the chairs, these works feature the theme of transformation, as the basic object type is run through a dizzying series of variations and rebirths. Again something about instantiation, particularization—an individuality as of human personalities—is involved.

The moment, about 1960, when Samaras added three-dimensional elements to his paintings, nudging them to expand into the box forms, also produced another series of developments. A wall-hung rectangle of 1960–1961 shows a heap of nails, screws, nuts, and washers in the middle of a rectangular frame of plastered feathers. Upright on the wall, the work is a late easel painting nodding toward sculpture, but lying on a table it would look more like a strange bowl of soup or plate of stew. This work was followed, between 1961 and 1965, by others employing more explicit depictions of dangerous dinners. Nails, razor blades, pins, forks with outwardly bent tines, and other sharp objects, along with softer but still inedible stuffs like colored yarn, are arranged on dinner plates and in stemmed glasses in dining-table place settings. Like the boxes, these works go beyond the monochromatic paintings with razor blades or pins, piercing more aggressively into the spectator's physical and mental spaces. Whereas the painting was there only to be gazed at from a distance, the plate of stew is an invitation to physically engorge —and, like the pin-covered box, one that cancels itself out by the repellent and threatening mannerisms that accompany it. The razor-blade painting bullies; the dinner invites first, then bullies. In these distinctions Samaras's art grows toward itself.

The threatening aspect of Samaras's work has often been interpreted as expressing hostility toward the audience. Among the most common terms in the critical literature on it are words such as "threatening," "menacing," "malign," "malignant," and so on. But in fact his iconography is more ambivalent than such words suggest. It contains, alongside the threatening materials, soft, curvaceous, and inviting ones—masses of colored yarn, feathers, fabrics, flowers, pastels, cotton. Even the threatening materials have a sort of domesticity that belies the threat— straight pins, forks, kitchen knives, and so on. More than an oedipal aggression, there is a memory of a childhood spent with Mother, with Father absent, in these materials and motifs.

Aggression here seems a method of defense, like the distancing exteriors of the brain-holding boxes. The "dinners" express a wish to be eaten, a desire to be

absorbed into the other, an offering of oneself to the most voracious appetites of the viewers. The menacing stuff upon the plate is a defense against the teeth and jaws of those who were invited to the dinner in the first place. One dinner work of 1961 shows a plate with a mess of stuff on it from which two eyes peer at the diner; the spoon that the diner is about to pick up is already in the mouth of the food. The eater and the food are each other.

Part of the remarkable openness of Samaras's work is his use of whatever is around him—his bedroom, his kitchen implements, his broken things. He throws it all into a cauldron of transformation that is, in a molten form, his personality. It was one of the characteristic acts of his generation of artists to bridge the gap between art materials and life materials, to aggressively introduce everyday or real-life stuff into their artwork. But for Samaras this seems to have happened differently than for others; for him, it seems, the distinction between art materials and other things was not so clear as to have to be eradicated by a special act of decision. For Samaras, whatever is at hand is already, automatically, an art material, a thing whose potential lies less in being itself than in being transformed. His wartime experience in childhood seems to relate to this acceptance of everything as raw material, as rubble to be reprocessed into new form.

In a sense Samaras has created a world to replace the threatened world of the bombed house—a world full of motherly things, but also full of the secrecy and defensive aggression of terrorized children. There is the empty chair for the ghost to sit on; the table is laid with the deadly meal; the box sits off to one side, protecting its secrets; the empty bed waits, silently and patiently. The room in which this meal is to be eaten, this bed slept in, this chair weighted, appeared in 1966 as *Room #2*—an eight-by-ten-by-eight-foot wooden construction completely covered, inside and out, sides, top, and bottom, with two-foot-square mirrors.

There is an ancient story of such a room being built, in the annals of the T'ang dynasty in China.[2] The Empress Wu Zetian, a great patron of Buddhism, asked the master Fa Zang to demonstrate the wonders of the Great Totality, including the containment of one by all and of all by one. A few days later Fa Zang led the empress into a room lined with mirrors, with an image of the Buddha in the center. In each mirror every other mirror was reflected, and in each reflection every other reflection was seen, and so on. One and all were inseparable and mutually contained.

Samaras's mirrored room is different from Fa Zang's in several ways. Whereas Fa Zang placed the Buddha in the middle, Samaras left *Room #2*—like the bedroom installation, *Room #1*—empty of human presence or representation. At the same time, he prepared the mirrored room, like the bedroom, for human presence, installing in it a table and chair that, like the room itself, are covered with mirrors and tend to disappear in the reflections, as, it seems, has the person for whom this room is prepared. Samaras's room expresses more directly than Fa Zang's the dependency of the self on its surrounding conditions—its tendency, when an attempt is made to grasp it, to disappear into them.

Samaras has made five human-scale mirrored spaces (*Room #2*, 1966; *Corridor #1*, 1967; *Room #3*, 1968; *Staircase*, 1968; *Corridor #2*, 1970) as well as hand-

sized or head-sized inwardly and outwardly mirrored boxes. There is a relationship between his mirrored spaces and the ancient Buddhist symbol. Both focus upon the concept of the self and seek it simultaneously as a thing that has wholeness and presence and as a thing that is torn apart by exteriority, absent among its own reflections. In the mirrored rooms, Samaras uses selfhood as a material, as he has always used whatever happened to be around. *Room #2* is the alter ego of *Room #1*. The endless ambiguity between self and other that is potential space is visually realized in their conflation; the mirrored room brings out into the light what happens in the bedroom where, with eyes closed and in the dark (having pulled the dangling string), one multiplies into the countless selves of dreams. The empty bed and the countless mirrors reflecting emptiness are complements showing the marks of subject and object, seer and seen, both defined by the space, though both absent.

The mirrored room is the ultimate metaphor for the question, or questions, of selfhood: Is it one or many, is it enduring or changing, is it defined by itself or by its difference from another? And so on. Here and in the empty chair (and in some other places too) Samaras's work has some overlap with Buddhist thought, but it would be deceptive to regard this overlap as devotional. It is the emphasis on the question (or questions) of selfhood, not a spiritualistic or pious mood, that is shared.

A common body of terms in the critical writing on Samaras's work, alongside the category of "threatening" words, includes words like "narcissism" and "solipsism." Narcissism, of course, refers to the state of mind of the Greek mythological character Narcissus, who fell into a trance while contemplating his own reflection. The image is related to certain widespread philosophical ideas, such as the idea, found in Buddhist and other contexts, of the mind which knows only itself, the subject which is its own object. It is an image of the inescapability of selfhood, along with its eternal elusiveness, of the tantalizing sameness and difference of subject and object, self and other. Solipsism is a related concept. Made up of the Latin words *solus* and *ipse* ("self only"), it indicates the idea that other beings and things may be merely thought projections or dreamlike extensions or reduplications of oneself (another common idea in Buddhist thought). And indeed Samaras's work is, to an uncommon degree, like the projection of an elusive selfhood onto a reflecting surround. His self-image, especially the photograph of his face, is a constant presence—like a motif—in his oeuvre. It is included, as photograph, in many of the boxes of the early sixties and appears also in many of the pastels and ink drawings. In many works it is present in the form of an X ray of the artist's skull—a photographic penetration into the taboo area inside the human self. At the same time that it is elusive, mysterious, or absent, Samaras's self-image functions as a unifying or cohering substance in the oeuvre.

But the theme of the self is the complement of the theme of relationship, and the theme of solipsism, of the self in and by itself, always carries with it as a whispered alter ego the theme of the other. Without an other, in contradistinction to which it can be defined, the self could not be perceived as a self. And in the self's need of an other, its helpless positing of an other, lies the unavoidability of relationship. This finally is what Samaras's work is all about: the trap of the mutual and

reciprocal need of self and other combined with their essential and eternal separation—the simultaneous need and impossibility of relationship. And this aspect is part and parcel of that other, menacing, aspect. It is because of its exacerbated focus on this edge between self and other that the critical literature applies to Samaras's work words such as "threatening," "malignant," and "malevolent." There is a brilliant and profound contradiction here, for the work itself features open and naked offerings of the artist's self to an unknown public. The sense of threat is there because so much is being offered that it has to be protected.

It is in Samaras's photographic works that this reciprocity or mutual containment of self and other is most clearly seen. His film *Self,* made with Kim Levin in 1969, shows Samaras in various activities, including waking in his small apartment; bathing; playing like an obsessed artificer with whatever object falls into his hand; viewing Manhattan from across a river while artillery shells explode on the sound track; eating photographs of his father, mother, and sister; destroying one of his own box creations; finally grinding the word "self" between his teeth. It is a series of symbolic images of both the constitution and the denial of the self.

The auto-Polaroids (1971) and photo transformations (1973) go beyond symbolic statement to direct embodiment of the role that the camera plays as a companion, a means of drawing the other out of the self, of arousing relationship out of the midnight void when home alone at night. In these series, Samaras photographed himself in his habitat, the same apartment shown in the film *Self.* There is a sense of masturbatory nocturnal solitude to the process. In the auto-Polaroids Samaras often appears naked while barring the viewer direct access to his nakedness by a defensive body position or an alteration of the photograph. In the photo transformations he often presents himself in monstrous and threatening guises as a kind of wolf man or nightmare apparition, both offering his nakedness and snarling at those who might want to approach it.

Samaras has described his self-photographs as "a complicated gift to others." They seem to express a desire to be loved that is so strong that it disgusts itself and creates in balance an appearance of a desire to be hated. They map the way photography relates to selfhood—its simultaneous capturing of the self and freeing of the self through creating for it a new persona—and at the same time they involve or even co-opt the viewer in a masterful act of manipulation. The act of presenting to a world a photograph of oneself is an act of seduction, while the often threatening qualities of the offered self-image, like the pin-covered exteriors of early boxes, intimidate. Again, Samaras seduces and bullies the viewer simultaneously, locking both himself and the viewer in the photograph, as the viewer's anticipated fears or reluctances to see the image are nakedly on view as a part of the image itself. The camera becomes a way of being seen without requiring another party's presence, a way to force a relationship upon the world with or without its consent. Much of this lonely nocturnal work seems to burrow deeper into solipsism while trying to escape it, as if seeking the back door out of solitude. It seems like what one might do if one were the only person left in the world and wished to conjure another up by dares, challenges, seductions, and teasings into the abyss of silence.

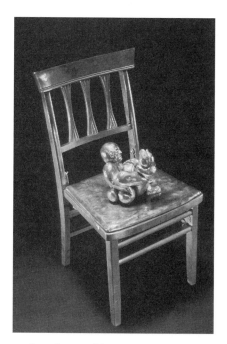

Lucas Samaras, Chair with Male-Female Entanglement II, *1983. Courtesy of the artist.*

It is not a coincidence that the camera is a box—and in fact that it is a box tricked out with mirrors inside. This box acts out yet again the theme of transgression of boundaries, of the empty, receptive interior where the elusive self may be penetrated. Taking a photograph involves opening up a box for a moment and letting something in, then closing the box and trapping it in there. What goes in, of course, if the camera was pointed at a person, is someone's visual identity, what the Egyptian *Book of the Dead* regards as the image-soul. It is a picture of someone, and that someone is usually sitting in a chair—filling out the open question that the empty chair proffers, and offering it up to encapsulation in the closing box.

From 1978 to 1980 Samaras did a series of portrait photographs of other people, posing them on a chair before various Polaroid cameras in his living room (once making a portrait of the empty chair alone). The subjects are usually naked, posed on top of a small platform. Off to one side, fully clothed, sometimes half-concealed, is the photographer himself, looking like a kind of Mephistophelian impresario. In contrast to Samaras's naked self-portraits, in which he allows himself the luxury of behaving aggressively to offset the vulnerability of his nakedness, the subjects of these sittings are sedately and passively confined to the chair. Indeed, these portraits are like acts of aggression in which the subject is stripped naked and captured in a state of infantile helplessness by the photographer, who seems in absolute, almost sadistic, control. As in the self-photographs, the camera creates and defines a relationship while the photographer remains somehow outside of it and alone. The resulting portrait of the photographer is often more magnetic than that of the ostensible subject. There is a muted relationship here with the semiotics of pornography, in which suggestions of dominance, submission, and penetration of another's selfhood cling around a situation in which one party is fully clothed, the other naked.

Samaras's iconography of selfhood had been spelled out pretty fully by 1980. His work of the eighties has seemed to involve a renewal of interest in traditional media, especially bronze sculpture and acrylic paintings. In fact, these works are all rooted in earlier strata of his oeuvre. The small bronzes relate to small cloth-and-plaster sculptures made in the early sixties. Like them, they often portray sexual intimacies with suggestions of hermaphroditism, two beings of the opposite sex conjoined in one body, and are in this sense linked to the self-photographs and

to the erotic-solipsistic level of Samaras's oeuvre in general. Samaras has exhibited them in clusters on a gilt bronze table or on the seats of gilt bronze chairs rather than on conventional sculpture bases.

The acrylic paintings, usually on canvas board (a support associated with the work of amateurs), also have early roots. In fact, Samaras has made paintings more or less consistently since college, though for many years he did not exhibit them. Unlike that of many of his contemporaries, his work, despite its emphasis on nontraditional media, does not involve a rejection of painting and its traditional sheltered exhibition space, the museum. As an outsider he is not much concerned with such intraprofessional issues. The question of the relation of art and life in his work is not so bound up with art-historical matters as is the case of many Western European and American artists of his generation. Although many have sought modes of installation that deny the sheltered space of art, Samaras has tended to separate his artworks from the surrounding space in Plexiglas boxes, almost as if trying to protect them from the space, from being sunken, merged, in the matrix of life. The dignity of art as an undertaking in addition to the usual requirements of life is thus upheld, the special sense of belonging to "the club of all the artists who have lived and died."

The acrylic paintings relate to the pastels, which Samaras has also made in great numbers since 1959. Some of the acrylics and pastels are abstract, some representational. The representational works are unified by recurring and character-istic Samaras motifs. Frequently self-portraits, some are direct predecessors of the photographic works, involving the same use of the self as material for analysis. Samaras's ultimate self-portrait, the X-ray of his skull that appears in many works of the sixties and seventies, leads into the ink-wash drawings of skeletal human heads of the early eighties and the art-system portraits in acrylic on canvas board exhibited in 1985. In these portraits, garish and confrontational skull-like heads with exposed eye sockets and bared teeth—and often double mouths, suggesting a voracity that the skeletal aspect mocks—glare at the viewer like mementi mori, reminders of one's inner essence of mortality, mirror reflections of oneself as a grinning skeleton. With their emphasis on almost demonic mastication, these works refer back to the early dinner works and to the transgression of the boundary before the taboo interior of the body. The fact that the various grinning skull portraits are named for roles in the art system—the dealers, the spectators, the critics, and so on—should not be allowed to obscure their universality. The art system is singled out because it is where Samaras happens to be located. One is defined, to an extent, by where one is located—by the surrounding other, that is, against which one's self takes shape through acts of both aggression and defense. Like a medieval artist painting a dance of death, Samaras holds up the mirror of mortality to the surrounding network while, as in his photographic portraits of others, his own self is implicated and reflected in it. In this sense the art-system pictures are like another mirrored room.

Many of the pastels, like many of the acrylic paintings, are abstract compo-sitions of types familiar from Samaras's boxes, chairs, and other three-dimensional works. The multicolored dotted surfaces, concentric squares and circles, discs with

multicolored radii, are all seen on both two- and three-dimensional works. There is less here of traditional abstract painting, with its burden of sublime implication and existential self-discovery, than of decoration frankly and forthrightly presented in the course of a systematic study of the relations and transitional stages between the two- and the three-dimensional. The boxes, for example, are treated as multiple conjoined paintings, as small installations in themselves, incorporating, both inside and out, miniature paintinglike spaces. Many of the chairs also function as unfolded paintings, paintings that, as in recent design-dominated abstraction in both Europe and America, have blossomed into quasi-architectural presences.

It is in another series of two-dimensional works, the Fabric Reconstructions, most made between 1976 and 1980, where a more determined incorporation of the principles of abstract art is found. From a few feet away these works look like pattern and decoration paintings. With their slashing diagonals and their sense of intense speed of execution, they share a feeling of Action Painting also. Up close one sees that they are formed of many strips of different patterned fabrics stitched together. Samaras's father was a furrier, and during teenage summers Samaras worked in his father's shop in New York City stitching small pieces together. The autobiographical aspect of the genre is deepened by its incorporation, like much of his work, of elements traditionally associated with craft, which Samaras has brought into the domain of art. The look of Action Painting is in a sense rendered absurd by the slowness of the process involved, but in another sense it is accurate. In making these works, Samaras begins with a large piece of fabric, which then is cut continuously from one edge to another. A third piece of fabric, of different design, is then stitched between the two pieces cut apart, and rejoins them. Another cut is made, again from edge to edge, of the new whole, and again a new piece is introduced into the cut, joining the severed pieces anew. The works are not cumulatively added, in other words, so much as they are reductively cut apart. The action, the analogue of the Action Painter's brush motion, is involved not in the stitching but in the cutting; it is the severing or destroying act that is the source of the formal qualities.

The distinction between Samaras's three-dimensional and two-dimensional works is not thorough. In general the conjunction of the qualities of intimacy and lethalness, which is a special gift his work offers, is more intensely present in the three-dimensional works. The paintings, for example, seem to show a design sense less profoundly transformative than his manipulation of objects in space. Samaras's three-dimensional works may be said to have been made new through a process of almost entering his body and reemerging. Most of the two-dimensional works, on the other hand, have a surface design sense which breaks away from the fullness of the three-dimensional embodiments and may be viewed in a kind of abstract isolation. The great exception, which renders the two- and three-dimensional distinction inadequate to his work, is his photographs. Photography of course is a medium that, though its product is flat, operates through penetration of space. Samaras has made this medium his own through a quasi-bodily incorporation, which produced his consummately intimate and lethal self-photographs and photographs of others.

These works will have a great deal to do with Samaras's position in the history of the art of his time. This position is made somewhat ambiguous by the elusive and inimitable personalness of his work, which has kept it out of lists of schools and tendencies. This positionless quality along with the rag-shop or leftover approach to materials gives him almost an outsider position in twentieth-century art history. His work, like that of many outsiders, is almost ahistorical. It has, for example, several important connections with the seminal figure Duchamp (such as the use of found materials, the alteration of everyday objects, and the use of himself as a subject for photographs), but one doesn't strongly feel the need to mention them, or to analyze the relationship in terms of history, philosophy, and theory. For many artists, dominated by historical awareness, a strictly chronological development dominates, suggesting sequential influences and decisions. They are somewhat easier to categorize. Samaras's thirty-year oeuvre, on the other hand, has blossomed less as a linear sequence than as a concentric series of layers. It is not that his genres have evolved so much as that they have expanded. His oeuvre displays both a relation to changing art-historical moments and a sense of the organic, of being a body that grows into itself without ulterior motive.

At this particular moment, Samaras's work seems more troublingly present than that of many of his contemporaries, whose history has already been written and, more or less, closed. It offers artistic insights that, while they occurred at the height, or end, of the Modernist period, are peculiarly relevant to the post-Modern situation. The two great themes of twentieth-century art have been history and the self. Since the Romantic period these themes have been linked in a particular way, the self assuming heroic proportions as the guide of history, while at the same time history has been viewed as a force of its own, fulfilling a grand destiny through the acts of its chosen heroes. Samaras's work is not based on this linkage. History's wreckage in World War II, a fact somewhat shrouded from American artists, left him not with a search for history, but with the theme of the self unsupported by historical mission: the delicacy and courage of selfhood on its own, finding new uses for the random remains of history, constructing a world out of them, a world in which the abandoned self may feel its way toward the possibility of relationship. No other artist has developed so full an iconography of both the privilege and the predicament of selfhood, an iconography wrested organically out of life itself, presented to the world with an unabashed honesty and an insistence—or demonstration, really—that art is a force through which a world may be recovered, though shaped anew, from its ruins.

Part Three

Spiritual Traditions

Neo-pre-Modernism was an attempt to establish channels of emotional and cultural connection with pre-Modern societies. This option was very prominent in the 1960s and '70s, especially in the United States. It included the flower-child movement, with hippie communes and the drop-out ethic; the ecology movement; the first generation of the women's movement with its emphasis on ancient goddess-worshiping cultures; types of Performance Art that were based on reconstructions of ancient rituals; works of Earth Art that recalled ancient monuments like Stonehenge; therapeutic approaches to art; and other things.

It is true that many artists of the abstract sublime had based their works on occult or spiritual traditions, as in Mondrian's Theosophy and Klein's Rosicrucianism. But these traditions reproduced the Hegelian myth of history, progress, and the end of history, which was to be a culminating transformation of humanity.

Now, many artists chose the neo-pre-Modern option instead, seeking to base their work on various spiritual traditions without Western style imputations of historicist directionality. The movement was fundamentally multicultural as well as ecological in its turning away from the Western type of civilization. The oeuvres involved ranged from Eric Orr's fixation on Old Kingdom Egyptian cultural models to Michael Tracy's penchant for Mexican pantheistic Christianity to Antony Gormley's incorporation of yogic elements to Marina Abramovic's crystal and shamanic works to Louise Bourgeois's recreation of ancient goddess icons, and more.

A key feature of this option is that it involves a whole or partial rejection of the tradition of the Enlightenment, which is regarded as tainted by the fact that it led, in supposedly civilized nations such as Germany, to barbaric atrocities hardly imaginable before.

The stream that flowed from Duchamp through the four compass points will now be seen flowing into many subsidiary positions—ten artists each in parts three and four. What started as a stream has spread and is becoming a flood. In the following section the reader will find essays on ten artists who have chosen to link their oeuvres with pre-Modern spiritualities. Though their works may be less critical and deconstructivist than Duchamp's, they are nevertheless among his descendents in their rejection of Kant's theory, their use of found materials, and their profligate mixing of traditional artistic genres.

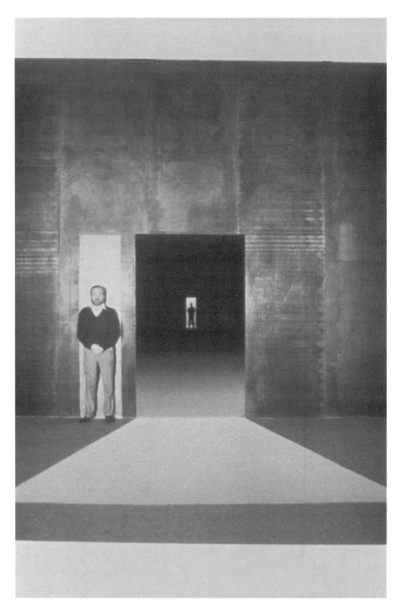

Eric Orr, Silence and the Ion Wind, *1980. Courtesy of the artist.*

Chapter Eight

Negative Presences in Sceret Spaces: The Art of Eric Orr

I am against painting and sculpture and what they stand for. The studio mind is better abolished. . . . I'm interested in the stuff you don't see but it's there. —Eric Orr[1]

Eric Orr first exhibited as an artist in 1964, in the student center of the University of Cincinnati. The work was a Colt .45 automatic pistol mounted on a stand at eye level for a seated person, facing a wooden chair. The hammer was in cocked position; the trigger was wired to a treadle where the foot of a person seated in the chair might comfortably rest. Seated there, one gazed down the muzzle of the gun about three feet away.

Some viewers experienced the work as a threat, some as an invitation; no one sat there for long. But while seated in the chair one felt strangely unnerved about the intentions of the artist. He was absent, hidden behind the ice-cold gesture of this diabolical machine.

Colt .45 was an act of aggression against the art experience as handed down in university courses. Working against the triviality of the exhibited object, it opposed the momentous fact of bodily death and was a declaration of war against the viewers' expectations of finding pretty objects in an art setting. Instead of being aesthetically stroked, the viewer was threatened and devalued. The artist was a gangster with his audience shoved up against the wall by his work.

In a sense the defiance expressed in this work was the defiance of a prisoner: It announced Orr's feeling that the overwhelming plethora of art objects amassed, cataloged, and disseminated in our culture had come to imprison the living artist. Long ago a surfeit was reached. I was once given a tour of the Metropolitan Museum by an artist who showed me only the harps and armor.

I'm an agent for a robot factory which has no people and no lights and runs full tilt at night, robots making other robots in the dark. —Eric Orr[2]

Orr moved to Los Angeles in 1966. In California he found an art-historical stream that he could deal with more comfortably, not least because at that time the various West Coast movements were regarded by their adherents as constituting

a new beginning for art, cut off—or liberated—from European art history. For a decade or so he was grouped with James Turrell, Doug Wheeler, Maria Nordman, Robert Irwin, and others loosely called space-light or phenomenological artists: In work by these and related artists, the perceptual situation is manipulated in order to focus attention on the vagaries of the perceptual process itself. Within this category Orr's work is conspicuous in its use of deliberate allusions to ancient religious and magical traditions.

In *Room Company #2* (1968),[3] walls of dry ice were installed in a gallery and vanished before closing time. The transition from corporeal to disembodied, from positive to negative presence, was Orr's first resolution of the theme of aggression. At the same time the piece is a satirical reduction of the art worship expressed in Seneca's famous line, *Vita brevis, ars longa* (Life is short, art is long).

Related works explored silences and shadows. In *Sound in Shape of a Pear* (1970), a standing wave—in which two sound waves intersect in such a way as to partially cancel each other out—was set up in a gallery. At a certain spot in the room one found oneself in a zone of eerie silence. In other pieces (e.g., *Wall Shadow*, 1969), structures were built, and the afternoon shadows they cast were painted gray-black, then the structures were removed, leaving a silent world of frozen shadows. In *Sound Tunnel* (1969), one walked through a lightproof tunnel where voices from hidden banks of audio speakers circled constantly, whispering. "Life, dream, shadow; life, dream, shadow; life, dream, shadow."

In most of man's history art was made by the living for the dead. The finest Egyptian art was made for the dead, buried, and lost. I wasn't supposed to mention this, but I live in the void and consider death my oldest friend. —Eric Orr[4]

In 1971, in a work called *Blood Shadow*, Orr and a friend (the artist John McCracken) carried a sheet of tempered glass onto the Venice, California beach on the night of a full moon. One side of the glass had been covered with the artist's blood blown on by breath and straw as Paleolithic painters are thought to have done. The glass was laid at waveside, where McCracken's moon-cast shadow fell upon it; Orr scraped away the blood outside the shadow, leaving a human silhouette. The glass was now, by sympathetic magic, a kind of "person," made of Orr's blood, McCracken's shadow, moonlight, and wave sound. The glass was crated and transported to the plain of Giza, just south of modern Cairo. When the moon rose, Orr uncrated the glass by the Mycerinus pyramid. Calculating the position, he dug a pit in the sand where the shadow of the pyramid apex would fall at moonset. The glass was laid face up in the gravelike pit. As the moon approached the horizon, the shadow of the pyramid apex (from which the soul of the pharaoh Mycerinus was to launch itself into the eternity of the circumpolar sky) glided slowly up the blood-self on the glass and tapped lightly at the brainpan just before moonset, summoning its spirit. When the moon disappeared, the glass was buried.

With *Blood Shadow* Orr began layering his work into a complex cultural archeology that was designed to free him from European art history. Egyptian art,

after all, was both eerily "Modern" and deeply concerned with the transition to the bodiless Prior, which is, in the language of an Egyptian coffin text, "the universal primordial form of life."[5]

From Egypt Orr traveled eastward, spending time in India, Burma, and Japan. Back in Los Angeles, he began a series of installations inspired as much by the empty spaces that archeologists have found in the plundered tombs of ancient Egypt as by the indefinite spaces of Robert Irwin's scrim installations. From ancient Egyptian burial places the soul was to flee through the crack of time to the Place of Eternity, becoming one of "those glorious beings who dwell in the beams of light."[6]

Infinity Space (1971–1973; later exhibited, with some variations, as *Zero Mass Space*) was an oval room whose floor, ceiling, and walls were paper; it was dimly lighted to bring night vision into play, and to create the impression of a sort of spatial meltdown within. It was phenomenological in the sense that it involved the attempt to alter perception through minor shifts of situation, yet its ancient roots may be more relevant than the display of perceptual shifts. The piece suggested a space beyond (or before) boundaries—an analogue to the realm of Chaos described by Ovid, the Primal Abyss of Egyptian mythology, or the world-edge realm of Ultima Thule, reported in Greco-Roman texts as a state between mist, liquid, and solid. From inside, one could not identify a wall, or limit, anywhere. The boundary-forming, and hence limiting, property of space had been dissolved into an indefinite light-substance surrounding one with equal density on all sides. A certain transmogrification analogous to those described in ancient funerary cults, mystery religions, and enlightenment texts was briefly glimpsed.

Why is space active and the object passive? —Eric Orr[7]

Though Orr called this work "sculpture," it was more concerned with the disappearance of the object than with its presence. Faith in the object was the quality of an earlier age—an age of certainty in which the ontology of the object seemed secure. In the age of doubt, in contrast, many sculptors have been more concerned with questioning the object—questioning its right to affirm the reality of definite things, and thus of definitions themselves. Such affirmations seemed cover-ups for a kind of *horror vacui*, a terror of emptiness and the uncertainty it brings with it. Orr and other artists wanted to directly face that emptiness, even to enter into it. The way was open for a sculpture which, like visionary architecture, contains the viewer rather than drawing the viewer's attention toward some concrete external object.

Orr's art of this period was based in part on the religio-philosophical tendency of space worship, found in Platonism, Hinduism, Taoism, Cabala, and elsewhere. These traditions regard materiality as primarily a limitation and aspire to a state where gravity and spatial boundaries will have been left behind. They do not regard space as dead emptiness. The *Chandogya Upanishad,* for example, says (III.8.1), "Space [Sanskrit: *akasa*] is to be worshipped as the absolute source [Sanskrit: *brahman*]." "It is space out of which all these creatures proceed and into which they are again received" (I.9.1). Space, in other words, both produces and

later reabsorbs the apparitions that seem to inhabit it. It is regarded as crawling with hidden life and bursting with universal feeling. Newton, in a similar spirit, called space "the sensorium of God," meaning, in Platonic terms, the screen on which the world dream is projected. Newton's contemporary, the seventeenth-century Platonist Henry More, spoke of space in the theological terms appropriate to deity, calling it, "One, Simple, Immobile, Eternal, Complete, Independent, Existing in Itself, Subsisting by Itself, Incorruptible, Necessary, Immense, Uncreated, Uncircumscribed, Incomprehensible, Omnipresent, Incorporeal, All-penetrating, All-embracing, Being by its Essence, Actual Being, Pure Act."[8] Earlier forms of such concepts are found throughout Egyptian mythology: the abyss of primal indeterminate space, regarded as the womb of the universe; the primal and self-renewing space above the world ocean just before the first sunrise; the Place of Annihilation in the afterlife, typified by the Gates, Caverns, and Mysterious Doors behind which darkness is reprocessed into light.[9]

> *Early Buddhism didn't have the figure, it didn't have any of that kind of stuff. They just worshipped empty space. That lasted about three hundred years, and then you have ten million, scrillion, jillion figures of this character named Buddha. Yet he was dead against the figure.* —Eric Orr[10]

In Theravadin Buddhism, a religion Orr encountered in Burma, the emphasis on empty space is combined with a rejection of the ordinary sense of self. In this tradition, the first of the higher meditation states (Pali, *arupa jhana*) involves the incorporation into one's own being of "infinite empty space."[11]

A related image that is implicitly involved in much of Orr's work is the empty throne by which the Buddha is represented in the cave art of Ajanta and Ellora. In Buddhist terms, the throne is empty because the Buddha has realized not-self: Though he is sitting there, no self is present. It is an inverted art of the figure, approaching the figure through its absence. Seen in light of this image which was to enter Orr's life years later, the *Colt .45* piece of 1964 opens into a softer and broader semantic dimension. The empty chair is the empty throne, the pointed gun activated by the sitter's own foot is his voluntary self-destruction through realization of not-self.

> *I want to make the best place on the planet. So that when you enter that space you're completely changed—you experience ecstasy or something . . . I altogether have no idea about not liking change.* —Eric Orr[12]

In the mid-seventies Orr decided that its combination of aesthetic elegance and an ability to exert an effect over a distance makes science an analogue to the ancient traditions of magical art.[13] The mythological/poetic power of such concepts as space-time curvature, black-hole singularities, and cloning, gives them archetypal status. "Beta decay," "red shift," "white dwarf," "cosmic ray," and "event horizon" are poetic phrases at once strange and somehow recognizable.

Orr's installation *Sunrise* (1976) began to knit together the scientific and

Egyptian strands, introducing silence, alongside space and light, as a third material. A room nine by nine by eighteen feet in exterior dimensions was built inside a gallery, its outer surfaces sheathed with sheets of lead—which by screening out most radiation—created, inside, a partial cosmic-ray void. The dimensions of the interior space were related to those of the King's Chamber of the Great Pyramid. A ceiling channel at one end of the room extended through the rooftop of the outer building to a tracking device on the roof that followed the sun from dawn to dusk and reflected it, through the channel, onto the back interior wall of the lead-sheathed room. Each sunrise, an upright silvery panel would catch a thin strip of light at its bottom edge that would grow through the day until sunset, when it would fade quickly. In late afternoon, the bar of light palpably throbbed in the darkness, like a solid gleaming substance floating several inches in front of the wall. Heavy insulation of the interior walls created an acoustically dead zone where one's interior body sounds, as well as the quiet and fragmentary thoughts that usually go unnoticed, bubbled to the surface.

Sunrise was a kind of sacred monster in the space-light tradition. It was also Orr's most Egyptian-influenced space, with its references to the King's Chamber; the flight of the *ba* bird through a small channel in the tomb to the sun; the sunrise of the dead, when Osiris rises into the morning sky as Re; the obelisk as source of sunrise; and sunrise as the primal moment reconstituted each day.

Above all the "lead box," as it came to be called, was a laboratory for certain types of exploration. Orr reconstructed it in his studio on the Venice beachfront, where it remained for several years, during which numerous people investigated it. While the cosmic ray void seemed imperceptible, and the bar of light changed so slowly that many found it fatiguing, the box was specially interesting at night, when its darkness and silence were almost complete in terms of human senses. Awareness of one's body, in that black silence, became overpoweringly absorbing while, at the same time, the sense of one's material boundaries receded. Sleep was unusually deep, and dreams were distant and bright. Orr's goal of producing spaces that would transform everyday experiences was mildly fulfilled here. Yet no one flew out the door as a bird. Rather, one walked out with a certain mental aura, as if one had dimly heard veiled promises of transcendence.

I started out believing that object art suffers from infantile paralysis or old age, something that had to be gummed by the toothless. Now object or space has no difference. Both sustain themselves in memory. (Is there clear memory?) —Eric Orr[14]

In 1976, Orr began making flat rectangular objects to hang on walls. Some of them are clearly sculptures; others combine the genre characteristics of sculpture and painting. The earliest series showed illusionistic (rather Magritte-like) windows and doors embossed into lead surfaces. These mysterious apertures suggest hidden dimensions of reality which cannot be entered physically. Chemical formulas adorn the windowsills like hieroglyphs: Phi (the Golden Number—an irrational number, approximately 1.618, on which the overall dimensions of the piece are based); the

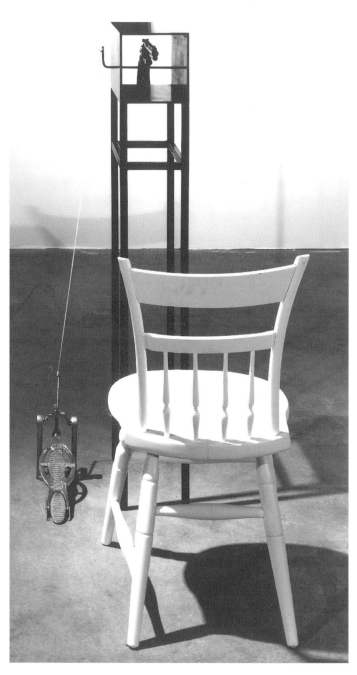

Eric Orr, .357 Magnum, 1988. *Remake of* Colt .45, *1964.*
Courtesy of the artist. Photo by Grey Crawford.

Eric Orr, .357 Magnum, *1988 (detail). Remake of* Colt .45. *Courtesy of the artist.*

chemical symbols denoting the transformation of uranium into lead; Enrico Fermi's formula describing the beta-particle decay process that is involved in this transformation; parts of Werner Heisenberg's uncertainty formulas; Orr's own name in runic characters; and a traditional runic blessing on the object itself, repeated three times. Science, with its black holes and antimatter, was presented as gatekeeper to other realms.

The series called Chemical Light (1979) is named after a seventeenth-century alchemy book, and the subtitle, Works in Lead and Gold, spells out this intention. Gentle, diagonal striations of the soft lead surface merge into a mist of gold which thickens and solidifies at the bottom edge; there is a suggestion of landscape swept by soft rain or the edge of the realm of form, where solidity melts into shapeless but still driving force.

> *I'm interested in figurative art in the sense that I'm interested in putting a figure in the art directly—I mean like blood or hair or whatever. Don't try to represent it, use it. When you try to represent things, they lose. They lose, you lose.* —Eric Orr[15]

Orr's ambition is to reconstitute the shamanic role in the art realm, to reestablish the artwork as a therapeutic force. Twice he has traveled to existing shamanic cultures (the New Hebrides and Zaire), located practicing shamans, and swapped stories and materials with them.

His wall objects of 1980 and 1981 involved an attempt to combine the artwork with the power object by merging his sense of the inner powers of the materials with their outer visual properties. Recent works have involved lead, gold, wood, meteorite dust, ground lion tooth, dust from the King's Chamber of the Great Pyramid, volcanic ash, human blood (Orr's), human bone ground to powder, human bone burnt to carbon and ground to powder, human skull burnt to carbon

and ground to powder, human skull broken into jagged fragments by being run over by an automobile, and a radio burnt to carbon and ground to powder. He grinds these substances by hand, with a mortar and pestle, combines them with a liquid binder, and applies them to the lead ground with a spray gun.

The process of pulverizing objects like a radio, a skull, a bone, deprives them of their identity as objects, grinding them into a primal and featureless stuff as alchemy reduces the separate elements back to Prime Matter again. Yet Orr feels that the process of reducing materials to dust or ashes does not drain out their separate identities altogether; rather, it hides them, renders them occult, but their powers still operate.

From a formalistic point of view, the original object-identity of a material is aesthetically irrelevant. If the art viewer sees two vertical bands of varying gray-black, it makes no difference that one is radio and the other human bone ash. To Orr, on the other hand, the magical value of the original form of the materials works along with the aesthetic value of the present surface. We react to color values, he feels, but we also react to the invisible or vibratory presences of the original radio, skull, bone, gold, ash, and so forth. The viewer is invited to work with more than the visual sense when relating to these works; he is invited to use (or discover) senses he may not have been aware of before.

> *I like to hunt the void. I have used silence, emptiness, and night vision to apprehend my undifferentiated friend. . . .* —Eric Orr[16]

Silence and the Ion Wind (1981) filled the Hammer wing of the Los Angeles County Museum of Art. It consisted of three chambers along a single axis. In the dimly lighted entrance chamber, one end of the axis was marked by a door-shaped rectangle of light projected onto a wall, in the proportions of the Golden Section; the irrational number, with its endless decimal places, leads to infinity, and something similar was implied about this door of light. Like the doors and windows on the lead surfaces, it suggested an entranceway to another dimension. About fifty feet from the light door was a lead wall with a central doorway, also of Golden Section proportions, leading to the second chamber.

The second space was dark enough that facial recognition was impossible, and, as layers of fiberglass insulation absorbed sound, the human voice flattened out. As one walked toward the third chamber—a tiny golden room which glowed invitingly at the end of the long dark space—three coordinated changes took place: The darkness was progressively dispelled by golden light; the silence increased, as the wall insulation thickened; negative ion generators near the golden room created an ion wind which increased in strength as one drew nearer. Negative ions, like the cosmic-ray void in *Sunrise,* are one of the invisible materials in the recipe. They increase in nature after a rain or near a waterfall; they are reputed to be invigorating and stress-reducing.

The tiny room at the end of the axis was electrostatically coated with 24-carat gold and glowed with a transcendental sheen. Entering its bright embrace and

gazing outward, one's eyes fixed on the light door at the other end of the axis, framed in the central leaden aperture. Somehow the moment had a certain completeness or peace.

Silence and the Ion Wind was innately awesome. One reviewer called it a Gothic cathedral of the interior; another, "a space-age abstraction of some ancient ceremonial burial place."[17] It seemed filled with phantom presences from mythology, like the tombs in the Valley of the Kings west of Luxor, or the hall of initiation at Eleusis, or the dark chamber of the third act of Mozart's *The Magic Flute.* It was a kind of architectural-iconic allegory of the alchemical process, as one walked from leaden wall to golden room, from darkness to light, from speech to silence. In this sense the piece had much in common with the Stations of the Cross and related religious icon complexes meant to be walked through with a special focus of attention. Mystery initiations usually feature a symbolic death and rebirth, and here too funereal connotations were present, with their promise of fleeing through the crack of time into a stronger force flow of the universe.

Silence and the Ion Wind was an homage to the mysticism of space-and-death—a grandiose unfolding of themes that had been mutely present in the empty chair and gun of 1964.

Why is light the rosy path for both physics and art? —Eric Orr[18]

In *Time Shadow* (1981), one opens a lead-wrapped door in a lead wall to enter a short, dark corridor insulated for silence and lined with gray scrim. Walking toward a lighted space at the other end of the corridor, one finds an empty seat in a recessed niche. Seated there, one seems at first to be looking out a window but quickly realizes that it cannot be a window as it shows only the sky. One is gazing into a highly polished gold mirror which reflects upward through channels in the ceiling to the open sky. In the dark, silent space the light lies on the golden mirror with solidity and peacefulness.[19]

The piece echoes aspects of earlier works: *Colt .45,* where one was also forced to sit on a chair and gaze directly ahead; *Sunrise,* in which also one entered a darkened and silenced space to gaze at a phenomenon of outdoor light guided in through roof channels; and *Silence and the Ion Wind,* where one also approached a lighted space with a highly polished gold surface through a dark and silent hall.

The guy who was the shaman . . . he's called the doctor too. You see, the artist had a much bigger job then. The guy who does the stuff on the walls is probably also the guy you go to when you're sick. —Eric Orr[20]

Orr's utopian goal is to make spaces which alter the visitor in a therapeutic direction. He thinks of a shaman's isolation hut, or some mad scientist's box in a movie, or Wilhelm Reich's orgone accumulator. The ancient practice of "incubation," or sleeping in a sacred place for its curative power, was practiced in Egypt at least as early as the fifteenth century B.C.; transformative withdrawal into a power

spot, often a cave, is attributed to Pythagoras, Epimenides, and other subshamanic figures.[21] The Tibetan Buddhist tradition includes a practice called "space therapy," in which the patient is put into a room of a certain shape (five shapes are used) and while in the room maintains a certain posture.[22] (Orr's spaces, too, often enforce posture: standing up only, in the gold room of *Ion Wind;* sitting down only, in *Time Shadow;* the strong tendency to lie down in *Sunrise.*)

At least, Orr's poetically evocative spaces return us to ourselves as does a solitary dark cell (whether in a jail or a monastery). While intimate, they are expansive and inviting; they shimmer with suggestions of noble antiquity from the unpacking of their cultural archeology, which the visitor's mind performs automatically.

I want to create a cultural sign as simple and influential as the zero. I want to get the sense of void inside an object. —Eric Orr[23]

Orr's wall pieces also hint at secret spaces—the leaden windows and doors that seem to open into tidal depositions of radioactive change—and sometimes they contain voids directly. *Blue Void* (1981) was a black granite slab installed high up in a wall with a nearly square hole at the top, opening onto the sky. Daylight flowed corrosively over the edges and locked one's gaze on the bright emptiness of the distant sky—a "piece" of infinity framed in granite as an icon of itself. At the same time, the Egyptian references (granite, vision directed through sighting holes or channels, the sky as destination), while muted, swim vaguely in the viewer's consciousness.

Double Vision (1981) is an enclosed void about eight by eight by twelve feet, with inner corners rounded and inner surface painted sky blue. Two eye-level square windows or "holes" face each other in opposite walls.[24] While walking around this "void" and gazing into it from various angles, what Orr calls a "double vision" occurs. The blue interior (especially just before sunset) loses the sense of surface and draws one's vision into a sense of floating in space-time. Then, as the second responding frame comes into view, one sees through it to ordinary life again.

Other wall objects have attempted to fuse the two points of view. In *Mu 2* (1982)—in Japanese art, a *mu* painting is a painting of zero—a central monochrome area of gray-white fades floatingly from top to bottom, ringed with a thin dark border and framed by two narrow, gold-leaf covered uprights. Gazing at the central field, one finds that it is a threshold which opens into what seems to be a three-dimensional space; when the threshold appears, then opens, one is imaginatively pulled into that space. And one hardly notices that the floating white cloud is human bone ash and the narrow dark border a painted stripe of the artist's blood. Still, the conceptual point of the materials is clear: We see the void within our own bodies.

Time Switch (1977) is a matchbook created by Orr and artist Gus Foster. On the front is a photograph of a City of Los Angeles electrical box reading "Time Switch"; on the back, the red-shift formula from Albert Einstein's General Theory of Relativity, describing the seizures that time undergoes at the event horizon of a black hole; inside, a celestial map locating Cygnus X-1, the official directional pointer for the first black hole discovered, along with advice from the makers: "You can't get there from here."

Like much of Orr's work this piece points toward a journey and arrival that cannot be experienced in the body. Science and mythology mingle as the black hole becomes an instantiation of Martin Heidegger's "open center" which "encircles all that is, as does the nothing, which we scarcely know."[26] And this piece, like the dry-ice works of earlier years, has its own immolation built in.

See, I think art's going to grow up eventually and we're not going to have so much of the dealing with special objects. It'll be more like an appreciation of what's here. . . . I think it definitely, maybe, will get to the way you look at things rather than the things themselves. (Does transient afternoon light on the wall look better than art?) —Eric Orr[27]

Anthropologists have observed that the shaman generally believes his own magic sincerely at the same time he is performing sleight of hand and must be aware of it. This type of pious repression is essential to the authentic shamanic performance. The shaman purveys his intentionality itself to the audience as one of his wares. Something similar is the case with Orr's art. It seems obvious that the maximum level of his ambition is unlikely to be achieved. Yet the intentionality is itself a basic material of the work. In this sense, his work, like the transcendental ambitions hidden within, say, the abstract sublime, is essentially Modernist, though it was born in a flight from Modernism into the pre-Modern, and maintained its inner force and determination by staying away from the center.[28]

Wolfgang Laib, The Rice Meals, *1987. Installation: Century 87, Oude Kerk, Amsterdam. Courtesy Sperone Westwater, New York.*

Chapter Nine

Medicine Man: Proposing a Context for Wolfgang Laib's Work

Wolfgang Laib has described himself as "isolated . . . from art and artists."[1] He tends to reject comparisons of his work with the work of other artists with one exception (discussed later)—and observes that "I have probably distanced myself from traditional European ideas of art in every respect."[2] Indeed, it is undeniable that his most widely known works, the rectangles of flower pollen deposited on the floor and seeming to float in a haze of pure color, are uniquely his own. Laib's work is so careful, so painstaking, requiring so much patience and contemplation, that surely he is right to protect it from easy but misleading categorizations. Still, anything that is completely isolated and unique, that has no relations to other things, is by the same token unknowable and ahistorical. It seems worthwhile, then, to attend to certain contexts that both the work itself and the artist's statements about it seem to suggest.

All discourse about Laib's work begins with the fact that he was trained as a medical doctor, obtaining the degree in 1974. (His thesis, according to his own report, was on "the purity of drinking water.")[3] But instead of taking up medical practice, Laib began making art. The change of direction implies a sense that his therapeutic ambitions could be implemented better through the making of art than through the dispensing of medicines—a sense that connects his work with certain venerable traditions as well as with the work of various contemporaries such as Eric Orr and Marina Abramovic.

The idea of a connection between art and medicine recalls ancient physicians from an era before the professions separated from one another, like Empedocles of Acragas, who was simultaneously a poet, a medical doctor, and a wonder worker, without much distinction among these roles. Pythagoras also was a medical doctor who seems to have believed that therapeutic effects could be attained through artistic means, both musical and visual. In the non-Western world this type of idea is not uncommon in philosophical and religious contexts. In Tibetan tantric tradition, for example (as mentioned already in connection with Orr), there is a healing method that involves putting the patient into a space of a certain shape and color, determined by the diagnosis, and letting these formal properties work the cure.

The therapeutic view of art overlaps significantly with the conception of art

as a form of magic—in fact it's hard to tell them apart. For the Neoplatonist Iamblichus, for example, artistically mediated healing resulted from ritual contact with icons that were regarded as literally containing the deity or power they represented. Countless instances of such belief occur, from Tibetan mandala practice to Navajo sand painting. This view of art as magico-therapeutic was characteristic of pre-Modern cultures.

The fact that Laib's work has pre-Modern and non-Western resonances does not isolate it but partially locates it. When Modernism as an ideology of history (and art history) began to seem spurious a generation or so ago, one available option was the attempt to revive channels of spiritual communication with pre-Modern cultures that supposedly were healthier (neo-pre-Modernism); the other, an attempt to wring out of the end of Modernism some ongoing but corrected current (post-Modernism). The therapy issue is one of the dividing factors among these positions. The Modernist finds the pre-Modernist view of art as magical therapy naïve and superstitious; but the neo-pre-Modernist sees the Modernist worship of pure forms for themselves, with no additional therapeutic end, as soulless, frivolous, and irresponsible. (The post-Modernist, meanwhile, looks sideways at the discussion, finding both criticisms valid and hence both positions distasteful for different reasons.) One suspects that Laib's almost phobic withdrawal from "art and artists" is primarily a rejection of Modernism. Through its location in pre-Modern revival, his work occupies a secondarily post-Modern position, insofar as pre-Modern revivalism has taken its place among the expanded array of options that post-Modernism has proffered as a corrective to Modernist exclusionism.

Still, cultural entities are rarely unmixed, and such divisions are not absolute. There is, for example, a vestige of the Pythagorean therapeutic theory in Modernist formalism, in the idea that contemplating pure forms is somehow "good for you." In fact, this view of the function of art underlies much classical Modernist art, and in this sense Laib's work also has a surreptitious Modernist context. Something like the therapeutic view can be seen, for example, in the path-oriented quality of spiritual abstraction such as Kasimir Malevich's and Piet Mondrian's.[4] For Malevich the ascent to the heights of non-objective art was equivalent to the mystics' ascent of Mt. Carmel: It had the ability to restore one to pure consciousness. Mondrian also seems to have felt that his work could harmonize the viewer with vibrational patterns in the atmosphere. Both of them, and many others, believed that their works were intimately connected to the inner structure of reality. The nature of this connection was assumed to be deeper than the visual surface. From deep within an immaterial stratum in the artwork, vibrations of cosmic harmony were regarded as emanating in a way that could contribute to a cure of mundane bound consciousness, setting it free to resonate to the fundamental rhythms and structures of things—what the Pythagoreans called the Music of the Spheres. In pre-Modern contexts, belief in the therapeutic impact of things that today would be called art was direct; in High Modernism it cohabited uneasily with pure Kantian aestheticism.

In the Modernist magico-formalist tradition, the most open embodiment

Wolfgang Laib, Pollen from Hazelnut, *1992. Installation: Centre Pompidou, Forum, Paris. Courtesy Sperone Westwater, New York.*

of this idea was in the works of Yves Klein, who imported the theory into art discourse from Rosicrucianism.[5] Klein believed that his works actually gave off vibrational emanations that would heal the viewer sensitive enough to receive them. Influences of his view spread to Fontana, the Zero Group, and Fluxus, and peaked in the work of Joseph Beuys. Dr. Beuys's healing fetishes include (the idea of) wrapping the subject, or patient, in fat and felt; "batteries" or energy accumulators made of various natural and cultural materials; and so on. With Beuys there was, I think, always a certain ambiguity about how literally he intended these curatives to be regarded as medicinal—or whether in fact they were primarily metaphorical gestures. (This issue arises with Klein too, though his public statements, whatever ironies they may have involved, always claimed fully serious belief.)

Laib situates his work, somewhat insistently, in the wake of Beuys's journey. "I have few connections to artists," he has said, but "some very open connections—to the work of Beuys."[6] In fact, Laib characteristically rejects comparisons of his work with the work of any artist but Beuys. He has rejected, for example, general comparisons of the simplicity of his work with Minimal Art and such specific comparisons as that between his little houses and the little houses of Joel Shapiro.[7] Regarding the comparison with Minimal Art, Laib has asserted that the simplicity of his own oeuvre is not so much the result of an artistic reductivism as of a religious renunciation: ". . . it has much more to do with the ascetic [than

with Minimal Art]," he has said, "and in art it is much closer to Beuys than to Carl Andre."[8]

It seems specifically the healing aspect of Beuys's oeuvre, not its aesthetic aspect, that elicits Laib's statements of commitment. Aside from the use of beeswax as art material, the aesthetic aspects of their oeuvres are very different.[9] But the combination of religious and therapeutic meaning that seems to underlie the value of art for Laib occurs of course in Beuys's statements, too. It is worth noting that the Buddha referred to his teachings—the source of the Buddhist scriptures which Laib has studied along with several other bodies of religious texts—as medicinal or therapeutic, and that this was a common attitude in Indian religions.[10] Laib has systematically attempted, in other words, to remove his work from the conventional art discourse and insert it into the discourse of therapeutic religion. On the assumption that the artist's intentions are, to an extent, revelatory about the work—not least if they seem unfulfilled in it—it seems a good idea to take this stance seriously. The question remains how literally it is intended.

Laib's oeuvre contains, for the most part, four types of works: pollen accumulations on the floor; little houses sometimes filled with rice, sometimes coated with wax; beeswax rooms large enough for a viewer to enter; and "milkstones," that is, slightly concave marble *planches* onto which milk is poured. Laib seems to specify the effect in question for at least two of these genres when he says: "If you have a milkstone or a pollen piece in a private space, the life around, in that space, has to be changed."[11]

What is the nature of that change? Is it simply that the environment has been changed in the sense that the addition of anything at all to a context changes it? Is it that the responsibility of repouring the milk every morning, or guarding the pollen against atmospheric disturbance, engages the viewers' lives more than, say, looking at a painting does? Is it again the question of beauty—that the trained sensibility, perceiving the beauty of Laib's work in the room, will experience the room as sanctified by its presence? Or is it that there is a palpable—and presumably in some way measurable—vibrational force emanating from the work that would affect any sentient being in its range, whether trained or untrained, human or non-human? Though Laib might shy away from such a bald statement of magical belief, it seems that without such an explicit magical or vibrational doctrine, his work is not so radically separated from Modernist formalism as he would evidently like it to be.

What some critics have called Laib's mysticism is a participation mystique that involves underlying assumptions of animism or pantheism and rejects the separation of nature and culture for an attempt to ground culture in nature. The performative aspect of his work—the slow, painstaking gathering of pollen, the daily pouring of milk on the milkstones—recalls priestly rite. The materials of his oeuvre—stone, wax, pollen, rice, milk—while all natural, represent a range of natural change or process, from the solid to the viscous to the granular to the powdery to the liquid states. A microcosm of natural process is involved as in Anaximenes's expansion-contraction model of the universe, in which all change was regarded as, fundamentally, change of density, from solid to liquid to gaseous, and so on.[12]

Wolfgang Laib, Rice House, *1996. Courtesy Sperone Westwater, New York.*

The ambiguity between visual beauty and vibrational efficacity in Laib's work reflects in part this rejection of Modernism's deeply ingrained distinction—or opposition—between nature and culture. Faced with the collapse of Modernism and the two alternative options already mentioned—a revival of pre-Modern cultural and spiritual modes as redemptive, and the alternative attempt to drag from the end of Modernism an inverted form of itself called post-Modernism—Laib's choice seems clearly to have been the neo-pre-Modern. As for other artists who have made that choice, it has featured the pre-Modern immersion of art into religion as a greater matrix. Indeed, many late Modernist and post-Modernist artistic trends have involved the tactic of the pre-Modernist revival—such as Land Art, Body Art,

feminist Performance Art (such as that of Carolee Schneeman and Donna Henes) based on the idea of a matriarchal aesthetic, and more. These and other feminist ritual performance artists have harked back to supposed Neolithic matriarchies based loosely on the remains of Catal Huyuk in modern Turkey. Beuys, late in his oeuvre, chose the Native American cultures as his idealized model of a spiritually whole pre-Modern society attuned deeply with nature. With a redirection of attention from North America to South America, Lothar Baumgarten followed him in this. Sigmar Polke's works involving the peyote-using Southwest Amerindian cultures continue this displaced Germanic tradition that retained eighteenth-century ideas of the Americas as the natural paradise rediscovered. Laib would seem to share this tradition when he remarks that "people told me about Red Indians in America who use pollen for some rituals—incredibly beautiful things. I never saw it, but I feel very close to this."[13] Laib also has referred to overlaps between his work and Australian aboriginal feelings about nature.[14]

Laib's feeling that his work relates more to religious austerity than to the intellectual and visual reductionism of certain late-Modernist and post-Modernist styles means in effect that he wants it to be—he insists it is—more than a style. He wants it to live and breathe within the art system, while being inserted into religious discourse, without a specific sectarian or denominational slant. Laib has referred to Rumi, St. Francis of Assisi, and various Indian philosophical traditions including both Buddhist and Jain. Jain nonviolence seems to have exerted a special influence. In connection with it Laib has referred to "the extreme meaning of things too precious to be touched" as one of the root motivations for his first milkstones and shortly after them the first pollen collections. The famous image of him crouching in a field of flowers and gently brushing pollen from individual blossoms into a jar is reminiscent of the Jain practice of sitting down gently so as not to hurt the grass-blades, or stirring water gently so as not to knock about the microorganisms in it too much, and so on. Somewhat similarly, Laib's statements that he sees his artistic work not as creation but as helping along the expressiveness of nature ("It is more participating than creating")[15] connects directly to Klein's assertion that as an artist he was the midwife of nature, and his reference of this artistic function back to the Great Art of the alchemists.

Yet, for all Laib's concern to locate his work outside the conventional art discourse, it still retains references to conventional art materials and practices, such as the conspicuous analogy between powdered pigment and flower pollen. Indeed, Laib's occasional concentration on the cone shape in the exhibition of pollen parallels elements of Anish Kapoor's work, in which conical structures on the floor are covered with powdered pigment to establish quasi-ritual umbilical "centers," or channels between above and below. The intentions between these groups of works by Laib and Kapoor seem similar in some ways—both, for example, involving references to Indian tantric visual and ritual traditions. But they are very different in other ways. Kapoor, who is Indian by birth, is revisiting his inherited tradition; Laib, a citizen of an imperial nation, seeks redemption through the Other. (Perhaps

similarly, Laib, in insisting on using pollen rather than the conventional art material, seems more literalistic in terms of the magico-religious power of the materials.)

Both the long historical association of art with magic and healing rite, and the nature of the late- and post-Modernist art realm as being essentially open or undefined make such ambiguity and range of intentions possible. It was not always so. In other, earlier contexts it was often religion (as in ancient India) and sometimes philosophy (as in ancient Greece) that allowed for cultural statements of layered complexity containing internal questions and contradictions with seeming serenity. Since Marcel Duchamp's introduction of the practice of appropriation, and its widespread naturalization in art practice in the 1970s and '80s, the realm of art has been the home of such multidirectional or contradictory impulses in our society. At the same time that Laib's art is processed through conventional institutions, the art press, and collectors, there is still enough slack in the situation for the artist to assert its privileged allegiance to another type of realm altogether.

Marina Abramovic, Cleaning the Mirror No. 1, *1995.*
Courtesy: Sean Kelly, New York. Photo: Heini Schneebell.

Chapter Ten

The Serpent in the Stone: Marina Abramovic's Sculpture

If Marina Abramovic's oeuvre is regarded in terms of the linear view of art history that has been widely accepted for some centuries, it seems to fall into three periods. The first comprises the years 1973–1975. Much of Abramovic's work of this period was presented to the public in Yugoslavia, though increasingly it appeared across Europe. Performance Art functioned, for her, as a means to channel out of what was then the closed world of Eastern Europe and into the more interactive culture of Western Europe and the United States. Performance Art was, from the very beginning, a path of liberation.

If one wanted to categorize the work of this early period by its surface characteristics, in terms of familiar art-historical categories, one would think both of Body Art, with its emphasis on the artist's own body as the site of the art event, and of women's Performance Art of the 1970s, with its tilt toward ancient prepatriarchal ritual, female nudity, and autobiography.[1]

But Abramovic's work was, in certain other ways, less easy to characterize. On one hand it was very freewheeling and intuitively derived. On another, it was rigorous and imbued with a strict inner order. It was a kind of tense intersection of Apollo and Dionysus, where the artist who had chosen the difficult balance of embodying both these forces refused to allow one ascendancy over the other.

A piece called *Rhythm 10,* performed at the Villa Borghese in Rome in 1973, illustrates this inner dualism. Abramovic splayed her right hand on a wooden floor, her fingers separated and extended. With her left hand she grasped a knife with which she stabbed quickly and repeatedly into the floor. The first stab went into the broad space between her thumb and forefinger. The next was in the narrower space between the forefinger and ring finger, then back to the space between the thumb and forefinger, then on to the space between the ring finger and the third finger, then back to the thumb space, and so on. The repetition of the security of the broad space between the thumb and forefinger played off against increasingly narrow interfinger targets.

As if in a trance, she did this over and over again, faster and faster, till she began to cut herself. Each time she cut herself she took a new knife from an array of twenty lying before her on the floor. Finally she had cut herself the ritually required twenty times, each nick or gash bleeding onto the floor. At last she seemed to back

off—and the viewers seemed palpably to relax. There was a pause in which Abramovic rewound a tape of the knife sounds and played it back, concentrating deeply on it.

Then just as the audience was breathing a sigh of relief, it started again. But this time the premise was frighteningly different. This time she called on her memory of the recorded sounds to try to repeat the same sequence of missteps and cuts that occurred in the first run-through. She would cut herself again in the same way with the same knife, the very beats of the rhythm recalled. After the twenty repetitions, with every cut redoubled, the piece was over. As she left the space the overlaid sound tracks of both series of stabbings was played.

There is a specially charged interplay of will and submissiveness in this work. The first cuts are accidental, but then they are taken as a law: the random becomes the universal. This universal then has to be reproduced: The artist/self-mutilator is both submissive to the earlier order and doggedly willful in her insistence on pursuing a rigorous method that is arbitrarily laid down by her whim or will. It is as if she embodied the mythological dichotomy of the male and female principles at once, and acted out their interplay within herself, the one aspect forcing her into frightening challenges, the other aspect compliant to the forcing.

In *Rhythm 2* (1974), in Zagreb, Abramovic took psychoactive medications in front of an audience and acted out their effects in an open and trusting way—laughing, weeping, chattering, and finally passing out. Again, she aggressively subjected herself to an ordeal that involved her assuming a stance of complete passivity. This pattern repeats.

In an especially intense instance of this theme, *Rhythm 0* (1974), Abramovic appeared at her opening in Naples along with a random crowd brought in off the street, with some art world aficionados. The gallery director announced that the artist would remain completely passive for six hours (8:00 P.M. to 2:00 A.M.), during which time the visitors could do whatever they wanted with or to her. The parameters were supposedly defined by an array of seventy-two objects laid out on a table near which Abramovic was standing. These included a pistol, an axe, a fork, a bottle of perfume, a bell, a feather, chains, nails, needles, scissors, a pen, a book, a hammer, a saw, a lamb bone, a newspaper, grapes, olive oil, a rosemary branch, a rose, and other things.

But it wasn't so easy to fix the parameters. As the time passed the randomly selected audience, many of them not accustomed to Performance Art, grew more and more aggressive. Abramovic was stripped, painted, cut, crowned with thorns, and had the muzzle of a loaded gun thrust against her head. When the art world constituency rebelled against the aggressive outsiders, the event was declared over.

In *The Lips of Thomas* (two hours, 1975), Abramovic, seated naked at a table with a white table cloth, first ate a kilo of honey with a spoon, then drank a liter of red wine and broke the wineglass with her hand. She proceeded to cut a five-pointed star into her stomach skin with a razor blade and, crouching on all fours, to whip herself till she could no longer feel pain. Finally she lay on blocks of ice for thirty minutes until the audience intervened and removed her from them.

Marina Abramovic, Shoes for Departure, *1991. Courtesy: Sean Kelly, New York.*

The Lips of Thomas, like *Rhythm 10* and *Rhythm 0,* was a kind of self-sacrifice in which the artist was both the sacrificer and the sacrificed: She offered herself up to the world with a tough-minded intensity that barely screened a tender-minded motivation underneath. The fusion of activity and passivity, male and female, tough-minded and tender-minded, Apollo and Dionysus, endowed the work with an inner tension. Yet the work appeared, in execution, as serene and whole.

This period culminated in the Freeing series of 1975. In *Freeing the Voice,* Abramovic lay on her back on the floor with her head tilted backward and screamed until she lost her voice, which took three hours. In *Freeing the Body,* she wrapped her head in a black scarf, leaving her body naked, and moved to the rhythms of a black African drummer until she collapsed from exhaustion (which took eight hours). In *Freeing the Memory,* she sat on a chair with her head tilted backward and continuously spoke whatever words came to her mind, stopping finally when no further word rose into consciousness (which took an hour and a half).

The second period of Abramovic's work, 1976–1988, is comprised of her collaborative works with the West German photographer and performance artist Ulay. The centerpiece of this period was the series called Relation Works. The works of the first period can pretty clearly be categorized as performance, though there are sculptural elements, such as the table of objects in *Rhythm 0* (which was reproduced as a sculpture in the Los Angeles Museum of Contemporary Art in

1998). In the Relation Works with Ulay the genre moved more into sculpture, often presenting the bodies of the two performers immobile and sculptural for long periods of time.

In some of the Relation Works, the inner duality that Abramovic had expressed by herself was externalized in the collaboration. In *Rest Energy* (1980), for example, Ulay and Marina held a bow, with an arrow notched to the string, so that the arrow was aimed at her and he had the decision whether to release it or not. He had assumed the severe patriarchal role that she had played for herself in earlier works, and she was now wholly compliant. They remained sculpturally immobile in these postures.

In other pieces each of the artists embodied the dualism, and they acted in perfect equality in this way. They ran naked toward one another, clashing bodies at the meeting point, over and over again for two hours. Here the seemingly endless repetition created a sculptural effect like immobility. In *Relation in Time* (1977), they sat immobile back-to-back with their long hair braided together for seventeen hours. In *Light/Dark* (1977), they slapped one another, hard, in alternation, for twenty minutes. In *Nightsea Crossing* (1982–1986), they sat across a table from one another, motionless, for ninety periods of about seven hours each. Some pieces emphasized ordeal and discipline, others mystical sensitivities. In *Three* (1978), they slithered around a floor with a snake, trying to merge their energy fields with that of the animal.[2]

This (second) period culminated in the walk on the Great Wall of China in 1988. Marina began at the east end of the Wall, traditionally regarded as the masculine end, at the shore of the Yellow Sea, and Ulay at the west—or female—end in the Gobi Desert. They walked toward one another for ninety days, meeting finally, after many unforeseeable adventures and contretemps, at a bridge amid a cluster of monasteries.[3] The piece was like a Relation Work blown up to macro-cosmic scale. It was like the piece where they ran together and bumped—but slowed down. The walk was the end of their collaboration. Each of them went on to make his or her own work independently.

Abramovic's third period, 1989 to the present (and beyond), has been characterized by more straightforwardly sculptural works that still retain performative aspects. Some of these have involved a tendency toward the furniture-like sculpture which turned up widely in the 1980s and '90s in the works of Richard Artschwager, Sol LeWitt, Fischli and Weiss, and many others.

But for Abramovic the making of sculptural objects is not enough. Her works of this type also involve a therapeutic aspect through incorporating large pieces of newly-mined crystal—quartz, amethyst, and others—as generators of curative forces. New Age associations of crystallography, or crystal healing, are clearly present in these works, but should not dominate their reception. The work belongs more accurately in a Euro-Modernist tradition of therapeutic abstraction. An artist such as Piet Mondrian, who derived certain principles of his work from the writings of Madame Blavatsky, regarded it as potentially bestowing a therapeutic effect on the viewer.[4] This was not, however, because of occult materials so much as

formal configurations that were regarded as harmonizing the personality by speaking to its basic structure.

Such ideas were not rare in the crypto-religious milieu of late Modernism. Yves Klein felt that spiritual entities which he projected invisibly into his works through meditation practices could awaken higher awareness in viewers. Something closer to Abramovic's approach is found in the works of Joseph Beuys and Wolfgang Laib, for both of whom certain natural materials— beeswax, animal fat, flower pollen, milk—have seemed likely to produce curative effects in terms of the complications and hassles of space-time. In this tradition natural materials, untouched by culture or industry, are regarded as inherently blessed or powerful. They confer upon the viewer a wholeness which art used to pretend to confer. Art lost this credibility about some time ago. That wholeness is now to be sought from nature, but still through the mediation of art, the intervention of the midwifing hand.

Abramovic's crystal-active furniture-sculptures involve performance also, and have links with earlier works such as *Nightsea Crossing*. That work of long motionless sitting came from both experiences with Australian Aboriginal cultures and practice in the tradition of Buddhist meditation called *vipassana*. In *vipassana* the traditional meditation postures are sitting, standing, lying down, and walking. Abramovic's beds and chairs and standing platforms equate with the first three; she extended her work into the walking category with *Shoes for Departure* (1991), large pairs of amethyst crystals hollowed out and roughly shaped like rude shoes. The weight of the pieces practically enforces the highly concentrated slow-motion walking of the practice. The pieces, in other words, are interactive. It is not merely that the crystal works its magic on the nearest body; it is also that body and mind must be engaged in meditative concentration to activate and receive the influence.

The connection of sculpture with performance is a late and post-Modernist trait that has appeared in various forms. Joseph Beuys, for example, would exhibit sculptures that originated as props in performances, as have Louise Bourgeois, Rebecca Horn, and others. The sculpture is recontextualized within an action. In the classical Modernist period, sculpture, like painting, was regarded as something primarily to be looked at. It was not noticed prominently that there was a radical difference between painting and sculpture. Whereas painting feigned the role of window on the wall, presenting an illusionistic deep space behind it, sculpture occupied the real space of the viewers' bodies and thus was essentially social, not illusionistic. One could, as Barnett Newman said, bump into it.

Thus when the anti-painting period of the late 1960s and '70s occurred, sculpture came to be associated with Performance Art (early on called "living sculpture"). The message of performance in that early heyday was inherently ethical, since it involved the actual body of the artist in a social situation, and much Body Art, for the same reason, was taken to be anti-illusionistic. What appeared to be happening to the body of the artist—getting cut, shot, raped, whatever—*was* actually happening.

Abramovic's beds, chairs, and standing platforms of patina-covered copper with incorporated elements of quartz crystal are mounted on the wall at various

heights, some quite high. It is understood that the viewers are invited to occupy them in meditative states of mind, seeking to absorb the vibrations from the crystal. At the openings of these exhibitions Abramovic has sometimes lain upon one of the high beds motionless for hours. Around her on the walls, members of the audience stand, sit, or lie on the crystal platforms—all presumably absorbing some healing power from the crystal. At the same time, all have become parts of the artwork, mounted on the wall, on exhibit. More recent versions of Abramovic's healing furniture have been finely crafted of elegant woods, with the crystal elements unhewn and unpolished, mounted within the polished wood as rugged mountain-like presences, recalling Shinto scholars' stones.

Both groups involve the theme of elevation. The earlier wall-mounted platforms were raised above the floor; more recent, freestanding versions are slightly higher than ordinary furniture. While one is seated in the chair one's feet do not touch the ground, creating both a mood of childlike vulnerability and a sense of suspension in which new forces might be channeled into one's life. The "bed" of that series is also higher than normal, creating an effect like an operating table, on which one might expect, with a mixture of hope and dread, to lie down as an old self and rise up as a new one. The standing platform involves a large crystal suspended overhead, with a polished area where one contemplates oneself as in a blurry black mirror, one's identity being, for the moment, in question or in flux.

In Abramovic's furniturelike works, the role of exit or escape hatch is always at the surface. They tend, for example, to be raised as if embodying an upward urge or offering themselves as launching pads. Some chairs and beds have been twenty feet in the air, as if offering their occupant to Heaven. There is also the question of orientation. Assuming that the chair or bed or mirror-viewing platform has been set up on the right energy line, the body of the viewer/participant is expected to activate it and be activated by it in turn. The act of experiencing art will be moved from the optical to the spinal, so to speak. The serpent brain will be activated, the brainpower that moves through the currents in the stone.

As in her earliest performance works, Abramovic has structured sculptural pieces around a balance of activity and passivity. The active Apollonian self commands the discipline and ordeal of quieting and situating the self for the influence of the crystal, and the passive Dionysian self sinks responsively into the stone's serpentine embrace.

In addition to the curative aspect, there is a cosmic dimension to the intentionality behind the work. In the traditional view about sympathetic substances, the reason certain materials or forms have the power to heal is that they participate in an energy line like a cosmic voice harmonizing in the music of the spheres. Much of Abramovic's work has been involved with attuning herself to that line and performatively following it wherever it might lead. The works with the serpents, the works with the crystals, and the *Great Wall Walk* were all based on this idea. In the case of the *Wall Walk*, the idea was that the wall had been mapped out over the millennia of its building by *feng shui* experts, so if you followed the wall exactly, you would be touching the serpent-power lines that bind together the

Marina Abramovic, Waiting for an Idea, *1991. Courtesy: Sean Kelly, New York.*

surface of the earth. It was a macrocosmic version of the Relation Work in which Marina and Ulay had slithered about the floor with a serpent, trying to attune to their energy.

This search for an intuitive connection with materials, as in *feng shui* divination, is at the root of the next stage of Abramovic's recent work. In 1991–1992 she acted it out in a series of sculpturesque confrontations with massed crystals. In an amethyst mine in Brazil she sat before a mound of crystals without moving, "waiting for an idea," that is, waiting for an idea that the stone would bring to her, not an idea that human motivations could produce. At a Brazilian quartz mine in 1992 she sat for hours without moving in front of a mound of quartz crystal— "waiting for an idea," that is, waiting for the stone to communicate its intentions. The motionless human, the mass of stone, and the vibratory link between them comprise the sculpture.

A lot of Abramovic's work involves the activity of "waiting." It is like waiting for nature to indicate the approach to take to it—like being the handmaiden of nature rather than the manipulator of it. The artist is conceived as a sensibility that remains still and open and waits for nature's impulse to create a ripple across its surface.

Dragon Heads (1992 and later) was a synthesis of many Abramovic themes: the combination of activity and passivity, the motionless sculpturesque sitting, the sense of almost spiritual prominence to the furniture involved, the waiting, the

tuning to the serpent power. Abramovic sat in a business suit and high-heeled shoes on a thronelike chair in a circle of blocks of ice. Motionless and statuesque, she absolutely was a kind of sculptural object. Five pythons and boa constrictors were placed about her body—one on her head, one on each shoulder, and one on each arm upon the armrests of the chair, spilling from the armrest onto her lap and back again. For a long hour, while she remained perfectly still, the snakes moved "around my body," as she put it, "following the lines of energy." The video record is marked by the incredible poise of the artist as she attuned herself to the serpent energy and waited through its slow unfolding. They slither about her face and throat, gingerly testing the resistance. One shits on her face—she remains unmoved. They creep and writhe about her lap and throat. Now and then a thick plop is heard as one snake falls to the floor. When the fifth has fallen, the piece is over.

Here again was a variation of the earlier serpent piece, *Three,* and of the macrocosmic version of it, *The Great Wall Walk.* Now, instead of the body of the artist moving around the serpent-power lines of the Great Wall, the serpent power itself moved around the body of the artist, which became reciprocally like the Great Wall. With that interchange of activity and passivity that marked her work from the beginning, Abramovic effected an identity shift with the object of her attention.

Abramovic's sculptural work since the crystal-and-serpent period has also been exhibited through its use in a performance context. Since 1995, she has been doing what she calls "Power Objects." "I think," she explains, "that energy can actually be captured in the objects themselves. You can start with any object and create an energy field around it again and again, through ritual. Gradually the object becomes a tool."[5]

Abramovic begins with human figures made of wax, which she buys in Brazil, though they can be obtained in Latin American communities in several countries. Their intended use is as Santeria candles, for which purpose they have wicks in them. To "empower" them, Abramovic bandages a male and a female figure together, soaks them in fresh pig's blood, then mounts them on the wall in one corner of the exhibition space. As more accumulate, the floor in the area becomes soaked with blood. During the exhibition that corner will be the power place. A performative act of some kind will take place there. It is above all the repetition that she feels creates power, working her way into a special vein as in a mine, scraping away at it little by little, because underneath the surface a network of energy lines lies waiting to "become a tool."

Abramovic's work presupposes a theory like that of the Great Chain of Being.[6] Each substance or form or aspect is related by intrinsic essence-lines with other substances and forms of other generic orders; the species and genera link into a vast network of interconnections and sympathies, the patterns of which allow or obstruct the free flow of current. The artist, or sorcerer, figures out and then intervenes in the Great Chain. Her intervention is intended to be benign, merely participating, not manipulating.

Abramovic's sense of the role of the artist is not based on this theory or that, but intuitively generated out of her own experience. Still, it parallels traditional

roles in religious or shamanistic settings. Medieval European alchemists, for example, would sometimes describe themselves as the midwives of nature, not creating anything, but assisting nature in her self-realization.[7] The self-realization of nature is the goal or inner meaning of art. Art, in fact, can be conceived of as teleologically set up to induce or contribute to this self-realization. The Hegelianism of this mythic approach is not less than its participation in the occult tradition. In either setting, the significance of the artwork is premised on its supposed ability to nullify the ordinary conditions of life. This view of the role of art goes back to the beginning in Abramovic's oeuvre, to the moment when it seemed to promise a way out of an inherited but unappreciated society.

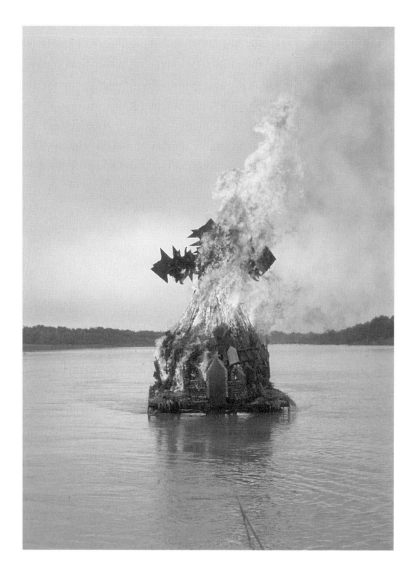

Michael Tracy, "Cruz: La Passion," 1990. From the event Sarcifice II, 13.4.90: The River Pierce.
Courtesy of the artist and The River Pierce Foundation.

Chapter Eleven

Your Flowers as My Hair: The Art of Michael Tracy

I am distilled shit. . . . I am the aphasic aphrodisiac. . . . I am Jesus Christ, madwoman, I am
blurred agony. . . . I am the green of yeast in beer. . . . I am the shiny chair. . . . I am the yellow
book of the sun. I am the white angel. I am the male member dismembered. I am the feeling of the
age of darkness. —Michael Tracy (from *Aphasic,* 1966–68)

At about age eight, Michael Tracy became an altar boy. He found his ritual duties satisfying.
St. Clement's, where Tracy went to grade school in Cleveland, Ohio, had a church in the
classical Byzantine mode, not unlike Saint Apollinaire's in Ravenna. Its well-appointed
sanctuary or altar space was thrilling to move in, amid the gongs and symbolic gestures that
proclaim death and Transubstantiation. The ecclesiastical apparel was also satisfying to
wear—more so than everyday clothes, which do not carry a sacred identity and purpose.
Under the influence of the liturgical calendar, the passing seasons were rich with recurrent
symbolic pleasures. On Good Friday, for example, the catafalque was covered with a purple
cloth on which a silver crucifix was laid. The faithful would kiss the foot of the cross as they
passed. Monsignor Joseph Schmidt was very particular about the altar boys' duties; he taught
them that these were really important things. As if to solemnify this point, Monsignor's
death was an impressive liturgical event, as he was laid in state in his chasuble in the nave.

After high school, Tracy went to St. Edward's University in Austin, Texas,
where he graduated in 1964 with a bachelor of arts degree in English and began to
emerge from sixteen continuous years of Catholic education. For three years, he
studied art back in Cleveland. Then, after a falling-out with the school administra-
tors, returned to Austin to work for an M.F.A. degree at the University of Texas. In
1968, while in graduate school, Tracy designed a production of a play written by a
friend, *The Death and Trial of Pope Formosus,* based on a historical figure who got in
political trouble in the ninth century for making overtures to the Eastern church.
His bishops murdered him, buried him, disinterred him, sat him upon a throne, put
him on trial, convicted him, cut off his consecrated fingers, and dumped his remains
in the Tiber. The violent story involves many of Tracy's later themes.

As the play was to be performed in an open atrium space in a classroom building without theatrical accoutrements, Tracy designed the actors more than the stage. They were bound into thick foam-rubber sheaths that emphasized their shoulders and upper bodies; over their massive bulks went huge capes and cloaks, some with liturgical symbols on them. A multiplatform ziggurat-like stage was installed. On top of it stood the cathedra—the throne on which the dead pope was to sit—a papier-mâché copy of the ivory cathedra in Ravenna; above the throne was a crucifix copied from bronze Carolingian models. Various staves, tiaras, rings, and books dotted the scene. Even more than most theatrical designs it was a sculptural installation, and Tracy's contributions were sculptures.

The themes of religion, death, and opening to foreign cultures are all parallel in their abnegation of the limits of conventional selfhood. In tying these themes together, Pope Formosus foreshadowed in a vague way much of Tracy's later life and work. The liturgical trappings and sanctuarylike space also remained with him. They were altar-boy work at one metaphorical remove; other removes would follow as Tracy's art or rite located itself in the world. In this process, the ancient connection of art with religion remained basic to him, as did its expression through a sacrificial rite in which the ancient pre-Christian cult of sex, death, and resurrection flowed from the veins of Osiris into those first of Dionysus, then of Christ.

In 1969, Tracy prepared his master of fine arts exhibition at the University of Texas, a guildlike rite in which a young artist is supposed to demonstrate that his or her personal direction and sensibility are already in focus. Tracy exhibited his works in an independent setting before their appearance in the university's MFA show. They were large paintings (or painted rectangular constructions) which he presented in a quasi-architectural installation that suggested the sacred space of the rite, the space where transactions between time and eternity are induced through the channels of sex and death with the mediating gestures of art.

Already, at the very beginning of Tracy's oeuvre, the tendency to sculpturize the painting medium was evident. It was much less the image surface of these works than their overpowering physical presence as objects that was memorable. Ten huge, square, gold-painted objects were arranged in an apsidal conformation of two triptychs and two loose pairs. The surfaces were thickly built up with polymer medium, then painted, some with a classical gold paint, some with a pinkish gold, some with a champagne gold. The paintings had particular identities in the artist's mind, like a child's toys or the fetish-objects representing characters in a rite; one stood for his mother, another for his father, others for Tracy himself and a friend. These four, grouped into two loose pairs, stood about ten feet in front of the walls like sculptures. There was an ambiguity to the space, which looked simultaneously like an art exhibition and a religious precinct for ritual activity. As with the Pope Formosus space and the sanctuary of St. Clement's with its purple cloth and silver cross, something was supposed to happen here beyond museum-style looking. Tracy has remarked that his paintings are not meant exclusively as the objects which the viewer comes to see, but as ritual settings or environmental backdrops for the events that transpire before them. Here his art stands in an ancient tradition that goes back to the caverns of Lascaux

and beyond them to Neanderthal shrines in the high Alps dating from 80,000 B.C.—a tradition in which art provides a fetishistic ambience for rituals of death and rebirth.

Like Egyptian, tantric, Byzantine, and medieval artists before him, Tracy was led to gold as a symbol of infinity, as an expression of a religiosity that exalts death as well as life, or conflates them into a *Liebestod* or love-death unity. His life at the time was strangely exalted and troubled, too. Various circumstances led him to an intuitive and radical decision, to go to Egypt, the land of Osiris, and kill himself—or anyway seek, or invite, or ritually incorporate death—at the foot of the pyramids. This plan had as much of exaltation in it as depression. The land of ancient gold, scattered with giant monuments to eternity, was long ago set up as a massive church for the rite of absorbing temporal suffering into an exalted mood.

Arriving in London, Tracy toured Europe in a simultaneous rite of greeting and farewell to Western civilization, on his way to disappear into its source. In Bruges, Ghent, Amsterdam, Paris, Ravenna, Florence, and Naples he gazed at the art of the Renaissance—of Giotto, Duccio, van der Goes, Caravaggio, and Bernini. Alone for a moment in a room with a van der Goes painting, he kissed it. From Naples he sailed to Beirut, where he visited Baalbek, an ancient temple site with the largest architectural monoliths in the world, then to Alexandria, and finally Cairo, the intended terminus. In July of 1969, his MFA not three months old, Tracy wandered among the pyramids at Giza looking for a spot to be alone. By the Mycerinus pyramid he found a space without tourists and guides, took off his clothes, and danced. The heat of the Egyptian sun and the loneliness of the desert wastes attended his dance of death, of renunciation of a worldly self, of a dedication of oneself to the communal and archetypal. He had intended to walk off into the desert and be gone. It no longer seemed necessary. Through the mediation of rite, death had become a part of life. Instead, he dressed and walked the ten miles or so back to Cairo and returned, by various stages, to Texas. There, as in Egypt and, later, in Mexico, he found the sacralizing solar heat and openness of space that give a ritual feeling to merely being out of doors. Tracy, who has always worked out of doors when possible, finds a source of art, or a reason for it, in such feeling. In his retreat from the ritual of death, or his ingestion of it, art became, as he later said, the "token fetish of the religious ritual of living," a kind of vocation, really, that gave to life a meaning and sanction beyond the personal.

In 1971, Tracy had an exhibition at the McNay Art Institute in San Antonio. He showed seven large gold paintings in an octagonal room, arranged sculpturally, as in the 1968 show, in a sanctuary-like installation that foreshadowed the arrangement of huge, nearly monochromatic paintings in the Rothko Chapel, which opened in Houston soon after Tracy's show. Tracy's paintings ranged in height from seven and one half to seventeen feet, and in width from eight to twenty feet. They are now in the St. Edward's University Chapel in Austin, where they function literally as backdrops for ritual.

In the following year, Tracy exhibited new works in the Philip Johnson–designed Art Museum of South Texas in Corpus Christi. Since the McNay show his sculptural paintings had been so large, and their weight of accumulated

substances so heavy, that they couldn't be stretched effectively. They were, in other words, ceasing to conform to the physical prescription for paintings, gaining the weight and ponderousness that is more characteristic of sculpture. For the South Texas show, Tracy mounted some of the paintings unstretched on the walls; others he presented on the floor, as he had worked on them. He continued the childhood-like practice of naming the paintings, but now in the form of dedications. One of the paintings at the Corpus Christi show, for example, was called *For Sylvia Plath*. Other names that would be placed on his objects in the years to come would include Caravaggio, Mishima, Pasolini, Rothko, and Schwarzkogler—all cultural figures for whom the natural content of art involved the nexus of sex and death.

The largest work in the exhibition, called *For Texas,* was composed of two gold paintings, twenty feet long, cemented together end to end. Heavily built up with sculptural whirls and swirls of gel medium before the final coat of paint, *For Texas* weighed several hundred pounds and was exhibited, like a sculpture, lying on the floor rather than hanging on the wall. The forty-foot-long altar carpet of tortured gold seemed, even more than the upright gold backdrops, an invitation to ritual activity. On the last night of the exhibition, Tracy performed an action on the painting, first sprinkling it with raw powdered pigment of Imperial Venetian Red, then expressing his feeling of becoming one with it, or merging into it, by running on it from end to end, lying upon it, writhing around on it, getting under it as under a blanket, and so on. The only audience was a photographer. The altar boy was taking over the rite.

Tracy has remarked that he could not make the work he needed to make until he returned to Texas. What would become increasingly clear is that it was at least in part Texas's connection with Mexico, with the Third World, that freed him to allow the altar boy to anoint himself, to take over the rite, or rather to allow his own rite to emerge from the darkness and find itself in the light. Tracy had first visited Mexico in 1971. After the Museum of South Texas show, he returned there, traveling to the pyramid site of Monte Alban near Oaxaca, and elsewhere, in early 1973, then returning again in the spring. Mexico made a deep impression on him, especially the Good Friday processions during Holy Week, when he first saw the self-wounding ritual of the Penitentes, a Mexican-Christian cult that preserves elements of the pre-Columbian religions in which celebrants drew blood from themselves to offer to the gods. The overwhelming reality of the Third World took over his work and humanized it, while stretching his religiosity into forms where it acquired new meanings.

In the Third World, the relation between art and life is different from that in affluent societies. One day, Tracy and a friend encountered a woman seated by a bucket of blood that she was hoping to sell. Tracy said to his friend, "I'm going to do a piece, and I want you to photograph it; I'm going to buy that bucket of blood and pour it into the street." His friend replied that the action would be a kind of insult or cultural aggression because to the woman, and to others nearby, the blood was food; its value was not that of a symbol. It was for sale to nourish someone, to

sustain life, not to make a gesture with. The purpose of art and the purpose of rite both seemed suddenly in question.

Returning to the United States, Tracy moved to Galveston, the port city about fifty miles south of Houston. In a studio near the waterfront, he continued to work on the huge, heavily encrusted canvases to which he began increasingly to add sculptural elements. At the same time, his work began to interact with that of others, to enter, as it were, the art history of his time.

Tracy's studio was in the same building as Joseph Glasco's; Julian Schnabel, a recent graduate from the University of Houston, visited them repeatedly there over the next five years, while Tracy and Glasco, in turn, would later stay with him while visiting New York. A mutually enriching friendship grew among them, based on their passion for art and a shared attraction to Abstract Expressionist stylistics; in Tracy's and Schnabel's cases, a growing interest in the aesthetic of thickly encrusted surfaces, sometimes with added found sculptural elements, strengthened and formed their work. Things important for the history of art were occurring in this backwater on the Gulf of Mexico. A romantic sense of artistic intensity was in the air, a sense that arose in part from the setting of Galveston itself.

A late-nineteenth-century seaside resort and commercial port center, Galveston is a city with a compelling sense of preserving another age; it has been called a fly in amber. A hundred years ago, it outshone its now famous neighbor, Houston. Galveston is a place that invites, almost enforces, a sense of participation; one is drawn in by its beaches, its ferries, its venerable old neighborhoods, its grand nineteenth-century homes, its sense of being—or lately, having been—something whole and healthy and classical and now bygone almost everywhere else. And, underlying its antique Americana is the raw geopolitical fact of its gaze across the Gulf of Mexico at the Third World, at Mexico, at a materially impoverished land that is humanly both real and other.

Tracy walked the city and ruminated on an art piece that would somehow involve the city as site in a way that went beyond architectural and historical references to focus on its relation to Mexico. The point was to involve its situation on the banks of the Gulf, beneath the intense sacrificial skies, on the hot beaches where, in the summer, the scent of blood from ancient Aztec rites can almost be whiffed in the air that puffs dreamily in from the South.

In late spring 1974, Tracy wandered into the Imperial Sugar Warehouse loading dock, where ships from the South Seas unload their tons of raw sugar, which are then carried by rail to Sugarland, Texas, to be refined for the market. What he saw was a vast rectangular space with a peaked ceiling perhaps sixty feet high, traversed by conveyor belts that carried the sugar along the ceiling and dropped it into huge heaps on the floor, where it formed a series of massive off-white cones. But what he felt was Giza; the massive cones seemed sculptural in the sense of the pyramids. It was a "warehouse/temple," as he has written, with "majestic Egyptoid presence." Pyramids gleaming in the sun of ancient hot climates stretched away from him—the sun-drenched sacrificial precincts of Giza, Baalbek, Chichen

Itza, Monte Alban—in an apparition that was sublime in suggestion yet extraordinarily human in meaning: This was the blood that people eat. This was a reality to which art had to be sacrificed.

Tracy obtained permission to use the warehouse and its contents as the setting for an art piece formally called *Sacrifice I: The Sugar*, but which has commonly come to be called the *Sugar Sacrifice*. In fact, despite this name, it was not the sugar that was to be sacrificed, but art that was to be sacrificed to it—to its reality as food. The pyramid-like mounds could have been rice, or wheat, or corn, and the piece would have meant the same. "If you believe," Tracy writes, "that there are more people in this world who do not have enough to eat than there are people who do, the basic idea of sacrifice in the presence of vast amounts of food would seem natural. . . . How we eat decides justice."

This was the first of Tracy's works to overtly confront the question of justice in the world rather than transcendence of it. It also was the first to be called a sacrifice, though the idea of sacrifice had long been present in his life. The Catholic rite is called a sacrifice. In it the blood and flesh of Christ, the symbolically sacrificed lamb, are offered up for the redemption of the world. The play of the death and trial of Pope Formosus was sacrificelike, too, as, in a sense, was the death and exhibition of Monsignor Joseph Schmidt. The theme of sacrifice (self- or auto-sacrifice in this case) also informed Tracy's suicidal pilgrimage to the home of Osiris. What would become increasingly clear was the importance of early Mexican sacrificial rites and their relationship with, or transmutation through, the Christian sacrifice.

The relationship between the relics of Renaissance Europe—so beloved by Tracy—and the increasingly living reality of the Hispanic Third World underlay *The Sugar Sacrifice* and much of Tracy's subsequent work. It is a relationship of crucial importance, yet one that is rarely focused on. It was in the late Renaissance—the Baroque Period in art history—that European culture colonized the New World. By the seventeenth century it was commonly believed in Europe that colonialism had proved the superiority of Western culture over others. Meanwhile, "barbaric pearl and gold," as Milton called the wealth of distant colonies, poured in. The forced Christianization of the New World was a part of this process of mastery. Cortés attacked Mexico City under the sign of the cross. Friar Diego de Landa, who destroyed the Mayan religious books as works of the devil, tells us that Francisco de Montejo, when he attacked the Yucatán, set on the mast of his ship "a banner of white and blue in honor of Our Lady, whose image, along with the cross, he always placed wherever he destroyed idols." It was a battle of signs, and the cross was the sign of the invading foreign culture's claim to universal jurisdiction. Christianity became Mexico's burden, its affliction, the sign of its loss of identity, its auto-sacrifice. History, viewed symbolically, shows Christianity incorporating the Third World of Latin America by forcing it directly into the hot spot of Christian sacrificial rite as the new Lamb; to assimilate the savage, Christian culture sacrificed him, making him a new Christ. Henceforth, in that world, to be reborn in the blood of the Lamb meant to be reborn in one's own blood. Mexican history can be seen as

a centuries-long Passion in which a crown of thorns is pushed down upon the pagan brow as the Third World is crucified on the cross of Western civilization. Tracy's deepest feelings for European culture are for the Renaissance, and colonization was an expression of the Renaissance. The Renaissance is what was being taken into the Third World. The Spain that conquered Mexico was the Spain of El Greco. In the tragic embrace of the Renaissance and the Third World, Tracy's two strata of feeling merge in cross-cultural paradoxes, expressed symbolically and ritually in his art.

Roaming the Galveston wharves, Tracy found materials for the sacrifice. He collected splinters of wood, eight to eighteen inches long, from broken loading skids on the docks and had them cast into bronze spikes, using the most traditional sculptural material and process. Over a hundred spikes were cast from seven or eight found originals. They were to be the instruments of the sacrifice. Tracy wrote on some of them at the wax stage, usually inscribing a name, as the gold paintings had once had names attached to them. One bronze spike was called "Schwarzkogler," another "Caravaggio," another "Rothko," another "El Greco." A couple were named after friends who had contributed money toward the piece. The altar for the sacrifice was an abandoned marine fuel-dispensing platform, a decrepit wooden structure about ten feet high, salvaged from the docks. Tracy removed the iron bolts holding it loosely together, had new ones cast from bronze at a local foundry that specialized in ship repair, and rebuilt the structure tightly. A set of sacramental dishes, involving gold and pyramidal shapes, was made for a banquet to close the rite. The sacrifice was scheduled for September 12, the arrival date of a shipload of sugar from Hawaii. Eight or nine friends came in from Austin and Houston to assist. Chasuble-like garments were made for them from fluorescent pink material cut in the center like ponchos. On September 12, the ship was delayed in the Panama Canal by a tropical storm. Twenty-four hours later it was berthed. On September 13 the ritual began.

Arriving at the warehouse around dusk, Tracy and his crew set things up. At his request the warehouse had unloaded 20,000 tons of sugar into a single mound—a huge bittersweet sculpture. This was not an unprecedented size for the warehouse; sometimes the piles of sugar were larger than this one, sometimes smaller. The sugar mound, in other words, was something perfectly ordinary that was going on there all the time. This manipulated readymade was an expression of an ongoing situation in the justice of how the world eats.

In front of the "pyramid" of sugar, the forty-foot-long gold painting, *For Texas,* on which Tracy had performed his action of self-dispersement or self-immersion in Corpus Christi, was laid down as a sanctuary rug. The warehouse had become a sculptural installation and was about to host a performance. On this rug, the altar was placed, near to the sugar mound. At the other end of the carpet was the sacrificial object.

In ancient Mexico human sacrifice was common. Often the victim was not a captive or a slave but an eminent citizen who had striven for the honor. Auto-sacrifice was the most direct expression of the feeling in which one literally offered oneself to the gods. Tracy's work hovers constantly around the theme of sacrifice,

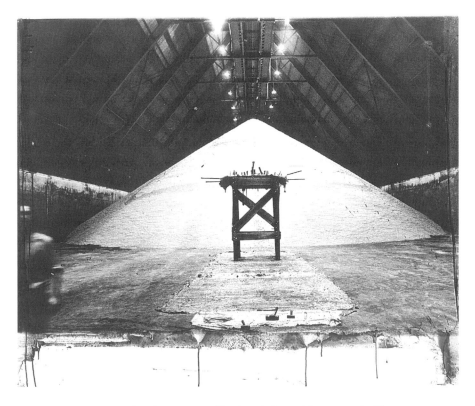

Michael Tracy, Sacrifice I, 9.13.74 (The Sugar); Suite of fourteen works–No. 14.
Courtesy of The Menil Collection, Houston. Photo: © Paul Hester, Houston.

veering back and forth between the sacrifice of the Lamb in the form of others—the *olvidados,* or lost ones, of the Mexican/U.S. border—and the sacrifice of oneself on their behalf. *Sacrifice I* represented a part of Tracy, indeed of Western civilization, which, while honored, would be eliminated for the greater good—which would, as it were, become the Lamb, for the sake of the Lamb. In addition to being a sculpture, the sacrificial object was also a painting. In fact, it was what Tracy regarded as his best single work.

Entitled *For H. B.,* it was painted during the Austin years, in the same period that produced the ritual cloth *For Texas* and the huge gold paintings of the McNay show. *For H. B.,* however, was different; it was a breakthrough painting for Tracy, the one in which he definitively moved beyond the illusionistic mystical space of Rothko to the semi-sculptural treatment of the surface that has dominated his later work. For the first time, after building up the surface with its whirls and beads and torments of rhoplex and polymer gel, he did not add a final coat of paint but left the surface raw, painful, and historical, not exalted and eternal gold. Symboli-

cally, in terms of the rite, *For H.B.* signified the value of painting altogether, the value of the Western easel painting tradition back to Caravaggio and beyond, the value, indeed, of the Renaissance, when colonization and the sacrifice of the Third World in the name of Europe's luxury had begun.

In order to make the large, heavy body of the sacrifice manageable, the painting was wrapped around an iron armature with processional carrying poles at both ends, not unlike the frameworks on which bulls were carried to sacrifices in the ancient world. It was treated, in other words, altogether like a sculpture, a heavy object to be carried from one place to another and solemnly put down. It was then placed at one end of the sanctuary carpet, opposite the mound of sugar, which stood at the other end. It was as if they were at opposite ends of a balance beam. The ritual was about the contradictions of value between them, about what was really important in the room. The verdict was simple. Art would be sacrificed to food, cultural luxury to physical necessity, Western tradition to the Third World. The event had profound ambiguities. At the same time that art was denied, it was denied in another work of art. At the moment the sugar was appropriated into art, it was affirmed as something other than art and more important, more human and necessary, more intimate, through its destiny in our bloodstream, than the cool optical passions of the picture plane.

At about 10:00 P.M. the preparations were finished. While a tape of the passionate Egyptian soprano Oum Khoulsoum played, the bronze spikes were hammered with difficulty through the folded layers of the wrapped painting. The eight or nine participants, donning chasubles, attended while the symbolically murdered artwork was raised by two forklifts and placed upon the high altar like a sacrificed bull or ox. The procedure, more laborious and time-consuming than its description, was over at about 2:00 A.M. A celebratory banquet of fruit was eaten from tables set up on the sanctuary carpet.

Sacrifice I was a primal statement in the symbolic debate about the value of painting that occupied much of the art of the 1960s and '70s, when Duchamp's legacy was reaped. Duchamp had demonstrated that quitting art could be a form of artwork, an artistic statement. Many had elaborated on this theme in works that questioned the ethical value of civilization's delicate obsession with the masterpiece. No statement of this type was closer to the passional roots of the question than Tracy's. In the following years, his criticism of the commodification of art would be brought even closer to its dark alter ego, the reality of hunger and hopelessness.

Several photographers documented *Sacrifice I,* and in the following days, Tracy worked with their products. He overpainted the photographs, to personalize them, to make them not reproductions but living magical fetishes, with his own blood, hair, and semen. The fourteen images (like the fourteen Stations of the Cross) and the equipment of the sacrificial scene—altar, sacrifice, and sanctuary carpet—were transported to Houston and exhibited in the Contemporary Arts Museum. A year later, Tracy took the sacrificed painting *For H. B.,* the altar rug painting *For Texas,* and the altar itself on the ferry over to the Bolívar Peninsula and burned them on the concrete bunker of a World War II fort that stood by the sea

like a lonely megalithic altar stranded out of its time and waiting for Tracy, or someone, to recognize it.

Sacrifice I inaugurated a new phase of Tracy's work. In the following years, his long emphasis on painting was largely superseded by a new interest in sculpture that, partly under the influence of the emerging liberation theology, focused ever more closely on the layering of Mexican Christianity. Often, Tracy's sculptures have been based on the Christian cross, the altar panel, or triptych, and the propitiatory objects (called *milagros*), in the shape of parts of the human body, hung on icons in Mexican churches to induce healing. His use of human blood and hair (sometimes his own, sometimes others') in many of these works unites Bernal Diaz's descriptions of the blood and hair rites of Aztec priests with the work of other modern artists who have been drawn to ancient rituals and ritual objects. More directly, it evokes the Christian sacrifice of the flesh and blood of the Lamb.

With *Sacrifice I,* Tracy began to become aware of a question that he would formulate in writing in 1979: "To carve an aesthetic out of realization of pain, suffering and death—can one live doing that?" Yet the question is irrelevant, too, because, he goes on, "it seems to be a call, a vocation."

Sacrifice I was followed by two other major Galveston actions. In the first, in 1975, Tracy and a collaborator performed an action that was documented in the collaged photographs called the *Caravaggio Notations.* The two men were photographed without an audience while they engaged in an "erotic combat," part wrestling, part dance. Each began with an elaborate makeup that wore off during the wrestling. Tracy had blue greasepaint in his beard; the other combatant had seven circles painted on his chest and groin. Each had panty hose, which had been slashed with a razor blade, over his head. Chinese characters representing the four seasons were written large on the walls, suggesting the processes of nature, the passing of the seasons, as an erotic combat not unlike the springtime battle rites of medieval Europe. "Modern artists," as Tracy has said, "take secular positions to make sacred statements." Fourteen photographic images of the action were mounted on Mexican cardboard and overpainted with sumi ink and Tracy's blood in tachistic ×s. The overdrawn ×, canceling an image, became in these years a recurrent feature of Tracy's work, suggesting the cancellation of personality and the denial of the priority of the image. A film made about Tracy's work in Galveston was entitled *Michael ×.*

This principle of self-effacement found a remarkable embodiment later that year in an action called *The Plaster.* In this piece, Tracy more or less became a sculpture, having himself put inside a full-body plaster cast by personnel from the local medical school. The procedure took hours in an intense Galveston heat wave. A ventilation patch was removed from the chest, like the vision into the heart of Mexican icons of Christ. Bound into the hardened plaster, Tracy was set up between two sawhorses like a log ready for the sawing. It was as if he had passed out of existence. His utterances from the hole of the plaster head were ghostlike and weak. His complete acquiescence in the bondage was a strangely compelling center of the action. Rites of descending into caves and emerging as if reborn, of assuming the

skins of others, rites of death and dying and resurrection, are suggested. The strange muteness and unintelligibility of the piece are echoed in Tracy's remark, not long after, "I am finding it increasingly impossible to discuss this work." Yet he discusses it unintentionally in a later writing: "We have only begun to deal with the PASIÓN TOTAL del ESPACIO PERSONAL." The total passion of personal space, aside from its reference to the passion of Christ, suggests the universalization of the person through sacrifice; its rendering, through the transmuting power of passion, into something no longer exactly personal or exactly space. Almost unconsciously, perhaps, there was a kind of allegory here of the isolated enclosure of the First World and the possibility of letting the Third World in.

The theme of sacrifice was carried on in *Caravaggio Sacrifice,* begun in 1977, on the steps of the Church of San Luigi de Francesi in Rome, where Caravaggio's altarpiece the *Cycle of St. Matthew* stands. Roses and violets were arranged between layers of colored paper on the church steps, gathered up, packaged between portfolio boards, and mailed to the United States. In Galveston, the package of flowers was sacrificed by Henry Estrada, a collaborator of Tracy's, who drove through it three of the bronze stakes recovered from the ashes of the sacrificed painting, *For H. B.*

Tracy's deep identification with Mexico goes beyond cultural sympathy to ritual incorporation. In his work since 1973, Mexico has become a mystical presence spread, like God, in (as Tracy once put it) "majestic mysterious ubiquity" over its land, its people, and their relics. Tracy has written of his identification with Mexico in terms of ancient fertility communions. "I kiss the sandy rock in honor of your presence, I want your sperm as my blood, your flowers as my hair." Mexico is Tracy's Egypt refound still alive, if staggering. The monolithic religiosity of that ancient theocratic culture is found again in Christian Mexico, a nation that is, like ancient Egypt, from end to end a vast haunted church. In Mexican Christianity, Tracy found "already all of my obsessions and ideas concrete. . . . Mexico," he wrote in 1979, "is the cross I want to be, am nailed upon. It is the final result of my life."

In 1978, Tracy rooted his life in a site that embodies his overtures to the south more actively, moving to San Ygnacio, a small village on the northern bank of the Rio Grande facing Mexico across the river. Though inside the United States, San Ygnacio might as well be a Mexican village. Only a handful of gringos live there. The population has been Mexican forever. The houses are mostly handmade and bear the signs of traditional Mexican crafts. The local newspaper has boasted that San Ygnacio is the only town that still annually acts out the Via Dolorosa, or Stations of the Cross, on Good Friday, with an antique mesquite cross that has been used there in the rite for over a century.

In San Ygnacio, Tracy works out of doors (a practice he began in Corpus Christi in the summer of 1977), in the usually blistering heat, and on the ground. After spreading a heavy layer of paint and medium on a surface, he leaves it in the sun until it crusts over, then pierces the surface crust to reach to the still-wet paint below and stirs and torments it, adding dirt, hair, glass, cactus, pieces of broken pottery, fringes of Mexican shawls, or other substances. New layers of paint and

medium are added, shaped, and left to dry. The surface builds up and weathers over a period of years. The big fetish-hung crosses and devotional panels similarly acquire their identity layer by layer, weathering deeply in the desert climate. The process of destroying and creating, piercing and fulfilling, becomes a fetish of a process that is bigger than history and contains it, a process, like ancient fertility cycles or the liturgical calendar, at once sad and triumphant to participate in. "The earth gives you everything," Tracy wrote, "and takes away all it gives. I at this moment worship the process itself—and feel it is the working of a divine force" (January 30, 1982). Through Mexico, Christianity has become, for Tracy, pantheistic and nature worshiping.

The Icon of Despair is a sculptural painting finished in 1979 after years of accumulation on its surface; dozens of bronze spikes, some from *Sacrifice I,* are driven through its tortured surface like abused earth. It is, as it were, the sacrificed painting resurrected for further ritual use, a second or double of the victim—a sculpture, one might say, of the painting. Its references to the sacrificed painting sum up the troubled and involuted nexus of the themes of the renunciation of art and the use of art to express renunciation, even its own. Tracy's activation of the surface by driving spikes through it in an allover pattern is a distant descendant of Pollock's existentialist Action Painting. The influences of the New York School—its allover composition, its action/tachism, its metaphysical anguish—merge with those of Italian and Mexican religious icons (with Byzantine and tantric influences more mutedly glowing in the gold).

During this period, the heavily encrusted altarpieces, sometimes cruciform, sometimes triptychlike, sometimes like Sienese devotional panels, with their suggestions of tiny churches, moved increasingly to the center of Tracy's oeuvre. Tracy has referred to this strain of his work as "a requiem for banished beliefs and an invocation of the forces from which the icons of the past sprang." But they are equally pointed toward the present and the future, the tragic predicament of Latin American culture caught in the double bind of liberation theology and religious reaction. These pieces are ambiguously placed between painting, sculpture, and architectural model; they often have a processional function, indicated by the presence of carrying poles. Tracy has remarked that in medieval art the support is as interesting to him as the image on it, and these works move the support into the foreground, giving the work a presence at once pictorial and sculptural. The *Cruz de la paz sagrada* (1980) is a cross on a pyramidal base, covered with Mexican tin and brass heart icons. It is thrust through with swords and knives, covered with ground glass, matted hair, rotting rayon, and a crown of thorns made of cactus. The *Cruz to Bishop Oscar Romero, Martyr of El Salvador* (1981) rises from a classical molded base and is weighted down with hanging devotional panels; it stands nobly upright yet dragged down by the weights hanging from it, like a religious leader carrying the hopes and aspirations of his flock. Run through with nails and spikes and surmounted by bull's horns, it is a sacrificial victim offered up for the communal good. Flowers are offered at its base as to the ancient Aztec god of springtime. The *Cruz de la paz sagrada* refers to the Christianization of Mexico since the Conquest; the

Cruz to Bishop Oscar Romero refers to the present situation of liberation theology and the wetbacks. In general, the heavy encrustation of the massive crosses, which are sometimes as much as ten feet high and weigh several hundred pounds, represents the accumulation of cultural layers, the colonial past, the burden of Christian imperialism; the carrying poles show the Third World bearing that weight.

The use of the heart-shaped tin *milagros,* in the *Cruz de la paz sagrada,* reflects a general theme in Tracy's work since his awakening to Mexico: the theme of the heart of the sacrificed victim. In this image, the pre-Columbian cult of the jaguar and the Christian cult of the lamb are brought uneasily together. In the human sacrifices of the pre-Columbian religions of Mexico, there was an emphasis on the sacrifice of the heart; holding the victim over an altar stone, the priests would open the chest, pull out the heart, and offer it to the gods. In Christianity it is Christ who is the human sacrifice, whose heart is worshipped iconically, whose blood is drunk and flesh eaten in the Communion rite—as the blood and flesh of Mexican sacrificial victims would be eaten. Both are cults of the bleeding heart. In Mexican Christian icons, the heart of the Christ can often be seen through a kind of window opened in his flesh. One common milagro shows a sword thrust through a heart. While it refers to Christ and the spear thrust through his side upon the cross, it also refers, in Tracy's work, to the sacrifice of the native culture by the sword-bearing conquistadors. A number of Tracy's works have titles like *Para los corazones de los mojados (For the Hearts of the Wetbacks).*

Related to the crosses are a series of works called generically *Stations of the Cross.* Most prominent are fourteen almost completed shaped canvases, *Stations of the Cross: To Latin America* (1982–1987). Most of these large semi-architectural paintings have arches in coronas at the top, as in traditional Mexican framing of holy pictures. They are huge, brooding emblems of blood, earth, and death, and the life that arises from them. Ranging from bronze to dark violet in color, they are like tormented fields—in one sense, ravaged by death, in another sense, torn up for planting. They mark an edge between culture and nature, between painting and bloody earth, an interface that is the Third World, that is Mexico. In these works, Mexican Christianity has managed to transmute Tracy's inculcated Catholicism: The metaphysical or redemptive sacrifice of the Catholic Mass has acquired the feeling-tone of an agricultural fertility rite.

Tracy's work has increasingly infiltrated the church. Not only does the St. Edward's Chapel in Austin contain the installation of gold paintings from 1969, but two chapels in Corpus Christi have commissioned sanctuary installations from Tracy, one of which is now permanently in place. This installation, from 1985, is an eighteen-foot-long triptych, in altarpiece form, in a Catholic chapel. First painted burnt sienna, then covered in squares of gold leaf, it faces the worshipper in an apsidal curve behind and around the altar itself. Mass is regularly celebrated before this backdrop. The other installation, in place from 1984 to 1987, was set in an interdenominational chapel of a medical facility. A triptych on a classically molded base opens its arms and reveals an inner panel of heavenly turmoil with suggestions of ascent, descent, and transformation.

Most centrally perhaps, when he moved to San Ygnacio, Tracy began working toward a piece which he refers to as the "big project for the river." The river is the Rio Grande, the "great river," the border between the United States and the Third World. It is another point of interface between nature and culture, or time and history. When the big river became an international boundary, and even more, an intercultural barrier, it ceased to be simply a part of nature and became a part of culture. No longer simply a river, it became a sewer and a bloodbath, a place of sacrifice of the forgotten ones, the wetbacks and migrant workers. In Tracy's studio, an old Mexican crucifix with a bleeding Christ is hung over a map of the river, which is seen as a place of crucifixion.

Tracy devised his project as an action that would symbolically or sacramentally reunite the two banks—First World and Third World. It took place on Good Friday (April 13), 1990. At the center of the action was the processional carrying of the largest of Tracy's crosses, *Cruz: La pasión* (1981–87), which he regarded as his preeminent extant work. *La pasión,* a ten-foot-high monument of the paradox of devotion and despair, heavy with the accretions of seven years of work and weather, was carried by twelve men to an ancient ruined mission on the north bank of the big river. About two hundred friends and associates—artists, writers, activists, ecclesiastics—gathered from around the country for what, in the tradition of the *Sugar Sacrifice,* was called *Sacrifice II: The River Pierce.* The ambience was flavored by pre-Modern elements—the mule-drawn wagon that brought the cross within carrying distance of the river, the swarm of naked mud-smeared performers who represented the prelapsarian condition, the long slow procession in the rain past fourteen stark wooden crosses erected along the path. The last Stations were celebrated beside the muddy riverbank. Then the cross of the passion was erected on a small barge which was pulled into midriver and cast adrift. Flaming arrows set the cross afire, and it drifted in flames past the assembled crowd, finally coming to shore on the opposite bank (as had been hoped but not prearranged). As at the *Sugar Sacrifice,* a celebratory meal followed. There was plenty, and everyone but Tracy ate to satiety.

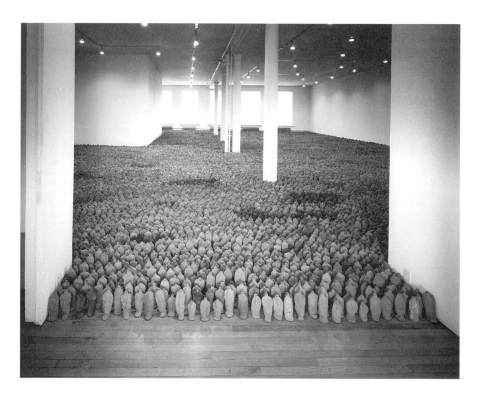

Antony Gormley, Field, *1991. Courtesy of the artist.*

Chapter Twelve

Seeds of the Future: Antony Gormley's *Field*

Three years in India during his early twenties preceded Gormley's art activities and were to a degree formative upon them. In those years he worked intensively with the vipassana meditation teacher Goenka, who is known for stressing the body as a channel for virtually every kind of awareness. Vipassana is a type of meditation that emphasizes what is called bare attention; a patiently cultivated, direct, non-mediated attention to bodily states, perceptions, and feelings progressively attenuates the acculturated impulse to contain them in conceptual categories. There is something ahistorical about it; bare attention to the present moment tends to remove one from the sense of specific cultural conditions and place one in an essentially timeless relationship with the immediate presence of the body and its foundational function as the site for the flow of events. At the same time that bare attention emphasizes the body, it leads contradictorily—in a paradox which also underlies the work— to feelings of dematerialization, as the body's boundaries seem to open up or dissolve. Returning to England in the seventies, at a time when art and the discourse about art were highly focused on language, Gormley centered the body as the focus of his art.

In *Land, Sea and Air I* (1977–1979), three mute and inexpressive objects were made by wrapping lead sheets around an egg-shaped stone and filling the resulting hollow vessels with, respectively, earth, water, and air. The lead-wrapped packages are egg-shaped to promote birth and growth when they are opened; they are protected caches of precious elements threatened by ecological and nuclear reduction. Within them are "sacramental" traces of the phenomenal world, removed from the perils of historical time and stored up as seeds with which to recreate nature in a post-nuclear future. Insulated from time and history by their leaden exterior, they lie mute and inert looking, yet alive with latency and the stirrings of a future, urgent to act in the world. The leaden membrane screens out radiation, keeping the sacramental elements pure like a ciborium around the Eucharists of a sacrament.

At the same time, the leaden surfaces suggest alchemy, with its desire to transmute lead into gold, as does the cosmology of three elements, which recalls alchemy's emphasis on mercury, sulphur, and salt. In alchemical theory a substance can be stripped of its qualities by a special burning, returned to featureless prime matter, then drawn out of prime matter again with other qualities—reborn, in

effect, as a new substance. The process has often been invoked as an analogue for art, in which one form of experience is transmuted into another. *Land, Sea and Air I* extends the analogy to include nuclear burnout: The *nigredo*, or blackening and cooking, phase of the alchemical process implies the nuclear burst, the *putrefactio* suggests the disintegration of a civilization so it can re-arise in new form, and so on. The muteness and smallness of the sacramental seeds in the face of the vastness of the threat to human life comprise their tiny whirlpool of tragic implication. They are not exactly burnt out residues of a world once fresh, but they are prepared to become so. It is their muteness that speaks, their inert immobility that reaches out to the viewer.

Though lead has become a significant art material in the last generation or so, no other artist has used it with such single-minded consistency as Gormley. For more than twenty years it has been a signature material for him. In the system of occult correspondences on which alchemical approaches to materials are based, lead connects with Saturn, melancholy, and absorptiveness. As it preeminently absorbs light, it is associated with darkness—the darkness of potentiality, in which gold lies latent in lead; or of the body, in which the spirit lies latent in the flesh; or of history, in which the future lies hidden as a seed within the present. Its lack of reflectivity gives it a hermetic presence, as if it were both there and not there, as if its heavy materiality were about to dematerialize.

Fruits of the Earth (1978–1979) again presents three small lead-wrapped objects. This time, instead of looking vaguely like eggs or stones, they look vaguely like vegetation or fruits. Inside the lead wrappings are a bottle, a machete, and a pistol; each has been wrapped with lead sheets, until the objects become like one another. Cultural identities are lost; the process of becoming parts of nature melts them down.

Three Bodies (1981) again shows three lead-wrapped forms, this time larger; from outside they appear to be sculptural representations of a shark, a pumpkin, and a boulder—animal, vegetable, and mineral. But these leaden forms are filled with soil. Earth appears as a kind of prime matter that has assumed these various forms outwardly while retaining inwardly its identity as a loam of potentiality. The secret earthen nature within the different forms implies that a principle of unity underlies things more strongly than the principle of diversity that parades itself on their surfaces.

In these early works nature is seen as a substrate on which culture depends and feeds. Out of prime matter, by a process of nourishment and growth, the life-forms develop. Into prime matter they will return. Meanwhile they are poised perilously on an ontological edge in which not only their identities but the natural substrate on which they subsist are threatened with oceanic engulfment and black burning at once.

These works imply a human presence in the universe but have not yet showed it. It appears, in a negative form, in *Bed* (1980–1981), a parallelepiped made of stacks of slices of white bread coated with wax. A hollow identical to the volume displaced by the artist's body lies half on one side, half on the other, so the empty

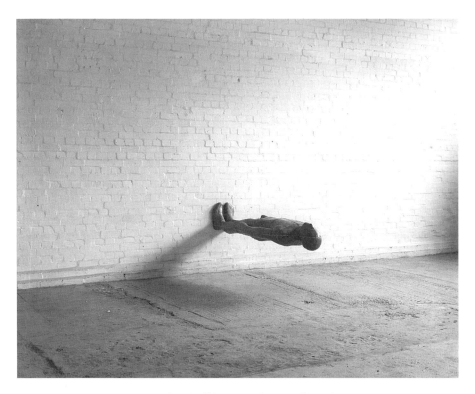

Antony Gormley, Edge, *1985. Courtesy of the artist.*

volume would be directly in the center if the piece were folded over on itself like a closed coffin. Gormley ate away the bread to create the negative imprint of his reclining body over a period of about three and a half months. The suggestion of Catholic sacramentalism ("This bread is my body") harks back to the more ancient mysteries of the Egyptian god Osiris, who was worshipped in folk contexts in tiny rough clay figurines. The wheat gardens which were called the Tombs of Osiris come to mind, and the empty tomb of Christ, symbol of his resurrection and elevation to the realm of the spirit. The "bed" represents at the same time the nourishment and growth of the body and its death, its absence, its tomb. Physical absence suggests spiritual presence.

The human figure not directly seen in *Bed* comes closer to visibility in 1981, in a mode fraught with the anxiety of annihilation. Taking plaster molds of his own body, Gormley began making from them hollow leaden figures which he strengthened with fiberglass, wrapped with lead hammered on with a wooden mallet, and soldered with a grid of rectilinear seams. The process of wrapping the body with plaster-soaked gauze recalls mummification, the process intended in ancient Egypt to maintain the integrity of the body as the site of spirit. The process

involves immobility as in Tracy's *The Plaster*, and an apocalyptic concealment and reemergence that suggests the promulgation of new states of consciousness. The artist seems to have left the hollow figures behind like snake skins, suggesting the spirit's triumphant escape, as in the ancient Orphic idea of *soma sema*, in which the body is the tomb or prison of the spirit which is destined to escape and transcend it. At the same time it can be seen as the tragic husk of a burned-out humanity: Is the nuclear *nigredo* an acting out of the Gnostic teaching that the darkness of the body must be stripped naked and reclothed? The heaviness of lead emphasizes the body's function as a gravitational tomb binding the spirit to the here below; at the same time its alchemical associations affirm the latency of spiritual realization within the leaden weight of the flesh.

In working the lead around the plaster casts Gormley erases details, joining the toes and fingers and smoothing off the facial features. So the leaden men become universal or generic figures of humanity. They are not bound to any particular time and place by garments or other cultural attributes, and seem devoid of individual personalities. Their nakedness removes them from culture and reduces them to an infantile vulnerability in a state of nature. They are almost fetal or latent, representing a state before personality has developed; they have been called "zombielike" and compared to "survivors of an apocalypse."[1]

But these figures do not unequivocally affirm the universal. Despite their tendency toward the featureless blank, they are placed in the world through the gridwork left by the soldered seams. The grid suggests cartographers' longitude and latitude lines, locating the figures within the web of causality. At the same time the grid superimposed on the organic bodies suggests the overlay of cultural methods of categorization and analysis on the indefinite continuum of life force. The work seeks to confront a tragic polarity: Universal in its life force, the figure is bound to the conditionality of its body.

The figures' stillness reflects their inability to escape from the web of causality. They sit, stand, crouch, lie down, bend over, or walk. Yet in the midst of these real-life functions they bear stamps of metaphysical otherness. Some (for example, *Three Ways*, 1981) have holes pierced at their highest points, escape openings for an upward flow of energy. This energy is rooted in the body yet impelled to leave it behind; its transcendence is a destruction. In *As Above, So Below* (1988), the figure floats spread-eagled upside down, crucified, seemingly, on the intersection of the universal and the particular. In *Untitled (for Francis)*, 1985, a standing man displays openings in his body like stigmata.

Theatrical implications portend the apocalypse as a theater of black burning. The three figures of *Land, Sea and Air II* (1982) stand on the beach like last lonely remnants of a dream of human life that the tide of a cyclical destruction is about to erase. They seem engrossed in bare attention to what is happening, or is about to happen, to them, offering their awareness as the only power they have in the face of an overwhelming desolation and abandonment.

Peer (1983–1984) points directly at the paradox of dual nature. An upright male figure gazes downward at his erect penis—one end of the spine, as Gormley

has remarked, looking at the other. The conscious mind gazes from the downward turned head at the urgent upward striving member. As in the tantric traditions of India, the spinal column is the axis up and down which energy flows betweeen its conflicting impulses, toward both transcendence and destruction. The upward force of spirit gazes downward, the downward pull of sexuality strives upward; the knot of their mutual implication is complete. The spirit gazes at the physical root that creates the body to anchor it, and presages its end. In *Three Ways* an ithyphallic male figure lying flat on its back recalls the tantric icon of the *shava-shiva*, the corpse Shiva lying on his back with an erection—and behind it the Osirian figure, called, in the Egyptian *Book of the Dead*, the mummy with the hard-on.

For Gormley art in general and sculpture in particular—with its special claim to non-illusionistic reality—is an evolutionary tool. *Mind* (1984) signifies a turning point in Gormley's attempt to intervene sculpturally in evolution. A leaden cloud like a giant brain is affixed to the ceiling as if floating to the highest available level, expressing the contradictory themes of upward impulse and downward gravity. It has within it both the need to float above in a realm of universals and the particularity of entrapment in the body.

The teleological primacy of consciousness—as the end toward which human development haltingly moves—comes to the foreground in 1984 as the idea of a mind-generated rebirth. This motif brings with it a second essential material, terracotta, which has since gradually taken over the work. The earthy terracotta represents a need to reassert the material world after long preoccupation with the spiritual implications of lead. A motif repeated in a number of these works is the emergence of a smaller figure or object from a larger one, usually from the head, as in *The Beginning, the Middle, the End,* and *Out of This World* (1983–1984). A small terracotta figure emerges like a mental excrescence or dream creation of the larger lead figure. It is the dream of the future about to emerge from the fact of the present—the new slimy fetal future for which the husk of the leaden present has sacrificed itself. It is higher consciousness emerging from matter after the long ordeal of its alchemical/historical purification. With connotations of prime matter or primeval mud, terracotta recalls the potter's clay out of which, in an ancient theological metaphor, the creating deity fashioned the first beings.

In *Man Asleep* (1985), several dozen terracotta homunculi walk past the head of a leaden male figure, which seems to be lying asleep. Gormley has thought of it as Adam's sleep from which Eve was produced and through her the stream of the humanity of the future. *Man Asleep* is the principal forerunner of *Field* (1989 and after), which occupies a culminating or climactic position in Gormley's oeuvre, unifying its separate threads. In this work, the leaden figure is finally absent and the terracotta figurines, produced somehow as forms of its consciousness, occupy the whole field of the future.

In *Field*, 35,000 small terracotta figurines, roughly hand-modeled and baked in a brick kiln in Mexico, totally occupy an exhibition space, leaving no room for the viewer, who gazes at them from a doorway. Not in serried ranks like a military installation, but loosely composed like pebbles left by high tide on a

beach—and, also like pebbles, each slightly different from all the others—the little humans gaze upward like unformed fetuses or primeval beings made by a Neolithic creator from softly glowing mud. Not accusatory so much as expectant, they gaze at the viewer as if awaiting some summons or announcement. Their eyes, black holes dug into the clay, stand out starkly against the terracotta. Their surfaces vary in darkness depending on how near to the fire each little figure lay in the kiln. A luminescence retained from the fire glows as if from beneath the skin. They come from within the earth, from beneath the visible surface of things.

Field represents a radical change in Gormley's work, greatly reducing the scale of his figures, multiplying them in number, eliminating his own body from the process and with it the element of lead. The installation has occurred in four versions from 1989–1991, the number of terracotta figures dramatically increasing from 150 in 1989 to 35,000 in 1991, as if from one version to the next the evolutionary project were advancing.[2] The lead figure of *Man Asleep* is tacitly replaced by the consciousness of the viewer; the terracotta figures that represent the excrescences of mind have taken over the piece completely. Excluded from their space and their company, the viewer is nevertheless called on somehow by them; they constitute a kind of seedbed whose fulfillment lies in the responsibility of the viewer.

Gormley worked on the 35,000 terracotta figurines with a family of brickmakers in Cholula, Mexico. Each small rudimentary figure, from three to eight inches high, was handmade, sun-dried, then baked in a brick kiln. The Mexican artisans—representing the Third World, the future, the ancientness of this type of work and its linkage to the earth—are in effect a part of the work. They stand in for the ancient potter-demiurge of, say, the Akkadian Creation Epic, shaping images of the people of the future, which is seen with an ecological optimism as made of the earth.[3]

As the course of evolution, on the spiritualizing model that Gormley tends to follow, proceeds from less consciousness to more, so history moves from so-called undeveloped to so-called developed societies. The fact that this family of artisans lives in agricultural Mexico, but near the huge devouring metropolis of Mexico City which supports their labor with its ravenous demand for more bricks for building, places them as it were at the historical boundary which, to Gormley, introduces a new evolutionary phase. In the 1991 version, for the first time in a career that has involved various collaborations, Gormley turned the most meaningful parts of production into the hands of his collaborators. In previous versions he had made the head and eyes himself; in this case each artisan made his or her own figures completely. The family relationship that bound the twenty or so collaborators contributed to his faith in the collective energy they generated. The work became a reservoir of feeling into which many related personalities poured their vibrations through their hands.

In the New York installation of 1991, the viewer entering the exhibition space found the front of it empty, then, after wandering quizzically through several empty rooms, encountered in the large room at the back the overwhelming mass of small crudely hand-molded terracotta figures gazing up at the visitor from floor

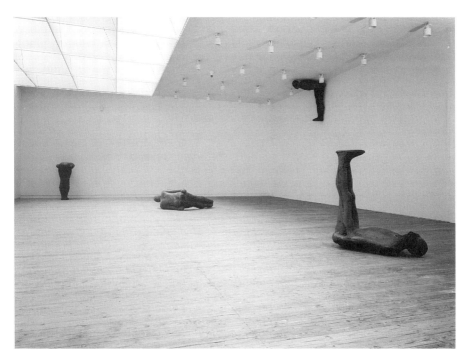

Antony Gormley, Testing a World View, *1993. Courtesy of the artist.*

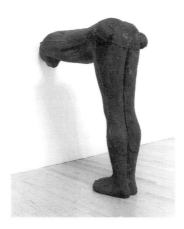

Antony Gormley, Testing a World View *(detail), 1993. Courtesy of the artist.*

level through their hollow black eye-sockets. Arrayed in an irregular tide like the future emerging raggedly into actuality, they gaze patiently and obediently up at the viewer. As with Neolithic and early Bronze Age figurines from Mesopotamia, the Indus Valley, and elsewhere, there is an innocence and vulnerability in their rudimentary barely formed bodies. Seemingly awaiting some call, they mass in intense upward gazing as if with a request for honorable survival. Facing them, the viewer may become aware of his or her "oblivion," as Gormley puts it, in relation to the future, which will arise from the viewer's body yet replace it, and at the same time of his or her responsibility toward the future, which will inhabit the world that the humanity of the present makes for it. The look of mute expectation and restrained beseeching focuses the living on their role of custodians of the earth and preparators of its destiny.

Gormley has said that he is tired of art about art. His oeuvre does not involve the Modernist obsession with thin linear developmental streams, nor does it engage in the post-Modernist historical gamesmanship intended to confute Modernist linearity. Still, it is not ahistorical, but emerges from a network of affinities without belonging convincingly in any single grouping.

It stands in the British tradition of Henry Moore in its closeness to nature, and in that of Barbara Hepworth in its focus on the figure. In its assumption that art should be used as a catalyst for the reorienation of the self, the work relates backward in the English tradition to Blake. It shares a somewhat Indian-derived spirituality with Anish Kapoor, while recalling Bill Woodrow and Tony Cragg in its emphasis (until recently) on found materials. It participates in the continental tradition of Yves Klein and Jannis Kounellis in its alchemical associations and materials. The use of the artist's own body as a spiritual object-lesson—and even more the feeling that sculpture must be used as an evolutionary tool—relates it to Joseph Beuys and, more distantly perhaps, the Viennese Actionists. The focus on hollow generic figures sometimes serially arranged relates to Magdalena Abakanowicz. References to sculptural icons from ancient traditions recalls Louise Bourgeois, as emphasis on the body as the site of the spirit recalls Helen Chadwick. Its tragic sense of a nearly insoluble inner duality in the human condition relates it both to Christian iconography like the Eisenheim Altarpiece and to the Northern Romantic tradition, as in Caspar David Friedrich and others, that sees the great powers of nature as forces against which it is a nearly futile human destiny to strive.

Gormley's work combines the urgency of its challenge in an arena that goes beyond the inbred and elitist concerns of art with a complex art historical balancing achieved through this inconsistent yet living set of references. Its relationship to minimal art, for example (from Walter De Maria's *Earth Room* to Richard Serra's mutely fetishistic use of lead), situates it in the realm of the contemporary, while its invocation of ancient modes removes it from the limitations of that realm. The work is neither primitivist, in the sense of being negligent of the moment it arises in, nor historicist in the sense of being dominated subserviently by that moment. Beginning with the ultimate particular of the artist's own body, it expands its reach through a

surrounding network of associations to his English tradition, beyond that to the broader contemporary milieu of both American and Continental European art, the larger tradition of the art of the figure both in classical antiquity and the Renaissance, and finally the vast reaches of the archetypes of more ancient religious traditions that lie behind the strata of culture.

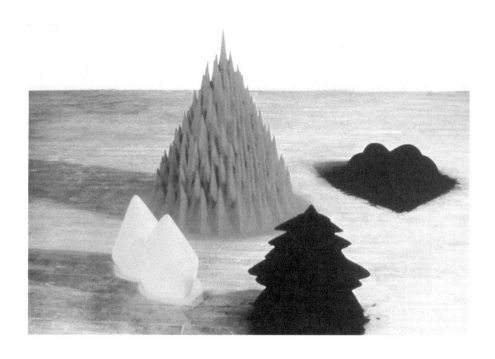

Anish Kapoor, White Sand, *1982. Courtesy Barbara Gladstone.*

Chapter Thirteen

Anish Kapoor: The Darkness Inside a Stone

The purpose of the lover is to establish a personal relation with the Beloved, and the plastic symbol is created for this end. —Ananda Coomaraswamy[1]

Art is a reflection of spirit which spirit has produced for its own contemplation. . . . So we have before us love itself objectified in what is loved. —G. W. F. Hegel[2]

The idea of a place which is out of time, original, and central in a metaphysical sense lies behind much of Anish Kapoor's work, from the early *1000 Names* to the more recent *Void Field*.[3] In one sense this "place" is a space inside the mind, not the space of the ego, which is evident, but the secret or hidden space of the unconscious, the abyss of potentiality from which thoughts and feelings emerge like unpredictable efflorescences. In another, but cognate, sense, the "place" established by the imprint of art is an ontogenetic space, a space charged with potential life that is barely nudging itself into view, like the tip of an iceberg. It is a space tingling with life ecstasy, one that is characterized by the ability to confer life in new forms, like a womb or an athanor. In terms of alchemy, it would be a space in which Prime Matter could be directly encountered as itself, which is a space beyond logic, a "place" founded on paradox; until Prime Matter has had some characteristic or differentiation imprinted on it, it remains unknowable, since it has no trait by which to be known. The idea of such knowing premises a nonparticularized knower, a sub- or superindividual conscious- ness, which might know that which is unknowable by the ego.

When, in 1980, Kapoor began exhibiting his rounded organic forms in their aureoles of powdered pigment on the floor, it was hard to take one's eyes off them. Their delicate powdery surfaces glowed with a primal simplicity. The serenity with which these seemingly slumbering spirits presented themselves to the world arose from a balance of tensions rather than a lack of them. These apparently simple visitations incorporated massive polarities: colonized (Kapoor's childhood in India) and colonizing (his long residence in England),[4] East and West, ancient and modern, particular and universal, sacred and secular, nature and culture. These tensions are internalized, in what Kapoor has called his "representational abstrac- tions about the unformed,"[5] and also surround them invisibly like unspoken impli-

cations. The object that seems as simple as an egg lies within a nest of meanings: Hindu symbology, Hebrew mystical thought, Modernist abstraction, Minimal or primary-shape art, post-Minimal poetic objecthood, metaphysical iconicity, psychoanalytic intuition, New British Sculpture. Each of these frames applies, and is appropriate in some way, even though they may contradict one another. This simplicity as presence and complexity of reference energizes a structural tension that creates a tight inner strength in the work.

The event that occurs in the Space of the Unformed is often conceived as a *hierosgamos,* or Sacred Marriage. At a primal moment, the One Center divides into two modes of expression. By the interaction of their differences, the two initiate a process of change that accelerates throughout history. The two modes have been formulated in various ways. For Pythagoras they were finite and infinite, for Plato they were presence and absence, for Hegel spirit and matter. In much of the world's thought, including the Sankhya philosophy and the tantric tradition of India, the distinction is imaged forth as male and female.[6] The gender principles are seen as complementary cosmic forces creating and sustaining the universe through their intimate interactions. At the same time, they are allegories of aspects of spirit. Something similar is seen in the exaltation of sexual love as a path to higher reality in Western Romanticism.[7] Human activity is conceptualized around the goal of dissolving matter back into spirit, as in the Romantic-Modernist ideology formulated by Hegel.

This cosmic love affair runs through Kapoor's oeuvre.[8] He presents, for example, in works such as *Black Earth* and *Untitled* (both 1983), variations of the lingam-and-yoni icon which are depicted as centrifugally spinning, as forms generating themselves out of a vortical center.[9] The world is seen as begetting itself through narcissistic desire.[10] The spinning lingam suggests the auto-generative absolute ("the Thought that Thinks Itself," as Aristotle called it; Spirit creating an image of Itself for its own contemplation, as Hegel put it). It also suggests the creative (phallic) artist spinning off the products of imagination and at the same time the artwork itself as an auto-generated entity. Because the artwork, in a metaphysical ideology, comes into being from no ordinary or worldly desire, but from an attraction toward the absolute, it follows that, in a sense, it comes into being from a beyond, another world, and from the artist's own inner (Orphic) imperative to contact that other world (the Beloved). Again, it suggests the narcissistic aspect of the process of art-making, in which the artist gazes into himself or herself as into a Beloved. In much the same way the concept of "place" (whether Meru or *makom*), the metaphysical center, relates to the artist's studio as the site where narcissistic auto-generation occurs, and to the art gallery, which is purified as a temple, to create a setting in which the walls and floor may seem to act like creative membranes.[11]

In the yogic centers of India, the colored powders that are used in Hindu folk ritual are encountered heaped up on tables or on the ground. They are used to mark certain elements of nature, such as stones, or places on trees where limbs have come and gone, which are associated with the goddess of fertility and the vagina.[12]

Anish Kapoor, Void Field, *1989. Courtesy Barbara Gladstone.*

The color signifies the indwelling divinity regarded as present in all matter. For Yves Klein, powdered color also represented spirit.[13] Being powder, it does not exactly have a body, that is, a solid material shape. It can be thrown into the air and become a mist or cloud or volume of colored light. Its almost immaterial touch transforms a material object into something that seems about to levitate, like the moment when the dreamer is about to lift off and fly. The use of powdered pigment to seemingly dematerialize or levitate an object is an expression of Hegelian Modernism's aspiration toward transcendence, immateriality, and pure spirit. In Kapoor's *Angel* (1989), the stone covered with blue powder is like a piece of sky orphically fallen to earth.

Raw powdered color has become a widespread late- and post-Modernist vocabulary element. In terms of Modernist art history, it is the last vaporous mist of the sublime, which is especially associated with blue. Goethe in his *Theory of Colors* associated blue with infinity, as did Van Gogh, and later Klein.[14] Blue is the paramount color of Modernism, or at any rate of the cult of the abstract sublime, which was the culminating phase of Modernism.[15] Like the powdered pigment itself, it indicates transcendence and the absolute.[16]

A conviction about the transcendental possibilities of the manipulation of color was a partially unacknowledged mystical element in Modernism. Walter Pater, for example, an incipient Modernist, regarded color as an aspect of things "by which they become expressive to the spirit."[17] The most central and intimate cult of

Modernist abstraction, that of the monochrome icon, was an acknowledgment of and homage to the mystical power of color, its ability to create a sense of metaphysical transformation.[18] The emphasis on pure saturated primary colors in Kapoor's work reinforces the message of spirit, borne also by the primal simplicity of shape and the levitational powders.

In addition to a sense of the spirituality of color, Kapoor shares with classical Modernism, especially the Abstract Expressionists, a preoccupation with the theme of the Origin, the Primal Moment and the First Light. Barnett Newman's *Day One* and *Day Before One,* with their positing of *makom,* or primal place, through pure color; Jackson Pollock's *The Deep,* with its portrayal of the face of the ocean before the first "Fiat"; Arshile Gorky's spermatozoa; Ad Reinhardt's glimmers in the night; Mark Rothko's first hints of predawn light; Franz Kline's primal scribbles: This art was a celebration of the metaphysical origin of the world of form, and also of its end. The space established by Kapoor's work is similarly cosmogonical. The early works sat on the floor like the tips or edges of gigantic cloudlike forms about to rise from Earth into the sky, or like images just poking up from the unconscious into consciousness. They created "place" in the area they occupied, that is, in the actual architectural space around them; Kapoor's more recent works enclose "place" within themselves, directly embodying a womblike interiority.

The Indian goddess of the vagina is Kali, who is worshipped by way of a direct, isolated image of the female generative organ. Of course there is another aspect; she is the goddess of the vagina, whose tongue lolls out with thirst for the blood of her own offspring.[19] In her the source and the receptacle are one, the womb that releases beings into the world becoming the tomb which receives them at the end. In the tradition of the abstract sublime as well, it is as much the end of the world as the beginning that the exalted ground refers to.[20] The emptiness within the source or container, or the blankness of the picture plane, is the void of potentiality from which forms arise and into which they are sedimented again after their momentary spurt of self-expression.

Kapoor's early work was dominated by exteriority, though it was an exteriority of delicate tissue that seemed properly interior, like a vagina or a womb turned inside out. Gradually, beginning with *Pot for Her* and *Mother as Mountain* (both 1985), the convexities curled into concavities that gently cupped the inner volume and held it out for direct inspection. The generative space was closing in on itself. The reference in *Pot for Her* to ceramic vessels relates to the ancient cult of the goddess as rounded vessel representing womb space, and to the custom of urn burial, in which the fecund void embraces the dead as a sympathetic stimulus to rebirth.[21] Still more recently, as in *At the Hub of Things* (1987) and *Mother as a Void* (1988), the concavities of Kapoor's work have been curling completely around on themselves, closing themselves off from the viewer's gaze into a complete interiority, as the "place" is relocated in inner space. With *Shrine* (1987) and *Virgin* (1987–1988), all attention is directed toward the contained inner volume. In *Blood Stone* (1988), the contained volume is almost completely sealed off. With a surprising clarity, the work points to the idea of a womblike metaphysical space in which

Anish Kapoor, Mountain, *1995. Courtesy Barbara
Gladstone. Photo: John Riddy, London.*

potentiality is able to become actuality. So interior is the work now that the viewer
has almost no access to it from the outside. The object that generated itself is
swallowing itself up again. The vagina has recovered its inwardness, having revealed
itself, then recoiled into its secrecy.

The work's drift from exteriority to interiority was accompanied by a shift
from diurnal to nocturnal colors. Kapoor conceptualized colors in the early pigment
works (like *1000 Names*) as a kind of elementary language of vowels. Red—the sign
of body, blood, birth, death, and life—was the center. It was conceived as containing
the other primaries as its constituents. Yellow was the passionate and expressive
element of red, its solar, flaming, amorous, outgoing self. White was its purity, its
chastity as against the bloodily sexy red, its attempt to negate or escape from the
fluidic fates of the body. Blue, finally, was the spiritual or transcendent element, that
which did in fact go beyond the body—beyond blood, life, death, and birth. Blue in
effect accomplished what white desired or signified—Malevich's white beyond, leapt
over by Van Gogh's blue infinite. The blue was as spiritual as the white, yet more
fecund, more creative. Kapoor, seeking a darker and deeper meaning of blue than
Klein's (one nearer in fact to the meaning of black) has used Prussian Blue, some-

times with an admixture of Mars Black, rather than ultramarine. Increasingly, his emphasis has been directly and simply on black. As the works have folded or curled around to enclose within themselves as a secret interior what once was their bright exterior, the colors have followed them from outside to inside and become consistently darker and more dangerous. This shift from bright to dark and from outside to inside may be conceptualized as a shift toward the dark aspect of Kali, toward the Dreadful Mother.

Void Field (1989) consists of sixteen roughly cubical pinkish stones, approximately one meter along each edge. On the outside, the stones are left as they came from the quarry, rugged and irregular, pocked by marks of the drill. But here the point is the inside. The almost fetishistic, bright, glowing perfection of the exteriors of the early works has given way to the dark, almost petulant secrecy of the interior. The big stones stand there mutely, the only artistic intervention seeming to be the rough black circles on their upper surfaces. From a distance these circles seem to lie upon the stone as if applied with black ink that sank slightly into its pores. Somewhat nearer, one sees that these circles are, in fact, holes sunk perhaps an inch or two into the stone and, seemingly, coated inside with black powdered pigment. Nearer still, one sees that they are actually deep holes. In fact they seem to go as far as the darkest night; one cannot begin to see to the other side of their velvety blackness. These stones have night inside them. The wings of crows might be heard inside these stones at midnight. They are hidden voids, enclosed darknesses, packaged nights. They show the void as a great darkness, a primal darkness, the darkness of the womb and the tomb, of the ocean before the first sun rises and after the world has redissolved itself at sunset. Darkness has become a material; only here it is maddeningly separated from the viewer, who can see it but not enter it. It is neatly contained within a package as if it were black ink in an inkwell.

The *Void Field* stones refer in part to what has been called the "Return to the Uroboros."[22] In Jungian terminology, the Uroboros is the unconscious, the abyss of inner darkness which is completely self-contained and devours or feeds on itself, like the tail-biting serpent. It is the darkness in which one seeks to know oneself. The ego approaches this void and feels its own boundaries become clear because they are terrifyingly threatened with a dissolution which at the same time they long for. The black smoke that comes off the void into one's lungs makes one gasp both with the thrill of near annihilation and with a new raw energy that can, perhaps, be redirected toward the world of form. From portraying nebulous forms rising dreamily from the unconscious, the work now portrays the unconscious itself.

What is most fascinating, from the transcultural point of view, in Kapoor's conflation of visual vocabularies from different times and places, is the appearance of a seamless fit on all sides—a virtual lingam-and-yoni union. It cannot be said that the Hindu elements are primary, or that Modernist elements are. What is primary is the way the work performs its homage to various deities without seeming to betray any.[23]

Kapoor's ambiguous placement in history is a part of the premise of the work. There is a paradoxical challenge to the situation of a colonial practicing

Modernism. Modernism was an ideology that incorporated India, and of course many other places, as fixtures of Empire, not sources from which new expressions of cultural identity—*British* cultural identity!—might arise. Any attempt to reestablish cultural collaboration after a colonialist period seems full of sad paradoxes and haunted by inner contradictions. Kapoor's work, in its smoothness, embodies the duality. On the one hand, it reverses the colonial relationship, incorporating the aims of the imperialist Modernist power into the forms of the colonized culture that is its vaster matrix; it takes revenge by reincorporating into itself the reflection that once had incorporated it. In another sense, the colonial culture is subsumed into that of the urban imperial center, betrayed. Yet again, the codes of the colonized and colonizing cultures can be seen as interpenetrated, a utopian glimpse of a possible post-Modern future. Pre-Modern in its relationship to an ancient communal tradition, Kapoor's oeuvre is Modernist in the artist's conviction of the purity of form and in his precise awareness of its Western art-historical antecedents; finally, it is post-Modern in its conflation of cultural codes from different historical times and places, and in its implicit relativization of its own metaphysical ambitions.[24]

The concept of the spirit in art, articulated by both Hegel and Coomaraswamy, is the mediating membrane which joins the diverse elements and smooths out the contradictions among them. Coomaraswamy's aesthetic theory, which is rooted in Indian metaphysics, is, as he recognized, not so different from that of Benedetto Croce, which is rooted in German metaphysics. Both emphasize the idea of a universal spirit with which the artist is trying to establish a channel of communication, through the art object or the yoga of making it. Underlying this dramatic image is the premise, understood in both ancient and modern contexts, that the soul has fallen from on high, and its incarnation as an artist is one of its better chances of finding the way back.[25]

Marinus Boezem, Della Scultura e la Luce, *1985.*
Courtesy of the artist. Photo: Wim Riemens, Holland.

Chapter Fourteen

Skywriting: The Work of Marinus Boezem

Marinus Boezem, born in 1934, is of the generation of artists—Minimalists, Conceptualists, Poverists, and others—who inherited Marcel Duchamp's delayed legacy at the moment of the collapse of High Modernism's credibility. But his generation also inherited the momentum of Malevich's transcendental post-aestheticist abstraction. These ideologically conflicting trends reached a refined conflation or resolution in Boezem's oeuvre.

In the 1960s and '70s Boezem's work dealt with the issues of ephemerality, immateriality, cognition, and site specificity that may be regarded as the assignment that history gave to him and his peers. More recently he has pursued his themes into the realms of sculpture and installation. His oeuvre has been accumulating, or exfoliating, now for thirty years. Through most of that time, it has shown a continually changing reinvention of its formal and material aspects alongside a seamless inner coherence in its thematics. In terms of the material and formal, the work has belonged to the broad stream of the Duchampian tradition in which aesthetic decisions are to be made with the goal of breaking and reforming habit systems rather than the goal of reinforcing a pattern of taste.

In keeping with this heritage, Boezem's materials have been primarily readymade or found. Some, such as the fan featured in *Signing an Itho-Fan* (1965), recall Duchamp's favored use of domestic tools such as the snow shovel or bottle rack. Alongside Carl Andre's bricks and Jannis Kounellis's acetylene torches, they are the types of materials to be found in the dry-goods stores that Duchamp wandered in. Traditionally such materials have been construed as contributing to the anti-Modernist, or early post-Modernist project of collapsing the breach between art and life, rescuing the art activity from the abyss of the sublime and restoring it to earth and society.

Others of Boezem's found or readymade materials, such as weather drawings, sky maps, and architectural floor plans, have been more in the classical Conceptual vein, advancing the project of conflating the aesthetic and the cognitive aspects of the human personality, which, like art and life, High Modernism had rigorously segregated. Unlike the dry-goods-store readymade, they have tended to point away from the earthly and the everyday. Despite the fact that they are readymade or found, they point not toward the Duchampian ideology but the

Malevichean. Boezem's oeuvre, in other words, despite its overall coherence, is not simple or unidirectional; it involves significant crosscurrents, inner tensions, and unresolved ambiguities. The procedures of reconciliation in his work—art/life, aesthetics/cognition—have been offset or balanced by a thematics of separation and alienation based ultimately on the Orphic tradition, which has remained powerfully effective in a variety of guises in the West for literally millennia. Throughout Boezem's oeuvre the Orphic theme functions dually, both as a unifying thread and as a continually restated message of disunion.

The Orphic thematics found in Greek sources from the sixth century B.C. and later may go back to Egyptian sources of a much earlier date.[1] Crucial early expressions of it occur on gold plates encased in gold sheaths and hung around the necks of the dead as reminders, like the Egyptian Book of the Dead, of the things the soul will have to remember in the afterlife in order to return to its true home. The fundamental idea is that the soul, or that part of a human being that supposedly survives the death of the body, originated in another world beyond the sky from whence, perhaps as a shameful exile, it descended here below to be imprisoned in a material body which, subject to the humiliating bondage of the law of gravity, lacks the ability to return to its home in the sky. Its goal is to disentangle itself from the webs of daily concerns that bind it to the here below and prepare for the moment of release from the present body, when the soul, if it remembers the way back and shakes off material concerns, will return over the back of the world (as Plato described it in the *Phaedrus*) to its place of origin, where it will reclaim its true nature. This idea system has something in common with the Christian mythos of the soul and its afterlife destiny, due to the fact that St. Augustine derived the Christian doctrine in part through his reading of Plato, who in turn had incorporated Orphic elements from his Pythagorean preceptors. It is not precisely and exclusively a Christian complex, however, but as pure Orphic signifier, or as culturally disconnected prophecy, it represents a stance that can be utilized in a number of moods.

Periods of massive social and historical stress and disruption tend to foster Orphic thematics; a promise of potential escape from worldly chaos into a beyond that is still characterized by unchanging verities.[2] It serves thus as a mediating device between change and changelessness, a proposed avenue of spiritual escape from processes of uncontrollable and frightening social and political change. In the nineteenth century this motif of spiritual escape into a realm of reassuringly unchanging verities not unlike the Platonic realm of Ideas arose in the wake of the Napoleonic Wars. In a Europe that was still largely de-Christianized by the Enlightenment, this tradition merged both with the crypto-theological Hegelian myth of history and with what Matthew Arnold called the religion of art and poetry. It became, that is, superficially secularized and available for significations outside the arena of organized religion. The transition into a timeless beyond, in other words, was to be accomplished through the spiritual channels provided by artists in their works.

In twentieth-century European art, the Orphic theme has been especially prominent in the Malevichean avant-garde.[3] It began to gain a foothold in the troubled era leading up to the First World War, when occult societies, many of them

Marinus Boezem, Windtables, *1968. Courtesy of the artist. Photo: Wim Riemens, Holland.*

involving some form or other of the Orphic myth, expanded greatly in Europe. Immediately after World War I, it rose into dramatic ascendancy in the works of Malevich, Mondrian, and others.[4]

This "flight from reason,"[5] as it has been called, recurred with greater force immediately after World War II, a period which saw another resurgence of the Orphic complex. Lucio Fontana's slashed canvases, for example, were, in his view, channels to the infinite, or unformed, or preformed level of reality—the reality of which the soul partook before its imprisonment in a body. Yves Klein's oeuvre as a whole was deeply charged with this idea system. His *Leap into the Void* (1961) represented the flight to the beyond; his signing of the sky expressed his assertion of his true home and nature. (As the Orphic gold plates reminded the freed soul, "I am a child of both the earth and the sky, but my true home is the sky alone.") There was virtually not a part of Klein's oeuvre that did not advance the project of embodying the idea of the ascent into the immaterial.[6] Some of Joseph Beuys's works, especially later works with regal motifs, share the thematics.

It is roughly in this lineage—the Malevichean avant-garde, with special emphasis on the oeuvre of Klein—that Boezem's work seems contentually to belong. But it does not belong there in a simple and unquestioning way; it has imbibed too much of the Duchampian critical mode for that. It is at once the work of a partici-

pant in a cult and the work of a critic. It is a cross-indexed inventory of motifs embodying the thematics of ascent, escape from the body, desire to become free of history, and so on, along with the counterthematics of obstacles and objections to such escapism. Its inner consistency round this thematics is such that one can enter into it, like a maze with many entrances, at any point and follow it throughout to its end.

One might begin, for example, with the emphasis on weather found in *Weather Drawings* (1969) and other works. These drawings employ the found subject matter of meteorological maps in an ambiguous way. On the one hand, this found imagery serves to disconnect the act of art-making from the tradition of the sublime and reestablish it firmly in the world of real objects—like Manzoni's use, a few years earlier, of calendar sheets or Kounellis's more or less contemporaneous use of elements of public signage, such as numerals and arrows. On the other hand, however, Boezem's Weather Drawings, by pointing to the sky, seem to affirm the sublime; they turn their back on the everyday world of Earth and gaze upward seemingly in expectation of ascent into higher realms. This aspect of the Weather Drawings connects them with the emphasis on the sky that is found in other Boezem works such as *Signing the Sky by an Aeroplane* (1969).

This perhaps most Kleinian of Boezem's works fulfilled in physical form a project that Klein had proposed in fantasy when he declared that in 1947, at the outset of his artistic career, he had flown into the clear distant sky and signed it as his first work. A generation later, in an action that was part parody and part homage, Boezem had the sky over Amsterdam signed with his (Boezem's) name by a skywriting plane. Boezem's characteristic bidirectionality is present in the piece: While fulfilling Klein's fantasy as an homage to him and to his dream of relocating himself in the sublime, Boezem's use of the material apparatus of the airplane parodies Klein's project of shamanic flight, pointing to the materiality of the body in the grip of gravity.

The motif of the sky returns upon Earth in the unseen movements of air particles as wind. In Klein's oeuvre, to which this motif in Boezem again seems to involve a reference, wind and air represented the idea of human levitation and the transposition of society onto an immaterial plane through his *Architecture of the Air*. Boezem's *Signing an Itho-Fan* again functions as both homage and parody—the latter by representing wind as a material entity that is mechanically, not spiritually, produced.

The idea of a possible linkage between above and below is underlined by the flag of *Sans titre* (1986), which bears as its solipsistic insignia a meteorological map illustrating the very wind patterns that are momentarily fluttering and extending it in space. The flag piece further introduces into the series of terms the idea of a nation or kingdom, the sky as a kingdom of the beyond and the immaterial, the kingdom of the transcendent void; it points also to the use of art as a way to sign the void, or to sign it forth, to invite it to present its signature, and to the idea of the artist, as once the mystical initiate, as a person who has willfully recreated himself or assigned himself a new nationality, an uncaused and occult citizenship.

L'uomo volante (*Flying Man*, 1979), Boezem's only performance sculpture, imbricates the theme of return beyond the sky—return to the distant nation of one's true but occult citizenship—with the theme of identity and the shattering of its earth-bound limitations. Boezem, attired in a kind of fantasied flight suit, struggles with two ropes to maintain upright a mirror whose weight is equal to his own; when he weakens, the mirror falls and shatters, its shards gazing upward toward the sky. The Orphic soul's supposedly true identity as inhabitant of the sky lies shattered with it—or has it escaped, in the shattering, from the bonds of the body and ascended? This action was performed in the Vleeshal, or Flesh-hall (butcher shop), in Middelburg, the past history of the site reinforcing the theme of bodily bondage and mortality.

Icarus (1981) restates the theme of attempted ascent, material anchorage, and the empty imprint of the artist who has disappeared if not into the beyond then into its signage. In this series of works and others related to it, Boezem shows a later stage of the Orphic theme than Klein had embodied. Klein, at the height of Modernism, felt justified in part by the mythic tug of the Hegelian view of history, according to which all Western civilization was on the verge of ascending out of ordinary causality into some spiritual beyond.

Boezem's variations on the Orphic theme are more ambiguous, more attentive to the mechanical nature of motion and the earthliness of the body. Boezem is parsing a Modernist theme at the point of its exhaustion. Though his work so far discussed does not seem exactly post-Modernist, it does derive some of its meaning from the terminal sense that Modernism, like a communal Icarus figure, has crashed and will not rise again.

In the 1980s, Boezem's work introduced, alongside its musings on the Orphic theme, a motif seeming to affirm the rootedness of culture, and hence of spirituality, in the earth and the two-dimensionality of its surface. This work seems in various ways to be post-Modernist, though that term may have less clear applications in European than in American art. I am referring to an ongoing series of works using the floor plan of the Gothic Cathedral of Reims as both a structuring element and a semantic sign.

Beginning in 1980 and continuing throughout the eighties, Boezem incorporated the ground plan of the cathedral into a series of works that both extend the theme of Orphic ascent as well as complexify and critique it. In the process a break or shift in his relationship to space occurs. Previously the wholeness of volumetric space had been indicated by outdoor sitedness and the thematics of the sky; space so conceived had exerted a redemptive force as the locus in which the escaping soul might regain its true home. But now, with the cathedral works, a three-dimensional space that was originally defined as specifically redemptive is contradictorily compressed into a two-dimensional diagram seemingly offering no escape, no room for refuge, sanctuary, or dreams of openness. The cathedral becomes abstract, a sign of itself, a logo. Still, there is a suggestion that it somehow transcends such distinctions, as a magical space in which dimensional crossings can be effected.

In *Green Cathedral* (1978–1987), the sacred floor plan is sketched by a

stand of specially planted trees. This work was actually realized in 1987 on a polder, or landfill area reclaimed from the sea, and thus a site of transformation; as culture has converted sea into land, so the artist converts culture (the cathedral) into nature.

In *Fossil* (1983), the cathedral floor plan is inscribed on a piece of basalt, suggesting ambiguously both its foundation in nature and its domination of it. There is also a suggestion of the enduring nature of the plan, which, etched in an especially hard stone, is here to stay. In terms of European cultural politics, the piece suggests that the past, in both its accomplishments and its follies, will not go away; there will be no effortless flight to a realm of openness.

In *Reims* (1988), the floor plan is formed by upside-down wineglasses on a white tablecloth. There is a hinted suggestion that the Communion rite has lost its sacral force, leaving a symposium or drinking party in its place. But even the drinking party is not happening yet—or is over. The glasses wait for some undefined activation.

The cathedral works are most intimately linked to the thematics of the sky in *Design for a Runway* (1981). A large jet passenger plane is inscribed within the floor plan as if taking off from inside the cathedral.[7] The cathedral is seen as a launching pad for entrance into the sky.

Throughout this series, the cathedral seems to function as a transformative membrane through which transpositions from nature to culture or below to above can be effected. The relations of the cathedral to nature on the one side and to culture on the other are explored visually as the trace of sacred architecture becomes an immanent structural presence that finds itself expressed as a kind of universal in various realms of being. At the same time that Boezem treats it as historicized, he also makes of it an archetype—or allows it to be one, as if accepting the inertia of cultural heritage. One can ascend out of one's culture only on the vehicle designed by one's culture. On the other hand, alongside works such as *Icarus,* which seem to emphasize the impossibility of transcendence due to the gravitational force of the body, there is a suggestion that "there is no escaping the gravitational force of culture."

The cathedral, artistically, represents a communal striving as opposed to the Modernist idea of art as expression of an individual sensibility in deliberate contrast with other individual sensibilities. Boezem's emphasis on it suggests the post-Modern break has occurred for him. It is no longer viable for the individual artist to seek the cultural transcendence of innovation and supposedly free or causal invention. Confronted with the collapse of the Modernist ideology the artist envisions a pre-Modernist rootedness in commonality. His or her work is no longer seen as a flight away from cultural heritage so much as an attempt to fly more limitedly within it.

On the one hand Boezem's work clearly points to a transnational reality, the reality of the sky, the immaterial, the signature of the beyond. On the other, it celebrates the Europeanness from which it arises, as in the positing of Reims Cathedral as a kind of universal structuring device.

Flying the Map (1978) embodies this bidirectionality. A skywriting plane

drew in the air over Boezem's city, Middelburg, the outlines of that same city. Middelburg was destroyed by German bombing during World War II and reconstructed meticulously afterward from photographs and plans of the earlier town. It is this precious inner city, the victim of the bombs, the jewel later re-cut, that Boezem transports to the sky in a typically bidirectional gesture. On the one hand the city torn and battered by history is relocated redemptively above the earth on which the tragedy occurred; transposed into the immaterial and transcendent, it will not again suffer distress and extinction. On the other hand, it is the very boundaries of the town that are held up as a spectacle to be viewed from below by persons still entrapped within those boundaries and still limited gravitationally to the materiality of the earth. Despite the celestial locale, the stress on boundaries suggests the impossibility of escaping into the immaterial.

The cathedral theme in Boezem's oeuvre found perhaps its most refined realization in *La Lumiere Cistercienne* (*Cistercian Light*, 1984–1986). Visiting the sites of twenty-one Cistercian churches and monasteries in the Netherlands, Belgium, and France, Boezem exposed photographic paper to the light in each until it turned black. Subsequently, each blackened sheet of photographic paper was exhibited as a monochrome record of the passing of time, of the absent presence of the past and of tradition.

Cistercian Light epitomizes that part of Boezem's oeuvre that is about absence—the absence of the flown-away soul from the body shed like a snakeskin; the absence of form in the void; the absence of transcendence in the here below. It is as if the selfhood of the real, flinching from its confrontation with hopelessness, drained by its incorporation of the void, causes form to shrink into a phase of latency or potentiality, which in turn is represented in the egg and jug motifs prominent in several recent works: *The Unbearable Lightness . . .* (1989), *Degli Uccelli* (1990), and *Fra cielo e terra* (1992).

Fra cielo e terra (*Between Heaven and Earth*) is comprised of two huge ceramic jars lying on the ground almost mouth to mouth as if breathing or pouring into one another. Inside each, a portion of the celestial map of the nocturnal sky is painted. They are incubatory spaces in which, as in an egg, the Orphic soul curls up and sleeps till its awakening in the sky, or rather, its sleep in that uterine regenerative space *is* its awakening into the sky. Locked permanently, perhaps, between sky and earth, it awaits that awakening forever, as in a tomb that is at once life and death.

An earlier work, *Della scultura e la luce* (*Of Sculpture and Light*, 1985), encapsulates the oeuvre. Inside a flat round candy box like a sectional slice of Parmenides' spherical universe, the earth lies tastily and topographically represented as a mountain range; the tip of the highest peak barely touches, when the box is closed, the upper lid, establishing there in the secret dark the connection between above and below, which is broken as soon as one opens the box to bring it into the light. Inside the lid, which is a deep cosmic blue, the constellations of the night sky are portrayed. It is our universe of the sublime and the worldly, the sky and the earth, wrapped like a gift of jewels or candy. Whose box is it? By whom was this gift intended, for whom?

Louise Bourgeois, Femme Maison, *1982. Courtesy Cheim
and Read, New York. Photo: Allan Finkelman.*

Chapter Fifteen

Louise Bourgeois: "The She Wolf Is My Mother"

Louise Bourgeois has often described her work as autobiographical—as a way of distancing fears and resentments that arose from tensions in her family in her childhood. The presence of her father's mistress in the household led to a girlhood fantasy that she and her siblings would dismember their father and devour him on the dining room table. The installation tableau *Destruction of the Father* (1974), which critics have described as like the leavings of a cannibalistic feast, refers to this fantasy. This autobiographical account extends through the oeuvre. In addressing the figure she calls the "She Wolf," for example, Bourgeois says: "The She Wolf is simply my mother." And the smaller creature sheltered protectively beneath the She Wolf's right paw? "The kid is myself."[1]

At times, taking another stance, Bourgeois has spoken of her works in broader terms, as dealing with sexuality, or with the presexual roots of life, the life force, and so on.[2] In line with remarks of this type, some critics have connected her work with icons from ancient religions. Lucy Lippard, for example, brought the Venus of Willendorf into the discussion of Bourgeois's work, along with the omphalos of Delphi.[3] Barbara Rose mentioned the Artemis of Ephesus.[4]

The two approaches, it seems to me, are not really antithetical. Psychology leads, by way of the unconscious, from an individual into something like a universal dimension. One could follow a path through the childhood neurosis into the unconscious and out the other side into the world of ancient religious archetypes. As Freud wrote, "In the mental life of children today we can still detect the same archaic factors which were once dominant generally in the primeval days of human civilization."[5] Bachelard noted, "Great images have both a history and a prehistory."[6] In Bourgeois's case, the explicit autobiographical references may be regarded as the history of the works. But they also have a prehistory that, with their determined driving of repressed contents into the light, they cannot renounce.

The Artemis of Ephesus is an ancient Greek icon. Her most striking feature is a nest of protuberances on her torso. In some examples these convexities appear through tight-fitting holes in a fabric garment. Bourgeois's *Cumul 1* (1969) and *Blind Man's Bluff* (1984) could be described as unmistakable partial examples of this icon. Other Bourgeois pieces recall it even more unmistakably, especially the costumes for her performance *The Banquet/A Fashion Show of Body Parts,* which was

held in 1978 in conjunction with the installation *Confrontation,* a later form of the cannibal feast in *Destruction of the Father.*[7]

The most common view of the unusual upper body of the Ephesian Artemis is that the rounded elements on her torso are representations of breasts. Clearly this is intended, at least in part, since one of Artemis's cult names was *Polymastos* (Many-breasted). But the apparent breasts lack nipples, which is not characteristic of Greek sculpture and may be intended to ambiguize the identification—as in a number of Bourgeois's works. It has been proposed that the appendages are intended to suggest both breasts and eggs. It has also been argued, on the basis of iconographic parallels in Old Carthage, that the egglike shapes in the Artemis icon are intended to represent bull testicles, referring to the theme of sacrifice. The bull testicles seem to have been slung around the neck of the statue of the goddess when the bulls were castrated. The closely related Phrygian cult of the Magna Mater, or Great Mother, is known to have emphasized ritual castration.[8] Artemis was so closely associated with bloody sacrifice that in Sparta, according to Pausanias, she was called "the Butcher." She was particularly associated with sacrifices of males. In Attica, at shrines to Artemis, small incisions were made in the necks of male worshippers through which their blood was extracted.[9] At Hierapolis in Pammukale, in Turkey, the heads of male human sacrifices were nailed to trees outside the temple of Artemis.[10] This aspect of the tradition echoes the internal connection that links Bourgeois's multi-breasted works, with their message of nurturing, with the castrating *Destruction of the Father.*[11]

Bourgeois's *Femme-Maison* (*Woman-House*) paintings and drawings show a woman's naked body topped by a house. Sometimes the house starts from her waist, sometimes from her neck; in either case the woman's face is not seen. Deborah Wye notes that the woman's face, her individuality, has been replaced by the house. "Domesticity becomes the very definition of these women," she says. "They are prisoners of the house."[12] No doubt that theme is prominent here; but there is another aspect to the woman-house icon. The Artemis of Ephesus is sometimes portrayed with a house on her head, or rather the walls of a city; the city of Ephesus was considered to be perched on her head, carried by her like her crown. There are also icons of the Virgin Mary that show her crowned with city walls, or with her torso opening into a house or a church. The woman-house icon, seen in this context, indicates the goddess, or the female, as the foundation of the human community.

The painting *Femme-Maison* (c. 1946–1947) echoes another ancient iconograph, the Displayed Female position, which also occurs in some of Bourgeois's drawings. The Displayed Female has her legs spread to signify the act of giving birth, though the emerging infant may or may not be depicted. *Untitled* (c. 1954), an ink drawing on paper, is an instance of the Displayed Female motif. Another of the ink drawings, *Untitled* (1941), depicts a Displayed Female giving birth.

Variants of the breast icon include Paleolithic ivories, which show two breasts on an upright member. Bourgeois's *Nature Study* (1984) closely resembles them. Still others of Bourgeois's variants, including *Trani Episode* (c. 1971–1972),

Louise Bourgeois, Nature Study, *1986.*
Courtesy Cheim and Read, New York. Photo: Peter Bellamy.

Point of Contact (c. 1967–1968), and at least one drawing show rounded bulbous
volumes that, whenever they establish a boundary or outside layer, do so in the
shape of a breast; they are multiple breasts seemingly growing out of one another.
Versions of this type of icon are also found in some traditional cultures, such as the
three- and four-breasted ceramic vessels known from pre-Columbian Peru.

Some of Bourgeois's multibreasted figures, such as *Nature Study* (1984), *The
She Wolf* (1984), and *The She Fox* (1986), are of a sculptural type anciently called the
sphinx—a composite monster with a human head, the upper body of a human
female, and the lower body of a lion; wings are optional. Bourgeois's headless sphinx
is bigendered, appearing to have both a penis and breasts, as is the sphinx at Giza in
Egypt, which has a man's head and a woman's upper body. Bourgeois's sphinx has
more visually in common with the Greek monster that proposed the riddle of human
nature to Oedipus.[13] This resemblance connects Bourgeois's iconography with the
myth of Oedipus and returns it yet again to the subject of the Freudian tragedy of the
nuclear family and the destruction of the father. Here is another overlap of the
imagery of childhood neurosis and religious history. Bourgeois's characteristic
autobiographical reduction ("*The She Wolf* is simply my mother") does not allow the
piece to fully express itself. In recent years Julian Schnabel and Leon Golub have also
used the sphinx image. It is a meaningful motif in the 1980s because it points to the
riddle of human nature, a riddle whose answer seems to be changing.

Artemis of Ephesus (left);
Louise Bourgeois, *Blind
Man's Bluff* (above)

Louise Bourgeois, *Cumul 1*

Femme-Maison, ca. 1946–47 (left); Sumerian cylinder seal
impressions showing the Displayed Female iconograph
(top); Louise Bourgeois, *Untitled*, 1941 (bottom)

Early Gravettian or
Pavlovian Mammoth
Ivory Figurine (top);
Louise Bourgeois, *Nature
Study*, 1984 (bottom)

Louise Bourgeois, *Untitled,*
mid-1960s (left, top);
Three-breasted vessel,
terracotta, Pre-Columbian
Peru (left); Four-breasted
vessel, terracotta, Pre-
Columbian Peru (above)

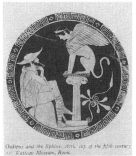

The Goddess Rati, Wood,
Bali, 19th Century (top);
Louise Bourgeois, *Germinal,*
1967 (bottom)

Oedipus and the Sphinx,
Attic cup, 5th Century B.C.
(top); Louise Bourgeois, *The
She-Wolf,* 1984 (bottom)

Bourgeois has said, "Sometimes I am totally concerned with female shapes—clusters of breasts like clouds—but often I merge the imagery—phallic breasts, male and female, active and passive."[14] The phallic breast appears in numerous Bourgeois works, such as *Germinal* (1967), and again there are parallels in traditional goddess religions, as in the icons of the Balinese goddess Rati, a goddess with phallic breasts. The image system suggested by the breast works, the phallic breast works, and the works involving androgyne, castration, and so on, involves also the phallic icon.

Bourgeois has made works which would commonly be interpreted as representations of penises and which also have resonances in ancient iconographies. Two, for example, *Janus Fleuri* (1968), and *Hanging Janus* (c. 1968–1971), have Greco-Roman forebears in popular icons of abundance and well-being.[15] But Bourgeois, the fantasied destroyer of the father, reverses the energy in the ancient icon, choosing the limp moment in the penis's cycle to record.

The breast and the penis in Bourgeois's oeuvre go beyond the particular into the realm of the universal. They are emblems of complementary forces that pervade nature. This is expressed in part by a slippage from biology to zoology. In many of her works, such as *Clamart* (1968), penis- and breastlike things seem to sprout from the ground in throngs. Again, there are traditional analogues. Bourgeois feels these works as representing groups of people clustering together for safety (the mother and children seeking safety from the father?). In some cases, such as *Eye to Eye* (1971), this is apparent. But in others, such as *Colonnata* and *Clamart* (both 1968), the specific biological association is unavoidable. In any case, there is not a big difference, really, between saying that it's a group of people and saying that it's a group of penises, breasts, or breast-penises. Something similar is involved when Freud, in the *Interpretation of Dreams,* says that the penis, in a dream, stands for the whole person. The two basic signs in Bourgeois's iconography, at least in this thematic area of it, are the breast and the penis—Mom and Dad. On one level they restate the plaint of the Greek tragedy again, the lament of the nuclear family hovering in the air. But again, as with the *Femme-Maison* icon, there is another side to it.

The emphasis on gender duality is a cosmogram. At least as early as Sumerian iconography, and devolving into Tantra, the universe was modeled as an interplay of two opposed yet complementary forces which were pictured through gender-specific body parts as male and female. The neurotic milieu of the nuclear family is writ large in religious history—cosmically large. Many of Bourgeois's works resemble the Hindu icon of the lingam and yoni, an abstracted representation of the engaged male and female genitals, which are pictured forth as a cosmic or world-sustaining act of sexual intercourse. But Bourgeois's drama has a neurotic and sinister edge. It is more in line with the Greek tragic view of the family. Her drawings of a man devouring children—ultimately versions of the ancient icon of Saturn eating his young—show both the father's crime for which his body was feasted on and, in a different time frame, his revenge for the feast.

The emphasis on gender duality in traditional non-Western religious iconography involves assertions of gender complementarity and even at times fusion

Louise Bourgeois, Blind Man's Bluff, *1984. Courtesy Cheim and Read, New York. Photo: Allan Finkelman.*

of genders into bisexed or intermediate icons. Both Freud and Jung felt that the human psyche was fundamentally male and female at the same time. Bourgeois too has declared that at times she combines male and female in one image, as in *The She Wolf* and the clusters of oblong shapes, like *Clamart,* that suggest breast and penis about equally. This seems to correspond to her statement that much of the subject matter of her work is not sexual but presexual. Its aura often evokes the period before the gender distinction dawned, the polymorphous-perverse state of the presexual infant secure among the fields of swaying flesh blossoms.[16]

Bourgeois's blending, mixing, and recombining of body parts led her in time to the sexual metaphor of the eye. In some of her eye works, such as *Eye* (1981), the pupil is sculpturally differentiated from the iris in a configuration much like the lingam-and-yoni icon of Hindu erotic theosophy. The pupil of the eye thrusts forward in the midst of the open iris. In others, such as *Nature Study, Pink Eyes* (1984) and *Nature Study, White Eyes* (1986), the pupil is an empty hole awaiting penetration. The sexual metaphor of the eye, found in the midst of a congeries of goddess-related iconographs dredged up from both art history and the unconscious, also has a linkage to an ancient vein of meaning. In ancient Nineveh, in the early Sumerian period, the Eye Goddess was a common icon.[17] Her eyes were thrust up as empty holes atop a featureless body. The entrance of the image into the eye is

pictured as a kind of penetration into a receiving matrix of consciousness. Like an analogue of sexual intercourse, the image thrusts into the black hole of the eye; subject and object meet—in the eye.

One problem with an exclusively autobiographical approach to any body of artworks is that it eliminates questions of larger context. Wye has remarked: "Bourgeois belongs to the line of twentieth-century sculptors that includes Brancusi, Arp, Giacometti, Moore, and Hepworth."[18] That seems clear enough but says little about the content of the work, leaving it to be accounted for only as "a personal and deeply autobiographical content."[19] There is a problem here. If the content is indeed strictly autobiographical, then the viewer, being outside of the autobiography, is left with only a formal appreciation of the work. Yet others do derive a sense of meaning from Bourgeois's work, indicating that its content goes somehow beyond the personal and autobiographical.

In fact, the work, in order to be fully appreciated, needs to be seen in a series of expanding contexts—first that of the artist's autobiography, then that of a certain formal tradition of modern sculpture, finally a much broader context, not merely art historical but cultural, including religious, philosophical, and psychological aspects. I have tried to shape here an approach to Bourgeois's work that does justice both to its specific autobiographical roots and to those broader cultural associations. The apparent relationship between many of her works and a variety of ancient icons does not invalidate the autobiographical subject matter but complements it. The autobiographical theme of the destruction of the father, for example, corresponds in religious history to the custom of king sacrifice found in matrilineal cultures around the world.[20] It is also universalized in individual psychology by way of the Oedipus complex, which in turn is named for a legend that survives at least in part from a period when matrilineal customs were in effect. The fact that the iconographical associations of Bourgeois's works are mostly from religions that featured goddesses also sharpens the feminist edge to the work. Its deep connection to the imagery of matrilineal cultures in turn bears meaningfully on the personal content of hostility toward the father and desire to be ruled by the mother. Psychoanalysis, Freud wrote in *On the Interpretation of Dreams,* is "concerned with the reconstruction of the earliest and most obscure periods of the beginnings of the human race." This is not so far from Bourgeois's remark that her work "was the reconstruction of the past;"[21] whether the past is the childhood of an individual or "the earliest . . . beginnings of the human race," the images that will be encountered in its reconstruction will be found to be in close relationship. The roots in infantile experience, in psychological universals, and in ancient religious archetypes demonstrate the sources of the feeling, shared by many, that Bourgeois's work has a certain claim to universality, to dealing with a level of reality so fundamental that any human can recognize it.

Louise Bourgeois, *Clamart*, 1968 (left); Phallic menhirs from Southern Ethiopia (above)

Louise Bourgeois, *Eye*, 1981 (above); Eye symbol on pedestal, Ninevite period, Brak (top right); Louise Bourgeois, *Nature Study, White Eyes*, 1986 (bottom right)

Louise Bourgeois, *Hanging Janus*, ca. 1968–71 (left); Tintinnabulum, bronze, from Pompeii, 1st Century B.C. to 1st Century A.D. (right)

Mel Chin, Extraction of Plenty from What Remains: 1823– , *1988.*
Courtesy of the artist and The Menil Collection, Houston. Photo: Paul Hester.

Chapter Sixteen

Explicating Exfoliation in the Work of Mel Chin

A good deal of Mel Chin's art-making time is devoted to research. With a scholarly meticulousness he loads or freights his work with multiple cultural references that, once recognized, convey a sense of the world's cultures interacting as an organic whole. The work itself, in other words, is a multicultural object combining elements from different ages and traditions. But the recognition of these references is sometimes problematic; in some cases, in fact, no viewer at all can be expected to recognize them. Here is a jar of little bars whose proportions are based on Mayan mathematical notations. Here is a wiggly line derived from the top silhouette of the signatures of the ten United States presidents who have intervened in Central America. Here is a shape based on the orbits of Mercury and Earth around the sun. Here is the seal of the CIA. And so on.

The Bead Game

In Chin's work such cultural references and borrowings are used as brush strokes in a cognitive pastiche that operates somewhat like the Bead Game of Hermann Hesse's novel *Magister Ludi*. The fictional game, as Hesse describes it, employs a "highly developed secret language in which several sciences and arts . . . play their part."[1] He goes on: "The Bead Game . . . comprises the complete contents and values of our culture; it plays with them as, in the springtime of the arts, a painter may have toyed with the colours on his palette. All that mankind . . . has produced in the field of beliefs, elevated thoughts and works of art, all that the ensuing periods have furnished in scholarly observation and concept and consolidated into intellectual property, will be utilized by the Bead Game adept. He will play upon this colossal material of spiritual worth as an organist plays upon the organ." While Hesse identifies predecessors of the Bead Game, such as Pythagoras of Samos and Nicholas of Cusa, he casts the game in the future in relation to his own time of writing—the early 1940s. He sees it in a sense as Nietzsche saw the Age of Comparison as a culminating activity or a retrospective vantage point from which one can see, compare, and mutually analyze various times and cultures. Nietzsche's Age of Comparison, and Hesse's Bead Game both seem to have been realized in the recent developments in post-Modernist art making. The Game, in

particular, has lately found its closest realization in an iconographically complex installation art.

In such art, as in Hesse's fantasized game, an individual, after long thought, presents a complex symbolic interplay of objects, images, and ideas to an audience. As the viewer studies both the plurality of these elements and the hidden web of unity governing their relationships, his or her mind is either integrated in a certain conformation or focused anew on a certain aspect of reality. As the Bead Game master would guide the viewers through the maze of his reasoning, so the contemporary installation artist often presents a key of some kind to the encodings in his or her work.

Some practitioners of this type of art attempt to poise it just at the limit of comprehensibility, so a viewer might be able to attune his or her mind to it and decode it without external help. Others rely on verbal keys, which have the advantage of allowing the work to become as complex as the artist might wish it to be, unconstrained by the limits of the viewer's conditioning. Keys to the research loaded into the work are provided either in a gallery handout, or on wall plaques accompanying the pieces, or in a notebook of "sources," or in some other way.

Along with this highly determined or prearranged aspect of Chin's work, which can seem at moments daunting, there is also a loose or flexibile aspect that is viewer-friendly. In the usual museum or gallery process, the pieces situate themselves in the viewer's sensibility through visual means before the cognitive indoctrination begins. Thus the experience of the work is fundamentally different from the Modernist idea of the unmediated visual impact of art on the viewer's soul. In encountering a piece by Chin, there is a staged initiation. The viewer's first response to the work will be to its visual and sculptural presence, without the minutely researched references being considered. This experience of the work might seem sufficient, and the viewer might choose to take the process no further or to provide interpretive tendencies of his or her own. One critic referred to such a viewer's interpretation as "unauthorized."[2]

Chin himself is as interested in the range of "unauthorized" interpretations as in his own intentionally loaded ones. Consequently he does not always supply a key to the iconography of his materials and forms.[3] In such cases the reception of the work involves a random play in which he loads something in and someone unloads something else out. The unspecified or indeterminate relationship between the input and output *is* in a sense the art material—the substance or arena of the work.

Another viewer, after experiencing the work "raw," as it were, might choose to consult the key (which Chin usually does provide in some form) and penetrate deeper into the complexities of the artist's intentions as they are loaded into the work, bringing his or her sense of the work closer to Chin's own—closer, that is, to the "authorized version." In this case there are at least two impressions that occur in sequence: that received before one reads the clues, and that which develops after—not to mention the transitional increments between these poles. In some cases, there will seem to be a close fit between the before and after impressions, conveying a

Mel Chin, Work Study, *1991–1992. Courtesy of the artist.*

sense of harmony, symmetry, and commensurability; the visual and the cognitive, by their apparent convergence, create a sense of well-being or wholeness that has something in common with the traditional aesthetic sense of the wholeness of the art object.

In other cases the relationship between the first "raw" take and the later "educated" one might seem skewed, leaning, inverted, jagged, pressed, or slashed. The apparent incommensurability will create a troubling sense of unresolved inner tensions. In a sense, the interplay between these two (or more) receptions is the crux of the work. The successive acts of comprehension through which the iconography of the work unfolds takes the place of narrative as the temporal challenge the work proffers to the viewer.

The work, in other words, is asking for a double take from the viewer; it focuses the structure of the viewer's response around the idea of second thought, reconsideration, rethinking. There is thus a redoubled or overlaid cognitive formation involved, conflating the idea of the unmediated aesthetic response achieved through pure intuition, with an essentially rational structure of response involving rethinkings and readjustments; but it also involves ambiguity and contradiction and the surprise of a kind of explosive narrativity wherein one's initial gut or feeling-tone reaction blossoms suddenly and unexpectedly into an exfoliated cognitive-and-sensual awareness.[4]

The Extraction of Plenty

Consider, for example, *The Extraction of Plenty from What Remains: 1823–* (1988–1989). In a softly and dimly lighted space the viewer encounters a melan-

choly vista of two upright white columns, their upper broken edges jagged; on the floor between them, visually retreating into the warm dimness of the light, lies a woven wicker cornucopia large enough for a human child to crawl into or out from it. Nothing stirs. A hint of some tragic folly is in the air. With the ease of melodrama, it works at once.

The initial unprepared confrontation of the viewer with the broken pillars gripping the cornucopia between them has a poetic impact that is present before the cognition of any conceptual key comes through. Various responses arise, depending on the viewer's conditioning. One attuned to the usual story of Western art history, for example, might see in the apparently broken columns references to ruins and the passing of civilizations as per Piranesi and others. The empty cornucopia might have related neoclassical resonances involving a sense of the lostness of the past and a lament for it. A solemn and lonely nostalgia may hang over the piece, tingeing it with a shadow of romantic melancholy.

After this first response, which will vary in duration and intensity according to whether the viewer is more visually or linguistically controlled, the harsh introduction to reality occurs. The viewer reads some details of the key: for example, that the jagged line of the tops of the broken columns is the upper silhouette of the signatures of ten American presidents who meddled in Central America; that the cornucopia squeezed between the two broken columns is shaped like Central America and is made of characteristic Central American materials redolent of labor, exploitation, and export, such as banana-tree fibers over Honduran mahogany coated with mud, coffee, and blood; that the columns are the same order and scale as those in the façade of the White House; and so on.

On the reception of this cognitive data, the immediate poetic response is, in this case anyway, not canceled out but adjusted. Suddenly beside it, and partially mingling with it, is an alternative reading, with different feeling tones and intentions. The ruined columns both refer to the colonial devastation of Central America and to the feeling that the United States itself bears within it the seeds of its own ruin, derived from the accumulated karma of its foreign interventions. The emptiness of the cornucopia suggests the draining of wealth and biomass out of Central America toward the North. The viewer finds himself or herself invited into a number of cognitive networks which in turn bring new emotional associations into alert focus.

At that point the viewer has an additional role to play or, perhaps, decision to make: either he or she submits to this additive process, or he or she resists in this way or that—and to this extent or that. For example, a very visually oriented viewer might experience Chin's cognitive encodings as a nuisance that interferes with the spontaneous autonomous play of sensibility. In such a case the relationship-formation between the first and the second takes assumes a blocked, thwarted, or crippled posture. The final experience becomes a complex interaction of sensual, emotional, and cognitive aspects that unfolds like a narrative of self-exposure and self-discovery. This interaction of the poetic or mood-evocative aspect of the work with its scholarly encodings appeals simultaneously to the viewer's intuitive and

analytic faculties—to both sides of the brain, as it were. This dual encoding of the visual and the cognitive is a part of Chin's stylistic signature.

Revival Field

Various of Chin's works cluster around the theme of the Above and the Below—which are specifically conceived, in a combination of ancient mythological terms with modern ecological ones, as sky and soil. The model of reality as bipolar between above and below is associated with the ancient Hermetic text called the *Emerald Tablet,* with its famous catchphrase, "As above, so below." The *Emerald Tablet* affirms astrology, with its positing of identity between events in heaven and on earth. More generally, it posits the idea of a structural correspondence between macrocosm and microcosm—that is, between the patterns of order in the cosmic world and the inner ruling principles of both society and individual life here below. The idea was that things in earthly life imitate the patterns of cosmic order or that these patterns somehow dwell in them as inner guides. Plato's theory of Ideas is derived from this apparently Sumerian concept, as are countless other models of the control of things below by things above.

But Chin's work, though it incorporates elements of myth and religion, is not fundamentally a spiritualistic art. Though it sometimes parallels the methodology

of sympathetic magic, it has a different structure of intentions. The term "sympathetic magic," as employed by Frazer in *The Golden Bough*, suggests that if one ritually enacts an event that is symbolically like what one hopes for (say, pouring water to induce rain), then the event one hopes for might be drawn into being by the ritual gesture, on the principle that like attracts like. Much of Chin's work observes this structure, *Revival Field* being perhaps the most obvious example.

Revival Field is a repeatable work in which a polluted plot of ground is planted with "hyperaccumulators"—plants that pull heavy metal toxins from the soil, purifying it through a kind of scientific alchemy. It was first installed in St. Paul, Minnesota in a landfill so polluted that it burned for two months in 1988 and tested for toxic levels of cadmium which apparently had leaked out from discarded batteries.[5] Chin demarcated a target- or mandalalike area, a circle within a square bisected into quarters by two elevated walkways. The site thus took on the ancient Sumerian model of totality, of the world as fundamentally circular but divided into four quarters based on the cardinal compass points. This conformation—circle centered in a square with inscribed quaternity—was the basis of the cosmic diagram from the first (Babylonian) world map[6] to the Indian yantra and mandala to the Rosicrucian or Masonic cosmograms of Robert Fludd and others; the *Emerald Tablet* was a primary text in regard to such ideas of centrality and order.

In *Revival Field*, this conformation of universal space functions as sympathetic magic to disseminate the developments in the restricted area throughout the cosmos. "As above, so below" also means "As in the great or cosmic world, so in the small or microcosmic world." *Revival Field* employs this idea toward the ecological restoration of the soil: In terms of sympathetic magic, "If this little plot gets cleaned, maybe the whole earth will too, due to the hidden connection between the microcosm and the macrocosm." But there is a significant difference from magical practice per se, for the piece has a pragmatic and scientific intention. Chin planted the microcosmic precinct with six varieties of plants with different purposes.[7] One was a hyperaccumulating hybrid corn that soaks one hundred times more cadmium than normal from the soil it grows in. Another, an Alpine Pennythrift, was targeted on both cadmium and zinc. Every year these plants are harvested, analyzed for their metal content, and incinerated; the accumulated metals can be recovered, or recycled, from the ashes. Theoretically, in a few years the hyperaccumulating plants will not only clean the soil but also turn the toxic metals into beneficent resources that can be recycled and used. The piece is an actual ongoing experiment, with scientist collaborators who monitor the data, and it may in time enter the stream of science as meaningfully as the stream of art.

At the same time, an array of sculptural elements both ritualizes and aestheticizes the field in which the scientific/alchemical metamorphosis is taking place. Each plot or unit of area, for example, is numbered by a method based on Mayan mathematical notation—a long bar equaling 20, a short bar 5, and a ball or circle 1. The appropriate counters—say a long bar, two short bars, and three balls, totaling 33—are cut from industrial rod stock in the target metals—long bars in

zinc-cadmium, short bars in copper, and balls in lead. The array is then hung in a little jar from the top of the site-marking stake as if to summon, or lure, the target metals upward from the soil. This invocation of a dead antique culture—along with other elements in the complex piece—suggests that there is a universal or trans-historical importance to the process of detoxifying the earth, an urgent importance which may unite all human cultures, even past ones, in the spirituality of its pursuit.

Revival Field is a symbolic totality. Mythically, it comprises birth, death, rebirth, redeath, and the process that unites them all, in a manner related to the ancient Eleusinian Mysteries. This ancient initiation cult featured the worship of Demeter, the Earth Goddess, and of the moment when she gave the primal ear of wheat to the young god Triptolemus, who was to spread it over the earth. Chin's field may be seen as an ongoing part of the Triptolomean mission of planting the earth, or, alternatively, one might say that Chin participates in the Triptolomean archetype by facilitating his mission.

In pieces where an outright scientific intention is not present, Chin's allusions to the methodology of traditional magic are still primarily pragmatic in intention. The above/below dichotomy is invoked not in reference to spiritual universals but to specific material problems such as ozone and soil depletion. In Chin's oeuvre, religious transformation and mythic metamorphosis are metaphors for the possibility of scientific reconstitution of corrupted natural resources. The restoration of Eden (as in various Modernist artistic utopianisms)[8] is the responsi-bility of the interaction between art, society, and science. Art, then, must not only confront spirit and matter, but also society.

Alongside the ecological theme with its appeal to science, Chin's work characteristically refers to ongoing cases of political repression around the world, from American neocolonialism in Central America to the Ethiopean civil war to Chinese repression of Tibetan culture to police actions in Pakistan. Here again his works may be seen as evoking the procedures of sympathetic magic, but now toward libertarian rather than ecological ends. His tactics involve, for example, the use of materials and images that come as directly as possible from the cultures in question, such as, say, the Honduran mahogany in *The Extraction of Plenty;* often, as in the use of traditional musical instruments, such as the Ethiopean "spike fiddle" in *The Sign of the True Cross* (1988), these appropriated elements may be regarded as expressing the essence or spirit of their cultures. A traditional magician will make similarly rigorous demands about the authenticity of his or her materials, for their effectiveness depends on it. The alchemical view of art as a means of transformation thus functions on several levels in Chin's oeuvre, which intervenes in the world process in the hope of generat-ing or promoting transformative forces in both nature and politics.

Landscape

In a work of 1990 called *Landscape*—or, as Chin describes it, "corrupted landscapes"—the viewer confronts three pictures, one straight on, one on the right,

Mel Chin, Uranus, *1987. Courtesy of the artist. Photo: © 1992 Will Brown.*

one on the left. The space is the foursquare mandala-based space of wholeness, with the viewer, entering from the fourth side, supplying the fourth quarter.

The three landscape paintings are made in the traditional styles of three cultures: a Chinese scroll painting in the style of Chao Meng Fu (1254–1332), who was born in the Sung dynasty but worked mostly in the Yuan dynasty; a Persian miniature in the Xvarnah style of the fourteenth century; and a nineteenth-century American-style Romantic oil painting in the manner of Albert Pinkham Ryder. All are painted by Chin (hence their description as "corrupted"). On the viewer's right the Yuan dynasty–style landscape symbolically shows a map of the Chinese coast as a landscape with five mountain groups representing the center and four quarters of the ancient Bronze Age conceptualization which is the root of the mandala. Each of these mountains is painted in a shape traditionally associated with one of the five Chinese elements. In making this picture, Chin traveled extensively to see famous Chinese paintings of the period, and painstakingly adopted ancient techniques, crushing malachite by hand and mixing the powdered stone with animal glue, and so on.

On his or her left hand, the viewer finds a nineteenth-century-like oil painting of a landscape in a style based on Ryder. Chin researched Ryder's style and, as far as it is recorded, his temperament, and spent three months working on the

Mel Chin, Uranus *(detail), 1987. Courtesy of the artist. Photo: © 1992 Will Brown.*

picture, attempting to act out something of Ryder's alleged impetuosity along with his drawn out fanatical application of glaze after glaze.

Straight on to the entering viewer is a gouache miniature of a fourteenth-century Moghul-style picture of hills and sky. The Xvarna school of Moghul painting was chosen because of the sharp focus on cultural particularity derived from its comparative lack of Chinese influence. Again the picture is a microcosm of its culture of origin, involving references to Persian geography. The three pictures confront the viewer with the idea of the relativity of cultural canons and the multicultural project of responding sympathetically to different cultural stimuli. Being landscapes, they tacitly say, "The earth belongs to all cultures." Taken together, representing three different cultures that span the world, they comprise a global view of the earth, a transcultural ecological snapshot.

While referring to the earth as a totality, the pictures also refer to different culturally expressive means as particularities. An arbitrary rule of order or linkage is found in the fact that China, Iran and Iraq, and the United States are all cultures lying on the thirtieth parallel. The bottom edges of the walls of the room are cut away in a topographical pattern derived from that parallel by a precisely worked-out system of scale and proportion (here are the Himalayas about an inch and a half high, and so on); through that gap, polluted soil from a local landfill, which fills the surrounding wall, seeps gradually into the room. The message is that the tendance of the earth belongs to all cultures. The oeuvre's dual focus is brought clear: first, on the particularity of cultural difference, second on the totality of global cultural wholeness. *Landscape* was both an analytic and a synthesizing event.

The Operation of the Sun

An ear of hyperaccumulating hybrid corn grown on the *Field* mythically refers to Demeter, the goddess of the Eleusinian Mysteries; to Triptolemus, who receives the ear of wheat from her and spreads it over the earth; and more generally

still to the mystery of agriculture which they both represent. Alchemically, the collaboration of nature and science has produced a clean plot of soil in which the primal seeding of the earth can be ritually repeated. The Old World mythological resonances are balanced by Chin's use of maize rather than wheat as the sculptural material, pointing to the New World and the possibility of Native American cultural remnants providing insights for the revival of the earth.

Balancing the Demetrian (earthly) theme is a Uranian (skyborn) theme from Chin's most complex work to date, *The Operation of the Sun through the Cult of the Hand* (1987). This is a sculptural-iconographic zodiac based on a conflation of Greek and Chinese astrological traditions. At one point in Chin's zodiac, the viewer sees overhead a crescent- or sickle-shaped recess cut into the wall; below this incision hang symbolic testicles made in the form of sea urchins. Uranus is represented by testicles and sickle in line with the ancient myth, preserved in Hesiod's *Theogony,* in which Uranus, or Father Sky, is castrated by his son Kronos, who throws his father's testicles down into the sea, thereby uniting above and below in a fertility gesture. Kronos uses a flint sickle for the act, referring to Neolithic rituals of royal sacrifice for the promotion of fertility. In the ancient myth, Aphrodite, the goddess of sex and fertility, rises from the sea-foam, which was impregnated by the seed spilling from the severed genitals. Among Aphrodite's many symbolic accoutrements is the sea urchin, that symbol of male and female united, which Chin has adapted to the castration theme. The ocean functions as cosmic womb, receiving the seed and giving birth. Thus the fertilizing rain from the sky and the healthy functioning of the sea contribute to the fecundity of the earth. In such myths Chin sees allegories for ozone and soil depletion and their hoped for scientific solutions.

The conceptual freighting of the work proceeds to elaborate itself in the ancient Sumerian macrocosm-microcosm structure, in which each part of the whole contains the whole in miniature yet in fully extrapolated detail. Inside the sickle hole are images of the twenty-eight "lunar mansions" (*hsiu*), or constellations, configured according to their traditional Chinese representations. Inside the urchin testicles, the nail heads of the urchin spines sketch out symbols of the constellations within the wobble of the northern polar precession.

The Operation of the Sun involves ancient Sumerian, Greek, and Chinese traditions with modern Western science. In the original full installation, nine intricate iconographic sculptures referred to the nine planets recognized in our solar system by moderns (the ancients recognized only seven). The nine sculptures were positioned in relation to each other according to the orbital distances and tilts of the planets they so intricately represent.

Chin used seventy materials in *The Operation of the Sun,* from black gorgonian fan coral to various oxides, nitrates, and the like. Each of them is drawn into the work by some specific conceptual association. In Chin's oeuvre (as, in a somewhat different mood, in Eric Orr's) materials are not simply the media through which ideas take form. They are both physically and symbolically active signifiers in the cognitive transaction between artist and receiver.

Degrees of Paradise

Degrees of Paradise (1990) is part of a larger project, *The State of Heaven* (in progress at the time of writing), which will address the crisis of ozone depletion. Even more than *Revival Field*, *The State of Heaven* will involve collaboration between the artist, members of the scientific community, and ethnic skilled laborers—in this case Kurdish weavers. It will culminate in a huge carpet floating overhead in a specially made structure, with representations of Earth's cloud cover woven into it. The carpet will be destroyed according to how much ozone depletion has occurred and will be rewoven in proportion to the restoration of that element. It will be about sixty-six feet square, with each knot representing five square miles, producing a finite representation of the whole Earth's atmosphere laid flat.

Degrees of Paradise interpenetrates with Persian nomadic views of the afterlife. The installation occupies a mandalic bifurcated form, a central vestibule opening to right and left into two opposing triangular rooms like the east-west or north-south polarity in a compass rose. In addition to its partial mandala form, *Degrees* is constructed around the above-below dichotomy. The title refers to the complex vertical geography of the ascent from Earth to Heaven that appears in Dante's *Commedia* and was earlier prominent in the Arabic and Persian traditions (whence it seems to go back to ancient Mesopotamian models).

As one enters the antechamber, one finds a small piece of roofing slate with an image of a lotus unfolding. The lotus image involves a tantric reference—a mandala is a lotus—and was encountered by Chin in a dream in which the lotus blossom appeared from the earth, soil spilling from its petals. Placed at the entrance like a holy water fount, it serves as the fulcrum, so to speak, between the two triangular petals of the adjoining rooms.

In these rooms the piece takes place primarily on the ceiling, but with ambiguities that refer down as well as up. The triangular room to the viewer's right includes fourteen video monitors mounted overhead, playing back multidimensional fractal images of climatological process. This is the sky, the above. Suspended at ceiling level in the opposing triangular section or lotus petal is a kilim or Kurdish carpet with a design of satellite mappings of cloud patternings over southern Iraq. The carpet, in its aspect as the traditional Persian paradise carpet, refers to the above. Yet functionally the medium of the carpet represents the below, the downtrodden of the earth. These carpets traditionally were reminders of Heaven that were carried over Earth by nomadic wandering groups, recalling the above in the below, or, better perhaps, pointing the below toward the above. The carpet was made by Kurdish women in eastern Turkey during the Gulf War—with Scuds falling from the sky not far away—with minimal guidance from the artist. The weavers put a helicopter into the picture unbidden, bringing into the celestial or macrocosmic equation an angry buzzing intruder from below.

Traditional art viewers often complain that artists shouldn't have to *tell* what their work is up to. The *New York Times* reviewer of Chin's show at the

Queens Museum attacked it primarily for having verbal keys, as if the era of the supposed autonomy of the visual realm were still in force.[9] Such reactions show that the art discourse is still torn between the Modernist and post-Modernist aesthetics, and this type of installation work has been received skeptically—even hostilely—by critics whose primary tool is the traditional aesthetic value judgment. Their leading objection is that the work should place itself in the viewer's receptive mechanism purely visually. A fundamental disagreement about human nature is involved in the dispute.

For various reasons, Modernism was at pains to keep the aesthetic, cognitive, and social realms apart (the case for this was argued by Kant in the *Critique of Judgment*).[10] But in the post-Modern loosening of categories, these three aspects of human experience seem to have flowed together—both confusingly and excitingly. The nature of human selfhood, in the wake of post-structuralism, seems more complex than either the idea of an integral Soul, or the Kantian trichotomy of faculties, could account for. The nature of the art experience—which since Plato has been considered one of the defining traits of the self, or soul—has been similarly complexified. Aesthetic appreciation is no longer experienced in isolation from social and cognitive forces. That there are aesthetic aspects to cognitive events seems easy to admit: Certain philosophical arguments, for example, have a definite aesthetic appeal (like Zeno's paradoxes or Avicenna's proof of creation). Scientists also have increasingly recognized an aesthetic aspect to what they do.[11]

Kant had been concerned, among other things, that the access to cognitive truths not be unnecessarily cluttered with aesthetic distractions. But in fact the recognition of an aesthetic aspect to science, scholarship, and philosophy, does not sever those disciplines from the idea of truth. Rather, it drains away the force of the idea that aesthetics, being supposedly noncognitive, is nonpractical, frivolous, or even decadent—a matter of Fabergé eggs for czars' children.

The nineteenth-century saying, "Art is I, science is We," no longer seems quite straight. Though it surely still contains a major element of individual sensibility, art too is now as much "we" as "I"—meaning that it deals with social and communal meanings and issues as well as individual expressive or stylistic impulses. Chin's work is social or communal in that it characteristically compares and conflates different cultural versions of humanity's biggest ideas, those which model man's relationship to the universe. At the same time the work is individual or even, in a sense, autobiographical in an odd way, based on the macrocosm-microcosm idea, which implies that one's personal experiences and reflections are cosmic in structure or reach, and that the biggest cosmic ratios are contained within oneself. Chin's parents came from China to Texas, where he grew up in a primarily African American community with some Latino and French Creole families, and one Polish household. This multicultural conditioning is a ruling principle in his artwork.

To a devotee of Modernism, Chin's work, by its layered or staged reception and its involvement of all three of the faculties in the Kantian trichotomy, may be seen as shattering the unity of the pristine artwork as conceived by Kant and most Modernist thinkers. But in terms of current art discourse and practice, such a

criticism would seem to miss the point. By restoring the social and cognitive aspects to the aesthetic activity Chin has reunited, rather than shattered, the bonds of human wholeness. *Revival Field,* for example, at the same time that it posited a union of microcosm and macrocosm, also reunited the three faculties or aspects severed by the Kantian theory. Ecologically it is sympathetic magic aimed at producing a whole earth; psychologically, a whole person.

James Lee Byars, James Lee Byars: The Perfect Thought, *1990.*
Courtesy Michael Werner Gallery, New York and Cologne.

Chapter Seventeen

"Perfect Things Move in Circles": The Sculpture of James Lee Byars

James Lee Byars died in Egypt in the spring of 1997.[1] At the time of his death I was
working on an essay to accompany his contribution to the exhibition *Amours* at the
Fondation Cartier in Paris and another for the catalog of his exhibition *The Palace of Perfect*
in the museum of the Fundacao Serralves in Oporto, Portugal. In fact, for almost twenty
years Byars and I had always had some piece of work in progress together.[2] He produced and
exhibited artwork from the late 1950s until the late '90s—forty years. For the first twenty
years or so he was primarily a performance artist, for the second twenty, primarily a sculptor.
In his mind there was an enormous difference between these two functions, and it was
centered in the idea of the object.

As a performance artist Byars professed a contempt for the making
of objects. ("The artist walks in," he once said disdainfully, "carrying his little
kunst. . . .") He did occasionally make physical objects, that is, sculptures, but only
the most ephemeral, such as folded papers and loosely stitched silk garments, and
only as props for performances. In his performance style, he eschewed the stolid
physicality of the object in favor of the lightest, most fleeting glimpses of momen-
tary presences. When he was in this primarily performance phase he declared, "I
make atmospheres." He prided himself on the fact that nothing physical was
involved, or at least nothing heavy, as he rejected traditional marble or bronze, and
nothing that would endure, as he rejected the claim of the eternity of the artwork in
favor of the exclusive reality of the present moment.

Some glimpses: *In the garden of an Italian villa, a small group of people are
softly told to look in a certain direction. As far off as they can see, a man in a pink suit
appears for a second on the horizon and is gone. On a street in Texas, a man in a gold suit,
with a black hood covering his eyes, walks up to a small group of people under a tree and
distributes tiny paper discs with a message printed on them in type too small to read. On a
street in Los Angeles, a man wearing a straitjacket and a pink tail lies quietly down on the
pavement, then quietly gets up. In an American forest at night, a man in a gold suit, black
hood, and top hat roams about shaking people's hands while a soprano aria is sung from the
darkness. In a town in Germany, a man in a gold suit climbs a tree by the public square
with a megaphone; hooded in black, he cries out German names to the passersby below, like
an angelic messenger summoning from on high. A man in a gold suit, black hood, and top*

*hat appears on the roof of the 420 West Broadway building in New York, and rains down
on the world below black circles of tissue paper embossed with the words, "The Black Paper
on Art."*

Byars's early work, in the exclusively performative period, may be described
as a grasping at indefinitenesses. In time it settled restlessly and shiftingly on one
particular formulation of the indefinite that he called "Question." Byars reified
Question, treating it as an autonomous principle that could stand meaningfully on
its own without any Answer being needed. The pink man who appears for a
moment on the distant horizon was Question. The masked man hollering names,
like death giving its summons, from the tops of the trees, was Question. The
soprano aria sung in a dark wood at night, the black paper on art floating down
from the sky, the covered eyes, the affected manner—Question, Question, Question.
Question was an assertion that reality is always open, that it is in fact incapable of
closure. Question was actually a rejection of Answer. Question was an open inter-
rogative stance toward the universe, embracing all things with a wide-eyed gaze of
wonder.

In the eighties Byars began to expand his genre-range to include heavy
physical objects ("I'm carrying all this heavy stuff around the world," he would
whine self-pityingly over the phone from Japan or somewhere). Grudgingly at first,
he became a sculptor, and gradually, over years, stopped talking about Question. The
making of objects, he seemed to feel, betrayed Question. Since the object would stay
around, one could go back and check it, measure it, weigh it, describe it: no more
Question. Gradually he realized that his objects or sculptures were dedicated not
exactly to Question but to a second principle, the idea of perfection—which he
called Perfect—an aspect of things that was signified visually for Byars by the color
and material gold.[3] In fact, Byars's era of foregrounding performance work over
object-making ended symbolically with his donning of a gold lamé suit as ordinary
performance wear in the early eighties. The point of it was his eternalizing of
himself, his insistence on otherworldliness, and his celebration of death, through
which otherworldliness would be attained. Gold bore not only the content of a
celebration of the glorious presence of life (money), but the opposite meaning of the
death and eternity that wait on it all. As a symbol of eternity, gold represented the
negation of this world and hence constituted a celebration of death and not-self:
The golden self was the negation of a self, and with it the positing of a universal
that was beyond selfhood in an individual sense. This new fetish of gold began with
Byars making himself into an object, thus beginning the shift from performance to
sculpture with the objecthood of his own body.

After making himself into a gold object, Byars began making other gold
objects, which were outside himself, though they often represented parts of him. In
The Conscience of the Artist (c. 1983) he presented a small gold sphere the size of a
human eyeball, exhibited in a globed vitrine. In *The Planet Sign* (1980), he showed a
gold lamé circle about eighteen feet in diameter mounted on a pedestal that tilted it
toward outer space like a mirror sending signals. He symbolically gilded language in
The Perfect Whisper (1984), a circle of glass eleven feet in diameter with a round

one-inch hole in the center ("The Hole for Speech"), the inner edge of the hole gold-leafed to ease the passage of eternal utterances.

For twenty years the preoccupation with gold endured. It expressed two contrary essences for Byars: the eternal essence of death and the fleeting essence of the present moment. In his simple language of colors, black and red (which together constituted a kind of equivalent to gold) also pointed to death. *The Ghost of James Lee Byars* (1969) was an invisible entity installed in a blood-red room that was otherwise empty. *The Book of Death* (1979) was a large red book with no text, laid in a vitrine table lined with pink silk and draped with gray. Each of these works referred in some way to death and transfiguration. *The New National Flag of Germany* (1981) was two circles of black silk, each about four feet in diameter and each lying upon a black-lacquered, circular wooden platform; the silk circles are spread wet on the tilted lacquer surfaces, dry after ten or twenty minutes, slip soundlessly to the floor (like the spirit silently leaving the body), and are remoistened and mounted again. *The Exhibition of Perfect* (1982) was a large red silk tent which no one was permitted to enter; peering through its huge doorway, one sees a thick atmosphere of rosy light, as if from a foyer of Heaven. In *The Devil and His Gifts* (1975–1981), a huge piece of pink silk was draped on the floor as a bed for a humanoid figure made of red satin rope. On the silk around this figure lay an array of objects as if spilled from the devil's bag: soft sandstone crescents; a pink powder puff; a large black book with no text inside; a loosely wound ball of pink yarn; some spherical stones; a white microdot in a globed vitrine; a tiny pink scrap called "The Miracle"; a tiny stone wrapped in pink tissue paper; other things. In an installation seen in New York in 1986, two darkened rooms were painted entirely gold. In the first, four black velvet "library sofas" (as he called them), or reading couches with gilded legs, were arranged around a cubical black book with no text inside. It was a reading room from some other world; slumberous presences seemed to float about its black and gold. In the room behind was the equipment of some imaginary kingdom: an enormous golden ring or halo, a golden tower, a golden flag, a golden spike, and a golden lettered sphere embedded in a wall. Through much of the exhibition the artist was present himself, silent and ghostly in gold suit and top hat, discussing the work with visitors or standing motionless as a part of it, acting out the death it all pointed to.

Such works were homages to the living moment and memorials to eternity at the same time. They were in a sense memorials to his own death, which was summed up in a brief performance work done several times: *The Death of James Lee Byars*—"Quietly lie down and quietly get up."

The artistic vocabulary that Byars built up over several decades was an attempt to arrive at the irreducible elements from which a universe might be constructed, like the elementary geometrical forms used by the Demiurge in Plato's *Timaeus*. Among the simple and pure essences which he steadily made his own were certain elementary colors—gold above all, but also the death colors (night-)black and (blood-)red—and simple shapes which seemed to have great complexity compressed into their elementariness and which were associated with the timeless

macrocosm of the astronomical night-sky. The circle and sphere were supreme, but other primary shapes figured in, too. This obsession with primary elements of the physical world was foreshadowed in the ancient tradition of Pythagoras and Plato, where the purest, most elementary forms and modes of visuality were regarded as metaphysical building blocks of the universe—as virtually sacred things containing ontogenetic powers that more developed and complicated entities had diffused and lost. This was the tradition of the Mosaic of the Philosophers from the Villa Albani, Byars's favorite document on the sphere.

It escaped Byars's critics—distracted as they were by his flamboyant and often abrasive persona—that they were dealing here with the most direct artistic attempt to portray Perfection in the sense in which the realm of Platonic Ideas is described as perfect—which involves, among other things, the simplicity of its geometry and the purity of its (cognitive) material. The German philosopher Schelling said in the nineteenth century that a great work of art was like pulling back the curtain on the realm of Ideas—but no one ever pulled it back like this, with such bravado and delicacy at once.

The basic cultural meaning of gold was first stated by the poet Sappho, who, in about 600 B.C., called the metal "deathless" (fr. 204), meaning that it does not rust; it was this that made it the fitting symbol for claims of eternity. But gold had become prominent as an art material much earlier, in Egypt and Sumer, about 3000 B.C. These states were founded on the idea that there is an absolute and undying order in the universe, which is reflected on Earth by the order and hierarchy of the state. Gold, used for royal and ritual objects, represented the state's claim to eternal power, and with it the claim of a particular ruling class. This is the ultimate reason for the gold standard once behind money, and for the gold hoards in the control of Celtic chieftains, Egyptian pharaohs, and Assyrian kings.

Undying gold is the stuff of eternity, so the Greek poets portrayed the other world—the home of the deathless gods—as a delightful golden realm whose inhabitants were relieved of the anxieties of time and its vicissitudes. The gods were said to drink nectar from golden cups, to live in golden houses, to travel about on chariots of gold. Apollo played a golden lyre with golden strings; his words were golden shafts of meaning. Pheidias sculpted the gods in ivory and gold. When life is good, said the poet Pindar (*Pythia* VIII 96–97), it is because Zeus rains down gold on men—because some aura of the world of the gods who live forever was vouchsafed to humankind.

And Plato, who would not allow the guardians of his ideal state to touch gold, aware of its darker reading as cash, nevertheless averred that "beauty is nothing else than gold" (*Hippias Major,* 289e). In the art context, gold represents an aesthetic absolutism. It asserts that the ingredients of beauty are always and everywhere the same, that what is beautiful now will always be beautiful, as "undying gold" will always be golden. Beauty, then, is understood as something from another world, something that comes down from Heaven, like a divine decree, not a thing dependent on changing and subjective mortal tastes.

This is a part of the paradox of gold: On the one hand it represents

James Lee Byars, The Spherical Book, *1989.*
Courtesy Michael Werner Gallery, New York and Cologne.

heavenly order and transcendence, and claims for its possessors a freedom from the natural web of cause and effect here below; on the other hand, and more terribly than iron, it is, as the pure sign of market value, the binding element of that web of cause and effect, which cuts all cultural beings and events down to size.

But the contradiction between eternal truth and base commodity is only part of a larger paradox of gold. Sappho, the first enunciator of gold as eternity, also offered a significant counterview to its signification of imperial wealth and power, a view intended to provide escape from the trap of the eternal. She used the image of gold to describe mortal and ephemeral things as if they were immortal and timeless in value. When she described young girls as "like golden flowers," for example, she meant that although such flowerlike beauty will wither in its season, it exerts for its moment, as it ravishes the eye of the beholder, a power like that of an ideal perfection. In this usage, goldenness is still regarded as otherworldly in origin—like a glint of light from beyond the clouds—but the emphasis has shifted from eternity to the present moment. It is the perfection of a moment of human feeling that is celebrated, not the prospects of its survival beyond the grave.

In Christian art again (as in Bronze Age Egyptian) gold represents the entrapment of eternity; it is not the poet's gold of the fleeting momentary perception but the imperial gold of absolute power and supernatural wealth. Used as ground for portraits of saints and kings, gold presents them as if already in the heavenly and eternal other world, or soon destined to be there. It also represents divine intelligence (that's why halos are golden). Yet gold, for all its transcendent sheen, retains its other reading as crass market value, the paradoxical double symbolism—gold as transcendent otherness, gold as filthy lucre. With the secularization of art in the Renaissance, gold passed out of artistic prominence, except in occult symbolisms like that of alchemy, in which it retained its old meaning of the transcending of ordinary cause and effect.[4]

Byars ended up caught on the paradox of gold, celebrating the Perfect as if it were an eternal ideal, yet celebrating it only in the most fleeting and ephemeral encounters. The outrageous way he dressed and went about—the eyes shrouded in black, for a while the pink tail dragging, or the straitjacket—reflects the deep tension of this paradox, the strain of trying to pull it off: to present the eternal truth of the Platonic ideal realm in a momentary glimpse as of the most transient atmosphere fleeing through the air.

Strategically he chose to believe in the eternal embodying itself in the purest of forms, and settled on an ancient and conservative geometry as ally. This is the geometry of shapes so simple and pure that they can hardly be broken down into parts, shapes which Plato's Demiurge, in the *Timaeus*, used as the fundamental building blocks of the world. By breaking the world of seemingly complex experiences back down into these elementary shapes, Byars was turning it back toward its source in ultimate simplicity.

The circle and the sphere are traditionally the natural shapes for gold, the shapes of the eternal (*and* of worldly coin). The philosopher Parmenides said that pure Being was spherical. Plato described the eternal order of the cosmos as made

up of interlocking circular movements. Aristotle declared that all perfect things move in circles. This was a basic point in Byars's sculptural work: Spherical rotation is movement that does not involve change of place; it is movement that stays where it is so it simultaneously evokes time and eternity. Circular movement also differs from linear, goal-directed motions by always returning to the same place. It does not involve getting anywhere but simply remaining where one is forever, engaged in perfect (circular) motion and stillness at once.

In the West the circle, like gold, remained prominent in art through the medieval period. But in the Renaissance, conditions took it (again like gold) out of religious art and into an underground that would include movements like Rosicrucianism and theosophy. Since Hellenistic times, the circle had been associated with the zodiac; Renaissance occultism produced the icon of the human figure inscribed in a circular zodiac. This image, expressing the ancient Sumerian idea of a correspondence between the macrocosm and the microcosm, remains to this day the foundation of Western occult philosophies, from the cabalism of John Pico of Mirandola to the Rosicrucians and theosophists. In architecture also, the circle and sphere—though prominent in the Renaissance in the work of Leon Battista Alberti, Donato Bramante, and others—made their way, after the secularization of art, underground, into a quasi-occult tradition. They became the special features of the so-called "visionary architects," Etiénne-Louis Boullee and Claude Nicolas Ledoux.

In mainstream Modernism these shapes (again like the material gold) have been virtually repressed. For two generations now the square (in the works of Kasimir Malevich and Alexander Rodchenko; in a sense Piet Mondrian, Theo van Doesburg, and many others since them) and for one generation the cube (in the works of Sol LeWitt, Donald Judd, Larry Bell, and others) have been accepted as primary shapes that carry an aesthetic value relevant in the urban Modern world. But not so the circle and sphere. A glance through the textbooks of Modernism shows few of them; those that exist are usually justified by some functional attribution, as in Jasper Johns's designation of his circles as targets. After all, the square and the cube, which have asserted themselves as virtual trademarks of Modernism, constitute more of a reference to cultural reality: to rectilinear ordering, gridlike containment, purposive linear movement toward a goal, boxing and saving. The circle and sphere, on the other hand, relate more to nature, to process, endlessness, eternal recurrence. The cube participates in what Hegel called Work, or History—the conscious project of cultural advance and containment. The circle and sphere lie outside the zone of Work, deny History, and represent the purposeless perfection of nature (which Hegel called "Madness"). The difference is enormous in terms of human intentionality. The square and the cube are manageable, they have been created by our intentions and for them. But the circle and sphere represent forces beyond our control, forces of cyclical regression and periodic descent into the abyss where human intentions count for nothing and the gold of beauty is one with the black of nihilation.

Byars was clearly not a Modernist, despite his preference for the universal. His lifelong relentless opposition to the medium of painting—the emblem of

Modernism—sprang from a visceral hatred of the dogmatism and authoritarianism of the Modern world. At the same time, he was not a post-Modernist per se. While he was drawn to relativism and skepticism, he also felt impelled to make absolutes of them. Finally his work was more pre-Modernist than either of the other options—an affirmation of the types of verities that would have been worshipped as universals in the Neolithic or early Bronze Ages, the ages of gold, astronomy, and the worship of the invariances and cyclicities of nature.

Byars made the circle, the sphere, gold, black, and instantaneity contribute to lifelong performance-sculpture dedicated to Perfect. His work is a constant contemplation of an "other" world, which for Byars was not a religious concept or a metaphysical postulate; instead, it arose from a belief in the power of the imagination. His work holds something of the spirit in which Plotinus portrayed the World Soul as saying (*Enneads*, III.8.4), "I contemplate [my mental images] and the things of the world take shape from my contemplation." Byars's goldenism does not posit another world as an escape from this one, but as an intensification of imaginative presence *in* this one. Thus, as it was for Sappho, the absolutism of gold insinuates itself into the passing moment and hides within the relative.

Byars's work thus lays bare an inner paradox in Modernism, a lack of synch between its self-image as a force of change and its secret agenda as a vision of eternity. As a doctrine of change, Modernism was inherently relativistic, each cultural form being understood as relative to the time and circumstances that produced it; as a doctrine of change toward a goal, or progress or improvement, it implied a final state of history-ending perfection. The millennialist aspect of the Modernist doctrine brought with it other hidden, religious structures of thought, such as ideas of the survival of the eternal self through art and the foundation of aesthetics on timeless verities. Byars's work almost unintentionally drives into the open the hidden absolutism and eternalism that paradoxically conflict with Modernism's overtly stated affirmation of change.[5]

Like a kind of omen, gold speaks to us darkly about the future. Byars's blacks are close behind it, muffling the splendidness of death's gold. This preoccupation, long present, came assertively to the foreground in the year or so before his death, when his obsession with gold and the sphere became like an incantation he chanted with his breath from moment to moment.

When I met James in 1980, I had been working for about ten years on a comparative study of ancient Greek and Indian philosophies. He was drawn to that work for several reasons, not least the fact that the complete manuscript was about one thousand pages long. To Byars, one thousand, like other decimal round numbers, was Perfect. Ten was the number of Perfect, and its decimal expansions—one hundred, one thousand, and so on—shared this luster. Decimality, however, was only one aspect of Perfect; a second was the form of the sphere.

In both these associations—Perfect as decimal, and Perfect as spherical—Byars had arrived on his own at the position of Pythagoras and his school in the sixth and fifth centuries B.C. For the Pythagoreans, 10 was the number of totality because it represented the sum of 1 + 2 + 3 + 4. In Pythagorean cosmology, 1

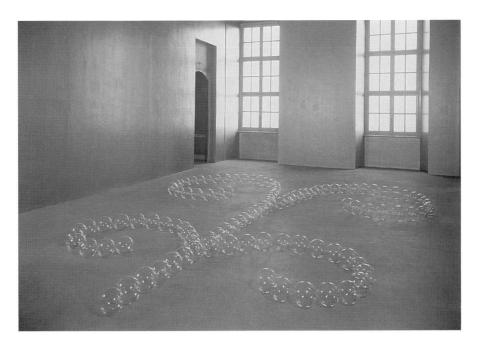

James Lee Byars, The Angel, *1989.*
Courtesy Michael Werner Gallery, New York and Cologne.

represents the point or dot, which is the first physical sign of something nudging its way into manifestation; 2 represents the line, two dots joined, the second move of reality once it has embarked on spatial extension; 3 is the triangle, three dots joined, which is the first plane figure, the only plane figure that can be constructed from only three points; and 4 corresponds to the tetrahedron, four dots joined, the first solid figure.

So the progression of the numbers 1 to 4 shows reality flowing by stages out of nonmanifestation into manifestation: first, on the blank slate of nonbeing, appears a dot; then the dot flows into a line; the line twists into a triangle; and, finally, the triangle bulges into a tetrahedron. Thus the whole complex and multi-farious world of three-dimensional geometric forms can be seen as flowing out of nothingness along the path of the numbers 1 to 4. The master number 10, the sum of 1 to 4, oversees the process.

In the Greek tradition, the concept involved was Totality. The sum of 1, 2, 3, and 4 was everything. The word "Perfect" means much the same: *per-factus*, thoroughly made, or made completely, not unfinished, a Totality. Byars's idea that 10 is the number of Perfect parallels the Pythagorean idea that 10 is the number of Totality.

The association of Totality, or Perfect, with the sphere is common through-out ancient Greek philosophy. It first appeared with Parmenides, for whom the

totality of all that *is* is a sphere, because a sphere, by revolving on its axis, can move without changing its location. This fact indicates the Totality of the universe, that it is complete and wanting in nothing; because if there were any space for the world to move *in*to, that would mean there was an emptiness somewhere, a lack, a deficiency, which substance was always rushing to fill and ever lagging behind. As substance rushed to fill the emptiness, it left another emptiness behind it, and so on. But the movement of the sphere, because it does not need empty space to move into, does not imply any lack or deficiency in Being. It is an immobile mobility.

The idea remained basic for Pythagoras, Plato, Aristotle, and other thinkers in this tradition down to Plotinus and Porphyry almost a thousand years later: that it was in the nature of Perfect, or Totality, to express itself through both decimality and sphericity.

The relationship of Question to Perfect is the central topic about the conceptual aspect of Byars's oeuvre. Question came first. Then when, in the eighties, Perfect came, Byars first tried to pretend that it hadn't obsoleted Question. He did this by the concept of the Perfect Question, which implied that somehow Perfect, which means the Complete, and Question, which means the Indefinite, can characterize the same entity.

But what was really, secretly, happening is that Perfect had presented itself as an Answer to Question. Byars didn't want to admit this; he wanted to maintain an appearance of total commitment to the idea of Question, when really he had begun to sell Question out for its Answer: Perfect.

The possible understandings of the relationship included these: (1) that Question underlay Perfect or Perfect underlay Question, and they were somehow the same; or (2) that Question led to Perfect and then Perfect superseded it, and, though they were causally linked, they were still cognitively separable entities.

The problem is in the temporal sequence: Question rises up and then its arising causes Answer to pop up in turn. So by the time Answer has come fully into being, Question no longer exists, or is just fading out of existence. So they are not the same entity, for they cannot exist at the same time, but only sequentially. Yet Byars deeply wanted Question and Perfect to exist at the same time and somehow be the same thing.

There was a period—was it the late eighties?—when Question seemed briefly to coexist with Perfect. But as the years passed, Question and Perfect separated; it turned out they didn't really belong together—they had only been passing each other by. As the artist grew older, Question (the restless booting-about of youth?) lost its dominant grip on his sensibility, and Perfect (the rich glow of the serene fullness of maturity?) ascended to the empyrean.

Meanwhile, my manuscript, *The Shape of Ancient Thought*, also dealt with the idea of Question in a way, studying the birth of the first classic questions people had asked; the famous "problems" of philosophy—the One and the Many, the Mind and the Body, and so on. It also touched on Perfect, the primary shapes of the *Timaeus*, and the mathematical mysticism of the Sphere. (*What shape is ancient*

thought? Round.) So we had walked on somewhat parallel paths, though one was pursuing sculpture, the other philosophy.

For these and many other reasons Byars asked me, from his deathbed next to the pyramids in Egypt, to make a sculpture from my book for his exhibition in the museum in Oporto. His request was that I exhibit the manuscript in a series of different-sized recensions. First the thousand-page Totality; then a hundred-page condensation, a ten-page compression, a one-page squeeze, a hundred-word whisper, a ten-word hint, and a one-word droplet (*bindu*). Assuming that each of these versions said more or less the same thing, the series could be seen as a staged extension and expansion of a single meaning, like the world flowing out of the elementary number series 1 to 4. In fact, my book reconceived in this series of decimal expansions and contractions would reproduce the world process of emanation and withdrawal as asserted, for example, by Plotinus: that the world flows from oneness into manyness and from manyness back into oneness by a series of regular and continuous stages.

In the weeks before his death, Byars had been working on a piece that paralleled sculpturally what he had wanted my book-condensing-and-expanding piece to embody conceptually. This involved the associations of Perfect with decimality and sphericity and, as a third and final essential aspect, the materiality of gold. A universe that was spatially perfect through its sphericity, and conceptually perfect through its decimality, would be, in addition, temporally perfect if it was pure gold and hence eternal.

It was this project that had brought him to Egypt some three months before his death. He had heard that there were gold blowers in Egypt who could blow gold the way glass blowers blow glass. He wanted one of them to blow him a perfect sphere of molten gold the size of a human heart, which he had decided was ten centimeters in diameter. He found that they do not in fact blow gold, but nevertheless pursued his project through a goldsmith's shop in Giza. Two days before his death he showed me a golden sphere ten centimeters in diameter; he also showed me some others, I don't know how many, that were one centimeter in diameter; and many others (he said there were a thousand) that were each one millimeter in diameter.

The project, I think, was not finished yet. I believe his intention was to have one thousand gold spheres each one-thousandth of a meter in diameter; one hundred gold spheres each one-hundredth of a meter in diameter; and ten gold spheres each one-tenth of a meter in diameter. The Totality of the decimal gold sphere would be worked out on three levels (three, for Byars, being yet another aspect of Totality, as Perfect had three defining characteristics—decimality, sphericity, and goldenness). Due to a shortage of funds, he had only one of the ten projected spheres each one-tenth of a meter (or ten centimeters), and a few of the hundred each one-hundredth (or one centimeter). Perhaps, as he said, he had a thousand of the one-millimeter ones; they seemed, anyway, when he showed them by opening a small box in his hand, uncountable.

My manuscript, you might say, was *about* the perfect order underlying the

gold spheres and Byars's conception of them in three scales. By asking me to decimalize it, so to speak, he was asking me to make it *embody* what it was *about*—to *be* what it *signified*. Really, that was always the central part of his pantomime. That is, after all, what *he* did with the gold suit, the black hood, the pink tail, the outrageous hillbilly whatever-it-was that the *New York Times* obituary referred to as an "aristocratic bearing." Or, as Eric once put it, "He was the gentleman's gentleman"— meaning that he poured wine well for other people.

Or does it mean more? A gentleman, perhaps, knows his tens, his thousands, his spheres, his seamless golds. These things, as Dr. Johnson said of Greek, "every gentleman gets as much of as he can."

An exhibition of 1993:[6] Black paper crescents, stars, circles, and towers ascend the walls. The gold writing on them is hard to read, every letter dotted with stars at each of its angles. "24 7d" signifies "24 hours a day seven days a week." "Eros," a constant, is repeated in the dead center of stars and circles. Pythagorean perfections are suggested by arrays of stars, crescent moons, round suns. Four scissored red Chinese papers make towers representing the four quarters. Little black moons rise overhead. In the midst, black stars map out unseen power-lines.

A show of 1995:[7] The whole astronomical order is seen as a jewel-encrusted brooch—the "rich adornments of our lady, Night," as Aeschylus said in the *Agamemnon* (ll.355–356). Byars's *cosmos,* made of white marble from the island of Thasos, unfolds like a bright night over the Aegean. First the sun sets: 365 white marble triangles arranged in a circle on the floor. Time passes. The moon rises: a circle of white marble gazing milkily upward. Again time passes. The stars slink silently out. One hundred white marble gleams clustering into a big fivepointed star. They flicker, sparks on the vault of heaven. Time circles.

Blessed and fortunate one! murmers a distant voice, bouncing off the stars and ricocheting among the spheres.

Well done, suppliant of Persephone! Drink ye now of the sacred spring and take your seat among the heroes who welcome you to their banquet.

Part Four

Secular Iconographies

At the demise of Modernism the second available option (in addition to neo-pre-Modernism) was a modified form of Modernism, which may be regarded as post-Modernism per se. The term post-Modernism in the broad or loose sense includes neo-pre-Modernism, also. Together neo-pre-Modernism and post-Modernism in the narrow sense combine to make up post-Modernism in the expanded sense. Whereas neo-pre-Modernism (characterized by a "flight from reason") led to phenomena such as ritually based Performance Art, post-Modernism per se (meaning rationalist post-Modernism or post-Modernism in the narrow sense) led, among other things, to classical Conceptual Art with its emphasis on cognition, and a variety of cognition-emphasizing developments in different media, such as conceptual painting, conceptual sculpture, and others.

There are two main differences between neo-pre-Modernism and post-Modernism proper. First, post-Modernism proper (or rationalist post-Modernism) does not involve a wholesale renunciation of the Enlightenment package of ideas. The main element of the package that is regarded as unacceptable in post-Modern terms is the Hegelian myth of Progress, which, serving as a justification for colonialism, is widely regarded as having exercised a negative effect on the world in general. Other ideas such as democracy, civil rights, rationality, and scientific investigation are not, however, widely renounced from this standpoint—though there is a keen desire to modify their methods of relating to society in more beneficent ways.

Secondly, the two positions relate somewhat differently to the Kantian theory of the faculties. Kant and the whole tradition that followed from him regarded the aesthetic faculty as the only one that contributes to art, and the ethical and cognitive faculties as irrelevant to it. The two post-Modern options shift the emphasis in different ways. The neo-pre-Modernist option emphasizes the ethical faculty, rationalist post-Modernism emphasizes the cognitive faculty. The ethical emphasis encouraged performance, the cognitive emphasis, conceptualism.

In the following section are essays on ten artists of the rational post-Modernist bent. The work of these artists may or may not involve references to ancient traditions. In either case, the main thrust is apt to be the critical working-out of some implication of the Enlightenment project. The distinction between these two groups is not absolute. Both are post-Modernist in the larger sense, and some artists in each grouping could also fit in the other.

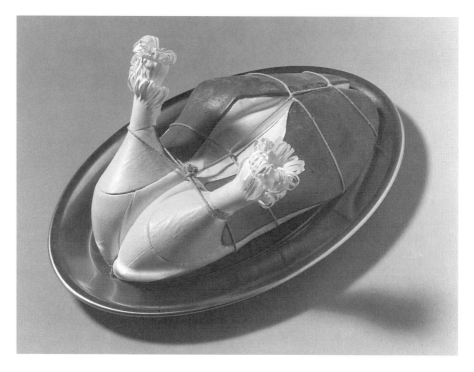

Meret Oppenheim, Ma gouvernante—my nurse—Mein Kindermädchen, *1936.*
Courtesy of Statens Konstmuseer—The Swedish National Art Museums, Stockholm.
Photo: © Per-Anders Allsten Moderna Museet.

Chapter Eighteen

Basic Dichotomies in Meret Oppenheim's Work

It is because of her connection with the tradition of surrealism that Meret Oppenheim can be treated as a post-Modernist artist. Surrealism, along with Dada, was an early foreshadowing of what we call post-Modernism today. Always tending against the formalist aestheticism of Cubism, and of Kantian theory in general, these were the first movements to deconstruct the Modernist paradigm in favor of a content-oriented art that aimed to disconcert rather than to give satisfaction, and to propose ironic, often humorous, cognitive conundra rather than sensibility-based resolutions of aesthetically nuanced formal problems. The explicit feminism of much of Oppenheim's work, along with its rejection of the grandiose, also place it squarely in the lineage that extends from First World War Dada to the 1980s post-Modern.

It is amazing that Oppenheim is so famous, so iconic as an artist, on the basis of a single work. Most of the world knows only the fur teacup and spoon—*Le dejeuner en fourrure* (*Breakfast in Fur*, 1936). Yet on this basis alone her reputation seems at once secure in regard to her stature, and mysterious or unknown in regard to her identity. She is known or vaguely regarded as a Surrealist, and the sense of mystery that has surrounded her has probably contributed positively to this somewhat simplistic designation.

Surrealism has often been exemplified by a phrase of Isidore-Lucien Ducasse (Le Comte de Lautréamont, 1847–1970), in *Les chants de Maldoror* (1868) ". . . the chance meeting of a sewing machine and an umbrella on a dissecting table."[1] The famous text was first published in 1868 (though not released until 1879), and a generation or two later was discovered and taken up by Dadaists and Surrealists. Ducasse was hailed as an ancestor or precursor of Surrealism, and Man Ray, in 1920, paid homage to him in *The Mystery of Isidore Ducasse,* a sculpture that appears to be a sewing maching wrapped in a blanket.

The three objects in Ducasse's parable—so to call it—are not normally encountered together. The surprise of their conjunction creates what Russian formalist critics called a "making strange." Reality is for the moment made strange, made anew; the world is redefined. The nature of a reality, or of a world, has to do with one's sense of what is appropriate or natural within that reality. The vision of the umbrella and sewing machine on the dissecting table posits a different naturalness and a different world altogether. It is no longer the place where these three

things do not belong together; it is now—somehow—the place where it is in fact appropriate to see them together.

Though Ducasse seems to attempt to express a state of lack of definition with his image, it nevertheless does come with a certain amount of inner definition. There is for example a hint of danger. The image has the effect of deconstructing existing culture by attacking its sense of the appropriate, of what goes with what. This is inherently threatening to reality as known—to intellectual, and perhaps even social, order.

Ducasse built this sense of danger into his image. Two of the three objects conjoined involve the acts of cutting and piercing. The third, the umbrella, is a traditional comic instrument for striking another human. The piece is not really undefined; it flaunts somewhat humorously its definition as a danger to society. At the same time, read iconographically, the three objects in the parable can be seen as reconstitutive: The sewing machine unites; the umbrella protects; the dissecting table has something to do with medical practice or training. A finely pointed ambiguity pervades the field—a sense of deconstructing in order to rebuild. It has also been suggested that the sewing machine, with its reference to crafts performed at home, is a female symbol, and the umbrella, with its reference to walking about in the world, not to mention its extended form, a male symbol. The image deals in a dangerous and threatening way with sexuality and its rogue relationship to social order.

Nature/Culture Contradiction

Oppenheim's *Breakfast in Fur*, as in Ducasse's formula, brings together two things that are not usually encountered in tandem, but rather are regarded as inappropriate for each other's company. However, the two things conjoined inappropriately are not, as they were in the Ducasse image, devices designed for different cultural purposes. Oppenheim makes a different point, conjoining a cultural object with the sign of a natural condition—the condition of furry beasts—that is, nonhuman mammals that do not drink from teacups or eat from spoons. Ducasse pointed to inner contradictions within culture; Oppenheim points to a contradiction between culture and nature. Rather than turning culture against itself through emphasizing its internal contradictions, she goes outside culture, threatening to sink it ultimately into the other. The fur grows over the teacup like fur growing on a werewolf in a horror movie. Does it become threatening and terrifying, a denial of the reality of what is regarded as human nature, an assertion that it contains the beast? Or is it a hopeful assertion to the effect that nature will ultimately somehow redeem the problems of culture? These two themes are enfolded in the strangeness of the piece, its ambivalence, a question mark about human destiny. At the same time, the female/male dichotomy is focused in the conjunction of the uterine vessel and the extended spoon that enters it.

The mingling of this theme with the nature/culture theme suggests, somewhat as Sigmund Freud did in *Civilization and Its Discontents*, that it is sexual

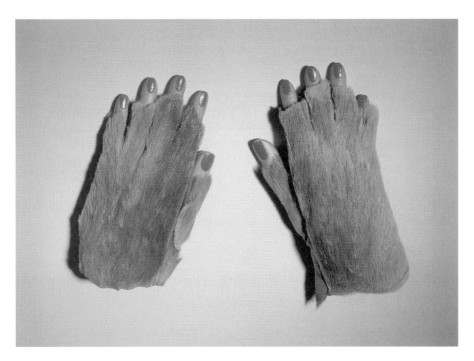

Meret Oppenheim, Pelzhandschuhe, *1936.*
Collection, Hauser and Wirth, Zürich and St. Gallen.

nature that binds us to the animal kingdom and threatens civilization. These themes were to intersect and interact in Oppenheim's oeuvre many times. Her classic piece is as oppositional as Ducasse's parable, but more radical or broader in import. Both are essentially programmatic; neither image is truly indefinite, though both have pretensions toward that goal. For some practitioners of Surrealism, the attempt to negate meaning was experienced as liberating and transcendent; a truly indefinite entity would in a sense transcend things with finite meanings, as an absolute is held to transcend everyday things.

Female/Male Parallel Distinctions

The nature/culture dichotomy seen in *Breakfast in Fur* recurs in works such as *Table with Bird's Feet* (1939), a cultural object that is either revealing its true identity as nature or reverting back to a natural state. The painting *Paradise Is Under the Ground* (1940) is a mysterious picture with many implications, one of which involves the interface between nature and culture: A piece of the sky is being lowered underground by a winch through a mortared brick well. The brick wall of the well is rigid and rectilinear, gridded—that is, culture. *Old Snake Nature,* a

sculpture of 1970, shows the snake's eye peering out from within its coils atop a sack of coal. The sack is culture trying to put its constraints around nature. But inside the apparently bagged and submissive nature, the old snake's eye still looks out. Its moment will return, the snake's skin will shed, the bag will pop, the worm will turn.

Alongside this frequently repeated nature/culture confrontation is a parallel distinction between female and male. This often shows itself as a comparative exclusion of the theme of masculinity and a bringing of the feminine to the foreground. It is a strategy—later prominent among feminist artists in the 1970s—to simply pretend the patriarchy doesn't exist. Works like *Spring Banquet,* a performance of 1959 in which dinner was served on the body of a nude woman, and *Geneviève,* a sculpture of 1971 which suggests megalithic goddess icons, imply a worship of pre-Modernist cultural forms traditionally associated with the dominance of a "female" spirituality and social structure.

Representation/Abstraction Opposition

Yet another group of works seems to feature a third parallel distinction: the opposition between abstraction and representation. *Blades of Grass in the Wind* (1964) would be read by most viewers as an abstraction, except for the title, which functions in partial opposition to the image. *Jungle River with Pirogue or Crocodile,* a painting of 1975, would also most likely be "read" as an abstraction without the title. This seems a special device of Oppenheim's, to attempt to make the viewer see a piece in two ways at once. *The Secret of Vegetation* (1972) combines abstraction and representation unapologetically in a mixing of styles or visual languages that has become common, almost a new kind of kitsch, in post-Modernism.

These three dichotomies are prominent in Oppenheim's oeuvre: nature/culture, female/male, representation/abstraction. They are not simply features that happen to be there, but parallelisms that bestow a certain overall coherence or shape on the work at the level of iconographic content. Roughly, nature equates with the female and representation, culture with the male and abstraction. But the overall shape of the oeuvre is not merely a tension of dichotomies in a static situation; there is also a temporal element. The relations among these bipolar pairs shifted in a steady and appreciable way through the fifty years of Oppenheim's self-expression as an artist. In brief, the linked themes of female, nature, and representation dominated the work from about the 1930s through the 1950s, then progressively gave way to the themes of culture and abstraction. This major shift in emphasis seems to correlate with certain biograpical information.

Depressions and Their Impact

According to Bice Curiger's biographical essay[2] on Oppenheim, the artist suffered serious depression for much of her life, sometimes preventing her from working for years at a time. This period of depressions seems to have become intense in the mid-1930s and to have lasted without much let-up until the mid-

1950s, when various factors contributed to its lifting and her return to work and public life.

One symptom, or perhaps one condition, of Oppenheim's depressions was a feeling of being deeply betrayed by the limitation of opportunities for women in patriarchal societies. "I felt as if millennia of discrimination against women were resting on my shoulders," she wrote in 1937, when the depressions were becoming increasingly severe, "as if embodied in my feelings of inferiority."[3] Her feelings of inferiority prevented her from working, and that in turn intensified the feelings of inferiority. Art making, like most cultural activities, was the domain of the male. As this awareness became increasingly repressive to her exercise of her own talents, her production of work diminished and she retired more and more from public life. Almost forty years later, in a talk given in Basel, Oppenheim restated the theme. "As I see it," she said to the audience, "since the establishment of a patriarchy—in other words, since the devaluation of the female element—men have projected their inherent femininity, as a quality of inferior ilk, onto women."[4]

It was in this difficult period of about twenty years that Oppenheim focused in her work on the traditional dichotomy between nature and culture as an embodiment of the female/male dichotomy. But there were problems to this strategy. By associating the male with culture and the female with nature, Oppenheim was perpetuating a patriarchal system. As many feminists of the first generation of the women's movement would later do, she attempted to reverse the value hierarchy while maintaining the distinction. This was difficult, since it was a distinction that had already been characteristic of the patriarchy, in which woman had seemed the weak link, the unbeliever who could betray civilization and go over to a primitive and nature-based viewpoint. The association of the female with nature, then, might contribute to perpetuating her oppression—and actually it was culture Oppenheim really wanted to participate in.

Again like many feminists of a later generation, Oppenheim, in her various strategies for dealing with this situation conceptually, revived notions of female identity from earlier, prepatriarchal ages. Some of her pictures, objects, and poems seem to refer directly to the idea of goddess-dominated societies or spiritualities. *Spring Day* (1961), for example, suggests various ancient goddess icons from Chalcolithic Cyprus to what historian Maria Gimbutas called "Old Europe."[5] A female-like biomorphic form rises as if celebrating from a tiny wire basket, which may refer to the latency period of winter or to the limitation of women in the patriarchy and their dream of breaking free.

Stone Woman, a painting of 1938, shows a female figure, reminiscent in its volume of Paleolithic Venuses, lying half immersed in the ocean and half upon the land. The parts on land have turned to stone, to boulders, to pure nature; the legs, not stone-colored, but white and still in the water, are vaguely identifiable as those of a human woman. The idea of woman's closeness to nature, her tendency to slip in and out of it like a shape-changing shaman or witch, is presented as the fundamental, indeed singular, fact in an otherwise empty landscape. But as usual, a puzzling reversal is involved. The parts of the woman or goddess that have crawled up on the

shore have turned to stone; the parts that have stayed in the water are human. But the human would more often be associated with the land, and the nonhuman with the sea. There is a suggestion that woman has not yet been fully born from the evolutionary womb of things, and that her ongoing attempt to force this birth is deeply problematic in some way that relates to patriarchal strictures.

Primeval Venus (1962) is a sculpture in which a terracotta teepee-like structure contains straw, showing through the apex of the triangle. It evokes ancient cultures of mud, straw, and clay—of the earth. *The Four Elements—Earth*, a drawing of 1963, shows the earth element as a humanoid female in spread-legged position. Iconologists sometimes call this position the "displayed female" motif, characteristic of the Neolithic period, which early feminists tended to regard as a matriarchal era. From each of her legs an evergreen tree sprouts. Her smiling face rises merrily above staring breasts. She is dynamic, creative, birth-giving.

Various poems from the same period express this theme. Characteristically, Oppenheim claims, for example, shamanic abilities to understand the languages of other species.[6] How, for example, do you find something in nature?

> *You turn the door around.*
> *You read the paeans of migrant birds, of*
> *waterfishes, of damned and cursed*
> *Purzta beetles.*[7]

How will you spend your afternoon?

> *I have to write down the black words of the swans.*[8]

And the ultimate goddess at the root of it all?

> *Anyone that sees her white fingers is ready to be*
> *transformed.*[9]

In a talk Oppenheim gave many years after the period of severe depressions had lifted, she echoed these themes. "When nature," she wrote, "has stopped being treated as the enemy of man, when the battle of the sexes has become an un-known . . . then at last, poetry and art will automatically come into their own again. . . ."[10]

It is true that when Oppenheim says nature is "treated as the enemy of man," she may be using the term "man" generically to include both men and women. Nevertheless, the fundamental accusation that the passage embodies is an accusation against patriarchy. Several of the visual works, also, seem to focus on the bondage of women, such as two sculptures of women's shoes. In *Ma gouvernante—my nurse— Mein Kindermädchen* (1936), a pair of women's shoes are tied together and presented like a cooked goose on a platter. In *The Couple* (1956), two old-fashioned, almost

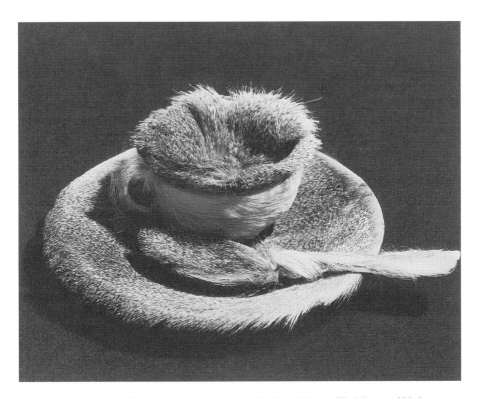

Meret Oppenheim, Object *(Le Déjeuner en fourrure), 1936. Collection: The Museum of Modern Art, New York. Photo: © 1998 The Museum of Modern Art, New York.*

sadistic-looking, women's shoes are joined at the tip. Among other implications is the suggestion that women are not supposed to move; they should stand still and do what they are told. Both of these sculptures refer eerily to the traditional Chinese practice of foot-binding, which, as a Chinese guide once explained to me, was done "so they can't run away."

During this same period, while much of the work expressed this desperate nostalgia for a more female-oriented culture, other parts of the oeuvre suggested the idea of the death of nature, under the baleful influence of patriarchy. For example, as Curiger notes, *Dead Moth*, a slate sculpture of 1946, is "the picture of a moth whose meta-morphosis has been utterly thwarted and confined in stony rigidity."[11]

He Rocks His Wife, a painting of 1938, shows, in a quaint style of representation that is at once charming and chilling, a male armadillo placing his paw upon the overturned body of his mate, who lies still on her back with legs and tail as it were tucked in and taken out of action. "Is this painting," Curiger inquires, "perhaps an image of futile consolation for womanhood condemned to inactivity?"[12]

Correlation of Polarities

In an overview of Oppenheim's oeuvre these two dichotomized themes—nature/culture, female/male—seem to correlate to the third such polarity discussed here: representation/abstraction. Within Oppenheim's oeuvre as a whole, one feels a continual tension between the down-to-earth desire to represent things as they seem to look, and a desire to abstract purer and more geometric forms from them. The classicist W. K. C. Guthrie once remarked that everyone is born either a Platonist (a worshipper of pure form) or an Aristotelian (an empiricist, more or less committed to the facts of perception). The tension between these two ideologies runs throughout Oppenheim's work as one of its inner, load-bearing walls. The aspect of her psyche that was depressed and felt inferior to men, having been brainwashed and bullied around, the aspect that retreated from a hostile patriarchal culture into nature, featured representation, the thing in all its simplicity, without apparent additions of cognitive mediations that take it from the realm of perception into the realm of conception. It is true that in the early period there are some more or less abstract works, such as *Sun-bedecked Fields* (1945), and that in the later period there are examples of representation, but the emphasis and the proportions shift dramatically.

When Oppenheim's depression began to lift in about 1954, her work seems to have changed direction, too. It progressively deemphasized the nature/culture theme in favor of the representation/abstraction dichotomy, which equates with it in many ways. Subsequently, her work tended more toward abstraction, though she continued her ironic practice of giving representational titles to essentially abstract works. This was yet another aspect of the gender issue, an echolike reflection of the tension between male and female, culture and nature. Throughout the 1960s and 1970s, Oppenheim evidently felt happier, more self-confident, less wounded in ego by patriarchy. Perhaps this was because the women's movement was gaining strength, and she became a part of it.

Yet the result of a renewed sense of empowerment was, paradoxically, that in her work she veered toward abstraction, the male symbol, the symbol of culture as an enemy of nature, or vice versa. It is true that she kept representational titles on visually abstract paintings, but the main thrust of her indomitable energy this time seemed toward abstraction and a sense of belonging in culture. Her commitment to nature—at least as it is embodied in the work—seems to have weakened. Her sense of participation in culture—the man's realm, according to the patriarchy—gained momentum. Her problems with "self-confidence" and "feelings of inferiority" seem to have passed. She felt confidently a part of culture's discourse and, even more, an important contributor to it.

By the time of her death in 1985, Oppenheim's work was traveling and becoming widely known as a whole. Major exhibitions in Milan, Naples, Bern, and Paris followed her participation in *Documenta 7* in 1982. Increasingly, Oppenheim's oeuvre is understood as complex, multifaceted, and rightly at home in many different categories: The three great oppositional pairs that she fought and worked with all her life are the structural tensions that hold her work together in meaning.

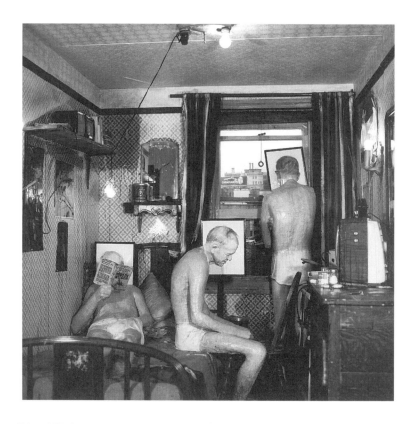

Edward Kienholz and Nancy Reddin Kienholz, Sollie 17 *(detail), 1979–80. Private Collection. Coutesy L. A. Louver Gallery, Venice, California. Photo: Nancy Reddin Kienholz.*

Chapter Nineteen

Location and Space in the Kienholz World

Ed Kienholz's life-size and lifelike sculptural tableaux of down-and-out social scenarios have been canonical parts of late and post-Modernism at least since *Roxy's* (1961–1962). Usually realistic—or naturalistic in the literary sense—the works have focused on the fate of those who have become socially invisible through economic failure. From the abortion table of *Illegal Operation* (1962) to the sadly reflective semi-derelict of *Solly 17* (1979–1980) and the dreary collection of late-night loiterers with no place to go in *The Beanery* (1965), Kienholz has insisted on seeing the downside of life as the real side. Something about honesty is involved. The whores in *Hoerengracht* (1984–1988) are far more forthright presences than the bourgeois art aficionados of *Art Show* (1963–1977), both because they are less protected and because they have less to protect. There is a Depression-era matter-of-factness to the frank immediacy with which Kienholz portrays those who fell through the meshes of society's safety net. There is also an unrelenting insistence that the world see what it might prefer to close its eyes to.

Despite its unquestioned iconic status, the work has experienced a difficulty in terms of location. It is hard to know exactly what stream of art-historical developments to put it in.

Due to Kienholz's early association with the Ferus Gallery in Los Angeles in the late 1950s, his name and his work have acquired a strong Californian identity in the eyes of the rest of the world, and indeed of California itself. Californians in general think of him as one of them, though he neither grew up there nor had lived there for many years when he died (he lived and worked in California from 1953 to 1972).

From the outside—from New York, for example—there was a long period when Kienholz's work seemed impressive, even what is art historically called "important," but still provincial or regional, due to its California connection; it was hard to produce what passed as mainstream art from California. But at the same time that Kienholz's work was regarded in New York as Other, it was also embraced there, partly on the assumption that it was somehow associated with East Coast Pop Art. This assumption arose naturally enough from a shared emphasis on real-world objects and images and a focus on so-called low culture as substrate of all social reality.

In fact, there were major differences between Kienholz's work and Pop Art. He did not, for example, directly address the issue of market forces, which seemed to many to be the essence of Pop's meaning. Further, his work is essentially different from Pop Art in its use of space. Pop space, whether painting or sculpture, emphasized two-dimensionality, or flatness, and thus remained residually late Modernist. (In fact, it could be called one-dimensional in Herbert Marcuse's sense, reflecting the falsification of reality as it was represented by the falsified images barraging the subject from all sides in popular media such as advertising.)

Kienholz, on the other hand, while he used populist scenes and references, became increasingly three-dimensional in his portrayal of reality. His paintings from the mid-1950s (such as *One Day Wonder Painting*, 1954), expanded into three dimensions through the addition of sculptural elements (as in *Conversation Piece*, 1959) and then into freestanding sculptural assemblage (as in *John Doe*, 1959 and *Jane Doe*, 1960). Several years of mixed-media assemblages followed, often involving a boxlike enclosure around the work (as in *History as a Planter* and *It Takes Two to Integrate, Cha Cha Cha*, both 1961), which forecast the room-enclosed installations to come, such as *Roxy's* (1961–1962). By 1962 (as in *The Illegal Operation*) life-size environments were being created without enclosing rooms; soon, with works like *The Wait* (1964–1965), and *The Beanery* (1965) the full-scale signatured Kienholz tableau-within-a-room had evolved. Kienholz's treatment of space, in other words, moved steadily away from late Modernist pictorial flatness into a three-dimensional space seemingly like that of real life in the body. His figures were not acting out the falsification of reality so much as its ruthlessly direct representation. By the late seventies, Kienholz's scenarios, or stage sets, quite unlike Pop Art, conveyed an uncanny sense of conviction that somehow passed for verisimilitude.

After their partial comparison with New York Pop Art, Kienholz's tableaux were compared, in their volumetric emphasis, with that most characteristic California genre, light-and-space art, a genre which reflects the openness of the sky and the sea in that part of the world. Kienholz's use of space, however, was not about openness but closedness. It is true that, like light-and-space sculptors such as Robert Irwin and James Turrell, Kienholz came to emphasize volume relentlessly. For that generation, volume became what surface had been for the abstract artists of classical Modernism. Nevertheless, the purposes to which the material of volume, or space, was used by these artists were very different.

In the postwar period, there was a certain reaction, on ethical grounds, against the illusionism of painting. Painting—especially abstract painting—was seen as presenting an ideal world that distracted attention from the problematic realities of this world and thus was socially counterproductive. Indeed, it is true that in the Western tradition the extraordinary emphasis on the two-dimensional illusionistic "window through the wall" type of picture has been somewhat scandalous. It has suggested a frame of mind given to fantasy, a reluctance to look at the wall itself, or at the everyday world that is really behind it, a desire to see it as controlled by a dream or by wishful thinking. In the general sea change marking the end of Modernism, the emphasis shifted to sculpture, which was felt to be more socially engaged because it

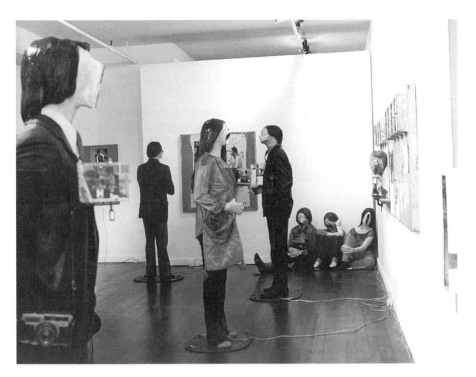

Edward Kienholz and Nancy Reddin Kienholz, The Art Show,
1963–1977. Collection: The Berlinische Galerie, Berlin.

occupied the actual space of the body rather than positing an illusionistic and thus delusional space. Kienholz, on the one hand, and the light-and-space artists on the other, took this tendency in exactly opposite directions—he into the junkyard of social reality, they into a transhistorical paradise. While the exquisite light-and-space compositions of Irwin, Turrell, Doug Wheeler, Eric Orr, and others might easily be compared to late Modernist paintings made by Mark Rothko or Jules Olitski, Kienholz's spatial picture is more Edward Hopper mated with Emil Nolde. Space for him is full rather than empty, and the meaning it carries is more social than theological, more jarring and depressing than reassuring or ecstatic.

The social quality of the Kienholz[1] approach to space is asserted in the nature of the objects which fill up that space. Although the Kienholzes' tableaux comprise a tour de force display of trompe l'oeil effects, even the massive ones like *The Art Show* (1963–1977) and *The Hoerengracht* (1984–1988) are composed mostly of found and reprocessed objects. They represent society reprocessing itself through a new version of its own detritus. The use of found materials is one of the defining traits of the moment when Kantian Modernism, with its emphasis on pure (ex nihilo) creativity, was losing its hold—and the separation of art from life was being

called into question. In the metanarrative of Western art history, the use of found rather than crafted objects or materials is understood as a delayed ripening of the art historical karma that first revealed itself in Marcel Duchamp's Readymades. There is an art-historically iconic lineage involved, for example, in Robert Smithson's idea of recycling urban detritus as newly created art, like a *fiat lux* in a garbage dump. Smithson contemplated the decaying areas of cities rather than the shining new ones: Out of the decay, he felt, the seeds of the future might sprout. Kienholz's practice may not contain that somewhat apocalyptic or prophetic sense of the future, but it shares a certain spiritual stance with Smithson's theory in its determined recycling of detritus, its insistence on making something new out of it. In the last generation, this tendency, which Rauschenberg presciently described around 1950 as working in the gap between art and life, has produced countless nuanced styles and approaches, from Kienholz's to, say, Bill Woodrow's or Haim Steinbach's. It has become an overpowering signature of post-Modernism.

Kienholz worked in the tradition of the found object and material, and usually honored its inward spirit by not seriously altering the surface of the object he was using. Even after an object had been composed into a piece, one could tell what it had been in its previous life, unlike, say, Woodrow's apparent desire to disguise the nature of the found material through an illusionistic transformation of it. Kienholz was like Duchamp in his loyalty to the original appearance of the object, but very unlike him both in his illusionistic use of the found and in his sense of the proper provenance of his findings. While Duchamp walked through dry-goods stores and selected new, clean products meant for human use but not yet consecrated or defined by it, Kienholz would walk through junk stores, junkyards, and automobile graveyards, seeking the more antique detritus, stuff already supposedly used up, not waiting pristinely to be used. Duchamp's use of a newly bought object, such as the snow shovel (*In Advance of the Broken Arm*, 1915), implied that it was a kind of blank to be filled in; the fact that it hadn't been used yet meant that it could be used in any way at all—it was indefinite, undefined, a universal blank to be written on by an abstract sense of artistic intention. Kienholz's practice, on the other hand, involves a sense that the found object has already defined itself by living out at least the first incarnation of its destiny—whereupon he vibes out its karma and gives it a second one.

Kienholz's approach to junk materials has a great deal in common with funk and fetishistic assemblage sculpture as known, in California, in the works of Bruce Conner, George Herms, and others—surely more than it does with New York Pop Art. But the dates of Kienholz's multimedia assemblages are very close to New York works such as Robert Rauschenberg's *Monogram* (1955–1959) and May Wilson's doll-based works, which often parallel those of Kienholz in their dark implications.

The question of the true or appropriate location of the post-1972 Kienholz oeuvre[2] was further complexified by the Kienholzes' decision, in 1973, to spend half of each year in Berlin and half in the small town of Hope, Idaho. This residential split, in its combination of the red-blooded beefy American farm boy and the

decadent expatriate in Berlin, sits directly astride the geopolitics of World War II and the continuing cultural fallout from it. Through its partitioning, Berlin had become in a symbolic sense the most international of cities, despite the insularity that German cultural attitudes can have. Hope, on the other hand, with its grand total of sixty residents, is the purest of home communities. In their choice of residences, therefore, the Kienholzes simultaneously evoke and evade both the universal and the particular.

So ambiguously placed, their work has nevertheless cut a swath of its own meaning through both American and European art without belonging unquestioningly to either. Their audience (and market) has been as great in Germany as in America. Perhaps Kienholz was attracted by the wreckage and ruination of Berlin, as well as its tensions. But even more, he must have sensed that California—like New York—was not the true homeland of his work and wanted a broader, more international arena for it.

From this broadened viewpoint the Kienholz oeuvre reveals relationships with various European tendencies as strong as the American comparisons. The reuse of real-life materials in elaborate scenarios, for example, relates to the works of Jean Tinguely from the same period, to somewhat later works by Ben Vautier, and in a sense to the explorations of Les Nouveaux Réalistes in general. Comparisons to Joseph Beuys and, only somewhat less directly, Arte Povera should also be drawn. Jürgen Harten has compared Kienholz's installation style to Beuys's *The Pack* (1969), a tableau of sleds equipped for survival in the wilderness flowing from the rear end of a classic sixties-era Volkswagen bus—the quintessential vehicle of the flower-child movement. Harten refers to the similarity in Beuys's and the Kienholz's aggressive intrusion into three-dimensional space. In this aspect of their practice, as well as their recycling of the worn-out things of civilization, Kienholz is as deeply embroiled in European art history as American. Such Arte Poverists as Jannis Kounellis have similarly opened space for related arrays of objects, from tethered horses to beds to fires.

Yet neither Beuys's nor Kounellis's installation tableaux involve the implications of narrative that have saturated Kienholz's major pieces ever since *Roxy's* (1961–1962). The European works seem more symbol than story. In *The Pack,* for example, volume is drawn out with vague implications of narrative—some people are trying or hoping to escape from something—but it is a symbolic narrative indicating an idea more than a particularity. The Kienholzes' figures, on the contrary, such as "Sollie" in *Sollie 17* (1979–1980) or "Mother" in *Portrait of a Mother with Past Affixed Also* (1980–1981), are explicit and literal. Sollie is a pathetic loser of the capitalist game, trailing off the end of his life in a welfare hotel; Mother is a monument to the futility of the nuclear family and the horrible delusions with which we see the past. In this regard, it is important that Kienholz figures are characteristically seen indoors, within the claustrophobic limitations of culture and psychology, while Beuys's, as in *Bog Piece, The Pack,* and many other works, tend to be set outdoors, attempting to burst free of the claustrophobic grasp of the inside, the walled space, the culturally defined.

In fact, a tension exists in the European tradition between the transcendental and the social views of space that parallels the American dichotomy between the meaning of space for, say, Irwin and Turrell on the one hand, and for Kienholz or Conner on the other. It is a dichotomy between the full and the empty, the transcendental and the particular. In 1960, for example, Yves Klein emptied the Iris Clert Gallery in Paris, painted it white, meditated in it, and presented it as a spiritual space in and by itself—*Le Vide* (*The Void*); in the following year, his friend and colleague Arman, in response to *Le Vide*, had the gallery filled from floor to ceiling with literal garbage and called it *Le Plein* (*The Full*). Klein's sanctification of space emptied of everything but light and thought was answered by a random massing of cultural and urban detritus. There is a parallelism in the two traditions' dichotomies about the meaning of space—one transcendental, one particular.

Similar relations with European art occur in Kienholz works involving body castings. This approach to the sculpture of the figure is obviously somewhat similar to Klein's castings of his friends, Les Nouveaux Réalistes, in 1961 and 1962. But while the practice is similar (though Klein used latex, not the plaster and mummy-wrapping technique of Kienholz and, by the way, Gormley), the motive is not. Klein cast his friends in order to immortalize them, to make them like gods; Kienholz, very different in spirit, rendered his figures not as eponymous heroes but as anonymous ciphers. They are not the candidates for a gleaming Olympus but the beaten-down inmates of a moderate yet inexorable circle of Hell. The space they inhabit overwhelms rather than liberates them.

In the Kienholz oeuvre, space, the figure, and narrativity turn curiously onto and into one another as if they were almost one—or one possible triangulation of forces somehow perilously remaining in balance. Space is the medium that enables the figure to exist; the figure, in turn, is the agent that activates space. Their collaboration, finally, is the necessary cause of the special situation in which narrative can occur: where event horizons explode into events. Space as portrayed in the mystical style of *Le Vide* or a light-and-space installation is a site of pure potentiality that has not yet been filled up with specific meaning; it represents freedom because it is not yet involved in phenomenality. It is still an event horizon, not an event. But in Kienholz's volumetric and crypto-narrative work, space functions not as a liberating but as an oppressive force. It is overcrowded and essentially depressing; its negativity almost implies a salvific alternative—but not quite. It is not a pristine space of potentiality but a soiled arena that has already been filled, perhaps irrevocably, with something so sad that one hardly wishes to look at it except with a guilty shame. It is a space saturated in sadness, beyond the blind panic of Beuys's fleeing sleds, though not entirely unlike it.

The difference implied in these various uses of space as a medium in which to envision the real is not unlike a distinction in ancient Indian philosophy. The Vaisesika School (roughly in the early centuries of our era) distinguished between various kinds of absences, that is, various kinds of empty space. The mystical projection of volume as a potential vibrating surface, like Mallarmé's blank page, equates in a vague way with what the Vaisesikas called the Prior Absence, that is,

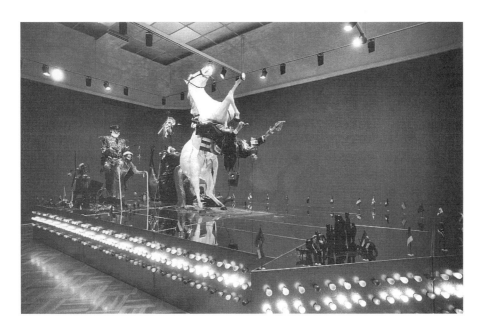

Edward Kienholz and Nancy Reddin Kienholz, The Ozymandias
Parade, *1985. Collection: Nancy Reddin Kienholz.*

the absence of a thing before it has appeared. This is a deceptive absence in a sense, since it is not truly indefinite. It is the absence of this exact thing and no other, like a prophecy of its imminent appearance. The emptiness is understood as already containing a space or outline that is perfectly sculpted to what will in fact appear there, one day.

Kienholz's work, on the other hand, relates to what the Vaisesika analysis calls the Posterior Absence—the absence of a thing after it has already happened and disappeared, or if not disappeared, as in obliteration, at least somehow ended internally. It is about to vacate its outline, or desolately waiting to. Kienholz's figures and the tableaux they occupy seem exhausted, withered, desiccated, one sad breath away from disappearing altogether.

That there is a prominent element of voyeurism in the reception of Kienholz's work has often been remarked on, and this imminent absence, with its end-of-the-road (not yet end-of-the-world) feeling, makes precise the mood of voyeurism that is appropriate. In *Sollie 17,* for example, the viewer peeks through a doorway into a private scene where the inhabitant (in three simultaneous embodiments) does not know he is being observed. He sits as if desolately waiting to vacate his outline in space. In *The Hoerengracht,* the viewer walks as if among the byways of Amsterdam's red light district, peering through the windows at the prostitutes awaiting customers.

The element of voyeurism involves the viewer in a kind of guilty secret, as he or she peeks into dreary and depressing corners of society not usually viewed in the art press. It is as if the Kienholzes wanted to remind the bourgeois viewer of the downside of things. A somewhat similar voyeurism evolves, through very different formal means, in the works of Leon Golub. Golub forces viewers to observe and, perhaps, to contemplate unpleasant scenes from their own society or its agents in the world at large. Golub has said of the purpose of his work that he doesn't want to let "them" forget or ignore the sea of blood and cruelty on which their prosperity floats. Although the Kienholzes' work is very different in its sad irony from Golub's angry confrontationalism, it also seems intended to remind other members of their culture not to forget those that are lost and betrayed in the system.

The Kienholz tableaux show the discarded of humanity, made from the inanimate things discarded by humanity. In a sense, the sadness of these tableaux involves a triumph of the inanimate: These objects have been resuscitated for a new life, but those people composed of them will not be.

The aspects of our society that the Kienholzes seem insistent on reminding us of have been called the issues of justice: the commodification of women and their subjection, the littering of the wayside of capitalism with those who fail to compete effectively in its essentially meaningless rivalries, the manipulation of the minds of the middle class by big media (especially network newscasts, as in *Six O'Clock News*, 1964), and the massaging of society's ills through a limited availability of illicit pleasures. The famous Kienholz exhibition *11 + 11 Tableaux*, which traveled around Europe in the early 1970s, pictures the inherently tragic consequences of bourgeois capitalist society as a closed functioning system, one stage set leading to another in an encompassing and seemingly inescapable tragedy. (As much could be said of the so-called Spokane cycle.) The interactions among these works could in fact be both an illustration and an embodiment of what Adorno and Horkheimer called the dialectic of Enlightenment, meaning the inherent and self-defeating contradictions of bourgeois liberal ideology.

A last approach to the ambiguity of location has to do with history: Was Kienholz a Modernist, a post-Modernist, or a pre-Modern revivalist? A Modernist believes in Enlightenment ideals and also feels that history is governed by a force of progress, and thus societies must be getting better. A post-Modernist may also believe in Enlightenment values, but does not believe history is to be trusted or that societies have an inherent tendency toward improvement. Pre-Modern revivalists (including the flower-child movement, ritual Performance Art, the Green Party, and, more recently, various New Age trends) believe neither in the Enlightenment nor in history; they wish to establish spiritual connections with pre-Modern, pre-Enlightenment social forms, as if the Enlightenment had never happened. Aside from mixtures of these, there are few other options available as cultural stances today. Yet Kienholz is strangely, and typically, ambiguous about these categories.

One can sense in the work of Kienholz a nostalgia for pre-industrial civilization, a horrified lamentation for the affliction of alienation that industrialization has wrought on humanity. So clearly he is not a classical Modernist. But

neither does his work imply an innocent belief in the viability of pre-Modern cultural forms. His eye is too jaundiced, his feeling for history too rueful, for him to be a straightforward flower-child–like pre-Modern revivalist.

Is he, then, a post-Modernist? The critical thrust of his work, its deconstructivist aspect, could be read in this way, yet what it expresses is some kind of visceral conviction more than a skeptical dodging. If one were to point to a single central theme in the Kienholz oeuvre, I would suggest, without meaning to ascribe any specific ideological discourse to it, that this theme would be capitalist alienation, with its dangerously two-pronged agenda: at once a nostalgia for a pre-capitalist civilization and a desire for a post-capitalist resolution.

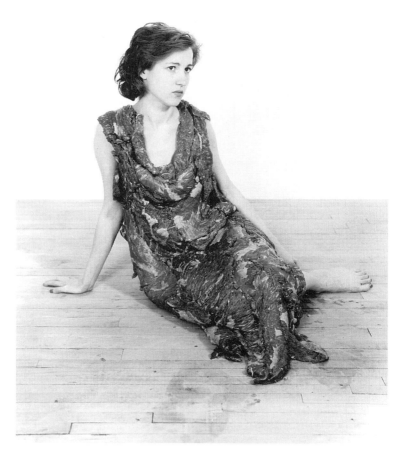

Jana Sterbak, Vanitas: Flesh Dress for an Albino Anorectic, *1987. Collection: Musée national d'art moderne, Paris. Courtesy Galerie René Blouin, Montréal. Photo: Louis Lussier.*

Chapter Twenty

Jana Sterbak: Materials and Their Truth

Jana Sterbak is a Czech artist by birth and upbringing who moved to Canada in 1968, at the age of thirteen, in response to the crushing of the "Prague Spring," and subsequently moved to Paris. From 1978 to 1990 she showed her work primarily in Canada, and since has showed it widely in Canada, the United States, and Europe.

Sterbak is an artist who honors the truth of the materials she uses—from the famous "meat dress" (formally entitled *Vanitas: Flesh Dress for an Albino Anorectic,* 1987) made of stitched-together flank steaks, to cast lead pieces whose sheer weight is a hidden but meaningful part of their presence, to store-bought objects like tape measures (in *Measuring Tape Cones,* 1979) that plainly proclaim their identity. Thus in her work, as in many late and post-Modern oeuvres, there is in effect an iconography of materials. The materials are not only to be contemplated visually but also to be "read."

The tape measures, for example, embody the theme of the "measure," the unit or scale or template of physical reality and especially of the human being, for whose clothing, shaped to the body, these measuring devices are intended. Sterbak's concern with the concept of the template of humanity relates her work to important European late Modernist oeuvres such as Joseph Beuys's, Janis Kounellis's, and Marcel Broodthaers's. The cast lead works might similarly seem to suggest alchemical associations and the theme of transformation. This resonance, though present, is not highly prominent, however, as the other materials of the alchemical *opus* are not present to interact with the lead, and some of the cast works are not lead but iron. In any case, lead is the base material to be transformed, not the supposedly transformative substance itself. So the lead again suggests the body, its weight, its subjection to gravity, its open invitation to a transformation whose agency is not seen. Both the lead and iron castings, by their weight, inertia, and resistance to change, again suggest the bodily aspect of the person with its various insistent limitations and its mute cry for release from them.

Above all, of course, the meat dress focuses with unsurpassed intensity on the theme of the bodily nature and its mortality. Perhaps an ironic residue of a scene of carnage, a token left, say, by a fiendish murderer for the police, the piece has both the smell and the look of death deep inside, ineradicably inside, the human "mea-

sure," which in this case is represented by the tailor's mannequin the meat dress hangs on.

Still, in the meat dress, as in the alchemical associations of lead and the tape measures' suggestion of a remeasured or rescaled reality, there is also an association of escape. When the meat dress was first shown, a young woman wore it on the night of the opening; subsequently it was hung on a mannequin and allowed to decay in the gallery space for the duration of the show (smell was definitely a material of the piece). In the emptying of the dress there is a suggestion of a human self, which can escape somehow from the meat-nature, which has in fact done so. Involving cultural associations of the young woman as a Romantic-era signifier of the spirit, the piece suggests the escape of the spirit from the body, or the possibility of somehow transcending the body.

The theme of transcendence is common in religious literature and in much of the world's art that still resonates to its ancient association with religions. Perhaps the classic instance is in the Orphic tradition of ancient Greece. In the remnants of that tradition preserved by Plato, Pindar, and others we learn that the body was regarded as the prison, or the tomb, of the soul (the Orphic motto *soma sema* means "the body is the grave"). The soul fell into the bondage of flesh through some primal crime committed during its life among the gods, and it is through the weary burden of the body's limitations that the soul must undergo its punishment, or imprisonment, finally to reascend to the company of the gods on high. The body is both the place of the soul's bondage and the potential instrument of its release.

The thematic drift of Sterbak's materials toward the theme of mortality and the body is deepened by her direct involvement in so-called Body Art as well as in the genre of art *about* the body. Much art, of course, back to Christian crucifixions and Greek athletes, has been about the body in one way or another. But that theme has become especially prominent recently, not with an implication of transcendence or religious feeling so much as a deconstructive response to the post-Modern sense of the decentering and indefiniteness of the self. The body is a down-to-earth materialistic channel through which to approach the theme of the self, and its implications of vulnerability and ephemerality mock the pretensions of much earlier art about the body, which covertly featured affirmations of the soul. Such works which deconstruct the self by way of the body have been offered up lately not only by male artists such as John Coplans and Robert Gober but perhaps even more prominently in the work of women such as Kiki Smith and Helen Chadwick. Sterbak's work is ambiguous in this respect: Tough-minded in its focus on the decay of the flesh, it nevertheless implies a more tender-minded, partially hidden theme of transcendence. In this ambiguity or double-edgedness it might be compared to the work of Marina Abramovic and Rebecca Horn.

In *The Artist as Combustible* (1986), a young woman stands naked with a heap of gunpowder on her head, which is ignited; a pillar of flame emerges from her skull—yogically speaking from her *sahasrara chakra*, the uppermost energy point at the birth crease in the cranium through which ascent to higher realms is considered to be effected in the yogic tradition. While there is something horrifying to the

image, it nevertheless suggests that moment when, in the yogic tradition, the inner energy is at last released upward, like the escape of the soul in the Orphic model.

I Want You to Feel the Way I Do (the Dress), 1985, is an electrified dress of metal mesh; as in the meat dress, the garment is empty, the inhabitant has fled. The feminist message is that the woman feels painfully electrified by the enforcement of her role as sex object (wearing a dress so one can easily reach under it), and wants to communicate this fact to men. A more Orphic suggestion is also present: that through the shock of bondage in the body, or of the realization of that bondage, a potential for release is found. Still, that potential is dangerous to the body and involves its destruction.

Seduction Couch (1986) is an electrically charged chaise lounge of perforated steel. The process of human mating, with all its romanticized reputation of ecstasies, is presented as a kind of punishment, like an electric chair, through which the murder of the soul and its incarceration in the tomb of the body is perpetuated rather than transcended.

Along with the stark theme of the flesh, Sterbak's portrayal of humanity also involves mechanization and the machine. *Remote Control 1 and 2* (1989) were aluminum structures with motorized wheels, designed on the lines of a Victorian-era hooped skirt or crinoline. The references to clothing point to, among other things, the idea of the bondage of women within gender stereotypes reflected in articles of dress which minimize the wearer's autonomy and self-sufficiency. At the top of these structures a fabric harness is hung and into it a young woman is placed. Suspended within the oversized symbolic garment, her feet unable to reach the floor, she steers it through the available space by a kind of "joystick," prevented by its voluminous circumference from directly contacting the surrounding world of experience. (Both the mechanization of Horn's work and certain works of Klaus Rinke, especially those in which he is suspended overhead, come to mind.)

In terms of the quasi-Orphic thematics implicit in some of the works, this piece suggests the helplessness and bondage of the person within the constraints of the body. It also involves social stereotyping and the power structures it buttresses. While not an explicitly or exclusively feminist artist, Sterbak's work is directed primarily toward themes involved with female humanity and its particular problems of autonomy within a patriarchal system. The human, it is implied, is made into a kind of machine or robot by the social and gender categories that constrict it.

As a part of its contemplation of the thematics of the body and its clothing, Sterbak's work focuses specifically on the reality of gender difference. *Hairshirt* (1992) is a transparent sleeveless shirt with male chest hair woven into it, which is to be worn by a woman, her breasts showing from behind the hairy male chest. There is an immediate suggestion of the idea of androgyne, of the human as a bisexed being whose destiny can be fulfilled only by a realization of both aspects. In addition the piece comments on power: The delicate breasts of the woman are bound within the hairy chest of the male, which holds them bondage for its desires. While the hair shirt is a piece of clothing, it does not so much protect its wearer as it does hold her prisoner.

As art in the last generation or two has moved increasingly out into the everyday world, turning its back on the sublime, various types of traditionally non-art objects have entered the art realm. Many artists have made furniture-like things, both aesthetic sculptures and functional worldly objects at the same time. Similarly, some artists have imprinted their sensibility upon clothing.

The genre is important in recent European and American art. Beuys's empty felt suit suggested the idea that humanity had temporarily vacated its identity—through the war and the Holocaust—and that its measure or shape awaited some new humanity to occupy it. Broodthaers's vests as well as works by Claes Oldenburg and other male artists reveal their tendency to view humanity as primarily male, presenting male clothing as a generic template for all humans.

More recently this genre has become associated with women artists such as Judith Shea, whose works deal with the ancient tradition of the sculpture of the figure along with the implications that clothing has for the social contextualizing of the female. Lisa Milroy's dressworks tend to emphasize the childishness of the roles thrust upon women in patriarchal societies.

Sterbak's series of dress-related works features empty women's garments such as the electrified dress alongside bigendered pieces like *Hairshirt*. The empty women's garments, with their suggestions of a falsified or vacated identity, tend also to involve signs of powerlessness or torment, as in the electrified dress or the suspended skirts.

Vest (1992) is the upper half of a military-style uniform mounted on a tailor's mannequin, with the usually open ends of the sleeves stitched together so the hands cannot reach free. The sculpture shows the male as empowered because of his access to official positions, but at the same time, with its sleeves linked together as in a straitjacket, implies his powerlessness in subjection to the social role that the uniform signifies. The corresponding garment piece, *Jacket* (1992), is revealingly different: The sleeves of a plain woolen jacket are linked together in the same position of claustrophobic helplessness. The man is characterized as a uniform, an official functionary of the patriarchal order, while the woman is signified by a featureless and anonymous garment which bears no sign of office. Both are equally disempowered by the straitjackets' grasp of their hands, yet their social positions are very different. There is an implication that the social forms in place today simply do not work, either for those supposedly empowered or for the disenfranchised.

Sterbak's focus on the body and on the social torments inflicted upon it in the name of gender leads naturally to an element of danger or threat in her oeuvre. *Seduction Couch*, as mentioned above, invites the viewer to recline while at the same time threatening him and her with electrocution. *The Artist as Combustible* elicits feelings of bodily dread, as do the meat dress and the electrified dress.

An edge of danger has been important art material, in works from Yves Klein's famous *Leap into the Void* (1961), in which he leapt from a second-story ledge to the pavement below, to Chris Burden's *Shoot* (1972), in which he was shot in the arm with a .22-caliber rifle in a gallery. In those cases it was the artist's own

body which was threatened, in the tradition of Body Art. In other cases, a kind of threat is implicitly directed from the artist toward the audience.

Such aggression against the audience is a longstanding practice of artist-provocateurs. In the fifth century B.C., the comic playwright Aristophanes had his cast attack the audience in the middle of the play, first throwing water, then wheat chaff, on them. Early in this century Eisenstein and Meyerhold had an actor enter the stage by way of a tightrope over the audience.

In the Performance Art tradition of the last thirty years, this way of conceiving the artist-audience relationship has been especially foregrounded. One could find the roots of that tradition in Dada and in more recent sources such as Klein, who conceived, but did not execute, a piece which involved handcuffing the audience to their seats. One could cite numerous pieces by Burden, such as the work in which he nailed shut the door to the exhibition space, trapping the opening-night crowd in a closed room. Carolee Schneeman has swung herself over the audience hanging from a long rope. Dennis Oppenheim once set up a skeet-throwing device to hurl a clay pigeon into the gallery space every few seconds.

Sterbak's work is sometimes physically intimidating in that way, as when, in *Remote Control 1,* the mechanized vehicles cruise around the gallery space. But mostly there are menacing associations in a theatrical sense: the *Seduction Couch* and related works suggest a scenario in which the viewer might fantasize about participating, but the works do not actually pose an imminent threat to the body.

Sterbak's work seems to rise from the currents and crosscurrents of political and social change in Europe and the world—the separation of Eastern Europe as well as the various stratifications within society. At the same time it rises from the tides of aesthetic ferment that attend such moments of social and political change.

Golem (1979–1982) is a series of small cast-metal sculptures laid out in a pattern on a gallery floor; they are representations of human bodily parts: eight lead hearts, a bronze spleen painted red, a lead throat, a bronze tongue, a bronze stomach and a rubber one, a lead hand, a lead penis, a bronze ear—as if these were among the array of parts that the legendary maker of the Golem might have put together to make his monster. All cast in metal, they occupy the floor with a deep inertia. Are they fragments of a new humanity about to be made, or of an old one which has fallen apart? Who or what is the Golem? Does humanity make the monster history or does history make the Golem man?

Sterbak's work seems to interrogate human destiny and its relationship to history in complex ways. Human aspiration is seen on the one hand as lofty, as, in effect, an aspiration to escape the inherited limits of the body. But at the same time the central message may be its formidable entrapment—in the body, the gender group, the surrounding society, the whole monstrous grasp of history upon it all.

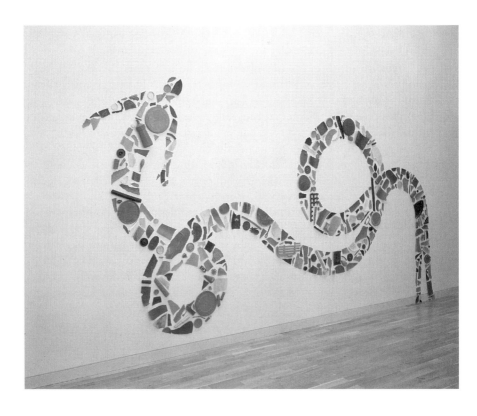

Tony Cragg, New Figurations, *1985. Courtesy of Marian Goodman Gallery, New York.*

Chapter Twenty-one

Tony Cragg: Landscape Artist

People say there's a great deal of variety in my work, but I'm not so sure that's true. . . . It's like
making a complete landscape with all the parts in it: There's the urban world, architecture and so on,
there's the organic world, there's the atmosphere, and there's the geological structure. —Tony Cragg

Tony Cragg is an artist who changes styles, materials, formats, and contents. To some
critics this has presented a problem. One suspects that their feeling is rooted in the view
(central to classical Modernism) that the artist deals with something like unchanging
aesthetic principles.[1] If that is true, then when an artist changes his work radically, he is
implicitly either denouncing his past work or arousing skepticism about that to come, or
both. Having found a supposed expression of universal aesthetic value, the artist had
better stick with it. To change styles, in such a view, is to treat art as fashion rather than
as a vehicle of unchanging verities.

 Cragg seems to have a different take on the issue. He has expressed himself
as feeling that the world is essentially characterized by complexity and layering; his
work, as a kind of wavy mirror of the world, must reflect these traits—hence its
appearance of diversity. If, however, his medley of forms portrays an integrated
world, a "landscape" with its many elements, then its apparent diversity is overlaid
on an underlying unity. The many parts are different limbs of a single dancer. The
question of which principle—unity or diversity—is preeminent (referred to in
philosophy as the "Problem of the One and the Many") runs through Cragg's oeuvre
and bestows upon it a difficult balance.

 Cragg's work of the early 1980s—specifically the figurative compositions in
bits of found plastic detritus—embodied this problem: Is the fragmented state of
the materials dominant, or the temporary appearance of wholeness that rises from
their composition into a recognizable representation? One solution is to allow the
factor of time to suggest a cyclicity or periodicity in which fragmentation and
wholeness alternate.[2] In Cragg's pointillistic constructions of small bits of discarded
plastic (for example, *Postcard Union Jack* and *Britain Seen from the North*, both 1981),
the monuments and signs of civilizations can be seen as shattered into tiny frag-
ments, meaningless in themselves, which the currents of change then reassemble

into new temporary meanings, or apparent wholes, which will in their turn undergo the process of disruption and decay. Civilization's debris become sedimented like a seedbed from which the future will grow.[3] The focus is on the process of change in the passage of time rather than on the thing undergoing the change. As the process builds things up and breaks them down, human selfhood becomes ambiguous, too; Cragg's *David* (1984), for example, composes an image of Michelangelo's *David* out of hundreds of bits of plastic trash; the human figure, or self, is recognizable in its overall shape but internally fragmented, ready to become debris in its turn and then be recycled. For the theme of fragmentation is closely related to—indeed a form of—the theme of transformation. The alchemist sought to reduce material form to the underlying formlessness of Prime Matter in order to make it susceptible to transformation—to erase its traits so new ones could be imposed on it. Without necessarily implying an alchemical metaphysics, Cragg's work presents a materialistic analogue of one.

The theme of fragmentation or dissolution, then, is necessary to the theme of change. It is precisely because things can lose their integrity and fragment into parts that they can be rearranged into new "selves." This primal realization tilts the balance of thought toward the Many. In our culture's first encounter with such cruces, in the pre-Socratic period, Democritus responded to Parmenides' idea of the absolute unity of Being by developing his philosophy of atomism. If things are integral wholes, they cannot change, since they cannot break up into fragments—say, molecules and atoms—to be shifted and rearranged. So the integral and unchangeable One of Parmenides had to be be broken down into the Many of Democritus in order to explain the change that so obviously occurs in the world. This process involves a sense of infinity: the infinity of molecules, the infinity of the ocean of fragments, which the artist, both parodying and embodying the idea of the demiurge, fuses into new temporary unions.

In the mid-eighties Cragg's work underwent one of its radical shifts. Gone were the plastic fragments; in their place appeared quasi-architectural sculptures of an unaccountable middle scale—too small to be habitable, too big to be architectural models. These complex, shifting, out-of-kilter volumes (such as *Als Es Wieder Warm Wurde*, 1985, and *Città*, 1986) made the transition from two- to three-dimensional representation; *Mittelschicht* (1984) was the turning point. They also asserted wholeness as against the fragmentation of the earlier works. Specifically, they asserted the idea of a city, a momentarily whole urban-sculptural form which had risen from the shards of the past and would in turn be fragmented and sedimented as a seedbed for the future. In these works the pendulum of thought swung away from the Many represented by the infinity of plastic bits and back toward the One, the idea of integration, meaning, and unity. Appropriately, since this phase of Cragg's work turned away from the theme of the fragment to the theme of the transient cultural whole, the work at this stage became less extra-studio; it involved less designating of found materials and more crafting of studio objects. The nature/culture distinction, another primal crux of human thought, began to work itself into new forms. The plastic scraps had seemed virtually parts of nature, like fallen leaves

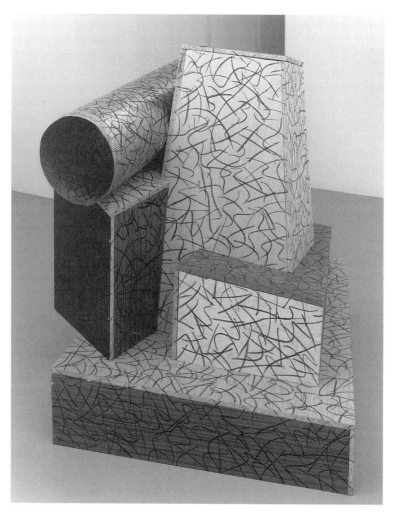

Tony Cragg, Black Drawing, *1984. Courtesy of Marian
Goodman Gallery, New York. Photo: Bill Jacobson.*

or bits of seashell on the beach; the studio-made city forms, on the other hand,
seem clearly to belong to culture. But in fact the distinction is not so clear.

Critical reflections on the nature/culture dichotomy—a fundamental tenet
of classical Modernism[4]—are prominent throughout Cragg's oeuvre. The fragment
works of the early eighties show culture operating as an analogue to processes of
nature such as erosion, the grinding of stones into sand by the sea, the rearrange-
ment of molecules, and so on. The work of the mid-eighties, with its references to
more or less intact urban architecture, seems to isolate culture and focus on it as a

separable category. The work of the late eighties seems to be an even more emphatic assertion of the separateness of culture. Cast in bronze, it seems an ultimate rejection of the plastic scraps. It echoes sculptural tradition intensely and evokes the distinction between low and high art that formal sculpture in bronze brings with it. The work of the eighties as a whole, then, seen in these three stages, would seem to parallel the unidirectional and progressive evolutionary idea of nature developing by stages into culture. But in Cragg's work the nature/culture distinction is never simple and clear. The plastic fragments, though they behave like nature (sand grains, leaves, things borne by wind or water into new arrangements and intentions), are in fact culture (what could be more culture than plastic?). The recent cast bronze work is similarly ambiguous; while its material and method point to culture, its content asserts the primacy of nature. The cast bronze, then, involves not culture itself, but culture's reproduction of the nature whose product it had seemed to be. Culture and nature interpenetrate or reciprocally produce one another.

Inverted Sugar Crop (1987), for example, involves the nature/culture dichotomy in a reciprocity or circularity; its bronzeness points to culture's representation of nature through sculpture, while its represented forms (sugar beets) point to nature as the underlying reality of culture. Shell (1989) shows a huge seashell lying atop the cases of modern brass instruments as if having spawned them or about to devour them. Their implied sounds seem to allude to the primal oceanic sound produced in the shell's secret inner chamber; similarly, their rounded cases, in which volumes of sound reside in potentia specify the primal oceanic sound's universality. Though the natural object seems to have begotten the cultural ones, it also devours them; the instruments have arisen from nature, or the universal, and to it they return.

The three stages of Cragg's work in the eighties suggest a reversed linearity in another sense. The first, involving plastic fragments, represents culture broken down and returning to nature; the second, using city forms, precedes the first conceptually, showing civilization before its shattering. The most recent phase, the cast-bronze works of the late eighties, precedes both, leaping back over the city and the naturelike process of the sedimentation of its detritus to portray the primordial level of evolutionary slime from which primal life forms arose. Trilobites and cephalopods crawl about a prehuman sea floor and gesture toward amphibian adventures onto the land. The DNA-like spiral of Code Noah (1989), for example, suggests the roots of the formal coding of life. Fruit Bottles (1989) shows slug- or snail-like elementary life forms, their rounded organic shapes implying primal sources of being. Generations (1987) depicts similar bloblike evolutionary proto-forms, but here in the temporal process of reproduction. Branchiopods (1987) presents primal forms with phallic and mammarian connotations. Bodicea (1989) portrays primal inchoate beings clustering and multiplying in an amphibious transition. The work's rounded protoform is a uterine volume or vessel in which the future germinates.

The motif of the vessel, with or without paleontological associations, runs throughout Cragg's work of the eighties, from Five Bottles on a Shelf (1982) to

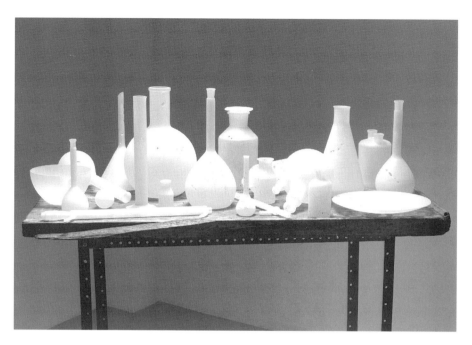

Tony Cragg, Eroded Landscape, *1987. Courtesy of Marian Goodman Gallery, New York. Photography by Jon Abbot.*

Bestückung (1989). Echoes both in titles and in forms relate it to the theme of primordiality. *Three Cast Bottles* (1989), for example, seems to represent giant bottles washed up on a beach, relics of an unknown ancient Gargantuan civilization. *Mother's Milk II* (1988) focuses another vessel work on ideas of fertility and the source.

Yet in another sense the vessel works refer not to the distant past but to the present and the future, portraying a nature that is both eroding into endless curves and bodying forth an unknown offspring. Above all, in regarding them, one feels they involve some reference to scientific investigation. It is through science that we have become aware of the look of that primordial beginning—some of the vessels simultaneously evoke ancient goddess icons and laboratory beakers. In *Mother's Milk II*, the vessel points both backward toward the primordial past viewed as a mothering vessel or source and forward into the technological or scientific future suggested by its industrial and laboratory look. In *Silence* (1988), glass vessels recalling a variety of laboratory types stand like athanors cryptically gesturing toward a future which will be born from the systematic investigation of the power of their uterine interiors; their silence is the mute anticipation of a future which, while it already resides in them *in potentia,* has not yet uttered its name or declared itself to be this or that. In *Eroded Landscape* (1987), some vessels echo classical Greek forms, others modern laboratory beakers, still others sexual organs. They evoke the passage of time, along with the fecundity of that passage and its expanding labyrinths of

meanings. Cragg regards these pieces as equivalent to "figures," implying that human life is a vessel into which various experiences are poured—as various chemicals are poured into a laboratory beaker or an alchemical athanor—to be transformed not into something transcendental but into new material configurations of energy in the stream of life.

The idea of the growth of scientific knowledge is like a structural member in the work of this artist, who is said to study science and to specialize in geology and fossil-gathering. Though it may seem antithetical to the themes of primordiality and regression, it is implicit in them as Cragg presents them. For it is through geological, paleontological, and biological investigations that culture has recovered the image of a primal nature from which it somehow seems to have emerged. Thus the vision of the slimy realm of cephalopods invokes the idea of progress in knowledge alongside the idea that, as the debris of culture overflows, civilization will sink back into the swamp.

It is here that the sequence of primordial thoughts in ancient philosophy again becomes relevant—specifically the way the Problem of the One and the Many led as if inevitably to the second great philosophical confrontation, the Problem of Knowledge. Fragmentation involves the theme of infinity, since there is no known limit to it. But infinity, because it contains everything, is beyond definition and distinction. In an infinity of parts, there is no up or down, no forward or backward, no right or wrong. There is, in short, no meaning, since in infinity every meaning contains all others. Hence, Democritus's positing of the infinity of atoms, while it loosened the world up and made room for change, led to chaos and meaninglessness. It was followed as if inevitably by Anaxagoras's intuition of pure will in the form of Mind moving the ocean of bits and creating in it a wave and hence a direction. The idea of progress, the directional ordering of infinity, was not far behind. Cragg's apparent commitment to the (at least partial) reality of scientific knowledge is an analogue of the hypostatization of Mind in the midst of an ocean of material fragments. Mind gives form to the infinity of scraps; science gives meaning to the chaos of data.

In art discourse outside Great Britain, Cragg more than any other artist has represented the so-called New British Sculpture of the 1980s. This category, while notoriously heterogeneous, does possess some inner coherence. Cragg's recent work, for example, resembles that of another New British Sculptor, Anish Kapoor, in its portrayal of primordial life forms. In different moods, both point to the foundations of the process in which life and death interpenetrate. Kapoor's approach is more metaphysical and Cragg's more materialistic. Yet Cragg's materialism does have a metaphysical or idealist aspect, which consists in the belief in science as a source of higher knowledge, knowledge which is not visual and hence is close to pure idea.

It is here that Cragg's attitude toward history becomes ambiguous. His affirmation of progress through science is classically Modernist, while his affirmation of regression (implied in the fragmentation and primordialism works) is anti-Modern. By "anti-Modern" I mean an extreme reaction against Modernism—not uncommon in the art of the late sixties and seventies—which simply inverts its

values. Anti-Modernism, in its puritanism, seems like a disguised or inverted shadow form of Modernism. In post-Modernism this polarity must be balanced and resolved. Post-Modernism advocates not a pure but an impure position—not in fact a position but a conflation of positions. In fact, post-Modernism is not so much anti-Modernist as it is a modification of Modernism to preserve its humane ambitions without its essentialist metaphysics and its view of history as both Eurocentric and providential. Some elements of Cragg's work achieve this post-Modern resolution—for example, his combination of the theme of fragmentation with gestures toward wholeness, his acknowledgment of a very relativized and diminished metaphysics, his tendency to change styles and formats while preserving an underlying continuity of purpose. So the work is an assemblage of Modernist, anti-Modernist, and post-Modernist elements.[5]

Other Cragg works resemble Bill Woodrow's in their exclusive use of trash materials. It is not simply that these works—with their vision of new life forms rising from the sediment, the past recycled as a present pointing toward a future— utter a word of hope or glance toward the future, for the voice is sardonic and the eye yearns also to delight in the erasure of the world of form. The hope is combined with a memento mori. Each critiques and mellows the other, and the work happens somewhere in their ambiguous embrace.

Inherent in the multilayered meaning of Cragg's work is the image of the artist roaming through alleys and over beaches looking for what the rest of the world has despised and thrown away. In *Self-Portrait with Sack* (1987), the loneliness of the image is as notable as its eccentricity. The work simultaneously embodies and parodies the romantic image of the artist as a lonely adventurer seeking realms that others flee. *Self-Portrait with Sack* is an assemblage of worn, softened, and rounded plastic scraps laid on beaches as sardonic gifts of the waves and tides— mementi mori from the sea, as it were, pushed up by lunar phases and oceanic rhythms. With ironic circularity these shards combine to depict the artist as a wanderer with a sack, probing the trashy places where bums go, looking for the very detritus out of which his own image will be made.

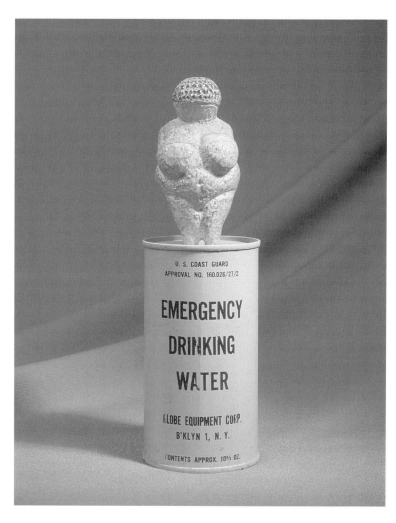

Francesc Torres, Emergency Drinking Water, *1992. Collection of the artist, New York. Photo: David Allison.*

Chapter Twenty-two
Francesc Torres: The Man with Three Brains

Francesc Torres is among the most philosophical of artists. His work exists in a discourse of thinkers as much as in the usual critical discourse surrounding the visual arts. The material it arises from and deals with is composed not only of human experience but of theories about human experience—its sources, meanings, and destiny. His work derives in part from a kind of shadow-play on a cavern wall, the spectacle of the wrestling of the figures whom he calls Fighting Philosophers. These figures seem in a sense the true protagonists of history or, as Percy Shelley said of poets, the unacknowledged legislators of mankind. In Torres's work they are acknowledged, albeit with a certain irony. He focuses his artwork on that vision of the world where it seems that human destiny is at this very moment being fought out by philosophers. His own work seems to assume that today the artist is not only an observer of the Fighting Philosophers but a participant in their fights. To understand the types of actions that art is engaged in here, it is necessary to enter into some of the philosophical thematics involved in the oeuvre, without pretension to completeness in this area.

Hegel and "50 Rains"

Torres has referred to some of his works as "Hegelian scenographies."[1] The phrase might be applied with special appropriateness to *Fifty Rains* (1991), in which he dealt with three events in Spanish history: the dawning of the post–Civil War era of Fascism in 1943, when Franco—humiliatingly to all Spanish liberals or leftists—was openly an ally of Hitler; the death (by assassination) of Franco's successor, Luis Carrero Blanco, in 1973, marking the end (for the moment anyway) of Fascism in Spain; and 1993, a year which immediately followed the Barcelona Olympics, the Quincentennial of the "discovery" of America, Expo '92 in Madrid, and the economic unification of Europe including Spain—all factors that suggested "the point at which Spain has overcome that fifty year heritage."[2] Each of the three moments is represented by an elaborate installation of furniture, some wrecked and burned, some new; cars (like the one Carrero was killed in); and pictures (abstract paintings with the new furniture of '93, photographs of marching boots in the trashed and burned-out room of '43) as well as other things.

In viewing this as "a Hegelian scenography," one is faced at once with the question: Which Hegel? For in terms of the reception of his writings, there are

several. On the one hand, there is Hegel the evil dictator of philosophy, the Hegel on whom so much of the tragedy of Modern history has been blamed for well over a century (at least since Rudolf Haym's *Lectures on Hegel and His Time,* published in Berlin in 1857).[3] This negative attitude toward Hegel recurred in the 1960s and early '70s, a period of "flight from reason" in which the hostility toward Hegel was second only to the hostility toward Aristotle (on whom Timothy Leary, in about 1967, blamed the mind's tendency to falsify experience by categorizing it).

This reception of Hegel received an influential articulation in Alexandre Kojève's *Introduction to the Reading of Hegel.* This series of lectures on the *Phenomenology of Spirit,* while not intended as antagonistic to Hegel, nevertheless emphasized the power-and-dominance aspect of the master-slave relationship discussed in the first six chapters of the *Phenomenology.*[4] This allegory or parable embodied a reflection on power that derives in part from reflections on the French Revolution, and that superseded Machiavelli's Renaissance concept of power. Hegel's parable of the master-slave relationship lies in the immediate background of Nietzsche's analysis of power, and hence of Foucault and much more that has been recently incisive. Delivered between 1933 and 1939, Kojève's lectures seemed to forecast the war, which hangs like a brooding but presiding spirit over much of Torres's work.

At the moment of high Modernism's cracking open, the anti-Hegelian reaction took either the form of the Hegelian revisionism of Western Marxism or the pre-Modernist revivalism of the flower child culture: the activist intervening in history and the drop-out withdrawing from it. Torres lived in Paris in the May 1968 era and was involved in the Marxist version of the Hegelian problematics for a while. This tendency still shows itself in his work's preoccupation with questions of social justice and the overall direction of history. The other option—of dropping out of Hegel's Work of culture into the surround of nature which Hegel had called Madness, and affirming this madness to be the true sanity—also shows itself in Torres's work, but not as a dominant note.

However favorably Kojève may have intended his Hegel, his vision of the philosopher of power nevertheless seems to have presaged the Fascistic Hitlerian strife of the war and the Franco regime. But there is another Hegel, whose contours can be seen in a somewhat different version of the redemptive modeling of history set out in a series of essays written between 1956 and 1968 by Joachim Ritter— *Essays on the "Philosophy of Right."*[5] Ritter emphasizes the revolutionary Hegel, rather than the Hegel who asserted that the Prussian society of his own day was the culmination of history. For Ritter's Hegel, "the Revolution represents the principle of European history."[6] "There is no longer any possibility of turning back from the Revolution."[7] "The unity of freedom and man's being is . . . the principle of world history."[8] For this Hegel, a person is only a person through living a self-willed life not subject to dominance; essentially a democratic idea in which, as Ritter said, freedom and human nature are synonyms, as Aristotle before him had taught in the *Metaphysics.*

Which is the Hegel who presides over Torres's selection of three moments from *Fifty Rains*? Despite Torres's distanced and ironic and complexly layered

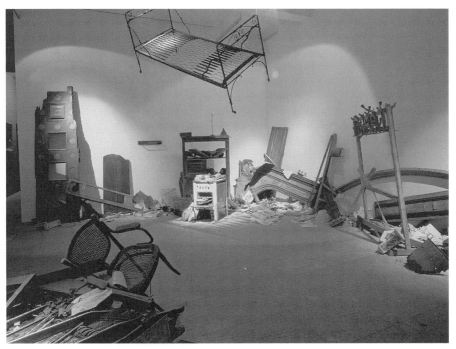

Francesc Torres, Fifty Rains, *1991. Courtesy of the artist. Photo: Museo Nacional Centro de Arte Reina Sofía, Madrid.*

attitude toward these matters, the selection of the three moments—starting in Fascism, witnessing its downfall, turning toward the future—seems to involve a redemptive sense or posited resolution. The triadic sequence suggests an Aristotelian structure of beginning, middle, and end, and even a Christological trinitarian view such as Joachim of Fiores's and Hegel's own. At the same time, layered upon those structures of culmination, a Hegelian syllogism of thesis, antithesis, and synthesis can be seen: Fascism, the negation of Fascism, some resolution of a new future direction.

This last is the most dynamic of the three models, for in the tripartite historical logic of Hegel which, with some revisions, is the structural mainframe of Marxism too, the synthesis, as a part of unending process, becomes the thesis of a new linked syllogism. So at the moment it is posited as a synthesis it is ambiguous, undefined, potential; subsequently, it tilts this way or that, and becomes defined at the same moment that it ceases to be a synthesis and becomes a new thesis. It is understood that this new thesis will emerge by the mysterious process of sublation (*Aufhebung*), whereby the prior thesis somehow incorporates its own negation in order to spring to a higher plane in the new one. In this way the three-staged logical argument of Torres's piece is caught at the early moment of unclearness; a redemption is implied by the first two limbs of the syllogism—yet it may be forestalled

when the third limb reveals its inner nature still obscured in the creative turmoil of the sublation. It is still possible that the as-yet-undefined synthesis may tilt toward a new and more horrific disaster at the next, presently unseen, moment, as if with an ignoble cyclicity. Torres's third-stage installation seems to have all this suspension and potentiality and noncommittal energy in it: The abstract paintings exude a slightly sinister threat of apolitical expediency; the anonymous new furniture reveals nothing yet of what will occur upon it.

In *Fifty Rains* and in some other works, Torres seems to tilt toward both the Aristotelian Hegel of the democratic self as expressed by Ritter *and* the Nietzschean Hegel of Terror as expressed by Kojève. Hegel's own phrase to describe the French Revolution, in the *Phenomenology,* acknowledges this linkage: "Absolute Freedom and Terror." As the sinister resonance of that phrase suggests, Torres's seemingly mixed feelings about Hegel are not uncommon. It is due to this ambivalence that the realization is spreading that so-called post-Modernism might better have been called late Modernism because it increasingly seems more a revision of Hegel than a rejection; specifically it is a revision of Hegel's idea of the end of history, seen by him as unitary (Prussian) but now seen as more pluralistic (multicultural), with an overall acceptance still of the idea of History itself.

Torres's *Fifty Rains,* with its undefined but threateningly artificial-looking third stage is not buying into post-Modern utopianism uncritically. The overall mood of the work is tough-minded in William James's sense; at any rate it presents itself as such, though perhaps with a tender-minded inside (a flower child lurking in the other room); Torres seems to have chosen neither to relax back into pre-Modernism nor to flee from a discredited Modernism into an unknown post-Modernism but to balance on an interface, that is, to stay on the fence. In refusing to locate himself definitively, Torres avoids another problem with the discourse of post-Modernism, which is that the term implies a tabula rasa, the dawning of a definitively new era. It is thus a somewhat wishful term, a kind of magical mantra designed to convince us that we are free of the past or have somehow gone beyond it. Torres's work does not seem to involve this hidden religious conviction. Thus Torres's work could be called post-ideological in the ambivalence that it shows to a variety of ideological positions. Shaped for a while by May 1968, when he was a student in Paris and, as he puts it, attended daily demonstrations "religiously,"[9] he now speaks of a "fall away" (compare the phrase "fallen-away Catholic"): "The fall, not away from Marxism but from its practice, from the everyday political activity and what I encountered there, was certainly a disenchantment."[10]

The fall and disenchantment, and the post-ideological position that comes with them, lead to what John Hanhardt has called a "radical skepticism" in Torres's attitude.[11] The radical skepticism may be seen as a result of ambiguizing Hegel, of seeing more than one Hegel, and Hegels at war with one another, annihilating one another's positions. There is then a dilemma pointed to by Torres's work—a moral-reflective dilemma which can be approached as a conflict between Kojève's and Ritter's Hegel, or in other ways.

McLean and the Dragon

One of these other ways is seen in Torres's incorporation, alongside Hegel's freewheeling historicism, of the biologistic determinism of neurologist Paul McLean's theory of brain formation. McLean argues that the different parts of the physical brain—the brain stem, the cerebral cortex, and the intermediary system—reflect and in effect preserve different stages of evolution: The brain stem, for example, is viewed as reptilian, and the other components as having developed at post-reptilian stages of evolution. Each stage is regarded as having frozen in a special formation and remained alive and active to this day albeit overlaid by later layers that may muffle or mediate its impulses—"as if we had three separate brains," Torres says—though in applications of the theory the middle level tends to disappear and the system becomes dualistic.[12] In different moments and aspects of social life Torres sees the momentary or partial ascendancy of one or another of these previous evolutionary stages. The reptilian stage regulates behavior involving territoriality and aggression, "leading to the paradox," Torres comments, "of having some of the most . . . potentially dangerous areas of social activity regulated by the oldest and most atavistic part of our brain."[13]

The Head of the Dragon (1981) consists of a battering ram on which a small steam engine labors, facing a door behind which is a live boa constrictor whose image is transmitted to a monitor on the head of the battering ram. Behind the ram, as its "tail," a row of eight monitors shows a loop of a racing car crashing. A film projection shows a man dancing while a snake (drawn onto the film) moves about. On a wall eight prints show a snake coming into focus, followed by a diagram of the brain with McLean's tripartite division marked out. On the floor the pieces of a jigsaw-puzzle map of the world lie scattered.

A mythical (Beowulfian) reading might take the boa constrictor behind the door as the "worm" (as the Anglo-Saxon calls it) guarding the treasure in the cave—or preventing the exercise of reason. The battering ram with the steam engine on its back driving it relentlessly onward is Modernism rushing apace to break down the barriers of instinct and superstition; yet it bears within its own brain the very reptile that it presumes to assault—thereby rendering its assault suicidal; the suicide/homicide issue is further complicated by another (baby?) snake just taking form as the monster History's tail and about to either drive it on or attack it from behind. So the idea of progress, for a being with two or three brains, is a deeply conflicted idea in which one part of the dragon of the self may betray and oppose another.

A complex of ideas hovers in the air around the work: genetic coding, evolutionary stages versus historical stages, what Torres calls the "dance of biology," skeptical contemplation of the idea of progress as manifest in the industrial revolution, the speeding onward thrust of capitalist Modernism and its crash, culture as a dialectic that always involves the negation of what is there in favor of a new development.

In Torres's oeuvre, McLean's tripartite brain or soul acts out the same dilemma found in the wavering attitude toward Hegel. It is implicitly Hegelian

while renouncing Hegelianism. Its positive Hegelianism consists in its tendency to reflect the mid and late-nineteenth-century equation of Darwinism with Hegel—a tendency that Darwin, a Hegelian himself, was involved in. Meanwhile, the reptilian theme derived from McLean's rereading of Darwin oozes an anti-Hegelian fog of pessimistic determinism. It implies that human life is not carried out *bei sich,* or in *Bei-sich-selbst-seyn* ("self-contained existence"), as Hegel called it. It negates the idea of the democratic individual posited as the governing subject of late bourgeois capitalism. In this aspect, it presents human existence as carried out not only in bondage, but in a deeper bondage than the master-slave relationship could ever account for: an actually biological bondage. The result is that, in effect, it offers an excuse to humanity: that it is not altogether human. Murders, wars, holocausts— these are momentary takeovers by the reptilian brain, alienated actions in which the human actor is literally not in his right mind. For, in the Aristotelian-Hegelian view, only the democratic mind can have an identity as an individual subject—a "self-contained" or "self-willed" mode of existence.[14]

Beuys and Haacke

This type of tension in Torres's oeuvre can be seen again in the antinomy between Beuys and Haacke, two artists who were formative on his oeuvre at an early stage—not on the style or shape of the work but on its internal directionality in relation to society. It has been remarked that Torres's work is in a sense situated in between theirs:[15] less oceanic than Beuys's, less specific than Haacke's. One way of focusing this antinomy is by considering the distinction between time and history. Time is an oceanic flow of moments with neutral value judgment placed on them. History is a selected thin stream of moments saturated with a sense of values; it is the series of explicit moments we pluck out of the shapeless mass of time to embody a shape according to which we define ourselves.

In Torres's *Fifty Rains,* for example, the three moments selected and focused on are distinctly historical; they represent a story with a specific shape and a precise value. Yet the title, *Fifty Rains,* views the story as embedded in the value-free, shapeless, or cyclical matrix of nature. The aspect of the work which deals with explicit political events is in the direction of Haacke's oeuvre; the aspect which retreats into the rainy universality of nature has more in common with Beuys running across and sinking into the peat bog, or escaping from the nightmare of history on a sled into the wilderness.

The two aspects of experience recognized by Hegel—his dichotomy of nature and culture—are again implied. This dichotomy is encountered frequently in Torres's work but usually as revised by McLean. Nature and culture both exist within humanity, one as the reptilian brain, the other as the cortex. Here is a hidden Zoroastrian type of dualism of human nature, which recalls the Apollonian-Dionysian dichotomy as well as the Christian dichotomy of the divine soul and the animal instinct-nature.

Ritter notes that "every present and future legal and political order must

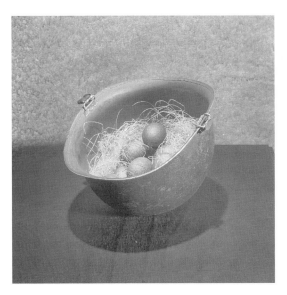

presuppose and proceed from the Revolution's universal principle of freedom."[16] This principle underlies all of Torres's work as an inborn yearning, a final cause, almost a prayer. But equally omnipresent is the pull of the reptilian brain which, like the worm that Blake says hides inside the rose, is everywhere. It is nature sucking culture down into the abyss. It couldn't begin to comprehend the idea of individual action arising from individual self-conscious will.

Calligraphy

Another avenue into Torres's work is offered by Eisenstein's description of the derivation of his own imagery from Japanese calligraphy viewed as an analogue to Hegelian dialectic.[17] Eisenstein wrote of how two calligraphic signs would be combined to create a third meaning, like thesis and antithesis making synthesis. Torres's work often follows a structure of internal dichotomy or antinomy not unlike this. A semiotic ideogram emerges from the combined counterforces of this and that. One example is a kind of signature image for Torres, the combination of a car and a video monitor. In *Field of Action* (1982), a jeep (repainted like a Pollock drip painting) stands not on four wheels but on four video monitors; on the rear end, where the spare tire would be mounted, is another monitor. In *Belchite/South Bronx* (1988), a video monitor rests on the crumpled roof of a wrecked and abandoned car while two more glare from under its hood, from the engine compartment. In *Dromos Indiana* (1989), a racing car stands on a field of monitors lying on their backs with their screens broadcasting upward. In *Destiny, Entropy and Junk* (1990),

wrecked cars surround a video projection on the floor. In *The Hay Wain* (1991), a large truck is involved with a series of video projections. Related images combine the monitor with a variety of weapons ranging from the battering ram of *Head of the Dragon* to the dive bomber of *Airstrip* (1982) and the cannon of *The Gladiator's House* (1985). In still other cases, video monitors or projections show cars in various social relations, from the crashing racing car of *Head of the Dragon* to the windshield washing activity of *Oikonomos* (1989).

The car represents transportation through the body, the TV through the mind; the car is in effect an extension of the body, the video screen an extension of the mind. The car is an old style Modernist machine, the TV a post-Modernist machine in Fredric Jameson's sense, meaning an instrument not of production but of reproduction.[18] The car is about the production of new experiences, the quest for something, the need to get somewhere, to bring something home, the whole project of going out upon the earth as opposed to the post-Modern project of sitting home and viewing reduced-scale images of things out there. The car is a Modernist image of questing for empire, the video a post-Modern image of diffusing one's consciousness into the stream of simulacra. In a sense the conjunction of car and TV is an allegorical picture of the dualistic human nature of McLean's theory—the car representing the drive for territoriality and aggression, the video involved in contemplation of such drives and activities. Their relationship is dynamic, however, like a truncated syllogism, thesis and antithesis interacting without yet having produced a synthesis.

Belchite/South Bronx

Somewhat similar structures of dichotomous superimposition occur in *Belchite/South Bronx: A Trans-cultural and Trans-historical Landscape* (1988), which is dedicated "to those whom Hegel doesn't mention by name." The large and complex work involves certain abstract relations between a small city in southern Spain that was destroyed in the Spanish Civil War and an area of New York City that was destroyed by peacetime urban blight produced in part by changing immigration patterns. Here again Torres is working extremely closely with philosophical ideas and texts, especially those of the French sociologist Paul Virilio.[19] Virilio has stressed the parallelism between the working class in a peacetime economy and the infantry in war. In total war as defined by Clausewitz (based on the Napoleonic example) an entire population is mobilized in one way or another into a war effort. Little distinction remains between the military and the industrial proletariats. Carried further, this parallel suggests that forces like those of war exist and operate among civilian populations. Divisions within a population, when charged with sufficient hostility, amount to a state of war, and the destruction of the South Bronx is presented as a form of civil war "because it was violence perpetrated by Americans on Americans, by a nation on itself."[20] Belchite and the South Bronx, in other words, were destroyed by the same forces operating now openly, now covertly, within a society inherently in a state of total war merely because of its class divi-

sions. "Any nation," Torres writes, "whether capitalist or socialist, that lives with the permanent stigma of unfairly distributed wealth (or the incapacity of generating wealth for the majority of its citizens) is perpetrating an act of violence on a massive scale, a definite attribute of war occurring in peacetime. The homeless, just to mention one group of victims, are the refugees of a social arena where only the strong (warlords?) can survive."[21]

The installation *Belchite/South Bronx* was extensive and complex, involving ruined buildings (smaller than life yet still large enough to suggest an urban milieu) based on both locales, wrecked cars, trashed furniture, a South Bronx–style neighborhood basketball court, video monitors drawing analogies between the Spanish Civil War foot soldier and the teenage street basketball player, and more. The viewer wandered through it as through a ghost town, a civilization that had voided itself. In this case the two entities which are conflated together are less clearly thesis and antithesis. At first they seem so: Belchite as war and the South Bronx as peacetime, but the piece as it sublates them within one another reaches a third term that is seen as underlying both—the concept of total war, war as a force saturating all human activities. This saturation is seen not only in the destruction of both cities but in the imbrication of team sports with military training and military-like competitions, especially in international arenas such as the long ideological competition between the United States and the USSR played out on the athletic courts of the world. Thus the ghostly panorama is called transcultural and transhistorical because it points to forces active in human societies at many times and places—"Beirut and Dresden and the slums of Mexico City and Port-au-Prince."[22] In this sense it is the reptile's legacy again.

The Theater of War

Often—but above all in *Belchite/South Bronx*—there is a theatricality or staginess to Torres's installations; they seem like sets on which a dramatic action either is about to take place or has recently taken place. This haunting presence-in-absence is a quality of poetic evocativeness in the work. There is a sense that perhaps the work is more evocative (Beuysian) than provocative (Haacke-esque)—more the work of an artist evocateur than provocateur. Like Beuys, Torres is not a purely political artist, but a poetic/political artist. The crumpled car on the monitors has an evocative emotional artistry and a sense of high drama.

The complex and laborious installations are also struck like stage sets, some parts being stored, some discarded, but except for the brief periods of exhibition, they do not strictly exist as themselves. They are thus like archeological sites, uncoverings of ancient theaters where the Fighting Philosophers wrestled, archetypal arenas where the reptile and the video screen gaze uncomprehending at each other. The exhibition space of art thus acts as an arena where human destiny strives to take new form, through combats and mutual incorporations of the different visions of itself.

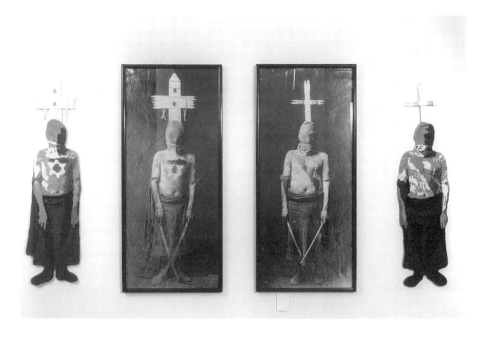

Elaine Reichek, Chiricahua Apaches, *1991. Collection: Irish Museum of Modern Art, Dublin. Photo: Orcutt Photo, New York.*

Chapter Twenty-three

Elaine Reichek: Sins of the Fathers

Elaine Reichek's artwork is a record of questioning the record. It focuses on the traumatic theme of European and American relations with the nonindustrial or traditional societies of the world. The visual traces that the psychological and ethical stresses of the confrontation have left behind are the heart of the matter. For the West's exploitation of the goods, labor, and natural resources of the non-Western world has presented it with difficulties in terms of its self-image. Both Christian ethics and the Greco-Roman ideals that have largely supplanted them as the putative conscience of the West stand in conflict with the centuries of conquest. The tactics designed to mediate this ethical dilemma emphasized denial, implemented through manipulation of image, word, thought, and feeling. It is the visual aspect of this pattern of denial that Reichek investigates. Her work, then, might be regarded as a self-critique of Western culture by one of its members.

Europe's violent confrontation with the native populations of the Americas began about the time Leonardo da Vinci undertook his *Last Supper* in Milan and Michelangelo his *Pietà* in Vatican City. At the very foundation of the European-American body politic lies this primal crime, which Nathan Huggins and others have treated as the Original Sin of American history.[1] It is the repressed memories of her own homeland that Reichek focuses on. Her work is an analysis not so much of non-Western cultures as of the West's way of dealing with them. Her work contributes to "a discourse on race that interrogates whiteness . . . [that lets] us know what's going on with whiteness," as bell hooks put it.[2]

What's been going on with whiteness is the strained effort to maintain the sense of self as distinct as possible from that of the Other. This dualistic position is no longer working. As Plato knew in the *Philebus*, Otherness is everywhere, for every self is an Other in relation to every other self. But in social history the idea of Otherness has a tendency to become specific rather than universal. Simone de Beauvoir felt that women had been made Other by the patriarchy. And in the colonial process, the concept of Otherness was fitted over the nonwhite—or non-European—world.

This use of the concept worked to the advantage of the white male colonialist for a long time. He could claim a status as an essential self in contradistinction to which the rest of the world was to be regarded—and in time regard

itself—as Other. The Westerner, in this construction, was *only* self, the non-Westerner *only* Other. It was deemed unforgivable in the British Empire for a colonizer to "go native," for he would be betraying selfhood itself. On the other side of the relationship, as Albert Memmi observed,[3] the colonized personality was turned, becoming an Other not only to others but also to itself. A situation emerged in which a nonwhite person whose mind had been colonized might look into the mirror and see not the self but the Other. His or her selfhood, co-opted by the Western image system, became inwardly alienated and found upon its throne an intruder who was, in fact, its worst enemy.

Reichek began making knitted sculptures in the late 1970s and began directing them specifically toward postcolonial issues in 1982. The constant that unites the earlier and the more recent work is a suspicion of Western codes of representation. Reichek chooses to face these codes in the crucial area in which they are formed—the border territory where Western culture meets others and its conceptual defenses or denials are called into play. Reichek has carried her exploration of this borderland from the position of the white female—knitting quietly in a corner. A three-way pattern emerges occupied by the white male, the white female, and the represented nonwhite world.

Reichek's "Dwellings," from 1982 on, are knitted sculptures of non-Western homes, the original and the replica joined by their bestowing of warmth and their both being in the province of the woman. Enlarged representations in ethnographic photographs are hung beside the corresponding fabric works on the wall. Reichek often selects the ethnographic content for her work on the basis of the location of the planned exhibition. For her show of 1989 in the Pacific Northwest of the United States, for example, the non-Western home-type involved was the tepee, and the underlying theme was the genocide of the Amerindian. Reichek's "Men," which first appeared in 1986, are knitted sculptures of nonwhite males from the same sources. So an ensemble array consists of an enlarged ethnographic photograph of a non-Western home with a man standing beside it, a knitted replica of the home the same size as the one in the enlarged photograph, and a knitted replica of the man, also the same size as the man in the enlarged photograph. The elusiveness of the real suggests the cluttered illusionistic space of the colonial denial system. By moving the flat image of the photograph into the three dimensionality of sculpture, Reichek brings the image closer to reality; but by using a representation of a representation, she moves further from reality at the same time.

Reichek does all the labor-intensive handiwork herself, performing as an archetype of Woman under the patriarchy; yet the fact that she performs this labor not as a homemaker but as an artist gestures toward a transformation of women's roles in Western culture. In another sense, the ancient handiwork erects a bridge of continuity with the work practices of the preindustrial cultures to which she refers. Through her alternative materials Reichek evokes the milieu of the nineteenth-century women who stayed at home and heard or read, with mixed feelings, about the adventures of their men in the outside world. This protracted hand labor also introduces a temporal dimension that relates to the ambiguous temporal reality of

old photographs, which have the duration of history in them along with the instantaneous space of the shutter release.

Reichek's tepees seem almost fragile and wistful, like lost options, evoking the possibly salvific realities of cultural spaces from which Westerners have excluded themselves. The knitted figures of Reichek's Men have the warm flexibility of living skin at the same time that they evoke the eerie absence of the eradicated culture. These pieces—a kind of masked and reversed art of the figure—extend the theme of woman's work into dangerous areas: the woman skinning the prey that the male hunter brings home; the woman, locked at home, longing for a male partner of a different cultural order from that of the man who has locked her in; the woman of one culture, in her home, approaching the mystery of a home from another culture; the woman contemplating seductive life options that the men of her tribe have either eliminated access to, or, incredibly, destroyed altogether.

Reichek's photocollages began to appear in 1984. In these works she uses only found imagery, images that are already, as it were, lying around the house, parts of the everyday formation of the communal Western mind. Finding this imagery highly manipulated already, she attempts to demanipulate it, or to remanipulate it to reveal its previous manipulation. In collages of found photographs such as *Burden of Dreams* (1986), *Desert Song* (1987), and *Aloha* (1988), she builds up, out of the false stuff of skewed representations, a surface of comic absurdity that barely masks a tragic blindness and cruelty. Tarzan and Victorian ladies on camelback, stills from *The African Queen* and *Blue Lagoon,* General MacArthur wading ashore in the Pacific, ethnographers at work with camera and sound equipment—these and other images are combined in mutually critical ways intended to deconstruct the Western system of denial by revealing its hidden motives. Because the artist acknowledges her complicity in the structures of vision through which the West perceives the non-West, the lady on the camel has Reichek's face.

In *Tears Were Shed* (1991), the manipulated photograph leads Reichek to another ideologically saturated image context—the natural-history-museum diorama. As we walk through such a museum and regard the relics of the primordial crime of this continent, Reichek feels, we always hear the ringing baritone of the white male voiceover—in headphones or in our memories—explaining everything in a way that turns everything to his purposes. In relegating the embarrassing evidences of hastily exterminated nonwhite cultures to the natural history museum and the docent's lecture, we muffle feeling about them. The context—alongside displays of prairie-dog villages, beaver dams, and fool's gold—renders these peoples parts of nature rather than of culture; it denies their humanness.

The colonialists' official view seems not to have been that the colonized peoples were without souls; indeed, through the Christian missions, their souls were supposedly all redeemable. But the Western belief was that in their own cultures their souls were undeveloped or unawakened, smothered beneath layers of animal habits. This degenerate imprint was to be wiped clean, making pristine the picture plane of the soul, which would then be refilled with eagerly sketched elements of white culture. Reichek's photocollage, *Sign of the Cross* (1991), involves before-and-

after photographs of three young Native American boys who were reeducated at the Carlisle School in Pennsylvania, where the motto was "Kill the Indian, save the man." Behind them Reichek shows photographs of the railroad pushing westward, the sign of human progress establishing its dominance over the wilderness.

The historic westward rush of the white race in North America was felt by whites as a realization of their historic destiny. Thus the depredations of nineteenth-century European immigrants against the Native American population became merely an epiphenomenon of a historical process that had the status of myth, of an archetype that could not be denied. This mythos was promoted in paintings such as Emanuel Leutze's *Westward the Course of Empire Takes Its Way* (1861), which shows a wagon train on its way to California. Set into the frame underneath are medallion portraits of Daniel Boone and William Clark of the Lewis and Clark expedition. Reichek handpaints a reproduction of this painting, then adds medallions of her own: a photograph of a Native American display in a natural history museum being explained by white docents, another of prairie grass with a McDonald's sign in the background, a third showing buffalo dead in the snow. A proclamation of white destiny in the West receives a silent subtext: For the advance of those railroad cars and covered wagons to succeed, nonwhite peoples and cultures had to be ground beneath their wheels.

In the works involving language, Reichek uses found bits of speech—quotations and sayings appropriated from the record of the culture in question. In the Native American–based body of work, for example, she uses quotations from the record of Amerindian political speeches so that voices from those cultures represent themselves. (She makes no claim to speak for them.) Typically, the format she has chosen for the language works is not one of the imperial modes of representation featured in the white male's system of denial—such as painting and sculpture—but one associated with the white female's cloistered, repressed self-inscription in history—the sampler, the embroidered wall hanging with image and homily. Though the flat representational format of the sampler relates it to the pictorial realm of the painting, its nonpainterly materials and its object-nature push it into the category of sculpture.

In late-eighteenth- and early-nineteenth-century America, the making of samplers was a pedagogical device through which young girls would learn the alphabet (the most frequently embroidered text) while rehearsing their handiwork—and programming their minds—through the stitching of conventional images. The sampler encapsulates Reichek's themes of cultural education and indoctrination, women's work, and ideological image manipulation. Her recreations are based on actual samplers, mostly from around 1820 to 1830, which she has altered by the addition or substitution of either a new text or a new image, creating a layered cognitive texture related both to the ensemble sculptures and the photocollages. The girls who made the samplers were not expected to use the writing they were learning to create history. The laborious slowness of sampler making, and the banality of the phrases traditionally inscribed on them, reinforced the prohibition on using language powerfully or truthfully. Reichek initiates the samplers into history,

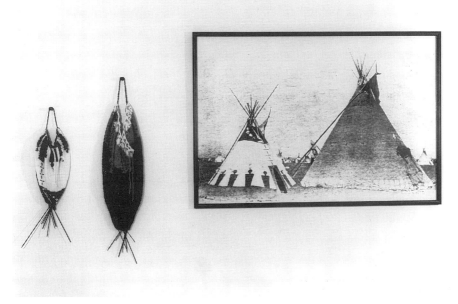

Elaine Reichek, Double Blackfoot Teepee, *1991. Collection:*
AT&T Corporation. Photo: Orcutt Photo, New York.

as it were, by inscribing them with the voices of others who could not control the record—in this case Native Americans.

In Reichek's recreation of a sampler made by one Margaret Ledden, age ten, in 1842, she has retained the little girl's touchingly—and chillingly—simple rendering of a colonial house with two trees and a fence. In place of the Latin alphabet (which carries the sanction of the Roman empire into this modern imperial age), however, she has inserted remarks of a Plains Indian chief, Wamditanka ("Big Eagle"): "The whites," Wamditanka observes, "were always trying to make the Indians give up their life and live like white men. The Indians did not know how to do that—and they did not want to anyway." A sampler made by Sarah Bottomley, age eleven, in 1827, as altered by Reichek, sums up with a brilliant concision a kind of mute communication between a woman of our time and a woman, or young girl, of the past. The Bottomley sampler shows a colonial house. Reichek has added a verbal message, "Home Sweet Home," and in place of the house that Miss Bottomley portrayed with such carefully learned technique and polite semiotics, she shows a tepee—to the white colonial mind, the locus of savagery, darkness, and chaos.

As Reichek switches from one medium to another, she reflects the pervasiveness with which coded messages hidden in images move through the culture—in painting, sculpture, photograph, fabric, wall-hung homily, and printed advertisement. Her work is post-Modern in its combinatory quality and in its orientation to

specific social issues; it deals with feminism, multiculturalism, and historical revisionism through combinations of sculptural, photographic, painterly, and linguistic elements. The work is Conceptual Art yet rooted in object-making or sculpture; in terms of medium, much of it might be described as Conceptual sculpture. In terms of subject matter it might be discussed in relation to the works of other artists dealing with the theme of the non-Western, such as Lothar Baumgarten, and in terms of materials and techniques, with the work of artists such as Rosemarie Trockel, whose work also features knitting, or Nicholas Mouffarege, who uses embroidery.

Yet there are differences. Baumgarten entered a non-Western culture (the Yanomami of the Amazon Basin), lived in the local fashion, and attempted to become one with it. Then, upon returning to the Western world, he represented it in exhibitions. Reichek, to the contrary, comments only upon her own culture and does not presume to speak for any other. Her intentions in the knitted works also seem distanced from those of Trockel, who sends work out to be made on knitting machines. But both Trockel and Reichek participate in the widespread post-Modernist use of empty clothing as sculptural objects. In this regard Reichek's empty knitted body stockings raise questions about human nature not unlike those raised by Joseph Beuys's empty felt suit and other sculptures (including Broodthaers's and Samaras's) of the absent figure.

Reichek's work also connects to Christian Boltanski's in its particular use of old found photographs. Both artists relate intensely to people long gone, and incorporate this feeling into the work through the temporal ambiguities of photography. Barbara Kruger's work shows a similar deconstructive approach in terms of combining texts and found photographs, but there is a difference in cognitive impact. Kruger's graphic devices seem to take their style from popular means of persuasion such as advertising and magazine design. Reichek, on the other hand, enters and undermines Western culture's inner temple, science; at a time when many people still take scientific propositions—like ethnographic photographs—as truth revealed, Reichek bends every effort toward revealing them—or at least portraying them—as fiction.

Like these artists and others—Fred Wilson, Lorna Simpson—Reichek draws the energy of her work from the ongoing, intensely felt, global crisis of representation. Everywhere around the world, including the countries of the West, non-Western peoples are struggling to regain images of their selfhood on their own terms. At the same time, Western peoples are recognizing, often with shock or dismay, the part their history has played in the oppressions of these other cultures. The system of denial is coming undone. We are realizing that the order of culture we have inherited has destroyed many of the options for selfhood that could conceivably suggest ways out of the global trap to which the white Western domination of history has led. Reichek's knitting and embroidery, then, and her frequent use of nineteenth-century photography and painting, may refer to the past but are entirely contemporary. Addressing the historic rupture of decolonialization, she is analyzing a trauma that the world will be shaken by for years to come.

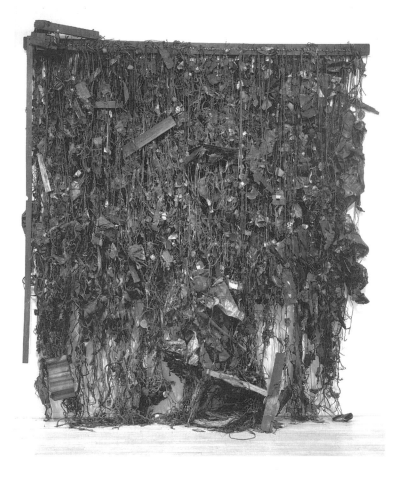

Leonardo Drew, Number 8, *1988. Courtesy: Mary Boone Gallery, New York.*
Photo by Adam Reich.

Chapter Twenty-four

Leonardo Drew: The Great Migration

Leonardo Drew was born in Tallahassee. He grew up mostly in the housing projects of Bridgeport, Connecticut, where he frequented the town dump, finding, arranging, and rearranging objects in shifting tableaux that amounted to a kind of private kingdom. At age thirteen he began exhibiting drawings and paintings in community-sponsored exhibitions. At age eighteen he went to New York City, where he briefly considered an illustrating job for DC Comics. But the idea of an art that goes beyond illustration had been planted in his mind by a high school encounter with Jackson Pollock's work in a book (probably Irving Sandler's *Triumph of American Painting*) from the school library. Much of his work since then shows the influence of Pollock's allover composition translated into sculptural modes. Rather than take the illustrating job, Drew entered Parsons School of Design and later transferred to Cooper Union, where he graduated in 1985 with a BFA in painting. His painting at Cooper had involved skillful post-Modern juxtapositions of seemingly unrelated details, with considerable attention to the art of the figure. This apprentice work was followed by a series of developments leading to a breakthrough into an authentic personal style.

In 1986–1987, Drew was making what he calls "totemic shapes" of cut paper, figures about eight feet high, which would be mounted on the wall. Flat and wall-mounted like paintings, these were nevertheless sculptures in that the flat plane was not a field for representation but rather was the representation itself. The work was influenced by, and in part an homage to, the frontal and diagrammatically two-dimensional look of much traditional African sculpture. With these works Drew undertook the synthesis of contemporary western and traditional African formal modes which is still a structuring principle of his oeuvre.

In paper cutout works such as *Number 1* and *Number 2* (both 1987), the figure began to form itself into a vaguely rectangular plane. While this brought the work still closer to painting, it remained sculptural in that the rectangle *was* the figure, rather than a field on which the figure would be represented. A later work such as *Number 15* (1991), maintains this mode, but with much greater intensity. The rectangular canvas is not a ground, but, rusted and pierced by wires, resembles a Saint Sebastian–like figure. The upright rectangle of canvas suggests painting, but the wires thrusting through it pierce sculpturally into the space of the viewer's body. A work such as Michael Tracy's *Icon of Despair,* similarly pierced and anguished, and

similarly combining elements of both painting and sculpture, might be compared.

The breakthrough work in the developmental arc that leads from *Number 1* to *Number 15* was *Number 8* (1988), an *art brut* hanging curtain of ropes, sticks, animal parts, and urban detritus. *Number 8* suggests the figure, as one critic put it, as "the sewn together remains of an undefined, unknown animal of either the distant future or the distant past."[1] *Number 8* was included in the *Pillar to Post* show in 1989 at Kenkelaba Gallery, Drew's first exposure in a New York exhibition. The ragged and tormented-looking hanging piece that incorporated rags, ropes, and dead birds along with entrails, hides, claws, antlers, and skulls of cats, porcupines, raccoons, and deer—the whole assemblage lightly sprayed with a gloomy black paint—made a jarring and arresting impression. The visual effect in and by itself implicated Pollock's allover principle with post-Minimal moods along the lines of Eva Hesse's hanging works, with suggestions of a kind of exhausted biomorphism.[2]

One writer described *Number 8* as exuding a "sinister melancholy,"[3] another as "death quilts."[4] This somewhat morbid quality arises from the work's intended content, which involves reflections upon the social history of the African-American tradition and evokes a feeling-tone experience of what Orlando Patterson has called "social death,"[5] with suggestions of the hanging tree, the lynch rope, the bitter taste of exclusion from culture and desperate relegation to the swamps of nature. While *Number 8* looks superficially like some of Hesse's seminal work, when one approaches it closely, it is forbidding, sinister, and tragic to a degree that her cooler work was not.

The piece also contains hints of fetishistic outsider art, southern rural voodoo, and primitivism. The years of gathering cast-off materials in the Bridgeport dump have left a mark on Drew's work that parallels to some extent the tradition of the southern African-American bricoleur, as in, for example, the works of Lonnie Holley today.[6] For one seeing the work without context or commentary, a question might have arisen as to whether this was a taught or an untaught, a learned or a so-called naïve artist. Indeed, Drew tends to amalgamate and synthesize these two traditions, as do certain other artists, such as David Hammons and Thornton Dial, who are involved in the opening of the art world to the African-American, as opposed to the European American, view of historicization. Beginning with this work Drew took slavery as a leading, though not exclusive or programmatic, subject matter—as have, for instance, Renee Greene, in her work on the autobiography of Harriet Jacobs, and Hammons with his fetishes of kinky hair and chicken wings and in his installation of cannons aimed at Teddy Roosevelt. Drew's work is delicately balanced at a crossroads between contemporary art history and African-American social history. Yet in order to understand its relevance to formal art history, one would not have to know about the other aspect. One could appreciate *Number 8*, for example, for its studied elaborations of post-Minimalism, without contemplating its inner historical narrative. Still, the narrative, which unfolds in both performative and material iconographies, is like the fingerprint of the work or its pulse.

In November of 1991, Drew held his artist-in-residence show at the Studio Museum of Harlem. It featured *Number 15*, the assemblage of wire and canvas that

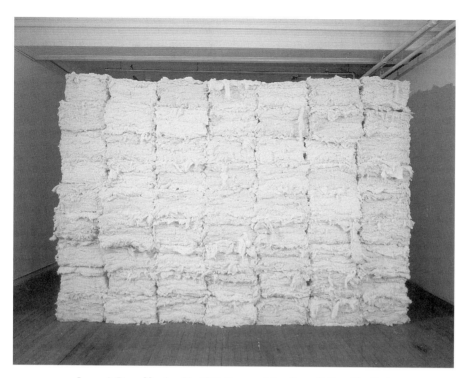

Leonardo Drew, Number 25, *1992. Courtesy: Mary Boone Gallery, New York.*

reiterates in new formal embodiment some of the themes of *Number 8.* Seen in terms
of the specifically African-American subject matter, the painful St. Sebastian–like
perforation of the canvas body suggests the pain of centuries of history now emerging
from repressed darkness into the expression zone of art. The classical European
theme of St. Sebastian transforms into hints of what Nathan Huggins has called the
"holy history" of African-American experience as a kind of ritual sacrifice which,
according to the sacred tale, was to culminate in the purification of America.[7]

In the same show was *Number 17c* (1991), a mass of raw cotton pressed
between rusted canvases mounted on plywood. The piece has a formal presence that
suggests Arte Povera even more than post-Minimalism. Formally it echoes a work
of Jannis Kounellis from 1967 in which a bale of cotton was compressed between
sheets of corten steel. But the iconographic intentions of the works arise from very
different awarenesses. Kounellis's work *Untitled* (1967) was about the incommensu-
rability between hardness and softness, the inorganic and the organic, the grid of
social order and the odd-shaped personality of the individual. It is a general reflec-
tion, in an almost Heraclitean mood, upon certain of the longstanding conditions of
human life. Drew's piece assumes much the same foundation, but then focuses it
into his specific narrative context. Cotton, as Drew has remarked, has blood on it.

The bale of cotton suggests the labor of enslaved Africans in the American South. The plywood-mounted rusted canvases, which look like metal plates, involve both the idea of rigid imprisonment and the idea of the art object, which is evoked by the iconographic material canvas. There is a suggestion of the incommensurabilities of two kinds of labor, that of the slave, whose activity is undertaken for the advantage of another, and that of the artist, who is doing a kind of praxis that Karl Marx, in the *German Ideology,* described as a living for oneself, a "self-activity," the non-alienated form of human labor. The work suggests a perplexity at this incommensurablility, but at the same time a dim utopian suggestion that they are coming together—perhaps in this generation.

Alongside cotton, rust is a central material in Drew's work. Its association with urban decay, rites of passage, and hints of rebirth, associate it with tendencies of Robert Smithson, Mel Chin, John Chamberlain, and others. Drew walks around Manhattan gathering rust, which at the end of a day he pushes home to Washington Heights in a shopping cart. He is, one might say, a connoisseur of rust— powdered, layered, or artificially induced. He has learned ways of accelerating the development of rust on various materials, especially canvas.

Number 14 (1991) is a large wall segment composed of found rust pieces painstakingly assembled on a plywood support into a delicate surface like ancient fine masonry and natural deterioration at once.[8] The work is anomalous in that no one has ever really seen anything like it (though some of Kounellis's constructions of rock and wooden debris might be compared). All the material is found, yet it is almost nonmaterial, an evanescent mist of time rushing into an irretrievable past.

All Drew's work is labor intensive; three months or so of sixteen-hour days are required for each piece. This labor-intensive aspect constitutes a performative iconography. The hundreds of hours of labor in each piece amount to an embodiment, by the piece, of the history of slave labor and the long laborious struggle of African-Americans toward the possibility of the type of autonomous, for-itself activity that Richard Rorty, echoing Marx's concept of self-activity, describes as self-creation.[9] Similarly, in Drew's iconography of materials, cotton, rope, and rust work together to suggest certain themes of African-American history—forced labor, lynching, and desuetude—and at the same time Drew's use of them as art materials suggests the overcoming of that history through which the African-American artist can recreate himself or herself.

Drew's recent pieces extend the iconography of the "holy history" and the escape from it. *Number 25* (1992) is a wall-like sculpture that appears to be built of stacked bales of cotton. Looming over the viewer, the work operates as both an obstruction and a challenge. The menial labor that excludes African-Americans from full participation in the life of the culture around them is a wall that not only blocks their way but, ironically, was built by their own labor. Drew's work ethic, or his labor-intensive performative iconography, prevented him from simply buying bales of cotton. They are hand-made by the artist from the cotton batting with which mattresses are stuffed, which is painstakingly cut and recombined into simulated bales. The process has something in common with the works in which

Leonardo Drew, Number 35, *1994. Courtesy: Mary Boone Gallery, New York.*

Dennis Oppenheim has returned the materials of a finished product to their raw state. Again somewhat reminiscent of Minimal and post-Minimal Art and Arte Povera, *Number 25* looks even more like Joseph Beuys's stacks of felt and other materials. In terms of the underlying content of Beuys's use of felt—as a regenerative material to assist in humanity's rebirth after the catastrophe of twentieth century history—this coincidental similarity has a certain depth.

 Number 26 (1992) is composed of forty-eight sacks visually reminiscent of cotton sacks from the era of hand-picked cotton, before the epochal invention of the cotton-picking machine in 1944 triggered the long mass exodus of African-Americans from the rural South.[10] Mounted on the wall in a rectangular array, the sacks again invoke both the format of painting and the presence of sculpture. Made of rusted canvas, each of them is hand-sewn on all edges in Drew's continuing homage both to labor and to craft. This labor-intensive aspect, as well as the particular African-American narrative involved, distinguishes the work from such relata as Kounellis's *Untitled* (1968)[11] and Marcel Duchamp's *Twelve Hundred Coal Bags Suspended from the Ceiling over a Stove* (1968).

 Drew has described his work as fusing African and urban impulses. As such it has a certain relationship with what Robert Farris Thompson and others

have called the Afro-Atlantic impulse in African-American art.[12] Yet it is also targeted at various forces in the contemporary white view of art history. To this end the work addresses, in other words, a question that remains unresolved in the post-Modern revision of Modernist categories: the relationship between folk art and contemporary art. This question is primarily one of historical consciousness. A simple distinction is that folk art is ahistorical whereas contemporary art is inevitably historicized, that is, it arises in large part from an impulse to resolve immediate historical issues, rather than from the folk or mythic impulse to underlie or overleap them. Drew's work, along with the work of some other African-American artists, embodies a post-Modernist reorientation toward history. It used to be that if an artist's work was about, say, slavery and social oppression, that artist was assumed to be either a folk artist or a sentimental socialist like Ben Shahn. If on the other hand one's work was contemporary art, it was not about such matters. It took its historical cue from the purely art historical play of formal nuances conceived as the visual aspect of a historical mainstream. But in the post-Modern awareness of history as a myriad of streams, rather than a single mainstream, this distinction will no longer hold. Drew's work is at the same time *about* slavery and oppression and *about* formal nuances relating to Pollock, post-Minimalism, Arte Povera, and more. Indeed there is a hint of a new art species—black and white, free of inherited boundaries, like post-Modern culture in its pluralism or polymorphism.

Among the forces linking Drew's work to the Western tradition are its frequent references to the tradition of easel painting: its tendency to assume an upright vertical shape, its frequent flatness, its use of paint, its homages both to the art of the figure and to Pollock's allover composition. At the same time, it contains countertendencies that balance these methodically. The primitivist material—including dead meat and feathers; the hairy encrustations of the surface, not like paintings so much as cavern walls; the fetishistic incorporation of natural objects and materials from dead flowers to industrial rust—amount to a rejection of the Western tradition and an affirmation of non-Western influences. Drew's works suggest a deterioration into nature, and the regeneration from that detritus of a new synthesis of social forms.

In the works that echo the more or less flat and rectangular format of paintings, such as *Number 8* and *Number 14*, the tradition of the painting as representation is confounded into the painting as presence; the idea of the picture as a window through the wall, through which some other world or vista can be seen, is implicitly denied in favor of an assertive this-worldly reality. The traditional illusionistic space beyond the picture plane now is replaced by a blocked, clotted, shaggy, thorny, forbidding, and opaque wall rather than an image receding beyond the frame. In some of Drew's works, there is a quality of feeling not entirely unlike that of Lucas Samaras's early forbidding pin and razor-blade-covered pieces, but even more closely related to the blocked windows and doorways—the denial of vision, the black curtain pulled across the painting—of Kounellis. Unlike Kounellis, however, Drew does not block the viewer's vision through space with a gridlike construction implying human intention, but with hairy, spinous, biomorphic

excrescences suggesting a more fundamental reality—a creature from the black lagoon—threatening to engulf human intention.

In other works, such as *Number 17c* (raw cotton between rusted canvases), which are more clearly and exclusively sculpture, space seems painfully concentrated, compacted in a kind of bondage, often squeezed tightly by rigid planes of alien material. The placement of works in the openness of room-sized space suggests an amplitude of options or movements, but the sculptural entity itself is bound, blocked, compacted, and seemingly unable to move at all.

The social implications of this compressed, blocked, pierced, and tortured space must relate to something like Patterson's concept of social death. The pierced St. Sebastian–like figure of *Number 15* and the rotting rainforest curtain of *Number 8* stand in the midst of social space at once like accusations and complaints. Yet at another level the hidden care and precision of their meticulous and laborious facture speaks of a commitment, or a hidden imperative, to social constructivism. In the elaborate but unseen artisanship of the works the country bricoleur's ideology is sublated into a Hegelianlike sense of a driving, inner spiritual purpose.

Gerhard Merz, Berlin Travertin Romano Classico, *Berlin, 1994. Galerie Max Hetzler.*
Photo: Wernen Zellien.

Chapter Twenty-five

"Nothing Behind It": The Sculpture of Gerhard Merz

Gerhard Merz began as a printmaker and painter. A print from that earlier period shows surfaces finely gridded with myriad perpendicular ink lines with no apparent expression or incident in the execution—no *"écriture,"* as Merz puts it.[1] His desire, he says, was for a "blank" art—presumably an art that lays no trips upon the viewer. But the concept of a "blank" art leads to questions. For one thing, "blank" suggests the absence of what is usually called "content"—and that would suggest an overlap with so-called formalist art, in which the optical surface was regarded as autonomous and self-reliant without any referentiality. Indeed, many of Merz's works, with their avoidance of representation as well as *écriture*, have a certain similarity with areas of formalist art, such as the works of Barnett Newman, that he admires. But the concept of blank art goes beyond that. It also involves an avoidance of most of what usually passes for artistic form, including "touch," painterly gesture, and personal expressiveness. There is a sense in which absence can be regarded as an aesthetic quality, and that at least is left in Merz's two-dimensional works. But the works also involve a philosophical rumination on certain issues, a rumination that passes for both form and content.

The grid involves the mathematical ordering of space, like latitude and longitude lines, and thus implies order and an insistence on rigorous cognition of that order. It also implies perspective—the idea of being in a certain place looking toward another place—which is the visual correlate of the historical process of colonialism. The map is laid out for the subject and object to take their positions on, but since they have not yet done so, the grid does not yet show perspectival skewing of the lines: that is, it does not yet show the subjective point of view inscribed into its objective matrix; it does not yet reveal the direction in which the parallels will converge or the location of the vanishing point toward which their convergence will lead. In another, but related, sense, the grid implies the ordered Hellenistic town based on a rectilinear grid. This way of laying out a town implies several things. First of all, it implies that the town is new, that there is no organically grown past archeology to deal with. The designer can start it with a ideal form in mind and simply carry that form out. So in this way too, colonialism is implied: The town that is newly designed on a previously uninhabited terrain was a mark of ancient Greek colonialism, which tended not to conquer and take over the lands of others, but to settle in previously unoccupied places. Secondly, the rectilinear gridded town-plan

asserts a claim to control of the human population; a census, for example, could be carried out more efficiently (and, by the way, a fugitive located and apprehended) in an environment in which an address could be objectively composed. In a larger sense the gridded town-plan is like a taunt of culture to nature, a claim of human control of the natural environment and, on a still larger scale, of human cognition of the order in the universe as a whole.

In terms of art history, the grid has long been useful as a means of transferring images from surface to surface; the previous version of the image is gridded, the new blank surface is gridded, and the part of the image that fall into each box on the first grid is transferred by hand to the corresponding box on the new one. So the gridded surface, in artistic terms, means a kind of creative membrane, a surface just palpitating with readiness to receive an image, or to allow an image to emerge from the abyss of nonmanifestation into the light of manifestation. The grid or grid-like ordering of a surface or space has come, in the works of artists such as Agnes Martin and Sol LeWitt, to function as a metaphysical ground zero from which figures can arise, a space which, while it does not even quite exist yet, because it has not been actualized yet, is already pregnant with the potentiality of the moment of emergence.

The blankness of Merz's grids thus points several ways. His purpose seems not to have been the creation of a palpitating creative membrane about to produce something through an artistic *fiat lux*, but rather, more along the lines of Malevich's *Black Square*, to block vision, to preclude it, to let no pictures or suggestions appear—in short, no meanings. A part of Merz's special sensibility is that he bothered to develop a method in which to use the grid as a signifier of meaninglessness. A gridded page, like an accountant's tabula rasa, clearly means meaninglessness—but also the possibility of meaning; there is no meaning upon it yet, but it has itself been inscribed into existence as a bearer of meaning. There would be no reason for it to exist except for the expectation that meaning will, sooner or later, be inscribed upon it. It is neutral in that it doesn't try to specify that meaning. But in other ways it isn't neutral: For one thing, most basically, it quivers with expectation of meaning like Mallarmé's blank page or the screenlike surface called the "receptacle" in Plato's theory of Ideas: the empty slate on which the dream of the world was projected as a set of mathematical ratios. Secondly, the rectilinear grid also lacks neutrality in the very fact that it *is* rectilinear. What if a nonrectilinear real wants to assert itself on this surface? There is nothing for it to grip to, to fit into. It's as if chance were excluded. Duchamp's *Three Standard Stoppages* deals with this problem, implying examples of a randomly anamorphic grid. So the reality portrayed upon such a grid would be like the "cracked looking-glass of a servant" that Joyce spoke of in *Ulysses*—a wavy surface which might reflect a wavy reality, or might distort it, or might simply not happen to fit it: Though both be wavy, they are wavy differently. It would take too many such mirrors or grids to happen to fit any conceivable twist of cosmic whimsy.

Merz is an Enlightenment Rationalist in that he will not accept the idea of a wavy grid which may never happen to find anything that will fit onto it. Yet he

also rejects the frozen or hypercontrolled stasis of the rectilinear and filled grid which leaves no slack for movement or change. He is left with a rectilinear grid on which it is likely that nothing will be inscribed. His grid is not about supplying meaning. It is about supplying the possibility, or the concept, of meaning, while it remains impossible on other grounds.

The grid as both rectilinear and full of inscribed meaning is a picture of Modernism. In terms of pre-Modernism, the grid wasn't rectilinear, but was still filled with a kind of meaning that seems random in terms of the rectilinear grid. Merz's blank grid is the rational post-Modernist version: It is rectilinear, affirming reason like the Modernist grid, but empty, denying, from a post-Modernist viewpoint, that anything can fit into a rational scheme. Reason holds true, but nothing holds true to it. Merz's grid is Late Modernism, by reason of its rectilinearity, but verging on post-Modernism, by reason of its emptiness. It's the portrayal of rational consciousness onto which nothing can be registered because its rationality is too perfect. The grid or place for meaning becomes in a metaphysical sense the void of nonmeaning, which is the real or ultimate outcome of the issue of meaning. This sense of meaninglessness is not conceived as a tragic vision, "full of sound and fury, signifying nothing," as Shakespeare's Macbeth observed; it is not presented iconoclastically as a tragic flaw in the character of civilization, or existentially as an agonizing emptiness that one can barely survive the transit through. Nor, when the grid suddenly opens its arms, is there a hushed reverence as at a sudden and unexpected vision of the sublime.

This grid attempts to be merely neutral—to transcend its implications— and as such to be an advanced representation of reality. The grid is empty because anything is meaningless unless one projects a sense of meaning onto it. Such projections would be the figures inscribed on the grid. A part of the work is that the artist seems to be inviting us not to make these projections of meanings.

In about 1985, the focus of Merz's work shifted into sculpture with architectural references. Two structures by Merz which can introduce the genre are parallelepipeds, about the size of small garages, built of travertine marble in an ashlar style of masonry;[2] they resemble architecture, but the fact that they have no entrances means that they do not function as architecture but as sculpture. You cannot enter them. They hold the space, but they do not offer it.

In the context of Modernism these structures invite metaphysical readings as of transcendental spaces with secret creative capacities. The Cabalistic zim-zum, for example, which lies behind much of Newman's work, is such a space. It is comprised of a "contraction of God," an inner withdrawal of plenipotentiary fullness which, in the creation myth that comes down from the sixteenth-century Palestinian Cabalist Isaac ben Luria, temporarily emptied out a space in which a universe might arise.

But the appearance of coldness and blankness that Merz's sculptural structures exude fends off the visitors' tendency to suspect inner sancta. As one circumambulates them, the point increasingly seems to be that there is nothing

inside. Insofar as they are mysterious enclosed spaces, their mystery is simply the neutral factuality of their emptiness or meaninglessness. The ashlar masonry of the coldly pale travertine recalls Merz's two-dimensional gridded surfaces that contain neither meaning nor feeling.

Merz has remarked that in the earlier gridded pictures the avoidance of suggestion or meaning or pictoriality was carried out "in order to retain the ambition of totality."[3] If there was some suggestion or meaning or picture, it would have to be a specific suggestion—a suggestion of this or that. Specification would delimit the work; it would no longer be neutral. But the blank surfaces and structures suggest totality without sentimentalizing the idea as an all-embracing spiritual matrix from which a creative act might arise, like zim-zum. Totality is simply the fact of meaninglessness: "There's nothing behind it," Merz says of his work.[4] No part of a picture is more important than any other. There is no guidance of cognitive focus.

Like the meaningless grids, the relentlessly neutral sculptural structures have an insouciance or casualness about their seemingly aggressive assertion of negation or emptiness. There are traditions in which emptiness is regarded with *horror vacui*, and others in which it is revered with emotions that rise in the throat. Here a different attitude obtains. Emptiness is simply a meaningless fact in the way that, say, numbers, by themselves, are meaningless facts.

The blank grid and the inexpressive structure parallel the monochrome painting in its appeal to the ultimate. Merz's work in this genre lies between the metaphysical monochrome (from Malevich's *Black Square* to Newman's *Onement 1*) and the materialist monochrome (from, say, Richard Serra's deformations of Malevich's *Black Square* to those by Jannis Kounellis). Though they may in fact look more or less identical, they are differently aimed or tilted by the intentions behind them, which are known to the viewer. The metaphysical monochrome "represents" the ultimate absolute beyond, where all particularization and differentiation are melted into the one; the materialist monochrome represents the sheer actual materiality of a thing, which differentiates each thing from every other.

Merz has worked on a position that derives historically from that articulated almost a century ago by Rodchenko. It is neither the work's sense of pregnant emptiness nor its sense of baldly stated material presence that is the message. The message is how hard it is to face neutrality: the cold fact of its emptiness or meaninglessess, stated without emotional projection—either lament or celebration. The sense of factuality is not, as in American Minimalism, the factuality of matter in all its threatening solidity. Nor is there sentimental feeling about "the Void" or some such idea of unthreatening immateriality. An arbitrary emptiness of meaning is simply experienced as a fact which often goes unacknowledged in culture.

In Merz's view of art history, Malevich's *Black Square*, neo-Plasticism, Russian Constructivism, Mies van der Rohe, the Abstract Expressionists (especially Newman and Reinhardt), Duchamp and the Readymade were the essential vocabulary elements that history created through its travail, and now, with the vocabulary lying on the table ready for use, Modern art can at last be made in a synoptic sense.

Gerhard Merz, Berlin Lustgarten I, *1994. Photo: Jörg von Bruchhausen.*

Merz's Lustgarten project occupies a park-like space in front of the Altes Museum in Berlin, an ornate neoclassical building designed by architect and painter Karl Friedrich Schinkle, the official state architect of Prussia at the time when the neoclassical was passing into the Romantic. The building was erected in the period 1822–1830. Goethe is said to have lived more or less next door to the museum and approved of it. The Altes Museum represents the German Neoclassical/early Romantic tradition of Goethe, Winkleman, Hegel, the Schlegel brothers, Schelling, Schiller, and so on.

The Lustgarten, or Garden of Pleasure, is a little parkland in front of the museum in the midst of which stands a granite bowl-like sculpture, about ten meters in diameter. The pedestrian on the sidewalk gazes across this parkland at the museum in the background.

Merz's addition to the site is a monumental façade that acts simultaneously as an autonomous construction of Modernist vocabulary elements and as a viewing frame and entranceway for the park and museum.[5] The structure is both multilayered and simple. A long central entranceway through which one enters the Lustgarten with the museum in the background is flanked by two massive wings; the three elements all lie in a straight line paralleling the street and share a flat, line-like roof.

The two flanking wings of the Lustgarten entrance feature inner spaces,

visible from outside, enclosed by vertical glass panels. These panels are separated by steel upright members which imply a grid of emptiness and at the same time refer to works of Mies such as the Farnsworth House in Plano, Illinois, with its multiple glass inner panels. But here again, as in the travertine mausolea, access to the interior space is unavailable. Since the exterior sheaths are not in this case impenetrable stone but transparent glass, each wing of the structure becomes a kind of hermetic theater that the passerby can gaze into like a voyeur, but which remains closed and separate. Again, though it looks like architecture, it functions like sculpture, as an object which presents itself solely for contemplation, not for use. Each glass-enclosed wing contains a kind of figure on its stage: a long freestanding inner wall covered on all sides with smoothly executed monochrome fresco of what Merz calls "Roman ochre," a yellow-brown that implies reference to the colors of the walls of ancient Mediterranean sites such as Pompeii. The color, Merz says, has "absolutely no life, no fire." The monochrome walls stand like vast sculptures announcing the flatness and coldness of the inaccessible unity of the inner sancta round which the daily life of the street and the city transpire without touching or affecting them in their pristine isolation. Though they are a theater that presents itself visually to the viewer, unlike the opaque travertine theatra, still, these too are theaters in which nothing transpires; there is a presence, there will be alterations of light and shade and ambience; but the drama that transpires is always like the empty grid or the inexpressible assertion of the seemingly immovable travertine enclosures.

Merz seeks, as he puts it, a "cold" art, meaning dedicatedly anti-sentimental. It's a position with a strategy and an agenda, like "cool jazz" of an earlier era or the cosmic cold of Bach cantatas and partitas. In the simplest sense it means that one has not projected emotional fantasies onto the work; one has not been able to use it for some purpose of desire or aversion.

Due in part to the somewhat excessive verbal supplements of the artists whom he has chosen to refer to—especially Malevich, Mies, Newman, and Reinhardt—it is natural to regard Merz's work in Platonic or ideal terms. He himself has compared his works with architectural references to Greek temples. Yet most of Merz's own verbal supplements do not go in this direction, and one does not think that he means the concept "Greek temple" in an archaizing or sentimentalizing way. In regard to transcendentalist art, Merz wrote in 1994, "corrupted by the devotional, one decays tastefully."[6] He seeks, on the contrary, artwork "without any clandestinely beating heart."

The lack of an inwardly beating heart implies that the art is dead. The denial of life and fire, and the idea of a "cold" art, also point toward the idea of death. Similarly, Merz once referred to the artists of the abstract sublime as death artists. And indeed, there is the sublime in his work, in the coldness-death theme, and in the neutral emptiness with static regard for the duration of things, and with little respect for their integrity as themselves.

So what is left? An art supposedly without ideology yet not based on feeling and impulse so much as on reason and formal purity, which point nowhere. There is about it an implication of Plato's realm of *Nous*, or universal mind, where

pure forms sustain one another, through myriad inscrutable connections, forever without change. This ordering, this cosmos, this emptiness of meaning, this coldness of factuality, is simply what is—on one level, anyway.

The simplicity and monumentality of the primary shapes in Merz's work also suggest something akin to the Platonic idea of pure eternal forms. But this is a cold Platonism, not a hot one. It is a Platonism emptied of philosophical kitsch. Merz's work seems to express a demystified sublime, though it is still a sublime. His artworks are not autonomous in the sense of being connected to metaphysical universals; they are simply autonomous the way numbers are autonomous, the way a list one encounters in a jacket pocket years after writing it may seem pointless and inscrutable. What was this ever a list *of*? In the most mundane sense, the sublime is simply the other—any otherness will do, such as the list whose point has been forgotten.

Since Yves Klein's exhibition *Le Vide* (*The Void*, 1959), the presentation of empty spaces has become a fundamental vocabulary element of late Modernism, and it has served a variety of sensibilities. Merz's emptinesses don't point toward a metaphysical beyond, as Klein's did. They don't point, in fact. They're just there in the meaninglessness of being themselves, emptinesses that are simply the plain facts of life.

When the metaphysical system of late Modernist abstraction first seemed to be breaking down, if an artist rejected the transcendental, it was understood that he or she was advocating a return of attention and concern to the social. There was really no third realm in the discourse. Minimal sculpture, for example, often employed construction materials in static rectilinear structures not entirely unlike Merz's walls of ashlar travertine. Carl Andre's arrangements of ordinary bricks on the floor are an example. In these cases there was often a Marxist or neo-Marxist intention: returning attention from the spirit to the body, from the immaterial to the material, from the aspiration toward a beyond to an engagement in the immediate project of reconstructing society on a material as well as a social level. For Merz, transcendentalist art is polluted by philosophical kitsch; socially engaged art is an ineffectual appendage to the reality of simply living.

In most art, as Merz once remarked, "Not enlightenment but rather atavistic desire and philosophical kitsch serve as proof"—that is, as proof of the supposed meaningfulness of the work. Merz's own work seeks to incarnate the Enlightenment, simply as an acknowledgment of the unrelenting presence of factuality. "Other artists," he remarks, "believe in creativity; I believe in construction."[7] Thus, life is free, in terms of the various emotional projections we can make upon neutral data, but art is not: it is dictated by the fact of factuality, "in the court of dead artists which allows us to do what we do."

Dove Bradshaw, Plain Air, *1991. Installation at P.S. 1 Contemporary Art Center, New York.*
© *Dove Bradshaw 1989.*

Chapter Twenty-six

In the Form of a Thistle: The Work of Dove Bradshaw

A Conversation between John Cage and Thomas McEvilley

29 May 1992

Eckhardt lived at the same time as Milarepa. He flew through the air in the form of a thistle.
—John Cage, *en passant*

[Traffic noise in background]

T: You've been a collector of Dove's work for a while.

J: Yes. Because there's an idea I had in the forties, and now that I'm a little bit older I still have the same idea more or less: that one of the ways of saying why we make art is that it helps us in the enjoyment of life. The way of enjoying life keeps changing because of changes in our scientific awareness. The way you enjoyed life in, say, 1200 is different from the way you enjoy it now. And that accounts for the changes in art.

I find Dove Bradshaw's work useful in this respect. She's involved, as we all are in our lives, with an almost scientific procedure. Her art is a series of experiments. And she can subject us to the results of her experiments, which can open us to the life we are living. It's very curious and very true.

I am thinking for instance of one of her works which uses, I don't know all the words, but this silver something or other that she applies, so that what she's putting on the canvas is not necessarily what you're going to see there in a few days or in a month or something. I saw a work of hers of that kind, and it corresponded with my then notions of beauty, and I own it now. Since I don't have much space, I put it in a closet. Then after a while a Jasper Johns picture went out to Europe for a year, and I took Dove's picture out. And it isn't what it was anymore; it's something else.

T: Is this one of the chessboard sculptures with liver of sulphur added to

silver leaf, causing it to change quickly in response to the air, so a conformation originally hidden comes to the surface in time?

J: Exactly. Now it looks like a chessboard, but when I acquired it, there was no indication of a chessboard at all.

T: Oh, how funny. So it's a real chess-game piece. It made a move on you. It tried to blow your mind, the grid of order rising up out of nothingness.

J: Yes, now the order is what you see. The mystery, the sense of landscape, of biomorphic reality, of things beyond human control, all of which was there before, is gone; now it's the presence of order.

T: To me, so much of Dove's work, including this aspect you have mentioned, seems to relate to the distinction between nature and culture. In this case the grid of the chessboard signifies culture; the amorphous, changing, process-oriented, unpredictable and hence unknowable ground is nature. And it changes back and forth.

J: It changes. The Lord knows when it will return to my then preference.

T: I was thinking something similar in relation to much earlier works, the eggshell sculptures from 1969 or so. First there was the broken eggshell in bronze, then in silver, then later the one in gold. I've thought of it as the Orphic egg that breaks, and the god Phanes appears out of it and the stream of the world of forms flows out of his gaze. I was thinking that the eggshell piece is like a matrix or womb out of which Dove's oeuvre unfolded its array of forms. And that it also [like the chessboard piece] has something to do with going through that veil between form and nonform. The broken eggshell is there like the record of a transit, a crossing of that border. It has also struck me that the distinction that you've brought up is like the Buddhist idea that form is emptiness and emptiness is form.

J: Yes.

T: It reminds me too of something of yours that I've read, where you talked about the possibility of there being nothing. And I took that phrase in a variety of ways. First there's the possibility of *nothing*, meaning it's possible that there would be nothing; then there's the *possibility* of nothing, meaning that the world of potentiality comes out of nothing.

J: Yes.

T: And the egg piece to me seems to suggest all of that—it foresees the transition between formlessness and form which your silver painting [or sculpture]

underwent to your surprise—the soupy stuff inside the egg being relatively un-formed, then when it cracks open, a fresh form emerges. And in these recent works where she puts that liver of sulphur on the silver leaf, something like that birth or that crossing or that transition happens again. That early eggshell piece states in a kind of fixed symbolic way what this new painting—that changed when you weren't looking at it—acts out.

J: Yes, it's quite amazing. The fact that the piece changes requires a change of attitude toward it. If I, so to speak, change with it, then I can change with the world that I'm living in, which is doing the same thing.

T: Which is also changing in uncontrollable ways.

J: Yes.

T: So this is what you meant about art being a tool to help you enjoy life.

J: Yes, and to not be set mad by it.

T: So at first the artwork fulfilled your expectations and then it ceased to fulfill them—

J: Now it's teaching me something.

T: Now it's teaching you about the limits of your expectations.

J: Yes. And that's a situation which I think we still can't confront in any other way than to be confused; it's in that confusion that we live. And to enjoy that absence of security, particularly when security raises its head—

T: Its tempting, seductive head—

J: It's testing us in our tranquility.

T: I'm reminded again of a Buddhist phrase, I think it's in the Perfect Wisdom texts, where Subhuti, speaking of the bodhisattvas, says, "They stand firmly because they stand nowhere."

J: Isn't that beautiful. Yes.

T: So in your experience of the chessboard work, there's a sense that we're standing, and the ground is underneath us, and then the rug is pulled out, and there's this experience of free fall, and yet both of those things are our location, both the standing and the free fall.

J: Yes, that's where we are, that's where we are. That's the confusion in which we live. Marcel Duchamp said, speaking of utopia, that we won't be able to reach it till we give up the notion of possession. And this work of Dove's confronts possession completely.

T: You've got it, and then it slips through your fingers, it's something else.

J: It's something else, which you may not have wanted.

T: Which you may not even like.

J: But if you change your mind, you may enjoy it.

T: So it's very challenging and demanding, isn't it?

J: Oh, very.

T: It cracks the whip over you a little bit.

J: Exactly like the Zen monks with the stick.

T: I remember in some earlier interview where you said, "I don't want to spend my life being pushed around by a bunch of artists."

J: Yes, I did say that.

T: Well, here's another artist pushing you around.

J: Yes, exactly.

T: There's an interesting passage somewhere where you said that for all your great admiration and friendship for Rauschenberg, you had a little difference with him in that he said he wanted to work between art and life and you would rather just collapse them altogether.

J: Yes.

T: Well, that line of thought brings me to raise the word "history."

J: Yes.

T: The idea of history is like the idea of riding the line of the boundary between nature and culture, tracing the arc of that line, where it is located at different times and places. In our Western, Hegelian, dualistic, Judeo-Christian

view, we have a really paranoid dread of nature, that nature will sweep up and overcome history and pull it down into some swamp of irrational meaninglessness. Western culture has been characterized by a mad ambition of somehow separating itself from nature and eternalizing itself as pure form, which leads to culture's paranoia of seeing nature as this vast, dangerous, potentially engulfing abyss that will sweep up over it, carry it away, hold its head under, and dissolve it into the swamp again.

I think you once said that one should get oneself out of whatever cage one is in.

J: Yes, I did.

T: Well, history, however we conceive it, is our cage. As Joyce said, "History is a nightmare from which I'm trying to awake." In trying to break out of it, we seem to pass through a kind of membrane where we flip over into formlessness and what we perceive as disorder, terror, the abyss, the swamp, the sublime and all of that.

J: Yes.

T: And there's that moment when it's almost like there's a choice between form and void, and yet we can't make the choice, we have to somehow have both. And this is that kind of perilous tightrope edge that I see Dove's work as walking.

J: Yes, the confusion in which we live.

T. You know, Hegel called history "Work" and called nature "Madness."

J: He did?

T: Yeah. He thought nature did no work; it had no meaning and no intention. And when we try in this paranoid way to separate off what we do from what's around us, we think of history as embodying an intention, and of nature as not having any intentions. And yet I'm wondering if nature doesn't reveal or at least suggest a set of intentions—for example, the cyclicity of the solar year could be interpreted as a kind of intention.

J: Yes, indeed. [Laughs]

T: And Dove's work can be seen as balanced at that line where you're seeking for that other sense of intention that is in nature, without completely losing your grip on culture, on that very circumscribed trap of limited intention which is history, and which has somehow constituted you. So in terms of your idea about getting out of whatever cage you are in, the liver painting is about hovering at the door of the cage: You've got the door open, but you're not sure which way to go.

It's not only the works based on change that involve this idea. There's that sculpture of hers, a big thorn which she has dusted with red pigment. Again, the thorn of course is nature, the pigment represents the idea that art can make nature into culture, which I guess is the quality of the alchemical transfiguration that art does, which is to move things back and forth across this line between nature and culture. Then there's the fact that she chose red for the thorn; iconographically again there's a hint of cruelty or sacrifice; the thorn pricks you and you bleed, and that's how it gets red. The crown of thorns. And of course the red/blood linkage, like the broken eggshell, signifies both the end and the beginning of something, and the mysterious linkage between ends and beginnings which can't be seen in the flow of process, but which makes up in some way the web of causes and effects. There's something about this transition being difficult or painful.

J: Or just full. Because the word "red" and the word "blood" are the same word in Chinese. It's a full word which goes in these different directions.

T: I was in Dove's studio yesterday, and we were looking at the large new silver-leaf and liver-of-sulphur piece in the front room. You know it?

J: Yes, it's very beautiful.

T: That's the point. We were looking at this work and I said, Dove, how do you deal with the fact that this work has such presence along lines of predictable aesthetic beauty that we associate with gestural abstract painting? Is the point of this work this condition of aesthetic presence, or is the point of it this underlying changing process that is quite indifferent to aesthetic presence or to any particular idea of aesthetic presence? There's an interesting tension between the aspect of aesthetic presence pulling the work into culture and the process of underlying change pulling it back into nature. That piece is very attractive at its present moment—that is, it corresponds to my present idea of the aesthetic.

J: So her work is anti-possession and pro-history.

T: But anti-history in its apparent affirmations of nature is a force that could engulf history.

J: Yes, except that now it's happened that many of us, not all of us but many of us, love nature.

T: Yes, I see what you mean. It would be perverse to call the love of nature an opposition to history. It's true that with the decline of Modernist ways of thought, it has become historically possible at last to love the idea of redeeming culture through a kind of baptismal immersion in nature.

J: Just now I mentioned Marcel's idea about ownership. And I was impressed by the difference between Rauschenberg's empty white canvases and the monochromatic white works that Dove has recently made, because if you touch Dove's, the pigment comes off. Not only is it in transition from within, but we can move it or remove it by contact. That's not exactly the same as those years-ago beautiful works of Rauschenberg. And the difference is the difference between then and now. That then became beautiful for me by receiving dust. This now, equally white and empty, is willing to give itself and to change itself, and without losing itself. So it too becomes a model for daily behavior, which has as its goal the enjoyment of life.

T: Yes.

J: I look forward to our daily behavior on a global scale becoming utopian, where we won't have this hellish difference between rich and poor, and where ownership will quite naturally no longer be useful.

T: The anthropologist Henry Lewis Morgan, in writing about private property, wrote, "The human mind stands baffled before its own creation"— meaning the institution of private property.

J: Yes [laughs], yes. I think it's very important that we see that what we own—we don't even know what it is. Or what aspect of nature or non-nature it's going to reveal to us.

T: So that when Dove's work changes, or gives part of itself away, it's asserting the impossibility of ownership or the blindness of the idea of ownership

J: Yes. Or even of the fixity of the thing.

T: Our idea of the fixity of the thing, which we project onto the thing, is the result of our desire for security and—

J: All of that—

T: Our desire that we ourselves be fixed and defined.

J: All of those things we need to give up. We're being hit over the head by the need, it's so clear.

T: What you're saying is interestingly parallel to the Marxist idea, in that the elimination of private property would function as the end of the nightmare of history.

J: Um-hmm.

T: The awakening from the nightmare of history.

J: Most people now cannot believe that ownership will go.

T: Much of the world is still at the beginning of the seduction of ownership.

J: And they believe that you should own a good thing rather than a bad thing. And that just leads to more problems. They develop all these things seeking something that's no longer spiritually available, namely fixity. But life is preparing us for both a constant loss and a constant gain, and also a not knowing whether it's good or bad.

T: So thinking of the broken eggshell again, you seem to be hinting that what might rise out of it is a new sense of our own selfhood.

J: Yes.

T: It's interesting how that eggshell piece changed in its materials, from bronze to silver to gold, with such alchemical associations. Sulphur too has great prominence in alchemical traditions. Even though I don't think that's why Dove adopted it, that association does become involved, in the weblike way that meanings construct themselves. Yet this alchemical implication of some of the work seems to suggest a reference to a higher transcendental fixity. The gold eggshell, for example, is a kind of contradiction. The eggshell is frail and changing; the gold is fixed. In antiquity, gold, because it supposedly doesn't rust or change, came to represent the idea of an essence.

J: And that idea in art makes people prefer paintings to drawings, and so on. Because they last longer and don't even get dirty.
It's like what's said at the end of a telephone conversation, "I'll talk to you later." And that's not what's meant.

T: Yes, there are so many things wrong with the statement—the I, the you, the later.

J: And the talk. It's all meaningless.

T: Yes.

J: To me it seems that the work of Dove Bradshaw focuses on our changing conceptions of time and space, which we have assumed for a long time are two different things. Nowadays more and more we say spacetime, and we are beginning

Dove Bradshaw, IV, series nothing, *1989.*
Collection: The Art Institute of Chicago. Courtesy of the artist.

to actually mean it. We don't think it any longer, we experience it. When we go from New York to Chicago, it's not only the space that changes but the time too; it's a timespace experience, and I think this is what Dove's work is about, preparing us for that experience, particularly her work of recent years. We're confronting now, I think, the fact that her work relates to the identity, not the separateness but the identity, of time and space. Of all the arts—certainly more than music anyway—painting is fixed.

T: I love that moment when the chessboard rose up out of the amorphous ground and confronted you.

J: Yes, and that's a real relation or identity of time and space, in the same fixed rectangle.

T: It's happening both as time and as space.

J: Dove has introduced time into space, and our living is in that confusion.

T: Of course there are historical connections. The famous story of the *Large Glass* breaking and Duchamp remarking that he liked it better. Polke also uses chemicals that cause his pictures to change color and texture in response to changes

in temperature and moisture in the atmosphere around them. So they're constantly changing, but on the other hand they are fixed: I mean in the same climatic conditions they will always look the same. They don't go away. Whereas in Dove's work, what goes away won't come back.

J: It won't?

T: It might come back in a random way. But in Polke's work it's controllable; if one put the picture through a certain set of changing conditions, it will go through the same responsive changes. But once Dove's work has gone through a phase, it doesn't go back.

J: Lord knows when it'll get back, if ever.

T: To a degree that element is part of the classical conceptualist project of subverting the idea of the painting, parodying the idea of the eternality of the masterpiece by changing almost before your eyes. But then of course traditional paintings change in time too. I was in Amsterdam a couple of days ago and went to the Rijksmuseum and saw the big Rembrandt picture, the *Night Watch*. A wall plaque said a number of interesting things about it. For example, all the people represented in the painting paid a share of its cost, and these shares varied depending on what position they got. It cost more to be in the front row rather than the back, to be in the center rather than at an edge, and to be in the light rather than the shadow. The wall plaque also informed me that this was not initially a painting of a nocturnal scene; it was a scene in the afternoon. The paint darkened. So traditional paintings as much as Dove's work are also going through this change from moment to moment, though more slowly.

J: In the pyramid style.

T: Yes. She speeds the process up as if to expose the secret: This pyramid is not eternal, any more than that thatched hut beside it is.
Do you remember those works of Dove's from about three years ago that are painted on lambskins?

J: I surprise myself and others sometimes by remembering something, but my mode of being now is not having a memory. I just don't remember anything.

T: Is that an ahistorical mode of being?

J: I'm thinking of those little computers where you put it in different modes.

T: There's a nice passage somewhere where you remark that when one says there's no such thing as cause and effect, what you mean is—

J: Everything causes everything.

T: Yes. Now, the idea that everything causes everything tends to reduce to absurdity the idea of history as embodying a narrow-focus stream of intentions. It flattens everything out at the same time that it posits infinite infinities. In a sense it seems obvious, yet still it's hard to fully live with. A moment ago, for example, you remarked that you look forward to a utopian condition in which the rich will no longer exploit the poor, or something like that. And there seems, in this looking forward, to be a specific focus of intentionality—more specific and focused than the idea that everything causes everything. If everything causes everything, then effects arise unpredictably out of the tangle of things, and the idea of our looking forward to something—or having a certain will about the way we want the world to go— suggests an underlying suspicion that in fact causality runs in a thinner stream than that.

J: Well, right now I am reading an ancient Chinese text on health. Do you know that one, the *Yellow Emperor*?

T: I don't think so.

J: Well, what they do, anciently, in terms of health, as far as I understand it, is to take nature as the model for human behavior, which is the cyclic succession of spring, summer, fall, and winter, together with Heaven and Earth, and to see all that as something which . . . If it works rightly, the normal course of events will be for each person to live for a hundred years. And if you do it incorrectly, if you don't act as nature does, you will die much sooner. So long life consists in acting as nature does.

Another thing that I learned from Zen and from the teaching of Suzuki is that the whole of creation is "Mind" with a big *M*, and each person is "mind" with a little *m*. The little *m* often thinks that it has purposes and senses of direction, but if it changes its direction, if it turns round or is converted, then it looks out of itself toward the big Mind, either at night through dreams or in the day through the senses.

T: Yes.

J: And what Zen wants is that it flows with the big Mind, and what Chinese medicine wants is a relation of conduct to nature.

T: Uh-huh.

J: And there's no fear of chaos.

T: In an earlier interview you said that back in the sixties, during that

moment when it seemed there was such a potential for social change immediately before us, you had a lot of faith in the idea of socially engaged art, politically engaged art; yet in an interview made in the early Reagan years you said that you don't believe in the efficacy of *art engagé* anymore.

J: No, I don't now either.

T: Recently again, of course, an increasing number of artists have begun to work with a sense of political engagement and purpose, a sense that historical intentionality can be used in a beneficial way to break out of the trap of history. I'm wondering, if everything causes everything, then there's no point to doing as Bertrand Russell did and getting out in the streets demonstrating against nuclear weapons. If everything causes everything, then he might as well stay home and drink tea and that might cause the end of nuclear weaponry. But within the framework of history we are encouraged to think that, even if in the grandest scale everything causes everything, still in a smaller scale some things cause some other things in a particularly visible way. This then directs our actions in a social context toward specific ends and meanings. Maybe the big *M* and the little *m* should be in balance rather than excluding or diminishing either for the sake of the other.

J: But don't you think that the things that are happening are all things we would have thought are impossible? I mean how is it possible that Russia has disappeared? And are we not moving in the same ignorant way into the history of the future?
Do you know about nanotechnology?

T: Only that something called that exists.

J: It could be a technology that Fuller would have loved. He often spoke of a new technology, one that we don't yet know, and advised us to save our oil in order to make the pumps go for the new technology. Nanotechnology is a microtechnology that says that we could build all the things we need out of the pollution in the air. So that after twenty years of nanotechnology we could have the environment equal, say, to that of 1800, without pollution. We would use it creatively rather than nearly kill ourselves with it.

[Long silence; construction noise muted]

And how will that come about? I don't think that making an art that promotes nanotechnology would help. The Japanese have made some buildings to study the possibility of nanotechnology. To do it. But I don't think our climate here conduces to intelligent action.

T: This particular climate of North America?

J: Of America.

T: The social and cultural climate?

J: I think our politics, our meeting as a society, is overcome by stupid intent. So that it wouldn't know what it should do even if it thought it should do something.

T: I've struggled a lot with the question of whether I believe in politically engaged art. There's a criticism that is often made of skeptical and deconstructivist and infinitist ways of thought—ways of thought that might lead to an idea such as that everything causes everything, or simply that causation is impenetrable or some such throwing-up of the hands. The criticism is that such ways of thought tend to remove one from an active attempt to generate a healthier social situation around oneself, because they belittle any finite purpose. I'm not convinced that this is or need be true. Even if, let's say, we're prepared to recognize and live comfortably with the idea of the ultimate indefiniteness of meaning, or with the infinity of causes, we still might feel in an emotional sense that nevertheless there are certain things that we must do or must not do. And this might be why a very sophisticated skeptical philosopher such as Bertrand Russell, very aware of the limits of meaning, would nevertheless go out on the street demonstrating against nuclear weaponry. It's not really the issue whether this can be proven to be effective. It's just that as myself feeling myself in the world, this I will do. So that it's possible to do both, to feel that everything causes everything and also to feel that one must act with specific ends in mind.

Anyway, the idea of the effectiveness of political art is not such a direct idea as, say, that an art promoting nanotechnology might lead to a government program to fund it. No, it's just that the art around us, or the visual culture around us, promotes an ambience in which certain things may be more likely to happen than others.

J: That again is something shown by Dove's work. That whether you did or didn't, it would happen. The things that happen in her work are, so to speak, full of not *her* determination but *its* determination, such as chemical change, or gravity. She uses the word "event" for what happens in her works. She doesn't try to help. She observes the event. I don't think she bothers either to encourage it or not.

T: Well, she has set up the situation for the event to transpire in, and has defined the parameters. I don't think her hands are quite as clean as you do. And let's think again of the question of the aesthetic presence of much of her work. Is she going to encourage that or remain indifferent to it or even oppose it, as some artists do who feel under obligation to resist aesthetic presence as a regressive force?

J: When I told her that the one I had liked had changed to an image that I didn't particularly like, she offered to let me exchange it for one I did like.

T: For one that at the moment corresponds with the conformation of your habit system. But for how long?

J: I said, No, I want to keep the one I have. I want to continue to see what will happen in it.

T: You once quoted, I think it was Thoreau, as saying, "When I hear a sentence I hear feet marching."

J: Yes, that was he.

T: By which I guess he meant that any assertion is a power move, that any assertion is like an army moving on reality and trying to dominate it and force it to submit to a certain vision to the exclusion of other visions.

J: It's in the preface of one of my books.

T: I think Thoreau is one of the key American authors.

J: I think he's the only one.

T: Well, Whitman means a lot, too.

J: Yes, increasingly so. Do you know that Thoreau, when he wanted to please someone or give a present, would give *Leaves of Grass*?

T: Incredible.

J: That thing we have noticed in Dove's work, that it might almost be more at home with science than with art, is also true of Thoreau. Walden was a scientific experiment to see if life was worth living. He says that.

T: He was really our American Diogenes. When he moved into the toolbox by the railroad tracks, he was consciously thinking of Diogenes living in the grain bin in the marketplace. And I suspect that his idea of civil disobedience came at least in part from contemplating the resistance tactics of Diogenes. It was the Diogenean impulse that led him to refuse to pay taxes. The gesture involved the postulation of the possibility of a culturally open space beyond any projection of an absolute or a framework. And I really think Whitman's about that, too. Still, I'm interested in your idea that maybe Thoreau is the *only* American author.

J: That's the effect of love speaking.

T: Yeah, right! And I observe with interest in myself that my reaction to that is to defend Whitman.

J: Well, Thoreau would have agreed with you. That's why we love him so.

T: Dove's work, like the oeuvres of many artists of her generation, began as sculpture, then became conceptual art and now is painting. This is an arc through which many people have moved, with painting so ubiquitous again today. But Dove's work, when it surprised you and changed while you weren't looking at it, was behaving more like sculpture in its performative aspect, its tendency to occupy the real spacetime of the human body. So that in her oeuvre, there seems to be an interpenetration of those categories.

J: Yes, and again, that is the confusion in which we live.

T: This work of 1975 is interesting. [Both begin to look at photographs supplied by the artist.] A crushed paint can that looks like it's been run over by a bulldozer. A lot of her works from this period are really classical Conceptual Art, the reduction of a painting to its materials. This again goes back to Duchamp, to his remark that the painting is an altered Readymade. And Yves Klein exhibiting the rollers that he had used rather than the painting he had made with them.

J: I like that.

T: Here is a piece called *Painting 78;* it's a tiny sculpture that consists of rolls of dry paint scraped off of a sheet of glass.

J: That's just marvelous.

T: I like its delicacy, its tininess. Of course it's again, like the bulldozed paint can, a part of that general conceptual project of converting the medium of painting into a form of sculpture. Here's another example, *Drawing 78;* it's simply an array of pencil shavings, another tiny sculpture based on reduction of the drawing to its material origin. There's also the sense that this is the detritus, the thing that would ordinarily be thrown away. This whole area of Dove's middle period work relates so closely to the themes that Yves Klein left, such as his famous remark, "My paintings are the ashes of my art." This piece seems to partake of that spirit to a degree. Another of Dove's works that relate to this idea is *Fire Hose.* It's a photograph of a fire hose coiled up on wall; I think the point is not the photograph as photograph, but the found object as sculpture. It is just what's there—it collapses that art/life distinction—but in addition it seems to have certain specific meanings and suggestions. It involves, for example, the idea of putting out a fire, like the ashes of art, the idea of danger and emergency as something about the nature of art today; as Lyotard said, "Art is a perpetual crisis."

J: I like that too. Yes, that's beautiful.

T: Something we haven't mentioned overtly yet is Dove's rather inspired use of materials.

J: Yes, and her constant experimentation.

T: You're right; they are kind of the same thing, aren't they? Making something art can be simply a matter of experimentally transposing it from one material to another. This, for example, is a little bottle of petroleum jelly that is smeared with petroleum jelly on the outside too.
And a work we haven't mentioned yet is the piece with the doves living in the gallery.

J: Yes, I'd love to hear what you have to say about it.

T: Well, it's her namesake work, and she's repeated it, it seems to me she's put some special emphasis on it. You mentioned that her work has a certain sense of scientific experiment—

J: Yes—

T: —which again, in terms of our little art history, goes back to Duchamp, specifically to the *Three Standard Stoppages* of 1913, in which he developed a quasiscientific procedure for generating lines that don't show the prejudice of a hand or a taste or a habit system. Dove, by introducing two doves into a gallery and providing stuffs they might build a nest from there, has brought nature into the place of culture. It's a strategy like that of Lamonte Young's piece years ago when he released a butterfly on the concert stage and that was the concert.

J: And it doesn't even seem to be art. I remember Jasper saying that when the *Étant Donné* is seen in a museum, it will be the most unlikely experience for a museum to give.

T: I remember a story about Ramakrishna being taken to the zoo in Calcutta. He saw the lion first, then insisted on going home. He couldn't take any more. It was already overwhelming. And it was like art, the experience of viewing something exhibited for that purpose—while at the same time it was terrifyingly beyond what we accomplish with art.

J: It's interesting how the nest is incorporated in the carbon paper removal. Not the way the birds have put it together, but crumbled so it can lie flat.

Dove Bradshaw, Without Title, *1991. Courtesy of the artist.*

T: Some of the carbon removal works [in which Bradshaw makes a carbon-paper rubbing over some substance or other] have an elegant aesthetic presence along recognizable lines even though they involve the direct incorporation of nature. I guess this quality of aesthetic presence goes back to Abstract Expressionism. I remember a passage where you were talking about the dichotomy between Tobey and Pollock. But dichotomy or not, both those artists, and others of their time, taught us to aesthetically respond to the idea of these randomly modulated allover fields which you compared to a pavement, and which are like other things that we see around us all the time. It's this type of aesthetic presence that the carbon removal works have, and it is like nature. Like the way rust moves and covers a surface irregularly.

J: There's something about the relation of time on the one hand to photography, and on the other hand to Dove's work. We speak of the snapshot, but it's almost like we've accepted that photography is a way of possessing something. But in Dove's work again, it's removed from possession.

T: The absence is left there by the removals, and the absence is what we see.

J: Yes.

T: I think that approach was a discovery of the postwar period. It involves, again, a tip of the hat to Yves Klein, whose work also was about these reversals, taking things out of a gallery instead of taking things in. Your own concept of silence relates, too, wouldn't you say?

J: I would just take out the word "concept."

T: [Laughs] I'd like to return to the distinction between form as a bound state and emptiness as a free one, or between history as form and nature as emptiness. You mentioned Suzuki earlier, and an aspect of Suzuki's work that I would like to point to is that it shows a very finely attuned historical consciousness. In his writings about the development of Mahayana thought and his tracing of developmental sequences from text to text, there is a finely honed appreciation of the idea of the unfolding of history with a kind of inner intentionality. While at the same time what is unfolding, in his view, is not supposed to be a bound form, nevertheless he approaches it through the bound form. In practice, he doesn't dismiss the little-*m* point of view.

J: He said so beautifully in one lecture, speaking of history, that such and such happened in the eighth century or the ninth or the tenth or the eleventh—in other words he didn't know when.

T: But you can bet he had looked into it very closely, and his four-century span was probably the most precise date available.

J: Oh yes, but he was at the same time accepting uncertainty.

T: Well, of course, but you don't need Zen for that; that's a fundamental part of scholarship and of science, basic to the scientific method: accepting uncertainty in the limits of available evidence. In this sense science and scholarship, which is a branch of science, are very Zen-like, and also very much like nature rather than culture. Culture, if it's not sure, pretends it is.

J: Yes, yes.

T: I remember an interview with John Wheeler, the famous physicist, in which he was asked, When you began a certain line of investigation, what were you looking for? And he said, Why, whatever I would find.

J: Isn't that beautiful.

T: Again there's this idea that in culture we work in a highly focused historicized way toward something that may not be goal-oriented or rigidly fixed at all, but with a complete acceptance of uncertainty. Dove's work, for all its acceptance of indeterminacy, is highly determined and clearly defined in an art historical sense. In the dove piece, for example, the wheel [a hanging bicycle wheel on which the doves perched] is a reference to Duchamp and the target [beneath them on the floor to catch their droppings] to Johns. With a post-Modernist self-consciousness she sets out a cogent lineage. The various references to Klein are appropriate and refined. One could list various other historical influences or references and they would hang together with an appropriateness that an art historian would recognize. Yet at the same time it involves an ostentatious acceptance of uncertainty and indefiniteness, even a prideful abrogation of control. I am drawn toward that in her work—the combination of location and free-fall. There is a kind of responsibility to art that takes a particularly focused stand within history rather than attempting to escape the cage of history—which accepts the cage of history as if to say, this is what we have to work with. I would think, let's say, of the work of Hans Haacke, which is highly political and deals with specific topics such as the Mobil oil company's sponsorship of art exhibitions. I'm not proposing him as an ideal but as a well-known and respected example of an approach. By this approach the artist implicitly is stating, I have no pretensions or ambitions to get out of history, I am born into history, I am a historicized being, I take my meanings from within history, and history is my material; I want it to go in a certain direction, I will attempt to push it in a certain direction.

J: Well, the distinction between artistic intentions, some being politically engaged and others not, makes me think of the distinction between pure and applied science. Dove's work is like pure science, Haacke's is applied. But you need both. I'm tempted to say something like "It takes all sorts. . . ."

T: That's the simple point of what everyone's been calling post-Modernism.

J: Do you think it's taken a clear meaning yet?

T: I do.

J: Do you think it includes non-possession?

T: I do think so.

J: Yes. And the identity of space and time.

T: Modernism already I think contained that. Possession is more to the point. Modernism consisted of highly assertive ideas like possession, position, and

essence, and post-Modernism represents a loosening or relaxing of such concepts. Instead of position, indefiniteness—

J: Renunciation.

T: But not involving any religious overtones of sacrifice or austerity. Just a renunciation that involves recognition of the relativity of the self—of one's habit systems, their tininess, silliness, and arbitrariness. This is what leads to pluralism. Modernism was always based on the idea that there's a right way to do things; that's why culture was work. Post-Modernism is no longer based on a dread of the dissolution of culture into nature. We don't dread that anymore the way Modernism did.

When Modernism collapsed, or lost credibility, one of the options that arose in the expanded post-Modern array of options was pre-Modernism—the idea of reestablishing connection with pre-Modern modes of spirituality, including the idea that relaxing and letting culture dissolve into nature might be a redemptive tactic. The flower child movement, the ecology movement, feminist recognition of concepts like the goddess, your own championing of randomness and found sound—all these were signs of the loosening of the uptight dread that Hegelian Modernism had that nature was this kind of madness that was going to surge up and pull us down into oblivion; that all our order was going to dissolve into chaos, all our chessboards were going to become fungus patterns. In late Modernism, we didn't really accept that it takes all kinds. We would have been more than happy to root up and cast out many of the kinds of things there were. What we construed as bad things.

J: Yes, the value judgment ruled.

T: I see Dove's work as partaking in a mixed way of Modernist, pre-Modernist, and post-Modernist elements all at the same time. It's true that in a sense she "does" nothing in the work; that *it* does it—as in photography, where also there is a chemical process working out its own destiny. But the idea of doing nothing doesn't preclude doing something. Think of the Vietnamese Buddhist monks immolating themselves in protest of the war. These people had imbibed the doctrines of not-self, of the limitations of purpose and intention, and yet this did not at all remove them from a deep engagement in the problems of their society.

J: Yes, to the point of death.

T: To an incredible point. In the art world lately there's been a lot of right-wing backlash against the NEA and other things, an iconoclastic attack on the image. It's a resurgence of Modernism, which I see as a savage tribal force, the tribal myth of western civilization. What has come to be the great issue is, Are there absolutes of value? The Modernists say without absolutes there's no place to stand, no directionality, no ground for action. So if you deny absolutes, they feel you have

emasculated yourself and left yourself no way to act in the world. This I don't believe. I believe that one can still act in the world without a claimed framework of absolutes. To say that the ground is shifting under your feet doesn't mean you can't get anywhere. This recognition seems to me to return the idea of action to the only ground it can legitimately have—the dimension of personal feeling.

J: Yes. Well, I agree that in this great confusion, what is clearly viable is individual action.

T: This work of Dove's from 1978 is just a burned book. Why? To me it again suggests the dread that nature—such as fire—will engulf history and reduce its monuments to fertilizer, as happened to the library of Alexandria. And also there's a kind of prophetic sense to it in the sense that civilization is something that will char like a leaf. The pages of a book as it burns fly off like leaves falling from a tree. Here's one called *Book Covered with Axle Grease*—

J: It looks like chicken legs. It looks like looking into the broiler.

T: It also looks like culture undergoing a meltdown, perhaps in that immolation that burned the other book; its being melted down into this kind of greasy substrate from which new life forms might arise—the idea of civilization as fertilizer, or of history as a series of fertilizings and refertilizings of that field of potentiality represented by the empty chess board.

[Long silence with upsurge of machine sounds]

J: I think that the truth that comes out of all this is that we are able as human beings to enjoy a good many points of view. Are you saying this is history burning? Well, we can take it unburned or burned. And we can see it as art.

T: But at moments we might nevertheless have preferences, between the burned and the unburned.

J: I think we're being taught not to.

T: I guess you're right, but then I keep remembering that a while ago you said that you look forward—

J: Yes, but that's just me.

T: Well, yes, that's what I mean. I mean, our preferences are relativized, in the sense that of course we do have preferences, but we must realize that a preference is "just me." Rather than being taught not to have preferences, I think what we're being taught is to relativize our preferences.

J: Yes.

T: We still have them.

J: Yes.

T: There's nothing wrong with having them.

J: Mm-hmm.

T: What's wrong is to generate an idea of their absoluteness.

J: Yes, yes, certainly. It then comes back to leaving no traces.

T: Yes. Or standing nowhere.

J: The white animal, in the snow, going into the tree to sleep in upper branches, no one can tell where he is.

[Silence with traffic sound softer and mellowed]

T: Well, we've had a wonderful background symphony of street sounds. Quite remarkable.

J: I find living on Sixth Avenue without cutting out the noise like living by a stream. It never ceases to be interesting.

T: I live in a little apartment directly over Houston Street and I always refer to Houston Street as the mighty river that flows by my window.

J: Yes, it is, it is.

T: So I'll work on this tape and try to turn it into something that will communicate to other people.

J: That is one thing that maybe we don't need anymore.

T: A discourse that can be communicated?

J: Communication.

T: That's like your famous saying years ago that we don't need government anymore.

J: Well, we don't.

T: So now you think that maybe we don't need communication anymore either?

J: I think that we can enjoy not making communication, not doing it. And not thinking that we're even engaged in doing it.

T: Well, I think I see what you mean, to a degree. I guess it's like saying that you can acknowledge indefiniteness and still have sources of action within yourself.

J: Exactly. That is the confusion, really.

T: Well, it seems like a simple enough thing to clear up.

[Laughter all around]

T: Well, maybe we've about said what we had to say, insofar as we can say it.

J: I think so. But I haven't given you anything to eat yet. Let's go in the kitchen and see what there is. Shall we?

James Croak, Dirt man with Shovel Ext. II, *1994. Collection of Martin Z. Margulies.*

Chapter Twenty-seven
Reassembling the Pieces: The Sculpture of James Croak

1.

James Croak simultaneously studied philosophy and theology at the Ecumenical Institute in Chicago and sculpture at the University of Illinois in Chicago. He graduated in 1974 as an abstract sculptor working in baroque quasifloral extrusions of aluminum that foreshadowed modes soon to be developed by Frank Stella. In 1979, his work turned away from abstraction to figuration, with overtones of religious iconographies from various traditions and eras but mostly the ancient Near Eastern milieu from which the religions of the West developed. It has since unfolded like an ancient mythology, such as Hesiod's version of early things in his *Theogony*, where one generation of monsters replaces another repeatedly through a punctuated equilibrium gone mad.

Vegas Jesus, an assemblage or composite sculpture of 1979, shows a stuffed ram in a black tuxedo and top hat being crucified on a ten-foot-high red cross encased in a black Greek letter Ω (omega). The ram, as one reviewer noted, "symbolizes the Lamb of God,"[1] yet at the same time it symbolizes the astrological sign of Aries, which governed the age from about 2000 to about 0 B.C. and thus prepared the way for the historical birth of Christ. The Horned Beast was the principal sacrificial victim in religious practice throughout the ages of Taurus, the Bull (c. 4000–2000 B.C.), and Aries, the Ram (c. 2000–0 B.C.). In the Neolithic and early Bronze-Age spirituality of the ancient Near East during that period, the sacrifice of the herd animal represented the oneness of plant and animal life—the crops and the herds, mankind's two modes of sustenance at the time, both being bound by the cycling rhythms of the passing years with their ritual sequence of sex (planting), death (harvesting), and regeneration (the careful selection and hoarding of the seed grain for the next spring's planting). It was the down-to-earth symbolism of this milieu that was allegorized into a spiritual symbolism in Christianity and other mystery religions such as Mithraism.

In *Vegas Jesus*, the crucifixion of the Ram suggests the end of the age of Aries and, thus, the birth of Christ, which marks the beginning of the age of Pisces, the Fish. The piece has a satirical quality, especially in the top hat and tux, which model the Messiah or willing sacrificial victim as a nightclub entertainer and his

crucifixion as a showtime like Siegfried and Roy. A contemporary social edge to the work appears also in such details as the "Walther" banner with its association with World War II and the American survivalist motto "Free Men Own Guns." The sculpture's satirical force is aimed at the popularization of messianism on the American Right in those debased forms of Christianity that Harold Bloom has called "The American Religion."[2]

Vegas Jesus was chronologically the first of the extravagant mythological works or taxidermy pieces that constitute Croak's first generation of mythological monsters; it was not the first, however, in terms of the narrative the pieces are involved in, because subsequent works refer to earlier moments in a mythological genealogy of which *Vegas Jesus,* though chronologically the first, represents the end point. These works, sometimes featuring recombined elements of religious iconographies, were baroque in their exuberance at the same time that they bore a heavy weight of despairing content.

Beast (1989–1990), although produced ten years after *Vegas Jesus,* represents the beginning of the mythological sequence. A sculpture of a female monster that bears within it the generations of future humans—the rough beast slouching to Bethlehem to give birth—is cast dirt, that is, a casting of a mixture of soil and binder that has become a signature material of Croak's since he developed the technique in 1986. This monster is one with the earth, pregnant with future beings as the earth itself is pregnant, not only the source of crops but also, according to Hesiod, of monsters. It is a human-headed quadrupedal monster based on Greek depictions of the sphinx, with their awkwardly long front legs like the archaic lions of Delos; in the Greek tradition, unlike the Egyptian, the sphinx is ordinarily represented as female, and this monster, pregnant with the future, is clearly so. Such composite monsters often show their evolutionary thrust from back to front, the head indicating the most advanced component. Croak's version not only has a human head in front but also has human fingers on her forepaws (fingers based on those of Michelangelo's *David*) and feline paws behind. Her rearmost part, her tail, also looks like a lion's. The lion (or other carnivorous feline) was the common ally of the destroying aspect of the birth- and death-giving Double Goddess; the Neolithic goddess at Catal Huyuk gives birth upon her throne even as she holds momentarily in check the leopards that in time she will release to devour what she has borne. Babylonian Ishtar was represented by a lioness, as, at times, was Greek Artemis. This tradition survived into the Renaissance, when, for example, the goddess of Justice at the apex of the Porta della Carta (1438–1442) of the Palazzo Ducale in Venice is heraldically flanked by obedient lions. Croak's sphinxlike goddess is pregnant with the future, filled with human babies who grasp at her ribs as if looking out from a cage or cell and which, ultimately, in her leonine aspect, she will destroy. She is a remnant of prepatriarchal theology, that of the Neolithic and early Bronze Age goddess-worshipping cultures of the ancient Near East.

Sphinx (1982), a related work, has the head of a woman, a reptilian tail, and the legs of a goose. Such composite beasts in Greek mythology suggest rapid irrational changes of nature that confute the security of the boundaries between

species; it is as if the process of change were happening so fast that the entity undergoing the change possesses the traits of two or more species at the same moment, both the species that is being left behind and that which is coming, so that it embodies in its composite monstrosity what Renaissance sculptural theorist Pomponius Gauricus, in his *De Sculptura* (1504), called the "pregnant moment," "an instant when the past is synthesized and the future suggested."[3] In *Sphinx*, as in *Beast*, the head represents the leading edge of evolution, the age that is dawning; the female human head shows humanity emerging from the reptilian-ornithic stages of evolution, which it still drags behind it. Croak's persistent theme—the struggle of humanity to raise itself on the Great Chain of Being—is shown here in an optimistic view (at least from a human standpoint), but in too early a stage for the optimism to be secure. The sphinx, after all, traditionally represents a question rather than an answer; it is the embodiment of the riddle of human nature, which must be answered before the teleology of human evolution and history can be understood, before man's ultimate destiny can be guessed, and before one monstrous generation can be evaluated in relation to others. It is thus a symbolic figure very relevant to the moment around 1980, when, as post-Modernism deconstructed the certainties of Modernism, the question of human nature was problematized again. Louise Bourgeois, Leon Golub, and Julian Schnabel have all worked with the sphinx figure as a representation of the human conundrum. From these mysterious mothers, the dream and the nightmare of the future is born.

Truth, Justice, Mercy (1983) is a centaur with a male human forepart that looks somewhat like Croak himself, ironically portrayed, as in the Romantic tradition, as the artist leading onward in the process of evolution. Here the dream of the future is in full sway; the patriarchy that promotes progress as an heroic endeavor of the state has replaced the Age of the Mother, and the male, human-headed monster feels positive that he is on his way somewhere with overweening purpose. The somewhat Hobbesian natural realm it seeks to leave behind remains active in the predation of the coyote on the lynx in the wasteland-like terrain from which the bearer of the promise of civilization rushes to depart. This is the realm of nature red in tooth and claw, as the lynx in turn eats a snake that eats a lizard that eats a scorpion.

In terms of the sculptural tradition, Croak has conflated two genres here. One is the heroic equestrian statue as developed by Leonardo in his study for the Trivulzio monument[4] and developed to its apogee by Velasquez in the heat of the age of colonialism: the mounted warrior facing backward to summon his army—the rest of humanity—while he gestures forward toward the evolutionary goal. The other is the Hellenistic centaur, symbol of education and civilizational advance, one example of which, the so-called *Young Centaur* from Hadrian's villa, foreshadows the extended arm gesture of Croak's mock-heroic monster.[5] The mock-heroism and irony with which the artist is portrayed as a visionary express post-Modernist doubt, ambiguizing the straight-faced references to the classical tradition of sculpture.

Untitled (1984) shows an iconic moment of cosmic evolution, a summing-up of the Great Chain of Being, staged on the basis of the Orphic creation myths

and related elements of Mithraic iconography. A winged human turns into a serpent in the lower half of its body. Various monsters from classical mythology are called to mind, such as Typhon, whom Zeus slew with lightning-bolt and flint sickle. "From the thighs downward [Typhon] was nothing but coiled serpents. . . . His brutish ass-head touched the stars, his vast wings darkened the sun. . . ."[6] The composite beast in *Untitled* is structurally parallel to Typhon—serpentine lower body, wings, mammalian head—but human-headed. The human head associates it also with the snakewrapped Orphic Phanes and the Mithraic icon of Zurvan Akarana, Endless Time, also wrapped round with serpent coils.

In *Untitled*, the serpentine lower body is coiled round and round a lioness (a Styrofoam taxidermy form) that seems to be attempting to impede its upward ascent. Viewing the work from the point of view of iconography and the history of religions, the lioness represents the prepatriarchal energy of the goddess-religion (as in the feline hind-paws and tail of *Beast*). The angel-winged upper body of the male human hero is attempting to fly upward, but the serpentine lower body, true to its Neolithic origins in goddess religion, is collaborating with the lioness to drag it down.

Another related mythological figure is Achelous, a monster whom Heracles slew as part of his Twelve Labors. Achelous was a river god who appeared in three forms: a bull, a serpent, and a bull-headed man. Achelous challenged Heracles, was defeated, and left behind the Horn of Amaltheia, later called the cornucopia. Such composite figures, especially those involving the serpent, survive from Bronze Age clashes between matrilineal and patrilineal theologies, as in Marduk's combat with the serpent Kingu in the Akkadian *Creation Epic*. The serpentine or composite monster is the consort of the ancient goddess, whom the anthropomorphic male hero of the incoming patriarchy defeats. From the point of view of the history of sculpture, *Untitled* is a monumental group of the vertical spiraling type—the *figura serpentinata*—rather than the more common triangular or pyramidal type represented by the *Laocoon* and the *Farnese Bull* group. This vertical grouping of two or more figures stacked and intertwined appeared in the archaic Greek period, in, for example, the group of Theseus lifting the Amazon Antiope onto his chariot from the archaic temple of Apollo at Eretria.[7] The format became more common in the Hellenistic era, when the arrangement of Theseus and Antiope was echoed by the Heracles and Antaeus pair in the Pitti Palace, the Niobe sheltering a Niobid in the Uffizi, and numerous other works.[8] It has Renaissance avatars such as Giambologna's *Rape of the Sabines* (1583), and Baroque ones, including several works of Bernini, such as *Faun Teased by Cupids* (1616–1617), *Aeneas, Anchises and Ascanius* (1618–1619), *Neptune and Triton* (1620–1621), *Pluto and Proserpina* (1621–1622), and above all the Moro Fountain (1653–1654), where the serpentine motif is handled similarly. In Bernini's use, this composition characteristically expresses an idea of transformation or change of place, and often of a conflict about this change—a usage that Croak's upward-struggling figures continue.

This generation of monsters, with its ambiguous commentary on the project of civilization and the directionality of human life, culminates mythologi-

cally in the massive post-Modern pastiche sculpture *Pegasus* (1981–1982). A full-sized 1963 Chevrolet hard-top, customized in the style of the Hot Rod culture commemorated in the car and motorcycle paintings of Big Daddy Roth and later in the Latino low-rider culture in East Los Angeles, seems to have exploded upward; its roof gapes open in a jagged hole like a tin can opened by a crude instrument not intended for the purpose. From this eruption a life-size winged stallion rises upward into flight as if it were the soul coming from within the car on the upward mission that the centaur had summoned it to, or a transformation form of the car itself as it enters mythology. With this work the problem of evolutionary direction is focused directly on present-day America. The post-colonial infusion of Third World (specifically Latino) cultural elements seems to have opened the America of the big car up to an unprecedented urge to flight. An attempt to escape the Modernist generation of monsters is implied. The Pegasus surges upward as the human half of the monster in *Untitled* struggles to ascend into flight also; as the lioness holds the angel-headed monster to the earth, so the automobile may weigh Pegasus down, his wings futilely and frantically struggling to rise above the heavy realm of earthen materiality.

<div align="center">2.</div>

Though his work involves the late and post-Modernist use of found objects and materials, such as the car in *Pegasus,* Croak has remained unusually committed to the traditional modes of sculpture, especially modeling and casting. His ambiguous form of post-Modern doubt rejects the Modernist tradition even as it attempts to use it—implying that so far it is all we've got. Rejecting the mode of bronze casting as too deeply and ideologically pervaded by tradition, he invented, around 1985, a means of casting an amalgam of soil and binder to make "dirt" sculptures. In 1986, Croak began the Dirt Men, of which sixteen have been made, and shortly thereafter the Dirt Baby series, of which there now are thirty-five examples. Croak never practices life-casting, which he regards as producing a deathlike face and figure; each piece is hand-modeled in clay as Rodin did, then goes through the casting process.

The material is ambiguous iconographically. On the one hand, it suggests a Neolithic closeness to the earth, human cultural production as part of nature, and so on. On the other, it is a debased material, "dirt," which suggests a massive downsizing of human ambition and the self-image it has been based on since the Renaissance heyday of bronze casting. The urban identification of dirt as refuse identifies the Dirt Men as the detritus of society, suggesting that humanity is at the rag-end of its time, devalued, upheld by no dreams of nobility, barely able to shuffle like a homeless person down the street of the so-called civilization he misguidedly made for himself to live in and that later became his entrapment.

The mythological reading of dirt as earth or soil—that is, as agricultural or fertility symbol—suggests the Hesiodic idea of a race of earth-born humans. The *Dirt Man with Dead Sphinx* (1986–1987) indicates a generational continuity with

the earlier work, signifying that the race of earth-born humans comes after the race of quasiserpentine composite monsters has perished. Whereas Hesiod locates this earth-born generation in the distant mythological past, Croak directs the image at present-day humanity. It seems that his race of humans was born of earth and now will return to earth, exhausted. There is a suggestion of fertility, of the failures of past attempts at civilization becoming the loam from which future attempts will grow, but generally the mood seems one of pathos not of hope. *Dirt Man with Shovel* (1993) seems about to dig his own grave in the dirt from which he also was born: earth to earth. The seated or slouched Dirt Man (*Untitled,* 1986–1989), who, in terms of the classical tradition of sculpture, looks most like the Capitoline *Dying Gaul,* holds a trowel and seems to have been digging into his own left leg before he slumped over from exhaustion. He is digging his grave in the earth and he is the earth in which he is digging his grave. The involution of relationship reaches a height in the dirt shovel of *Handing* (1993). *Dirt Man with Fish* (1985–1986) has lost his identity as earth-element and has become permeable to the denizens of the water element: On the one hand, he is dissolving; on the other, he is unconscious of the intrusions of meaning from subtler, more spiritual states that flow through him and leave no trace. The Dirt Man of *Untitled* (1987) is hung on the wall like an empty coat or a suicide, or like the skin of Marsyas in the myth of Apollo's musical contest with the satyr.

The Dirt Babies may be offspring of these Dirt Men, or they may be earlier views of them, at the beginnings of their lives. In the context of art history, they are grounded putti, cherubs whose proper element is neither the ether nor the air but the earth. There is a suggestion of the impossibility of transcendence, of being earth-bound, or doomed to the earth that, in Christian tradition such as Milton's *Paradise Lost,* is the realm of the Devil. The earth people are irredeemably polluted as by original sin; they can never rise above this pollution. The great sky eludes them forever. By their very nature they are excluded from it.

Croak's *Dirt Man with Dead Sphinx* was his last ensemble-like narrative sculpture. After that, the Dirt Men are based on the Rodinian isolation of the individual figure, like most figurative sculpture of the twentieth century, Giaco-metti's above all. Viewed in this mode, the figure becomes an image of mankind as a whole, or the human condition, or the proper attitude of man, and so on. The figure returns to the purity of its own naked presence facing the world without mediation, as in the icon which began it all in the West, the kouros—the seventh- and sixth-century B.C. Greek form of the upright naked male figure staring ahead with a little smile at the world he is about to walk into.

The tradition of the kouros changed with history and became capacious enough to stand for the whole tradition of the solitary sculptural figure, in its many moods, smiling or otherwise. Sculpture in ancient Greece was a close reflection of political, military, and social events. With the trauma of the Persian Wars, the blissfully naïve expression that art historians call the "archaic smile" was wiped off the kouroi's faces. They became hardened by the Olympian gaze, distanced, dis-trustful, wary, but still gloriously in charge of their destiny. But with the Hellenistic

period, with the end of the democracy and the restoration, through the Macedonian conquest, of the Bronze Age type of oriental despotism, the picture of humanity as a being in charge of its destiny breaks; a look of anguish replaces the Olympian gaze, as in the suffering figures of the Great Altar at Pergamum or the *Laocoon*. The body twists and bends with agonized stresses, no longer innocently erect gazing openly and incautiously outward at the oncoming world. In this lineage, which goes through nuanced stages, Croak's Dirt Men have something in common with the "Wounded Warrior" type of classical Greek sculpture—wounded, limping, but still upright.[9]

The postures of Croak's Dirt Men are ambiguous but tend toward the same end. *Dirt Man with Shovel* seems to be standing more or less still as he looks at the spot on the ground where he is preparing to dig. *Dirt Man with Fish*, in contrast, seems to be walking in a slow shuffle of tiny steps, supported by his cane, his left foot slightly in front of the other as with a kouros. *Dirt Man with Dead Sphinx* would also seem to be walking, in the manner of someone carrying something (not unrelated to the type of the classical *Menelaus Carrying the Body of Patroclus*).[10] These postures are all ambiguous between standing and walking, an ancient motif of Western iconography first seen in renderings of the Egyptian pharaoh, and subsequently adopted as the stance for the kouros. In this hieratic posture, the left foot is extended about one foot-length ahead of the right, as if walking. Yet the heels are both flat on the ground, as if not actually moving forward, and the arms hang straight at the sides as if the figure were standing still. In later Greek art, the posture was developed in both directions: A stance like that of Polycleitus's *Doryphorus* suggests a contraposto standing position; in other works the implication of a forward striding left foot is emphasized, as in the Poseidon from Artemisium, the Theseus from the Amazonomachy pediment (perhaps from Eretria), the clay group of Zeus abducting Ganymede, from Olympia, and the Harmodius and Aristogeiton copy from Hadrian's villa.

The original pharaonic posture deliberately conflated standing still and walking—reflecting on where to go, and aggressively striding toward the decided goal. Through this posture the pharaoh was presented as in this world but not of it; he strides ahead as if a person on Earth, but at the same time is eternally still, like the Osiris-archetype of which he is the instantiation. The Greeks moved the image in both directions, toward an unambiguously standing-still posture and an unambiguously striding-forward posture.

The posture returns as a leitmotif throughout Western sculpture. Rodin's Balzac, in the *Nude Study for Balzac* (1892), has one foot thrust ahead of the other as if walking, but both heels on the ground as if standing still. Rodin's *Walking Man* (1876–1878), despite its title, has both heels planted firmly on the ground like a kouros, as does his *John the Baptist* (1875–1876). Something similar is seen in Giacometti's figures. *Man Walking* (1947) seems to have his rear heel rising from the ground, but *Man Walking I* and *Man Walking II* (both 1960) have both heels planted firmly on the ground. Giacometti also observes the Greek practice of having female figures, like the archaic korai, standing with feet together, while the male figures,

kouroi, seem, somewhat ambiguously, to be walking. In general Giacometti's walking men have their arms hanging straight at their sides as if standing still, like kouroi or pharaohs. (As David Sylvester observed, "The style of his mature work . . . deriv[ed] above all from the Egyptians.")[11]

It is in this five-thousand-year-long tradition that Croak's standing/ walking figures should be seen, but with a difference. The narrative underlying the ancient figures involves walking toward a goal, the theme of evolutionary advance. The kouros in general seems to be thinking about what he is going to do and, motivated by his reflection, just beginning to do it. The *Doryphorus* is widely interpreted as an athlete who has walked to the front of the arena to be crowned with laurel after his victorious throw. He too, though pictured just after his walking rather than just before it, expresses the theme of goal-oriented action and movement toward a goal. But in Croak's Dirt Men the hesitation between standing and walking seems to express exhaustion. These figures have walked about as far as they can go. They are on the verge of collapsing and, like the slouched Dirt Man of *Untitled,* leaking their life force into the earth or onto the pavement. They are pictured at the end of their walking, not at the beginning of it. They are post-historical, not proto-historical. They are more about returning to the earth than emerging from it. Like Michelangelo's *Slaves,* which "within the matrix of the primordial block . . . evoke humanity bound to its earthliness,"[12] the Dirt Men, through their literally earthen materiality, do the same. Croak might have preferred to be directing his work, as Michelangelo and others of his day did, toward the triumphant anthropocentrism of Pico della Mirandola's *Oratio de dignitate hominis* (*Oration on the Dignity of Man,* 1486), but by the time the Dirt Men shuffled onto the scene there was not so much dignity left. The isolation of the human from other animal species that was assumed in Renaissance humanism no longer obtains; the boundaries between nature and culture are breaking down, and mankind is losing definition and morphing into monstrous new identities. History is running out or losing direction. The Dirt Men shuffle onto the scene not even to wait for Godot, but merely to look for a soft place to dig a hole to sink into.

3.

In 1991 and 1992, Croak made cast-dirt sculptures of windows in a number of styles, each different from the others. They range from arched Renaissance-evocative lunettes and narrow leaded-glass verticals as in a church to conventional home window-sashes; some that are rectangular and without internal division look like framed pictures. Viewed in art-critical terms they propose a synthesis of twentieth-century tendencies: Both painting and sculpture, both art work and everyday object, both abstraction and representation, they also refer obliquely to the earthwork and the surrealistic object. They embody the way, at the end of Modernism, its categories were dissolving, a process which post-Modernism hastened on its way.

Viewed art historically, the windows look back to precedents from the Modernist era. Duchamp's *Fresh Widow* (1920) was a window sash with casement,

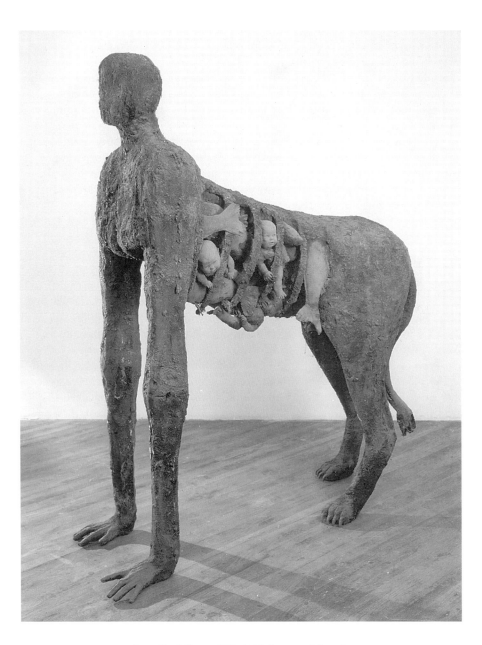

James Croak, Beast, *1989–1990. Courtesy of the artist.*

bought whole at a construction materials store and exhibited as a sculpture. Duchamp's title puns lightly on the phrase "French Window," and implies that the widow's husband jumped or fell or was pushed out the window to his death. The window figures here more as an exit from some implied confinement than as an aperture to see through (the panes are painted black). It implies the larger thematics of bailing out of Modernism, as Duchamp did with the Readymades, or even bailing out of art into an unspecified alternative—from ordinary life into some beyond.

The motif is echoed by Yves Klein's *Leap into the Void* (1961), a photograph that shows the artist leaping, apparently into flight, from a second-story window ledge. The piece was an icon of transcendence, or of the urge to escape the limitations of the human condition, but with tragic overtones, as the viewer knows that the upward-gazing leaper will not in fact continue to rise upward but will fall painfully, and with risk of injury, to the pavement below. The theme of escape into a beyond was extended by Eric Orr's lead-and-gold windows with their theme of alchemical transformation.

But escape or transcendence is not the only theme carried by the window. Jannis Kounellis's windows filled with rocks or construction debris or pieces of broken classical statuary have a different resonance. Kounellis employs the window motif more for its comment on the possibility of vision than the possibility of escape. His blocked windows suggest a blocked vision, a historical situation—late Modernism—in which the process of artistic vision has become blocked, as in the dead end of the monochrome painting or the Minimalist sculpture. Kounellis's use of this motif harks back to the windows opening out from interior rooms onto near-infinite, distant landscapes in countless Renaissance paintings. Kounellis's feeling is that the penetrating truthfulness of the Renaissance vision has been lost, the window to that infinite landscape has been blocked, the artwork has turned in upon itself in the enclosed gallery or museum space (in which also the windows are usually blocked or covered).

Croak's windows seem more about malleability, reciprocal passage both inward and outward, the porosity of categories and traditions, as the late Modernist and anti-Modernist meltdown prepares for the post-Modernist reorientation. They function at a number of levels from folktale motif to cultural allegory. In mythological terms they express the transformation of one generation into another as realities leap through the window, leap into the void, head for the far horizon. Through this windowness the age of animal monsters, such as the sphinx, the lioness, and Pegasus, yields place to the age of the Dirt Men, as one generation of monsters is replaced by another. *Coyote and Window* (1994) seems to show such a moment in process; the coyote has either begun an age by leaping in the window or is about to end one by leaping out.

The window, in effect, provides a potential space in which internal contradiction can subsist. *Pegasus* was a massive exuberant sculptural installation that perpetrated a profound surprise with a feeling of enormous strength and confidence. It did not focus on the idea of the exhaustion of Western civilization, but on a

redemptive eruption of new and previously unknown energy from within it. In a cultural sense this was the energy of the displacement of Latino culture within the United States, especially California (where Croak lived at the time), by almost unrestricted illegal immigration over the Mexican border. The winged horse explodes from the roof of the car like a new transformation of Western civilization after a fresh dose of Third World energy has given it new life and sent it rocketing upward for another exciting flight through history. Having lost its Eurocentric identity, history turns in a strange new direction that seems—at first anyway—like no direction at all. On the common equation of the Third World with Nature, in the Hegelian nature-culture dichotomy, the piece optimistically suggests a resurgence of natural strength and energy in the midst of culture, the escape of this mighty being from the grip of culture, and so on. An *Aufhebung*, or sublation, has taken place. Western civilization, which has long regarded itself, however self-deceivingly, as the incarnation of reason and consciousness (of the Ego), has incorporated its Other either in the form of nature or of the Third World, and the inner alchemical transformation of its energy has caused it to explode upward, transcendently, toward the sky, in a renewed and redirected wave of energy.

Croak's work since *Pegasus* involves the same theme to an extent, but in a mood eerily different from one of exuberance and confidence. The Dirt Men, for example, like figures in Beckett, or Magritte, or Giacometti, shuffle along as if depressed in their monochrome dark brown business suits and fedora hats. Far from the majestic ascent into the sky of *Pegasus*, the Dirt Men hide in their dark coloration as if hiding in the earth itself.

But their substance conveys not so much the fertility of rich loamy soil (as in Walter De Maria's *Earth Room*, say, or various works of Ana Mendieta) as the dirt of urban detritus. These men are literally made of the dirt of civilization. Unlike Pegasus, they will never escape it. The window has closed on them, and, unlike the wonder horse, they are strengthless and unable to burst through the roof. Even though one Dirt Man's shovel suggests digging into the earth as if seeking a natural substrate of human nature hidden in the unconscious, and even though the fish swimming through another Dirt Man suggests the founding of humanity on the oceanic expanses of nature, still both Dirt Men seem unquestionably trapped in the slow attrition, or grinding down, of civilizations. The window through which they once entered has closed, or they have forgotten it or lost the strength to leap out through it again.

<div style="text-align:center">4.</div>

Croak's work participates in the post-Modernist critique of history and civilization. The Dirt Men and Dirt Babies, while figurative, are nevertheless deconstructions of the tradition of cultural wholeness in which the figure exercised its selfhood and the art of the figure arose. They signify a zero degree or end point or meltdown of the ability of the figure to be itself, to exercise selfhood within a world where that possibility is still viable. Dregs of humanity, dregs of civilization,

they persist meaninglessly for the sake of survival alone. The Dirt Man belongs in a sculptural lineage of fallen warriors and exhausted kings, wandering from his homeland into exile like the aged Oedipus entering the grove at Colonus, his selfhood hidden behind protective clothing, his cultural density so attenuated that fish swim through his body as if it did not interrupt their passage. The Dirt Babies bury their implications of new life and freshly tilled soil in a hopeless burned closure or detritus; they are the offspring of humanity too late, humanity that has lost it already, leaving survival as the last remaining option after a holocaust or other civilizational trauma.

But at the same time Croak's work belongs to tradition in a more linear or straightforward way than much post-Modernist art. It seems based on the feeling that one can still rely to some extent, however desperately, on tradition—or at least that one has no other alternative except to give up. The fact that his mature work has been exclusively figurative is significant in this regard. His figuration does not refer to debased tradition, like the post-Pop figuration of, say, Jeff Koons, or to involutions or reversals of historical sequences, like Mike Bidlo's "Not Brancusis" or the primitivizing chainsaw-cut figures of Georg Baselitz. The issue of sculpture is involved, or even Sculpture, meaning by the capitalization a tradition that has inscribed itself at a deep historic level in many cultural matrices, not least the Western art-historical matrix. Croak's work seems residually Modernist in its acknowledgment of a still-surviving usefulness to art, or at any rate to Sculpture. Even though he presents a post-historical humanity disguising itself among the garbage of a lost or ruined civilization, still, his work is driven at a more fundamental level by a belief in the ongoing validity of the sculptural tradition in and by itself. Whatever its lowdown low-rider contents, his work remains the art of the figure, it remains Sculpture, in the sense of belonging in the tradition that extends from Michelangelo to Rodin and not desiring to deconstruct or problematize that tradition but to sustain and extend it. In this sense, the work is not as inwardly broken and in disarray as, seemingly, is the civilization it portrays. It knows where it belongs, and that is within a vast historical sequencing but not a universal one. This is specifically the tradition of Western sculpture per se: Pheidias, Polycleitus, Praxiteles, Myron, Lysippus, Donatello, Ghiberti, Michelangelo, Canova, Rodin, Giacometti—basically the tradition of the kouros. There is virtually no crosscultural pastiche, no reference to African or Asian sculpture, no light sampling of traditions or use of references to traditions as vocabulary elements or mosaic fragments. When Gino DeDomenicis, for example, invokes Sumerian sculpture in his work, he does so to make a statement about the origins of civilization and an underlying secret identity of the West, not because he feels that his work and the Sumerian are mutually embraced by a tight and uncompromising linkage of art-historical tradition. Croak would not bring in a reference from so far outside his work, even if it could reasonably be invoked as lying in the background of that work at some greater distance. His sense of the coherence of this particular tradition is still too strong for that. He shares the widespread post-Modern feeling that the premises of Western civilization have either been totally discredited or at least rendered deeply question-

able; still he stubbornly clings to sculpture in his hopes of somehow weathering the storm.

In a sense, the window serves a double purpose here, both to allow a transitional space for internal contradiction within the work and also to mediate between the work itself and the outside world. Croak's work seems to involve an acceptance of the tradition of Western figurative sculpture as still generative, still alive and able to beget new life, still, in terms of the integrity of its inner life force, whole—and here a question rises. Does his acceptance of the still-viable wholeness of the figurative tradition not imply some degree of belief in the wholeness of the humanity in whose image the figurative sculpture is begotten? On this point, the work maintains a reserved silence as if embarrassed by the rawness of the admission requested. The work is based, in Derrida's terms, on the end of the metaphysics of presence or, in Foucault's terms, the end of humanity. At least it presents humanity as very nearly extinct, in extreme disarray, in tatters, abject, homeless, wandering aimlessly—goalless except for an amoeba's motivation for mere survival. Yet it presents it in a representation, a figuration, a mode, that strives to elevate the situation by injecting its own wholeness or integrity as tradition. By its faithful invocation of tradition, the work attempts to salvage something from the devastating situation it portrays. In this way, it participates in a residual Modernist motive that remains active, however hiddenly, in much post-Modernist work: that of redemption.

But here too there is ambiguity. The conjunction of images of brokenness with an assertion of the wholeness of the mode of imaging their brokenness may point toward a redemptive situation in which movement or affect is possible; there are overtones of the Eucharist feast—that life is broken but one can eat of the brokenness and be made whole. But on the other hand it may just point to a situation of irredeemable paradox that is inherently tragic and uses the ploy of tragic nobility to ward off open expressions of despair. Ghostly forms brush by one another, flying in or out the window.

5.

In the mythological and dirt series, Croak has traced humanity from its primordial beginnings to a moment that seems to presage its coming end, without portraying it at a moment of triumph or culmination in between. The triumph or culmination of its narrative may be still in its future, but that possibility is deeply problematized, a dark cloud of doubt hanging over it. This is the situation that Croak's third major series of sculptures—or generation of monsters—comments on.

The title of the series New Skins for Coming Monstrosities (mostly 1995) reinforces the stratification of Croak's oeuvre as a series of generations of monsters. The concept "new skins" suggests that the indwelling spirit or life-force remains in some way the same from one generation to the next, only being processed through a sequence of monstrous outer husks; yet this processing seems evolutionary to a degree—or devolutionary—the inner spirit rising or sinking in some kind of cosmic

hierarchy or chain of being through its outer transformations. This series of trans-formations does not seem to be very hopeful. True to evolutionary theory, Croak refers to the garment or skinlike works as survival strategies for desperate situations, as a threatened species adapts to its peril through developing protective colorations or other such strategies. By the mid-1990s Croak's work dealt openly with the issue of mere survival—no revivifying and transformative explosion of energy, no more heroic centaur pointing the way or mighty Pegasus bursting through the roof, but exhausted and desperate survival strategies in a hopeless situation. *Trash Suit* (1995) is a cast latex human skin, or skinlike garment, or camouflage skin, lying on the floor (the pavement) as if it were a person naked and partially covered with trash. Socially, the work refers to increasing violence against homeless people or, more broadly, to the urban experience of anxiety leading to panic, creating the feeling of wanting to dive under something for cover and safety. If you are the trash of society, fair prey for random urban violence, or a member of an evolutionary loser species, the suggestion is, you might as well cover yourself with trash and hide beneath it while sleeping in hopes your natural enemies will not recognize your presence. Ashes to ashes, trash to trash.

Interpersonal Relationship Suit (1995) extends the danger zone to everyone not living in total seclusion. Life-size cast latex covered with pebbles embedded in the latex, the suit is like a coat of armor inexplicably hanging on the wall. The context or warfare for which this armor is to be worn is simply the everyday interpersonal relationship. Humans, it is implied, are a generation of monsters so dangerous to one another that one should not enter a relationship without arming oneself against psychological, emotional, and even physical aggression—like hiding under trash.

Decentered Skin and *Child Skin* (both 1995) are cast latex, rubber, and dirt, yet they actually look like the molds themselves, not the casts made from the molds. They stand upright and hollow and open, as if inviting a wandering and homeless soul to enter and take refuge there. There is an association with the Orphic idea of the body as the prison in which the soul is confined, yet the emotional charge is reversed. In the Orphic tradition, the opened body, revealing the inner hollowness left behind by the soul that fled, would be a celebratory icon, indicating that the soul had escaped its limitations and ascended to its true home on high. In Croak's more historicized approach the absent but implied soul seems not freed but lost, not flying on high but wandering homeless and cold in a lonely wind that it has no protection against. The invitation to enter the empty body is double edged, as it offers both refuge and vulnerability to attacks upon the flesh.

Croak's Dirt Men and hanging empty skins might be compared with Antony Gormley's life-size, apparently hollow figures, but they do not involve Gormley's aspirations toward yogic purity. Though Croak's "skins" are not life-cast but modeled, their presence nevertheless recalls Yves Klein's practice of casting his associates among Les Nouveaux Réalistes. But Klein painted his figures in colors aspiring to transcendence (gold and blue), and his purpose was to immortalize both himself and his cronies as a kind of heavenly court not unlike that depicted in

Byzantine mosaics of Justinian and his associates against a ground of gold. Croak's figurative practice more directly recalls Ed and Nancy Kienholz's works such as *Solly 17* (1979–1980), which refers not upward toward Heaven but downward toward the troubled gutters of society.

Croak's empty suits hanging on walls recall an aspect of the twentieth-century art of the figure that began with Marcel Duchamp's empty vest, extended through Joseph Beuys's gray felt suits on hangers on walls, and Marcel Broodthaers's exhibition of a folded laundered shirt. In terms of female selfhood as suggested by apparel, one thinks of the work of Judith Shea and others. This tradition in general involves a questioning of human nature—what can fill this empty suit?—but Croak's examples seem more to question human survival.

<div align="center">6.</div>

Art is not precisely philosophy; nevertheless it is true that, as William Wilson wrote, "Art is a way of thinking about reality," and, as Lyotard put it, "a postmodern writer or artist is in the position of a philosopher."[13] The output of many artists of Croak's generation might be termed "post-sculptural," in the sense that it reneges on the tradition of the kouros, that is, the art of the figure or of humanity. But in addition it has gone beyond Rilke's precept, which must have seemed universally transparent in its day, that sculpture must "distinguish itself somehow from other things, the ordinary things which everyone can touch. It must become unimpeachable, sacrosanct, separated from chance and time through which it rose isolated and miraculous. . . ."[14] For Rilke, it seems, the value of verisimilitude—of looking like an ordinary object—was in one sense the greatest temptation and in another the greatest threat, a threat that had to be offset by the pedestal or monumental setting, which would separate the object "from chance and time" and protect its sacrosanctity.

Twentieth-century sculpture has radically breached this principle in several ways, above all in the tradition of the Duchampian Readymade. The ordinary snow shovel hanging on a wall or coat rack positioned on a floor are made strange by their inappropriate locations, but by nothing else. Similarly, the only thing designating Carl Andre's bricks as artworks rather than construction materials was the gallery context. Public sited works without pedestals are set off from the ordinary only by some detail such as the lack of color, as in George Segal's life-cast figures waiting to buy a ticket at the Port Authority bus terminal in New York City. The edge is getting finer and finer.

The tradition of the readymade, or found object presented as artwork, may be called anti-sculpture.[15] Herbert Read noted the situation before the term "anti-sculpture" had been coined, saying: "We continue to call all free-standing three-dimensional works of plastic art 'sculpture,' but the modern period has seen the invention of three-dimensional works of art which are in no sense 'sculpted' or even moulded."[16] Croak's work, however, pursuant to its acknowledgment of the Michelangelo-to-Rodin lineage, has resolutely remained sculpture rather than anti-

sculpture; even when it is expressing a similar sensibility of awareness of post-historical reality, it does not become post-sculptural, or anti-sculptural. It remains sculpture both in its technique—modeling and casting—and in its faithful adherence to the tradition of the figure, the unabashed open humanity of the kouros. The existence of such sculpture today is a necessary part of post-Modern pluralism, as is painting like, say, that of Arnold Mesches, which is post-Modern in its social orientation and its quotational referentiality, but Modernist in its tenacious faith in the pure painting of the touch and the brush. The weakness of post-Modernism is its tendency to betray its own premises by becoming a new orthodoxy that excludes the elements of tradition it rebelled against.

The story is getting old and familiar. Modernism in its early stages saw itself as an antitraditional attitude that would always retain its confrontational edge. Then it lost its confrontational edge and, instead of undermining traditions, became a new tradition itself. Post-Modernism then set out to undermine the tradition of Modernism, as Modernism had once set out to undermine earlier traditions. In its early phase this new movement was not yet actually post-Modern; it fixated on the confrontational task of the moment and became anti-Modernist. As such it became a set of prohibitions against various Modernist practices: There was to be no metaphysics, no formalistically legitimated myth of progress, no cult of aesthetic feeling, no acceptance of the tyranny of historical chronology, no foundational belief system.

Post-Modernism itself would be born out of a conflation of Modernism and anti-Modernism; as opposed to the system of prohibitions that made up anti-Modernism, it was supposed to have no prohibitions. Simply put, it was more or less a reappearance of traditional liberal pluralism—a position that must at one time have invigorated Modernism as well, but which Modernism had long since betrayed.

For a condition of pluralism to continue, there must be no hardening round a new consensus or canon that, merely by existing as a canon, becomes exclusionistic. It would not be truly post-Modern, or truly pluralistic, for example, to exclude sincere rather than ironic homages to Modernist tradition; indeed, residual or recurrent aspects of Modernism might legitimately appear not only as homages but as continuations (as what George Kubler in *The Shape of Time*[17] called suspended sequences that could be reopened). Mature artists still practicing Modernist approaches, from Robert Ryman and Agnes Martin in the United States to Howard Hodgkin and Lucian Freud in Britain, must be accepted as legitimate parts of a pluralistic landscape which wishes to avoid the kind of repressive homogenization that leads to consensus and canon formation.

It could plausibly be argued that by, say, 1995 or so at the latest, the transition between Modernist types of art (with their emphasis on aesthetic unity and sameness) and post-Modernist types of art (with emphasis on multiplicity and difference) had already been accomplished. The persistence of residual Modernists in the midst of post-Modernism was truly, for once, the exception that proved the rule—that is, the rule of pluralism.

Meanwhile, as the logic of power refused to listen to reason, a new canon

was in fact forming. When the Museum of Modern Art in New York City (the paradigmatic institution of Modernist exclusionism) paid in seven figures for a suite of Cindy Sherman's *Film Stills* in 1997, one heard the death knell ringing for pluralism. It meant that the exciting period of transition, when the cards are thrown in the air and for a moment there is breathing room for all the players, was over. The new hands had been dealt. A new canon was in place, backed by the financial, social, and art-political authority of conservative institutions. A new Mafia had grown up, and could be expected to be as jealous in the protection of its turf as any previous generation had been. It appears that the moment of freedom is over.

James Croak's rootedness in tradition, alongside his awareness of the cultural omens of the moment, betokens neither Modernist nor post-Modernist exclusionism. Refusing to reject out of hand the achievements of Modernism, he refuses as well to blind himself to the manifest truths of post-Modernist skepticism and deconstruction. His work acknowledges and embodies the negative mood of this age of doubt but refuses to give in to it completely by abjuring even the means to deal with it honestly that tradition has provided. He sees that the Renaissance dealt with as sweeping and as deep a revaluation of human identities and goals, and that art was one of its useful tools in doing so. He is not sure that the present situation is radically more insoluble than that one was.

7.

In Croak's oeuvre there is no wholeness of narrativity. There are no metanarratives, unless it be the metanarrative of fragmentation and layering, the metanarrative of a wholeness straining upward to be reborn and falling into its own ashen fragments. In *Pegasus,* is the horse a transformation of the car, cultural energy become natural energy? Or is it trying to escape the car right before it wrecks? Is *Pegasus* implementing a survival strategy that looks exuberantly alive but is doomed?

By the time of *Trash Suit,* the strategies of escape or real transformation no longer seem available. The vacated humanity of *Trash Suit* debases itself in a pretended transformation that is a transformation downward on the energy chain, not upward, and that is fake anyway. But then, the fact that the transformation of man into garbage is fake suggests that perhaps a pre-garbage form of man still lurks—licking its wounds, perhaps—within the trash suit, waiting for an opportunity to reappear and begin again its slow ascent. Trash Suit Man and his colleagues such as the shuffling Dirt Men could suggest the Orphic narrative of the soul hidden within a coating of karmic mud (*pēlos,* as Socrates calls it in *The Republic* [363d] and elsewhere), a dense dirt attained through being imprisoned in the body and dragged through the back alleys of the slum of the world—that is to say, embodied life. In Socrates' vision of the meaning of life in *The Phaedo,* the soul must cleanse itself of this barbaric dirt that keeps it reincarnating in the slum of the body. Then it can see the right direction in which to emerge from the mud of the body, like the discarded dirt suits on the wall, and ascend like Pegasus bursting winged through the barren integument of the machinery of the body.

In the narrative interconnectedness that links these works, one glimpses the internal coherence of the oeuvre. Croak's work emphasizes the single figure, though traditionally it is the sculptural group that bears the weight of narrative. Rodin, for example, produced both sculptural groups, such as *The Kiss* (1882), and single figures, such as *Walking Man* (1877). The single figures were criticized in his day as incomplete because they did not reveal a narrative but remained fragments of an as yet unseen whole. The whole would have been a grouping or monument that dictated a subject matter and a specific narrativity, as in salon topics of the day like, say, Cupid and Psyche, or Danaids, or, in an ancient example, the large tableau-like grouping in which the isolated piece that we call the *Charioteer* of Delphi was included. Most of Rodin's own works of this type, such as *Eternal Spring* (1884) and *The Kiss,* are widely regarded as his most vulgar; but in *The Age of Bronze* (1877), *John the Baptist, Walking Man,* and *Study for Balzac, F* (1896), he proposed a new approach in which "the sculpture is the figure, the figure is the sculpture," an approach whose axiom was "the congruent limits of the figure with the sculpture."[18] Croak has somewhat combined these two Rodinian modes. In his work there is narrativity, but it is derived from an overview of single figures, rather than from dramatic groupings. The narrative does not exist entirely in one work but in the relations among them overall.

<p style="text-align:center">8.</p>

Traditional Western sculpture of the figure, from Pheidias to Michelangelo to Rodin, attempted to portray the soul in the body—or rather, the body ensouled. Though what one sees is ostensibly the body, it is portrayed with clear implication that the soul is present in it, informing and enlivening it and giving to it hints of divinity. In fact, at the very moment when one sees the body lying back in all its inertia, as in Bernini's *Teresa* or in ethnographic descriptions of shamanic performance, the soul may be soaring on high in realms unspeakable. This was the central point of what might be called the sculpture of presence: The soul was the essential truth of human nature and the sculptor was engaged in the portrayal—ultimately the embodiment—of that essence. There were magical or fetishistic resonances clinging round this artistic endeavor, as in the late Neoplatonic belief, enunciated by Porphyry, that the soul of the deity represented in an iconic sculpture was actually present in it.

It is one of the clearest signs of the transition from Modernism to post-Modernism that recent art of the figure has portrayed the body not as presence but as absence. The body is presented as an empty vessel, like T. S. Eliot's *Hollow Men,* "headpiece filled with straw." Either it has always been empty because that is its nature, or it has been emptied out, perhaps in anticipation of its being refilled with a new substance, perhaps just before discarding it. The more optimistic possibility, that it may have been vacated temporarily to prepare for refilling, is the implication of an older artist still deeply touched by the Modernist metaphysics of Presence— Joseph Beuys's empty felt suits for example, which seem to have been an invitation

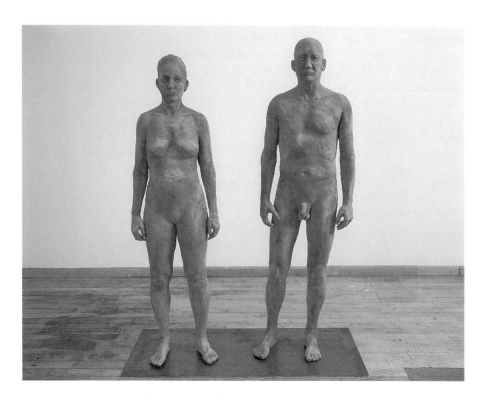

James Croak, Man and Woman, *1998. Collection of the artist.*

to a new age to produce a new soul. Beuys's work was still implicitly the sculpture of Presence; he portrayed the soul by its absence, presenting the empty body as an invitation to the soul to occupy, or reoccupy, it. The empty shirts and vests of Marcel Broodthaers carry related thematics, as do various works of Jannis Kounellis—such as those involving empty beds and shelves of statue fragments—which similarly suggest a humanity that has vacated its place so that place may be reoccupied by a redefined humanity.

This optimistic tinge is not so apparent in the sculpture of the 1980s. The puppetlike figures of Jonathan Borofsky, for example, portray a robotic humanity of empty containers, vacated husks, acting without authentic impulse, as puppets or robots might act, without free will or self-determination. There is no clear implication that they will be refilled or re-ensouled. Something similar could be said of the seated hunch-backed figures of Magdalena Abakanowicz, the empty yogic practitioners of Antony Gormley, Kiki Smith's crawling excreting women, Juan Munoz's laughing little demon men, the mechanized puppetlike figures of Paul McCarthy, the worn-out and discarded doll-people of Mike Kelley, Robert Gober's body parts squirming to escape, Jeff Koons's wooden bears and lobotomized Playmates, Louise

Bourgeois's breast- and penis-fields, and many other recent instances. All represent the human figure as empty in itself or emptied out, gutted, by experience. Perhaps it awaits a renewal by redefinition, but it is not a mood of renewal that dominates such recent figuration; nor is it a wholehearted despair such as only whole people could feel. The moods of these representations range from frank exhaustion to a weary but clear-minded acceptance of hopelessness. Clearly, this bleak postapocalyptic vista is where the Dirt Men and empty camouflage skins of James Croak belong. They are a part of the post-Modern landscape, with its ambiguous or indefinite stance toward the human future. Is the self merely a gaseous spark or static burn-off of the chemical combination occurring in the body, just going "out" when one of the chemicals is exhausted or when they all happen to dissolve apart, as in what is called death? In this view, recent sculpture with its evident rejection of the myth of the soul is simply realistic; illusion has been drained from it.

Post-Modernist thinkers have taken the antisoulist tendency to the limit in such ideas as the end of history and the end of humanity that go back to early (probably Neolithic) mythologems of the Flood and the Great Year, functioning in cyclical myths of time where the end of a Great Year is followed by the beginning of a new one. But in the Christian, and in the Modernist, view, time is linear, not cyclical, and the line of time will end forever when it ends.

In the Hegelian tradition, the End of History meant, more or less, the End of Modernism. This meant implicitly the end of self-conscious rational purpose to human action, either a reversion to purposeless primality (the state of nature) or a post-purposive loss of will. Numerous post-Modernist thinkers have spoken as if the end of history has already happened (again, perhaps introducing hints of the cyclical myth); in this view, the end is no longer something to look forward to, but something to look back upon. We—post-Modernist humanity—are what is left over after the end. And what is left over is precisely that vacated self lying like flotsam on the beach of eternity that our sculptors have been showing us so relentlessly of late. This robotic figure has no sense of what freedom is, not even enough sense to desire it. Or rather, it has realized freedom as the perfection of bondage, somewhat as B. F. Skinner meant when he wrote, "Freedom is what we call the way we feel when we do what we have been conditioned to do."[19] There can be no meaningful action from this robotic corpse, which acts only from its conditioning. Alexander Kojève wrote that ". . . the end of human Time, or History—that is, the definitive annihilation of Man properly speaking, or of the free and historical Individual—means quite simply the cessation of Action in the full sense of the term."[20]

Or is the present situation a theological trompe l'oeil or sleight of hand? Has the soul left the body as a husk that, while it may not be innately empty, has been emptied out for the time being so the soul can fly on high, into metaphysical realms beyond the pathetic inertia of the flesh, essentially transformative realms whence it flashes intimations of its redefined glory back into vision through the quirky suggestiveness of the flesh itself? Clearly, this possibility is not emphasized in the current visual realm (or the current philosophical realm); still, a post-Modernist stance toward the future must be open and questioning. Anything can happen.

The point is that the situation of the transition from Modernism to post-Modernism has conflicting inner currents. Croak's most recent work arises from a reflection on issues of belief or disbelief, maintenance of tradition or destruction of it, art as construction or art as destruction—"making a culture," as Croak puts it, "or continually tearing down the old one."[21] On the one hand, he has imbibed the lessons of deconstruction and post-Modern skepticism in general, and the nightmarish lessons of what Hannah Arendt called "this terrible century" have not been lost on him. But, on the other hand, there is an open question about how far such issues must be pressed in order to affirm their reality in a useful way.

The deconstructivist approach was aimed primarily at the claims of knowledge that characterize a culture that feels itself to be in control of its time. These claims, with which cultures attempt to convince themselves of their ultimate legitimacy and the possibility of their permanence, amount to residual religious projections; the religious/Platonic postulation of eternal verities, for example, remains effective in ideas such as the permanence of the values of Western civilization. But such ideas have historically been used to validate a nation's ambitions for hegemony over its neighbors. And such ideas have played havoc with the world's peoples more than once.

Croak sees the deconstructive impulse of post-Modernism as an instrument with which Western civilization was able, precariously, at a time of crisis, to correct its course with a desperate but accurate application of critical reason. To shift the metaphor, it was a necessary instrument, however painful, with which to lance and drain the suppurating wound of the past centuries. In terms of the world history of the last five hundred years, that wound arose from a false feeling of strength. The asseverative certainty of Western civilization, egged on meretriciously by the messianic irrationality of Christianity, caused a global pattern of wounding by stabbing thrusts of false certainty from the West. The use of knowledge claims as a tool for domination in the colonial period spread the wounding around the world. The condition was treated in the nick of time by resolute negations of false certainties. To this degree deconstruction and other skeptical procedures—and those who refined and applied them—were, in effect, heroic and redemptive.

But suppose what has been necessary to correct the course at the level of logical premises and epistemological critique has now been done: Suppose that, essentially, what Lyotard called the rejection of metanarratives was all that could be achieved by philosophical methods, and that it has by now been achieved: that post-Modernist epistemology has managed, in the last forty years or so, to inculcate in the general cultural community of the Western world a rational skepticism about the possibility of the ultimacy of any foundational belief. Then the question arises of what to do next. If maintained past its moment of usefulness, the deconstructive turn is in danger of becoming another mannerism, even a formalism based on the generation of elegant negations and paradoxes.

The alternative is an attempt to be at peace with one's situation that is not

based on a disguised absolutism. When the workshop has fallen in, or been razed to the ground, the workmen may proceed piecemeal and patiently to gather up, assemble, and work with what is left. It was never, after all, a tabula rasa that post-Modernist skepticism aimed at. The idea of a truly cleansed mind involves either the angelic absolutism of the virgin birth or the cauterized mind of the catatonic. The fact that we have corrected course does not mean that we are no longer on any course, nor does the fact that the ground is shifting under our feet mean that we cannot get anywhere. Is it time to start, more modestly, making a culture again, rather than continuing to mime the redemptive moment of tearing down the past?

10.

Rodin's work has seemed like kitsch for half a century or so. In part, it acquired this reputation due to the taboo on figurative art in the Modernist era of abstractionist Puritanism. The fact that Rodin was especially picked for censure on grounds of the supposed vulgarity of the figure indicates how successful he had been in implementing his figurative program: He became equated in reputation with the figurative impulse, which no doubt he would have approved. But the fact that the figure was ever regarded as vulgar, or the representation of it as necessarily kitsch, must give pause. This belief was characteristic of the age of the abstract sublime, which also was an age of great wars, holocausts, subjections, and dominations—an age that devoted itself more broadly and successfully than any other in recorded history to the literal destruction of human beings in their actual bodies. An over-weening contempt for embodied life characterized the age of Modernist abstraction, and the contempt for figurative sculpture seems not accidentally linked to the contempt for the living body it is based on. It is still not widely realized how transcendentalist Modernist ideology was—how oriented, like Christianity, and Platonism before it, toward the idea that the soul is inimical to the body and has as its highest destiny the transcendence of its bondage to physical form. Much Modernist abstraction was actually based on millennialist views to the effect that the body had been obsoleted and a new purely spiritual age was dawning; such feelings lay behind the work of Mondrian, Malevich, Kandinsky, the Abstract Expressionists in general, and the Platonist sculptors of pure form from Brancusi to Caro. The various theosophical, cabalistic, and Neoplatonist backgrounds to their oeuvres all taught that the age of the body was almost at its end, and the age of pure spirit was about to begin.[22] That was why the artist who was anticipating the imminent dawning of the new age never showed the body: It was supposedly gross and outmoded, and he was aiming at something higher.

Rodin's work had several directions but some have seen at its center the dictum that "the sculpture is the figure, the figure is the sculpture."[23] In certain of his works, he attempted to break the figure away from context, narrativity, and referential accumulations, and present it isolated as itself. This portion of his oeuvre resides above all in his focus on the individual figure, sometimes abbreviated to a walking torso, in contrast to the emphasis in the salons of his day on sculptural groups

dripping with juicy narratives. The main examples include *John the Baptist*, *The Age of Bronze*, and perhaps above all the *Walking Man*, and *Study for Balzac F.* Though some of these figures still have narrative clinging round them because of their titles, they are sculpturally isolated, and there is a concentration of humanism in this isolation. In these few central works, Rodin shows a concentration on the figure that goes back even beyond Michelangelo to the kouros, a figurative type that seems to have been intended, in its own context, to stand alone, as a simple statement of humanity in and by itself, without adventitious ideation or narration. Michelangelo's work, though undoubtedly humanist in its emphasis on the figure, still retained something of the feel of the sculptural group, and hence of a storytelling impulse rather than a pure confrontation with the fact of the existence of the human body or self. Even in figures seemingly desolate in their isolation, like the *Slaves,* there was a grouping and a narration somewhat like that of the ancient group of the *Dying Niobids;* and even in a purely solitary figure like the *David,* there was a surrounding, if unseen, narrative group: the Goliath in the gleam of his eye, the Hebrew people silently backing him up, and so on. But Rodin in certain figures tried to return all the way to the kouros (though he might not have expressed it that way, since he thought more in terms of his Renaissance predecessors than his Greco-Roman ones). Parallel to his isolation of the figure from the group was his isolation of the body part from the whole figure. Beginning around 1880, during work on *The Gates of Hell*, Rodin sculpted fragments of figures—mostly arms, hands, and heads. On the one hand, he was making fragments, and he seems to have shared the romantic love for the fragment that was based both on nostalgic longing for a beautiful thing that has been lost, and on sublime horror at the prospect of similarly losing what one still has. This would be the aesthetic of the fragment that was characteristic of the age. Or there is the somewhat different fragment-aesthetic adumbrated by Ezra Pound in *Personae,* during what you might call his Archilochean-Sapphic period, where the little sliver of reality is not regarded as a shiver from a lost whole but as a leaf, single but whole, turning in the breeze in simultaneous freshness, purity, and detail.

But Rodin's use of the fragment was somewhat different. At times he regarded it as nothing, as just a curiosity that might be shown to a visitor as such. In another sense, it was a curiosity that was simply the Whole—not a fragment, or a tiny but perfect detail, but a wholeness that was not tiny, not broken, not lost, simply isolated as under a conceptual microscope so as more intensely to appreciate its inexplicable yet undeniable truth as itself. In Rodin's work (as in Nietzsche's), it has been observed that "the fragment carries with it the conceptual weight of a major vision."[24]

11.

In Croak's Hand Series (1998), the cast dirt sculptures of hands and arms sometimes relate directly to these fragmentary works of Rodin. *Hand Series #1,* for example, is based on the right hand of John the Baptist. *Hand Series #3,* portraying an adult hand whose index finger is clutched by an infant's hand, reminds one of

Lovers' Hands, date unknown.[25] And in general the accumulation of fragments in Hand Series recalls the accumulation of hands and arms in Rodin's *Fragments* (1912).[26]

In Croak's work, as in most art since the eighteenth century, the fragment carries the theme of the passing of civilizations, the brokenness of what was once whole, the end of it all—and the converse of the same theme, as in *Hand Series #3*, the child's hand grasping the adult's, which suggests a way to go on, like Aeneas leading his toddler son Julus from the burning city of Troy (*Dextrae se parvus Julus*, Aeneas recounts to Dido, *inplicuit, sequiturque patrem non passibus aequis:* "Little Julus wound his hand in mine and followed his father with unsteady steps"—Vergil, *Aeneid* II. 723–24). In Croak's work (as in Rodin's), the fragment also bears the paradoxical sense of being more whole than the whole, a condensation of essence into detail wherein the part seems to contain the whole in stripped-down and highlighted meaningfulness.

Finally, in Croak's work the fragment conveys another theme that was not a part of Romantic symbolism but is peculiar to the post-Modern situation; it suggests something picked up in the hope of preserving it by someone who is going around the ruins and lovingly gathering the fragments to put them together into something new. But as in Kounellis's works on this theme, there may not be enough fragments left to put the whole back again as it was—like the archeologist recon-structing a broken vase in his pottery shed. So the theme of "new monstrosities" still hangs vaguely in the air as the figurative artist in the age of genetic engineering, like a mad scientist after Armageddon, gathers pieces of this blown apart monster and that one, aiming to put them back together into something that works somehow, for someone, at something.

It is meaningful that *Hand Series #1* is based on the outstretched right arm of Rodin's *John the Baptist*. This New Testament figure assumed a special impor-tance as a representation of humanity in the Christian tradition. The condemnation of the Arian controversy at the Council of Nicaea in the fourth century eliminated the Christ figure as an Everyman. Subsequently, the humanity of the Christ became exhausted by surfeit of meaning in the Gothic era and had to be avoided or ap-proached through displacement. And, in the visual tradition, that displacement was easily available: John was always there like an alter ego, as a naked babe gently frolicking in the ambience of Mary on Anne's lap, then as an adult reapproaching with tormented look to administer the rebirth rite. The arm is muscular, thrusting, demonstrative. In its reaching, pointing, stretching, and grasping, it defines the character of man as active, eager to bend the world to his purposes. It points toward a new time. Yet that new time is to be approached somewhat timidly through fragments of the old. The material of Croak's isolated human arms and hands links humanity to the earth with ecological overtones, implying that human destiny is intertwined with that of the earth and will not survive it.

12.

Man and Woman (1998) is composed of two life-size standing figures loosely based on a piece by Antonio Lopez-Garcia, *Hombre y Mujer* (1968–1990), but with changes. The woman's face is new, as is much of the man's body. In addition, Croak has altered the man's face to bring it closer to the face of Jean d'Aier, one of the Burghers of Calais in Rodin's group of that name. Croak's *Man and Woman* form a group, but at the same time they preserve the sense of isolation characteristic of the kouros and its female counterpart, the kora. This is achieved through an almost total elimination of narrative, the figures simply staring nakedly at the world in front of them. Significant differences from the kouros/kora relationship include the fact that the woman, like the man, is naked, whereas in the archaic Greek period the kouros was naked but the kora was clothed; in addition, the kouros was portrayed with one foot advanced as if striding or considering it, whereas the kora stood with her feet demurely together, not going anywhere. Lopez-Garcia preserves a hint of these gender-role conventions in the fact that his male figure's feet are spread apart (though not striding), while the woman's are almost touching. In Croak's version the gender-role differences are erased: Both the man's and the woman's feet are spread apart but positioned side by side; no one is striding or leading; they are standing still together, looking forward.

But they are not simply facing the world with wide-eyed curiosity, as were most of the kouroi. For one thing, Croak's man and woman are apparently middle-aged, perhaps in their fifties, whereas the kouros and kora were understood as youthful, according to the Greek ideal of the athlete, young adults perhaps in their early twenties, still feeling the wonder of the mere fact of being a subject confronting a world object. The meaning of the kouros could be characterized, in light of its chronological association with early Greek lyric poetry and pre-Socratic thought, as eager subjectivity, dawning awareness of selfhood, something like the infancy of the world or, as Bruno Snell put it, the "discovery of the mind."[27]

Croak's man and woman are very different. Middle-aged, they have been through the mill already. Their bodies and their faces show the traces of far more experience than the kouros shows with his innocent smile. The woman's body seems already to have experienced motherhood, her hips wide and solid, her breasts pendulous and used, her arms looking as if they had worked many hours. Likewise, Croak's male figure seems to have gone through the traditional experiences of a man; the solidity of his stance looks like the strength of a worker, and his slightly defensive gaze and posture suggest experience of war.

Other revealing traits are quietly present, dimly hinting at a minimal narrative. Despite their nakedness, there is no suggestion of erotic feeling between them. They do not signify the theme of *hieros gamos*, or sacred marriage, as such sculptural couples in antiquity usually did.[28] Perhaps they have had their children already years before. And it is highly significant that they stand without contrapposto. They are not relaxed, like figures in the Polycleitian tradition, such as the two bronze warriors from Riace, who seem to be idly observing some spectacle.[29] On the

contrary, Croak's man and woman are not watching something at their leisure; they themselves clearly are the subject of attention. They stand with an artificial formality, not relaxed and not at ease, almost as if they were standing at attention to present themselves for inspection or awaiting the attention of some inspector. The closest parallels in the sculptural tradition are certain Old Kingdom Egyptian groups that show a pharaoh and his wife standing in a similar posture of presentation as if they were showing up for the serious work of the world, presenting themselves to the gods who oversee such matters.[30]

In terms of Croak's oeuvre, it seems indeed as if these strong, competent, and sane-looking humans were offering themselves for work that needs to be done. It is the work that defines humanity, the work of its massive communal project of civilization, which they, without joy it seems, yet willingly, present themselves for. They are not clearly post-civilizational figures, like the Dirt Men. Their wills are not broken, nor are their bodies exhausted. Still, they are connected somehow with the Dirt Men. They may represent a later stage of the same generation of humanity, a stage when the figure picks itself up again from its posture of debasement and finds within itself the strength to go on.

Notes

Chapter 1: The Art of Doubting

1. Bertrand Russell, *The Will to Doubt* (New York: The Philosophical Library, 1958), p. 9.
2. The more common orthography is "postmodernism." I think it misses the point, which is that Modernism, with its dependence on universals, was a crypto-religion—hence capitalized; post-Modernism, on the contrary, is an attempt to demystify Modernism, that is, to eliminate its appeal to universals.
3. Joseph Natoli and Linda Hutcheon, eds., *A Postmodern Reader* (Albany: State University of New York Press, 1993). The theme of "what the word could possibly mean" (p. 1) occurs, with varying emphases, in the essays by Zygmunt Bauman, Hans Bertens, Jurgen Habermas, Andreas Huyssen, Linda Hutcheon, Ihab Hassan, Cornel West, Stephen Slemon, and Paul Maltby—nine out of twenty-five.
4. Zygmunt Bauman, "Postmodernity or Living with Ambivalence," in ibid., p. 10.
5. Ibid., p. 11.
6. Hans Bertens, "The Postmodern *Weltanschauung* and Its Relation to Modernism: An Introductory Survey," in Douwe Fokkema and Hans Bertens, eds., *Approaching Postmodernism* (Amsterdam/Philadelphia: John Benjamins Co., 1986), reprinted in Natoli and Hutcheon, *A Postmodern Reader,* p. 45.
7. Ibid., p. 61.
8. Joanna Hodge, "Feminism and Postmodernism," in Andrew Benjamin, ed., *The Problems of Modernity: Adorno and Benjamin* (London: Routledge, 1991), p. 88.
9. John Milton, sonnet 12, "On the Same;" see, for example, John Milton, *The Poetical Works of John Milton* (New York: A. L. Burt, n.d.), p. 434.
10. Hans Bertens, "The Postmodern *Weltanschauung* and Its Relation to Modernism: An Introductory Survey," in Natoli and Hutcheon, *A Postmodern Reader,* pp. 45, 64.
11. Karl Popper, *The Logic of Scientific Discovery* (New York: Basic Books, 1959). Italics added.
12. Philip B. Yampolsky, trans., *The Zen Master Hakuin: Selected Writings* (New York: Columbia University Press, 1971), p. 144.
13. Ibid., pp. 144–145.
14. Ibid., p. 145.
15. R. G. Bury, trans., *Sextus Empiricus,* vol. 1, *Outlines of Pyrrhonism,* 1.12 (Cambridge, Mass.: Harvard University Press, The Loeb Classical Library, 1933), p. 9.

16. Thomas McEvilley, "Pyrrhonism and Madhyamika," *Philosophy East and West* 32, no. 1 (January 1982), p. 4.

17. Heinrich Dumoulin, *Zen Buddhism: A History*, vol. 2, *Japan* (New York: Macmillan Publishing Company, 1990), p. 373.

18. H. Saddhatissa, trans., *The Sutta-Nipata* (London: Curzon Press, Ltd., 1985), p. 95.

19. Cited in McEvilley, "Pyrrhonism and Madhyamika," p. 5.

20. R. D. Hicks, trans., *Diogenes Laertius: Lives and Sayings of the Philosophers* (Cambridge, Mass.: Harvard University Press, 1925).

21. For more on this see Thomas McEvilley, "Penelope's Night Work: Negative Thinking in Greek Philosophy," *Krisis* 2 (1985).

22. For more on this, see Thomas McEvilley, "Early Greek Philosophy and Madhyamika," *Philosophy East and West* 31 (1981), and "Pyrrhonism and Madhyamika."

23. A. J. Ayer, *The Problem of Knowledge* (Harmondsworth: Penguin Books, Ltd., 1956).

24. Ibid., p. 52. Cf. Ludwig Wittgenstein, *Tractatus Logico-Philosophicus* (London: Routledge and Kegan Paul, 1974), p. 74: "What we cannot speak about we must pass over in silence."

25. Ayer, *Problem*, p. 53.

26. Or, to put it in terms that an ancient Pyrrhonist would have approved: There are no statements whatsoever that are invulnerable to a rational doubt, including the statement that there are no statements whatsoever that are invulnerable to a rational doubt—and the same goes for *that* statement, and for *that* one, and so on ad infinitum. So behind each statement there lurks not only a doubt, but an infinite series of doubts—and the same behind *that* one, and *that* one, etc. A Pyrrhonist might also approve of saying: There *seem* to be, then, no statements whatsoever that are invulnerable to a rational doubt.

27. On Thucydides see, for example, Robert Nisbet, *History of the Idea of Progress* (New York: Basic Books, 1980), pp. 25–27.

28. See especially Thomas McEvilley, *Art and Discontent: Theory at the Millennium* (Kingston, N.Y.: McPherson and Company, 1991), pp. 133 ff.

29. See Richard H. Popkin, *The History of Skepticism from Erasmus to Spinoza* (Berkeley: University of California Press, 1979), chaps. 2–4.

30. Ibid., pp. 33–34.

31. Ibid., p. 28.

32. Ibid., p. 34 and note 84.

33. Ibid., p. 14.

34. Ibid., p. 15.

35. Ibid., p. 36.

36. Ibid., pp. 19, 32.

37. Richard Popkin, *The Philosophy of the Sixteenth and Seventeenth Centuries* (New York: The Free Press, 1966), p. 111.

38. Popkin, *History of Skepticism*, p. 45.

39. At least in the edition of 1952: W. T. Jones, *History of Western Philosophy* (New York: Harcourt Brace and Company, 1952).

40. Wilhelm Windelband, *A History of Philosophy*, vol. 2, *Renaissance, Enlightenment, and Modern* (New York: Harper and Brothers, Harper Torchbook, 1958), p. 362; see also p. 355.

41. *Sextus Empiricus*, vol. 1, p. 17.

42. Popkin, *History of Skepticism*, p. 54.

43. Quotations from the *Apology for Raimund Sebond* use the translation of Donald M. Frame in Popkin, *The Philosophy of the Sixteenth and Seventeenth Centuries*, pp. 72–73.

44. Ibid., pp. 72–75.

45. Ibid., pp. 344, 346, 341. And compare Timon *ap*. Aristocles: "All things are by nature equally indeterminable, admitting of neither measurement nor discrimination. . . . our sense experiences and beliefs are neither true nor false. Therefore we ought not to put our trust in them, but be without beliefs, disinclined to take a stand one way or the other." Cited in McEvilley, "Pyrrhonism and Madhyamika," p. 5.

46. See Popkin, *History of Skepticism*, pp. 29 ff.

47. Robert Hughes, *Culture of Complaint: The Fraying of America* (New York: Oxford University Press, 1993); Dinesh D'Souza, *Illiberal Education: The Politics of Race and Sex on Campus* (New York: Random House, Vintage Books, 1992); Allan Bloom, *The Closing of the American Mind* (New York: Simon and Schuster, A Touchstone Book, 1987); Alex Callinicos, *Against Postmodernism: A Marxist Critique* (New York: St. Martin's Press, 1989); Christopher Norris, *Uncritical Theory: Postmodernism, Intellectuals, and the Gulf War* (Amherst: University of Massachusetts Press, 1992); *The Truth about Postmodernism* (Oxford: Blackwell, 1993).

48. Though as R. J. Forbes and E. J. Dijksterhuis point out, Bacon "did not make any positive contributions to [science's] development. . . . If Bacon's name and all his writings were eliminated from the history of science, not a single conception, not a single result would be lost." His value is that "his ideas about science and its social importance . . . had a highly stimulating effect on the development of thought." *A History of Science and Technology, Ancient Times to the Seventeenth Century*, vol. 1 (Baltimore: Penguin, 1963), pp. 180–181.

49. Richard Rorty, *Consequences of Pragmatism: Essays: 1972–80* (Minneapolis: University of Minnesota Press, 1982), p. 162.

50. Stephen Toulmin, *Cosmopolis: The Hidden Agenda of Modernism* (Chicago: The University of Chicago Press, 1990), p. 72.

51. Forbes and Dijksterhuis, *History of Science*, vol. 1, p. 183.

52. Ibid., pp. 250–251.

53. Lionello Venturi, *History of Art Criticism*, trans. Charles Marriott (New York: E. P. Dutton, 1964), pp. 112, 115, 121, 123, 124.

54. Cited by Jacques Derrida in "The Supplement of Copula: Philosophy before Linguistics," in Josue V. Harari, ed., *Textual Strategies: Perspectives in Post-Structuralist Criticism* (Ithaca, NY: Cornell University Press, 1979), p. 85.

55. Toulmin, *Cosmopolis*, p. 11.

56. Ibid., p. 35.

57. Hannah Arendt, *The Origins of Totalitarianism* (New York: Meridian Books, 1960), p. 468.

58. Peter Gay, *The Enlightenment: An Interpretation*, vol. 1, *The Rise of Modern Paganism* (New York: W. W. Norton and Company, 1966), p. 35.

59. Ibid., vol. 1, p. 17.

60. Cited ibid., vol. 1, p. 36.

61. Cited ibid., vol. 1, p. 46.

62. Cited ibid., vol. 1, p. 48.

63. Ibid., vol. 1, p. 55.

64. Ibid., vol. 1, p. 58.

65. Edmund Burke, *On Taste, On the Sublime and the Beautiful, Reflections on the French Revolution, A Letter to a Noble Lord,* ed. Charles W. Eliot (New York: P. F. Collier and Son Corporation, The Harvard Classics, 1937). Christopher Norris writes of "the Kantian sublime, a topos [with] extraordinary prestige and prominence in recent critical debate" in *The Truth about Post-modernism,* p. 15. Indeed, the Kantian sublime has become a post-Modernist topos in a way in which Kant might not fully recognize. As Lyotard said: "modern aesthetics is an aesthetic of the sublime. . . ." "Answering the Question, What is Postmodernism?" in Ihab Hassan and Sally Hassan, eds., *Innovation/Renovation: New Perspectives on the Humanities* (Madison: University of Wisconsin Press, 1983), p. 340. The Kantian sublime is ambiguous in this respect; my account will work with the solidly Modernist topos of the Burkean sublime.

66. T. S. Dorsch, trans., *Classical Literary Criticism: Aristotle, On the Art of Poetry; Horace, On the Art of Poetry; Longinus, On the Sublime* (Baltimore: Penguin Books, 1965), p. 99.

67. Ibid., pp. 102, 108.

68. Ibid., p. 109.

69. Ibid., pp. 110, 111.

70. Jonathan Richardson, cited in Andrew Wilton, *Turner and the Sublime* (Chicago: University of Chicago Press, British Museum Publications Ltd., 1980), p. 9.

71. Ibid.

72. Ibid.

73. Ibid., p. 27.

74. Rudolf Otto, *The Idea of the Holy,* trans. John W. Harvey (London: Oxford University press, 1958), pp. 12–30.

75. Georg W. F. Hegel, *The Philosophy of History,* trans. J. Sibree (Buffalo: Prometheus Books, 1991), pp. 450–451.

76. J. N. Findlay, *Hegel: A Re-examination* (New York: Oxford University Press, 1976), pp. 29, 125.

77. Arendt, *Totalitarianism,* p. 465.

78. Ibid., p. 467.

79. Rose MacAulay, *Pleasure of Ruins* (London: Wiedenfelt and Nicolson, 1953).

80. For more on this, see Thomas McEvilley, "*La peinture monochrome . . .*" in *Le couleur seule: l'expérience du monochrome* (Lyon: Musee St-Pierre, art contemporain, 1988); republished in English as "Seeking the Primal through Paint: The Monochrome Icon," in Thomas McEvilley, *The Exile's Return: Toward a Redefinition of Painting for the Post-Modern Era* (New York: Cambridge University Press, 1993).

81. For this and other texts of St. John, I am using *The Collected Works of St. John of the Cross,* Kieran Kavanaugh and Otilio Rodriguez, eds. (Washington, D.C.: Institute of Carmelite Studies, 1979).

82. Ibid., pp. 67, 75.

83. Steven Best and Douglas Kellner, *Postmodern Theory: Critical Interrogations* (New York: The Guilford Press, 1991).

84. Ibid., p. 3.

85. "The meaning of meaning is infinite implication, the indefinite referral of signifier to signi-fied. . . . Its force is a certain pure and infinite equivocality which gives signified meaning no respite, no

rest . . . it always signifies again and differs." Jacques Derrida, *Speech and Phenomena, and other Essays on Husserl's Theory of Signs* (Evanston, Ill.: Northwestern University Press, 1973), p.58.

This argument is somewhat pervasive in Derrida's writing, appearing in various forms in different texts. It is really the underlying argument for *différance* and slippage of meaning. It appears repeatedly in "The Supplement of Copula," for example in the passage about "mistaking the chain of expressing units for the chain of expressed units" (p. 100). This is an essentially Zenonian type of argument, displacing Zeno's argument about physical space to semantic space. See A. Szabo, "Eleatica," *Acta Antiqua Academiae Scientiarum Hungaricae* 3 (1955), pp. 67–103, and "Wie ist die Mathematik zu einer deduktiven Wissenschaft geworden?" ibid., 4 (1956), pp. 109–152.

86. Zygmunt Bauman, "Postmodernity, or Living with Ambivalence," in Natoli and Hutcheon, *A Postmodern Reader*, pp. 10 and 11.

87. Best and Kellner, *Postmodern Theory*, p. 3.

88. Theodor Adorno, draft introduction to *Aesthetic Theory*, cited by Peter Osborne, "Adorno and the Metaphysics of Modernism: The Problem of a 'Postmodern' Art," in *The Problems of Modernity: Adorno and Benjamin*, Andrew Benjamin, ed. (London and New York: Routledge, 1991), p. 23.

89. Ibid., p. 24.

90. Ibid.

Chapter 2: Sculpture, Painting, and the Post-Modern Reversal of Values

1. Cf. Michael Kohler, "'Postmodernismus': Ein begriffsgeschichtlicher Uberblick," *Amerikastudien* 22, p. 8: "Despite persisting controversies as to what constitutes the characteristic traits of the new era, the term 'postmodern' is now generally applied to all cultural phenomena which have emerged since the Second World War and are indicative of a change in sensibility and attitude, making the present an age 'post the Modern.'"

2. For more on this theme see Thomas McEvilley, "Art History or Sacred History?" in *Art and Discontent: Theory at the Millennium* (Kingston, N.Y.: McPherson and Company, 1991); "History, Quality, Globalism," in *Capacity: History, the World and the Self in Contemporary Art and Culture*, with Roger Denson (New York: Gordon and Breach, Critical Voices Series, 1996).

3. A *coupure épistemologique* should not be understood as involving a tabula rasa—a completely new beginning on a fresh slate. What happens after the break has some relation to—some continuity with—what went before it, however oppositional or revisionistic it might be.

4. Hans Belting, *The End of Art History?* (Chicago: University of Chicago Press, 1987). Some of the papers delivered at the session on "The New (?) Art History" have been published in Philip Alperson, ed., *The Philosophy of the Visual Arts* (New York: Oxford University Press, 1992), pp. 515–532; Donald Preziosi, *Rethinking Art History* (New Haven, Conn.: Yale University Press, 1989).

5. Heinrich Wölfflin, *Principles of Art History: The Problem of the Development of Style in Later Art* (New York: Dover Publications, Inc., 1950), pp. 1 ff., 226 ff. And see Michael Podro, *The Critical Historians of Art* (New Haven, Conn.: Yale University Press, 1982), pp. 129–133.

6. The first list is cited by Hans Bertens, "The Postmodern *Weltanschauung* and Its Relation to Modernism: An Introductory Survey," in Natoli and Hutcheon, eds., *A Postmodern Reader*, p. 46. The second is from Ihab Hassan, "Toward a Concept of Postmodernism," ibid., p. 282.

7. "Pastiche" is Frederic Jameson's term for post-Modern cultural objects. See *Postmodernism, or, The Cultural Logic of Late Capitalism* (Durham, North Carolina: Duke University Press, 1991), p. 16.

8. Gerald Graff, *Literature against Itself: Literary Ideas in Modern Society* (Chicago: University of Chicago Press, 1979), p. 55.

9. Compare Zygmunt Bauman, "Postmodernity, or Living with Ambivalence," in Natoli and Hutcheon, *A Postmodern Reader*, p. 16.

10. In Bertens, "The Postmodern *Weltanschauung* and Its Relation to Modernism: An Introductory Survey," ibid., p. 45.

11. For more on this subject, see Thomas McEvilley: "The Millennial Body: The Art of the Figure at the End of Humanity," *Sculpture* (October 1997).

12. Translation appears in J. J. Pollitt, *Art and Experience in Classical Greece* (Cambridge: Cambridge University Press, 1972), p. 100.

13. Pheidias himself (at least according to the anecdotal record) gives an interestingly similar and different account, to wit, that he was not contemplating any visual model at all, whether ideal or particular, but rather a line of Homer: "Thus spoke the son of Kronos and nodded his dark brow and the ambrosial locks flowed down from the lord's immortal head, and he made great Olympus shake." (*Iliad* I.527–530) Cited by Pollitt, *Art and Experience*, p. 99.

14. W. B. Yeats, "The Statues," in M. L. Rosenthal, ed., *Selected Poems and Two Plays of William Butler Yeats* (New York: Collier Books, 1962), p. 175.

15. This points to an inner contradiction in the thought of Clement Greenberg: The realization of the presence of the surface that he advocated leads to a perception of a painting not as an illusion but as an object—that is, no longer as a painting but as a sculpture. The ultimate result of his formalism, as others have observed, was not painting at all but Minimal Sculpture.

16. For more on this, see Thomas McEvilley, "Absence Made Visible: The Work of Robert Ryman," *Artforum* (Summer 1992); reprinted in McEvilley, *The Exile's Return: Toward a Redefinition of Painting for the Post-Modern Era* (New York: Cambridge University Press, 1993).

17. Graff, *Literature against Itself*, p. 55.

18. Arthur Danto, *Encounters and Reflections: Art in the Historical Present* (New York: Farrar Straus Giroux, The Noonday Press, 1991), p. 289.

19. Wilhelm Windelband, *A History of Philosophy*, vol. 2, *Renaissance, Enlightenment, Modern* (New York: Harper and Brothers, 1958), pp. 600–603.

20. In Pierre Cabanne, *Dialogues with Marcel Duchamp* (New York: DaCapo, 1979), p. 16.

21. A point made by Thierry de Duve in "The Readymade and the Tube of Paint," in *Kant after Duchamp* (Cambridge, Mass.: The MIT Press, 1996), p. 150.

22. Duchamp tried it in 1916 and did not repeat it. See Schwartz, *The Complete Works of Marcel Duchamp*, 2nd revised ed. (New York: Harry N. Abrams, Inc., 1969), p. 462, catalog entry 239: "*The Battle Scene*, 1916, New York. Ready-made: mural at the Cafe des Artistes, New York, to which Duchamp added his signature." Duchamp did not repeat the act. The problem is that a painting, like anything else, when designated as an artwork by someone other than its maker, is designated as a "thing" or object—that is, as a sculpture. (If a painter pays an assistant to make a painting to a certain design, then signs it as his own, this does not involve an act of designation.)

23. Rosalind E. Krauss, *Passages in Modern Sculpture* (Cambridge, Mass.: The MIT Press, 1981), pp. 84, 72.

24. In Cabanne, *Dialogues with Marcel Duchamp,* p. 72.

Chapter 3: Duchamp, Pyrrhonism, and the Overthrow of the Kantian Tradition

Originally published as "Empyrrhical Thinking (and Why Kant Can't)," Artforum *(October 1988).*

1. Rudolf E. Kuenzli and Francis M. Nauman, eds. *Marcel Duchamp, Artist of the Century* (Cambridge, Mass.: The MIT Press, 1990); Janis Mink, *Marcel Duchamp, Art as Anti-Art* (Cologne: Benedikt Tascher, 1995), p. 7.

2. Arturo Schwarz, *The Complete Works of Marcel Duchamp* (London: Thames and Hudson, 1969); Octavio Paz, *Marcel Duchamp: Appearance Stripped Bare* (reprint, New York: Seaver Books, 1979); Jack Burnham, "Unveiling the Consort," *Artforum* (March and April 1971); "Duchamp's Bride Stripped Bare," *Arts* (March, April, and May 1972); Gianfranco Baruchello and Henry Martin, *Why Duchamp: An Essay on Aesthetic Impact* (New Paltz, N.Y.: McPherson and Company, 1985); Pierre Cabanne, *Dialogues with Marcel Duchamp* (French ed., 1967, English trans., 1971; reprint, New York: Da Capo Press, 1979); André Breton, quoted in Cabanne, p. 16; Alice Goldfarb Marquis, *Marcel Duchamp: Eros, c'est la Vie, A Biography* (Troy, N.Y.: The Whitson Publishing Company, 1981); Donald Kuspit, "Marcel Duchamp, Imposter Artist," in *Idiosyncratic Identities* (New York: Cambridge University Press, 1996); John Canaday, "Iconoclast, Innovator, Prophet," the *New York Times,* 3 October 1968, p. 51.

3. Paz, *Marcel Duchamp: Appearance Stripped Bare,* p. 184.

4. Burnham, "Unveiling the Consort, Part One," p. 59.

5. Quoted in Calvin Tomkins, *The Bride and the Bachelors* (New York: Penguin, 1976), p. 22. The Independents were particularly reluctant to accept the title of the *Nude* . . . and asked Duchamp to change it. He preferred to withdraw the painting from the show.

6. Quoted in Robert Lebel, *Marcel Duchamp* (London: Trianon Press, 1959), p. 71.

7. Cabanne, *Dialogues,* p. 15.

8. Schwarz, *The Complete Works,* pp. 98–99, 105–107, and passim.

9. Marquis, *Marcel Duchamp: Eros, c'est la Vie,* pp. 76, 80.

10. Ibid., p. 96.

11. This is actually a fairly common view. Marquis seems to have stated it first, but before Kuspit took it up, it had already been propounded by Michael Fried and Thierry de Duve. Fried wrote, "Duchamp was a failed modernist . . . before he turned his hand to the amusing inventions [the Readymades] by which he is best known." Michael Fried, *Three American Painters: Kenneth Noland, Jules Olitski, Frank Stella* (Cambridge, Mass.: Harvard University Press, 1965), p. 47. And de Duve says: "Duchamp found a way out of painting after having discovered that he was not too gifted." Thierry deDuve, *Kant after Duchamp* (Cambridge, Mass.: The MIT Press, An October Book, 1996), p. 150.

12. Donald Kuspit, "Marcel Duchamp, Imposter Artist," pp. 64, 65.

13. Ibid., p. 67. Kuspit's view that there was a complicity in falsehood between Duchamp and his

audience was shared by Thomas Hess in his polemic "J'Accuse Marcel Duchamp"; Duchamp, Hess says, was "the first artist to enter into this kind of compact with his audience . . . disastrously. . . confus[ing] art with life." Thomas Hess, "J'Accuse Marcel Duchamp," *ARTNews* (February 1965), p. 53. The compact was, in Kuspit's view, that both sides would pretend to believe that the Readymade was a real work of art, whereas at some level of their minds both sides knew it was not.

I think this is much what Michael Fried meant by calling Duchamp's work theatrical: By making his work cognitive Duchamp sent a (sly, ironic) message to his audience, which they then cognitively apprehended and played along with; this shared cognitive activity *is* the conspiracy. On the same grounds Fried, writing in 1982, called all of post-Modernism theatrical: "In the years since 'Art and Objecthood' was written, the theatrical has assumed a host of new guises and has acquired a new name: postmodernism." From Fried's note 17 in "How Modernism Works: A Response to T. J. Clark," reprinted in Francis Frascina, ed., *Pollock and After* (New York: Harper and Row, 1985), p. 78. What Fried called a "full" rather than a "theatrical" artwork had no admixture of the cognitive but, as in Greenberg's reading of Kant, was purely and exclusively aesthetic in a formal sense.

Roger Shattuck agrees to an extent with the basic idea of the imposture ("Everyone has been taken in, with foreknowledge and gusto"), but is not hostile about it, referring to Duchamp's lifework as "an edifying hoax." *The Innocent Eye, On Modern Literature and the Arts* (New York: Washington Square Press, 1986), p. 347.

14. Except for brief mentions by Schwarz, *The Complete Works*, p. 33 and note 23, and Paz, *Marcel Duchamp: Appearance Stripped Bare*, p. 35.

15. Most authorities give 1913 for the commencement of Duchamp's employment at the library— for example, Paz, ibid., p. 185; Cabanne, *Dialogues*, p. 114; Anne d'Harnoncourt and Kynaston McShine, eds., *Marcel Duchamp* (New York: Museum of Modern Art, 1973), p. 14. At least one gives 1912: Jean-Christophe Bailly, *Duchamp* (New York: Universe Books, 1986), p. 112. Lebel describes the period of employment as "early in 1913" (*Marcel Duchamp*, p. 27). Perhaps the job began late in 1912 and ran into 1913.

16. Cabanne, *Dialogues*, p. 17.

17. Schwarz, *The Complete Works*, p. 38, note 23. For a discussion of Pyrrho's thought see Thomas McEvilley, "Penelope's Night Work: Negative Thinking in Greek Philosophy," *Krisis* 2 (1985), pp. 41–59. Reprinted in Thomas McEvilley and Roger Denson, *Capacity: History, the World, and the Self in Contemporary Art and Criticism* (New York: Gordon and Breach, Critical Voices series, 1996).

18. The only other philosopher he ever singled out in this way was the nineteenth-century German anarchist Max Stirner (1806–1856), whose work he encountered in Munich right before taking the librarian job. Stirner does not really compromise the Pyrrho connection, however, as he also rejected all philosophical systems and all appeals to authority. Duchamp, in this turning-point year, seems to have chosen two thinkers who would reinforce his own feelings of intellectual doubt.

19. R. D. Hicks (trans.), *Diogenes Laertius: Lives of Eminent Philosophers* (Cambridge, Mass.: Harvard University Press, 1966), vol. 2, p. 483.

20. Timon's remarks are preserved in a text of Aristocles found in Hermann Diels, ed., *Poetarum Philosophorum Fragmenta*, fascicle 3, part 1, of U. von Wilamowitz, ed., *Poetarum Graecorum Fragmenta* (Berlin, 1901), pp. 175–76.

21. See, for example, Paz, *Marcel Duchamp: Appearance Stripped Bare*, p. 48; Schwarz, *The Complete Works*, p. 39; Marquis, *Marcel Duchamp: Eros, c'est la Vie*, p. 182; or Harriet and Sidney Janis, "Marcel Duchamp, Anti-Artist," in Joseph Masheck, ed., *Marcel Duchamp in Perspective* (Englewood Cliffs, N.J.: Prentice Hall, Inc., 1975), p. 36.

22. Cabanne, *Dialogues*, p. 17.

23. Ibid., p. 85.

24. Quoted in Schwarz, *The Complete Works*, p. 194.

25. Cabanne, *Dialogues*, p. 70.

26. Ibid., pp. 89–90.

27. Ibid., p. 48.

28. Quoted in Alexander Keneas, "The Grand Dada," the *New York Times*, 3 October 1968, pp. 1, 51.

29. Marquis, *Marcel Duchamp: Eros, c'est la Vie*, p. 227.

30. Henri-Pierre Roche's explanation as cited by Marquis, ibid., p. 234.

31. Quoted in Marquis, ibid., p. 234.

32. Letter to Katherine Dreier, 1929, quoted in Marquis, ibid., p. 236.

33. Quoted in Marquis, ibid., p. 311.

34. See, for example, Schwarz, *The Complete Works*, p. 34.

35. Ibid.

36. Ibid.

37. John Cage, for example, remarks, "I asked him once or twice, 'Haven't you had some direct connection with oriental thought?' And he always said no. . . . There weren't any specific oriental sources. But there may have been other sources." Moira and William Roth, "John Cage on Marcel Duchamp: An Interview," in Masheck, *Marcel Duchamp in Perspective*, p. 154.

38. See Thomas McEvilley, "Pyrrhonism and Madhyamika," *Philosophy East and West* 32, no. 1 (January 1982), pp. 3–35.

39. Schwarz, *The Complete Works*, p. 34.

40. Seung Sahn, quoted in Stephen Mitchell, ed., *Dropping Ashes on the Buddha: The Teaching of Zen Master Seung Sahn* (New York: Grove, 1976), p. 133.

41. Bury (trans.) *Diogenes Laertius*, p. 477.

42. Joseph Beuys, for example, entitled a 1964 performance *Das Schweigen von Marcel Duchamp wird uberbewertet* (*The Silence of Marcel Duchamp Is Overvalued*).

43. Michel de Montaigne, "Apology for Raimund Sebond," in Richard H. Popkin, ed., *The Philosophy of the Sixteenth and Seventeenth Centuries* (New York: The Free Press, 1966), p. 72.

44. Cabanne, *Dialogues*, p. 42. Duchamp was referring specifically to his work on the *Large Glass*.

45. See, for example, Keneas, "The Grand Dada."

46. Marquis, *Marcel Duchamp: Eros, c'est la Vie*, p. 285

47. James Johnson Sweeney, interview with Marcel Duchamp, "Eleven Europeans in America," *The Museum of Modern Art Bulletin*, 13, nos. 4–5 (New York, 1946), pp. 19–21.

48. Thierry de Duve's book *Kant after Duchamp* (Cambridge, Mass.: The MIT Press, 1996) is a strangely ambiguous contribution to the discussion. The author attempts to stay on the fence about Modernism and post-Modernism, saying, for example, that "the choice between the modern and the postmodern is a false one" (p. 325). Still, it seems clear that his bottom line is a personal commitment to Modernism. At the beginning (p. xiv) he says he will use "the modern when the issue at stake . . . is the appreciation of art; the postmodern when it is a matter of

looking back, 'archeologically,' on modernity . . ." So the post-Modern relates to the Modern, and the Modern relates to art; the post-Modern does not really relate to art. Despite the author's attraction to the Duchampian position, a devotion to the Kantian tradition seems finally to have priority.

49. Cabanne, *Dialogues,* p. 48.

50. Ibid., p. 94.

51. Quoted in Paz, *Marcel Duchamp: Appearance Stripped Bare,* p. 28.

52. Quoted in Marquis, *Marcel Duchamp: Eros, c'est la Vie,* p. 96.

53. Cabanne, *Dialogues,* p. 71.

54. Quoted in Keneas, "The Grand Dada." Carried to the limit, Duchamp's theory—for it is a theory—duplicates some of what it was intended to oppose. Like the Kantian doctrine of taste, it posits something like a free, pure, absolute faculty of mind, beyond habit systems and conditioning. The danger was surely recognized by Pyrrho, who refrained from formulating theory per se, and one suspects Duchamp was aware of it, too.

55. Georg W. F. Hegel, *The Philosophy of Fine Art,* in Albert Hofstadter and Richard Kuhns. eds., "Philosophies of Art and Beauty" (1964; reprint ed., Chicago: The University of Chicago Press, Phoenix Books, 1976), p. 445.

56. Friedrich Wilhelm Josef von Schelling, *System of Transcendental Idealism,* in ibid., p. 373.

57. Quoted in ibid., p. 448.

58. Duchamp sometimes fell into this kind of discourse, which was all-pervasive during his youth, as when he said, "Art opens onto regions that are not bound by time or space" (quoted in Paz, *Marcel Duchamp: Appearance Stripped Bare,* p. 88). But these remarks are contradicted by countless other statements he made. He felt, for example, that the cracks in the *Large Glass* brought it into the world: "It's a lot better with the breaks. A hundred times better. It's the destiny of things" (Cabanne, *Dialogues,* p. 75).

59. Cabanne, ibid., p. 67.

60. Quoted in Tomkins, *The Bride and the Bachelors,* pp. 18–19.

61. Marquis, *Marcel Duchamp: Eros, c'est la Vie,* p. 206.

62. Arthur Danto, *Encounters and Reflections: Art in the Historical Present* (New York: Farrar Straus Giroux, The Noonday Press, 1991), p. 289.

63. Rosalind Krauss, "The Naked Bride," review of Octavio Paz, *Marcel Duchamp: Appearance Stripped Bare,* in *Partisan Review* 46 (1979), p. 619; William Camfield, *Duchamp's Fountain* (Houston: Menil Collection and Fine Arts Press, 1989), p. 88; Jack Burnham, *Great Western Salt Works: Essays on the Meaning of Post-Formalist Art* (New York: George Braziller, 1974), p. 71; Timothy Shipe, in Rudolf E. Kuenzli and Francis M. Naumann, eds., *Marcel Duchamp: Artist of the Century* (Cambridge, Mass.: The MIT Press, 1996), p. 231; Rudolf E. Kuenzli, "Introduction," ibid., p. 1. J. G. Merquior, "Spider and Bee: Toward a Critique of the Post-modern Ideology," in *Postmodernism/ICA Documents 4/5,* ed. Lisa Appignanesi (London: Institute of Contemporary Art, 1986), pp. 16–18; Amelia Jones, *Postmodernism and the Engendering of Marcel Duchamp* (New York: Cambridge University Press, 1994), pp. xi–xvi.

64. Jones, *Postmodernism,* p. xiv: ". . . the American postmodern Duchamp has tended to be reduced to his readymades (and as the 'readymade Duchamp,' he instigates the critique of the institu-tion . . .)."

65. Quoted in Schwartz, *The Complete Works,* p. 39.

66. Jones, *Postmodernism*, pp. 38, 39, 37; Max Kozloff, "Duchamp" (1965), in *Renderings: Critical Essays on a Century of Modern Art* (New York: Simon and Schuster, 1968), p. 121.

67. Jones, *Postmodernism*, p. xiv.

68. Keneas, "The Grand Dada."

69. Roger Shattuck, *The Innocent Eye*, p. 346. John Canaday, "Philadelphia Museum Shows Final Duchamp Work," the *New York Times*, 7 July 1969.

70. John Canaday, "Leonardo Duchamp," the *New York Times*, 17 January 1965, section 2, p. 19.

71. Hess, "J'Accuse," p. 53. Canaday, "Philadelphia Museum."

72. Canaday, "Iconoclast, Innovator, Prophet," p. 51.

73. Marquis, *Marcel Duchamp: Eros, c'est la Vie*, p. 312.

74. Tomkins, *The Bride and the Bachelors*, p. 1.

75. Cabanne, *Dialogues*, p. 104.

76. Tomkins, *The Bride and the Bachelors*, p. 1.

77. Clement Greenberg, "Counter-Avant-Garde," in Masheck, *Marcel Duchamp in Perspective*, p. 124.

78. Greenberg's definition of academic art is relevant here: "The academic artist tends, in the less frequent case, to be one who grasps the expanded expectations of his time, but complies with them too patly. Far more often, however, he is one who is puzzled by them, and who therefore orients his art to expectations formed by an earlier phase of art." In Masheck, ibid., p. 131.

79. Cabanne, *Dialogues*, p. 74.

80. Quoted in Marquis, *Marcel Duchamp: Eros, c'est la Vie*, p. 310.

Chapter 4: Another Alphabet:
The Art of Marcel Broodthaers

Originally published as "Another Alphabet: The Art of Marcel Broodthaers," Artforum *(November 1989).*

1. *Pense-bête* is the French for a mnemonic device, a way of remembering something. It is also a pun translatable as either "think like an animal" or "think dumb."

2. *Marcel Broodthaers* opened at the Walker Art Center, Minneapolis, in April 1989, and was seen at the Museum of Art, Carnegie Institute, Pittsburgh, from 29 January to 18 March 1990, and at the Palais des Beaux-Arts, Brussels, from 15 April to 24 June 1990.

3. *Art in America* 77, no. 9 (September 1989), p. 129.

4. Benjamin H. D. Buchloh, "Open Letters, Industrial Poems," in *Broodthaers: Writings, Interviews, Photographs*, ed. Buchloh (Cambridge, Mass.: MIT Press, October Books, 1988), p. 68. Also published as *October* 42 (Fall 1987).

5. See Michael Oppitz, "Rubens und der Wintergarten," in *Catalogue/Catologus*, exhibition catalog (Brussels: Palais des Beaux-Arts, 1974), pp. 40–46.

6. Buchloh, "Open Letters, Industrial Poems," p. 71, note 8.

7. Marcel Broodthaers's "concept of *space*," according to Buchloh, "is historically concrete and determined by the political and ideological functions which the work of art assumes in its cultural extrapolation; his concept of *form* is that of *form-determination* in Marx's sense of *circulation-form* (which implies that objects are determined by their commodityform), and in

regard to aesthetic production means that the work is defined by both the institutional framework that guarantees the work's semblance of autonomy as well as its distributional principles, its circulation-form of *cultural* commodity." Buchloh, "Marcel Broodthaers: Allegories of the Avant-Garde," *Artforum* (May 1980), p. 56. "Numerous statements by Broodthaers make clear," Buchloh claims, "that he was systematically addressing these issues in his work." Ibid. He proceeds to array quotations from Broodthaers that do not seem to bear on this topic at all, such as "if space is really the fundamental element of artistic construction (either in form of language or in form of materials) I would have to oppose it with the philosophy of what has been written with a certain common sense. . . . The constant search for the definition of space serves only to cover up the essential structure of art,—a process of reification. Every individual, perceiving a function of space, and even more so if it is a convincing one, appropriates it either mentally or economically. . . . Space can only lead to paradise." Ibid. This article is prefaced with a quote from Walter Benjamin. Remarks in Buchloh's "Allegorical Procedures: Appropriation and Montage in Contemporary Art," *Artforum* (September 1982), p. 47 and his "The Museum Fictions of Marcel Broodthaers," in *Museums by Artists* (Toronto: Art Metropole, 1983), p. 55, also relate Broodthaers's work to Benjamin.

8. Buchloh, "Open Letters, Industrial Poems," pp. 68–69.

9. For example, when he made himself an artist, Broodthaers wrote that he had had the idea of "inventing something insincere"; Crimp responds that "such negative qualities are rarely so frankly admitted as the necessary stance of the artist working under the conditions of late capitalism"—as if Broodthaers had directly addressed the issue in those terms. Douglas Crimp, "This Is Not a Museum of Art," in *Marcel Broodthaers,* exhibition catalog (Minneapolis: Walker Art Center, and New York: Rizzoli, 1989), pp. 71–72. Again, Crimp mentions a time when Broodthaers "could no longer perform the task of the historical materialist in the guise of the collector's countertype" (ibid., p. 75), evidently assuming that Broodthaers's conscious intention was to "perform the task of the historical materialist."

It is cautionary that in a prefatory note to the Walker book in which Crimp's essay appears, Maria Gilissen, Broodthaers's widow, writes, "Critics should not be too certain in attributing thoughts to Broodthaers, even when they quote extracts from his own words. And too many have tried to fit him in the mold of the thought of fashionable theorists."

10. In a telephone conversation with the author, 21 May 1989. In a later conversation, on 5 September 1989, Gilissen spoke of Broodthaers's professed lack of interest in Marxist authors generally.

11. Broodthaers shared with Benjamin a concern about the commercialization of art, but the stance is characteristic of the whole Romantic tradition. Even Marcel Duchamp—surely no Marxist—shared it.

12. Broodthaers, quoted in Michael Compton, "In Praise of the Subject," in *Marcel Broodthaers,* p. 32.

13. Broodthaers, "Ten Thousand Francs Reward," 1974, in *Broodthaers: Writings, Interviews, Photographs,* p. 45.

14. See Thomas McEvilley, "Empyrrhical Thinking (And Why Kant Can't)," *Artforum* (October 1988), pp. 120–27; republished in a revised form in the present volume as chapter 3: "Duchamp, Pyrrhonism, and the Overthrow of the Kantian Tradition."

15. Broodthaers, "Ten Thousand Francs Reward," p. 45.

16. Ibid., p. 46.

17. One wonders whether the name of Broodthaers's work *Pense-Bête* might not relate to

Duchamp's phrase *bête comme un peintre*, with which he underscored his rejection of the Kantian theoretical heritage. Broodthaers surely meant these and other parallels to operate as a kind of semaphore establishing an art-historical parameter for his work, as well as a sense of shared intentions. So clear are the parallels that they imply elements of satire of the process of imitating, reproducing, influencing, and alluding that constitutes art history.

18. Broodthaers, "Ten Thousand Francs Reward," p. 43. In this passage he rejects André Breton's quasi-mystical approach to Surrealism, saying, "With *Ceci n'est pas une pipe* Magritte did not take things so lightly. But then again he was too much Magritte. By which I mean he was too little *Ceci n'est pas une pipe*. It is with that pipe that I tackled the adventure." To paraphrase: Breton was too "light" in his rejection of experienced distinctions; Magritte, on the other hand, emphasized distinctions such as that between word and image, though he did not pursue the problem in his other more "Magrittean" works. Broodthaers intended to continue the adventure begun and abandoned by Magritte—the critical investigation of representation to which the pipe paintings were the signpost.

19. Broodthaers, "Gare au défi," 1963, reprinted in *Broodthaers: Writings, Interviews, Photographs*, pp. 33–34.

20. Buchloh writes, "Broodthaers anticipated, as early as the mid-1960s, the complete transformation of artistic production into a branch of the culture industry, a phenomenon which we only now recognize" (Buchloh, introductory note to *Broodthaers: Writings, Interviews, Photographs*, p. 5). Yet this recognition was at the root of Pop Art in general. Andy Warhol pinpointed it with his paintings of money and commercial products in the late fifties, as did Jasper Johns with his bronze ale can and other works. Indeed, this recognition was central to Duchamp's work. It is true that Broodthaers wrote, "I took a flaming critical position against [Pop] art" (quoted in Buchloh, "Marcel Broodthaers: Allegories of the Avant-Garde," p. 54), and that the Pop artists were following the "road to hell that was begun by Dada" ("Gare au défi," p. 34). Still, the confrontation with this art seems to have had a lot to do with his conversion from poet to artist, and his own work would soon be on that road to hell.

21. Nicolas Calas describes the work as a "critique of art by artistic means." Calas with Elena Calas, "Extracts from 'Human Comedy' 1982," in *Marcel Broodthaers*, exhibition catalog (New York: Gallery Marian Goodman, 1984), n. p. The phrase could serve as a definition of Conceptual Art. Compton denies that the work is Conceptual Art while saying that for Broodthaers, "complexities of meaning . . . were the essential material of art" ("In Praise of the Subject," p. 40), again a virtual definition of Conceptual Art.

22. Compare, for example, Broodthaers's use of "Fig. 1" as a visual image with Joseph Kosuth's 1965 work *Three Color Sentence*. In both, the verbal name is the visual image and vice versa.

23. Compton argues that Broodthaers's work is not a critique of easel painting but an impassioned affirmation of it. His approach seems contradictory. The argument that the appeal of Broodthaers's objects is "primary," i.e., that it has its effect before any conceptual associations, is essentially a formalist approach that keeps the artist in the Kantian fold. Yet at the same time Compton argues that the work is a puzzle that requires to be solved yet never can be—a conceptual, deconstructive art, in other words, attempting to stymie the mind's impulse to categorize and interpret.

24. See Thierry de Duve, "The Readymade and the Tube of Paint," *Artforum* (May 1986), pp. 110–21.

25. See *Yves Klein 1928–1962: A Retrospective* (Houston: Institute for the Arts, and New York: The Arts Publisher, Inc., 1982), p. 21.

26. The idea of Broodthaers's unique, uncategorizable role may result in part from the fact that his position on the issues is not always clear. Kosuth, for example, clearly opposes traditional aesthetics; Broodthaers, though perhaps equally skeptical of them, works much more closely with them. Similarly, both Daniel Buren and Michael Asher extended Yves Klein's use of the gallery as the exhibited thing (the container instead of the contained) in a way clearly critical of the gallery; but Broodthaers venerated the collection of things at the same time that he undermined the ideology of collecting. He avoided taking straightforward for-or-against positions, but this does not make him mysterious or obscure. It suggests a respect for the subtlety and complexity of issues combined with a Duchampian abstinence from partisan statements of position.

27. Marge Goldwater, introduction to *Marcel Broodthaers* (Walker/Rizzoli), p. 9.

28. Broodthaers, "Ten Thousand Francs Reward," p. 39.

29. See, for example, ibid., p. 41: "A mussel conceals a volume."

30. In the classical period, a certain relationship between art and political power, or the power of force, was encapsulated in the eagle icon: the eagle of Zeus, the gods' instrument of foreseeing and violent intervention, was lulled to sleep only by the lyre of Apollo. See Pindar's first Pythian ode. And Pindar himself was called "the Theban eagle"—the eagle now representing not the force that the poet would soothe but the actual poet.

31. Important examples include the Sumerian myth of Etana and the Hindu myth of Vishnu and Garuda; see James B. Pritchard, ed., *Ancient Near Eastern Texts* (Princeton: Princeton University Press, 1955), p. 114, and Alain Danielou, *Hindu Polytheism* (New York: Pantheon Books/ Bollingen Foundation, 1964), p. 160.

32. Of the eagle in Broodthaers's work, Compton says that "it may surely be understood to stand both for the myth of the free artist and for the power of the systems which control him" ("In Praise of the Subject," p. 50). Gildemyn has spoken similarly, and there are hints of this direction in Broodthaers's writings.

33. Broodthaers, quoted in Rainer Borgemeister, "*Section des Figures:* The Eagle from the Oligocene to the Present," in *Broodthaers: Writings, Interviews, Photographs,* p. 147.

34. Broodthaers, quoted in Buchloh, "Open Letters, Industrial Poems," p. 69.

35. Broodthaers, in "An Interview with Marcel Broodthaers by the Film Journal *Trepied,*" in *Broodthaers: Writings, Interviews, Photographs,* p. 36. The work in question is the film *Le Corbeau et le renard,* 1967.

36. In the flyer for the exhibition *Un jardin d'hiver* (*A Winter Garden,* 1974). Quoted in Buchloh, "Marcel Broodthaers: Allegories of the Avant-Garde," p. 58.

37. Broodthaers, untitled poem, 1966–1968, in *Marcel Broodthaers* (Walker/Rizzoli), p. 6.

38. Found in Gorgias, *On Nature, or on Non-Being,* in M. Untersteiner, ed., *I Sofisti, testimonianze e frammenti,* fasc. 11, 2d ed. (Florence, 1961).

Chapter 5: The Rightness of Wrongness: Modernism and Its Alter Ego in the Work of Dennis Oppenheim

Originally published as "The Rightness of Wrongness: Modernism and Its Alter Ego in the Work of Dennis Oppenheim," in Dennis Oppenheim: And the Mind Grew Fingers, *with Alanna Heiss (New York: Abrams, 1991).*

1. Oppenheim refers to his work as a residue rather than as the very thing intended—as Yves Klein described his physical works as "the ashes of my art."

2. In a parody of a scientific experiment, Duchamp took three strings, each one meter long, dropped them onto a canvas on the floor from a height of one meter, and recorded the configurations in which they landed.

3. Again a characteristic of anti-Modernist work, originating in Duchamp's 1913 introduction of the aleatory into his work, more recently echoed by Klein's "painting," in 1961, made by strapping a gessoed canvas to the roof of his car and driving from Paris to Nice in a rainstorm. These trends worked themselves out in parallel forms in Europe and America, although generally the mood assumed in the European works was more metaphysical, while in the American works it was more materialistic. Oppenheim's work is somewhat between the two extremes.

4. *Dennis Oppenheim, Retrospective, Works 1967–1977/Dennis Oppenheim: Retrospective de l'oeuvre 1967–1977* (Montréal: Musée d'Art Contemporain, 1978), p. 53.

5. This work also presaged works by Marina Abramovic and Ulay, among others, which involved relating to snakes in close bodily proximity in a gallery space.

6. The awkwardness of it is the remarkable thing: the awkwardness of Joseph Beuys lying on the floor, of Marina Abramovic and Ulay crawling around on the floor making eye contact with a snake, and so on.

7. *Dennis Oppenheim: Retrospective,* p. 62.

8. Ibid., p. 67.

9. Ibid.

10. Janet Kardon, *Machineworks: Vito Acconci, Alice Aycock, Dennis Oppenheim* (Philadelphia: Institute of Contemporary Art, 1981), p. 7.

11. Nehama Guralnik, "From Factories to Fireworks—Technology as a Poetic Extension of the Mind in the Work of Dennis Oppenheim," in *Dennis Oppenheim: Factories, Fireworks 1979–84* (Tel Aviv: The Tel Aviv Museum, 1984), pp. 7, 9.

12. Ibid., p. 13.

13. Steven Poser, "Dennis Oppenheim: The Fugitive Image," in *Dennis Oppenheim* (Geneva: Galerie Eric Franck, 1984), p. 67.

14. Ibid., p. 68.

15. See Tricia Collins and Richard Milazzo, "Behind the Eight Ball with Dennis Oppenheim," in *Dennis Oppenheim: Recent Works* (Brussels: Liverpool Gallery, 1990).

16. Ibid.

17. Ibid.

18. Stuart Morgan, "Dennis Oppenheim: Gut Reaction," *Artscribe* (Spring 1979).

Chapter 6: The Art of Jannis Kounellis

Section One: Mute Prophecies (1986)

Originally published as "Mute Prophecies: The Art of Jannis Kounellis," in Jannis Kounellis,
with Mary Jane Jacobs (Chicago: Museum of Contemporary Art, 1986).

Section Two: Winnowing Fan on His Shoulder? Kounellis's Voyage (1995)

Originally published as "Winnowing Fan on His Shoulder? Kounellis's Voyage," in Kounellis: M/S
Ionion Peraias, *(Athens: Bastas-Plessas Editions for the J. F. Costopoulos Foundation, n.d.)*

1. Kasimir Malevich, *The Non-Objective World,* trans. L. Hilbersheimer (Chicago: 1959), p. 88.
2. Ibid.
3. Kasimir Malevich in Enrico Crispoli, *Lucio Fontana,* vol. I (Brussels: 1974), p. 7.
4. Ibid., pp. 123–124.
5. Christos Lazos in conversation with the author, Athens, December 1985.

Chapter 7: Intimate but Lethal Things: The Art of Lucas Samaras

Originally published as "Intimate but Lethal Things: The Art of Lucas Samaras," in Lucas
Samaras, Objects and Subjects, 1969–1986 *(Denver: The Museum of Fine Arts; New York:
Abbeville Press, 1988); republished in Japanese in* USIA *journal, 1989.*

1. Cited by Lawrence Alloway, *Robert Rauschenberg* (Washington, D.C.: Smithsonian Institution, 1976), p. 3.
2. See Garma C. C. Chang, *The Buddhist Teaching of Totality: The Philosophy of Hwa Zen Buddhism* (University Park, Pa. and London: The Pennsylvania State University Press, 1971), p. 24.

Chapter 8: Negative Presences in Secret Spaces: The Art of Eric Orr

*Originally published as "Negative Presences in Secret Spaces:
The Art of Eric Orr,"* Artforum *(June 1982).*

1. Eric Orr and Kent Hodgetts, "Safe Food for Tigers," *Mt. Adams Review* (Cincinnati, Ohio), May/June 1964, pp. 21–22; conversation with author.
2. Conversation with author.
3. Made in collaboration with Judy Gerowitz (Judy Chicago) and Lloyd Hamrol.
4. Statement prepared for 1982 Documenta; statement to accompany the exhibition of *Double Vision* at the Lonnie Gans Gallery, Venice, Calif., 1981.
5. R. T. Rundle Clark, *Myth and Symbol in Ancient Egypt* (London: Thames and Hudson, 1959), p. 141.

6. Ibid., p. 145.

7. Statement prepared for 1982 Documenta.

8. Cited by Giorgio de Santillana, *Prologue to Parmenides* (Cincinnati: University of Cincinnati, 1964), p. 24.

9. See, e.g., Alexandre Piankoff, ed., *Egyptian Religious Texts and Representations,* vol. 1, *The Tomb of Rameses VI* (New York: Pantheon Books for the Bollingen Foundation, 1954) and vol. 3, *Mythological Papyri* (New York: Pantheon Books for the Bollingen Foundation, 1957).

10. Typed transcript of tape-recorded conversation between Eric Orr, Ron Cooper, and Larry Bell; Taos, N.M. (3 January 1982).

11. The *locus classicus* is Bhadantacariya Buddhaghosa, *Visuddhimagga: Path of Purification,* 3d ed. (Kandy, Sri Lanka: Buddhist Publication Society, 1975), pp. 354–360.

12. Conversations with author.

13. See Judith Wechsler, ed., *On Aesthetics in Science* (Cambridge, Mass.: MIT Press, 1981), on Henri Poincaré and other scientists who have emphasized aesthetic elements in both procedures and results.

14. Statement prepared for 1982 Documenta.

15. Conversation with Cooper and Bell.

16. Statement for *Double Vision.*

17. Christopher Knight in the *Los Angeles Herald Examiner* (23 November 1980), and William Wilson in the *Los Angeles Times* (5 December 1980).

18. Statement prepared for 1982 Documenta.

19. This installation is still in place, at the time of writing, in the Neil G. Ovsey Gallery, Los Angeles.

20. Conversation with Cooper and Bell.

21. See, e.g., E. R. Dodds, *The Greeks and the Irrational* (Berkeley: University of California Press, 1951), p. 100.

22. Chogyam Trungpa, "Space Therapy," *The Middle Way: Journal of the Buddhist Society* 50, no. 3 (November 1975), pp. 107–11, and unpublished material by the same author.

23. Conversations with author.

24. This installation is still in place, at the time of writing, in the Lonnie Gans Gallery, Venice, Calif.

25. Statement prepared for 1982 Documenta.

26. Martin Heidegger, "The Origin of the Work of Art," in D. F. Krell, ed., *Martin Heidegger, Basic Writings* (New York: Harper and Row, 1977), p. 175.

27. Conversation with Cooper and Bell; statement prepared for 1982 Documenta.

28. Eric Orr died on November 13, 1998, in Los Angeles. This book was already in production, and except for adding this note I have made no changes. A review of performances that Ulay and I did in commemoration of both Orr and James Lee Byars, at de Bally in Amsterdam on November 23 and 24, 1998, has appeared in *Art in America* (May 1999).

Chapter 9: Medicine Man: Proposing a Context for Wolfgang Laib's Work

Originally published as "Medicine Man: Proposing a Context for Wolfgang Laib's Work," Parkett (Spring 1994).

1. Interview of Wolfgang Laib by Suzanne Pagé, in *Wolfgang Laib* (Paris: ARC, Musée d'Art Moderne de la Ville de Paris, 1986), p. 15.
2. Martin Schwander, "The Difference between a Blue Picture and a Blue Sky" (an interview with Wolfgang Laib), in *Wolfgang Laib* (Luzern: Kunstmuseum, Luzern, 1990), p. 25.
3. Pagé, interview, p. 15.
4. For extended discussion of this aspect of Modernism, see Thomas McEvilley, *The Exile's Return: Toward a Redefinition of Painting for the Post-Modern Era* (New York: Cambridge University Press, 1993), especially chaps. 2 and 3.
5. See Thomas McEvilley, "Yves Klein and Rosicrucianism," in *Yves Klein: A Retrospective* (Houston: The Rice Museum, and New York: The Arts Publisher, 1981).
6. "I feel much closer to Joseph Beuys's work than to that of Shapiro." Pagé, interview, p. 15.
7. Klaus Ottman, "Wolfgang Laib" (an interview), *Flash Art* (February/March 1987).
8. Pagé, interview, p. 16.
9. Laib has specifically distanced himself from the dread of beauty characteristic of Beuys's work and his generation. (It was a "strange idea," Laib says, that "beauty was bourgeois." Pagé, interview, p. 17.) Still, it is not precisely in "beauty" that Laib locates the power of the artwork. (Beuys's oeuvre, the only one he will suffer comparison with, is after all the paradigm of the rejection of beauty.) Exactly what function it plays in Laib's view of the artwork is not yet clear.
10. Also here and there in Western philosophy from Sextus Empiricus to Ludwig Wittgenstein. See, e.g., Martha C. Hussbaum, *The Therapy of Desire: Theory and Practice in Hellenistic Ethics* (Princeton: Princeton University Press, 1994), chap. 1, "Therapeutic Arguments."
11. Pagé, interview, p. 21.
12. See, for example, G. S. Kirk, J. E. Raven, and M. Schofield, eds. *The Presocratic Philosophers*, second edition (Cambridge: Cambridge University Press, 1983), pp. 148–149, 155–156.
13. Pagé, interview, p. 19.
14. Ibid., p. 20. It seems an interesting question why European artists wanting to employ reference to pre-Modern societies in their work displace these references to other continents rather than, say, referring to Cro-Magnon cultures. Interestingly, I can think only of American artists who have chosen the Cro-Magnon field of reference—such as Elaine de Kooning and Jo Baer. That choice and the redirection of much American feminist art toward Near Eastern models reverses the displacement, as American artists locate the natural paradise in an earlier phase of the Old World. (It is difficult to find a sense of sanctified ancient culture in one's own backyard.)
15. Pagé, interview, p. 17.

Chapter 10: The Serpent in the Stone: Marina Abramovic's Sculpture

Originally published as "The Serpent in the Stone: Marina Abramovic"
(Oxford, U.K.: Museum of Modern Art Oxford, 1995), with elements from "Stadien der
Energie: Performance-Kunst am Nullpunkt?" Marina Ambramovic: Artist Body,
Performances 1969–1997 *(Milan: Edizioni Charta, 1998).*

1. See Moira Roth, ed., *The Amazing Decade: Women and Performance Art in America, 1970–1980* (Los Angeles: Astro Artz, 1983).

2. For a more extensive discussion of this work, see Thomas McEvilley, "Marina Abramovic/Ulay, Ulay/Marina Abramovic," *Artforum* (September 1983).

3. *The Lovers* (Amsterdam: The Stedelijk Museum, 1989).

4. Maurice Tuchman, *The Spiritual in Art: Abstract Painting 1890–1985* (New York: Abbeville Press, 1986).

5. In conversation with the author, Los Angeles, 1998.

6. Arthur O. Lovejoy, *The Great Chain of Being: A Study of the History of the Idea* (New York: Harper Torchbooks, 1936).

7. Yves Klein, whose way of thinking about art parallels Abramovic's on several points, spoke of the artist as nature's midwife and so on. See Thomas McEvilley, "Yves Klein, Conquistador of the Void," in *Yves Klein, a Retrospective* (Houston: Rice University and New York: The Arts Publisher, 1982), and other writings soon to be collected and republished by Schirmer-Mosel Verlag, Munich.

Chapter 11: Your Flowers as My Hair: The Art of Michael Tracy

Originally published as "Your Flowers as My Hair: The Art of Michael Tracy,"
in Terminal Privileges, *New York: P.S. 1, 1987.*

Chapter 12: Seeds of the Future: Anthony Gormley's *Field*

Originally published as "Seeds of the Future: The Art of Antony Gormley,"
in Field *(Montreal: The Montreal Museum of Fine Arts, 1993).*

1. By, respectively, Kim Levin, "The Clone Zone," *Village Voice* (15 May 1984), and Michael Brenson, "Images That Express Essential Human Emotions," the *New York Times* (26 July 1987).

2. In *Field* at the Salvatore Ala Gallery in New York in May 1989, there were about 150 figures; at the Art Gallery of New South Wales, Australia, in October 1989, there were 1,100; at the Salvatore Ala Gallery, New York, in March 1991, there were 35,000; at the Spoleto Festival USA, Charleston, S.C., in May 1991, there were 20,000.

3. One critic speculated, Gormley "runs the risk of being charged with exploiting Third World artisans to sell his own name" (Kay Larson, "Mixed Messages," *New York* magazine, 15 April

1991); such a charge might also be raised about collaborations between such First World artists as Alighiero Boetti, Lothar Baumgarten, Mel Chin, Ulay and Marina Abramovic and Third World artisans. On the other hand, such collaborations might in time be regarded as a socially useful stage of a long process.

Chapter 13: Anish Kapoor: The Darkness Inside a Stone

Originally published as "The Darkness Inside a Stone," in Anish Kapoor
(London: The British Council, Venice Biennale catalog, 1990).

1. Ananda K. Coomaraswamy, *The Dance of Shiva* (New York: Farrar, Straus and Giroux, The Noonday Press, 1967), p. 29.

2. Henry Paolucci, ed., *Hegel: On the Arts* (New York: Frederick Ungar Publishing Co., 1979), pp. 108, 112.

3. Many pieces suggest a concept like that of the central mountain in Hindu cosmography, Mt. Meru or Sumeru. Mt. Meru is not a geographical center, but one that is cosmic or metaphysical in meaning. It is the origin point and the *axis mundi*, which holds the world together by establishing a center in order to make sense of space. Forms suggesting Meru began to appear in Kapoor's oeuvre in 1979, in the seminal multiwork called *1000 Names.* The title suggests the 1,000 names of Shiva, listed in the *Linga Purana* (Bombay: Venkatesvara Press, 1925, pp. 65, 98), which affirms that Shiva is all things. (The *Shiva Purana* lists 1,008, as does the *Mahabharata.*) It points to the idea of a real unity underlying an ontologically questionable multiplicity, the idea embodied in the Hindu doctrine of *namarupa*, or name-and-form: that the many names and different forms of things point to a single unchanging substrate. Insofar as all names point to one entity that is beyond name and form, the concept also refers, though less directly, to the hidden or unspeakable name of Yahweh. In *1000 Names* the central mountain was scattered over a floor in multiple forms in a loose allover pattern. The ritually designated center, multiplied until it occupies every place, implies a pantheistic transformation of life. The multiplicity of Meru-like forms, a visual analogue of the idea that Shiva is everything, asserts that the center is everywhere (as Nicholas de Cusa observed also).

4. Kapoor was born in India of an Indian father and a Jewish Iraqi mother; he moved to Israel at age seventeen for two years, then in 1973 to London, where he went to art school.

5. Anish Kapoor, in conversation with the author (October 1989).

6. Often in Kapoor's work, mountainlike forms suggest the lingam, or infinite phallus of the god Shiva; at other times the cosmic vagina of Kali, the world mother and Dreadful Mother in one. Both suggestions appear in *1000 Names* and persist in the later works. Sometimes, as in *Three* (1981) and *Untitled* (1983), it is primarily phallic elements that designate the primal creative place. At other times, the cosmic center seems to be presented as a vagina or womb image, as in *Shrine* (1987) and *Sky* (1988). In this case, it is the hollow womblike space inside the mountain-like form that is dominant. Multibreasted forms relating distantly to the Artemis of Ephesus also occur as part of what Kapoor calls his "cosmology of the body," as in *To Reflect an Intimate Part of the Red* (1981) and *Six Secret Places* (1983). Kapoor has remarked that the role of art involves establishing a "place" as Barnett Newman called it, or Place. Newman, an artist whose work has been influential on Kapoor's thinking, used the word "place" to translate the Hebrew

makom, which means a ritual and metaphysical center. Kapoor's half-Hebrew, half-Indian heritage brings the tradition of *makom* into play in reference to his work alongside that of the Hindu Mt. Meru.

Formally, the allover patterning of *1000 Names* retained something of Kapoor's painterly sensibility, his respect for the wholeness of the surface. In 1982, his installations contracted into tighter topographical arrangements, emphasizing the sculptural identity of the Meru-form, as in *As If to Celebrate I Discovered a Mountain Blooming with Red Flowers* (1981) and *White Sand, Red Millet, Many Flowers* (1982). More recently, as in *In Search of the Mountain* (1985), *Mother as a Mountain* (1985), and *Body* (1988), the center contracted still further, into a single sculptural figure that by itself seemed to be everywhere, like *Shrine* (1987).

7. As for example in Goethe's novel *The Sufferings of Young Werther* (London: Dodsley, 1779).

8. In *1000 Names,* rectilinear elements are sometimes juxtaposed with rounded ones, suggesting a male-female dichotomy. At other times an upright member and a hole—or a lunar curve and an upthrusting mountainlike form—make this point. In other early works, male and female suggestions seem united in a single object, which expresses the mythological traits of both. One example is erect, yet describes a lunar curve.

9. In Hindu iconography, the conjoined sexualities of Shiva and Kali are represented above all in the lingam-and-yoni icon, a representation of the cosmic phallus and vagina engaged in the sexual embrace which actively generates the universe from moment to moment.

10. In a line of thought that goes back to the early *Upanishads,* and is dimly present in the tenth book of the *Rig Veda.* For a collection of passages, see, for example, Paul Deussen, *The Philosophy of the Upanishads* (New York: Dover Publications Inc., 1966), pp. 182–183.

11. For more discussion of this aspect of gallery space, see Thomas McEvilley, introduction to Brian O'Doherty, *Inside the White Cube: The Ideology of the Gallery Space* (San Francisco: The Lapis Press, 1986).

12. The tree goddess goes back to the Bronze Age. She was found in ancient Egypt and Mesopotamia and also in the Indus Valley culture, the Bronze Age culture of northwest India. For an Indus Valley example, see Sir John Marshall, *Mohenjo-Daro and the Indus Civilization,* (London: Arthur Probsthain, 1931), vol. 3, pp. 111, 355.

13. For Klein and color, see *Yves Klein 1928–1962, A Retrospective* (Houston: The Institute for the Arts, Rice University, and New York: The Arts Publisher, 1982), especially pp. 238–254.

14. As in Kapoor's *Angel* (1989). On the cult of pure color, see Thomas McEvilley, "La peinture monochrome," in *La couleur seule* (Lyon: Musée Saint Pierre d'Art Contemporain, 1988), pp. 15–35.

15. For more on this subject, see ibid. Several artists have found that blue gives a more impressive, or livelier, darkness than black. Ad Reinhardt used an admixture of blue in his black monochromes; Eric Orr uses blue for black. Kapoor feels that black by itself "doesn't do it, it lacks a cosmic dimension." In *Void Field,* for example, seeking a black effect, he used a darkened Prussian Blue inside the hollowed stones. To the eye it reads as a deep living black.

16. In Hindu iconography blue exerts a similar signification. The body of Kali is blue, as is Krishna's; Shiva's throat turns blue after he drinks poison to save the world. See Wendy Doniger O'Flaherty, *Hindu Myths* (Baltimore: Penguin Books, 1975), p. 277.

17. Cited by Richard Ellmann, *Oscar Wilde* (New York: Vintage Books, 1988), p. 81.

18. In tantric tradition, both Indian and Tibetan, a related belief is encountered, for example in the use of different-colored monochrome environments as a means of therapy.

19. She is addressed in the *Hymn to Kali,* or *Karpuradi-stotra* as "Thou who art beauteous with the

beauty of a dark rain cloud. . . . Oh mother with gaping mouth. . . ." See Arthur Avalon, *Hymn to Kali (Karpuradi-stotra),* trans. Sir John Woodroffe (Madras: Ganesh and Company Private Ltd., 1965), p. 49.

20. See McEvilley, "La Peinture monochrome."

21. See E. G. S. Crawford, *The Eye Goddess* (New York: Macmillan, 1957), fig. 5; Eric Neumann, *The Great Mother* (Princeton, N.J.: Princeton University Press, 1955), figs. 20, 27a.

22. By Carl Jung and Eric Neumann. See especially Neumann, *The Origin and History of Consciousness* (Princeton, N.J.: Princeton University Press, 1954), pp. 5–38, 266–292.

23. Although Judeo-Christian references extend even to the titles of recent work (for example, *Madonna, Virgin, Adam*), Kapoor's preoccupations remain the same, with the viewer being drawn ever closer to the edge of the dissolution of all boundaries.

24. In this respect Kapoor's inclusion in the category "New British Sculpture" is interesting. Clearly his work is different in certain fundamental ways from most of what is included in that category—less critical and deconstructivist, and more mystical and affirmatory. What makes sense out of the inclusion is the post-Modern relativism that causes any point of view to wish to include its own opposite coding as part of its sanity.

25. Socrates is quoted in Plato's *Phaedrus* as describing four types of "divine madness," which can lead to release from the wheel: the madness of the lover, the poet, the prophet, and the philosopher.

Chapter 14: Skywriting: The Work of Marinus Boezem

*Originally published as "Skywriting: The Work of Marinus Boezem,"
in* Marinus Boezem *(Washington: The Corcoran Gallery, 1993).*

1. See W. K. C. Guthrie, *Orpheus and Greek Religion: A Study of the Orphic Movement* (New York: W. W. Norton, 1966), and M. L. West, *The Orphic Poems* (Oxford: The Clarendon Press, 1983).

2. For a more detailed discussion of this mechanism, see James Webb, *The Occult Establishment* (LaSalle, Ill.: Open Court, 1991), pp. 7–30.

3. Kasimir Malevich, *The Non-objective World,* trans. L. Hilbersheimer (Chicago, 1959), p. 88.

4. For more on this parallelism, see Thomas McEvilley, "De Berg Karmel en de Woestenlj Voorblj de Vorm," in *Fuente, Juan de la Cruz, 1591–1991* (Amsterdam: D'Arts, 1991), pp. 81–89.

5. Webb, *Occult Establishment,* pp. 9–10.

6. For more on this subject, see Thomas McEvilley, "Yves Klein, Conquistador of the Void," in the exhibition catalog, *Yves Klein: A Retrospective* (Houston: Institute for the Arts, and New York: The Arts Publisher, 1982). This essay, along with my other writings on Klein, is forthcoming in a book to be published by Schirmer Mosel Verlag, Munich.

7. Or perhaps, as Philip Peters has it, the airplane is attempting to lift the cathedral into the immaterial. Philip Peters, "Through Space and Time," in the exhibition catalog for XX Biennale.

Chapter 15: Louise Bourgeois: "The She Wolf Is My Mother"

Originally published as "History and Prehistory in the Work of Louise Bourgeois,"
in Louise Bourgeois *(Frankfurt: Frankfurt Kunstverein, 1989).*

1. In "Taking Cover, Louise Bourgeois Interviewed by Stuart Morgan," *Artscribe* (January/February 1988), p. 33.

2. Deborah Wye, "Louise Bourgeois: 'One and Others,'" in *Louise Bourgeois* (New York: The Museum of Modern Art, 1982), p. 27.

3. Lucy Lippard, *Overlay: Contemporary Art and the Art of Prehistory* (New York: Pantheon Books, 1983), p. 63.

4. Barbara Rose, "Sex, Rage, and Louise Bourgeois," *Vogue* (September 1987), p. 824.

5. Sigmund Freud, in *The Problem of Lay Analysis,* Introduction S. Ferenczi (New York: Brentano's, 1927).

6. Cited by Jean Fremon, in *New Observations* 50 (September 1987), p. 11.

7. For other Bourgeois works reminiscent of the Ephesian Artemis, see *Louise Bourgeois: Drawings* (New York: Robert Miller and Paris: Daniel Lelong, 1988), plates 103, 104, and 106.

8. See, for example, Resit Ergener, *Anatolia, Land of Mother Goddess* (Ankara: Hitit Publications Ltd., 1988), p. 48.

9. See Barbara G. Walker, *The Woman's Encyclopedia of Myths and Secrets* (San Francisco: Harper and Row, 1983), p. 53.

10. Herodotus, IV, 103. *Herodotus, the Histories,* English trans. by Aubrey de Selincourt (Baltimore: Penguin Books, 1968), p. 276.

11. In Aeschylus's *Agamemnon,* the most primal and authoritative of the extant Greek plays, Artemis sees the lion kill the young rabbit and she empathizes with both the lion and the rabbit. This is presented as the origin of cosmic conflict. Her inner contradiction of motherly feelings sets going the tragic theme of the world. At one level this theme in Bourgeois's work traces back to the Surrealist impression on the first-generation New York School. They shared the theme of the primordial, the origin, the source.

12. Wye, in "Louise Bourgeois: 'One and Others,'" p. 17.

13. Bourgeois's sphinxes look even more like the one in Ingres's painting of Oedipus and the Sphinx, in the Louvre.

14. Quoted by Wye in "Louise Bourgeois: 'One and Others,'" p. 27.

15. See Michael Grant, *Eros in Pompeii: The Secret Rooms of the National Museum of Naples* (New York: William Morrow and Company, 1975), pp. 138–143.

16. This aspect of Bourgeois's work seems to have something to do with the idea of potential space—the psychological state of the infant dozing on its mother's breast and losing clear awareness of the separation of its body from hers (the infant flowing into the mother's body again, as it were—the place where those bodies meet and separate is hidden: potential space). The breast is the icon of potential space. Bourgeois associates it with the mythologem of the double goddess by making the breast threatening—a castrator, set upon the destruction of the father.

17. See E. G. S. Crawford, *The Eye Goddess* (New York: Macmillan, 1957).

18. Wye, in "Louise Bourgeois: 'One and Others,'" p. 33.

19. Ibid.

20. As Sir James Frazer demonstrated in *The Golden Bough*. (See Sir James George Frazer, *The Golden Bough*, 1-vol. abr. ed. (New York: The Macmillan Company, 1942), pp. 264–283.

21. Quoted by Wye, "Louise Bourgeois: 'One and Others,'" p. 20. Bourgeois said this of her Peridot Gallery show of 1950.

Chapter 16: Explicating Exfoliation in the Work of Mel Chin

Originally published as *Soil and Sky: Mel Chin* (Philadelphia: The Fabric Workshop, 1993).

1. Hermann Hesse, *Magister Ludi*, translated from German by Mervyn Savill (New York: Frederick Ungar Publishing Co., 1949), pp. 16–17.

2. Daniel Barbiero, "Mel Chin," *Sculpture* (May/June 1989), p. 92.

3. At the Menil Collection in 1991, for example, there were no texts available to the viewers; at the Walker Art Center, Chin supplied wall plaques at the gallery's request.

4. This is not to imply that the initial response is not cognitive, or that the reconsidered response is not sensual. An approach like the Buddhist abhidharmic psychology in which cognition is simply a sixth sense—the mind sense, with concepts as its proper object—is called for.

5. Chin has provided me with the following note: "The landfill burned for two months in 1988 due to build up of methane and other noxious and combustible solutions (including a release of cyanide compounds). On this larger 300+ acre landfill the *Revival Field* test site is situated on a 31-acre plateau of contaminated ash and soil. The plateau is a layer of incinerated sludge deposited over a ten-year period by a Waste Control Commission. Contamination of the sludge occurred due to lax laws that allowed heavy metal industries from the whole area to dump into the municipal sewage system. *Revival Field* was specifically sited by soil sampling for the locus with the highest levels of extractable cadmium."

6. For the Babylonian world map, see *Grosser Historischer Weltatlas*, vol. 1 (Munich: Bayerischer Schulbuch-Verlag, 1963), p. 8. This cosmogrammic form goes back in the Mesopotamian tradition to the fourth-millennium Halaf and Samarra wares.

7. "Some," Chin says, "were to test for tolerance in polluted soils. Some were to test for their relationship with the food chain. Two were specifically used to test hyperaccumulation. The most powerful accumulator was the Alpine Pennythrift, which has the capacity to become the tool to remediate and recycle zinc and cadmium out of the soil. The corn is a hybrid used to measure plant-to-animal-to-human heavy-metal transference." (Letter to the author, 9 January 1993.)

8. Examples include Yves Klein, Lucio Fontana, the Zero Group, and others. See, for example, Thomas McEvilley, "Yves Klein, Conquistador of the Void," in *Yves Klein, A Retrospective*, exhibition catalog (Houston: The Institute for the Arts, and New York: The Arts Publisher, 1982).

9. See Holland Cotter, "Art in Review," the *New York Times* (17 January 1992).

10. For more on this subject, see McEvilley, *Art and Discontent* (Kingston, N.Y.: McPherson and Company, 1991), pp. 133–168; McEvilley, *Art and Otherness* (Kingston, N.Y.: McPherson and Company, 1992), pp. 85–108.

11. See, for example, the essays gathered in Judith Wechsler, ed., *On Aesthetics in Science* (Cambridge, Mass.: MIT Press, 1981).

Chapter 17: "Perfect Things Move In Circles":
The Sculpture of James Lee Byars

See note 2 in the chapter.

1. My obituary article for him was published in *Artforum* (September 1997), with an incorrect title. See Thomas McEvilley, "Johnny Wakes," *Artforum* (September 1997). It has since been republished, in French, with the proper title: See "The Death of James Lee Byars (*Johnny Wakes Uneasy in the Dark*)," *Amours* (Paris: the Cartier Foundation for Contemporary Art, 1998).
2. None of them seemed exactly right for this book, so I have picked parts of one and another and added new passages. The main sources are: "James Lee Byars and the Atmosphere of Question," *Artforum* (January 1981); "More Golden Than Gold," *Artforum* (November 1985); "Falling Angel," in *The Palace of Perfect* (Oporto, Portugal: Fundacao Serralves, 1997); "The Sun, The Moon, and the Stars," in *The Sun, The Moon, and the Stars* (Hamburg: Hamburg Museum, 1995); "The Death of James Lee Byars," in *James Lee Byars* (Valencia, Spain: IVAM, 1994); "James Lee Byars at Michael Werner," *Artforum* (January 1996).
3. At a moment when art had gotten deeply involved in politics—however briefly—American reviewers expressed doubts about such opulent display. This was not, as the *New York Times* called it, "crackpotmanship aimed at the rich," nor, as the *Village Voice* opined demurely, "preposterous charlatanry" by "the Liberace of the art world." In fact it was a much older and more classical tradition that Byars was working in. Not since the ancient poet Empedocles donned a purple robe with a golden girdle, bronze shoes, and fillets, and walked among the people of Agrigentum like a god (DL VII.73); not since Diogenes begrimed himself and roamed the streets of Athens with the dogs. . . . In our time artists have become very well behaved indeed, like businessmen, most of them. The decadence of gold as an art material does not affect the rapidity with which gold as cash enters their pockets.
4. Since Yves Klein a generation ago, a kind of secret society of golden art has gained momentum again. The *Documenta 7* exhibition in 1982 was a milestone, embarking on the controversial project of reconstituting a golden age, or temple of dignity, for art. In the entrance hall of the big show's main building, the Fredericianum, one saw Byars's *Golden Tower with Changing Tops* (1982), a fire-gilded cast-bronze cylinder twelve feet high; a few feet away one found a golden wall by Jannis Kounellis, glowing like a Byzantine ground behind a lonely black coatrack. Nearby was more gold by Luciano Fabro—how odd it seemed that artists associated with *arte povera* (impoverished art) should turn to gold, what a sign of a shift from the street to the temple. Some reacted to the romantic otherworldliness of the installation as an uncritical abdication from the responsibilities of art in this world, made the more vulgar by the obvious reference of gold to commodification.

 Still, in the 1970s and '80s, the stain of gold spread, appearing almost mockingly in artworks that stressed a mystical appeal. Kounellis's Byzantinism was answered in America by Michael Tracy's Christian icons saturated with gold and blood, and by Eric Orr's quasi-alchemistic recipes in which gold is juxtaposed with remnants of human bodies—gold and bone, gold and blood, gold and skull. Anselm Kiefer's work investigated the politics of gold, or of Germany and gold, in works like "Margarete-Sulamith" (1981), inspired by Paul Celan's terrifying poem about the death camps, *Todesfuge* (1952). Marina Abramovic and Ulay performed their in-progress work *Nightsea Crossing* with various gold or goldlike accoutrements:

golden spears leaning on the wall, gold leaf floating in water—in another work the artists ate gold-leafed food. In 1970, Joseph Beuys gilded his head to speak to a dead hare, evoking a reality that supposedly transcended the concrete boundary between life and death. The giltlike brass of Walter De Maria's *Broken Kilometer* (1979) and his other icons of metallic perfection partake of goldenism, as does much latently religious work, such as Californian space-and-light installations, which by evoking light as spirit tacitly evoke gold as its material analogue.

5. While Byars's work looks Platonic, and to a significant degree is, his Platonism was adjusted somewhat by influences encountered in Japan at an early age. This adjustment was not as radical as it might superficially seem. It was the Shinto concentration on simple and perfect things that appealed to him, and probably the Shinto emphasis on brief and ephemeral appearances of truth—the stone half-buried in the garden, the bird flying off with a scarf in its beak, the painting of a circle made with one brush stroke, the priest who walks fifty meters a year in pubic because he has a beautiful walk. The Japanese influence figured primarily into Byars's performance work, and thus into the first half of his career as artist. When his attention shifted from Question to Perfect, the Japanese influence had much less presence, and the classical Western influence rose to the foreground.

 Generally, the Japanese influence on Byars's work contributed to its tendency to cut through the mystique of transcendental Modernism, the Platonic (not Sapphic) emphasis on the unchanging and enduring mode of perfection, rather than its fleeting and contingent glance from the beyond. Our writers keep comparing him to Western showmen from Giordano Bruno to Liberace, when Pythagoras or Ze-ami may be the more relevant comparison.

6. *Five Points Make a Man, the Moon and Constellations*, at the Michael Werner Gallery in New York.

7. *The Sun, the Moon, and the Stars*, in Hamburg Museum, Germany.

Chapter 18: Basic Dichotomies in Meret Oppenheim's Work

Originally published as "Basic Dichotomies in the Work of Meret Oppenheim,"
in Meret Oppenheim *(New York: The Guggenheim Museum, 1996).*

1. For this translation, see Harold Szeeman and Jean Clair, ed., *Le Machina Celibi—The Bachelor Machine* (New York: Rizzoli, 1976), p. 36; for the full text, see Comte de Lautréamont, *Les chants de Maldoror,* English trans. by Guy Wernham (New York: New Directions, 1965), p. 263.

2. Bice Curiger, *Meret Oppenheim—Defiance in the Face of Freedom* (Zurich: Parkett Publishers, and Cambridge, Mass.: The MIT Press, 1989), pp. 26, 42, 61.

3. Ibid., p. 43.

4. Ibid., p. 56.

5. Maria Gimbutas, *Goddesses and Gods of Old Europe, 7000–3500 B.C.: Myths, Legends, and Cult Images* (Berkeley: University of California Press, 1982).

6. Male poets such as Johann Schiller (1759–1805) and Friedrich Hölderlin (1770–1843) had expressed such claims, too, but without the feminizing emphasis.

7. Curiger, *Meret Oppenheim,* p. 110.

8. Ibid., p. 111.

9. Ibid.
10. Ibid., p. 87.
11. Ibid., p. 56.
12. Ibid., p. 45.

Chapter 19: Location and Space in the Kienholz World

Originally published as "Location and Space in the Kienholz World,"
in Kienholz, A Retrospective *(New York: The Whitney Museum of American Art, 1996).*

1. In 1972, Kienholz met and began working with a young Los Angeles artist, Nancy Reddin. She became his wife and partner in making art until the end of his life in 1994. In 1981, at an exhibition in Zurich, he announced that all works produced from 1972 onward would bear the signatures of both Edward Kienholz and Nancy Reddin Kienholz.
2. See note 1.

Chapter 20: Jana Sterbak: Materials and Their Truth

Originally commissioned by Fundacio Tapies, Barcelona, 1995.

Chapter 21: Tony Cragg: Landscape Artist

Originally published as "Tony Cragg, Landscape Artist," in Tony Cragg *(Newport Beach, Calif.:*
The Newport Harbor Museum, and New York: Rizzoli, 1990; republished in French translation in
catalog of the Museum of Limoges, France).

1. Plato's *Phaedrus* and Plotinus's *Enneads* underlay Kant's *Critique of Judgment* and the whole formalist tradition of criticism that tacitly depended on that text.
2. This idea, like so much of the thematics underlying Cragg's work, goes back to the dawn of philosophy, in this case to the work of the Greek philosopher Empedocles.
3. This idea is associated with a thread of contemporary art that goes back to Robert Smithson and includes such disparate works as those of Jannis Kounellis and Julian Schnabel.
4. The distinction between nature and culture as a modernist idea is above all Hegelian, but it can also be found at the roots of pre-Socratic thought, specifically in Protagoras and other Sophists.
5. See my essay "The Darkness Inside a Stone," in *Anish Kapoor* (London: The British Council, 1990), republished as chapter 13 of this volume.

Chapter 22: Francesc Torres: The Man with Three Brains

Originally published as "Francesc Torres: The Man with Three Brains," in Too Late for Goya: Works by Francesc Torres, *ed. Marilyn Zeitlin (Tempe, Ariz.: Arizona State University, 1993).*

1. At the beginning of an interview with David Levi Strauss in *Artscribe* magazine ("Francesc Torres Tough Limo," November/December 1991, pp. 39–51), Francesc Torres was asked why he called one of his large complex installation works a "Hegelian scenography." He replied, "Hegel's vision or concept of history was of the materialization of reason through struggle." Suddenly the interviewer became an intervener, saying, "But in that way I take your work to be anti-Hegelian." "Well, yes," Torres replied, sounding slightly defensive. "The result of reading history according to Hegel is that you set the stage for the bloodbath which is what the history of Europe has been for the past two thousand years at least. So my work is anti-Hegelian in the sense that I am showing the consequences of that approach to history and to political and social processes."

 A reader cannot avoid the uneasy feeling that something has been left out. The interviewer's aggressive intervention—no matter how obviously right it was in terms of the overall thrust of Torres's work—seems to have prevented Torres from saying something more interesting about his motives in titling his work after Hegel.

2. *Artscribe* interview, p. 45.

3. Rudolf Haym, *Vorlesungen über Hegel und Seine Zeit* (Berlin, 1857). The so-called Young Hegelians, with whom Karl Marx was associated in various ways, began the critique of Hegel before 1848.

4. Alexandre Kojève, *Introduction to the Reading of Hegel: Lectures on the Phenomenology of Spirit,* English trans. by James H. Nichols Jr. (Ithaca, N.Y.: Cornell University Press, 1969).

5. Joachim Ritter, *Hegel and the French Revolution: Essays on the "Philosophy of Right,"* English trans. by Richard Dien Winfield (Cambridge, Mass.: The MIT Press, 1982).

6. Ibid., p. 57.

7. Ibid,. p. 52.

8. Ibid., p. 50.

9. *Artscribe* interview, p. 43.

10. Ibid.

11. John Hanhardt, "Francesc Torres: The Limits of Discourse," *Francesc Torres, Works from the Field, A Selection* (Ithaca, N.Y.: Herbert F. Johnson Museum of Art, Cornell University, 1982), p. 4.

12. *Artscribe* interview, p. 51.

13. *The Head of the Dragon (Anthology)* (Madrid: Museo Nacional Centro de Arte Reina Sofia, 1991), p. 51.

14. Aristotle's formulation of the self-willed existence in the *Metaphysics:* "That person is free who exists for him or herself rather than for another." *Met.* 982b25f (*anthropos . . . eleutheros ho autou heneka kai me allou on*). It's interesting that Aristotle expressed it as being rather than as will, though clearly, since for Aristotle being means selfhood, the two are closely related.

 The idea of Will in Hegel comes directly from Aristotle—the only classical ethicist, East or West, who said that you had to have a certain amount of money to be happy. The idea is not

that the individual human will be materially well provided for and live under favorable climatic conditions and have a good sexual relationship and own his or her own home. The idea is that even under the worst material and social circumstances this individual will somehow shape the ends of his or her life out of pure identity/will, as the whiplash on the end of the impact of desire: that Will should shape Self in a pure disinterested way except for self-expression and self-realization. The reasoning is somewhat circular: If the will already realizes what it wants to be then it is not disinterested. Still, there is something there, or can seem to be.

This idea of Aristotle's is at the basis of Hegel's distinction between life *bei sich* and *für sich*. The idea is that the exercise of citizenship in a democratic society matures a reality principle leading to a self-willed self—a kind of solipsism of self-realizing will that is covertly based on the religious idea of the self-caused cause—the standard Aristotelian and Scholastic slogan-definition of God.

15. *Artscribe*, p. 44.

16. Ritter, *Hegel and the French Revolution*, p. 52.

17. Sergei Eisenstein, "The Cinematographic Principle and the Ideogram," in *Film Form: Essays in Film Theory* (New York: Harcourt, Brace and World, 1949), pp. 28–44.

18. Fredric Jameson, *Post-Modernism, or, The Cultural Logic of Late Capitalism* (Durham, N.C.: Duke University Press, 1992), p. 37.

19. Especially relevant are Paul Virilio and Sylvère Lotringer, *Pure War* (New York: Semiotext(e), 1983), and Paul Virilio, *Speed and Politics* (New York: Semiotext(e), 1986).

20. Francesc Torres, *Belchite/South Bronx: A Trans-cultural and Trans-historical Landscape* (Amherst, Mass.: University Gallery, University of Massachusetts, 1988), p. 86.

21. Ibid., p. 87.

22. Ibid., p. 102.

Chapter 23: Elaine Reichek: Sins of the Fathers

Originally published as "Elaine Reichek: Sins of the Fathers,"
in Elaine Reichek *(New York: The Grey Art Gallery, 1992).*

1. It was actually the founding father James Madison who, in a letter of 25 November 1820, to the Marquis de Lafayette, first referred to "the original sin of the African trade." Huggins referred to slavery as "a structured part of the foundation" of what was falsely regarded as a "holy nation" with a "holy history." Nathan Irving Huggins, *Black Odyssey: The African-American Ordeal in Slavery* (New York: Random House, Vintage Books, 1990), p. xiii.

2. Bell Hooks, "Expertease," *Artforum* (May 1989), pp. 18–20.

3. Albert Memmi, *The Colonizer and the Colonized*, expanded edition (Boston: Beacon Press, 1967).

Chapter 24: Leonardo Drew: The Great Migration

Originally published as Leonardo Drew *(New York: The ThreadWaxing Space, 1992).*

1. Christian Leigh, *The Day after Today* (New York: Thread Waxing Space, 1991), p. 10.
2. There is a significant overlap of sensibility between Hesse and Drew. Her *Stratum* (1967–1968) compares interestingly with his *Number 15;* and her *Connection* (1969) compares with his *Number 8.* But there is a major difference in the feeling-quality of the oeuvres, which relates to the question of content; her work does not espouse the reflections on tragic destiny which are involved in his ruminations on African-American history.
3. Gretchen Faust, "New York in Review," *Arts,* April 1992, p. 94.
4. Leigh, *The Day after Today,* p. 10.
5. Orlando Patterson, *Slavery and Social Death* (Cambridge, Mass.: Harvard University Press, 1982).
6. See Judith McWillie, "Lonnie Holley's Moves," *Artforum* (April 1992).
7. Nathan Huggins, *Black Odyssey: The African-American Ordeal in Slavery* (New York: Random House, Vintage Books, 1990), p. xiii.
8. This piece was included in an exhibition curated by Corinne Jennings for the Dakar Biennale in Dakar, Senegal, in 1992.
9. See, for example, Richard Rorty, *Contingency, Irony, and Solidarity* (Cambridge: Cambridge University Press, 1989), chapter 5.
10. See Nicholas Lemann, *The Promised Land: The Great Black Migration and How It Changed America* (New York: Random House, Vintage Books, 1992).
11. *Jannis Kounellis* (Chicago: Museum of Contemporary Art, 1986), fig. 31.
12. See the essays by Thompson and others in *Black Art: Ancestral Legacy: The African Impulse in African-American Art* (Dallas: Dallas Museum of Art, and New York: Abrams, 1989).

Chapter 25: "Nothing Behind It": The Sculpture of Gerhard Merz

Composed with elements from Berlin: Kunstwerke, *with Gerhard Merz (Edition Schelmann, 1995) and* Archipittura, *with Gerhard Merz (Edition Schelmann, forthcoming).*

1. In conversation with the author in Berlin (19 March 1995).
2. I saw them at Max Hetzler's in Berlin in 1995.
3. In conversation with the author in Cologne (18 March 1995).
4. Ibid.
5. At the time of this writing the Lustgarten entrance is not yet built; it is thoroughly designed and embodied in miniature in maquette, computer simulation of multiple views of the site with the projected work upon it, and strict architectural drawings which eschew expressionist nuance. Its construction is funded and scheduled.
6. In conversation with the author and Jorg Shelmann in Berlin (March 19, 1995).
7. In conversation with the artist in Cologne (19 March 1995).

Chapter 26: In the Form of a Thistle: The Work of Dove Bradshaw

Abridgment of "In the Form of a Thistle: A Conversation between John Cage and Thomas McEvilley." Different selections from this conversation have been published in Artforum *(October 1992) and in* Dove Bradshaw: Works 1969–93 *(New York: Sandra Gering Gallery, 1993).*

Chapter 27: Reassembling the Pieces: The Sculpture of James Croak

Originally published as The Sculpture of James Croak *(New York: Abrams, 1998).*

1. Kathleen Hegarty, "Sculpture Criticized by Students," *Los Angeles Times,* Reviews (February 1982).

2. Harold Bloom, *The American Religion: The Emergence of the Post-Christian Nation* (New York: Simon and Schuster, A Touchstone Book, 1992).

3. Roberta J. M. Olson, *Italian Renaissance Sculpture* (London: Thames and Hudson, 1992), p. 151.

4. Ibid., fig. 116.

5. R. R. R. Smith, *Hellenistic Sculpture* (London: Thames and Hudson, 1991), fig. 162.

6. Robert Graves, *The Greek Myths,* vol. 1 (New York: Penguin, 1981), p. 134.

7. See John Boardman, *Greek Sculpture: The Archaic Period* (London: Thames and Hudson, 1978), fig. 205.2.

8. Smith, *Hellenistic Sculpture,* figs. 138 and 140; see also figs. 118, 133, and 134.

9. See, for example, John Boardman, *Greek Sculpture: The Classical Period* (London: Thames and Hudson, 1985), fig. 237.

10. See Smith, *Hellenistic Sculpture,* fig. 133.

11. David Sylvester, *Looking at Giacometti* (New York: Henry Holt, An Owl Book, 1994), p. 99.

12. Olson, *Italian Renaissance Sculpture,* p. 170

13. William S. Wilson III, "Art Energy and Attention," in Gregory Battcock, ed., *The New Art* (New York: E. P. Dutton and Co., 1973), p. 247; Jean-Francois Lyotard, "Answering the Question: What Is Postmodernism?" in Ihab Hassan and Sally Hassan, eds., *Innovation/ Renovation: New Perspectives on the Humanities* (Madison, Wis.: University of Wisconsin Press, 1983), p. 340.

14. Rainer Maria Rilke, *Rodin,* English trans. Jessie Lamont and Hans Trausil (London, 1949), p. 9.

15. The category of "Conceptual sculpture" may contain "anti-sculpture" but is not limited to it.

16. Herbert Read, *A Concise History of Modern Sculpture* (New York: Oxford University Press, 1964), pp. 14–15.

17. George Kubler, *The Shape of Time: Remarks on the History of Things* (New Haven, Conn.: Yale University Press, 1962).

18. William Tucker, *The Language of Sculpture* (London: Thames and Hudson, 1974), pp. 25 and 37.

19. B. F. Skinner, *Beyond Freedom and Dignity* (New York: Alfred A. Knopf, 1971), *passim.*

20. Alexandre Kojève, *Introduction to the Reading of Hegel: Lectures on the "Phenomenology of Spirit"* (Ithaca and London: Cornell University Press, 1981).

21. In a letter to the author (27 March 1998).

22. For more on this subject, see McEvilley, "The Opposite of Emptiness," in *The Exile's Return: Toward a Redefinition of Painting for the Post-Modern Era* (New York: Cambridge University Press, 1993).

23. Tucker, *The Language of Sculpture,* p. 25.

24. Rainer Crone and David Moos, in Rainer Crone and Siegfried Salzmann, eds., *Rodin: Eros and Creativity* (Munich: Prestel, 1997), p. 28.

25. Ibid., p. 54.

26. Ibid.

27. Bruno Snell, *The Discovery of the Mind: The Greek Origins of European Thought* (New York: Harper and Row, Harper Torchbook, 1960).

28. See, for example, the wooden plaque from Samos illustrated by Boardman, *Greek Sculpture: The Archaic Period,* fig. 50.

29. See Boardman, *Greek Sculpture: The Classical Period,* figs. 38 and 39.

30. See, for example, Kasimierz Michalowski, *Great Sculpture of Ancient Egypt* (New York: William Morrow and Company, 1978), pp. 51 and 86.

Index

Note: Illustrations are indicated by *italicized page number*s

Books from Allworth Press

Beauty and the Contemporary Sublime
by Jeremy Gilbert-Rolfe (paper with flaps, 6 × 9, 208 pages, $18.95)

The End of the Art World
by Robert C. Morgan (paper with flaps, 6 × 9, 256 pages, $18.95)

Uncontrollable Beauty: Towards a New Aesthetics
edited by Bill Beckley with David Shapiro (hardcover, 6 × 9, 448 pages, $24.95)

Imaginary Portraits
by Walter Pater, Introduction by Bill Beckley (softcover, 6 × 9, 240 pages, $18.95)

Lectures on Art
by John Ruskin, Introduction by Bill Beckley (softcover, 6 × 9, 264 pages, $18.95)

The Laws of Fésole: Principles of Drawing and Painting from the Tuscan Masters
by John Ruskin, Introduction by Bill Beckley (softcover, 6 × 9, 224 pages, $18.95)

The Artist-Gallery Partnership: A Practical Guide to Consigning Art, Revised Edition
by Tad Crawford and Susan Mellon (softcover, 6 × 9, 216 pages, $16.95)

The Swastika: Symbol Beyond Redemption?
by Steven Heller (hardcover, 6 × 9, 288 pages, $21.95)

Design Dialogues
by Steven Heller and Elinor Pettit (softcover, 6³/4 × 10, 272 pages, $18.95)

Artists Communities
by the Alliance of Artists' Communities (softcover, 6³/4 × 10, 224 pages, $16.95)

Looking Closer: Critical Writings on Graphic Design
edited by Michael Bierut, William Drenttel, Steven Heller, and DK Holland
(softcover, 6³/4 × 10, 256 pages, $18.95)

Looking Closer 2: Critical Writings on Graphic Design
edited by Michael Bierut, William Drenttel, Steven Heller, and DK Holland
(softcover, 6³/4 × 10, 288 pages, $18.95)

Looking Closer 3: Classic Writings on Graphic Design
edited by Michael Bierut, Jessica Helfand, Steven Heller, and Rick Poynor
(softcover, 6³/4 × 10, 304 pages, $18.95)

Please write to request our free catalog. To order by credit card, call 1-800-491-2808 or send a check or money order to Allworth Press, 10 East 23rd Street, Suite 210, New York, NY 10010. Include $5 for shipping and handling for the first book ordered and $1 for each additional book. Ten dollars plus $1 for each additional book if ordering from Canada. New York State residents must add sales tax.

If you would like to see our complete catalog on the World Wide Web, or order online, you can find us at *www.allworth.com*.